DRAWING
TO
God

Art as Prayer, Prayer as Art

DRAWING
TO

God

Jeri Gerding

SORIN BOOKS Notre Dame, IN

© 2001 by Jeri Gerding

International Standard Book Number: 1-893732-24-X

Interior art by the author

Cover and text design by Katherine Robinson Coleman

Printed and bound in the United States of America.

Library of Congress Cataloging-in-Publication Data
Gerding, Jeri.
Drawing to God : art as prayer, prayer as art / Jeri Gerding.
 p. cm.
 Includes bibliographical references.
 ISBN 1-893732-24-X (pbk.)
 1. Prayer--Catholic Church. 2. Art and religion. I. Title.
BV215 .G47 2001
246--dc21 00-011331
 CIP

To my parents

with gratitude and love.

We play at paste,

Till qualified for pearl,

Then drop the paste,

And deem ourself a fool.

The shapes, though, were similar,

And our new hands

Learned gem-tactics

Practising sands.

 Emily Dickinson

Contents

An Invitation 11

Part One: Before You Begin 17

1. Working Guidelines 19
2. Buying and Using Art Supplies 27

Part Two: The Art Activities 39

3. Increased Awareness of the Inner Self 41
 Activity One: The Mandala 45
 Activity Two: Scribble Drawing 49
 Activity Three: Gesture Drawing 53
4. Increased Awareness of the Environment 57
 Activity Four: Contour Drawing 59
 Activity Five: Shorthand Expression 63
 Activity Six: Spark of Nature 66
5. Increased Awareness of God 71
 Activity Seven: Greeting Card 73
 Activity Eight: A Pattern of Praise 77
 Activity Nine: Illuminated Manuscript 82
6. Increased Awareness of Growth and Need 90
 Activity Ten: Examining Conscience 91
 Activity Eleven: Growth in Prayer 95
 Activity Twelve: Epiphany 100

7. Increased Awareness of Others 107

 Activity Thirteen: The Intercessory Portrait 108

 Activity Fourteen: The Holy Card 111

 Activity Fifteen: Discovering Art 115

Notes 121

Bibliography 123

An Invitation

The purpose of this book is to show you how to create your own artwork as a form of prayer. Unless you are gifted in art, and even if you are, the idea of drawing or painting and calling it prayer might seem strange. Drawing or painting are activities avoided by most people after they graduate from junior high school. Yet there was a time in the lives of each of us when we still had the joy of artistic freedom and happily drew pictures out of crayons, poster paints, sidewalk chalk, or whatever other materials were handed to us. Children draw because it is fun to make things. For them, art is a way of telling and showing and expressing how they feel, and they feel better for having done so. When left to their own choices, young children will most often want to make a picture for someone else, such as a parent or teacher, and they often will finish by writing the words "I love you" with lots of hearts and flowers all around. It is not only fun to make things, it is even more wonderful to make them for someone you love. It may be easier to think of art as prayer if you can reach back and "become like children" in your approach to this type of prayer, perhaps by imagining that God has a blank refrigerator door, is ready to receive your drawings, and will treasure them and find them beautiful even when you do not.

My interest in using art as prayer began after I was having difficulty finding meaning in making art, and my work had become stale. I revised my whole approach and started to paint a series of watercolors which expressed my feelings about prayer and my relationship with God. From there, I began to explore the possibility of not just recording prayer experiences but using the whole process as a form of prayer. My first attempt made use of the mandala (described in Chapter Three). When it came to actually making that first drawing, however, I felt reluctant and skeptical. For one thing, it was fun to draw in this unsophisticated fashion. How could this count as prayer when

prayer is supposed to be serious? This was too easy. Perhaps a precedent existed, but I could not think of one for doodling your way into the heart of God.

On that first day of experimenting, I made two mandala drawings. Upon their completion, I could see in the images a few of the same insights I knew from my "legitimate" times of prayer and meditation. The first drawing contained mountainlike shapes sharply rising up from the edges, which needed to be traversed in order to reach the blue water which lay beyond them. If I were walking in those mountains, I would be trying to rest in the waters of God and be healed there. The mountains seemed insurmountable and their sharp points spoke of anger or pain. Odd, wavy bird shapes flew about and reminded me of "ruffled" feelings. The word "pique" came into my mind, which I learned by definition means "to affect with sharp irritation and resentment, especially by some wound to pride." Unfortunately, since this drawing was made seven years ago, I can't recall the source of this resentment or difficulty, but on the back of the drawing I wrote a note, wondering if God intended for me to learn humility from this experience. Now I had much to think about.

The second drawing also showed a distant blueness, but this time a fortress or a series of barred windows walled it off. I wanted to breathe in the air from beyond those windows. In the center and within the walls was a compressed, amorphous shape which felt like inner tension seeking life and breath. The fortress represented some type of defense, but I was also compressed and trapped within it. Again I had unearthed something from deep within me, and was convinced this could become an ongoing part of my prayer life. For the next two years, I drew a mandala almost every weekend. Sometimes they were unclear, but almost always I could uncover some type of useful meaning. Some of the recurring images I carried over into other artwork. The experience was enriching. Later, I explored alternative approaches to using art as prayer with different materials and methods.

In order to understand how art and prayer fit together, it might be best to look at each separately. Art is primarily a form of communication and expression. As children, scribbling and early attempts at drawing happen before written words are employed. Art professor Peter London calls art "our native language." Art carries meaning and emotions for us in the form of a visual metaphor, sometimes made up of simple lines, shapes, and colors.

Prayer is a way of being with God. Thomas Merton describes it as a "yearning for the simple presence of God, for a personal understanding of his word, for knowledge of his will and for capacity to hear and obey him."[1] St. Teresa of Avila speaks of prayer as drawing near to Jesus in "intimate friendship." The *Catechism of the Catholic Church* defines prayer as "the raising of one's mind and heart to God" (613).

Art as prayer, therefore, is communication and expression in the form of a visual metaphor which is directed with the intention of our mind and heart toward God. To shift from art to art-as-prayer is a shifting of intention. It is not enough just to call it prayer and proceed. One must enter into the activity with a sincere, single-focused intention of seeking God. The overriding purpose is not to make art but to reach out to God. It is also not just to God, but with God, who is invited to share in the process of making, to guide and direct our efforts while we are working. It will be important to listen for God in the process as well as in the final product.

No artistic ability is needed to make art part of your prayer life. The activities in this book have been designed to help someone with no previous art training. The directions will guide you easily through a step-by-step process using many of the simple materials found in elementary schools, with only a few exceptions. These materials have the added advantage of being for the most part inexpensive and easy to locate. If you are a working artist, you might want to substitute with the art supplies you already have, or you might choose to use the childhood version as this may help to stop

the temptation toward performance and achievement which have nothing to do with prayer.

The activities have been divided into five sections (Chapters Three through Seven), each containing three different art-as-prayer experiences. Each section encourages increased awareness of a specific aspect of your life as it relates to your spirituality. Chapter Three involves the inner self, and these are brief, spontaneous expressions which will help you let go of tension and control. In her book, *Drawing on the Right Side of the Brain*, Betty Edwards explains how, in creating art, we utilize our capacity to "suspend judgement" and rely on intuition instead of logic and discourse. These first activities will allow you to bypass critical thinking and respond with a more gestural or bodily type of expression without preplanning what your work will look like finished.

Chapter Four involves observing nature outdoors and then engaging in activities which allow you to identify with God as Creator. You will attempt to listen as God speaks as a visual artist through the color and beauty found in the natural world. Working in this section will teach you to slow down visually. Mike and Nancy Samuels, who write on visualization and creativity, note how we are conditioned to scan images and rapidly condense information, thereby missing the subtle details. For example, if you were to compare the different experiences of saying the word "flower," seeing a flower, and then drawing a flower, you would find that until a drawing is made you do not truly know what a flower looks like. Art can also result from extending your gaze and reaching beyond merely what you see. Artists will try to capture not only the outward appearance but also the response of their innermost thoughts, emotions, and beliefs. The original subject matter may be transformed or abandoned altogether in favor of expressing this deeper response. What you will seek includes the spiritual, the discovery of God in nature.

Chapter Five focuses on your relationship with God. You will make artwork which praises and helps you to listen, as well as enables you to speak to God through visual

symbols. Symbols are important to prayer because they can express thoughts and feelings which are hard to put into words. Symbols can hint at the mystery of what is unseen and unknown. A wide variety of symbols have been used from the early history of the church to the present day. The cross, stars, thorns, ashes, and wheat are just a few of these. Chapter Five will enable you to utilize both traditional symbols and new ones you create as you listen and respond to God.

Chapter Six addresses areas of growth and need. When you produce artwork, you are also making a record which helps to remind you of prayer experiences or insights you may have forgotten. Self-expression contributes to self-knowledge, which is a significant aspect of spiritual growth. Art allows the experience of looking at feelings by giving them shape and form. This can reveal new insights about what is presently of concern and where you may be blocked in personal or spiritual growth.

Chapter Seven is meant to increase your awareness of others. This is done, first of all, by engaging in forms of intercessory prayer that use art to enhance your ability to empathize with those for whom you pray. Then there is opportunity to study works by selected artists to discover how others interpret their experience of the spiritual. Listening to others broadens your sense of God, and it may broaden your sense of art as well, which may be necessary if you are going to hear and understand what these individuals are sharing with you.

In general, increased awareness of the visual can give God another way to speak to us and gives us another way to respond, thereby adding variety to our prayer life. Art as prayer is not meant to be a primary form of prayer, but an adjunctive activity, added on to whatever an individual is already practicing. It may fit into a schedule, as something done on a weekly basis, for example, whereas a primary other form of prayer, such as silent meditation, would be done on a daily basis and given precedence when time is short. Effort has been made to allow completion of many of the activities in this book in about an hour, and those that

take longer can be set aside after an hour and finished over time. In this way, even individuals with limited free time will be able to participate.

We start where we are, in prayer and in art, and move forward by allowing ourselves to begin. The heart will not open under a closed mind, and so we prepare ourselves to try what is new and unfamiliar. We can be silly and enjoy ourselves and make discoveries that challenge our ideas about what prayer is supposed to be like. We can reenter the world we knew as children before adult inhibition set in, restricting us and leaving us unsatisfied. We can act on our desire to preserve special moments, like little snapshots, of this or that experience. We can have a place to go when we feel heavy with emotion and want to pour out our feelings. We can throw away what we don't like. We can make things that no one else understands. We can be true to our own voice, our own rhythm, our own choices, our own pace. Unlike the artist, however, we are not alone with our work.

If you are already producing artwork on a regular basis, it may seem strange in the beginning to invite God to be part of what has before been an apparently private undertaking. Expect God to be a welcome partner. Whether you consider yourself to be an artist or not, you will have placed yourself in the hands of a very sensitive and careful teacher, who will be guiding you and finding new ways of sharing with you through this approach to prayer.

PART ONE

Before You Begin

Working Guidelines

Art and prayer both involve trusting a process. What they share in common is that we don't know what's going to happen until we begin. We cannot control the outcome. If we could, it would not be worth doing because we would be practicing what we already know. The experience would remain at a superficial level and no new insights would be gathered. Minimal growth would take place. We tend to cope with uncertainty by avoiding what unsettles us. This is unfortunate because avoidance is a sure way to increase fear. The only real cure for fear is to do the very thing we are afraid of. Prayer will never become comfortable if we never pray.

Making art can teach us about confronting uncertainty and surrendering to a process we cannot control. Getting started solves the bulk of the problem, most of the time. It generally goes well once you begin. If you are a practicing artist, you will know that times of real anguish are rare. There is a quiet satisfaction, along with periods of genuine excitement, in the process of creativity. It would not be easy to give it up. Your artwork has challenged you, listened to your problems, given you escape and pleasure, and shown you endless new ways of considering the world, yourself, and anything else you care to look at closely. It has been a friend.

After getting started, fear can still creep in, manifesting itself in a number of ways: impatience, trying too hard, competing, and avoiding anything new or unusual. It can help to slow down. Alert and calm is a good state of mind to be in when you are producing art. Art educator Florence Cane advises her students to breathe and engage in rhythmic movements to free the body before beginning. She also discourages continuing to work if you are tired.[1] Take a break from the project if you feel your shoulders are tight and you are getting a little too determined. It may also help to adopt an attitude of play. Julia Cameron, author of *The Artist's Way: A Spiritual Path to Higher Creativity,* advocates this approach. Think of how you felt when you played with rocks, sand, or blocks when you were a child. Think about modeling clay and finger-paint. Think about the fun you had before you knew anything about trying to be perfect. Play is a great antidote for rigidity and perfectionism. Play also awakens your imagination and frees you to try things that are pure, original, refreshing, and avant-garde.

One thing that can interfere with making art is the ideas you hold about what art should be like, how to do it, and what constitutes good or bad art. Artists of the twentieth century have done a great deal to shake up our ideas about what art is supposed to be like. Art is no longer confined to conventional materials, such as paper and paint, and art is no longer bound by conventional subject matter. Art can exist as words on a screen or as a moment in time acted out in a public performance. Art can be made which seems to contain no visible display of technical skill. Artists have forced us to revise again and again the tools by which we measure them. All of these developments can give you permission to share in their freedom and not worry so much about comparing yourself to a standard. If you have trouble accepting the more recent developments in art, move back in time to artists from the early part of the twentieth century like Henri Matisse, Gustav Klimt, or Paul Klee. Their work is appealing because it is sincere and unencumbered.

Of course making museum quality art is not our purpose in using art as prayer. Depending on the activity, the art you make is either a record or journal of your experiences or it

is a gift, unwrapped and presented to God. You are opening yourself, making discoveries, and sharing all of this with God. Sometimes it will be only the process or act of creating and not the final product that is the focus. If you find yourself becoming uptight about how well you are performing, stop and remind yourself of the real reason you involved yourself in the first place, which was to pray. What do you imagine God is thinking about or listening for while participating in this task with you?

Remember to be sincere. Let the work reflect who you really are and how you really feel. Do not try to create some type of artist-image that is not you. It is important to be yourself not only in art but in prayer, and especially in prayer. As Sister Wendy Beckett tells us, "As soon as pretense steps in, prayer stops." It is also important to set aside the notion of pleasing others when you create art as prayer. You may decide to show the work to no one. After all, no one needs to see it, just as no one needs to know what goes on when you are alone in prayerful communion with God. There is nothing wrong with showing your work to others if you really want to, but there is no need to. You can pray "in secret." When you have genuinely expressed yourself, and your work is true, you will care less what people think or even what it looks like. You can make a misshapen, pathetic drawing and love it if it contains the expressions of your heart. On the other hand, you may not like what you have made because it reminds you of something scary or painful, but the work itself may be wonderfully expressive. It is not possible to evaluate your art (or anyone else's) simply based on whether or not you like it.

What If I Can't Draw?

If you are a beginner and not a practicing artist, your biggest concern might be that you "can't draw" very well, or at all. Artistic ability is not important or necessary for any of the activities contained in this book. Anyone can complete them. You might run into difficulty if you want to add a particular object (a person, a tree, a horse, a vase of flowers) and your efforts at trying to draw it only frustrate you. There are a few ways around this dilemma. You can:

1. Make a simplified symbol which stands for the object. For example, arrange and fit together circles, triangles, oblongs, and other shapes until they represent the object in a simplified way. Children make their first drawings using this system. Decorative pattern also derives from this principle of simplifying objects into geometric shapes (as in quilt patterns). Plastic stencils of geometric and other shapes can be used to construct the drawing.

2. Trace the object from a coloring book, needlework pattern, clip art book, magazine, etc. A few of the activities already call for tracing paper or transfer paper (described in Chapter Two). If it seems appropriate, cut out the actual object or make a photocopy of it and glue this right on to your artwork. Photocopies are especially useful because they can be enlarged or reduced. If one transferred image seems out of place or draws too much attention to itself, add a few more, as you would in a collage or scrapbook. Another idea is to take your own photograph and use it.

3. Utilize abstraction. For example, don't draw the tree; draw how the tree makes you feel. Describe your inner experience using nonobjective shapes, lines, and colors. After all, art is not about duplicating what you see; it is about self-expression.

4. If possible, sit in front of the object with a sheet of paper and try to draw it. If you've never done this, you

might be surprised at how well you do. It is difficult for any artist to draw an object without looking at it unless he or she has drawn it in the past or is well acquainted with it. If you can't locate the object, see if you can find a good photograph to draw from. Alternatively, try making a contour drawing of it first (see Chapter Four).

Another thought to keep in mind is that the finished work will rarely match what you first visualized in your mind. Sometimes the result will be better than what you imagined, and sometimes it will fall short. Sometimes it will be different because you deliberately changed your mind, and sometimes it will be that the unconscious mind has been at work, pulling on your illogical, intuitive capacities. Finally, if you are a beginner, you can take comfort in knowing that the activities in this book are rather structured. After sticking close to the directions in the first few attempts, feel free to wander away from the format given and follow your own inclinations.

Evaluating Your Work

At the end of most of the activities a few suggestions are given which lead you toward evaluating, interpreting, or reflecting on what you have made. Some activities call for more reflection than others. Art professor Peter London's ideas about evaluation will help point you in the right direction. He writes:

> Instead of asking, "Is it right?" . . . , we could ask, "How honest was I in disclosing what I know and feel? How deep did I allow myself to go? What range of new territory have I explored? How close to the center of my sense of self did I dare to go? What really resonates within me as true in the work, what is false, tinny?"[2]

Since the purpose of art is to express yourself and convey meaning, it makes sense to try to figure out what you have communicated. The meaning will be clear and straightforward or obscure and require a degree of probing. It may happen that you never know for sure what it means and have to settle for your vague notions.

Gregg Furth, author of *The Secret World of Drawings*, advises us to begin this process by considering the first overall impression of the picture. If you just walked in the room and came upon this artwork, what would your initial emotional response be? Be sure to record the date and any significant thoughts in pencil on the reverse side of the drawing or on a separate sheet of paper, as you will not be able to fully recall them later. The thoughts you had shortly after creating the piece are often the most interesting. Next, take note of what stands out as the most central feature. Describe its shape, color, size, etc. Move on to the next thing you notice and describe it, continuing in this manner until your eyes have traveled across the entire surface. A few other suggestions from Gregg Furth involve taking note of anything odd or out of place, anything distorted, anything missing, anything cut off by fences or other linear barriers, and anything that is repeated more than once.

Once you have made these observations, you can begin to make an interpretation. Look at the individual elements and ask what they remind you of or cause you to think about. Take note of how one section or object relates to another and how it is placed on the paper. Why do you suppose you arranged things in just this way? After considering its parts, look at the picture as a whole. If you started out with an idea or theme, does the work carry the meaning you intended? Are there any surprises? As you consider all of this, keep an eye out for spiritual content. You have invited God into this activity to create with you and have worked at being open and receptive. It is therefore likely that you will discover spiritual meaning in your work, because that has been your focus. These discoveries will be the most noteworthy. Has your artwork caused you to think about God, yourself, or spirituality in a new way?

What have you learned? Has this experience helped you in your relationship with God? It may be that you uncovered an area of need or resistance. It may also be that you have simply found a new way to worship, show gratitude, or otherwise express the desires and longings of your heart as you reach out to God.

Transitional Activities

At the beginning of each activity is a reminder to invite God to join you in the process of creating by praying in a way that is comfortable for you. This prayer can take any form: silent or spoken, brief or more prolonged, the same each time or different—it doesn't matter—just do what you normally do when you pray. Try not to skip this step. It will help set the stage for you and keep the experience prayerful rather than merely busy. Art is a private venture and, despite the fact that God is always with you, it is thoughtful to extend an invitation. It isn't necessary to continue to pray as you work, unless this enriches the experience for you. Some people have difficulty focusing on doing two things at once. It would be a good idea to call on God again when the project is completed and ask for help in understanding and interpreting the results.

Trappistine nun Miriam Pollard reminds us that "prayer isn't a thing or a performance but a personal presence and love."[3] She uses the metaphor of a vestibule to describe the transition we make from our active lives into the quieter atmosphere of prayer. Just as we pass from the outside world through the vestibule before entering a church, we can pass from noise and distraction into prayer by means of a transitional activity. Her suggestions include creating a sacred space in which to pray and quieting the mind through breathing, visualization, or a verbal prayer. Other suggestions might be to go for a solitary walk or do some stretching exercises. Soothing music can help. You might also lie down and rest until you begin to calm down and feel restored. Gathering art materials and clearing your

workspace can become part of a ritual. None of these activities needs to take long. If you are already somewhat quiet and composed, you may need little or no preparation time. Once you have reached a state of relaxed awareness, move on to your initial prayer, the start of your adventure.

CHAPTER TWO

Buying and Using Art Supplies

All but three of the fifteen activities can be completed using materials from the first part of the list given below. The second part contains the additional materials needed for Activities Nine, Twelve, and Fourteen. If you prefer to start out gradually, you may decide to purchase materials from the first part of the list, and save the final three activities for later. Since crayons, drawing paper, and newsprint are all you need to complete Activities One, Three, Four, and Five, you could also begin with only those few supplies before deciding if you want to go further.

Following these two lists is a description of the materials and some suggestions for their use. Most of the art supplies you will need can be found where school and office supplies are sold. For the rest, you will need to locate an art supply retail store or catalog. You can request a catalog through the mail. Companies may ask you to pay a small amount to receive your first catalog, which is often subtracted from your first order. If you are connected to the Internet, check to see if your supplier has an online store. After placing your first order online, a free catalog is often sent to you. A listing of a few well-known art supply companies can be found at the end of this chapter.

Art Supplies

Papers:

white drawing paper	newsprint
colored construction paper	graphite carbon
transfer paper	graph paper (optional)

Tools:

no. 2 pencil	colored pencils
fine-tip black marker	crayons or oil pastels
paintbrushes	scissors
ruler	mat (or Exacto) knife
eraser	plastic stencils
compass (optional)	

Other:

glue	removable scotch tape
tempera paints	paper towels
water dish	makeshift palette
freezer paper	cutting board

For Activity Nine:

gold metallic paper	correction fluid ("Wite-Out")
ink eraser	hot press illustration board

transfer type or plastic letter stencils in Old English style

For Activity Twelve:

watercolor paper	makeshift stretching board
brown paper craft tape	pan for soaking (optional)

For Activity Fourteen:

card stock	laminating film sheets

decorative papers, stickers, lace, etc.

White drawing paper can be purchased as loose sheets or bound together into a pad. It comes in different weights, and the number of pounds refers to how much 500 sheets (a ream) of paper that measures 17 x 22 inches would weigh. A weight of around 80 lbs. will accept paint as well as pencil. A few of the activities require paper that is 18 x 24 inches. You could buy a package of this size and cut it down to the size you need for the other activities.

Newsprint is the paper on which newspapers are printed. Artists use it as an inexpensive drawing paper, usually for rough sketches that will not be kept. A 50-sheet pad or package of 18 x 24 inch newsprint will keep you well supplied.

Colored construction paper costs very little and a 50-sheet package of 12 x 18 inch paper of different colors will meet your needs. The smaller 9 x 12 inch size will work for all but Activity Eight (A Pattern of Praise), which calls for a 12-inch square. You could reduce the size to a 9-inch square, if you have the smaller paper on hand and do not wish to buy more. You can substitute other colored papers for the construction paper, as long as they are not lighter in weight.

Tracing paper comes in pads or rolls. Buy the 11 x 14 inch size or larger. Buying by the roll is cheaper per inch, if you think you will eventually use the 50-yard length.

Graphite carbon paper is sometimes called "transfer paper." It works like any carbon, except it transfers a dark gray and can be erased if you haven't pressed too hard and have a sturdy eraser. It is possible to make your own graphite carbon by coloring one side of a sheet of tracing paper or newsprint with a pencil until it is filled in solid.

Graph paper is optional and may help with lettering and designing if you like to use it. The smaller notebook size paper with 1/4 inch squares is fine.

A *no. 2 pencil* is the only drawing pencil you will need.

Colored pencils vary in quality. Look for the brand name Berol Prismacolor or Faber Castell. Prismacolor is a popular brand and is not difficult to find. Better quality pencils have a softer lead and produce a richer color. The lead may also break off more easily, so be careful not to oversharpen. If you want a fine point, rub the edge of the lead tip against fine sandpaper or a scrap of your drawing paper. You can erase your pencil marks only if they were lightly applied, but you don't want to limit yourself to a light touch. Colored pencils are not opaque, and you can apply them in layers of overlapping colors if that suits your purpose.

A *fine-tip black marker* with permanent ink is used as a drawing tool. Look for the ultra-fine tip which has a metal casing enclosing the tip. Two possible brands are the Sanford Ultra-Fine "Sharpie" or the Pentel Super-Fine Point. The metal casing allows you to use the marker against a plastic stencil without marking it up.

Crayons and oil pastels both work well. Choose the one you prefer. Crayons are, of course, cheaper and easier to find. Crayons are soft and can produce attractive colors, but are not so soft that they crumble or rub off onto your hands. Oil pastels, on the other hand, have a tendency to do both, so you will want to keep a tissue close by to catch the little crumbs and to rub your pastels clean when they pick up smears of other colors from your drawing surface. Despite

these inconveniences, you may still prefer the creamy rich colors of the oil pastels, which resemble paint. Oil pastels come in round or square sticks. The square sticks give you the option of drawing a fine line at times by using just one corner. You can apply crayons in layers, and you can blend oil pastels by rubbing with your finger.

Crayons or oil pastels can be used in combination with colored pencils. In addition to supplying thin lines and small details, the colored pencils can smooth out the edges of a flat area of color and leave a clean line along the edge, which would not be so easy to accomplish with the use of crayons or pastels alone.

Tempera paints that are sold in plastic bottles for school use are of a slightly better quality than the sets of jars found at discount stores which are sometimes called "poster paints." The bottled paints come in varying sizes up to one gallon. You might initially invest in a starter set of 2 oz. bottles. Starter sets usually contain black, white, red, yellow, blue, and green. Tempera paint dries quickly and will dry out in the containers if they are not sealed well. Consider placing all six bottles in a sealed plastic bag or sealed plastic container for additional preservation.

Tempera paint is essentially an opaque watercolor paint with a gum arabic binder. It remains somewhat soluble when dry, which means that if you are attempting to cover a dry layer with a wet one, you may pick up some of the paint from the underlayer. Tempera paint can be thinned with water. If applied too thickly, it has a tendency to crack and flake off. Activity Twelve makes use of a "wet in wet" technique in which the wet paint is applied to wet paper, causing it to spread out rapidly into a streaming bloom of color. Using an almost dry brush with undiluted paint will give a textured pattern similar to wood grain. In general, however, you will apply paint by first dipping your brush in water, then into the paint, and applying it in strokes of fluid color on your paper. If you have not painted before, take out a sheet of scrap drawing paper and play with different brush strokes until you become a little more comfortable. Try mixing colors together and add white or black for

tints and shades. Brown is a color that is not included in starter sets, but can be mixed from equal parts of red, yellow, and blue.

Acrylic paint can be a substitute, if you prefer not to use tempera.

A *makeshift palette* for your paints can be any flat, clean, washable surface of a plain and neutral color. The plastic jar lids from coffee cans or large containers of food work well. A small plastic or glass tray or old dinner plate would work. Aluminum pie tins or trays are another possibility. Squeeze out a nickel size dab of each color and add more as you need it.

A *water dish* is for rinsing and dipping your brush. Change the water when it becomes murky. The water dish will also keep the brushes suspended in water until you are ready to clean them. A large, clean, plastic margarine tub or similar container works well. You can also use a glass jar. You might use both—a jar for soaking brushes and a tub for rinsing.

Paper towels will be needed to wipe too much water or paint off your brush or off your picture.

Freezer paper is useful for protecting your tabletop from paint spills and drips. The plastic coating keeps your table dry. As an alternative, use a few layers of newspaper.

Paintbrushes vary in quality. Any brush that is used for watercolor can be used with tempera paints. There is no need for you to buy expensive paintbrushes, but avoid the cheapest ones. Cheap brushes refuse to come to a point and will soon begin shedding their bristles. Camel hair is a good choice for a mid-range quality paintbrush. Another option is a synthetic white sable watercolor brush. Paintbrushes are available in numbered sizes and are either flat or round. Consider buying two: a no. 6 round and a 1-inch flat. A useful third brush to add would be a no. 2, to use for details. Your round paintbrushes should come to a point when wet.

If you take care of your paintbrushes, they will last a long time. Remember to stroke the brush while you are painting,

as opposed to scrubbing or twisting it against the surface of the paper. Do not allow the paint to dry in the brush. Keep it suspended in water when you set it aside while you are working. Do not, however, keep your brushes soaking on their tips for a prolonged period of time or they will lose their shape. Clean them in soap and water by adding a drop of liquid soap to your palm, then gently work up a lather and rinse. For bar soap, stroke the brush against it to gather soap onto the bristles. After rinsing, shape it into a point and allow it to air dry with the bristles pointing upward.

Scissors designed for precision or detail work have a finer point and a longer stretch between the hinge and handles. If you want to do more elaborate paper cutting, these might be worth considering. Another option for paper cutting is the scissors with special blades for cutting decorative edgings with scallops, deckles, and zigzags. Otherwise, all you need are the standard all-purpose scissors you have in your desk.

A *mat (or Exacto) knife* is needed to trim paper to the correct size.

A *metal ruler* is your best choice for use with your knife. A 24-inch ruler will be large enough for paper trimming, but small enough to use for drawing lines on your artwork. If you are buying one, look for one with a cork backing on the metal. This will raise the ruler off the paper to prevent ruled ink lines from smearing. If you can't find one with a cork back, adding a few layers of masking tape to the back of your ruler will achieve the same result.

A *cutting board* will be placed under your paper while you are cutting it with the knife. This will protect your tabletop. Any wooden board will work. Self-healing cutting mats are available for twenty to thirty dollars. Otherwise, layer a few inches of newspaper on a sheet of cardboard and keep checking to make sure you aren't cutting through it.

Trim your paper by making a few pencil marks where you will align your ruler. Draw the blade against the edge of the ruler, completing the cut in one continuous stroke. If possible, place the knife on the side you wish to discard, so if you

slip you will not have destroyed the side you wish to keep. Keep your fingers, hand, and body away from the path of the blade. An alternative way to cut paper to size is to hold the ruler firmly in place and tear off the discarded edge. This will give you a torn edge or deckle rather than a cut edge, but that may suit you just as well. If you are cutting a heavier board, such as the illustration board used in Activity Nine, you may find that making more than one pass down the edge rather than cutting completely through the first time gives you more control.

Glue in squeeze bottles, such as Elmer's, is preferred. Be sure to use it sparingly, by squeezing out tiny drops instead of trailing a long stream, which buckles the paper.

Erasers are designed for different purposes. A white, vinyl pencil eraser is good for most of your needs. The pink erasers on the end of pencils can stain the paper and tend to wear out quickly. An ink eraser may come in handy for times when the pencil eraser is too soft to erase completely.

Removable scotch tape is needed to hold tracings in place temporarily. It will not damage the surface of your drawing paper when you remove it.

Plastic stencils of geometric shapes will help you to create designs where shapes are repeated. Stencils will also give you structure if you feel uncertain of your drawing ability. You can find sheets of decorative stencils which contain hearts, stars, clouds, flowers, and all kinds of simple shapes in craft stores and in the wallpaper and paint department of discount stores. They are also for sale in office supply stores. It is also possible to buy a thick, soft, and translucent uncut stencil film. You can use it to trace and cut out your own design from a drawing or other source. It cuts with scissors or a knife.

A *compass* is optional and used for drawing circles. You can accomplish the same task by collecting plastic jar lids of varying sizes. If you search in your kitchen, you can find a variety of circles to trace, from plates to drinking glasses to vases and pan lids.

Watercolor paper is sold by weight just like drawing paper; the only difference is the standard size for 500 sheets is 22 x 30 inches instead of 17 x 22. An 11 x 15 inch pad of 80-lb. paper will meet your needs in Activity Twelve. The paper can be larger or heavier, if you prefer.

Watercolor paper needs to be stretched if it is to stay flat while it dries. The directions for stretching are given in Activity Twelve.

A *pan for soaking* the watercolor paper during the stretching process is optional. You can also use a clean bathtub or large sink. If you have a large pan, make sure it is clean. An oversized plastic storage bin can be used for soaking watercolor paper. Large paper can be rolled or doubled over to fit inside, just don't crease it.

Brown paper craft tape is also needed for the stretching process. It is usually about 2 1/2 inches wide. Be sure you have the tape that needs to be moistened and not the self-sticking type.

A makeshift stretching board is any flat surface larger than the watercolor paper you are stretching. This could be a cutting board or surface protector made from glass, marble, Plexiglas, or Formica. You will be able to return it to its former purpose when you are finished using it for stretching. A wooden board will also work, but use scrap wood you don't care about, as it will be exposed to water for a period of time.

Card stock is the material used to make index cards. Index cards are an acceptable substitute for making the holy cards in Activity Fourteen, unless you want to create a card that is larger than the 3 1/2 x 5 inch standard size. Plain, rather than ruled, cards are suggested, although you could glue two cards together with the ruled lines facing inside or cover the lines completely with decorative papers. Card stock is sold in packages of 8 1/2 x 11 inch sheets. If you are put off by the quantity you may have to buy in a package, consider substituting poster board, bristol board, oak tag, or you can even use the white cardboard used to package new shirts, stationery, or other items. Another

option is to buy plain white greeting cards and cut them apart. You can use some of the leftover cards for Activity Seven.

Laminating film sheets are sold in a variety of sizes, from the small, pocket-sized sheets intended to protect identification cards to larger 9 x 12 inch sheets. You can also buy film in rolls. The 9 x 12 inch size will accommodate holy cards of any size you decide to make. Make sure the film you buy is self-adhering and is not intended for use with a dry mounting or laminating press.

Decorative papers, stickers, lace, sheet music, wrapping paper, discarded greeting cards, paper doilies, aluminum foil, pages torn from magazines and old books, pressed flowers, and anything else you find which is flat and can be glued to paper are acceptable additions to your holy cards. These materials can be used in other activities too, such as the Illuminated Manuscript or the Greeting Card.

Gold metallic paper is needed to create the large initial capital letter in the illuminated manuscript page from Activity Nine. The paper can also be used as a decorative element. Look for the self-sticking sheets, but if you cannot find them, you may have to settle for the type you glue on yourself. If you cannot find the sheets, look for a metallic gold gift wrapping paper.

Correction fluid is found with office supplies. "Wite-Out" is one possible brand.

Hot press illustration board is sold in sheets. Be sure you are selecting hot press and not cold press. Hot press board has a smooth surface which will produce clean edges and fine details. A medium weight board is fine. The smallest size you can buy is usually 15 x 20 inches, and that is large enough for Activity Nine.

Transfer type or plastic letter stencils in Old English style—refer to Activity Nine for a detailed description of these materials.

Other Equipment and Supplies

In addition to the list above, you will want to gather together some additional supplies and equipment, most of which you will already have in your home.

An *inexpensive dishtowel* is useful for wiping up water when you are painting or stretching paper. You can use it for drying your hands after painting or using oil pastels, which will prevent your better quality hand towels from becoming stained.

A *drawing board* can be used as a makeshift easel to prop up your larger sheets of paper against the wall, as suggested in a few of the drawing activities. A wooden board, slightly larger than your 18 x 24 inch drawing paper, is ideal. If you don't have a wooden board and prefer not to buy one, you can tape your drawing paper directly to a wall or door.

Plastic storage bins will give you a place to store your supplies. The larger bins can be used to store paper and finished artwork.

Save a *file* of artwork from magazines, church bulletins, greeting cards, calendars, and catalogs to keep you supplied with ideas and sources of imagery.

Art Supply Catalogs

Sax Arts and Crafts
(800) 558-6696
www.junebox.com/sax

Pearl Paint
(800) 221-6845
www.pearlpaint.com

Utrecht
(877) 887-3248
catalog.utrechtart.com

Daniel Smith Artists'
Materials (800) 426-6740
www.danielsmith.com

Dick Blick Art Materials
(800) 447-8192
www.dickblick.com

Nasco Arts and Crafts
(800) 558-9595
www.nascofa.com

The Art Activities

Increased Awareness
of the Inner Self

The concept of inner self, as it is used here, refers to all that is deep within us. This includes both the psychological and the spiritual aspects of ourselves. We strive to know and understand ourselves better in order to grow. Opening ourselves by way of art places us in a receptive mode where God can step in and guide us to a better understanding of core parts of ourselves.

Self-knowledge is important to prayer. At some point in our ongoing relationship with God, we will discover places where we are in need of healing. We might find that we keep repeating the same mistakes despite our best efforts to uproot a problem. We might find that we continue to place a human limitation on God's ability to love. We might feel resistant to further growth and unable to pinpoint the reason. Any number of issues can emerge which are primarily psychological or spiritual or some combination of both. In addition to seeking the appropriate help for our concerns, we can use our artwork to help us gain a different perspective.

Art can release imagery from the unconscious which may give us the missing piece we were looking for or raise concerns previously hidden from view. The first two activities in this section, the mandala and the scribble drawing, have this potential. The emerging images can be interpreted in the same way dreams are: by thinking about the underlying meaning after decoding the visual symbols and determining what they are referring to. When an answer is found it will intuitively seem right.

If you allow the work to happen without too much control or rationality, there is an even greater chance of uncovering hidden impulses. As an example, suppose your finished picture resembles a battlefield, complete with shapes suggesting bunkers and dynamite. Everything is predominantly black and red except for the center which begins to blur and soften into a pale yellow. How would you interpret this? Battles can point to conflict, especially as it comes to a point of explosiveness. You might wonder if anything in your life is causing you conflict or if there is an inner turmoil at work inside you. Consider what the blurring to yellow might signify. Is it a sign of hope? Is the anger beginning to soften?

There might be some initial fear about uncovering what has been repressed and buried within us. The fear is usually about uncovering emotions which are intense or uncomfortable. One benefit of the process of making art is that strong emotions can be identified, released, and contained or redirected. Strong emotions, such as anger, will typically cause more problems if they are held inside rather than released. Our artwork gives us an opportunity to express and understand our feelings, rather than deny and repress them. In most situations, we won't feel overwhelmed by the experience, but more likely will feel enlightened, or perhaps relieved. We may feel as if we have gotten to the root of an important concern.

Sometimes we struggle against looking inward because we are afraid we won't like what we see. Many of us are uncomfortable with the darker side of ourselves, and it is not uncommon to think there is something wrong and that

we are better off not to know what is there. The truth is, if we dislike ourselves, we probably don't know ourselves well at all. If we take a closer look, we will find much to value and will end up with a more balanced and realistic view of who we are.

It seems important at this point to stress that uncovering repressed material need not happen every time. When it does happen, the results may be useful and interesting to consider, but this will be true even if such imagery does not appear. Sometimes you will have just portrayed a mood or concern you are well aware of and there is no need to probe for a deeper meaning. For example, a gray, somewhat empty and lifeless drawing will agree with your current depressed state of mind. There will also be times when the meaning of the work does not reveal itself and you may never know what it was about. If this happens, you may somehow still feel better for having expressed it. Be careful not to force meaning to make the attempt seem more successful. At other times, the work may not be all that significant from a psychological point of view. You may find yourself simply recounting the events of the day, perhaps by drawing bright colors with green and yellow after spending the morning in your garden. Your experience will vary with each attempt and the results will be satisfying for different reasons.

The purpose of all this exploring is to share ourselves at a deeper level with God. Miriam Pollard writes:

> Realizing how much God loves us as emotional beings can change our whole relationship to him. We will go to him when we feel awful. We won't stay away because he couldn't approve us until we feel all the correct things. . . . If we are confused, puzzled, doubtful, we will share it with him. Whether we get answers or not, because the confusion and doubt are part of us, and he wants all of us.[1]

In addition to the psychological, spiritual concerns will also reveal themselves in your artwork. Questions you have

been turning over in your mind or have brought to God earlier, perhaps in other forms of prayer, will surface in your drawings. Sometimes new insights will emerge with them. God can speak through your art and may choose to do so. You might find messages of hope and reassurance. You might discover new symbols which express your relationship with God. You might find that an earlier lesson learned but forgotten reappears. Art can cement this experience into a tangible product which, now that you have associated it with an image, stays with you.

Approach these exercises with the realization that you will never know yourself completely. There will always be an element of mystery about each one of us. Spiritual writers teach us that our ultimate identity is who we are in relation to God, and in order to discover this truth we will eventually, through grace, renounce our limited images of self. Thomas Merton writes that there "is only one problem on which all my existence, my peace and my happiness depend: to discover myself in discovering God."[2] In the meanwhile, as beginners in a life of prayer, we function with our images because they are what we have to work with.

As mentioned above, the following three activities are all done without any preplanning. Each of them can be completed in less than an hour. Your first efforts are often the best in terms of expression, and it is a good idea to begin working before you have too much time to think about it. Keep up the pace until it is finished. This will, hopefully, keep doubt and rigidity from creeping in. Allow yourself to do whatever seems to immediately feel right without stopping to analyze anything. You are relying completely on intuition and impulse. Enjoy the freedom of being loose and experimental. You have full permission to be yourself.

Activity One: The Mandala

The first activity will be the making of a mandala (pro-nounced MUHN-duh-luh). This ancient art form has an unknown origin. In her book *Creating Mandalas,* art thera-pist Susanne Fincher tells us "mandala" is a Sanscrit word which means "center, circumference, or magic circle." A mandala is simply a drawing or design inside a circle. It is found in different cultures and is often used for sacred purposes. A well-known example is the intricate Tibetan mandala which is made by dropping colored sand into a prayerful design of religious significance. Once it is completed it is gathered up and destroyed to represent nonattachment and the temporal nature of things. A Christian example of a mandala given by Susanne Fincher is the circular labyrinth, such as the one on the floor of Chartes Cathedral in France, which was developed in the

twelfth century and may have been used as a symbolic pilgrimage to the Holy Land, as a form of walking meditation. The making of mandalas has been used in art therapy since psychiatrist Carl Jung began experimenting with it in 1918. He writes:

> My mandalas were cryptograms concerning the state of the self which were presented to me anew each day. In them I saw the self—that is, my whole being—actively at work. To be sure, at first I could only dimly understand them; but they seemed to me highly significant, and I guarded them like precious pearls.[3]

After spending some time creating his own mandalas, he encouraged his patients to make them and found them to be a useful tool in treatment. He described mandalas as a "path to the center, to individuation." Individuation is Jung's word for self-realization or wholeness.

Mandalas can be drawn by anyone, including children, with good results. There is something about creating a circular design which seems to draw us inward. Susanne Fincher writes that "drawing a circle may be something like drawing a protective line around the physical and psychological space that we each identify as ourself."[4]

With its spiritual origins, the mandala appears to be a ready-made prayer form. It fits well into our explorations as we open our inner selves to God. The directions which follow have been adapted from Susanne Fincher's book.

Directions for the Mandala

Supplies needed:

no. 2 pencil	12 inch dinner plate
writing paper	white drawing paper (at least 14 x 14 inches)
crayons or oil pastels	colored pencils (optional)

1. Before you begin, be sure to invite God to join you in this process by briefly praying in a way that is comfortable for you. Close your eyes for a moment in order to clear your mind and try to relax your body.

2. Open your eyes and choose a color to begin. You may almost feel as if a color chooses you. Next, draw a circle on the center of your paper by tracing around the dinner plate with a pencil. You may use a colored pencil to trace the circle in your chosen color if you prefer.

3. Begin to fill in the circle with color and form. You may begin in the center or around the edges. Although it is fine if recognizable images, such as suns, flowers, or rainbows appear in your mandala, do not consciously try to draw them. Remember to follow your intuitive impulses and allow the drawing to grow by itself. Use colored pencils along with the crayons or pastels if you want to include fine lines or small details. Work until you feel the mandala is completed.

4. Now turn the drawing, looking at it from all angles until you find a proper orientation that "feels right" and mark the top of your drawing with a small "t".

5. Mark the date on the back of the mandala, and if you do more than one in the same day, indicate the sequence.

6. Look at your mandala for a few minutes, perhaps from a distance, and see if you can think of a title that reflects your first impression of the work. Note it on your writing paper.

7. You may also decide to list the colors you have used and then write your associations (words, feelings, objects, memories, etc.) that come to mind as you consider color. You may also repeat this step, concentrating on the shapes in the design. Another idea is to pretend you are very small and are able to magically walk across the surface of the drawing and note your impressions as you go. If you allow your imagination

free reign, different sensations of touch, temperature, road blocks, forbidden zones, and other unexpected experiences can emerge as you travel around the paper.

8. Attempt to express the central theme of your mandala, writing a few sentences. This can be derived from both the title and the associations. Be sure to record your final interpretation on the back of the mandala for future reference.

9. Sometimes the meaning of a mandala will be immediately evident. Sometimes it will be difficult, if not impossible, to come up with any verbal interpretation. Sometimes coming back to the same drawing a month or a year later will reveal fresh insights. Each time the experience is different and has its own value.

After you have made a few mandalas and are comfortable with the process, feel free to follow your own inclinations if you wish to deviate from the directions given here. You might find that initially, instead of choosing one color to begin, you want to pick two or three or even a handful. You might want to fill in the area outside of the circle or decorate its edges with a border design. You might want to begin with a smaller or larger circle. Just be careful to follow the basic format, which is to work in an unplanned and spontaneous fashion, using intuitive impulses to guide your choices. Don't stop to analyze until you are finished and, above all, don't try to make a pretty picture. Any time you try to force an outcome, you are pushing God out of the process.

Activity Two: Scribble Drawing

Scribble drawing is an art therapy exercise which originated in the work of art educator Florence Cane. Her innovative teaching strategies are outlined in her book *The Artist in Each of Us*, which was published in 1951. She would make use of sound, music, or bodily movement to help her students to loosen up and overcome their initial fear of picture making. One of her exercises begins with drawing a scribble, which is described as a "kind of play with a freely flowing continuous line" which is made "without plan or design." The next step is to look for a picture to emerge from gazing at the scribble, in the same way you might find recognizable forms in looking at clouds, and to retain the lines which bring out what has been seen. Florence Cane observed that young children would find simple objects

such as animals or flowers, and older individuals found objects which "very often reveal deep inner problems, conflicts, or aspirations."

The following prayer activity makes use of this method as a way to begin drawing. There will be times when an image seems to jump out at you from the scribbled lines almost immediately. At other times, some introspection is needed first. In either case, you want to wait until there is a sense of having found something of real significance to you before you stop looking. You will know when this has happened. After opening yourself in a prayerful way at the beginning of the activity, you might find your discoveries are often of spiritual relevance. As in the mandala, there might be psychological meaning in the final product. Be open to whatever happens and expect to be surprised.

Some suggestions are given to help with bringing your discoveries to a completed form. Florence Cane would allow her students complete freedom to finish the drawing in their own way. On a new sheet of paper, they would not replicate the scribble, but merely use it as a springboard to inspire the final work. There may be times when you want to try this option. Always feel free to break away from the format given below to follow your own impulses.

Directions for the Scribble Drawing

Supplies needed:

newsprint (about 12 x 12 inches)	no. 2 pencil
colored crayons or oil pastels	colored pencils
pencil eraser	fine-tip black marker
removable scotch tape	
white drawing paper (same size as newsprint)	

larger sheet of newsprint, newspaper, or freezer paper to protect work surface

1. Before you begin, be sure to invite God to join you in this process by briefly praying in a way that is comfortable for you.

2. Place the larger sheet of paper over your work surface to protect it throughout the activity. This will also enable you to feel free to run your lines on and off the edges of the paper.

3. Using the no. 2 pencil, begin in one continuous motion to draw a large loose scribble on your 12 x 12 sheet of newsprint. Allow your line to travel around the page and to overlap in places. As a variation, you might close your eyes while you draw the scribble or use your nondominant hand. When you are finished, use removable scotch tape to tack your drawing to a wall or some other vertical surface for viewing.

4. Stop and sit quietly, gazing at your scribble until you begin to see objects suggested by the lines. If nothing emerges, turn the paper to view it from another angle. It doesn't matter if you find recognizable shapes or an interesting design. For your finished drawing, you will be keeping only those lines needed to define your imagery. It is possible to rearrange and piece together shapes in the finished drawing.

5. After returning the drawing to your work table, use a fine-tip black marker to go over the lines you wish to keep. Locate a window you can use as a makeshift light box for tracing. Use removable scotch tape to attach your drawing to the window at a comfortable height. Determine where on the white drawing paper you want the highlighted areas of your scribble to appear and position it on top of the newsprint scribble, securing it with tape. Unless your drawing paper is very thick, you should be able to see the marker lines through it. Trace these lines on to the white paper using the no. 2 pencil. If you are satisfied with the results, you can discard the newsprint scribble.

6. At this point you may want keep the design as is or make changes with the addition of new shapes. The scribbled lines will create some interesting abstract shapes which you may feel give a modern look to your work. Finish off the drawing by filling it in with the crayons or oil pastels and colored pencils. One option is to create a stained-glass effect by tracing around the shapes using a black colored pencil and adding lines to represent the lead strips. You can break up larger areas of color into sections of "glass" divided by these black strips, and, if you wish to carry the illusion even further, slightly lighten or darken these individual broken areas by altering pressure on the crayon.

7. When you are finished, stand back and view the work from a distance. Listen for your first impressions. Does the image speak of any recent concerns or of your spirituality in any way? If it appears there is nothing to take from the image, or it just seems confusing, put it away for a while. Date the drawing and write down anything on the back which seems important to remember about the experience.

Artists generally allow their ideas to dictate the choice of materials and, after gaining a little experience with your art supplies, you will want to adopt this way of working yourself. For example, there is no reason why you need to stick with the 12 x 12 inch format for this activity. The size and shape of the paper can have an impact on the overall meaning of the completed artwork. Also, if you want to use an opaque substitute for the white drawing paper, such as poster board or black construction paper, you can transfer the scribble using graphite carbon paper. Refer to the chapter on art supplies for information about either buying or making your own graphite carbon and how to use it.

Activity Three: Gesture Drawing

If you were to take a life drawing class (human figure drawing from a live model) at any university or art school, one of your first lessons would involve gesture drawing. You would be instructed to sketch from the model, who would hold a pose of suspended action—such as swinging a golf club—and you would complete the drawing in less than a minute, using a crayon on rather large paper. If these were the only directions you received, after a few halting attempts you would discover that the time constraint allows for nothing more than a rapid scribble that vaguely looks like a stick figure in motion. You would have made your first gesture drawing.

Gesture drawing is the invention of Kimon Nicolaïdes, who taught at the Art Student's League in New York. His textbook, *The Natural Way to Draw*, was published in 1941. In it, he writes that gesture "is movement in space." When

making a drawing of this type, you first try to feel the movement in your own body and then, guided by this sensation, make a rapid drawing in one continuous motion, working to capture the essential action of the model. Nicolaïdes advises the student to "not draw what the thing looks like, not even what it is, but what it is doing."[5] He also writes: "In the first five seconds you should put something down that indicates every part of the body in that pose."[6] In doing so, you ignore the usual tendency to draw around the edges of the model's form. What you are making is a representation of something that is felt more than seen. You might start with a quick oval for the head and a line that traces the spinal cord followed by a loop or two to indicate the pelvis. From there you will make a rapid finish without lifting your crayon or pencil off the paper. The finished sketch will have a wildly scribbled appearance and might look a little like the marks you make on a paper when you are trying to get a reluctant pen to start writing.

Gesture is further defined as not simply movement or action. Nicolaïdes uses the example of a man sitting "as stiff as a poker." The gesture of the pose is implied, even though no movement is seen. He tells us that gesture applies to everything that is drawn. An example is the thrust of a tree growing upward. Inanimate objects also have a gesture, which we ascribe to them as we identify with the object through our own bodies.

Gesture drawing teaches us to be aware that what we are after is something much more than the surface appearance. We are interested in the quality or character of things, in the emotions they stir in us, and in our ability to capture meaning and tell a story with our pictures. Gesture drawing challenges us to pack a lot of power into our drawings using simple materials and minimal lines. The lines we draw are curvy or straight, wild or timid, sharp or soft, noisy or quiet, empty or full.

To complete the following prayer activity, you will not have the benefit of a model and will need to rely on your imaginative inner eye. If you are already familiar with gesture drawing, skip ahead to the directions below. If this is your

first attempt, try this exercise as a preliminary warm up: Gather together the supplies listed for the activity. Stand in the center of the room and assume an active pose (dance-like, one that expresses mood) and freeze—holding the pose, closing your eyes, and paying special attention to how your body feels. Note the different parts—shoulder, pelvis, feet, etc. What parts seem to contain the emotion? What parts are tense and what parts are relaxed? How does the overall pose feel in terms of energy—lifted up, intent, downtrodden? Hold this memory in your mind as you make a quick gesture drawing on the paper. Repeat this as many times as you need to, until you feel comfortable with the process. If it is helpful, set a timer for 45 seconds for each attempt so you will have a sense of how quickly you should be working.

Directions for the Gesture Drawing

Supplies needed:

a few large sheets of newsprint (about 18 x 24 inches)

a black crayon or black colored pencil

If you have an easel, use it here. If you have a large enough drawing board, it can be tilted against a wall on a table. Another option is to tape the paper directly to a blank wall or closed door. Otherwise, draw standing up with the paper laid out flat on a table. The main concern is to have freedom of movement as you work.

1. Before you begin, be sure to invite God to join you in this process by briefly praying in a way that is comfortable for you.

2. Sit quietly and close your eyes in preparation for a brief meditation. Select a scene from the life of Christ in which his emotions play a role. It may be a moment of tenderness or compassion. It may be one of agony and betrayal. It may be one of joy and glory. After you choose, picture this scene in your mind, elicit details

from your imagination, and try to make it as real as possible. If this is difficult, ask Jesus to help you. Focus on the emotional aspect of the scene and try to imagine as clearly as you can how he is feeling. Feel his feelings with your own body. Immerse yourself into the situation and empathize fully. Locate the parts of your body which contain the emotion. Freeze frame in your mind a posture which best describes the experience.

3. When you feel ready, pick up your crayon or pencil and quickly complete the gesture drawing in 30 to 60 seconds. Do not lift your crayon or pencil off the paper until you are finished.

4. At this point you may turn the paper over to make another drawing. If you make several drawings in a row of the same pose, you may find yourself becoming looser and more specific. You can also return to the first step and pick another "frame" to draw.

5. The appearance of the completed sketches may be interesting to consider, but are not all that important. The central feature of this activity is experiencing empathy for Jesus and reflecting on him. The drawing helps you to focus. It may also cause you to consider a familiar event in a new way. Date and title the drawings.

All the activities in this chapter have the advantage of needing no preliminary inspiration or information gathering. You can jump right in. You may want to keep these in mind for those times when you are low on time and energy but still want to pray and create something. These activities also give the timid beginner a place to start. Some of what is learned here can carry over into the exercises in the upcoming chapters.

Increased Awareness

of the Environment

If we think of God as the artist of all created things, we need not puzzle long when we so easily sense the spirit of God in the beauty of nature. It may also be that we are more open and receptive in this outdoor environment, especially if we are alone. The art activities in this chapter will enable you to become more aware of God's signature in nature as you learn to see as an artist sees.

The first activity begins with contour drawing, a fundamental in any art school curriculum. Contour drawing is a mindful, meditative way of looking. It will slow you down so you are not simply scanning an object, but truly seeing it. Your art can come from whatever habitat is nearby—the desert, the woods, a beach, a meadow, or even the vegetable garden in your backyard. Take a walk through these places and observe what is around you. Awaken all of your senses. Try to memorize details that interest you. Notice pattern and texture (touch things). Notice color, light, and atmosphere. Look at things close up and far away. Notice what is overhead and what is underneath. Practice being

aware and receptive, but do not pressure or force yourself to have a certain type of experience. As an experiment, try stopping along your path and become very still and quiet, as if you are invisible. After a little while, the birds and other animals will become more active and you will be able to observe some of what goes on when you are not there. As you contemplate the beauty and mystery of your surroundings, you might remember that you are also a created part of this scene—and just as lovely to God.

In using art as prayer, we record our experience in order to enter more deeply into it. As Roger Lipsey states in *An Art of Our Own: The Spiritual in Twentieth-Century Art,* we see with spiritual sight by "'looking beyond' or looking more deeply within." He writes:

> Developed eyes for art measure not only the distance between two points but, so to speak, their common distance from God. They see form, and then its power as a symbol for some part of life or for the whole. A tower is not only an impressive pile of brick or stone, it is a vertical symbol between the lower and the higher. The question is how effectively and with what new insight it expresses its larger function.[1]

We have all shared the experience of the cathedral-like splendor of the forest, the divine majesty of the mountains, and the heavenly scent of fresh pine. If we keep in mind our desire to seek God and learn more about the spiritual as we study the natural world, we are likely to stumble onto more of these symbolic images.

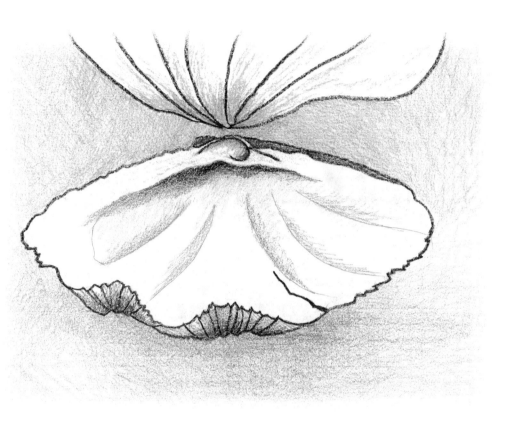

Activity Four: Contour Drawing

Kimon Nicolaïdes, who invented gesture drawing (used in Activity Three), also invented contour drawing as a practice exercise for art students. What most distinguishes this type of drawing is that it is done without looking at the paper. While gazing only at the object, the eye is coordinated with the pencil and both move together at the same time. The focus is on sharpening perception and noticing every detail. He advises working "slowly, searchingly, sensitively."

Directions for the Contour Drawing

Supplies needed:

writing paper	no. 2 pencil
drawing paper (approximately 9 x 12 inches)	crayons or colored pencils
newspaper	

1. Before you begin, be sure to invite God to join you in this process by briefly praying in a way that is comfortable for you.

2. Select an object from the natural world that somehow sparks your interest. The object should be small enough that you can easily carry it with one hand and have a form that is at least a little complex. Examples are a branch, a piece of driftwood, a section of a leafy plant, a pine cone, a seashell, or a few dried autumn leaves.

3. Take a moment to become acquainted with the object you have chosen. Rub your finger across its surface texture. Does your object have a particular scent? As you observe, take some time to make a few written notes about the following:

 a) Why do you think God designed this object in this particular way? See if you can imagine our Creator's touch, carefully conceiving and sculpting this fragment of nature with the care and love of a master craftsman.

 b) Listen to the object as if it could tell you its story. How has it changed during its life span? Think about where it has lived and how the environment, weather, or change of seasons may have affected it.

 c) Do you know what it was about this object that caused you to select it? What essentially appealed to you? Does it have a mood or a personality? How does

it make you feel when you look at it? What does it cause you to think about?

d) Finally, is there anything you might learn from this object about God or about life or perhaps simply about art and design?

4. Place your drawing paper on top of a sheet of newspaper (to protect your work surface if you happen to run your lines off the edges of the paper). Now turn the object in different directions until you decide from which viewpoint you would like to draw it. Remember that contour drawing is done very slowly and mindfully while looking at the object and not looking at the paper. Begin by locating a spot on the outside edge of your object from which to begin drawing. Place the point of your pencil on the paper. Hold this position until you can imagine you are touching the object with the point of your pencil. Very slowly move the pencil as you are tracing around the form, noticing and recording every tiny curve and indentation, until you come to a natural stopping point. Then you may glance down to reorient yourself, shift the pencil to a new point and begin again, working until you feel the drawing is finished. Try to exactly coordinate the movement of the pencil with your eye. Do not worry about proportions or what the final product will look like—it will be distorted.

5. When you are finished, stop and reread the notes from step 3. Your drawing may tell something about what the object looks like, but the words tell a more important story about the meaning it carries for you. Out of your written notes, select what seems most significant to you.

6. Your task now will be to complete the drawing in such a way that it carries your message visually using crayons or colored pencils. Feel free to erase, change, distort, or darken any lines you have already drawn and to add whatever new lines, patterns, or images you

need to emphasize certain characteristics. You can even incorporate words into the drawing if you like.

7. When the final work is completed, look at it from a little distance. Does it express what you originally intended or has something different emerged? Be sure to record today's date on the drawing and keep your written notes for future reference.

Activity Five: Shorthand Expression

As mentioned in Activity Three, gesture applies to everything that is drawn. This activity will involve seeking the essence of what you observe in the natural world through the use of gesture drawing as defined by Kimon Nicolaïdes. As you may recall, gesture drawing is done in one rapid continuous motion which completes the drawing in less than a minute. Nicolaïdes writes that gesture relies on "sensation rather than thought." When you encounter a subject, you respond to it emotionally and can feel its movement or energy in your body. The gesture results when you spontaneously capture that impulse on paper. You are drawing what you sense or feel rather than what you see, and the resulting picture may look nothing like the subject at hand. To obtain the desired intuitive response, work quickly before you have too much time to think about it. Because it

is rapidly made, the finished product will look a little wild and scribbled. Even if you are unhappy with your drawing, the exercise will have given rise to a deeper response than simply looking at an object because it forces you into a different way of perceiving.

Before beginning this activity it is necessary to first spend some time outdoors in search of a subject. Look for some part of the natural world which seems to be alive for you. It could be a cluster of tall grass blowing in the wind, a wave hitting the shoreline, the falling of leaves, or the scurrying of birds or insects. Focus on one aspect rather than trying to capture a whole scene. As you observe, pay particular attention to rhythm, movement, and energy. Allow yourself to be still and receptive as you absorb sensory information about what you see and experience.

Directions for Shorthand Expression

Supplies needed:

several large sheets of newsprint (18 x 24 inches)

one sheet of white drawing paper (18 x 24 inches)

crayons or oil pastels

1. Before you begin, be sure to invite God to join you in this process by briefly praying in a way that is comfortable for you.

2. Lay out your first sheet of newsprint and select one crayon in a color which you feel best expresses your intention. In order to be certain you have nothing restricting the movement of your crayon, you may choose to either tape your drawing paper to an easel or wall or stand up with your work flat on a table. You will be making and throwing away a number of practice drawings before executing the final work, so let nothing inhibit you at this stage. Allow your image to fit the large size of the paper. In your mind, return

yourself to the outdoor scene you have selected and begin, remembering to draw only the energy or movement—the gesture.

3. After completing the first practice drawing, think about how you might make it even simpler and more to the point. What lines can be eliminated or changed? Make another practice drawing.

4. Repeat step 3 as many times as you need to until you are satisfied with the result.

5. Stop a moment and reflect upon what has happened thus far. Try to describe for yourself what steps you have taken in your mind as you moved from your initial observations to this last sketch. Has this experience awakened anything deeper in you? What is the movement, energy, or essence on which you have been focusing? If you were going to write a spiritual poem or song using this image as a metaphor or symbol, what would you say or what would it sound like?

6. When you feel ready, take the sheet of white drawing paper and prepare to make your final drawing. Look over all of your newsprint drawings and decide what you like or dislike about them. One drawing may stand out as the best or you may find favorite qualities in two or three. Complete your final drawing. Turn the paper over and record any significant thoughts on the back along with today's date.

You may find with this activity that it is not the drawing itself which is of importance but the insights you gather. It may be the sequence of events that tells a story for you, that is, for example, what happens from the time the leaf leaves the tree until it lands on the ground. It may be the actual rhythm or pattern of the movement that speaks to you. As a variation to this activity, you might try capturing the gesture of a subject that is not actually in motion. Refer back to Activity Three for a discussion of applying gesture drawing to inanimate objects. Another variation is to work with more than one color.

Activity Six: Spark of Nature

Theology professor Kathleen Fischer has written that "artists open up the way to contemplation by showing us the hidden qualities of our inner and outer worlds."[2] Our discovery of the spiritual in nature results from an increasing sensitivity to what happens in our inner world as we observe the outer world of the environment. As you wander through the woods, for example, or the city park near your home, allow something to spark your interest. It might be the shimmering reflections of light on water, the linear patterns on a stone, or the soft dampness of moss on wood.

What catches your attention need not be visual—the chanting of birds might stir you or a tiny rush of wind. Deepen your experience by asking what this reminds you of or causes you to think about. It might be that when you think of a foggy day it reminds you of how faith is shrouded in mystery. Or you might imagine a few rays of sun breaking through, which gives you hope. Or you might consider how a very still pond reminds you of perfect prayer. When you translate this into art, you will want to portray the fog (or the sun or the pond) in a way that shows this underlying meaning or message. One way to do this is through abstraction.

Artist Nathan Cabot Hale defines abstraction as "drawing out the essential qualities in a thing, a series of things, or a situation."[3] You have already used abstraction in this chapter and the previous one. There are many ways to abstract an image. What follows is a listing of some common methods:

Simplify: Eliminate unnecessary details. Turn complex shapes into simple shapes.

Distort: Alter size, shape, texture, etc. Elongate or shorten. Use unnatural colors to carry emotional impact. Draw things out of proportion.

Isolate: Draw attention to the most important part of your picture by altering its size, adding flashy details, placing it against a plain background, surrounding it with light, or making it brighter or darker than the surrounding elements.

Cut up and rearrange: Take apart a form and move it into a different position. Allow wings to grow out of a tree trunk. Show two viewpoints at the same time or show a sequence of events—such as a rock changing into a seagull and taking flight.

These departures from reality do not seem so foreign to us because we encounter them regularly in our dreams. Our unconscious mind does not hesitate to distort reality in order to convey meaning. Abstraction is a preexisting, inherent language for us.

Be sure to take a look at work by artists who abstract from nature in making their paintings. Doing so will enable you to understand how abstraction can be used to carry meaning, and might also give you ideas to incorporate into your own pictures. Here is a partial listing of these artists:

Paul Cezanne	Vincent van Gogh
Paul Gauguin	Paul Klee
Piet Mondrian	Georgia O'Keeffe
John Marin	Arthur Dove
Joan Mitchell	Helen Frankenthaler
Adolf Gottlieb	Joseph Stella

The degree of abstraction need not be overly dramatic in order to make your point. Sometimes artists remain rather faithful to realism while still carrying their message. However, some degree of abstraction is critical to meaning in any work of art, as Georgia O'Keeffe has written:

> It is surprising to me to see how many people separate the objective from the abstract. Objective painting is not good painting unless it is good in the abstract sense. A hill or tree cannot make a good painting just because it is a hill or a tree. It is lines and colors put together so they say something. The abstraction is often the most definite form for the intangible thing in myself that I can only clarify in paint.[4]

Directions for Spark of Nature

Supplies needed:

white or colored drawing paper	writing paper
pencil	crayons
scraps of colored paper	scissors

glue tempera paints

paint brushes paper towels

palette water dish

freezer paper to protect working surface

1. Before you begin, be sure to invite God to join you in this process by briefly praying in a way that is comfortable for you.

2. After you have found an outdoor subject, take notes using a pencil and writing paper and ask yourself: "What exactly it is about this particular aspect of nature that has aroused interest in me? Specifically what part of the image appeals? What sort of feeling does it awaken and what does it cause me to think about?" Try and complete sentences beginning with: "It is like . . ." or "This reminds me of. . . ."

 Begin to visualize what the final product might look like. Allow your thoughts to wander as you open yourself to different interpretations of your idea. Do you want to depict a whole landscape or zero in on one or two elements? How will you abstract the images? Close your eyes if this helps you to focus. Continue to write (or sketch, if you prefer) whatever comes into your mind.

3. Once you have found your idea, you will need to decide which art supplies would best portray it. (Refer back to the chapter on materials if you need assistance with using art supplies.) Remember you can also combine materials together (pencil and crayon, paint and crayon, crayon and cut or torn paper, etc.). Do you want white or colored paper? What size and shape will this final work be? Do you want to plan it out or just start in and see what happens? Give yourself the freedom to trust your imagination—even if the final picture is so abstracted that you can no longer recognize what originally inspired it. If you find yourself

wanting to include a particular element but "can't draw it," refer back to Chapter One.

4. When you are finished, stand back and notice your overall first impression. Does anything stand out? Is there a feeling? How well does it carry the deeper meaning you intended to portray? Does anything surprise you? Can you think of a title or would you prefer not to impose words on your work? Note any impressions on the back of your picture along with today's date.

There are endless ways to vary this experience, especially in terms of art materials. One idea, which may not occur to you, is to begin with a black sheet of paper and allow the night sky to inspire you. It is difficult to consider the immensity of our universe without thinking of God. Observing the sky during the daylight hours will also provide you with endless study, for it is indeed a canvas on which God appears to be constantly experimenting with an invisible paintbrush.

Increased Awareness of God

A symbol is an outward and visible form for an inward or invisible reality. Artists will borrow from the outside world to explain what is happening within. If a black, sharp, and jagged line appears on the canvas, it carries meaning because it reminds us of lightning bolts, the darkness of night and a stormy sky. Immediately we imagine anxiety or pain. A single line can carry the meaning of many words. Symbolic language is both concise and deep.

Religious traditions are full of visual symbols. Since it is impossible to explain the mysteries of our faith, we rely on symbols to represent what is invisible or beyond description. Candles, palm branches, lilies, ashes, water, and incense are examples. God also speaks to us using this language. In the Bible many examples can be found. God is in the burning bush, the wind, and the pillar of cloud and fire. God is the potter and we are the clay. Jesus is the vine, the way, the light, the lamb, the cornerstone, and the bread of life. So many religious symbols exist that dictionaries have

been published to list them, such as the recently reissued *Signs and Symbols in Christian Art* by George Wells Ferguson.

Symbols are an important part of worship and prayer because we can communicate through them our heartfelt, and sometimes difficult to express, inner feelings to God. For our purposes, it is fine to stay with what is familiar and traditional, but there will be times when you want to come up with new symbols of your own. It doesn't matter if your inventions at times result in artwork that would be confusing to anyone but God. In intimate relationships, people will often share a private language in which objects or words are given a meaning understood only by them. After all, the symbols we are all familiar with today had their origins in someone's private thoughts.

The first activity described below involves speaking directly to God in a handmade greeting card. Its design and format can be relatively simple to complete. The next two activities combine what we know about God through scripture and other sources with our own (symbolic) decorative ornament or pattern. If you are a beginning artist, it is important to complete Activities Seven through Nine in order as each builds on skills just learned in the previous exercise. When you first start out, you will probably be focusing more on learning how to make the art rather than on expressing yourself. Once you are comfortable with the technical aspect, you can direct your attention more toward personal expression and the results will be more satisfying. Also, in this group of activities, you can at times indulge in your desire to make suns, rainbows, flowers, little birds, and other light and lovely decorative forms.

Activity Seven: Greeting Card

Greeting cards allow us to share our tender feelings with others. We may give a card to someone on an occasion, but it isn't necessary to have a special event in mind to create your card for God. It may be that you are simply thinking of God and want to send a simple message, as to a friend. Your card can be used to express gratitude, praise, to ask forgiveness, or to express affection, as you would in other forms of prayer. You can share with God some recent news or just the details of your day or anything else you happen to be thinking about. You might especially want to bring up anything which is causing doubt, confusion, or separation in your relationship with God.

The directions which follow are intended for the beginner. If you have experience making art, feel free to venture off on your own at any point after you grasp the basic concept.

Directions for the Greeting Card

Supplies needed:

paper, such as white drawing paper and colored construction paper

tracing paper	graphite carbon paper
notebook paper	glue
scissors	removable scotch tape
pencil	ruler

fine-tip black marker or colored pencils

plastic stencil for tracing geometric shapes

graph paper (optional)

1. Before you begin, be sure to invite God to join you in this process by briefly praying in a way that is comfortable for you.

2. Establish the purpose for your card in your mind. On scrap paper, spontaneously write down your thoughts, addressed to God, in a paragraph or two. This may take the shape of a brief informal letter. When you are finished, condense the message to a length suitable for a greeting card by pulling out your main points and rephrasing them if necessary.

3. If this is your first attempt and you are feeling a little intimidated, complete the card using only the words to make up your design. In this way, you need only to solve the problem of forming and arranging the letters. Think about designing the letters to fit the message. Important words can be emphasized by making them larger or in a brighter color. Color can also be selected to match the feeling the words are expressing. Some or

all of the letters can be handwritten using marker or colored pencil, and some or all of the letters can be cut out of colored construction paper using one of the following four methods:

a) Write (in cursive) or print the letters at least 1/2 inch high in your usual handwriting on lined scrap paper or graph paper. Tape the paper, print side down, to a window (which works well as a substitute light box) and trace the letters, which will cause them to appear in reverse. Remove this from the window and trace the reversed letters, using the graphite carbon, onto the colored paper you have selected. This way, when you cut them out, the traced lines will be on the back and will not show when you paste the letters onto your card. When you cut, you will be adding some thickness to the letters, which is why they needed to be of a bigger size or you would not be able to cut around them easily.

b) Use graph paper to help you form block letters of even thickness, then trace and cut as you did for the letters in method A.

c) If you have a word processor or computer, you can use those letters as they are or use them as a pattern, then trace and cut as you did for the letters in method A.

d) Simply cut out the letters without a pattern, keeping them informal and irregular.

4. Complete the card by arranging the letters on scrap or graph paper to determine the size of your final work. Some of your letters can go on the inside of the card, or you can leave the inside blank. The card itself will be cut out of white or colored paper using scissors. Fold the card in half before you cut, so the edges will line up.

5. At this point, you have the option of writing additional thoughts on the inside of your card. You can make or

find an envelope, which will keep the card a little more private, or do without an envelope.

6. After you have made a few cards or when you feel ready, you can add a single symbolic image to go along with the words. The image will be very simple, so you need not worry about being able to draw. You can incorporate these directions into step 3 above:

 a) Reread the words you have written. Close your eyes and allow the words to suggest some type of visual symbol, such as a feather in a cloud, a heart surrounded by a wreath, arrows pointing in different directions, a wilting flower, an open window, or anything else which presents itself to your mind.

 b) Simplify that image by first eliminating any unnecessary details. Then reduce the image to very simple shapes. The shapes can be geometric (triangles, squares, circles, etc.) or freeform and irregular, but very simplified. Commercially cut plastic stencils which contain geometric shapes of different sizes can help you construct your image, which is then cut out of colored construction paper.

 c) Cut out all of the shapes and arrange them on the card, making sure you are satisfied before gluing them down.

If you prefer, instead of a brief message, you could compose a poem for your card. Looking at greeting cards when you are out shopping can give you an endless supply of other ideas for adding variety to these basic directions.

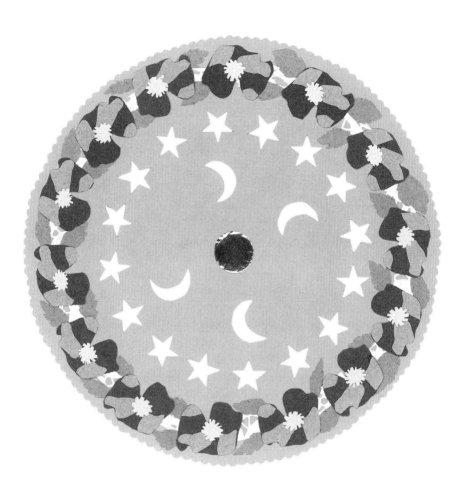

Activity Eight: A Pattern of Praise

Pattern is created when a single shape or image, referred to as a "motif," is repeated many times along the path of a grid or network, as in a quilt pattern. Many examples of historical and present-day use of pattern can be found in our churches and cathedrals. We find them in stonework and ironwork, in wood carvings, in tile floor patterns, in border designs on vestments and altar cloths, and in stained-glass rose windows. In this activity, you will be cutting different types of patterns out of colored paper.

Paper cutting has a tradition of its own, and the production of stencils, valentines, and portrait silhouettes are just some of its offshoots. In Europe, early cut paper work often had a

religious theme. In *The Paper Cut-Out Design Book,* Ramona Jablonski writes:

> In the Middle Ages, when the Church was the only stable institution left in western Europe, cloistered members of religious orders became the leading artists and craftsmen of the day. Their "Klosterarbeit" or cloister work took many forms. Medieval manuscript illumination was practiced widely and was well known. At the same time, almost as a recreational activity, religious paper-cuttings or "prayer pictures" developed. These usually featured sacred scenes or figures cut from single pieces of paper and intricately hand-painted. They were used by the monks as gifts to one another or to laymen in commemoration of religious occasions. Sometimes they were done simply as a religious exercise.[1]

You may recall cutting snowflakes out of folded paper as a child. Those skills will be put to work again as you complete the following activity. Experienced paper cutters like Chris Rich, author of *The Book of Paper Cutting,* recommend keeping your hand stationary and turning the paper as you cut. If you plan to do a lot of paper cutting, use scissors with small blades and sharp points, such as surgical, embroidery, or manicure scissors. Art supply catalogs will carry scissors that are used for precision or detail cutting.

On the average, it will take you about an hour to design your piece and two additional hours to complete it. You may choose to spread this over more than one session.

Directions for a Pattern of Praise

Supplies needed:

colored construction paper notebook
 paper

tracing paper	graphite carbon paper
removable scotch tape	glue
scissors	ruler
pencil	graph paper (optional)

plastic stencils for tracing geometric and other shapes

compass for drawing circles (optional)

1. Before you begin, be sure to invite God to join you in this process by briefly praying in a way that is comfortable for you.

2. Before proceeding, you will need to decide on a theme. Out of the theme will come a series of symbols which describe it, and these will combine to form the pattern of your finished work. As an example, if you choose the Holy Spirit as your theme, your design might incorporate a dove, rays of light, and flames or tongues of fire. As an option, you might invent and add personal symbols of your own to represent the Holy Spirit.

3. Good sources for symbolic imagery to fit your theme are the scriptures, a dictionary of symbols such as *Signs and Symbols in Christian Art* by George Wells Ferguson, mentioned earlier, or the *Dictionary of Subjects and Symbols in Art* by James Hall. You might also want to consult your library for other ideas and resources.

4. You will now have in front of you a written list of the symbols you have selected. You may want to narrow down the list, if it is lengthy, so that it consists of no more than four or five symbols. It is fine for you to choose based on whether a particular symbol can be easily translated into a simplified visual image.

5. On scrap paper (or graph paper, if you prefer), try to simplify the image by removing all unnecessary detail.

Construct your symbol out of geometric shapes (or simple freeform and irregular shapes) with the aid of the plastic stencils, a compass, or a ruler. Experiment until you find something that works for each of your four or five choices. If you feel unable to draw one of your images and can find a picture of it, feel free to reproduce it by tracing.

6. Your final work can be in the format of a circle or a square. If you choose the circle, use a dinner plate or a compass to establish the size it will be, trace the circle onto a sheet of tracing paper, cut it out, and fold it in half twice. Unfold it and cut out one of the four pie shapes. To use the square format, you need to draw a square that is 1/4 the size of your finished piece on a sheet of tracing paper and cut it out.

7. Arrange your symbolic motifs from step 4 into a design that fits within the boundaries of your pie shape or small square. Keep in mind that in the final piece, this smaller design will be traced and repeated four times. If it is necessary to have a specific number of elements in the final work, such as twelve stars, you would only draw three stars in the small section. If there is an element you do not want to repeat, consider placing it in the center of the design and adding it later, after tracing the rest.

8. Visualize how the piece will look completed and decide what colors of construction paper you will need for the motifs and the background. Make sure there is contrast between any edges which touch and between the motifs and the background. Next you will individually trace each of the motifs that make up your design. Tracing paper is translucent, which enables your image to be visible from the reverse side. Trace from that reverse side of the tracing paper onto the construction paper using your graphite carbon, so the transferred pencil lines will be on the back after the pieces are cut out. Each individual piece will be traced and cut four times and then reassembled into your finished design.

Assemble all of the cut pieces before you glue anything down, so you have an opportunity to make last minute changes. If you are designing a square, read step 9. If not, skip ahead to step 10.

9. The circle will fall into place easily, as there is only one way for the pieces to go. The square is a little more complicated as there is more than one way to position the four smaller squares. They can line up all facing in the same direction, they can be alternated with two of the squares upside down, or they can be arranged in a rotation—all sharing a common corner—as in a pinwheel. Decide what arrangement you prefer and take careful notice before you glue to be certain you haven't accidentally faced one square in the wrong direction.

10. All that is left now is gluing the pieces onto the background. A common mistake is to squeeze out too much glue, resulting in a surface that will not stay flat as it dries. Tiny dots of glue are all that is needed to adhere paper together. If you apply too much, dab off the excess with a piece of scrap paper. After the glue is dry, if you discover an edge did not adhere well, use a tiny piece of paper to slip some glue underneath.

This is an activity which, like the greeting card, lends itself to endless variations. One idea is to add a decorative outside edge by using special scissors which cut decorative edgings. You can also experiment with different papers. It can sometimes be difficult to cut a clean edge into construction paper when it is cut in layers, and other papers may work better for you. You might also incorporate words into your design, taking care to cut so they are facing the correct way.

After a while, try branching off into new directions by combining your symbols in a design of your own making, by omitting the circle or square repeat pattern altogether or using it only in part. You can set up your own compositions, and the way you arrange the symbols will contribute even more to the meaning and impact of the piece.

The heavens are telling the glory of God; and the ✕ firmament proclaims his handiwork. Day to day pours forth speech, and night to night declares knowledge. There is no speech, nor are there words; their voice is not heard; yet their voice goes ✕out through all the earth, and their words to the end of the world. Psalm 19:1-4

Activity Nine: Illuminated Manuscript

Illuminated manuscript is the name given to handmade books produced before the printing press was invented in the later part of the fifteenth century. Christopher De Hamel, the author of *A History of Illuminated Manuscripts,* informs us:

> The word "manuscript" literally means "written by hand." When we talk about medieval manuscripts we usually mean the books produced by hand in Europe between about the fifth century and the Renaissance of the late fifteenth century.[2]

De Hamel tells us that in the strict definition, "illuminated" refers to only those books which contain the addition of a fine layer of gold or silver as part of the decoration, which can be found often, but not in every book from this period.

> As Christianity advanced across pagan Europe in the Dark Ages, it brought with it the Mediterranean skills of reading and writing. The Rule of St. Benedict encouraged monks and nuns in the use of books, and monasteries and religious communities needed libraries. . . . Until the eleventh or twelfth century, probably most manuscripts were indeed made in monasteries. Monks sat in the cloisters copying and studying texts, and devoted leisure and skill to doing so . . . by 1200 there is quite good evidence of secular workshops writing and decorating manuscripts . . . by 1300 it must have been exceptional for a monastery to make its own manuscripts: usually, monks bought their books from shops like everyone else. . . .[3]

De Hamel also outlines the process of making the book, from start to finish. Craftsmen specialized in different steps of the process. Parchment was made from animal skins by a parchment-maker, who transformed them into a surface for writing. A scribe used pens cut from feathers or reeds dipped into ink made by ink-makers. Blank spaces were left for decoration and illustration, which were generally contracted out to professional illuminators and artists. The bookseller was typically also a bookbinder, who gathered the pages, sewed them together (as our hardcover books are sewn today), and bound them into covers made from wooden boards, which were then covered in leather or another fabric.

For this activity, you will be making your own illuminated manuscript page. This project will be different from any of the others in this book in that it will take longer to make (allow several sessions) and will require more supplies. Also, the finished product may be framed and displayed, if

you wish. Seek out a book or two on this subject from your library, hopefully with many colored examples, so you can become familiar with medieval manuscript pages and allow inspiration for your own work. If you are lucky enough to live near a large city or university which may have preserved original manuscripts in their museums or libraries, you will of course want to examine them first-hand.

These manuscripts were written in a type style that is now called "Old English." If you have calligraphy skills, learning to write in this style should be no problem. If not, two other methods are given to create the letters. The more expensive method requires the purchase of transfer type, which is sold in both art and office supply stores and catalogs. Transfer type is a sheet of (usually black) letters and numbers attached to a film-like tissue, which can be individually transferred to a paper surface. Common brand names are Geotype and Chartpak. They are available in a variety of type styles, but you will want the Old English, which can sometimes be more difficult to find. You can ask your local office or art supply dealer to order it for you. Old English comes in different sizes. Ask for the 36 point, that is, letters which are 3/8 inch high. You will need to figure out how many sheets will be needed to complete your manuscript page. There will be more than enough capital letters; it is the lower case you may run out of. Look at your chosen passage for the manuscript page and count out how many of the most common letters are needed; this will give you an estimate. A sheet of Old English Geotype, 36 point, has only six of the letter "y," eleven of "a," nine of "i," eleven of "o," nine of "u," all being letters frequently used. An advantage of the transfer type method, despite all the fuss and bother, is that you are able to erase the letters by scratching them off with a mat knife or other single-edged razor blade and thereby correct mistakes easily. You may need to follow up with an ink eraser to clean up any residue that might remain. Scribes in medieval times also had the advantage of using a knife to scrape their mistakes off the parchment.

The second method is to create the letters using plastic stencils, sometimes called lettering guides. Again, the letters come in different type styles (you want the Old English) and sizes. The underside of the stencil has tiny little feet called risers, which prevent ink from smearing as the stencil is lifted off the paper and moved into position. A black felt-tip marker with permanent ink and a very fine tip can be used. Be certain the tip of the marker extends out with a metal casing into a very fine tip, like the Sanford Ultra-Fine Point "Sharpie" or the Pentel Super-Fine Point Marker. You need not pencil the letters first. Hold the pen upright when it is inside the stencil (not at an angle). Hot press illustration board is one of the very few surfaces which readily accepts marker ink without bleeding. It also works best for using transfer type.

Directions for the Illuminated Manuscript

Supplies needed:

transfer type in Old English style or plastic letter stencil in Old English style

hot press illustration board	mat knife and cutting board
tracing paper	graphite carbon paper
removable scotch tape	pencil
ruler	colored pencils
fine-tip black marker	correction fluid ("Wite-Out")
scissors	pencil and ink erasers
graph paper (optional)	compass for drawing circles (optional)

plastic stencils for drawing geometric and other shapes

gold metallic paper (self-stick is preferable)

1. Before you begin, be sure to invite God to join you in this process by briefly praying in a way that is comfortable for you.

2. Select a passage from scripture that is no more than five average sentences in length. If you have a favorite passage, use that. If a passage has had particular meaning for you recently, use that. If you know of a sacred hymn, prayer, or poem from a source outside the Bible which especially speaks to you, use that.

3. (Steps 3 and 4 are preliminary drawings done on tracing paper.) In many manuscript passages, an enlarged capital letter is used for the first word and is enclosed in a square border and placed in the upper left-hand corner of the text. The capital will be in the same Old English style, but because it is enlarged to at least twice the size of your transfer type or stencil, you will need to draw it freehand. Graph paper may be used to help you construct the letter.

4. The next step is to design the borders around your text. The borders can be on one, two, three, or all four sides of the text. You can make them any width you desire. Look at examples of illuminated manuscript pages from library books to give you ideas about the size and placement of your decorations.

 The artwork in these old manuscripts is wonderful, and you will be tempted to try and reproduce it, but this activity will lose all personal meaning if you copy from someone else. Medieval craftsman often worked from pattern books and were "expected to work according to a specific formula, and this must often have meant using designs and composition with a familiar precedent."[4] We have no such restrictions placed on us and are free to fully express ourselves. Furthermore, although illumination has been correctly

defined above as the addition of gold or silver orna-
ment, let us consider another definition of the word
"illuminate," which is "to make clear" or "enlighten."
When you think about what sort of decoration you
want to add to your manuscript page, think of how it
can bring out the meaning of the passage for you. You
have chosen this particular passage because it speaks
to you in a special way. Show through your artwork
how this is so and what it causes you to think about.

It is likely you will be using symbolic imagery, as you
have in the previous two activities. The primary differ-
ence is that you will be using drawing materials
instead of colored paper. You can again simplify your
idea into a design motif constructed out of geometric or
other basic shapes.

Finally, combine your symbolic motifs into a pattern.
One or more motifs can be repeated along the length of
your border. Using tracing paper to plan out the design
will make the job of repeating a motif quick and easy.
If you are feeling stuck, refer to books on patterns for
ideas.

5. Once you have a plan in mind, select a sheet of illus-
tration board that is more than large enough for your
finished work. It is difficult to know at this point exact-
ly how much space your text will take up in length
until it is inked in. Using a pencil and ruler, determine
how wide you want the text area to be and rule in a line
for each margin. Rule across as many lines as you think
you'll need, stopping at the margins on each side.
Transfer type has dashed lines above and below the let-
ters to help with spacing the rows. Stencils will also
often have guidelines to help you. These ruled lines
need not be erased in your final work, so keep your
lines visible, but not so dark as to be distracting.

Pencil in only the outer edges of any side and top bor-
ders, using a ruler. Determine the placement of your
introductory enlarged capital, and pencil that in as
well, using the graphite carbon to transfer it to the

board. You will not be able to add a bottom border until the text is written.

6. Now you are ready to begin the text. Working at a slower pace and stopping when you feel fatigued can help you to avoid mistakes in your work. Remember to start with the second letter of the first word.

Position the transfer type so the desired letter is in the correct spot, lining up the dashed lines underneath the letters on the sheet with your pencil lines before gently rubbing the letter into place, using a blunt pencil. Make sure you go over the whole letter or bits of it will remain on the tissue-film. If this happens, fill in the broken spot with a part of a seldom used letter or number from the sheet. Periods, commas, and other punctuation can all be found on the same sheet.

If you are using a plastic letter stencil, position it in the same way, lining up the spacers on the stencil with your penciled lines each time you create a new letter. Fill in the letters completely with your marker before lifting the stencil. If your stencil does not come with punctuation, you may have to invent your own. You will not be able to erase mistakes. Your best hope for corrections is to cover the mistake with a thin layer of correction fluid ("Wite-Out").

In both methods, stop about halfway across each line and try to determine how many of your remaining words will fit on that line. You may need to make some spacing adjustments in the second half of the line so the words come out flush with the right margin. Problems with spacing can also be accommodated by inserting little decorative leaves, flowers, or squiggles into any unwanted gaps between words.

7. After the text is completed, use the graphite carbon to transfer your border designs to the illustration board. The removable scotch tape will keep your tracings from slipping out of place. The designs can be filled in using colored pencil just as you would fill in the

images in a coloring book. If you prefer, you can outline the design first using a fine-tip black marker.

Any illuminated elements will be traced first in reverse on the backside of your gold metallic paper. If you are using self-stick gold paper, you need only remove the backing paper before laying it carefully in place. Otherwise, apply a thin layer of glue to the back.

8. At this point, all that remains is to erase any stray pencil marks and cut the board to size. Store any unused transfer type in a plastic bag or container as it will dry out with age.

If you find yourself using a symbol many times in your artwork, it is possible to create your own plastic stencil. Uncut plastic stencil material is available in craft or home decorating departments, where paint and wallpaper are sold. You can see through the translucent plastic to trace your design, and the plastic is soft enough to cut with scissors. If you have trouble locating gold foil, consider using metallic gift-wrapping paper.

Increased Awareness
of Growth and Need

Just as "we do not know how to pray as we ought,"[1] we also by ourselves do not know how to grow spiritually. We cannot perfect ourselves. We cannot, by our own actions, prepare ourselves to meet God. We don't know how. Only God knows. The single most important thing we can do to grow spiritually is to spend time with God in prayer. When we pray, we give God an invitation to work in us. After sessions of prayer, we grow in spite of ourselves. Our hearts are softer and our desires conform more easily to what is good. The art-as-prayer activities in this section will help you to become more aware of what is taking place within you. You will be noting your progress and recording some of the events you experience along the way.

Activity Ten: Examining Conscience

Building strong relationships of any kind requires honesty, communication, and a willingness to listen. When problems which arise are brought out and resolved, trust and intimacy increases. Many of the same things which strengthen or weaken our human relationships apply to our relationship with God as well. We must be known in order to feel loved. Disclosure creates closeness while withholding creates detachment. Miriam Pollard writes that awareness of our faults and weaknesses is an opportunity for deepening our relationship with God:

> There is security in knowing we are loved for who we are, and not for the sake of our goodness. No sin can cause the loss of God's love or its diminution. . . . Forever we will have the joy of knowing that he loved us in this way. . . .

He's not out for the kind of perfection we want.
He's out for the love, the faith, the sharing, the
trust, the picking up of pieces, the coming
back. . . . It is more important for us to taste our
helplessness than to be interminably good. He
wants all the moments of reconciliation every
step of the way.[2]

Examining conscience is a traditional spiritual exercise
which can be done at any time. It involves reviewing our
lives and asking God to help identify ways in which we
have sinned. It is important to remember that sin not only
affects our relationship with God, it affects our relationship
with others, with the world, and with ourselves. If several
problem areas come to mind, we are advised to focus on
one issue that stands out as being the most significant.

We can prepare to complete the following activity by iden-
tifying one area of our lives which needs attention and heal-
ing. This is the sin we choose to bring to God, and about
which we feel remorse, seek forgiveness, and wish to
repent.

Directions for Examining Conscience

Supplies needed:

| colored construction paper | glue |
| fine-tip black marker | scissors |

1. Before you begin, be sure to invite God to join you in
 this process by briefly praying in a way that is com-
 fortable for you.

2. In this activity, you will be making a picture of a tree
 using construction paper and words. The tree will be
 placed against a simple landscape background. Begin
 with a sheet of brown construction paper (which
 roughly measures 5 x 8 inches) to define the trunk,
 roots, and branches.

3. Think about the sin you have identified, ask yourself what sustains it, what are its temporary benefits, or what do you get out of it?

Using the marker, write a few short phrases which tell what sustains your sin in the center of the brown paper. Contain the words inside an imaginary rectangle that is about one inch high and three to four inches across. This will be the trunk. (The tree will be constructed as it lies on its side, to be set upright later on.)

4. In your drawing, the branches will extend from one end of the trunk, and the roots from the other.

Consider the consequences of your sin. How does it impact on your life? Write one of the consequences in a phrase, which will form a first branch growing out of the top of the trunk. If the phrase is long, add a side branch growing out of the first. Continue to form branches until you have run out of the consequences you have listed in your mind.

5. The roots will be fashioned from phrases which tell the "roots" of your sin.

Think about its origins. When did it begin to be a problem? Were you influenced by something or someone? Richard Gula suggests that by "focusing on where the treasure of our heart lies, we can recognize the root cause of our sins."[3] Are you attached to something, such as a need for admiration or power? Write anything which you think is significant and finish filling in the roots.

Using the scissors, cut out the tree by cutting around the words.

6. Decide on what sort of simple background you want your tree to be set against. For example, will it be winter or summer? Will the ground be hilly or flat? Do you want a sun or moon in your sky? Select a sheet of 6 x 9 inch construction paper in the color of your sky. Cut out the ground from another sheet (green for grass,

white for snow, e.g.) and glue it to the bottom. The ground should extend up from the bottom of the paper to a height sufficient for the roots to be underground.

Your tree can be "grounded" in words chosen from scripture. You can look up the name of your sin in a concordance and see if you can find any appropriate passages which address your situation. The gospels and apostolic letters are recommended sources. Another idea is to choose one of the seven penitential psalms, which are identified as Psalms 6, 32, 38, 51, 102, 130, and 143.

Begin writing on the left side of your drawing paper and proceed across with the intention of covering the ground completely with words, stopping at the trunk or roots, jumping over them, and continuing on the other side. If you meet with an obstacle or the right edge of the paper and you have only filled in half a word, don't bother to crowd it in, just break off there and start again with the end of the word on the other side. When you reach the bottom of the paper where no more room remains, stop there, even though your passage may be left incomplete. For your own reference, finish writing the rest of the passage on the other side of the paper.

7. Think of possible benefits which would appear in your life if this sin were to be forgiven and eradicated.

Write these benefits, in a word or two, as leaves growing out the tips of your branches—the "fruits" of your conversion. One way to make a leaf is to shape both ends of the word into a point. Add fruits, too, if you want, and turn your tree into one that might grow apples, cherries, oranges, or peaches. If you have a winter landscape, simply add additional branches to your tree. Turn over your drawing and write today's date on the back. Write the name of the sin on the back as well.

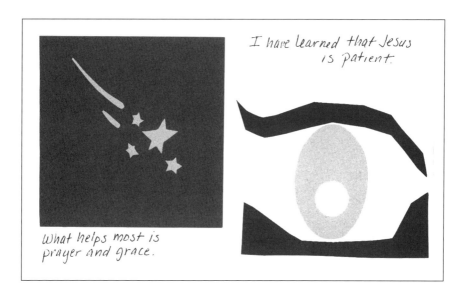

I have learned that Jesus is patient.

What helps most is prayer and grace.

Activity Eleven: Growth in Prayer

In this exercise, you will be making a record of what is presently taking place in your relationship with God. If this activity is completed many times over a period of time, you will have begun to map your growth by recording what you have been feeling and thinking about at different points along the way. This activity is called "growth in prayer" not because you will limit your concerns to include only what happens in your prayer life, but to place the story of your growth into God's hands as a form of prayer.

Each time you complete this art-as-prayer activity, you will have a new little book in which you have recorded your thoughts and images. The directions are given in two parts because you may want to make up four or five books at a

time, while your materials are out and the directions are fresh. This way you won't have to complete the first part of the instructions each time.

Directions for Growth in Prayer

Supplies needed:

white drawing paper	pencil
colored construction paper	notebook paper
ballpoint pen	glue
scissors	ruler
cutting board and mat knife	sewing needle and white thread

plastic stencils for tracing geometric or other shapes

a heavier colored paper or a lightweight board such as thin poster board (the lightweight cardboard from new shirts or gift boxes will also work)

Part One:

1. There are two methods for making the books. You can choose either method to make yours:

 Method A: Fold a 9 x 12 sheet of white drawing paper in half twice. Set the folded sheet on your cutting board and trim off the folds on the 4 inch side. This will give you two sheets of paper, folded in half to form pages, one inside the other.

 Keeping it folded, take your ruler and mark the center of the folded edge with a pencil. Make two more marks on each side of the first one, so the edge is divided into 6 spaces of almost equal size.

 Take the sewing needle and make a hole in the edge, through both sheets, where each of the pencil marks are.

Thread the needle and sew in and out, starting and ending in the middle of the outside edge. Then tie the ends in a double knot on the outside of the spine and trim the ends with scissors.

Cut a sheet of lightweight board or heavy drawing paper into a rectangle that is about 1/4 inch larger than the pages, all the way around, when your book is laid open and flat. If you want to score the lightweight board before folding it in half, use your mat knife to cut only slightly into it along the edge of a ruler at the place where it will be folded. The heavy drawing paper is folded without scoring. This will be the cover.

Spread a thin layer of glue on the front and back pages of your book where the cover will attach. Blot off any excess glue with a piece of scrap paper. Press these two pages onto the cover, while it is opened flat on your table or desk. Allow it to dry in this opened position. You may want to set it under a heavy book to keep it flat. Your finished book will have six blank pages inside.

Method B: Cut a large (18 x 24 inch) sheet of white drawing paper into three strips, so each strip is 6 x 24 inches. These strips will make three books.

You will be folding each strip in opposite directions, forming accordion pleats. Begin on one end and measure in four inches to start. When you fold, be sure to line up the edges. Continue until the whole strip is folded. If the last flap is a little short, cut the first flap to match it. If you hold one side of the folds together, you will form a book with six inside pages.

Cut a sheet of lightweight board or heavy drawing paper into a rectangle that is about 1/4 inch larger than the pages, all the way around, when your book is laid open and flat. You may want to score the lightweight board before folding it in half. Use your mat knife to cut only slightly into it along the edge of a ruler at the place where it will be folded. The heavy drawing paper is folded without scoring. This will be the cover.

Spread a thin layer of glue on the outside of the front flap where the cover will attach. Blot off any excess glue with a piece of scrap paper. Press this into place, inside the front cover. Do the same with the back flap. In this design, the edges are not secured to the spine. Close the book and allow it to dry. You may want to set it under a heavy book to keep it flat. Your finished book will have six blank pages inside.

Part Two:

1. Before you begin, be sure to invite God to join you in this process by briefly praying in a way that is comfortable for you.

2. On a sheet of notebook paper, complete each of these sentences by thinking about your relationship with God:

> At present I am . . .
>
> I am afraid of . . .
>
> What helps most is . . .
>
> I have learned that . . .
>
> God seems . . .
>
> If I continue this way . . .

3. Each of these completed sentences will appear, in order, one sentence to a page, in your book. Your next task will be to make up a simple little design, cut out of colored construction paper, to illustrate each sentence. This design will be formed from a minimum of shapes, either traced from the plastic stencil, cut freehand, or some combination of both. You are not creating an elaborate decoration or complex scene, but a compact, concise, unadorned, single image. Feel free to use stick figures if you want to. You can also create a simple setting or suggest an atmosphere (night or day, seasons, weather changes) for your object to exist in. Your image can be recognizable or nonobjective.

Some of your sentences will easily bring an image to mind and take very little time to complete. In any case, you don't want to labor too much over the illustrations. Trust your first impulse. If you find you are still stuck, allow some of the following expressive words to suggest an image to you, but only if it also fits the meaning of your sentence:

blocked, closed, hard, obstacles, compressed, crowded

open, relaxed, free, floating, lifted, light, expansive, quiet, still

layers, untangling, overflowing, beneath to above the surface, towering

boundaries, fences, walls, limits

broken, shattered, split, torn

heavy, full, flat, burdened, tired, empty, lonely, darkness

connect, join, bond, merge

rhythm, energy, movement in, up, or down, turning point, near, far

whole, mended, balanced

bursting, tingling, radiant, inflamed

Cut out and arrange your colored shapes on the page before gluing them down, so you can change your mind before they are fixed. Think about where the line of words will fit on the page and be sure to leave enough space to write them in.

4. After you have completed the illustration, write in the sentence in your own handwriting or printing using a ballpoint pen. Write the date in pencil on the first or last page of the book.

Activity Twelve: Epiphany

Upon hearing the word "epiphany," the feast involving the Magi usually comes to mind. Epiphany refers to a manifestation, such as the manifestation of Christ which the Christmas feast celebrates. For our present purpose we will also consider its other meaning, as "a sudden, intuitive perception of or insight into the reality or essential meaning of something." We will further extend the use of the word to mean this: a moment of awareness of God, of insight, or of conversion.

There is no human event which can rouse or unsettle us more than an experience of God. It is natural that the urge toward expression would follow. Artists make art when they feel moved in a deep way to express something they have experienced. The moment of awareness needn't be overly dramatic to be significant. Awareness of God can come at any time—in quiet moments when you are open and receptive, in response to a petition, while on retreat or taking part in a liturgical ritual, or unexpectedly, when your mind is completely occupied with something else. What makes the experience significant is its impact on your life, your capacity to love, and your relationship with God.

Once you have an experience in mind you wish to portray, there will be two ways to approach the activity described below. You can seek out a visual metaphor by considering what the experience reminds you of. If you attempt to describe verbally what you felt, your words may lead you to an image. Perhaps the experience was "like my heart was melting after it had been frozen," or you may have felt "safe and secure, like being wrapped in a warm blanket."

The second approach involves closing your eyes and allowing an image to appear in your imagination. Focusing inward helps stir the imagination by allowing unconscious imagery to come into play. Merely quieting yourself and closing your eyes may be enough to spark an idea. If you remain long enough in this posture and enter into a deeper state of relaxation, you might come into even more direct contact with the unconscious. In the years 1913 to 1916, psychiatrist Carl Jung made this discovery and perfected a technique he called "active imagination" for use in psychoanalysis. He would often encourage his patients to draw pictures of their discoveries, as he had found benefit in his own artmaking:

> To the extent that I managed to translate the emotions into images—that is to say, to find the images which were concealed in the emotions—I was inwardly calmed and reassured.[4]

It is not necessary for you to probe the unconscious to the extent he did to arrive at content for your artwork, but the directions which follow offer a modified version of active imagination for you to try.

Before beginning, a word about materials might be in order. You will be working on very wet watercolor paper with wet tempera paint. Watercolorists refer to this as the "wet in wet" method. When the brush touches the surface, the paint disperses and spreads out quickly into runny streaks or fan shapes, causing a brilliant explosion of color. It is difficult to gain partial control and impossible to gain full control over the paint, even with much experience. Paintings that turn out well using only this technique are sometimes referred to as happy accidents. The lack of control is also what makes this perfect as a spiritual exercise, as giving way to the process is unavoidable. You will be satisfied with the outcome only some of the time, but don't let this deter you. Your times of success will make the effort worthwhile.

Very wet paper will buckle and wrinkle as it dries, which may spoil your painting. To avoid this, you will need to secure it to a flat surface as it begins to dry—a process which is called "stretching" the paper (although you do not actually stretch it). If you are new to the process, begin with watercolor paper that measures around 11 x 15 inches. You will need a large pan to soak it in. Large flat plastic storage boxes work well for this. If the paper is too wide to fit, gently roll it into a fold, but do not crease it. The paper can also go directly into a clean sink or bathtub.

You will also need a sturdy flat board, larger than your paper, which could be made of glass, marble, Plexiglas, or Formica. Look around your house, especially the kitchen, as cutting boards or surface protectors work well. The surface should be cleaned until it is free from any oil or dirt. You will be able to return it to its former purpose without any damage when you are finished. A wooden board will also work, but use scrap wood you don't care about. Once you have the board, you will need to find gummed craft paper tape. It is brown and comes in a large roll and looks

like postal packaging tape, except it is not self-sticking. You must have the tape you moisten yourself, and you may have to order it from an art supply catalog, as hardware and discount stores don't seem to carry it. It is also used in silkscreen printing. If you absolutely cannot find the tape, an alternative way to stretch the paper is by stapling all around the edges with an ordinary stapler. The problem now is to find a sturdy surface which accepts stapling. You can buy foam board, a lightweight board with a Styrofoam core, as a temporary solution. It is generally available where poster board is sold. Tape two of these boards together to give it more protection against warping and to keep the staples from poking through. If you become more serious about painting, homosote board, available at a lumber yard, works extremely well if you prefer stapling.

Directions for Epiphany

Supplies needed:

watercolor paper (medium weight, 80 or 90 lb. paper is fine)

tempera paints	brushes
water dish	paper towels
board for stretching	paper tape
pan for soaking paper	

1. Before you begin, be sure to invite God to join you in this process by briefly praying in a way that is comfortable for you.

2. Recall to your mind a moment in which you have had an awareness of God. It might be a recent event or it might be something that took place in the past but remains fresh in your mind. Some examples are: a prayer experience, an insight into scripture, a response during a time of need, a feeling of peace or assurance, or an awareness of God during a life-changing event

such as the birth of a child or the death of someone close. The experience might be dramatic, like a conversion experience, or gentle, like a sense of security.

Are you able to identify any visual images you associate with the experience? Try completing the sentence: "It was like . . ." to invite comparison with a visual metaphor. (It was like being lifted up. It was like waking from sleep. It was like a door opening.) The word list from the previous activity might help you arrive at a visual image. Keep it simple, direct, and to the point. For example, if your image is a twirling dancer, you could paint a spiraling line to show the movement, rather than the complicated human figure. Another option is to omit any reference to an object and show the feeling in a completely abstract way, using only shapes and colors.

If you need additional inspiration, try to enter into a quiet state with the intention of receiving an image. Some people may feel uneasy about this loosening of awareness. Do stop or skip this particular suggestion if it does not appeal to you or feel comfortable.

Assume a posture that enables you to relax your body, close your eyes, and settle your mind into a state of quiet attention. Wait for an image, but don't force. Sometimes it helps to relax a little more, as if you are preparing to sleep. It may be you don't actually visualize an image, but simply that an idea comes to you. Another possibility is that you receive a series of images and need to choose one. Stop when you have gathered what you need to shape your imagery.

If you are still without an idea of what to paint, you can either begin anyway and see what develops, or you can set this project aside and sleep on it for a few days. A period of rest (called "incubation" in the creative process) often brings new solutions to artistic problems.

3. Fill your large pan with water and slide your watercolor paper in, allowing it to sink below the water's

surface so that it is submerged. Allow it to soak about five minutes.

4. You can use this time to set up your materials. If you are concerned about protecting your table or desk from the very wet paper, cover it with newspaper, followed by wax coated freezer paper or a large sheet of Plexiglas, or use an old vinyl tablecloth. Fill your water dish and set out your paper towels and art supplies, ready for use. Keep your stretching board and tape nearby.

5. After soaking the paper for approximately five minutes, lay the paper out in front of you and begin to paint. Dip your brush in the water before dipping it into the paint. Expect the paint to expand and spread out rapidly when you touch the paper with your brush. Since you cannot easily control it, you will be making adjustments in your plan—a continuing compromise between what you want to make and what the paint wants to do. You can lift out some glaring mistakes with a small piece of the paper towel or a tissue. You will need to work at a moderately fast pace, as you must stop when the corner edges of the paper start to dry out slightly. (If you proceed past that point, the paper will no longer be evenly damp, and this may create unwanted cauliflower shaped edges where wet and dry meet.)

6. When the corner edges just begin to dry, they will curl up slightly. At this point, carefully shift the paper to the stretching board, keeping it horizontal to prevent the paint from shifting and running across the surface. Tear off four strips of paper tape, a little longer than each side, wet the tape, and apply it to secure the edge of the paper to the board. When you finish, you will have framed your painting with the four strips of tape. Allow it to dry flat and undisturbed for several hours or overnight.

7. When the paper is still damp, it is cool to the touch. If in doubt, allow the paper a longer stretching time, to be

certain it is completely dry before removing the tape. The easiest way to remove it is to pull off the painting with the tape still attached and then cut off all four borders using a mat knife and cutting board. Be sure to date the back of your painting and write any comments you wish to preserve.

If you don't like the results, you can always make a second attempt. You will notice the colors dry slightly lighter than they appear when wet, and the paint may continue to blend and settle. Only when it is completely dry can you see what it will finally look like.

Increased Awareness
of Others

These three activities are very different in the way they help to increase awareness of others. The first will invite you to pray for others. When you pray for another person, you feel more empathy for that person and may feel closer to that person as a result. The second activity involves making a holy card; the prayer is addressed to the subject of the card (for example, Jesus, the Holy Spirit, or an angel or saint). The third activity enables us to find God by listening to what is being revealed in the artwork of others.

Activity Thirteen: The Intercessory Portrait

Intercession refers to prayer that is offered for others. To begin this activity, you will think of a person you would like to pray for. Then you will paint a portrait of this individual which expresses your concern for him or her. Remember that you will need no more artistic ability to complete this activity than what you had as a child, when you drew pictures of yourself and your family.

Before you begin, you might want to visit your library and look for works by artists who are grouped under

Expressionism, an art movement of the early 1900s. Viewing the works of these artists and noticing how freely they dash paint around will help you to feel less afraid about your efforts. These artists often used unnatural colors (often dark and moody) or exaggerated certain features to show how they felt about the individuals they painted. Look for portraits by Vincent van Gogh, Henri de Toulouse-Lautrec, Edvard Munch, Henri Matisse, and Georges Rouault. You'll see that picture-perfect appearance was not their primary concern.

Directions for the Intercessory Portrait

Supplies needed:

white drawing paper (12 x 18 inches)	tempera paints
paintbrushes	palette
jar or plastic container (for water)	paper towels
freezer paper or newspaper (to protect working surface)	

1. Before you begin, be sure to invite God to join you in this process by briefly praying in a way that is comfortable for you. At this time, you will also want to pray for the person who will be the subject of your portrait.

2. Take a few moments to think about this person. How well do you know them? Do you know their life history at all? Do you know what is important to them? How would you describe this individual to someone who doesn't know them? Artists typically make an effort to empathize with their subjects—to understand how it feels to be them. You might also consider the present state of your relationship with this person. Are you growing closer together or further apart? Do you know what their relationship with God is presently?

3. Try to think of some colors which seem to fit this individual or their present situation, even if you can't explain with words why you are choosing them. Briefly try to visualize a completed portrait in which these colors are utilized. Do you want to show just the head and shoulders or more of the person's body? What sort of brush strokes would you use—soft and blended? wild? spotty? It helps to have a starting point, but don't be surprised if the resulting portrait conveys a different mood than the one you intended.

4. If you have an easel, you will want to use it. If you have a drawing board, prop it up so the portrait is facing you, or you might tape the drawing paper onto a wall or door. If you prefer to lay it out on a tabletop, experiment with standing as you work, to give your arms more freedom of movement. Tape some freezer paper behind it so you can bring your paint to the edges of the paper if you choose to. Set out your paints, water, and brushes. If you have not painted before, refer back to Chapter Two for advice and suggestions.

5. You will not be making a pencil drawing first. The idea is to be free and spontaneous. It doesn't matter if the eyes are crooked and don't match, or if the head is lopsided. These distortions may, in fact, ultimately add meaning.

6. Stand back from your work as it nears completion to see if it needs any adjustments. At some point, you will need to make a decision about the background. You can leave it white, paint in some colors (perhaps to bring out the mood or atmosphere even more), or add whatever else you choose. For future reference, date the back of the painting.

Activity Fourteen: The Holy Card

Traditionally, holy cards are small, measuring around 2 1/2 x 4 inches, and have an image on the front (usually Jesus, a saint, or an angel) and a verse or prayer on the back. Holy cards are described in *The HarperCollins Encyclopedia of Catholicism* as:

> . . . small printed cards containing pious senti-ments or depicting popular religious figures.

Widely distributed after the advent of printing, the cards are used as mementos of religious events, to foster a particular devotion, or as a means of remembrance, e.g., for a deceased person.[1]

In making your own holy card for this activity, you may either stay with this traditional format or invent something new, with a non-traditional image you design yourself. If you choose a traditional format, you will need to find a suitable image for the front of the card. Pamphlets, church bulletins, greeting cards, clip art, and illustrations torn from discarded prayer books or other spiritual reading material are all possible sources for pictures. The activity will be more meaningful if you add personal touches, such as a decorative frame or border of your own design. If you are opting for the non-traditional, the image can be an abstract design of a few simple shapes and colors, or it may be more detailed, but it need not be a portrait. In either case, it will be useful to refer back to Chapter Five for ideas about making symbolic designs out of paper. A reference book, such as *Signs and Symbols in Christian Art* by George Wells Ferguson or the *Dictionary of Subjects and Symbols in Art* by James Hall, will give you background information on religious figures and the symbols traditionally associated with them.

If you enjoy this activity and would like to repeat it several times, it will be useful to keep a file of supplies. Craft and hobby stores carry an assortment of decorative papers, metallic foil, lace and ribbons, stickers, and marking pens. You may also have useful items in your home, such as wrapping paper, aluminum foil, magazine pages, discarded greeting cards, sheet music, junk mail, and scraps of fabric. Pressed flowers are another option—you can press them between the pages of an old telephone book until they dry flat. Plain index cards can serve as the base for your creation, or you can buy card stock, available at office supply stores, if you wish to sometimes work on a larger scale. Heavyweight paper can be a substitute for the card stock. When the design is complete, you will cover it with clear laminating film, also available at craft and office supply stores.

Directions for the Holy Card

Supplies needed:

plain index cards or card stock glue

clear laminating film scissors

stencils of geometric and other shapes pencil

colored paper and other decorating supplies as described above

1. Before you begin, be sure to invite God to join you in this process by briefly praying in a way that is comfortable for you.

2. Your first decision is whether to make a traditional or non-traditional card.

For the traditional format, you will need to choose a saint or other image for the front of your card. Unless you are already very familiar with this person or symbol, doing a little research to learn more will help to make this activity more meaningful. If you choose a saint, you will need to locate a picture of the saint, as mentioned above. If you are choosing to depict a symbol, you might find it easier to design your own image. In either case, add some of your own personal touches to the card. If your picture is black and white, you might color it in yourself. Perhaps you will want to change the background or add details of your own. If not, at least consider making your own decorative frame or border.

For the non-traditional format, your card will not show a portrait. Instead, you will be either telling something about Jesus, the Holy Spirit, or another image, or making something for them or addressed to them. You can use symbols commonly associated with them or invent your own.

3. Your card can be any size, but you will probably want to stay smaller than 6 x 9 inches. The card stock can be cut to size and form the base on which you will glue your design. When the front of the card is finished, cut a sheet of laminate larger than the card, peel off the backing, and carefully cover the front of your card with this protective top layer.

4. The reverse side of the card will need a prayer, poem, or scripture passage which relates to the image on the front in some way. You can compose your own original prayer or poem. The words can be photocopied, typed, or handwritten. Affix the words to the back of your card and cover this side with the same laminate you used for the front. Trim the edges and you are finished.

There are unlimited ways to vary this activity by using different materials. One idea is to make a mosaic from little cut pieces of paper. Any paper will do. For example, you can remove sections of color from magazine pictures. The cut pieces can be little squares or rectangles and the plastic stencils will help them to be all the same size. You can also make a mosaic from pieces that are irregular in shape and size.

Another idea is to add gold foil of the same type you used for the illuminated manuscript activity. Gold adds a special feeling of reverence or majesty. If you are gifted with a needle, you can add stitchery to your design or border. Rubber stamping and folded paper cutting are other methods to try. Some art and greeting card stores sell beautiful, ready-made laser cut images which you can incorporate. Don't forget that paper can be woven into a flat design by using paper strips of contrasting colors. You can also use your own photographs. Another idea is to combine images from magazines, wrapping paper, or greeting cards into a tiny collage.

Activity Fifteen: Discovering Art

Each time you complete the following activity, you will have explored the work of one artist. In this way, over time, you can become acquainted with several. As you listen to others through their art, you will hopefully be able to find God in them, just as you do when listening to individuals you encounter in your life. Each person is a special expression of God, and each person has something to teach us.

The word "listening" may not seem to apply here, since we *look* at art. Listening, however, implies that more is being asked of us than merely looking. A good listener takes time, is fully present, suspends judgment, and also hears what is not directly stated. In observing art, the most difficult task

at times will be suspending judgment. Hasty judgment cuts us off, because at that moment we stop being receptive.

Art can be hard to understand, and recent postmodern art is especially challenging. In art museums today, we find basketballs floating in glass water tanks, rocks scattered on the floor, and meaningless phrases running across blinking signboards. We have been taken to and past the limit. Finding the right information about art—that which is geared toward the uninitiated—can help sort through the confusion.

Understanding a work of art might begin with placing it into a time frame. Art has evolved over time. What was radical and difficult to assimilate in the 1800s is commonplace and credible to us now, as master artists often break new ground and move art into the future. In researching your artist, you will look for what that individual contributed to the art world at the time. He or she may have been part of a group of artists committed to a new style or movement. A reference book which spans the history of art and highlights important events will be a great help to you. One of the best, because it is written in friendly and clear language, is *The Story of Painting* by Sr. Wendy Beckett and Patricia Wright. Sr. Wendy has appeared in a series of programs on art appreciation for public television and has a gift for opening the world of art to everyone. Her book follows a time line from ancient art to the present day and has colored reproductions throughout. Another interesting reference is *Art and Civilization* by Edward Lucie-Smith. His book follows the history of art and architecture by noting what was also happening in world history, philosophy, literature, drama, and music in each era. He is also the author of *Visual Arts in the Twentieth Century*, which will take you from the advent of modern art up to 1995 and also has useful time lines at the beginning of each chapter. Another possibility is a textbook marketed for junior high and high school students entitled *History of Art for Young People* by H. W. Janson and Anthony F. Janson. Simply leafing through and looking at the pictures in a book like one of these will give you a good start in acquiring a basic overview.

In order to understand art it is helpful to consider what the critics and art historians say about the work or artist in question. The artist may also have an opinion and, while this is interesting, it may be only somewhat useful in discerning the meaning of the piece. The evidence of meaning must be in the work itself, and (ideally) it should stand on its own merits and speak with its own voice. You will be attempting to answer some of the same questions critics ponder in formulating their assessments as you complete the activity below.

In looking at art, you experience your own personal response, which says something about the artwork and something about you. You bring your concerns and present state of mind, along with your life experiences, values, and other attributes, into your experience of viewing. Discerning the actual meaning of the work will be a different experience each time. Sometimes the meaning will be obvious. Other times you might think you've grasped it, only to discover you overlooked a whole other level or layer of meaning. It may also happen that you arrive at an understanding gradually, perhaps with repeated exposure or additional reading. Sometimes the title of the work will offer clues. Remembering that creating art is a process of decision-making will lead you to a series of questions about why the work is a certain size or shape, for example, or why certain elements were included or left out, or why they were arranged in a particular way, and so on. The artist will choose what best communicates the message to the viewer.

In completing this study, you will arrive at an interpretation, based primarily on the artwork itself, your response to it, and what you have been able to learn from your research. You don't, however, want to struggle so much over meaning that you forget to enjoy the piece you have chosen!

If you were just interested in learning to look at art, we could stop here. If this is to be a prayer experience, we need to go further. To begin, think about how we detect the presence of the artist in the artwork. First of all, we note the expression that lives on in the piece. Art is essentially a container which embodies the expressions of its creator. We

also say the artist has spoken to us through the work. In addition, we talk of the artist having a characteristic style, which enables us to immediately recognize a Monet or a Renoir, for example.

As creations of God, each of these three aspects of art can apply to us: God's expression lives in us, we are containers who embody the spirit of our Lord; God speaks through us; and we can say God has a characteristic mark or signature, which we are able to recognize—as Jesus tells us: "My sheep hear my voice."[2] Each of these realities enables us to find God in each other.

To find God in art, we are joining these two premises together. God speaks through the artist, who speaks through the art. We are already accustomed to understanding this connection as we discover God in written words, especially scripture, but other sources as well. We listen for God in sermons, in hymns and music, in ritual and dance, and we listen for God in the visual arts. This Presence is detected easily where goodness and love are expressed. Elements of hope and beauty (as in Henri Matisse's "The Tree of Life"), justice (as in Mike and Doug Starns' "Lack of Compassion"), and mystery (as in Mark Tobey's "Edge of August") also reveal God to us. God may be sensed as the source of life and energy (as in Vincent van Gogh's "The Starry Night"). Additionally, suffering and darkness (as in Pablo Picasso's "Guernica") may bring images of Christ into our minds.

As you look, be aware of this hidden voice of the Spirit in all of its varied manifestations. You might gain new insights or a broader view of your faith. You will certainly have many opportunities to increase your awareness of the inner realities of your fellow human beings as you listen to their stories from their viewpoint and know their joys, hopes, and sufferings. Art allows for a special kind of window into the private, emotional world of another person. It is difficult to be truly intimate with others and not find God, since it is in the center of our being that God lives.

Directions for Discovering Art

For this activity, you will need to select a piece of artwork to study. If you do not have access to the original work, a colored reproduction from a book, postcard, or poster are possible alternatives. In addition, any information you can find about the artwork and the artist will be helpful. It is understood that for certain types of artwork information may be hard to come by, and in that case, you will not be able to answer all of the questions below. You will need a pen and a sheet of writing paper in order to record your responses.

1. Before you begin, be sure to invite God to join with you in this process by briefly praying in a way that is comfortable for you.

2. Describe the work you have chosen:

 a) What was your first impression of the piece? Be sure to also notice any bodily, emotional responses.

 b) Does the work express a mood? What words can you use to describe it?

 c) What is the center of interest, that is, the part that stands out as being most important?

 d) How has the artist used abstraction? Is anything altered, exaggerated, or rearranged?

 e) What does this piece of artwork cause you to think about? Is there any spiritual or religious content?

 f) As you look at the work a second time, what did you miss the first time around?

3. See if you have any first thoughts about the meaning or message of the work.

4. Briefly summarize what you know about the artist's life and career.

a) Does the artist have a working philosophy about making art?

b) What does the artist say about the work you are studying?

3. What do the art critics or art historians have to say?

a) Is this artist's work part of a style or art movement?

b) What do the critics have to say about the meaning or message of the piece?

6. Finally, see if you can sense the presence of God in the piece you are studying.

a) What attributes or aspects of God are you noticing?

b) Does the artwork enhance your image of God or impact on your faith?

In the final, sixth step of this activity, it is fine to venture far away from the artist's intentions in order to respond from a prayerful place within you. Allow the artwork to be present just for you, and set aside what you have researched to complete this final, most important step in the exercise. You may choose to stop writing after step five and put the task aside for a while—perhaps even completing it on another day, when you can approach the work with new eyes.

Notes

AN INVITATION

1. Thomas Merton, *Contemplative Prayer* (New York: Image-Doubleday, 1989) 67.

CHAPTER ONE

1. Florence Cane, *The Artist in Each of Us* (London: Thames and Hudson, 1951) 37.

2. Peter London, *No More Secondhand Art: Awakening the Artist Within* (Boston: Shambhala, 1989) 57.

3. Miriam Pollard, *The Laughter of God: At Ease with Prayer* (Wilmington, DE: Michael Glazier, 1986) 30.

CHAPTER THREE

1. Miriam Pollard, *The Laughter of God: At Ease with Prayer* (Wilmington, DE: Michael Glazier, 1986) 44.

2. Thomas Merton, *New Seeds of Contemplation* (New York: New Directions, 1972) 36.

3. Carl Gustav Jung, *Jung on Active Imagination*, ed. Joan Chodorow (Princeton, NJ: Princeton University Press, 1997) 38.

4. Susanne F. Fincher, *Creating Mandalas* (Boston: Shambhala, 1991) 24.

5. Kimon Nicolaïdes, *The Natural Way to Draw* (Boston: Houghton, 1941) 15.

6. Nicolaïdes 17.

CHAPTER FOUR

1. Roger Lipsey, *An Art of Our Own: The Spiritual in Twentieth-Century Art* (Boston: Shambhala, 1988) 17.

2. Kathleen R. Fischer, *The Inner Rainbow: The Imagination in Christian Life* (Ramsey, NJ: Paulist Press, 1983) 52.

3. Nathan Cabot Hale, *Abstraction in Art and Nature* (New York: Watson-Guptill-Billboard, 1980) 13.

4. Georgia O'Kceffe, *Georgia O'Keeffe* (New York: Viking, 1976) 88.

<div align="center">CHAPTER FIVE</div>

1. Ramona Jablonski, *The Paper Cut-Out Design Book* (Owings Mills, MD: Stemmer, 1976) 12.

2. Christopher De Hamel, *A History of Illuminated Manuscripts* (Boston: David R. Godine, 1986) 9.

3. Christopher De Hamel, *Scribes and Illuminators* (Toronto: University of Toronto Press, 1992) 5.

4. De Hamel, *History* 195.

<div align="center">CHAPTER SIX</div>

1. Romans 8:26.

2. Miriam Pollard, *The Laughter of God: At Ease with Prayer* (Wilmington, DE: Michael Glazier, 1986) 81-82.

3. Richard M. Gula, *To Walk Together Again: The Sacrament of Reconciliation* (New York: Paulist Press, 1984) 180.

4. Carl Gustav Jung, *Memories, Dreams, Reflections*, ed. Aniela Jaffé, trans. Richard and Clara Winston (New York: Vintage-Random, 1961) 177.

<div align="center">CHAPTER SEVEN</div>

1. Richard P. McBrien, gen. ed., *The HarperCollins Encyclopedia of Catholicism* (San Francisco: HarperSanFrancisco, 1995) 618.

2. John 10:27.

Bibliography

Bayles, David and Ted Orland. *Art and Fear: Observations on the Perils (and Rewards) of Artmaking.* Santa Barbara, CA: Capra, 1994.

Beckett, Wendy. *The Gaze of Love.* New York: HarperCollins, 1993.

_____. *The Mystical Now: Art and the Sacred.* New York: Universe, 1993.

Beckett, Wendy and Patricia Wright. *The Story of Painting.* London: Dorling Kindersley, 1994.

Cameron, Julia. *The Artist's Way: A Spiritual Path to Higher Creativity.* New York: J. P. Tarcher-Putnam's, 1992.

Cane, Florence. *The Artist in Each of Us.* London: Thames and Hudson, 1951.

Chodorow, Joan, ed. *Jung on Active Imagination.* Princeton, NJ: Princeton University Press, 1997.

Cummings, Charles. *Monastic Practices.* Kalamazoo, MI: Cistercian, 1986.

Dalley, Tessa, ed. *Art as Therapy: An Introduction to the Use of Art as a Therapeutic Technique.* London: Routledge, 1996.

De Hamel, Christopher. *A History of Illuminated Manuscripts.* Boston: Godine, 1986.

_____. *Scribes and Illuminators.* Toronto: University of Toronto Press, 1992.

Dickinson, Emily. *The Poems of Emily Dickinson.* Ed. Martha Dickinson Bianchi and Alfred Leete Hampson. Boston: Little, Brown and Company, 1943.

Edwards, Betty. *Drawing on the Artist Within.* New York: Simon and Schuster, 1986.

_____. *Drawing on the Right Side of the Brain*. Los Angeles: Tarcher, 1989.

Essers, Volkmar. *Henri Matisse: Master of Colour*. Germany: Taschen, 1990.

Feldman, Edmund Burke. *Varieties of Visual Experience*. New York: Abrams, 1987.

Ferguson, George Wells. *Signs and Symbols in Christian Art*. New York: Oxford University Press, 1954.

Fincher, Susanne F. *Creating Mandalas*. Boston: Shambhala, 1991.

Fischer, Kathleen R. *The Inner Rainbow: The Imagination in Christian Life*. Ramsey, NJ: Paulist, 1983.

Furth, Gregg M. *The Secret World of Drawings: Healing Through Art*. Boston: Sigo, 1989.

Grundberg, Andy. *Mike and Doug Starn*. New York: Abrams, 1990.

Gula, Richard M. *To Walk Together Again: The Sacrament of Reconciliation*. New York: Paulist, 1984.

Hale, Nathan Cabot. *Abstraction in Art and Nature*. New York: Watson-Guptill-Billboard, 1980.

Hall, James. *Dictionary of Subjects and Symbols in Art*. New York: Harper, 1979.

Hughes, Robert. *The Shock of the New*. New York: Knopf, 1981.

Itten, Johannes. *Design and Form*. New York: Van Nostrand Reinhold-Litton, 1975.

Jablonski, Ramona. *The Paper Cut-Out Design Book*. Owings Mills, MD: Stemmer, 1976.

Jung, Carl Gustav. *Memories, Dreams, Reflections*. Ed. Aniela Jaffé, Trans. Richard and Clara Winston. New York: Vintage-Random, 1961.

Kandinsky, Wassily. *Concerning the Spiritual in Art.* New York: Dover, 1977.

Keyes, Margaret Frings. *Inward Journey: Art as Therapy.* LaSalle, IL: Open Court, 1983.

Liebmann, Marian, ed. *Art Therapy in Practice.* London: Jessica Kingsley, 1990.

Lipsey, Roger. *An Art of Our Own.* Boston: Shambhala, 1988.

London, Peter. *No More Secondhand Art: Awakening the Artist Within.* Boston: Shambhala, 1989.

Lucie-Smith, Edward. *Art and Civilization.* Englewood Cliffs, NJ: Prentice Hall, 1992.

_____. *Art Today.* London: Phaidon, 1995.

_____. *Visual Arts in the Twentieth Century.* New York: Abrams, 1997.

Maloney, George A. *Your Sins Are Forgiven You: Rediscovering the Sacrament of Reconciliation.* New York: Alba, 1994.

McBrien, Richard P., gen. ed. *The HarperCollins Encyclopedia of Catholocism.* San Francisco: HarperSanFrancisco, 1995.

Merton, Thomas. *Contemplative Prayer.* New York: Image-Doubleday, 1989.

_____. *New Seeds of Contemplation.* New York: New Directions, 1972.

Moore, Thomas. *Care of the Soul: A Guide for Cultivating Depth and Sacredness in Everyday Life.* New York: HarperPerennial-HarperCollins, 1992.

Nicolaïdes, Kimon. *The Natural Way to Draw.* Boston: Houghton Mifflin, 1941.

O'Keeffe, Georgia. *Georgia O'Keeffe.* New York: Viking, 1976.

Pollard, Miriam. *The Laughter of God: At Ease with Prayer.* Wilmington, DE: Michael Glazier, 1986.

Rich, Chris. *The Book of Paper Cutting.* New York: Sterling, 1994.

Samuels, Mike, and Nancy Samuels. *Seeing with the Mind's Eye: The History, Techniques and Uses of Visualization.* New York: Random, 1975.

Stowell, Charlotte. *Making Books.* New York: Kingfisher, 1994.

Teresa of Avila. *The Life of Teresa of Jesus.* Ed. and trans. E. Allison Peers. New York: Image-Doubleday, 1960.

Underhill, Evelyn. *Worship.* New York: Harper and Row, 1937.

Journey to the Heart

Journey
to the Heart

Christian Contemplation through the Centuries

AN ILLUSTRATED GUIDE

Edited by

KIM NATARAJA

ORBIS BOOKS

Maryknoll, New York 10545

Founded in 1970, Orbis Books endeavors to publish works that enlighten the mind, nourish the spirit, and challenge the conscience. The publishing arm of the Maryknoll Fathers and Brothers, Orbis seeks to explore the global dimensions of the Christian faith and mission, to invite dialogue with diverse cultures and religious traditions, and to serve the cause of reconciliation and peace. The books published reflect the views of their authors and do not represent the official position of the Maryknoll Society. To learn more about Maryknoll and Orbis Books, please visit our website at www.maryknollsociety.org.

First published in Great Britain in 2011 by
Canterbury Press
an imprint of Hymns Ancient and Modern Ltd (a registered charity)
13a Hellesdon Park Road
Norwich
Norfolk NR6 5DR
UK

First published in the USA in 2012 by
Orbis Books
P.O. Box 302
Maryknoll, New York 10545-0302

Printed and bound in Great Britain.

Library of Congress Cataloging-in-Publication Data

Nataraja, Kim.
 Journey to the heart : Christian contemplation through the
 centuries-an illustrated guide / Kim Nataraja.
 p. cm.
 ISBN 978-1-57075-938-3 (pbk.)
 1. Contemplation--History of doctrines. I. Title.
 BV5091.C7N38 2011
 248.3'409--dc22
 2011005654

I dedicate this book to my grandson Zachariah
and the future generation of contemplatives.

The journey to our own heart is a journey
into every heart. And in the first light of
the real we see that this is the communion
which is the kingdom Jesus was born
to establish and in which he is born again
in every human heart.

<div align="right">John Main OSB, Monastery Without Walls</div>

Contents

ACKNOWLEDGEMENTS IX

CONTRIBUTORS' BIOGRAPHIES XI

LIST OF ILLUSTRATIONS XV

1 Jesus I
 Laurence Freeman OSB

2 St John and St Paul 21
 Laurence Freeman OSB

3 Clement of Alexandria 35
 Bishop Kallistos Ware and Revd Professor Andrew Louth

4 Origen 48
 Bishop Kallistos Ware and Revd Professor Andrew Louth

5 Early Christianity and the Gospel of Thomas 65
 Kim Nataraja

6 The Cappadocian Fathers 79
 Marcus Plested

7 The Desert Tradition 92
 Kim Nataraja

8 Evagrius of Pontus 109
 Kim Nataraja

9 John Cassian 124
 Kim Nataraja

10 St Augustine of Hippo 135
 Margaret Lane

11 St Benedict 148
 Esther de Waal and Stefan Reynolds

12 Hildegard von Bingen 158
 Revd Professor June Boyce-Tillman

13 St Francis 170
 Brother Nicholas Alan SSF and Brother Samuel Double SSF

14 St Dominic 192
 Revd Canon Roland Riem

15 Meister Eckhart 202
 Kim Nataraja

16 Dante Alighieri 218
 Professor Dennis McAuliffe

17 Richard Rolle, Walter Hilton and Margery Kempe 229
 Stefan Reynolds

18 The Cloud of Unknowing 248
 Brother Patrick Moore and Stefan Reynolds

19 Julian of Norwich 259
 Margaret Lane

20 St Ignatius of Loyola 271
 Sister Winifred Morley

21 St Teresa of Avila 284
 Julienne McLean

22 St John of the Cross 301
 Peter Tyler

23 George Herbert and Thomas Traherne 315
 Brother Patrick Moore

24 The Jesus Prayer 331
 Revd Professor Andrew Louth

25 Evelyn Underhill 342
 Liz Watson

26 Etty Hillesum 355
 Liz Watson

27 Thomas Merton 368
 Peter Tyler

28 Swami Abhishiktananda 384
 Shirley du Boulay

29 Bede Griffiths 396
 Shirley du Boulay

30 John Main 411
 Stefan Reynolds

 SUGGESTED READING 423

Acknowledgements

The chapters in this book are based on talks given by the individual authors on the 'Roots of Christian Mysticism' course, organized by my husband Shankar and myself. This was run for four years as a one-year course of 30 weekly sessions under the umbrella of the World Community for Christian Meditation at the London Christian Meditation Centre at St Mark's Myddelton Square. It offered the unique opportunity to explore in depth the history of Christian mysticism. Meditation, contemplative prayer, was an integral part of the course, so as to combine theory with practical experience.

The objective of the present book, as it was of the course, is to follow the rich stream of Christian mysticism throughout the ages seriously and in depth by using certain key spiritual teachers as stepping stones along the way. There is diversity but also a common thread, as tradition is passed on and develops.

It leads the reader from the New Testament roots of this tradition in the teaching of Jesus to the great Patristic teachers, then on through the Desert Fathers, Meister Eckhart, the English Mystics and the Spanish Mystics and up to modern times, where there is a special emphasis on key figures such as Thomas Merton, John Main and Bede Griffiths.

My grateful thanks go to Laurence Freeman OSB, Peter Tyler and Kath Barnard, whose useful advice helped greatly in setting up the programme of the course.

I sing the praises of the individual contributors, most well-known specialists in their fields, who generously gave of their time and energy to share their expertise and love of their particular topic. I marvelled at the tour de force they achieved in imparting the essence of their particular figure or tradition in two hours of an

evening. My grateful thanks go to all of them. The important point to remember is that the talks were aimed at a non-specialist audience; these written versions are therefore under no circumstances to be seen as academic papers.

The readers of this book are very much encouraged to see their progress through the chapters as a spiritual journey of discovery; it is not considered to be primarily information gathering, more a process of growth by being exposed to the whole rich stream of the Christian spiritual tradition.

Unfortunately we were not able to include all those who came to contribute to the course, but had to restrict ourselves to those who faithfully came every year. In some chapters there are two different reflections on the same figure because some speakers equally shared their commitment to the course.

The book would not have come about without the invaluable assistance of Liz Watson, the former Centre Director, who made sure the recording equipment worked and all was set out properly. But the stars of this venture are Kathleen Carroll, who faithfully and painstakingly transcribed all the recordings, and Margaret Lane, who thoughtfully prepared summaries of the talks week by week, much appreciated by the participants of the course and by the editor of this book.

I should also like to take the opportunity to acknowledge the unceasing efforts of Christine Smith to find co-publishers, the creativity of Mary Matthews and the painstaking attention to detail of Joanne Hill in preparing the final version of this book.

But most of all this book would not have come into being without the loving, unstinting support of my husband Shankar, my daughter Shanida and my son Ramesh.

KIM NATARAJA
Editor

Contributors' Biographies

Brother Nicholas Alan SSF

Brother Nicholas Alan was born in Sussex in 1965. He studied Theology and Religious Studies at university, and went on to do interfaith work in the Midlands. After further study of Buddhism, he spent three years with the Church Mission Society in Korea. He returned to England in 1995 to join the Society of St Francis, a religious community of the Anglican Communion. As a friar he has spent time as a prison chaplain, hermit, cook, gardener and librarian. He is at present a member of the community at Glasshampton Monastery in Worcestershire.

Shirley du Boulay

Shirley du Boulay was for twelve years a producer of religious programming for BBC television. She has written many books, including *A Modern Pilgrimage: The Road to Canterbury* (Fount, 1997), and biographies of St Teresa of Avila, Dame Cicely Saunders, Bede Griffiths, Abhishiktananda and Desmond Tutu.

Revd Professor June Boyce-Tillman

Revd Professor June Boyce-Tillman read Music at St Hugh's College, Oxford. She is a composer and has written widely in the areas of intercultural issues in music, particularly in composition and education, the spirituality of the musical experience and, recently, in music and peacemaking. She is a Professor of Applied Music at the University of Winchester, and has been a visiting Fellow and Scholar-in-Residence in Indiana and Cambridge, USA. She has written and spoken widely on Hildegaard, and her most recent book is *Unconventional Wisdom* (Equinox, 2007). She is a non-stipendiary priest and in 2008 received the MBE for services to music and education.

Brother Samuel Double SSF

Brother Samuel joined the Franciscan Order in 1982. During 1992–2000 he was the Guardian at Hillfield Friary. During 2001–2005 he was the Vicar of St Bene't's, Cambridge, and since 2002 he has been the Minister Provincial at the Society of St Francis, Dorchester. He has a wide range of interests: apart from Franciscan theology and spirituality he is also involved in the fields of ecological and environmental sustainability, peace and justice issues and interfaith dialogue.

Laurence Freeman OSB

Laurence Freeman was born in London in 1951. He was educated by the Benedictines and studied English Literature at New College, Oxford. After experience at the United Nations, in merchant banking and in journalism,

he became a Benedictine monk. His spiritual guide was Dom John Main, whom he had known before entering the monastic life. He learned meditation from him and was ordained a priest in 1980. He succeeded John Main and for some time has been travelling widely to continue the work and develop the community that meditation has generated. In 1991 the World Community for Christian Meditation was formed and he became its spiritual guide. Laurence Freeman is a monk of the Benedictine Olivetan Congregation. He leads retreats and seminars world-wide and nurtures interfaith understanding. He also leads meditatio, the recently launched outreach of the community that brings the fruits of meditation into the secular world. Laurence Freeman's works include *Christian Meditation: Your Daily Practice* (Novalis/ Medio Media, 2001), *Light Within* (Canterbury Press, 2008), *The Selfless Self* (Canterbury Press, 2009), *Short Span of Days* (Novalis, 2001), *Common Ground* (Continuum, 2000), *Jesus the Teacher Within* (Canterbury Press, 2010) and many audio sets.

Bishop Kallistos Ware

The Most Reverend Metropolitan Kallistos Ware of Diokleia is a titular Metropolitan of the Ecumenical Patriarchate in Great Britain. He was born Timothy Ware, in Bath, Somerset, in 1934 and was educated at Westminster School and Magdalen College, Oxford, where he took a Double First in Classics and holds a Doctorate in Theology. After joining the Orthodox Church in 1958 he travelled widely in Greece, staying in particular at the monastery of St John, Patmos, of which he became a monk. In 1966 he was ordained priest. From 1966 to 2001 he was a Fellow of Pembroke College and Spalding Lecturer in Eastern Orthodox Studies.

Margaret Lane

Margaret Lane lives in London and is married with three children. She is a spiritual director, prayer guide and retreat giver, and teacher of Christian meditation. She has an MA in Patristics and is working for a PhD on St Augustine.

Revd Professor Andrew Louth

Revd Professor Andrew Louth studied at the Universities of Cambridge and Edinburgh. During 1970–85, he was a Fellow of Worcester College and University Lecturer in Theology at the University of Oxford, teaching principally patristics. During 1985–95, he was at Goldsmiths' College, University of London, where he taught religious studies and Byzantine and early medieval history. Since 1996 he has been at Durham, where he is now Professor of Patristic and Byzantine Studies. In 1989 he was received into the Orthodox Church, and in 2003 was ordained priest in the Russian Orthodox Patriarchal Diocese of Sourozh. He is the author of several books, mainly exploring the theology of the Greek Fathers of the early Christian centuries, including *Origins of the Christian Mystical Tradition: Plato to Denys* (Oxford University Press, 1981), *Denys the Areopagite*

(Continuum, 1989), *Maximus the Confessor* (Routledge, 1996), and *St John Damascene: Tradition and Originality in Byzantine Theology* (Oxford University Press, 2004). His latest work is *Greek East and Latin West: The Church AD 681–1071* (vol. 3 of a six-volume history of the Church; St Vladimir's Seminary Press, 2008).

Professor Dennis McAuliffe

Professor Dennis McAuliffe is a New Yorker and studied at St Peter's College, a Jesuit university, before proceeding to Italy to study. He did a PhD at New York University in Medieval Latin and Greek and Renaissance Italian Literature. He now teaches Italian Literature at Bryn Mawr College in Pennsylvania, USA, and directs the John Main Center for Meditation and Inter-Religious Dialogue at Georgetown University in Washington DC.

Julienne McLean

Julienne McLean practises as a psychologist and Jungian analyst in north London, having studied in Australia, the USA and England. She is also a spiritual director who has had a lifelong involvement in the Christian contemplative tradition, with a particular interest in the relationship between depth psychology and Christian mysticism. She teaches at St Mary's University College, Strawberry Hill, London, and Sarum College, Salisbury, where she recently became a Visiting Scholar in Christian Spirituality and co-leads study retreats in Avila, Spain. She is the author of *Towards Mystical Union* (St Paul's, 2003), a modern spiritual and psychological commentary on St Teresa's text on contemplative prayer, 'The Interior Castle'.

Brother Patrick Moore

Brother Patrick Moore is a De La Salle Brother and has taught in California, Cambridge and London. He is presently Scholar-in-Residence at Sarum College, Salisbury, and has been a Guest Fellow at Yale. His doctoral studies were in Aesthetics.

Sister Winifred Morley

Sister Winifred Morley is a Sister of the Cenacle currently living in Netley Abbey. She first met St Ignatius on a workshop at the age of 14 and has been inspired by his teaching and methods ever since. She has been involved in leading retreats for many years and is teaching in the London Spirituality Centre on the Spiritual Director course.

Kim Nataraja

Kim Nataraja is a Benedictine Oblate. She has been coordinating the School of Meditation internationally for the World Community for Christian Meditation since 1999. She is a spiritual director, an experienced retreat leader, and has held a variety of meditation days/weekends and retreats in Australia, Canada, Europe, Singapore, the UK and the USA. Her particular interests are those inspiring figures from the Christian spiritual tradition who guide us in the contemplative life, and the ways in which psychological insights can aid our progress. On the latter topic she has written a book, *Dancing with Your Shadow* (Medio Media, 2007).

Dr Marcus Plested Dr Marcus Plested has been at the Institute for Orthodox Christian Stud-
ies for more than ten years and is its Vice-Principal and Academic Direc-
tor. He read Modern History, followed by Theology at Merton College,
Oxford. His doctorate is in the Macarian Homilies. Other research inter-
ests include the understanding of wisdom in the Christian tradition and
the interaction between western and eastern theological traditions. He
teaches, lectures and publishes widely in the field of Orthodox Christian
studies. His most recent book is *The Macarian Legacy: The Place of Macarius-
Symeon in the Eastern Christian Tradition* (Oxford University Press, 2004).

Stefan Reynolds Stefan Reynolds is currently working on a PhD on fourteenth-century
English mysticism. He is a Benedictine Oblate of the World Community for
Christian Meditation and leads retreats teaching the practice of contem-
plative prayer. He is also a Tutor of Church History at Heythrop College
in London.

Revd Canon Canon Roland Riem is Canon Chancellor and Pastor and Missionar at Win-
Roland Riem chester Cathedral, where he has educational and ecumenical responsibilities
as well as concern for the spiritual interpretation of buldings. His previous
roles have included church ministerial training and university chaplaincy.

Dr Peter Mark Tyler Dr Peter Mark Tyler is Senior Lecturer and Programme Director of Pastoral
Theology at St Mary's University College, Twickenham. He has had a long in-
terest in the works of St John of the Cross and Thomas Merton, and regularly
leads pilgrimage retreats to the sites associated with St John in Spain. His most
recent books include *The Return to the Mystical: Ludwig Wittgenstein, Teresa of
Avila and the Christian Mystical Tradition* (Continuum, 2011) and *St John of the
Cross: Outstanding Christian Thinker* (Continuum, 2010).

Dr Esther de Waal Dr Esther de Waal, after studying and teaching history at Cambridge Uni-
versity, married, moved to Canterbury and had four sons. She now lives in
a small cottage on the Welsh/English border. She leads retreats, lectures and
travels widely. Her major interests are the fields of the Benedictine and
Celtic traditions.

Liz Watson Liz Watson, born in 1951, became interested in the Christian mystical trad-
ition after returning to Christianity and beginning to meditate in her early
forties. Previously she had pursued a career in public libraries, having grad-
uated from Manchester University with a degree in Latin. She has since
studied for a Master's Degree in Theology at Exeter University and is now
closely involved with the World Community for Christian Meditation,
teaching, leading retreats and as a spiritual director.

List of Illustrations

The publisher and author have made every effort to trace the original sources of illustrations, and would be grateful to be informed of any omissions. Where the source has not been found, it is referred to as location unknown. Wikimedia Commons images are available under a Creative Commons Attribution ShareAlike 3.0 license.

Chapter 1 *page* 1 Icon of Christ Pantocrator – Moscow School, 1670. Location unknown.

5 Jesus at the home of Martha and Mary, *Harold Copping*. Location unknown.
http://commons.wikimedia.org/wiki/File:Harold_Copping_Jesus_at_the_home_of_Martha_and_Mary_400.jpg

12 Judean Desert, 2004.
http://commons.wikimedia.org/wiki/File:JudeanDesert.jpg

Chapter 2 21 St John the Evangelist, *Guido Reni* (1575–1642). Location unknown.
http://commons.wikimedia.org/wiki/File:JohnEvangelistReni.jpg

29 Ananias restoring the sight of St Paul, *Pietro da Cortona*, c.1631. In the Capuchin Church of St Maria della Concezione, Rome.
http://commons.wikimedia.org/wiki/File:Saint_Paul_Ananias_Sight_Restored.jpg

31 St Paul writing his Epistles, *Valentin de Boulogne* or *Nicolas Tournier*, c.16th century. Blaffer Foundation Collection, Houston, Texas.
http://upload.wikimedia.org/wikipedia/commons/7/71/PaulT.jpg

Chapter 3 35 Clement of Alexandria. Artist and location unknown.
http://commons.wikimedia.org/wiki/File:ClemensVonAlexandrien.jpg

37 The Pharos of Alexandria, hand-coloured engraving, *Martin van Heemskerck* (1498–1574). Location unknown.
http://commons.wikimedia.org/wiki/File:Pharos_of_Alexandria.jpg

44 Ancient library. Artist and location unknown.
http://commons.wikimedia.org/wiki/File:Ancientlibraryalex.jpg

Chapter 4 48 Origen. Artist and location unknown.
http://platonism347.tripod.com/Origen.jpg

51 The Rosetta Gate and Alexandria, engraving, *Michael Wohlgemuth* (1434–1519). *Photograph by Alexandria42*. Location unknown.
http://flickr.com/photos/cam37/1230508585/

59 Origen initiating neophytes into the death and re-birth experience. Artist and location unknown.
http://wikipedia.org/wiki/File:Origen2.jpg

Chapter 5 *page* 65 The Nag Hammadi gospels, discovered in the 1940s south of Cairo, date to the 3rd–4th centuries. In the Coptic Museum, Cairo.
http://commons.wikimedia.org/wiki/File:Kodeks_IV_NagHammadi.jpg?uselang=en-gb

 67 St Irenaeus, *Photograph by John Hanscom* Artist and location unknown.
http://flickr.com./photos/johnhanscom/6643811729/

 70 Constantine with Holy Fathers at the first Council of Nicaea, AD325. Icon from Mount Athos. Artist unknown.
http://commons.wikimedia.org/wiki/File:NicaeaConstantine.jpg

Chapter 6 79 Mass of St Basil, *Pierre Subleyras* (1699–1749). The State Hermitage Museum, St Petersburg.
http://commons.wikimedia.org/wiki/File:Mass_of_St_Basil_by_Pierre_Subleyras.jpg

 81 View of Cappadocia. *Photograph by Mila Zinkova.*
http://commons.wikimedia.org/wiki/File:Cappadocia_Turkey.jpg

 84 Gregory of Nyssa, fresco in the Church of St Savior in Chora, Istanbul. Artist unknown.
http://commons.wikimedia.org/wiki/File:Gregory_of_Nyssa.jpg?uselang=en-gb

Chapter 7 92 St Antony and St Paul, icon in St Alban's Orthodox Church in Chatham, Kent. Artist unknown.
http://www.orthodoxmedway.org/icongallery.php

 97 St Antony's cave. In John Chryssavgis, *In the Heart of the Desert*, World Wisdom, 2009.

 99 St Catherine's Monastery at the foot of Mount Sinai, Egypt. *Photograph by Shankar Nataraja.*

Chapter 8 109 Evagrius of Pontus, *Giorgos Kordes*. Location unknown.
http://avidaintelectual.blogspot.com/2011/02/pe.html

 111 Kellia (Cells), south of the Nitrian Desert, founded in 338.
http://commons.wikimedia.org/wiki/File:Kellia.jpg

 117 St Antony's temptation by demons, from the Isenheim Altarpiece, *attributed to Matthias Grünewald, c.*1520.
http://www.flickr.com/photos/28433765@N07/3532421955/

Chapter 9 124 John Cassian, *Giorgos Kordes*. Location unknown.
http://gbsadler.blogspot.com/2011/02/john-cassian-on-anger-revisited.html

 126 The 12th-century St Victor Abbey replaced the 5th-century monastery, founded by John Cassian and destroyed by Saracens. *Photograph by Evgeny Prokofyev.*
www.shutterstock.com

 133 The Desert Fathers, fresco in the Abbey of Monte Oliveto Maggiore, south of Sienna. *Photograph by Shankar Nataraja.*

Chapter 10 135 St Augustine, *Philippe de Champaigne*, 1660. Location unknown.
http://www.google.co.uk/imgres?imgurl=http://www.episcopalnet.org/Pictures/StAugustine.gif&imgrefurl

Chapter 10 *page* 138 Book of Confessions, *Pedro de Ribadeneira*, 1654. Location unknown.
http://commons.wikimedia.org/wiki/File:onfesiones.jpg

143 St Augustine, *Aidan Hart.*
http://www.aidanharticons.com/western_orthodox_saints.html

Chapter 11 148 St Benedict, fresco in the Abbey of Monte Oliveto Maggiore, south of
Sienna. *Photograph by Shankar Nataraja.*

150 St Benedict delivering his *Rule* to St Mauris and other monks of his
order. In the Monastery of St Gilles, Nîmes, 1129.
http://commons.wikimedia.org/wiki/File:St._Benedict_delivering_his_rule_to_the
_monks_of_his_order.jpg

Chapter 12 158 Hildegard's self portrait, receiving a vision and dictating to her scribe.
From the *Liber Scivias* (*Know the Ways*), Lucca, Biblioteca Statale, su
concessione del Ministero per i Beni e le Attivita Culturali.
http://commons.wikimedia.org/wiki/File:Hildegard.jpg

167 Hildegard's 'Universal Man'. From the *Liber Divinorum Operum* (*Book of
Divine Works*), Lucca, Biblioteca Statale, su concessione del Ministero per i
Beni e le Attivita Culturali.
http://upload.wikimedia.org/wikipedia/commons/thumb/2/2e/Hildegard_von_
Bingen_Liber_Divinorum_Operum.jpg/135px-

168 Hildegard's 'Ecclesia', the depiction of the Church as the Bride of Christ.
From the *Liber Scivias* (*Know the Ways*), Lucca, Biblioteca Statale, su
concessione del Ministero per i Beni e le Attivita Culturali.
http://upload.wikimedia.org/wikipedia/commons/5/57/Meister_des_Hildegardis-

Chapter 13 170 St Francis meditating with a skull, *Francisco de Zurbarán*. In the Alte Pina-
kothek, Munich.
http://commons.wikimedia.org/wiki/File:Francisco_de_Zurbar%C3%A1n_057.jpg

174 St Francis holding up the falling church, Dream of Innocent III, Legend of St
Francis, *Giotto di Bondone* (1267–1337). In the Basilique Assise, Assisi.
http://commons.wikimedia.org/wiki/File:Giotto_-_Legend_of_St_Francis_-_-
06-_-_Dream_of_Innocent_III.jpg

179 Stigmatization of St Francis, Legend of St Francis, *Giotto di Bondone*
(1267–1337). In the Basilique Assise, Assisi.
http://commons.wikimedia.org/wiki/File:Giotto_-_Legend_of_St_Francis_-_-
19-_-_Stigmatization_of_St_Francis.jpg

Chapter 14 192 St Dominic in prayer, *El Greco*, *c.*1586–90. Placido Arango Collection,
Museo del Prado, Madrid.
http://commons.wikimedia.org/wiki/File:El_Greco,_St_Dominic_in_Prayer.JPG

194 The Transfiguration, *Fra Angelico* (1395–1455). In the cycle of frescos in
the Dominican Monastery of St Mark, Florence.
http://commons.wikimedia.org/wiki/File:Fra_Angelico_042.jpg

200 Saint Catherine of Siena, *Andrea Vanni*, *c.*1400. Fresco in the Church of
San Dominico, Siena.
http://commons.wikimedia.org/wiki/File:St_Catherine._San_Domenico.jpg

Chapter 15 *page* 202 Old wood block of Meister Eckhart teaching.
http://www.academici.com/webstorage/userfiles/1267/mydocuments/Eckhart-
Teaching.jpg

204 The memorial doors to Meister Eckhart at the Predigerkirche (Preacher's
Church) in Erfurt, Germany 'Light shines in darkness and the darkness has
not comprehended it' (John 1.5). *Photograph by Michael Sander.*
http://commons.wikimedia.org/wiki/File:Meister-Ekkehard-Portal_der_Erfurter
_Predigerkirche.jpg

216 Oldest fragment of sermon 5b of Meister Eckhart. In the Georg-August-
Universität, Göttingen.
http://commons.wikimedia.org/wiki/File:Meister_Eckhart_Fragment_1003.jpg

Chapter 16 218 Dante Alighieri, *Andrea del Castagno, c.*1450, one of the Famous Men and
Women cycle. In the Uffizi Gallery, Florence.
http://commons.wikimedia.org/wiki/File:DanteFresco.jpg

221 Dante and the Divine Comedy, *Domenico de Micheino*, 1465. Fresco in
the dome of the church of Santa Maria del Fiore, Florence.
http://commons.wikimedia.org/wiki/File:Michelino_DanteAndHisPoem.jpg

222 Dante and Virgil Enter Hell, *William Blake*, 1826. Location unknown.
http://commons.wikimedia.org/wiki/File:Blake01.jpg

Chapter 17 229 Richard Rolle, Hermit of Hampole. In Rotha Mary Clay, *The Hermits
and Anchorites of England*, Methuen & Co, 1914.
http://www.historyfish.net/anchorites/clay_anchorites.html

238 Medieval illustration of the ladder of perfection, unattributed. Location
unknown.
http://taishangzhenren.blog.163.com/blog/static/3166318520073120319292/

245 Margery Kempe, medieval image, unattributed. Location unknown.
http://www.holycross.edu/departments/visarts/projects/anglia/bio.html

Chapter 18 248 Cloud of Unknowing, *Helena Hadala*, 2004.
http://www.helenahadala.com/image_cloud_of_unknowing.html

250 Greek icon of Dionysius, Rusticus and Eleutherus, in the *Menologion of Basil
II*: 11th-century illuminated byzantine manuscript. Location unknown.
http://commons.wikimedia.org/wiki/File:Menologion_of_Basil_025.jpg

257 Noli me Tangere, fresco, *Fra Angelico*, 1425–30. In the Convent of San
Marco, Florence.
http://www.artchive.com/artchive/F/fra_angelico/tangere.jpg.html

Chapter 19 259 Icon of Julian of Norwich, *Anna Dimascio*. Used by permission of the
Rector and PCC of St John the Baptist, Timberhill, with St Julian's.

261 Window in Mother Julian's cell. Used by permission of the Rector and
PCC of St John the Baptist, Timberhill, with St Julian's.

262 Door to Mother Julian's cell. Used by permission of the Rector and
PCC of St John the Baptist, Timberhill, with St Julian's.

Chapter 20 271 St Ignatius Loyola, scratchboard drawing, *Maria Laughlin*.

Chapter 20 *page* 273 St Ignatius dressed as a knight, unattributed. French School, 16th century. Location unknown.
http://commons.wikimedia.org/wiki/File:Ignatius_of_Loyola_(militant).jpg?uselang=en-gb

275 Ignatius at Manresa. In Seattle University.
http://www.jesuitvocations.org.uk/spiritual-exercises/

Chapter 21 284 St Teresa of Avila, detail of 'Apotheosis of St Teresa and St John', D. Joseph Garzia (17th century). In the Chapel of the Sepulchre of St John of the Cross, Discalced Carmelite Friars, Segoria, Spain. *Photograph by Julienne McLean.*

288 St Teresa icon, the Melkite sisters of the Monastery of the Annunciation, Nazareth.

293 St Teresa of Avila, window in the Convento de Santa Teresa, Avila, Spain.
http://commons.wikimedia.org/wiki/File:Avila_Convento_de_Sta_Theresa_Church_window01.jpg

Chapter 22 301 St John of the Cross, *Lynne Taggart.*
http://freespace.virgin.net/g.ramos-poqui/Lynne/carmelicons/.

308 City of Toledo.
http://www.destination360.com/europe/spain/toledo

309 Philip II of Spain, Spanish School, anonymous, 15th century. Location unknown.
http://upload.wikimedia.org/wikipedia/commons/1/14/Philip_II,_King_of_Spain_from_NPG.jpg

Chapter 23 315 Portrait of George Herbert, unattributed.
http://www.hanscomfamily.com/2009/02/26/george-herbert-priest-poet-1633/

320 Folio page from *The Temple*, 1671.
http:// www.english.cam.ac.uk/cambridgeauthors/wp-content/uploads/2009/ 09 /herbertparson.jpg

324 Charles Cotton's Fishing House, 1674. He wrote a section of Isaak Walton's *The Compleat Angler.*
http://commons.wikimedia.org/wiki/File:Fishing_house_Compleat_Angler_276173_17064574.jpg

Chapter 24 331 The oldest surviving panel icon of Christ Pantocrator, *c.*6th century. In the Monastery of St Catherine, Sinai.
http://en.wikipedia.org/wiki/Depiction_of_Jesus

333 Illustration from the anonymous Russian book, *The Way of a Pilgrim*, published in 1881.
http://4.bp.blogspot.com/_oN5K_WcO5JM/S-VzNZKbXiI/AAAAAAAAFVs/iVrtFIAkCtY/s1600/2067147519_42fefcebfb_o.jpg

335 Eastern Orthodox prayer rope, *chotki*, with 50 knots and five beads.
http://reference.findtarget.com/search/Prayer%20rope/

Chapter 25 342 Evelyn Underhill.
http://anamchara.com/mystics/evelyn-underhill/

Chapter 25 *page* 353 Baron Friedrich von Hügel.
http://www.google.co.uk/imgres?imgurl=http://upload.wikimedia.org/
wikipedia/en/f/f2/Friedrich_von_Hugel.jpg

Chapter 26 355 Etty Hillesum.
http://fy.wikipedia.org/wiki/Ofbyld:Etty_Hillesum.jpg

 359 Westerbork Concentration Camp, where Etty Hillesum was interred.
http://www.google.co.uk/imgres?imgurl=http://upload.wikimedia.org/wikipedia
/commons/thumb/4/49/Hut-Westerbork.jpg/200px-Hut-Westerbork.jpg

 363 Jews being deported to Westerbork Transit Camp. *Photograph by Yad Vashem.*
http://www1.yadvashem.org/yv/en/exhibitions/this_month/july/10.asp

Chapter 27 368 A Portrait of Thomas Merton © *Joseph Malham.* Used with the
permission of the artist.
http://psnt.net/blog/2010/12/in-gratitude-for-thomas-merton/

 373 Interior of Thomas Merton's hermitage. *Photograph by Bryan Sherwood.*
http://commons.wikimedia.org/wiki/File:Thomas_Merton_hermitage_inte-
rior2 _(Abbey_of_Gethsemani).jpg

 375 Thomas Merton outside his hermitage.
http://newtravelingshoes.blogspot.com/2009/01/thomas-merton.htm

Chapter 28 384 Swami Abhishiktananda.
http://www.flickr.com/photos/14683443@N06/3117105526/

 390 Ramana Maharshi.
http://www.img2.desicolours.net/2009/august/ramana-maharshi-05.jpg

 392 Arunachala mountain in Tamil Nadu, South India.
http://www.trekearth.com/gallery/Asia/India/South/Tamil_Nadu/Tiruvanna-
malai /photo238636.htm

Chapter 29 396 Bede Griffiths. *Photograph by Kim Nataraja.*

 403 Bede Griffiths walking with Brother John Martin and Brother Christu-
das. *Photograph by Kim Nataraja.*

 407 Bede Griffiths celebrating an Indian Rite Mass. *Photograph by Kim
Nataraja.*

Chapter 30 411 John Main.
http://www.wccm.org

 414 John Main with the Dalai Lama and Laurence Freeman.
http://www.wccm.org/

ONE

JESUS

Laurence Freeman OSB

Icon of Christ Pantocrator

Introduction

Mysticism, the personal experience of the presence of God, is not limited to any particular religious expression of humankind, but forms an essential part of all world religions or wisdom traditions. Christianity is certainly no exception, although this fact may surprise many modern Christians.

In the ancient Judaic tradition, mystical experiences are well attested; there are many accounts of being in the Divine Presence in dreams and visions: just think of Abraham, Jacob and Moses, not to forget the prophets, especially Ezekiel's vision when exiled in Babylon and Elijah's vision of God on Mount Horeb.

Although the Cabbala, the Jewish mystical tradition, is generally seen as developing only in the twelfth century, there was already, centuries before Jesus' time, and during his time, a well-established practice of meditation, the *Merkavah* or 'Chariot' mystical tradition. This was based on Ezekiel's vision of the 'chariot', the 'throne' of God, as well as the very significant and influential vision of the 'throne' by Enoch in the *Book of Watchers* and that by Daniel in the Book of Daniel.

It is, ironically, practically a truism that deep spiritual experiences, born out of profound silence, often flourish in times of political and social turmoil. Jesus himself was born in a land subjected to many political struggles and conquests. It is in the ensuing precarious and troublesome climate that Jesus had his mystical experiences, out of which developed his own unique sense of the Divine Presence.

> **Jesus of Nazareth** *c.*AD1-34
>
> As with all figures from an ancient oral culture, little is known with certainty about Jesus. We only have approximate dates for his birth and crucifixion. There were unusual circumstances surrounding his birth in Bethlehem. His parents were Mary and Joseph, who had four other sons and at least two daughters. What is generally agreed is that he was a Jewish rabbi, exorcist and healer from Galilee, who was accused of blasphemy by the High Priest Caiaphas and sedition against Rome by Pontius Pilate the Roman Governor at that time and sentenced to death by crucifixion. Any other details about him – his birth, meeting Simeon and Anna, flight into Egypt, return to Nazareth after the death of Herod, visit to the Temple in Jerusalem, his baptism by John, temptation in the desert and his public ministry, transfiguration witnessed by three disciples, his crucifixion and Resurrection – we learn from one or more of the various writings about him. Important in this respect are the Gospels, Paul's letters, the Book of Acts, the Apocrypha, the ancient creeds, and the writings of the early saints and Church Fathers, including Clement of Rome, Ignatius of Antioch and Justin Martyr, and historians of the time such as Josephus, who mentions in *Antiquities of the Jews* James 'the brother of Jesus, who was called Christ'.

Laurence Freeman OSB starts our journey through the rich Christian tradition by reclaiming the importance of the contemplative dimension of Jesus' being and teaching, with its emphasis on interiority and silence. He does so by engaging with the question of who Jesus really is.

UNDERSTANDING JESUS

There are many ways of understanding Jesus, who he is and what he means, perhaps ultimately as many ways as there are human individuals and cultures. Jaroslav Pelikan's study of this across the centuries illustrates the immense diversity of responses to the great central question of Jesus, 'Who do you say I am?' (Luke 9.20). As we begin the journey on which this book will guide us through the centuries of the Christian mystical tradition, this question will help start us in the right direction. Of the many ways of responding to the defining question of Christian identity I will concentrate here on this: Jesus is a teacher of contemplation.

This is not how many first understand Jesus and, indeed, some Christians would argue that that is not what he is about at all. Christianity has become identified,

particularly in its dominant western form, with action (if not hyper-activism) rather than contemplation; it may seem to be characterized more by a missionary zeal to convert rather than a contemplative capacity to co-exist with other partners in the search for wisdom. For some Christians, contemplation even seems suspect, a dangerous approximation to 'eastern' spirituality, even an infection from the East, or the self-fixated mentality of so much contemporary culture. For the sake of the world and its crisis, however, it is urgent that we correct this misperception about the un-contemplative nature of Christianity, and equally urgent that we see the need for an inter-religious dialogue that arises from and leads back to the contemplative common ground. So many conflicts in the modern world proceed under the banners of religious identity and intolerance of other identities, ignorance of each other's beliefs and even fear of the similarities that naturally connect us. The Holocaust is a perpetual indictment of this failure of religious understanding. But it did not stop there. The European wars of the twentieth century ended with four years of Orthodox 'Christians' besieging and shelling Muslims in Sarajevo, a city where the three 'peoples of the Book' have co-existed for centuries. The new century's terrorism still masquerades under religious banners threatening imminent social polarization. There is nothing in the teaching of Jesus that justifies such intolerance; everything in his teaching breathes the spirit of unity. His injunction to non-violence, mental and physical, is one central pillar of his message to humanity and is complemented in every sense by his emphasis on contemplation.

Jesus is a teacher of contemplation. His life models it. We cannot begin to respond to his question, 'Who do you say I am?', or understand the meaning of the Kingdom, his critique of religion, his understanding of humanity or his death and Resurrection unless we see how central contemplation is to his life and teaching. One explicit example of this is a short episode in the Gospel of Luke, the story of Martha and Mary which, even this early in the Christian tradition, expresses the primacy of contemplation over action while also recognizing the difficult, inherent tension between the two (Luke 10.32–42).

Mary and Martha

Jesus comes to visit Martha and Mary, two sisters, two friends of his. Martha, representing the active life, welcomes him into the house while Mary, symbolizing the

Jesus' teaching

Jesus taught a less harsh and more complete version of morality than that of the Old Testament, and stressed the importance of discovering the Kingdom of God within and among everyone.

We find his teaching recorded in the various Gospels:

'Sermon on the Mount' – Matthew 5–7; Luke 6.17–49

'Discourse to the Jews' – John chapters 5, 8 and 10

'Discourses to his disciples' – John chapters 14–16

'Final discourse to his disciples' – John chapter 17

Gospel of Thomas – a record of Jesus' oral sayings.

contemplative life, sits at his feet listening to his words. The text says that she sits and stays there. Martha, however, becomes distracted by her many tasks and emerges as a kind of domestic terrorist by bursting in complaining to Jesus: 'Lord, do you not care that my sister is leaving me to do everything by myself? Tell her to give me a hand!'

Martha is clearly the star or anti-heroine of this story. The ordinary reader identifies and sympathizes with her. Who hasn't at times felt like her? She is not in a pleasant mood but she is not condemned by Jesus – or the narrator, or the reader – because she is so clearly in a state of suffering, isolated, angry, paranoid, overwhelmed, feeling abandoned. Her ego has painfully inflated and she sees everything revolving around herself. If we were to give the multi-tasking Martha one more job in her heavenly rest it would be to be the patron saint of stress, of which she is showing all the classic symptoms. Yet behind the self-dramatizing she is only trying to get a good meal ready, to be hospitable. Why doesn't she ask Mary to help her directly? Why does she blame Jesus and become the only disciple in the Gospels who tells him what to do? These are questions that make the story instructive for us at one level of reading Scripture by yielding us insight into its 'moral sense'. How does the story help us understand our own behaviour? However, at a deeper spiritual level we are not dealing with psychology but with the very makeup of our humanity. The two sisters represent not just two personality types but the two halves of the human soul. This is implicit in the way Jesus responds to Martha.

Calmly and in a friendly way he explains to Martha, first of all, that she is way out of touch with herself. He says her name twice to bring her back. She is now, we hope, learning to listen to him as Mary was doing. 'Martha, Martha, you are fussing and fretting about so many things,' he tells her. Jesus is not blaming, but diagnosing her problem by pointing out how alienated she has become from her other half, her sister. He tells Martha she has become unmanageably stressed in her many tasks whereas 'only one thing is necessary'. He does not define this one thing.

But surely the 'one thing' is to be one, to re-integrate the divided self whose internal fracture has led her into anger and violence. In his next words he defends the contemplative dimension of life which routinely comes under attack from the activist side of the divided self for being useless, non-productive and selfish. This primary unity of the soul, the balance and harmony between action and contemplation, decides the whole pattern and tone of life. Without it every aspect of life is fragmented. In religious terms, theology, prayer, worship are all crippled by this internal division. Faith itself eventually degenerates into ideology and social conformity without the contemplative dimension. In more general terms, the human psyche collapses into one-sidedness, imbalance and disharmony. This is why Jesus says something that might be misread as a putdown of Martha: 'Mary has chosen the better part and it will not be taken from her.' In fact

he is saying that being comes before doing and the quality of our being determines the quality and effectiveness of all our actions. We don't hear how Martha responds. Does she lift her hands in despair and leave banging the door, or suddenly calm down and do what she should have done at first, which is to ask Mary to help her? It would be the test of Mary's work. If she had said 'No, I'm contemplating, leave me alone', she would have shown her work to be inauthentic. If she had jumped up and helped, her other side would have been in harmony. Martha's mistake, made by cultures and religions as well as individuals, is not to have remembered that Mary was working as well.

Jesus at the home of Martha and Mary, *Harold Copping*

We are all Martha and Mary. Our imbalance is represented here by Martha, who shows it up as a universal problem. The one thing necessary is to get the two halves of our soul back into friendship and balance. There are many ways we can do this. Most important of course is to recover the work that Mary is doing – Martha had forgotten the value of Mary's non-action: even though Mary seems to be doing noth-

ing she is working, listening and paying attention and being still.

The story shows us Jesus as a teacher of contemplation who understands and communicates that wholeness is holy balance and integration. Jesus taught this, not only in words but by example. Particularly in Luke's Gospel we see him frequently stopping his fast pace of life, his preaching, healing and travelling, by withdrawing to quiet places to pray alone or with a few of his disciples (Luke 6.12; 9.18; 22.39). If there was not a harmony between what he taught and what he did his teaching would lack authority. Christian identity depends directly on this authority. If we fail to see Jesus as a teacher of contemplation the rest of the picture, the other half of Christian identity, is lost. Bede Griffiths once urged the World Community for Christian Meditation to come to India and start teaching meditation to Christians there. His reason, he said, was that most Indians hardly saw Christianity as a real religion. They saw and admired the many good works, the schools and hospitals, although they were less impressed by the history of intolerance and exclusivism. But a religion without contemplation, as many of them saw Christianity, lacked an essential part of holiness.

'Who do you say I am?'

Teachers are powerful figures and many can abuse this power. Some teachers dominate and enslave their students. True teachers liberate and empower and are delighted when their disciples personally own what they have learned and put it into practice. Even more:

> Whoever believes in me will perform the same works as I do myself and will perform even greater works, because I am going to the Father. (John 14.12)

A good teacher asks questions. Like a good therapist, the good teacher knows both the right question and the best time to ask it. A contemplative teacher knows that questions posed rather than answers delivered are more effective in opening minds and leading people to that personal verification which is their true aim. Then, it is not so much the answer that matters, it's the way the question is listened to, how deeply it is taken in, the degree of attention it leads to. The right question opens the hearer to that process of integration (the 'one thing necessary') that brings healing and is the work of wholeness.

There are slight differences in the Gospel accounts of the occasion where Jesus poses his all-important question. There are also discrepancies between the Gospels in most of the stories and important events of the life and teaching of Jesus. The canonical Gospels are like four windows looking onto – or into – the same events. They were written for different audiences in different faith communities at different times. The reader needs to be aware that she is reading not a newspaper or court proceeding but a document inspired by the experience of the Resurrection and of the indwelling Christ. The Gospels are based on oral and written traditions that connect us to historical events which still have influence on human consciousness. But the dominant reality is the Risen Christ in the spiritual present. For this reason, it always helps to ask why this particular evangelist put in this story or left out that detail. This diversity in faith has led to an immense richness in theological traditions over two millennia and mystical commentators rather than ideologues are perhaps best at reading these sacred texts at the level at which they were composed and meant to be read. Meditation tunes you to this level and enables you to read them as an endless source of inspiration and wisdom.

In both Luke and Mark, Jesus is 'praying alone in the company of his disciples' when he asks his question. That is how it is paradoxically described and in fact this is what we do whenever we pray deeply together. We are alone in the sense that we are in solitude. We are praying uniquely but not in isolation; we are in each other's company but not indistinct. We are doing what we can only do in our uniqueness. Contemplation is solitary in this sense. But in that solitude we are discovering our common ground with those we pray with and also all humanity. In this sense 'meditation creates community', as John Main said.

After the prayer Jesus asks the disciples a first question: 'Who do people say I am?' They respond by telling him what the people are saying – Jesus is one of the prophets come back to life. Jesus can certainly be understood by his place in the biblical prophetic tradition – Jews and Muslims see him in this way. Jesus does not comment on this, however. Instead he asks a second and more personal question: 'But who do you say I am?' This changes both the tone and meaning of the question radically. Peter characteristically jumps in with a statement of faith: 'You are the Christ, the Son of the living God.' The response of Jesus to this theologically correct answer is not what we might expect. It is not a simple affirmation (as in Matthew's

version) but a strong warning not to tell anyone who he is. Having commended Peter, he shortly rejects him ('Get behind me Satan') for his failure to understand the meaning of what he had said. As a contemplative teacher Jesus is wary of answers and titles. It is so easy to cling to a formula and close down the mind once you think you have the right answer. Questions suit the contemplative approach much better because they keep the mind open as it gets to know the truth more fully. They encourage the personal discovery and verification of the truth. So what does the question of Jesus do? What is the point of the question? This is important for an understanding of the contemplative content of Jesus' teaching as well as the foundations of the Christian mystical tradition.

It is a question that rings down the centuries and yet reaches us just as personally as it did when it was put to Peter and the other disciples. I wonder how you would respond to the question, 'Who do you say I am?' I once taught a university course on 'Modern Christian Identity' and I began the term by asking the students this question. Most of them came up with good and bright answers. But actually no one answered the real question, who they thought Jesus was. They were commenting on or quoting what other people thought. The point of the second question is that it is unflinchingly personal and therefore, unlike the first question which allows us to remain safely behind other people's views, it touches directly into our self-knowledge. There is an intimacy, almost an intrusion into our privacy, in the second and more powerful question. If we listen to it we cannot hide from ourselves. At the end of the term, three months later, I asked the students the same question. By now we had meditated together, explored the gospel and looked at some major contemporary Christian teachers and witnesses. This time nearly everybody answered the actual question and it seemed to come from the heart. The only Jewish student in the class put his response in a way I was particularly moved by. He said: 'Well, I'm a Jew and this has helped me to understand my Jewish identity even more. I'm still a Jew but I'd say that I have come to know Jesus and I'm sure he will be a presence in my life for the rest of my life.'

This is a question that shows Jesus as a teacher of contemplation and what contemplation leads to. It does not aim to test dogmatic orthodoxy, although Christianity later became more concerned with this than any other religion. It opens the way and leads to the goal and fruit of contemplation. Contemplation is a path, an

experience, a lifelong practice, an expansion and deepening of consciousness. It is about being in the present moment. It is, according to Aquinas, the 'simple enjoyment of the truth'. Above all, it leads to self-knowledge. The Christian mystical tradition, which this book will guide you through, affirms more clearly in every generation that self-knowledge is the ground and necessary prelude to the knowledge of God. St Augustine, at the beginning of the *Confessions*, says: 'Let me know myself so that I may know thee.' In a later work he developed this when he said: 'The human being must, first of all, be restored to himself or herself so that, making of themselves a stepping stone they rise from themselves to God.' Self-knowledge is a kind of springboard. Contemplation is the reverse of self-fixation. It is dynamic and transcendent. With each level of self-knowledge that we enter we are changed.

Peter called Jesus the 'messiah' or Christ, which means 'anointed one'. He was speaking from a Jewish vocabulary of faith and the biblical tradition. As Jesus was born, lived and died in this religious culture, this vocabulary is naturally appropriate and still remains relevant. Anyone who wishes to understand Jesus cannot ignore his historical setting and will need some knowledge to be able to navigate the primary biblical language of the Christian tradition. At the same time, the question of Jesus, over the centuries, has spread far beyond this cultural milieu and has touched people who are steeped in quite different systems of religious symbolism and concepts. Actually, this expansion beyond cultural frontiers happened at the outset. In his lifetime and immediately after the Resurrection the first Jewish Christians encountered the challenge of communicating the faith to Greeks and Romans who had little or no knowledge of biblical language and history. Today this 'dialogue of the question' has expanded far beyond the Greco-Roman world and further than the early Christians could ever have imagined. The question survives, though, and is as challengingly simple as ever. How then would a Buddhist, Hindu, Muslim or modern Humanist answer this question? Who we say Jesus is can radically redefine how we understand ourselves and our traditions. This does not mean that his question forces us into a rejection of other traditions and their streams of wisdom. It simply challenges us to a new level of self-knowledge, a greater authenticity and a deeper experience of universal truth. So an Asian response, using the language of the Vedas or the Sutras, is not 'wrong', nor is the western European, using more familiar Greek or scholastic terms, 'right' at the expense of the others. Jesus as a uni-

Also around this time

63BC
Pompey conquers
Jerusalem for the Roman
Empire and even enters
the Temple.

47BC
Rule of Julius Caesar in
Syria and Palestine.

40–4BC
Reign of King Herod the
Great under Rome.

31BC
Octavian defeats the fleet
of Antony and Cleopatra at
Actium.

4BC
Death of Herod; his king-
dom divided between his
sons, Herod Antipas rules
Galilee; Archelaus in
Judaea.

AD2–8
Roman writer Ovid writes
Metamorphoses.

3
Conjunction of Jupiter and
Venus.

14
Augustus Caesar dies,
succeeded by Tiberius, who
reigns until AD37.

29
Beheading of John the
Baptist by King Herod;
start of Jesus' public
teaching.

37
Pontius Pilate and
Caiaphas removed from
power.

versal teacher of contemplation allows us to expand towards the infinite horizons of his own breadth and depth. In contemplation we focus on these receding horizons. We can use, but we are not obliged to be imprisoned in, a wide range of formulas and concepts. This contemplative freedom from language and thought in our experience of God (the 'apophatic' dimension of faith) is therefore central to the meaning and achievement of Jesus.

Christianity carries heavy baggage in its nearly exclusive identification with European culture, thought, language and art. If you go into an Indian church, you will most likely see a white, blond, blue-eyed Jesus and many of the worshippers there would be offended to have it otherwise. The 'search for the historical Jesus' is not, however, the only element in our response to his question. But the historicity of Jesus and the Gospels is foundational. Jesus was a first-century Jew. This calls for common sense as well as faith both in reading the texts and commenting on them. But he is at the same time more than this.

Jesus as prophet, priest and King

The early Christians did not get stuck, as do many modern scholars, in the reductionism that an excessive emphasis on historical identity carries with it. They thought of Jesus as prophet, priest and King: traditional biblical symbols that Jesus seemed to them to exemplify, to fulfil and to transcend. He was a prophet because he was so clearly part of that religious tradition of his people, even to his controversial status and fate. Jesus is especially revered by Muslims as one of the great prophets and messengers of the divine plan. Prophets, in the Muslim sense, are those who re-enforce the revelation of God and the meaning of the Scriptures. Messengers also bring in a new Scripture. Jesus is a prophet and a messenger.

Of the 25 prophets named in the Qu'ran he is one of the five outstandingly great prophets. Like all prophets, he above all affirms and proclaims the unity of God. God is one: this is the basic revelation and message of the three sister faiths. Their common mission includes the exposure and rejection of any form of idolatry that is substituted for God. The biblical prophets insist repeatedly on the importance of fidelity, religious monogamy; and the great symbol of human marriage – an indissoluble sacrament in Christian understanding – is used to describe all human relationship with God. Jesus speaks in this way of his and our unity with the 'Father', the term he uses to describe the tender, loving, forgiving, utterly loyal friend to humanity and the source of all being. The theme of the 'mystical marriage' in the Christian tradition derives from this. Marriage to God, individually or socially, is a passionate love affair and a bumpy ride for humans.

Throughout their history the Israelites told stories of how, driven by their desires or fears, they were always going off committing adultery against this marriage by fooling around with the pagan gods. Under pressure, as in all marriages, faith is tested and often snaps when one or both spouses revert to the marital form of polytheism. Jesus is not calling the people back from worship of the Canaanite or Babylonian gods, but he is clearly in the prophetic tradition when he exposes the idolatry of the Temple – religion as a substitute for God – or of wealth and social power.

But he is also a priest in the sense that his life has a sacrificial meaning. Priests offer sacrifice – not only or essentially blood-offerings but the contemplative 'sacrifice of praise'. Sacrifice 'makes sacred' and involves, at the very deepest level, exchange, transfer and transformation. The parables often illustrate this in the image of a seed falling into the ground and dying in order to yield life. The inner, contemplative meaning of the teachings and the parables on the Kingdom require this kind of interpretation. In the New Testament Jesus is seen as both 'priest and sacrifice' and by exploring the meaning of this combination we are brought into the mystical dimension of his identity. Once we arrive there we can see why Jesus, as a teacher of contemplation, is simultaneously a teacher of non-violence. Once you offer yourself you have done away with the need for and even the sense of scapegoats (see R. Girard, *Violence and the Sacred*). This explains why such a large proportion of each of the Gospel narratives is taken up with his last few hours of life and the way he approached and accepted death. His death is seen as crucially important for under-

standing who he is. He lived and died as he taught and so his life and death are themselves supreme expositions of his identity.

The meaning of sacrifice is mystical, however, not economic. Jesus was not paying off a long-overdue debt which had grown to such astronomical proportions that it demanded a divine death to settle. This 'atonement' idea is attractive because it is so close to our human ways of thinking about debt and punishment, but we are constantly warned to remember that if God 'thinks' he does so in ways very different from ours. Yet it is not easy to say exactly what the New Testament offers as the meaning of the sacrifice of Jesus. There is not one clear-cut explanation of why Jesus had to die to save us from our sins or how it worked this effect of salvation. The atonement theory is that God was very angry because Adam and Eve ate of the fruit of the forbidden tree and that the only way to get this angry and relentlessly just Father to calm down and show mercy was through the terrible death of his Son; that is a powerful and dangerous metaphor but not the explanation. The Gospels and the New Testament are surprisingly vague, we might think, about why this sacrifice had to happen and how it worked. The mystical tradition shows that actually it is not vagueness but that the meaning is communicated only to those who have entered the experience in question. Only those who are losing themselves

will see what Jesus means by 'laying down his life' for us. Again we need to see Jesus as a teacher of contemplation, not a trader on cosmic markets.

Prophet, priest and King – he did not refuse the sarcastic attribution of this title by Pilate. One sense of this is social. He is one of the rulers of history whose course he continues to

Judean Desert

influence. It is as if he planted innocent-looking seeds in the field of human evolution and let them grow. The apparently total failure of his mission was itself part of its accomplishment. Unfortunately but predictably, his followers soon confused this influence with power, conceived as a social and religious force. Whenever this mistake

has taken institutional form it has blatantly betrayed the teacher and the teaching. Yet miraculously (there's no other word), the history of the Church is the continuous recovery from these immense lapses achieved by reactivating the contemplative dimension of the faith. The saints and mystics, more than any others, understand and remind the rest that his 'Kingdom is not of this world', although it is now certainly at work in this world. The Kingdom, he tells us, is both within and among us. It is entered, not through the accumulation and exercise of power or the building of edifices, but in quite different, radically paradoxical, ways: the letting go of power; forgiveness; compassion; identification of self with the other in need; human growth; childlikeness and wisdom.

The meaning of the Resurrection

It does not take much wisdom to see that the question 'Who do you say I am?' is not as easy as Peter perhaps thought. Jesus does not require a quick, easy answer or even a 'right answer'. Theological analysis is, of course, necessary but it is not enough to get the real point of the question. As in all Gospel passages, its meaning calls for a multi-layered work of attention. We have really to pay attention to the quest in the questioning. As it calls for deep and sustained clarity of attention it also calls for silence. Silence and imageless prayer help to reveal the meaning within the stories. The miracles, the healings, the teachings, the Resurrection are not just factual answers: they express the truth of the questioner being disclosed in the meaning of the question.

The Resurrection, of course, is central to any understanding of Jesus and the nature of Christian discipleship. It was not that the Resurrection was generated by the Christian community; it was the other way round. Christian community was formed by the experience of the Resurrection. Yet there is no specific description of the Resurrection happening in the Gospels. Jesus appears to people who generally fail or fear to recognize him, but we don't see him suddenly jump out of the grave and come alive. There are descriptions of this in some apocryphal gospels but not in the canonical ones. It is not even just the fact that the tomb was empty that proves that Jesus was raised from the dead. That 'emptiness' was clearly part of the earliest tradition, but what really constitutes the Resurrection experience is a surprise encounter with the living Christ who is the same person as before but a person, someone in relationship with others and with us, in a quite new way.

Again there is no easy explanation outside a faith-oriented mind, or even outside a faith community, of what the Resurrection means or how we experience the Risen Christ today. Because there is not scientific proof for it, it outrages and perplexes the rational-analytical mind. So much the better, for it is then a living koan[1] that brings us to the cliff-edge of the mind and invites us to look into the boundless space of the spirit. So, for that matter, does the beauty of a Bach cantata or the selflessness of a Good Samaritan. The theological explanation of the cross and Resurrection is not cut and dried; but what does it mean to say that Jesus died to 'save us from our sins', or that he is living and 'dwells in us'? A satisfying response to these questions is greatly helped by the way we approach Jesus as a teacher of contemplation. It is as much about praxis, lifestyle, as it is about thought. We must come back to his asking, 'Who do you say I am?' By listening to this question and allowing it to lead us to self-knowledge and to changes in the way we live and understand life, we grow in spiritual knowledge of the mysteries: 'The theologian is one who prays and one who prays is a theologian' (Evagrius of Pontus, *The Praktikos and Chapters on Prayer*, ch. 60).

Teaching through parables

The answer above all entails Jesus as a person, who is in himself a question to humanity as well as one who poses great questions to all cultures and epochs. In the Gospels we see him as a teacher, a teacher of his own time and of all times, for his culture and for all cultures. Rabbi, Master, Teacher, he is called by these terms more than by any other. What did he teach?

Typically, as a Jewish teacher of the first century, he was called 'Rabbi' and had followers. He accepted the fundamental tenets of Judaism founded in the truth that God is One and that there is no other. There are outstandingly original aspects to his teaching but in many ways he is a teacher in the context of his time. He uses the golden rule of ethics, to 'treat others as you would like them to treat you'. And even some of his modifications of the Law ('you have heard ... but I say to you ...') have contemporary parallels.

The Gospels, however, show the unique personal impact he had as a teacher 'with authority' on those who heard him. No one was indifferent to him, nobody

1 A koan is a teaching story in the zen tradition, often unrealistic, paradoxical, not admitting a logical explanation. It allows the mind to break free of rationality.

fell asleep while he was talking. A characteristic and in some sense unique style of his teaching is his use of parables. St Mark actually says: 'He only taught in parables.' How do we see Jesus as a teacher and especially as a teacher of contemplation through the parables?

Mark chapter 4 has a good crop of parables. As always the language and imagery of Jesus are close to ordinary life, not God-talk or religious jargon. The parables are a form of teaching that people can immediately relate to: images of growth, relationship, work, need, losing and finding. They illustrate his contemplative content and orientation because they act upon us where we are rather than pushing ideas or beliefs into us. He called to conversion but did not coerce.

Jesus was talking about the 'Kingdom of God' (better translated as the 'reign of God' because it refers more to presence than place). He said:

> *The Kingdom of God is like this. A man scatters seed on the ground. He goes to bed at night and gets up in the morning and meanwhile the seed sprouts and grows, how he does not know. The ground produces a crop by itself, first the blade, then the ear, then full grain in the ear, and as soon as the crop is ripe he starts reaping because harvest time has come.* (Mark 4.26–29)

Meditators would read this with a particular resonance to their own daily practice. In the early stages, the daily rhythm of morning and evening meditation may not always seem very productive. Yet they persevere because of some sense that (how, they do not know) something is happening. There is an intuition of growth even before its signs appear – the signs are the fruits of the Spirit as St Paul describes them: love, joy, peace, patience, kindness, goodness, gentleness and self-control (Gal. 5.22).

This is Mary's work and, as we have seen, it is complemented by Martha's work in the daily round of life. Mystical and moral: Jesus embraces and unites both. As a teacher of contemplation he is not just pointing to interiority and calmness of soul but to wholeness. This is illustrated by a powerful ambiguity in his response to a question about when the Kingdom of God would come. Clearly the questioner was thinking of the Kingdom as a place or a change in social politics rather than growth into presence. Jesus, however, does not reject either the internal or the external dimension. He says: 'You cannot observe the Kingdom of God coming because the Kingdom of God is within/among you.' The small Greek preposition *ev* contains it all.

Contemplation simplifies and integrates. Jesus simplified the Law, reducing the moral universe to the single great commandment of love. Contemplation also reveals the reciprocity of inner and outer work, the mirroring of the state of one's soul in one's behaviour. So it would be misleading to say that Jesus is only a teacher of contemplation. It is also necessary to see how he is an unambiguous teacher of non-violence. Then it is clear how these two pillars of his wisdom support each other and form the spiritual building of his teaching.

The non-violence is crystal clear: turn the other cheek, pray for those who persecute you. Go the extra mile. Do not respond with violence when you are attacked, even though the Law and common sense give you the right to (Matt. 5.38–48). The Law requires an eye for an eye, a tooth for a tooth. This does not mean vengeance but the balance of a certain kind of justice called today 'appropriate response'. If someone attacks you with their fists you can punch back but not use a gun. If someone bombs your munitions dump you cannot retaliate by bombing their civilians. It is not a perfect rule but it helps to moderate the level of violence. Jesus, however, invites us to renounce this right to retaliate in kind and adopt a policy of complete non-violence. 'What I say to you is …' This call to non-violence is not based upon a moral idealism (thinking that it is, few bother to take it seriously). It is based upon a contemplative insight into the correspondence between human and divine natures. The God whom Jesus knows is one who 'shines on good and bad alike and who is kind to the ungrateful and the wicked' – a long way from the wrathful Jehovah of the fundamentalists. Further, the teaching is built on an ontological truth, that humanity has the same spiritual genes as this God. 'Your love must have no bounds as your heavenly father's love knows no bounds.' Our true nature is non-violent because our true nature is divine. This does not mean we are God. But it means we are Godlike. All Christian morality is essentially – though not historically – derived from this mystical insight into the human being as the image and likeness of God. Indeed the early Christian thinkers, who did their thinking in the light of their mystical experience, theologized this human–divine correspondence-in-nature with the doctrinal equation of the Incarnation: God became human so that human beings might become God.

Rebuke the evil spirits!!!

Jesus' sense of urgency

When he began his public teaching Jesus condensed it into a sound bite: 'The time has come, the Kingdom of Heaven is close at hand; repent and believe the Good News' (Mark 1.15). His message is driven by insight into eternal truth as well as by a very human sense of urgency. His teaching thus has a contemporary–contemplative axis. It speaks of the discovery of the treasure buried in the field of one's heart, the finding of the pearl of such value that one willingly sells everything else. Poverty, emptiness, detachment are at the contemplative core of the gospel. But he also speaks of recognizing the signs of the times, of staying awake, alert and ready, because we 'know not the day nor the hour'. Look round on the fields: they are already ripe for the harvest. The reaper is drawing his pay and gathering a crop. Happy the eyes that see what you see. Now, I tell you, many prophets and kings wished to see what you see and never saw it, to hear what you hear and never heard it.

The Greek for judgement is *krisis*. Life is a critical matter and there is a zero time limit to Jesus' teaching. John the Baptist is the watershed, the bridge between the old, cyclical view of things and the new confrontation with the overwhelmingly good presence of God now. In this 'now' the Law and the Prophets have come together, as they did in the Transfiguration scene with Jesus, Elijah and Moses (Matt. 17). There are two universal aspects of religion: laws, moral rules, rituals deriving from a transcendental authority on the one hand and, on the other, the spiritual teachings of transformation, the prophets, the mystical and immanent vision. These come together – the one thing necessary – in the Kingdom of God.

Where does this leave religion? If the Law and the Prophets have been integrated in the Kingdom and if the Kingdom is now, a present reality rather than a reward for a good moral life, what's the point of all the religious baggage? The baggage carries this message and serves many human needs, but much of it can be jettisoned as the teaching is personally appropriated and verified in experience. Jesus delivers the most radical of all religious critiques of religion. He delegalizes sin, associating it with grace and forgiveness, not with exclusion and punishment. The urgency of his message is as great for us now as it ever was. It's not urgent in the sense that the end of the world is going to come next week. The urgency is that you and I now need to listen and respond to this announcement. The great mystical teachers of the

tradition whom this book introduces were often in trouble with the institution for this reason. They saw and heard what Jesus was really saying beyond the immense, beautiful, cultural, moral baggage that grew up to carry his simple – too simple, devastatingly simple – message.

The problem is that once you have heard this you are never the same. At times one might even wish it had never been heard. You can't unhear it. What difference does hearing it make?

Ivan Illich coined the phrase 'the corruption of Christianity'. He saw the problem of the Church today as being caused not by secularization or materialism but by the mishearing and distortion of the gospel's teachings. And 'the corruption of the best is the worst'. Recovery and healing lie in a return to the roots, in a new listening that purifies the eye of the heart and restores health to our capacity to see God. This is the language and content of the Christian mystical tradition, which reconnects us freshly to the contemplative heart of the gospel and to Jesus as a teacher of the inner journey that transforms outward reality and the life of the Church with it.

Jesus the exorcist and the healer

I have been concentrating on Jesus as a teacher of contemplation, and this focuses every aspect of his meaning. But we also see him as an exorcist who casts out the dark forces of the mind that control us through fear and anger. The most frequently used phrase in the Bible is 'Do not fear'. It also begins and ends the Gospels. Jesus liberates from the fears that inhabit the interior darkness. These stories prepare the way for the later mystical tradition's exposition of the purifying work, dark night, inner ascesis and spiritual warfare of prayer.

We see Jesus also as a healer. His healing miracles will be used later to illustrate the mystical tradition's sense that prayer is the great therapy of the soul. He restores people to physical, mental and social wholeness, but not in order to prove anything about himself. He heals because of a direct relationship of compassion with the suffering. Usually he attributes the healing to the faith of the person who has asked to be healed, not to magic or even his own unusual powers. Through compassion he initiates a revolutionary ethos in the way we define our neighbour. As the parable of the Good Samaritan teaches, our neighbour is whomever we allow ourselves to

be compassionate towards and feel bonded with in the mutual needs and wounds of the ever-changing human condition.

The parables and sayings of Jesus critique morality, sin and religion in ways humanity can never forget. Yet because his teaching flows from his unitive experience of God, his aim is not to teach a new morality or establish a new religion. The effect is rather to awaken a new consciousness. The rabbis of his day often discussed – as religious thinkers always do – what the essential commandments and teachings were. He entered into that debate by saying: 'Love the Lord your God with your whole heart, soul and strength, and your neighbour as yourself. This is the Law and the Prophets.' The commanding term here is love. It not only simplifies morality and religion, but in the later tradition would describe both the very nature of God and the work of prayer by which the human becomes divine. When we say that Jesus is a teacher of contemplation we are actually saying that he gives us a whole new consciousness, a whole new way of seeing the presence of God within each of us and the presence of God in all human relationships and in human society. 'Teacher of contemplation' does not mean that he inhabits an other-worldly, cotton-wool world. As soon as he comes out of Nazareth he is in conflict for the rest of his life. Because he has seen the truth of non-violence he is not frightened of conflict. He promises peace and rest but not a false peace or stagnation. /

Emphasis on interiority

In the 'farewell discourses' (John 13–16), Jesus describes praying 'in my name'. The term 'name' suggests not just what you put in the required field on a bank form, but real presence, the living, mysterious essence of a person. As the Christian mystics would go on to discover, we pray 'in him, with him and through him'. In the rest of this book the masters of Christian prayer will be playing the great variations on this theme.

By making their acquaintance we open ourselves more fully to experience Jesus as our teacher of contemplation, as a living Master. As it is made, this inner journey takes flesh in an enhanced capacity to love: 'People will know you are truly my disciples as you love one another' (Luke 9.28–36).

It will open the spiritual senses to help 'verify the truths of faith in your own experience', as John Main put it, and so to understand the meaning of the sending of the Spirit which is the culmination of the life of Jesus:

I will not leave you bereft; I am coming back to you . . . your Advocate, the Holy Spirit whom the Father will send in my name, will teach you everything, and will call to mind all that I have told you. (John 14.19–26)

Finally, it will help us to see that when we meditate we are putting the teaching of Jesus on prayer into practice in a serious way. In the Sermon on the Mount (Matt. 6.5ff.), where he gives his condensed teaching on prayer, the first element he emphasizes is interiority. Prayer is not about public show or winning other people's good opinions so as to nurture our own ego. We should instead go into our 'inner room and close the door'. Prayer is not about 'babbling on, thinking that the more you say the more likely you are to be heard. Your heavenly Father knows what you need before you ask.' So prayer is about brevity, simplicity, trust – and the natural completion of these is silence. It is also about freedom from anxiety and obsession with material needs. It is about mindfulness – setting your mind on God's Kingdom before everything else. And it is about living in the present moment, free from fear of the future.

These are the core elements of Jesus' teaching on prayer – interiority, silence, calmness, mindfulness and presentness. They are the elements of contemplation. If we put them into practice we are praying as he – the master of the very source of contemplation – taught. When we pray like this we discover what John Main also said – that every time we sit to meditate we enter into a living tradition.

LAURENCE FREEMAN OSB

ST JOHN
AND
ST PAUL

Laurence Freeman OSB

St John, *Guido Reni*

ST JOHN

Introduction

The disciples of Jesus had already been empowered to spread his teaching during his lifetime in the immediate vicinity. But after Jesus' death and Resurrection they took his message further around the Mediterranean basin despite great personal danger. John was one of the early disciples of Jesus and concentrated his teaching around Jerusalem and later near Ephesus. Paul is reported never to have met Jesus in person but to have been inspired by a visionary experience of Jesus on the road to Damascus. After living in Arabia for three years trying to make sense of this revelation, he felt the call to take Jesus' message to the Gentiles. It is his interpretation of Jesus' teaching, the Pauline version of Christianity, that really forms the basis of the Christian faith today.

Both John's and Paul's witness is different from that of the other Apostles and was perceived as such at the time. Paul was considered to be unfaithful to his Jewish roots, very much the 'Apostle to the Gentiles', and John was considered too 'Gnostic'. Laurence Freeman brings out how both concentrated on Jesus' mission to redeem humanity and how both bring Jesus' private teaching to the fore and interpret him mystically, emphasizing the wider aspect of Jesus in his cosmic dimension.

St John

Most orthodox researchers assume that the writer of the fourth Gospel, 'the beloved disciple', was John, the son of Zebedee and brother of James, who started out life as a fisherman on the lake of Genesareth. According to tradition he and his brother may have first been disciples of John the Baptist, and then with Peter and Andrew joined Jesus. But why does he then not claim to be one of the Twelve? Others disagree and claim that the author was 'John the Elder' from Ephesus, a more educated and articulate man. He too is assumed to have been an early follower of John the Baptist, who after the latter's beheading travelled with Jesus in his public ministry. Is he the one who as an old man returned to Ephesus and took Mary with him? Paul mentions a 'John' in his Letter to the Galatians as an 'acknowledged pillar of the Church'. Tradition has him as a witness to the raising of Jairus's daughter and the 'Transfiguration', as well as following Jesus with Peter after his arrest and as the only male disciple to stay at the foot of the cross with Mary, the mother of Jesus, Mary Magdalene and the other women. But which one is it? Is it likely that the Galilean John would have retired to Ephesus? John was for a while exiled from Ephesus to Patmos but returned to Ephesus, where he is thought to have died.

THE MYSTICISM OF ST JOHN AND ST PAUL

There is a transition from the historical Jesus of the Synoptic Gospels to the Christ of faith described, celebrated and encountered in the Gospel of John and the Letters of the school of St Paul. It is not really such a clear or easy distinction, of course. The Synoptics also draw a picture of Jesus that is infinitely more than a simple narrative of events and literal sayings. He is already a real, risen presence encountered deep within the personal experience of the disciple and new believer. Everything in the New Testament is bathed in the light of the Resurrection faith experience. The mystical roots of the Christian tradition lie in the heart of the seeker as it opens to the proclaimed word of the gospel, the transmission of the faith of others, touching and bringing spiritual perception to a new level and clarity. In John and Paul, however, the reflection on the meaning of this 'Christ-event', both personally and communally, moves into sharper outline even as the sense of its inexplicable mystery deepens.

St John

John is the most mystical of the Gospels but at the same time it offers us moving glimpses of the humanity of Jesus – his being tired on a hot day and needing a drink

of water, his weeping for a friend who has died – which we do not find in the other three accounts. It is a text of great depth and potency while also being simple and readable. It was probably written in AD80–100 in Ephesus or Syria. Its style is poetic and this is often reflected in the way some passages are laid out on the page. (The Prologue, for example, was probably originally a hymn.) It is written for an educated, Hellenized Judaism at a time when the new religion was in painful conflict with its cultural and religious origins.

This is my prayer, that by your love you may grow ever richer in knowledge and insight of every kind, enabling you to learn by experience what things really matter.
(Philippians 1.9)

Of John the author we know little that satisfies our contemporary curiosity for personality and biography. The tradition that the author of the fourth Gospel is the 'beloved disciple' described in the Gospel is an ancient one and is claimed in the text itself (John 21.24).

The tone of deep intimacy in the Gospel coincides with this claim. Scholars believe that a school formed around the disciple and that the texts that bear his name, the Gospel and the three Letters, were products of this community. The greatest modern scholar of John's Gospel, Raymond Brown, has enabled us to read it with new insights into its beautiful and intricate internal structures and resonances.

Bede Griffiths (see Chapter 29) felt his life take a new direction after reading this Gospel at an intense moment in his search for depth and meaning. It was clear that this was one of the most significant works of human genius. Whatever its precise import might be, it was the record of an experience of unfathomable depth. Both the person and the doctrine portrayed were of a beauty beyond all human imagination. There was nothing in Plato that could be compared with them.

I realized that to reject this would be to reject the greatest thing in all human experience. On the other hand to accept it would be to change one's whole point of view. It would be to pass from reason and philosophy to faith.
(Bede Griffiths, *The Golden String* (Medio Media, 2003), p. 87)

Modern criticism has been engaged in tearing the Gospels to pieces to discover the truth behind them, but might not it be that a true meaning could only be seen as a living whole by which all the apparently conflicting elements were integrated? In judging a work of art, it is by one's sense of the whole of an integral organic

structure that one is able to see the significance of the parts. Might there not be a sense of the whole, a spiritual perception by which the inner meaning of the gospel would be revealed?

John's mysticism is new in world history, not merely philosophically but because of its vision of the highest reality integrated with the most ordinary aspects of the human sensory world. This is evident not only in the Gospel that bears his name but in the Letters attributed to him and which declare this to be a mysticism of love – humanly divine or divinely human according to your starting point:

It was there from the beginning; we have heard it; we have seen it with our own eyes; we have looked upon it and felt it with our own hands; and it is of this that we tell. Our theme is the word of life. This life was made visible: we have seen it and bear our testimony . . . so that you and we together may share in a common life. (1 John 1.1–3)

Yet despite this this-worldliness, the 'high Christology' of John is laid out daringly in the Prologue to the Gospel where he equates Jesus the man with the eternal Logos. Word and flesh uniting is the core paradox of John's Gospel.

As we might expect from the core opposition of Word and flesh, the whole Gospel is built on paradox. Throughout the Christian mystical tradition the expression of the deepest experience usually employs paradox to say the unsayable. It is a language quite different from dogmatic theology and often quite foreign to legalistic language, yet it underlies the whole meaning of Christianity which could never be transmitted by these means alone. So in John's Gospel and his Letters we see many polarities in the imagery he uses – light and darkness, flesh and spirit, life and death, Church and world.

Mysticism and discipleship

The person of Jesus himself is the unifying focus of these apparent contradictions, and personal discipleship is the way this focus becomes a force in one's own life. The first appearance of Jesus in the Gospel (John 1.35–39) is a good illustration of this connection between discipleship and transformative experience in Christian faith. It is also a good text with which to explore how to access this tradition for oneself.

> John the Baptist was standing with two of his disciples when Jesus passed by. John looked towards him and said, 'There is the Lamb of God.' The two disciples heard him say this and followed Jesus. When he turned and saw them following him he asked, 'What are you looking for?' They said, 'Rabbi (which means a teacher), where are you staying?' 'Come and see', he replied. So they went and saw where he was staying and spent the rest of the day with him. It was about four in the afternoon.

Origen (see Chapter 4) was one of the first Christian teachers to develop a multi-layered approach to scriptural interpretation. It includes the literal, the moral and the mystical levels of meaning. Here we can see some kind of composite historical memory of the formation of Jesus' core disciples. We also glimpse a possible tension between them and the disciples of John the Baptist. John speaks his confession and his disciples hear – this is how the transmission always begins. The Word is actually spoken. A response (following) is expected and a journey begins. This implies a moral change of direction. But a new stage is initiated when Jesus turns (towards their turning) and sees them. One might say this is the beginning of a deeper, more mutual and mystical relationship with the person of Jesus. Yet he remains a teacher and expresses this in his starkly simple question. Put on the spot, they respond with their own question, which evokes not information but an invitation. 'Come and see' is what the whole mystical dimension of Christianity is about. They go and see and spend the rest of the day (their life) with him. The Zen-like detail of it being 'about four o'clock' adds specificity but also symbolizes a regular hour of prayer for the early Christian community. Discipleship, community, prayer are among the essential elements of Christian mystical consciousness.

The mysticism of friendship

John's mystical vision explores the highest state of union with God. This is explicit theologically in the assertion in the Prologue of the Word made flesh. Existentially, it is illustrated in all that Jesus says and does and undergoes in his humanity, including his death. He does and says nothing that does not explicitly reflect his (non-dualistic) relationship with the Father. Spiritually, it is manifested in friendship.

The Gospel has many instances of friendship. Martha and Mary are friends with Jesus in Luke's Gospel. In John's Gospel we see the close friendship between Jesus and their brother Lazarus, whom he weeps for and raises from the dead. Friendship is a level of human relationship that the classical world took most seriously – a life without a friend is not worth living, according to Aristotle. Jesus lifts this to a mystical level when, at the Last Supper, he shocks his disciples by calling them and treating them as friends.

I call you servants no longer; a servant does not know what his master is about. I have called you friends because I have disclosed to you everything I heard from my Father.

(John 15.15)

Hidden within this profound symbolism – expressed in the unique Johannine story of the washing of the disciples' feet – is both a theology of the Incarnation (the powerlessness of God) and an anthropology of the human condition (our destined divinization). Friendship is possible only between those who have reached an awareness of some level of equality. The Incarnation thus triggers human awareness into a sense both of its own origin and of its innate tendency to return to its source. Developing the idea of the friendship of the divine and the human realized in Jesus, Christian mystics have always revelled in the discovery of the universal capacity for *theosis*, divinization. This doctrine, which was made explicit in the mystical theology of the Fathers of the Church ('God became human so that human beings might become God'), constantly pushes the envelope of a more reserved form of Christianity that concentrates

John's writings

Justin Martyr (160) attributed the Gospel to John, son of Zebedee, 'the beloved disciple', as well as the three Epistles of John and Revelation. Yet modern scholarship disputes that all were of one pen because of clear differences of style in the writing. 'John the Elder' is mentioned as author, even by Cerinthus, a second-century Gnostic; the assumption is also made that the different writings were probably penned by followers.

more on the limitations and sinfulness of the human person. Not surprisingly, then, the dominant symbol of the Latin Church, with its increasingly marginalized sense of the mystical, became the crucifix, often interpreted in a reductionist way as the paying off of a divine debt for original sin; whereas in the eastern Church, which retained a sense of the centrality of the mystical, the characteristic icon is that of the Transfiguration. Friendship is carried on through death. John, the beloved disciple, stands with Mary, the mother of Jesus, at the foot of the cross. Jesus returns to show himself in his risen life first to those who were his friends and disciples, even though they had not performed their part of the relationship very well. In the light of the Resurrection the words of Jesus at the Last Supper – the great 'farewell' discourses of chapters 13–17 – that speak of union and friendship, take on the deepest significance. The 'great priestly prayer' of Jesus is for unity among all peoples, a universal friendship rooted not in self-interest but in the ultimate nature of reality.

> *I in them and thou in me, may they be perfectly one. Then the world will learn that thou didst send me, that thou didst love them as thou dist me.* (John 17.23, NEB)

Christian mysticism, being a mysticism of love focused in the person of Jesus, as John makes unmistakably explicit, integrates even the paradox of contemplation and action. Union for the Christian then becomes not a last port of call but another place of departure in transmitting the Word and in service of others. Mysticism and mission in the Christian life, as in the life of Jesus, are not incompatible. 'Love must not be a matter of words or talk; it must be genuine and show itself in action' (1 John 3.18).

I am

On seven auspicious occasions Jesus spoke of himself in the simple language that characterizes his teaching, yet using metaphors of mystical meaning that the later tradition has long mined and pondered. Of himself he said, 'I am . . . the bread of life, the door of the sheep, the good shepherd, the resurrection and the life, the way, the truth and the life, the true vine.' An eighth statement with no object, 'It is I; be not afraid,' also reads in Greek simply as 'I am'.

I pray that your inward eyes may be enlightened so you may know what is the hope to which he calls you. (Ephesians 1–18)

These teachings point to the nature of all mystical experience as unconditioned pure being that seeks expression necessarily in conditioned language.

They also reflect the unimpeachable authority of Jesus' self-knowledge. He knows where he comes from and where he is going, as he confidently says to his examiners and doubters. A teacher is as necessary for the spiritual path as parents are for physical birth, and the influence of the teacher is drawn from the level of realization he or she has attained – that is, self-knowledge.

So the self-knowledge of Jesus, born directly of the union with his Father, is an active influence on the disciples who listen to him and follow. His desire is that they too should know themselves as children of the Father, inheritors of that 'eternal' or unbounded life that opens up for those who know him. Self-knowledge and the knowledge of God have always been connected in the Christian traditions, and we see in the Gospels themselves how powerfully this connection is rooted in the relationship of Jesus to the Father.

The knowledge in question here, though, is not conceptual. Faith is something different from belief that is embedded in concepts and words. Faith is commitment to personal relationship. 'The beginning is faith, the end is love,' said St Irenaeus. So the knowledge St John refers to is best described as love, using the term *agape*, which is the New Testament word expressing the particular experience of divine love. The commandment of Jesus to love God and one's neighbour as one's self summarizes and radically simplifies the Law. He tells the disciples to love each other 'as I have loved you'. In the Letters of John we learn that the unloving know nothing of God because only those who love know God. This is distilled into the great core statement of Christian faith, that 'God is love' (1 John 4.16).

ST PAUL

Introduction

St Paul represents another river flowing from the same source of the Resurrection faith and on towards the Christian mystical delta.

Ananias restoring the sight of St Paul, *Pietro da Cortona*

He is sometimes credited with being the real founder of Christianity, not an empty claim considering the influence he had on all aspects of its later developments, and his passion for organizing communities and for enforcing right belief. His Letters, or those attributed to him, constitute 14 of the 27 books of the New Testament and are read at nearly every church service. Certain passages in particular have been essential to the self-understanding of Christian mysticism from the beginning of the Church.

St Paul c.5/10BC–AD64

He was born in Tarsus in the Diaspora and originally named Saul. He was a Jew, but at the same time a Roman citizen. In his twenties he came to Jerusalem to study the Law with the famous Rabbi Gamaliel. His writings show that he had a good knowledge of Greek and non-Jewish cultures. He aided in the persecution of the Christians at first and was a witness to the stoning of Stephen around AD32. Then he had a powerful conversion experience on the road to Damascus and renamed himself Paul. After that he spent three years in Arabia, allegedly in solitude. He went to Jerusalem for a meeting with Peter and James to explain and defend his calling to spread the teaching to the Gentiles. He continued to have a difficult relationship with the other disciples and went many times to Jerusalem to confer with them. His journeys took him among other places to Cyprus, Syria, Corinth, Ephesus and Rome. He supported himself as a tent maker. He was arrested in Ephesus and stayed in prison from 54 to 58 and was then taken to Rome, where he was imprisoned for two years, 61–3, and finally beheaded in 64 under Emperor Nero.

CONVERSION

Certainly Christianity would not have developed as it did without Paul. Nor would he have developed as he did if he had not been thrown from his horse on the road to Damascus and in a blinding light seen Jesus and had his life utterly changed (Acts 8.1–19). But to say that he shaped the future form of Christianity does not mean that he deposed Jesus but that, like us, he did not know him 'after the manner of the flesh' (2 Cor. 5.16). Though Paul insists on the humanity of Christ he is not much interested in the historical Jesus or the narrative histories in the Gospels. He describes Jesus as a Jew and refers to the Last Supper, the crucifixion and the Resurrection, but his attention is firmly fixed on the new and evolving Body of Christ which is the Church, and on the indwelling of the Spirit of Christ, the 'mind of Christ', in the human heart.

Nor should the influence of Paul on institutional Christianity suggest that he was preoccupied with structures and rules. In fact, religiously he was a radical, a pioneer not an administrator, a mystic rather than a lawyer. St Peter called Paul his friend and 'dear brother' and recommended his Letters, though cautioning that there were passages that were hard to understand and that could be misinterpreted (2 Pet. 3.15). Peter had tussled with him at the Council of Jerusalem over admitting Gentiles into the Christian fellowship. But at the end of their lives they were both revered equally as they awaited their martyrs' fate in Rome. Nevertheless, tradition traces the see and succession of the Prince of the Apostles to Peter, not Paul. Paul was not the kind of person you would ever choose as a safe pair of hands in a diocese. He knew himself as a founder rather than as an administrator (1 Cor. 3.6).

He was probably born into a prosperous Jewish family in the pluralist Greco-Roman city of Tarsus. Some think that in his twenties he came to Jerusalem to study the Law and by his own admission became a fundamentalist zealot hounding Jesus' followers. Before his conversion experience and by his self-description, he ranks with the worst of ayatollahs or Grand Inquisitors. Not only was he all right but others should be punished for being wrong. After his fundamentalist shadow exploded, he reversed his deepest religious ideas concerning grace, sin and salvation. Sin was no longer associated with Law and punishment but with grace and resti-

tution to wholeness of the divided self. These insights fed the Christian theology of mystical experience, especially with the idea of prayer as healing and contemplation as a gift of grace, not the product of a technique in our control.

This religious revolution in his soul, therefore, was not primarily intellectual but spiritual. For several centuries, beginning with Paul and the apostolic Church, theology developed under the influence of mystical experience born in deep contemplation. Over time the tables turned, especially in the western Church, and theology as the 'queen of sciences' separated from the supposed 'subjectivity' of prayer and began to monitor the experiential and scrutinize the 'personal' verification of faith. The roots of this perennial, natural tension between the spiritual and the religious, so commonly invoked today, can be seen in the Letters of Paul, though he could hardly have guessed where it would lead – to seminaries where no formation in contemplative experience is given; to eucharistic celebrations that run from the moment of communion to the last collection and coffee without a pause.

Key ideas

His first Letter to the Thessalonians is the oldest piece of Christian writing we know. Its third verse invokes the triad of faith, hope and charity that, like so many of his formulas, shaped the Church's theological vocabulary. His use of these and other terms influenced all later mystical writers: *gnosis* (knowing through personal experience), *pistis* (faith as personal relationship), *agape* (divine love). Through his Letters,

written to small house churches, in whose lives he had an intense, even possessive, parental interest, we can make guesses about his complex, religious personality. Like Moses he seems not to have been a charismatic speaker. He was fiery in loving and in anger. He could be tender, harsh, forgiving and impatient.

His 'thorn in the flesh', whatever

St Paul writing his Epistles, *Valentin de Boulogne* or *Nicolas Tournier*

it was, kept him humble in his drivenness and his total immersion in the experience of Christ.

The phrase 'in Christ' appears 164 times in Pauline writings, referring always to this life, whereas the phrase 'with Christ' refers to the next one. The polarity suggests the ambiguity of Jesus' saying that the Kingdom is both within and among us.

As with other founders, the line between the man and the myth is tenuous. Only about half the Pauline Letters are now thought by scholars to have been written by him. Yet Paul is greater than his personality and historical identity. His conversion experience, however, is utterly personal and is described more than once in his Letters and in Acts. It floored him for three years before he could resume life. Mystical experience, he shows us, is of a transcendent 'otherness', but it cannot be separated from the individual psyche in which it occurs and which it can easily overload.

Paul's experience was a 'light mysticism', but the writings it inspired contain material that was subsequently mined for all kinds of Christian mystical literature, including the 'dark night'. In later chapters we will see how various are the descriptions of the mystical experience in Christianity. Paul's theology contains in a non-systematic way both the 'kataphatic' (what we can say about God) and the 'apophatic' (trying to say what we can't say). For example, he tells us that 'in Christ the Godhead in all its fullness dwells embodied' (Col. 2.2), an important assertion in the developing dogma of the Incarnation. But he also prays that, through faith, Christ may dwell in our hearts in love so that we may 'know' it in its totality 'even though it is beyond knowledge' (Eph. 3.17).

His mystical experience

His conversion was just the beginning and perhaps as much of an implosion of his dark side as a full mystical moment. Paul's experience has intrigued many later thinkers trying to distinguish the psychological from the mystical. But there are other descriptions of mystical import described from the other point of view. In chapter 12 of the second Letter to the Corinthians Paul refers to an experience of being 'caught up into paradise' ('whether in the body or out of the body I do not know – God knows') in which he heard 'words so secret that human lips may not repeat them'. It has similarities in expression to Jewish apocalyptic mysticism but is unique too, especially in being so clearly autobiographical. The significance of his recounting this, however, is not to 'boast', which he says does no good, but to insist that people form an estimate of him on the basis of what they see, that is to say his

human weakness. What is he like, this individual apostle who had received such a great mystical grace? Surprisingly but significantly, just like us. He goes straight on to say that he was given a 'thorn in the flesh' to keep him humble, an affliction which, despite his prayers, God did not lift from him. Thus he was kept weak and humble while being empowered with a great, guiding grace to fulfil his mission.

And it is the weakness, not the mystical experiences, that he is proud of because the 'power of Christ' rests on the weak and divine power is seen fully only in human weakness. 'For when I am weak then I am strong' (2 Cor. 12.10). Here we see the essential renunciation of power that is at the heart of the mystery of Christ and the Christ-centred life. Christian mysticism focuses not only on the subjective experience, which can so easily puff the ego, but even more on the work of God in the greater context of the world and the service of others. Thus Julian of Norwich was in a great tradition when she understood her 'revelations of divine love' as being given to her for the benefit of others.

Paul's description of his ecstasy inspired and influenced many subsequent mystical writers, such as Origen and Ambrose. It helped them to Christianize the Platonic *theoria* (contemplative vision) that was to become the key Christian word for contemplation. In allowing connections with earlier figures like Plotinus it shows how interfaith dialogue flourishes in the mystical, a point not to be forgotten today as Islam and the Christian West line up politically with little or no sense of a common ground or core values.

By reading Paul's description of spiritual transformation, Gregory of Nyssa was led to develop theologically the concept of *epiktasis*, the never-endingness of the experience of God. Paul taught that 'we are being transformed into [Christ's] likeness with ever-increasing glory' (2 Cor. 3.18). By contemplating the Risen Christ the human being, as an image of God, is both healed and completed. Paul, like subsequent Christian mystics, emphasizes the priority of experience over the fondness of religious people for disputes about 'mere words' that do no good and are the

Paul's writings

There are 13 Letters in the New Testament attributed to Paul; it is generally agreed that he definitely wrote these:
in the early 50s 1 and 2 Thessalonians;
in the late 50s Galatians, Philippians, 1 and 2 Corinthians, and Romans;
then in captivity Philemon, Colossians and Ephesians between 50 and 90.
His pastoral Letters, Titus 1 and 2 Timothy, were written between 65 and 100. These Letters deal with specific problems in local churches, apart from Romans and Ephesians, which deal with wider issues.
He recommended the reading of his Letters in the churches in general, and they were soon taken as Scripture. Many of his Letters have been lost and others were written by schools of his disciples.

'ruin of those who listen' (2 Tim. 2.14). Yet also later teachers in the mystical tradition, influenced by the model that Paul set, warn of becoming caught up in 'experiences' for their own sake. This merely dazzles and serves to inflate the ego. Freezing attention on individual experiences is spiritual consumerism. The selfless extension of experience over time in the service of others is faith.

Two among many other aspects of Paul's mystical experience that shaped the Church could be highlighted. First, its impact on moral thought. Paul's conversion and ongoing enlightenment in Christ made him jettison religious law as the way to rectify the human condition. He discovered the fatal attraction of seeing sin as the breaking of a rule that the Law could in turn put right. In Romans he sees the Law as a Band-Aid solution. It cannot do the radical surgery needed to heal that self-alienation in the human soul which *is* the root of sin. What achieves it is grace and – wonderful news – where sin is, grace abounds all the more.

From grace it is but a step to seeing love as the primal energy of prayer and of the Christian's deepening union with Christ, the world and all other people. The emphasis settles on love – a universal potentiality – not just on extraordinary mystical experience or insights. For Paul the Cosmic Christ *is* the inner Christ. Knowing this is the sober intoxication of love that dispels fantasy. And as Bernard Lonergan, the twentieth-century Jesuit theologian, came to believe, 'The love of God that floods the inmost heart through the Holy Spirit He has given us' is the essential Christian experience (Rom. 5.5).

LAURENCE FREEMAN OSB

THREE

CLEMENT OF ALEXANDRIA

Kallistos Ware
and
Andrew Louth

Clement of Alexandria

Introduction

With Clement we move from Palestine to Alexandria in Egypt. It had been founded
by Alexander the Great a few centuries before, a vibrant and cosmopolitan town
with a Pagan Academy to rival Athens, a wondrous library containing all the wisdom
of mankind up to that stage, and the first important Catechetical School. As Bishop
Kallistos Ware says, 'Alexandria was, at that time, the chief intellectual centre of the
Roman Empire, more alive philosophically, spiritually, than the city of Rome itself.'
This was the place where the main important cultures of that time, Greek, Jewish
and Christian, met in dialogue; not only that, but Gnosticism was flourishing here.

The Christian Church was thriving in Alexandria, as there had not really been
any persecutions up to that time. Instead of scattered house churches there were al-
ready purpose-built places of worship. In this cultured environment the establishment
of a proper Catechetical School seemed appropriate. The teaching of catechumens
– those wanting to be baptized into the Christian faith – was not narrowly restricted
to the Christian faith but was carried out against a background of the general Greek
education in philosophy and science prevalent at that time,
with students from all the main cultures intermingling and in
dialogue. The challenge for Clement was to present Christ-
ianity in a way the educated Greek world in Alexandria
found acceptable.

If you do not hope,
you will not find what
is beyond your hopes.

Bishop Kallistos points out how Clement's teachings arose out of a convergence of Jewish, Greek and Christian philosophy, and how he is in fact considered to be the first Christian philosopher/theologian, who tried to express mystical experience and the relationship between the human soul and the Divine in the 'apophatic' way.

Clement of Alexandria AD150–215

We know really very little about Clement of Alexandria, as is the case of most notable figures in these early centuries of Christianity. He was born somewhere around 150, probably in Athens, as he was thoroughly familiar with Greek culture and literature. We know that his parents were pagans and that he studied philosophy in Athens. Clement was a person who came to the faith later on. He was a convert. Like many young seekers of his time he travelled widely and explored various schools. Some time before he arrived in Alexandria he discovered Christianity. On meeting Pantaenus, a converted Stoic philosopher, he settled in Alexandria, as he admired him greatly.

Clement succeeded his teacher Pantaenus, the first head of this school, which was open to pagans as well as Christians, when the latter was sent on a Christian mission to India around 190.

Unusually, he was married. He is thought to have been ordained a priest by about 190. Bishop Kallistos Ware summed him up by saying:

> He is, in some ways, quite aesthetic in his approach, yet he is positive about the value of the human body, the value of material things. He has a keen sense of beauty and he insists on the total sanctification of the whole human person. 'Jesus', he says, 'heals the whole human person both body and soul.'

He led the school very ably until the persecutions under Septimus Severus at the beginning of the third century allegedly forced him to flee. He died around 215.

CLEMENT THE CHRISTIAN HUMANIST

In Clement's religious teaching we find a double attitude. First, he is very definitely centred upon Christ Jesus, the only Saviour. But Clement also felt a deep attachment to Greek culture, Hellenic philosophy and poetry. His writings are full of quotations from non-Christian Greek philosophers and poets.

All men, all women, may choose to believe or disbelieve.

In fact, we could call him, in the true and best sense, a Christian humanist. He believed that, while the Old Testament was a tutor to bring Jews to the truth, at the same time

philosophy was given to the Greeks for the same purpose. There is a preparation for the gospel, not only in the Old Testament but also in the Greek philosophies. As Clement himself puts it: 'The way of truth is one, but into it, added to a never failing river, there flow different streams on this side and on that.'

The Pharos of Alexandria, *Martin van Heemskerck*

Clement was convinced that it is not by one path alone that humans approach the inexhaustible fullness of the truth. He believed that Christ's words, 'I am not come to destroy but to fulfil', apply not just to the Law and Prophets of Israel but also to the wisdom of non-Christian Hellas.

He saw Christianity as the true philosophy that fulfils all the intimations, incomplete, yet partly true, found in earlier Hellenic thinking. He was not syncretistic, because he was absolutely convinced that Jesus Christ is the one Saviour of the world. But he believed that Jesus Christ had taken up and fulfilled all that was best in human history before his time.

In the monasteries on Mount Athos, and also in Romania, in the outer entrance or narthex of churches, you will see frescoes of the prophets. But among the prophets you will also see the Greek philosophers, such as Plato. And that is exactly Clement's view, a double preparation for the Gospels.

Clement's mystical theology – the via negativa

In his mystical theology, Clement's dominant idea, his master theme, is the divine mystery. He is an apophatic theologian, the first great Christian thinker to use negative theology, and his ruling symbol is divine darkness.

'Apophatic' is basically a grand word for 'negative' and 'kataphatic' is a grand word for 'affirmative'. To illustrate the

Clement's writings

His most important works are the *Protrepticus* (*Exhortation*), the *Paedogogus* (*Tutor*) and his longest book the *Stromateis* (*Carpet bags*). The *Exhortation* introduces pagans to Christ, the Logos, with stress on belief. The *Tutor* goes further into the discipline of being a Christian and moral purification. The *Stromateis* are about the 'true Gnostic', acquiring *gnosis*, direct experiential, intuitive knowledge of Truth. This last book in seven volumes is really a compilation of seemingly unconnected thoughts. It seems to be aimed specifically at Clement's pupils; unless you are one of them it is difficult to understand. Every chapter ends with a quote from the Septuagint and from Greek philosophy.

meanings of kataphatic and apophatic, here are examples from public notices.

Here is a kataphatic sign at a level crossing over a railway line – a pole with a box attached, with evidently an electric bell in the box, and a notice that says:

> *Danger! Stop, look and listen. When the bell is ringing, do not cross the line. If the bell is not ringing, still stop, look and listen in case the bell is not working.*

So in a kataphatic approach all possibilities are expressed and allowed for.

Here is an apophatic notice from Australia:

> *This road does not lead to either Townsville or Cairns.*

That is exactly the method used by the apophatic mystical theologians. They do not say what God is, because he is mystery beyond our understanding. They say only what he is not. This approach to experience of God has its roots, from the Christian point of view, in Clement. He in his turn was following the Jewish philosopher Philo, who had been in Alexandria about a hundred years before Clement was there. And Philo in his turn is drawing on the tradition of Platonism, which uses the negative apophatic approach to convey the meaning of divine transcendence.

Not without special grace does the soul put forth its wings.

Clement suggests that we should apply to God the mathematical principle of 'abstraction' – in Greek *analysis* – and carry this to the ultimate limit. Start by imaging a body; but God is not material, so from your concept of God you've got to take away all the physical qualities: depth, breadth, length and colour. What would you be left with then? You'll be left with a unit possessing position. Now take away the idea of position. Then you would be left with the idea of a simple monad. Now go a step further. Take away even the notion of the one or the monad, for God is beyond that. What are you left with? You might say nothing at all, but Clement says:

> *You are left with the notion of pure being and that is the closest you can come to God. God is beyond the one and above the very monad itself. He is ineffable, beyond all speech, beyond every concept, beyond every thought.*

God is not in space, but above both place and time and name and thought. God is without limits, without form, without name. He is anonymous.

So in order to convey a sense of the otherness of God, his transcendence, his mystery, Clement pushes the negative apophatic approach about as far as you can go. We know not what God is but what he is not. This is Clement's refrain. And to convey some understanding of this supreme mystery of God, Clement gives us a symbol from Scripture, Exodus 20.21: 'Moses entered into the thick darkness where God was.' So this idea of the darkness on the summit of Mount Sinai for Clement conveys the mystery of God.

And here he is following Philo. According to Clement:

Moses is convinced that God will never be known by human wisdom, so he entered into the darkness where God's voice was. That is, into the impenetrable and formless thoughts concerning that which is. Yet God is not in darkness or place, but above both place, time and specific objects.

So the darkness in Clement, the darkness of Mount Sinai, doesn't really symbolize God himself. It expresses the limitations of the human mind, our ignorance, our unknowing, our inability to comprehend the ineffable and invisible God.

This has a clear implication for the way in which we pray, although Clement doesn't himself draw this out. If we think of God in this way as transcending all words, all images, all intellectual concepts, then we might encourage people to pray – not all but some of the time – in a manner that involves the laying aside of thought, stripping ourselves of pictures and words, trying to pass beyond that to a simple sense of presence, of waiting on God, of union with him. That would be the practical implication in spirituality of Clement's approach.

But Clement's approach, it has to be said, leaves many people deeply uneasy. For example, a distinguished writer about Clement and Origen in the nineteenth century, Charles

Also around this time

AD166
A Roman envoy arrives in China.

166–80
Marcus Aurelius is Roman Emperor.

180
Smallpox epidemic in Rome: up to seven million people die including Emperor Marcus Aurelius.

193–211
Septimus Severus becomes Roman Emperor; terrible persecutions of Christians during his reign.

c.200
Barbarian invasions and civil wars begin in the Roman Empire.

c.200
Important commentary written on the *I Ching* by Wang Bi.

Glossary

Nous – our divine centre, organ of deep intuitive knowledge.

Theosis – deification, becoming like God; communion with God.

Via negativa – a contemplative way of prayer; way of getting to know God without attributes, leaving thoughts and images behind.

Bigg, in his book *The Christian Platonists of Alexandria* – a book still well worth reading – rebukes Clement. He says that Clement has made God not the everlasting yes but the everlasting no. 'Clement's God', he says, 'is a chimera, a bare force, which neither is nor is not, which neither thinks nor thinks not.' Bigg feels that through this process of stripping and abstraction Clement has, in fact, ended up not with God but with nothing at all.

Now is this true? Let's think of two possible images, the onion and the statue. Is the process of stripping away of images that Clement is commending to us like removing one skin after another from an onion? If it is, then if you carry on the process of onion stripping indefinitely, you will eventually end up with no onion at all. And has Clement done this with the notion of God?

Or does the apophatic approach rather resemble the action of a sculptor chipping away the stone on a block of marble so that the latent image can gradually emerge? This is an analogy actually used by Plotinus and later on by Dionysius the Areopagite. The sculptor begins by chipping away at the stone; that's a negative action, but its aim is positive: to reveal the form within.

The defenders of the apophatic approach would say this is exactly what we are doing with the knowledge of God. A person has first to chip away or negate his or her human ideas about God as they fall far short of the truth. And then, if we gradually strip away these unworthy notions of God, slowly there will emerge before us, by God's grace, a true vision of what God actually is. But this is something we can't express in words.

The sculptor does not chip away aimlessly until he has reduced his block of marble to a heap of tiny fragments. And in the same way the mystical theologian doesn't negate simply for the sake of negating but seeks through negations to convey a positive experience. Now the defenders of Clement and those who follow Clement's apophatic approach would say that the result of negation is not just a gaping void, not just a blank abyss, but specifically a realization of God's true being. The process of negation is not just an intellectual exercise: first you make a positive statement and then you negate it. But it's a kind of springboard or trampoline; through this process

of negation you bounce upwards into an experience that is supremely positive, so positive that you can't put it in words. /

So the defenders of the apophatic approach would say that, actually, it does not leave us with an absence but leads us to a presence. Negations can carry a positive message. And that is true, as in the example that I gave earlier: 'This road does not lead to either Townsville or Cairns.' If you happen to know the geography of the district, you might get some inkling of where the road was actually going. And so it is with the negations about God. They can convey a positive message. In denying attributes to God, we are making not a non-affirmation but a super-affirmation.

This is exactly what Dionysius says about the divine darkness: 'It is darkness beyond all light. A darkness that is supremely bright.' So God is darkness, not in a negative sense as an absence of light, but in a positive sense of radiance infinitely greater than all other radiances.

This is the effect, then, as Clement sees it, of using the negative approach. We are not brought to empty blankness. We are brought to, as he puts it, 'a state in which we reverence God in awe and silence and stand before him with holy wonder'.

So that's what entering the divine darkness means. Silence and wonder.

The question arises, 'Does one find the apophatic approach also in non-Christian mystical traditions?' The answer is yes, most emphatically. This approach is, one might almost say, universal. It seems to be deeply inscribed in the human heart.

The more we love the more deeply do we penetrate into God.

You certainly find the same emphasis of negative theology, the *via negativa*, in the Sufi mystics of Islam. Of course, they have probably been partly influenced by Christian writers such as St Isaac the Syrian of the seventh century. But when you move further to the East, you would certainly find this tradition both in Hinduism, long before the Christian period, and in Buddhism. Zen Buddhism is strongly apophatic.

We do not need to think in terms of direct influences. People have come to this quite independently. It is something deep in the human heart, a sense of wonder, a sense of reaching out towards that which we do not understand but feel to be present to us.

Theosis

While insisting upon the transcendence of God, Clement at the same time also stresses the immanence of God. God is above and beyond everything, yet he is more intimate to us than our own soul. Clement stresses therefore not simply the otherness of God, but also the nearness of God. And he employs in this connection the word 'participation'. We participate in the transcendent God. We share in his life and power. And in this connection, Clement envisages salvation as deification, *theosis*.

The background to this term *theosis* is the statement in Psalm 82, 'I said you are Gods', which is quoted by Christ in John 10.34. This is taken up in the Christian tradition and it is said that salvation means that we become God.

Clement is one of the first people to use this kind of language. Of course, this does not mean that we become additional members of the Holy Trinity. The Greek Fathers were always quite clear that the process of becoming God does not abolish the distinction between the uncreated God and created human beings.

But what they wanted to express through this language of *theosis* was the following. Salvation doesn't just mean a change in our juridical status through some kind of imputed righteousness. Equally, salvation doesn't just mean imitating Christ through moral effort. On the contrary, salvation means that we share in the life and power of God. This sharing results in a total inner transformation. Salvation means an all-embracing transfiguration. This is what Clement means when he talks about God 'divinizing' us: 'Christ divinizes us through his heavenly teaching.'

So salvation is not exterior, but within us.

Here many eastern Christian writers think in terms of an exchange. This idea is already present in 2 Corinthians 8.9: 'You know the generosity of Our Lord Jesus Christ, though He was rich, yet for our sakes he became poor so that, we through his poverty might become rich.' There St Paul envisages an exchange. The riches of Christ are his divine glory. Our poverty is our fallen and broken state. Christ, who is God, shares in our position. He becomes man; he enters into all the fullness of human life, and not only that but into the fullness of human death. He shares fully in our fallen condition, only without sin.

The result of his sharing in our condition is that we then are enabled through him to share in the divine glory. He shares in our poverty so that we can share in

his riches. This is St Paul's idea in 2 Corinthians 8.9. And he expresses the same idea in Philippians 2: Christ comes down so that we can go up. The divine descent makes possible our ascent to Heaven. God comes down, we go up: an exchange.

Irenaeus takes this up by saying, 'He became what we are, that he might make us to be what he is.' Athanasius later in the fourth century spells it out yet more directly: 'God became man so that man might become God' – an exchange in and through the Incarnation. As Clement puts it: 'The Word of God became a man, that you might learn from a man how man may become God.'

So God, we might say, is humanized so that we can be deified. He shares in our human nature so that by grace we may share in his divine life.

So this is one theme in Clement which does not contradict, contradict, but counter-balances, the emphasis on divine transcendence. He sees salvation in terms of sharing in the divine life and he expresses this sharing, paradoxically, by saying that we are deified or divinized: salvation as *theosis*, deification.

Important figures

Origen AD185–254
Most important early Christian theologian (see next chapter).

Pantaenus c.AD180
Jewish philosopher, also trained in Stoic philosophy. First head of the Catechetical School in Alexandria; mentor of Clement of Alexandria; Christian missionary to India.

Philo 20BC–AD50
Hellenized Jewish theologian, who synthesized Jewish and Greek philosophy; very important to early Christian theologians.

Plato 427–347BC
Most influential Greek philosopher, student of Socrates.

Tertullian c.AD155–230
First major African theologian of Carthage, who later joined the Montanists, a charismatic group.

This concept has a long history right up to the present time, and the Christian East draws on this, but so does the Latin West. St Augustine also thought of salvation in terms of deification. But Clement here, along with Irenaeus, is a pioneer. Clement is probably the first to speak of salvation as *theosis*.

A corollary to this point is that for Clement the process of deification is unending. God is infinite and so there are no limits to our journey into God. Salvation is never complete. Deification goes on, and the journey continues even in the age to come; there is infinite progress. This is already an idea in Irenaeus, who says: 'Even in the age to come God will always have new things to teach us, and we shall always have fresh things to learn.'

So there will never come a point when we can say to God: 'You are repeating yourself. We have heard it all before!' God will continue to be the God of wonder, the God of surprises, even in the age to come. As Tolkien says, 'The road goes ever, ever, on.' That is certainly the way Clement thinks of the journey of salvation, of

deification: 'God ever recedes and as we pursue he withdraws the further.'

So we possess God even if we do not possess him completely. He is with us to an ever-increasing degree: that is the way Clement thinks of eternal life, in dynamic terms. Perfection consists precisely in the fact that we never become perfect. The very journey is its own fulfilment. Every end is but a starting point. These ideas are very much emphasized in St Gregory of Nyssa.

The importance of love

> God is love and he is knowable to those who love him. We must be made like him through divine love, that we may contemplate like by like.

There you have an idea deeply rooted in Greek philosophy: that in order to know something, you must become like that thing. So God is love and if we are to know God we must become love also. Love is the key to the mystical door. As Clement puts it: 'The more someone loves God, the more deeply he enters into God.'

The *via negativa* is also a *via amoris* – the negative path is a way of love. That again gives positive content to the divine darkness. What do we experience when we've laid aside all images, all thoughts and all intellectual concepts? What do we experience when we enter into the darkness of the unknown? We experience the love of God.

In this connection, Clement stresses the importance of the Incarnation. The unknown God has made himself known to us in Jesus Christ. There is throughout Clement's writing a sense of personal experience when he speaks of Christ. Christ is someone whom he knows personally, whom he loves personally. So counterbalancing the negative way, the apophatic way, there is the Incarnation. We may ascend up into the divine darkness, but at the same time God has revealed himself to us in Christ.

Clement, however, would also have said that, though God is revealed in Christ, yet the Incarnation itself is a mystery. Even within the Incarnation, there is the sense of beyond, the sense of mystery, the sense of wonder.

Ancient library

BISHOP KALLISTOS WARE

The Revd Professor Andrew Louth shows us the most important way in which Clement has been influenced by Plato and how in turn he influences us: through the concept of *nous* and the way that this relates to prayer and our relationship with God.

THE *NOUS* AS THE ORGAN OF PRAYER

Clement's central insight, which bears most closely on what he means by prayer, is a sense of human inwardness, a sense that what we really are is hidden within us and therefore needs to be searched for. The first step towards knowing anything is therefore to know yourself; thus begins a voyage of self-discovery. The 'self' is the 'soul', though in Plato and Clement a more specific word is used, namely *psyche*, meaning 'life-force'.

They were tempted to go as far as stating that we are souls inhabiting bodies. They did not deny that we are both souls and bodies, but the essence of what we truly are is found in the soul.

The word *nous* is difficult to translate into English. The normal translation is 'intellect', but the trouble with 'intellect' in English is that it doesn't convey what the Greeks meant. For Plato the *nous* or soul was right at the centre of what it meant to be human. *Nous* does include an intellectual capacity, but it was more than that; it was having some sense of the real value of things, knowing the Truth. In fact, our *nous* is our point of contact with God.

Good works follow Gnosis as shadow follows substance

Plato had this idea that the soul or *nous* can either concern itself with the world of shifting reality in which we live, or it can attempt to see what lies behind this reality and try to find out the nature of Truth itself.

The picture we have of Socrates in the *Dialogues* is of a man trying to move us beyond the usual way of understanding the world drawn directly from our own experience. He attempted to get us to look beyond that to a deeper Reality.

And in so doing two things happen. First, we enter that Reality itself, which allows us to judge things directly and properly. Second, we discover who we really are. We discover in ourselves a centre that is capable of relating to Reality itself, which is not distracted by things in this world. It is not tempted to build up a picture

of the world that is really simply our own construct, the way we would like things to be.

We may seem terribly far from prayer, but we are not. It is in fact very closely related to prayer, in that Clement sees prayer as a way in which we commune with God. Most of us would take that as a fairly good definition of prayer.

This is why, in the Byzantine tradition particularly, *nous* is thought of as being the organ of prayer. What we pray with is that part of ourselves that is capable of engaging with Reality. In the *nous* we are 'like God', and thus able to engage with him.

Prayer isn't just asking for things, nor is it a way of trying to have elevated feelings and thoughts about God. What prayer ultimately is, for Clement and for those who follow in this tradition, is an engagement with genuine Reality, which is God. There is no reality apart from God, because cut off from God nothing could exist. Everything is created by him.

There is one point at which Clement relates this Platonic idea of *nous* to a fundamentally biblical vision of what it is to be human. Remember how Clement always sees any point he wants to make as a confluence of these two traditions. In this case he relates *nous* to the 'image of God'. In the first book of the Bible, Genesis, it is stated that we are created in the 'image of God'. This doctrine remains fundamental in the Byzantine and Orthodox tradition. We are created in some way as replicas, if you like, of God, with some of the characteristics of God in the world.

This idea appears in Genesis, though not much is made of it in the Hebrew Scriptures. However, it is taken up by the Christian tradition and becomes very influential. Clement sees the *nous,* therefore, as that which is the 'image of God' within us. There we are purely spiritual beings, entirely free beings, and these he sees as reflections of God.

The theory of 'Like knows like'

The importance attached to the concept of the *nous* is therefore the thought that we have something in common with God. This makes it possible for us to achieve communion with God, as stress was laid in Greek philosophy on the idea that 'only like can know like'; completely unlike cannot know completely unlike. In the latter case there is no point of contact; there is no communication, no knowledge.

This is a very plausible intuition. We often say: 'People are so different; I don't

know how they tick.' If two people know each other they have formed some sort of common ground that allows them to begin truly to know one another.

Becoming like God was the destiny of the soul, according to Plato. There is a passage in one of the *Dialogues* which states that 'flight from the world is assimilation to God as much as possible'. For Plato to know the Truth was to be assimilated to the Truth.

Clement was so taken with this idea of 'assimilation' in the Platonic tradition that he quoted it over and over again. He associated it with the idea in the Hebrew tradition of being created in the 'image and likeness of God', which allows us to know him and become more and more like him. He rephrases Plato's saying that the 'destiny of being human is to become God'. God has created you in his image so that you can become so like him that you are transformed into him.

When it says in Genesis that we are created 'in the image and likeness of God', modern biblical scholars understand 'image and likeness' as two terms for the same thing. But the Greeks didn't see it like that at all; particularly not the Greeks who read the Old Testament in the Greek translation, the Septuagint, made a century or two before the birth of Christ.

The translation of the 'image and likeness' of God into Greek comes out as one word only, namely *ikon*, which is the ordinary word for a picture. This word doesn't exactly mean likeness, but more a process of likening, a process of assimilation: *homooisis*. For the Greeks, genuine knowledge therefore entails a sort of assimilation to what you know. This was a basic premise of virtually all Greek understanding of what it means to 'know'. It remained the same throughout the Christian tradition, certainly up to the time of Aquinas, maybe even longer.

It was therefore essential to Clement that we discover this 'image and likeness' at the heart of our being and that we make it a genuine part of who we are. Then we can come to 'know' God genuinely and be assimilated by him, in other words literally 'become God', which is our destiny. We become gods because our life is his. We share his love.

REVD PROFESSOR ANDREW LOUTH

FOUR

ORIGEN

Kallistos Ware
and
Andrew Louth

Origen

Introduction

Origen was a native Alexandrian, highly educated in Greek, Jewish and Christian wisdom. At the young age of 17, Bishop Demetrius of Alexandria appointed him Head of the Catechetical School as successor to Clement. He was an extremely talented scholar, a gifted teacher, and the first to present, in his *On First Principles*, a systematic and profound Christian theory of the cosmos in response to the Gnostic theology and cosmology. He based this wholly on an allegorical and mystical reading of the Scriptures. It was probably written in response to questions by thoughtful and educated students at the Catechetical School, who were trying to understand the Christian teaching against the background of Platonic, Stoic and Gnostic philosophy.

Like Plotinus, Origen may have studied under Ammonius Saccas, the most famous teacher of Greek philosophy at that time. Like Philo and Clement of Alexandria before him, he saw the correspondences between the wisdom of the Greeks and that contained in the Hebrew and Christian Scriptures.

Bishop Kallistos stresses the importance of Origen and focuses in particular on his significant map of the Christian life and his concept of the 'spiritual senses', both hugely influential for later Christian Fathers.

Origen AD186–251

He was a native of Alexandria and brought up as a Christian. His parents may not have been Christian when he was born, as they gave him the name Origen, which means Son of Horus. Yet when he grew up his father was a leading member of the Christian community and died in the Severan persecution of 202. Eusebius tells us that the young Origen at 15 years old was anxious to share his father's fate, but his mother hid his clothes to prevent him from leaving the house! Ever since then he felt a passionate longing for martyrdom; he decided, however, that God hadn't called him to die but that he could be an inner martyr through following the ascetic life. He fasted and slept very little, and even that was on the floor. He never married.

He was a brilliant scholar, warmly encouraged by his father to study the accepted wisdom at that time, both Greek philosophy and Christian writings. He may, like Plotinus, have studied for a while under Ammonius Saccas, hence his Neo-Platonic leanings.

He was known throughout the Church and travelled widely, even teaching at the imperial court of Severus in Rome at the invitation of the Emperor's mother. In later life he moved to Palestine and settled in Caesarea in 230. There he set up an academy with the help of a wealthy patron. He was ordained priest there. He was tortured under Decius in 250 and died of his injuries in 254.

ORIGEN'S REPUTATION

There is a deeply paradoxical element in the way Origen has been regarded in later Christian times. On the one side he has been deeply admired, highly praised. St Jerome calls him 'the greatest teacher after the Apostles'. St Vincent of Lérins says, 'Who would not rather be wrong with Origen than right with anyone else?' But at the same time, he's been greatly attacked, as for example in the following anecdote from fourth-century monastic Egypt. St Pachomius, the founder of Coenobitic monasticism, was one day visited by a group of monks who were seemingly devout and respectable and certainly well educated. As he talked with them, however, he noticed a very nasty smell, and he could not work out where this smell was coming from.

At last he discovered the reason. The seemingly well-educated monks were, in fact, followers of Origen, and this leads St Pachomius to say to them:

Behold, I testify to you before God that everyone who reads Origen and accepts his writings will descend into Hell. His inheritance is the outer darkness where there is

weeping and gnashing of teeth. Take the books of Origen that you have and throw them in the river.

All too many people have done exactly that. So the Greek texts of many of Origen's works are lost and we have to depend on Latin translations, often inexact.

Origen was a daring and speculative thinker. His fault, if it is a fault, is to try to say too much. He even believed in the pre-existence of souls and also in the final restoration of all things including the devil.

In Origen we see two sides. On the one side he is a Platonist, a philosophical theologian. On the other side he is an ardent lover of Holy Scripture, warmly devoted to the person of Jesus.

The active and the contemplative life in Origen's mystical theology

Origen provides us with a map of the Christian life, which remains classic in the Christian East.

He made a twofold contrast between *praxis* and *theoria*, between the active life and the contemplative life. This distinction goes back at least to Aristotle and is certainly found in Philo and in Clement. It's important to realize the way in which these terms are being used in eastern Christian sources. In the modern West, when we talk about the active or contemplative life, we are usually thinking of people's external status. The active life means life in the world, the life of a social worker or a missionary or a teacher; it means people who belong to an active religious order. In modern usage the contemplative life usually means life in an enclosed religious community, giving oneself to prayer rather than to outside service.

The end will be like the beginning.

In the Greek Fathers, however, these terms do not refer to external situations but to inner development. The active life means the struggle to acquire virtues and to up-root vices, whereas the contemplative life means the vision of God. So it may often be that somebody living in an enclosed religious community, even a hermit, is still at the first stage of the active life. Whereas it's possible that a lay person committed to a life of service in the world might be at the second stage, might be a true contemplative.

For example, in the sayings of the Desert Fathers, we hear that there came a voice to Abba Antony saying:

The Rosetta Gate
and Alexandria,
Michael Wohlgemuth

*In the city, there is someone just as holy as you are, a layman, a doctor, who gives all
the money that he saves to the poor and all day long he sings the thrice holy hymn
with the angels.*

If you sing a hymn all day long, you are certainly a contemplative, but here we have
it said of somebody in the middle of a city following a very demanding profession.
And yet he is said to be the equal of the great Antony, the Father of hermits.

Origen links these two stages with the figures of Martha and Mary in Luke 10:
Martha being the active life, busy about many things, and Mary being the one who
concentrates on the one thing that is needful.

The threefold map of the Christian life

Then Origen refines this twofold scheme and breaks it up into three stages or levels,
which he calls 'ethics', 'physics' and 'enoptics'.

'Ethics', the first stage, corresponds to the active life, the acquisition of virtues.
The other two are both forms of contemplation, but Origen distinguishes between
what he calls 'physics', which means the contemplation of nature, seeing God in
his creation, seeing God in all things and all things in God, and 'enoptics', which
means the direct vision of God.

This threefold scheme is linked by Origen to three books of the Bible. For the
active life, 'ethics', we have Proverbs as the appropriate book full of instructions

about how we are to act. For 'physics' we have Ecclesiastes. The preacher of Ecclesiastes surveys the creation, but then looks beyond it. And for the third stage, the direct contemplation of God, union with God, the appropriate book is the Song of Songs. Origen wrote a notable commentary on the Song of Songs. He believed that the Song of Songs alone among the books of the Bible has no literal sense.

For Origen, Scripture has a double sense, a literal external sense, and then the inner spiritual sense. The story of Moses, for example, is first of all a story of somebody who actually lived, and we hear in Scripture what he did and what happened to him. But Moses is often taken also as a symbol of the mystical life. So most books, then, have an outer sense and an inner sense, but Origen thinks the Song of Songs has no outer literal sense. He does not accept the idea that it was originally written as a human love poem. He will only accept that it is an account of the relationship of the soul to God.

We find this threefold scheme particularly in Evagrius of Pontus, a late fourth-century Egyptian Desert Father (see Chapter 8), and Maximus the Confessor in the seventh century.

It is clear, when we look carefully at the way Origen or Evagrius or Maximus speaks about the threefold scheme, that it isn't a question of successive stages, the one ending before the next begins. It's rather a question of deepening levels that might overlap, that might be simultaneous rather than successive. In other words, you might advance from the active life to the contemplation of nature, but you would still have a struggle to lead a moral life. And you might go further and have experiences of the direct vision of God, and yet you would still practise the contemplation of God in nature.

Metanoia

The starting point of *praxis*, the active life of 'ethics', especially according to Evagrius, is *metanoia*. This literally means a change of mind, that is, repentance. Repentance is not a paroxysm of guilt and self-hatred; repentance means changing your mind, a new way of looking at yourself, at your neighbour and God.

So that's where you start in the active life; then you seek purification from sinful acts, purging of evil thoughts. And at the end of the active life – and this is a point made by Evagrius rather than Origen – you reach what he calls *apatheia*, which

does not mean apathy. It means passionlessness, being dis-passionate. In a negative sense this is the elimination of sinful desires; in a positive sense the affirmation of purified and transfigured desires.

It doesn't mean immunity from temptation, because we expect to face temptation right up to the end of our earthly life.

It is closely linked by Evagrius with the quality of love: having ceased to lust, we begin to be able to love. *Apatheia* is therefore not just negatively the elimination of sinful desires, but positively the replacing of our disordered impulses by a new and better energy from God. So it means health of soul, reintegration, spiritual freedom.

St John Cassian, in presenting the teaching of Evagrius in the West in Latin, uses *puritas cordis*, purity of heart, instead of the word *apatheia* (see Chapter 9, p. 128). That has the great advantage of being positive rather than negative in its form, and also of being scriptural.

Diadochus of Photike, writing in the fifth century, even used the phrase 'the fire of *apatheia*'. *Apatheia*, despite its sounding like apathy, is in fact something intensely dynamic.

Origen's writings

He wrote about 6,000 works: exegetical writings, commentaries on most of Scripture and sermons. He had a team of shorthand secretaries to whom he used to dictate these; when one became exhausted, he continued with the next.

Most of his writings have not survived. In the middle of the sixth century Emperor Justinian called a council of bishops together in Constantinople to discuss his reservations about Origen. There is some uncertainty about whether certain of his teachings were then formally declared heretical.

Extant are:

On First Principles, a comprehensive account of the universe.

On Prayer, stressing the necessity and advantage of prayer with much practical guidance.

Against Celsus, a response to the pagan philosopher Celsus attacking Christianity.

Contemplation of nature

So having advanced some way on the path of *praxis* or ethics, having come close to 'purity of heart', we can begin with God's help and grace to move on to the second stage, which Evagrius calls 'natural contemplation': to see God in everything, to treat nature as God's book; to view each created thing as a sacrament of the Divine Presence.

You may recall the seventeenth-century poem of George Herbert often used as a hymn, 'Teach me, my God and King, in all things thee to see; and what I do in anything, to do it as for thee.' Now that's exactly what Origen and Evagrius mean by the contemplation of nature. As it says in the second-century text the *Gospel of Thomas*, 'Lift the stone and you will find me. Cut the wood in two and there am I.'

In the Christian context this is not pantheism, identifying God and the world, but panentheism. The pantheist says: 'God is the world and the world is God.' The panentheist says: 'God is in the world and the world is in God.' But the panentheist, if he or she is Christian, will add: 'God is in the world, but he is also above and beyond the world; utterly immanent, he is also utterly transcendent.' But before we can experience the transcendence of God, we need to have some sense of his immanence. We need to feel the nearness before we can fully experience the otherness.

This is what is meant by the second stage, contemplating God in nature and nature in God. There is a pleasing story told about St Antony of Egypt and a philosopher:

> There came to the righteous Antony one of the wise men of that time and said, 'However do you manage to carry on, Father, deprived as you are of all the consolation of books?' Anthony replied, 'My book, philosopher, is the nature of created things and it is ready at hand whenever I wish to read the words of God.'

This is what is meant by 'physics', contemplation of nature – reading God's book.

There is a story about a hermit of our times on the mountain of Athos. He lived at the top of a precipice, about five hundred feet above the sea looking out towards the West. It was his custom to sit on his balcony each day watching the sunset, watching the sun go down into the sea. It was a marvellous view.

Listening to the Scriptures is like trying to listen to a symphony. You won't be able to understand it if you haven't become attuned to it.

Now one day a young monk joined him as his disciple and the old man made him come and sit each day and watch the sunset. The young monk was a person of energy and practical character. After he had done this for several days, he said to the old monk: 'Why do we have to sit and look at the sunset every day? It's a very nice view, but we saw it yesterday.' And this they would have done just before going into the chapel for their night office, for the vigil.

'What are you doing when you sit looking at the view?' the young monk said. And the old man replied: 'I am gathering material. I am collecting fuel. I am assembling firewood.' In other words, before he went into the darkness of the chapel and sought God present within his heart through inner prayer, through the Jesus prayer, he looked out at the world that God has made and affirmed the Divine Presence in the whole of creation.

So this is what is meant by the contemplation of nature, but very many of the Fathers, including Origen, view it in a slightly negative way. It's not just contemplation of the wonders of God in the creation, but also a perception of the transience of the world and a desire to pass beyond it. The created order is envisaged not as an end in itself, but as a ladder of ascent.

Contemplation of God

Then we come to the third stage, the contemplation of God. Evagrius, rather more clearly than Origen, emphasizes that this signifies a movement from multiplicity to unity; from the complexity of discursive thinking to the simplicity of direct gazing. 'Our mind', said Evagrius, 'is to become naked, stripped of all images, of all thoughts.' We are to attain a unified awareness in which we are conscious of the Divine Presence, but without any particular picture or shape or verbal phrase in our mind: a touching and a one-ing in love that is apophatic, non-iconic.

So those are the three stages which Origen puts before us and which Evagrius develops. There is, however, a clear distinction between the contemplation of God in nature and the contemplation of God in unmediated union. Many of us, when we read in the works of the mystics about the unmediated vision of God on a level beyond all thoughts, feel that this lies far beyond our present capacities. But the contemplation of God in nature, to affirm the Divine Presence in all created things round us, is within the scope of all of us. If this distinction is made, contemplation becomes far more accessible. We are all of us contemplatives, and contemplation is possible whatever our way of life. No one is excluded. We can all affirm the world in God and God in the world.

This particular threefold approach helps to make contemplation less daunting. No way of life, except the life of sin, conflicts with contemplation. You can be fully committed to the work of active service to the world, marry, be responsible for a large family, and yet you can be a contemplative, if not yet on level three, at least on level two.

When Origen speaks about level three, the contemplation of God, he adopts a different approach from Clement. Clement stresses the divine darkness of Sinai and makes that his dominant symbol. Origen, by contrast, is a theologian of the divine light. He sees the Christian life as an ever-increasing illumination. Indeed, in his

commentaries on the Book of Exodus and the Book of Numbers he passes over the incident which for Clement is supremely important: he only in passing makes a small mention of the darkness of Sinai, but it's not a central symbol for him. Origen does believe in the mystery of God, that God is beyond our understanding, but he doesn't emphasize it nearly as much as Clement does.

Important figures

Ammonius Saccas 175–242
Eminent philosopher teaching in Alexandria with possibly both Plotinus and Origen among his students.

Demetrius of Alexandria 189–232
First influential Patriarch of Alexandria during Clement's and Origen's lifetimes.

Evagrius 344–99
Started life as friend of the Cappadocian Fathers; first had high ecclesiastical career; influenced greatly by the teaching of Origen; retired from public life to become one of the foremost Desert Fathers.

Maximus the Confessor 580–622
Ascetic; mystical theologian; bridge between eastern and western theology; defender of the decisions of the Council of Nicaea.

St Pachomius 287–347
A founder of monasticism; wrote the first strict rule for monks.

Pseudo-Dionysius c.541–613
Anonymous Christian Neo-Platonic theologian and philosopher; summed up the apophatic mystical theology of the Fathers; was hugely influential.

Ecstasy

Neither Origen nor Clement talks about ecstasy. Philo talks a good deal about ecstasy. He believes that when the human person meets the living God, the experience is so overwhelming that we are taken out of ourselves and lose all consciousness of our surroundings, even all awareness of who we are.

Origen, following Clement, differs here. When he uses the word 'ecstasy' it usually means madness, delusion, possession by evil spirits. Sometimes Origen speaks of ecstasy as meaning amazement, astonishment. But we do not find in Origen or in Clement the idea of mystical ecstasy, in the sense of being drawn out of oneself in an intense longing for God.

Origen says, very definitely, that when the evil spirits take hold of a person's mind, the result is that he can't understand or think clearly. He is possessed; but the good spirit, the Holy Spirit of God, does not do this: 'When the Holy Spirit is at work within us, we do not undergo mental disturbance or aberration.' We do not lose the free judgement of our will: 'The prophets and the apostles attended upon the divine oracles without any mental disturbance.'

The Holy Spirit, so he believes, does not destroy our normal awareness but heightens it. The fact that Origen, and for that matter Clement, speak in this way is probably because they are reacting against the group in the second century known as the Montanists. The Montanists felt that the

Church was compromising with the world. More particularly they felt that the original inspiration of the Spirit, which you see in the Book of Acts, was beginning to die out, and so they revived an approach to Christianity that involved speaking with tongues, dreams, visions, prophecy, trance and loss of consciousness.

In reaction, people like Clement and Origen exclude ecstatic phenomena, but ecstasy is reintroduced again into the Christian tradition by Gregory of Nyssa.

The spiritual senses

Origen regarded the Song of Songs as the book describing mystical contemplation. And indeed, it is in the Prologue to his commentary on the Song of Songs that we find the threefold scheme outlined above.

In his commentary Origen develops a doctrine of the spiritual senses. He is a pioneer here. He says: 'Besides our bodily senses, there exist in human beings five other senses.' He talks about a sensuality that has nothing of the senses in it; a higher sense faculty, a divine sense perception. The soul has its eyes, ears and its sense of taste, of smell and of touch. And these spiritual senses need to be developed in our inner life.

Origen through this language is trying to express the richness and variety of the Christian life. We don't just hear the word of God, we can also see God. We can taste him. We can smell him. We can touch him. There is a great variety of inner experience.

Christ our God is not just apprehended in abstract conceptual terms through the reasoning brain but also through feelings, through inner sensations. He is known in a personal, experiential way.

The spiritual senses come into full play at the third stage of the spiritual journey, the contemplation of God: 'enoptics'. Hearing and seeing are rather more distant among the senses: you can hear about something or see it from a distance without being involved. But the other senses, smell, taste and touch, involve a far more direct relationship, giving a sense of close and intimate union with God.

A sense of God's absence

While Origen stresses the experience of God, his divine closeness, he also emphasizes that from time to time we may undergo a withdrawal of the conscious sense of God's presence. There will be times when we shan't taste, touch and smell God,

but we shall feel his absence, as the following statement proves:

> *The Bride then beholds the bridegroom and he, as soon as she has seen him, goes away . . . This is something that nobody can understand who has not suffered it himself. God is my witness that I've often perceived the bridegroom drawing near me and being intensely present with me. Then suddenly he has withdrawn and I could not find him, though I sought to do so. I long, therefore, for him to come again and sometimes he does so. Then when he has appeared and I lay hold of him, he slips away once more and when he has so slipped away my search for him begins anew: so does he act with me repeatedly.*

The first interesting thing in that passage is the way Origen appeals to his own personal experience – the Fathers in the Greek tradition don't do that very often. But a second point is that the Christian life does not consist simply of the experience of God's presence consciously. We must also expect that there are to be times when that conscious experience is withdrawn from us. Here we may think of how, in the West, St John of the Cross writes about 'the dark night of the soul': a sense of God's absence, a sense of desolation, that God has deserted us.

There is a difference certainly, in that Origen seems to have envisaged these periods of the absence of God as being quite brief, whereas St John of the Cross emphasizes that they may go on for a long time, many years. But it shows how we can find an equivalent in the Christian East to the dark night of the soul.

BISHOP KALLISTOS WARE

The Revd Professor Andrew Louth brings out the importance of Origen as a teacher, especially with regard to his exegesis of Scripture and his method of *Lectio Divina*.

ORIGEN'S TEACHING CAREER

Origen was put in charge of the Catechetical School while still young. It is difficult to say how formalized this school was, particularly as these were times of persecution. Being a catechumen in the early Church was a serious business. You had to find a Christian to present you; then you were enrolled for three years at this school and only then would you be baptized.

Origen initiating neophytes

He was famous and much sought after as a teacher. He even went to Rome at the instigation of the mother of the Emperor to speak to her about Christianity. When he fell out with the Bishop of Alexandria he moved to Caesarea, around 230. There he set up an academy with the help of a wealthy patron. The roll call of those who studied there is really quite amazing: he turned out all the great bishops of the late third century.

Through Gregory Thaumaturgus we have an insight into his teaching programme. First came a thorough training in 'dialectics' to train the mind; then 'physics', the study of the natural world. This was followed by the study of 'ethics', considered to be the most important part of the curriculum with its aim of achieving 'likeness' to God. Then at last theology was tackled, with Greek philosophy seen as a way of preparing the mind for the essential scriptural exegesis. The Bible was considered the essential source of wisdom, which could only be truly approached by those who were morally purified.

In the mid third century there was mass persecution of the Christians under Decius. Everyone was required to obtain a certificate saying that they had sacrificed to the gods. Many Christians apostatized; those who refused to do so

and obtain a certificate were killed. Origen was one who refused but because of his importance he wasn't killed. He was tortured for up to a year but remained firm. However, he lived after the persecution in a broken state and died shortly afterwards.

Origen's exegesis of Scripture

Everything Origen wrote, and he wrote prolifically, was concerned with the interpretation of Scripture and took the form of commentaries and sermons. It was the heart of his scholarship and his mystical theology; in fact this formed the foundation of his teaching. He probably wrote commentaries on every book of the Bible, most of which are now unfortunately lost, as some of his teaching was considered to be 'heretic' after his lifetime.

His most important extant work, *On First Principles,* contains a systematic account of how to read Scripture.

There is no rational creature which is not capable of both good and evil.

Much of modern biblical scholarship concerns itself with critical analysis of individual words. Even though Origen did indulge in this to some extent, he stressed the importance of going beyond the first level of reading, that is, concentrating solely on the surface meaning of the text. The real point of reading Scripture for Origen was to bring us to an encounter with Christ; it was essentially a spiritual experience. The voice we hear in the Scriptures is Christ speaking to us and our understanding of Scripture is a way to union with him.

The tradition of *Lectio Divina,* the slow meditative reading of the Scriptures that eventually leads to the marrow of the text, may be traced to him. He expresses the experience of discovering spiritual and theological meaning in Scripture through allegory, often in mystical language; he speaks of a 'sudden awakening', of 'inspiration', and of 'illumination'. It is quite clear that Origen's mysticism is centred on the Word, and that the eternal Word is apprehended in Scripture.

Christianity in his view was the fulfilment of the Old Testament. Glimpses of the truth seen through Moses and the prophets were actually made flesh in Christ. The Old Testament was the history of God's dealing with his people, but Christ was the truth and the key to understanding Scripture. If we listen carefully to the

Old Testament we will hear there the gospel of Christ: for instance, Origen talks of Christ's love for the Church in his introduction to his commentary on The Song of Songs: Christ is the bridegroom seeking us in love.

However, the liturgical context is never far away, for Scripture would mainly have been heard in church and most of Origen's work consisted of sermons.

In the fourth century Basil of Caesarea and Gregory of Nazianzus made a selection of Origen's writings, the *Philokalia*. Towards the beginning (in chapter 6) they select a passage in which Origen suggests that listening to the Scriptures is like trying to listen to a symphony; you won't be able to understand it if you haven't grasped the principles of harmony. How do we learn these principles? From our life as Christians and through the Rule of Faith. With this understanding, we can hear the harmony.

On prayer

Origen wrote a book *On Prayer*, of which the central part is a commentary on the Lord's Prayer. But it starts off with a discussion about the nature of prayer and the way we pray, followed by discussions of various other topics related to prayer. It is a unique work.

There were three works on prayer before the Council of Nicaea written at around the same time: the one by Origen and two by his contemporaries Tertullian and Cyprian. After Nicaea there were various commentaries on the Lord's Prayer, for instance those by St John Chrysostom, St Augustine and St Maximus the Confessor. The latter saw the Lord's Prayer as a summary of the whole of Christian faith and our response to it. It includes the doctrine of the Trinity and the doctrine of the Incarnation. Maximus felt that in praying the Lord's Prayer we were entering into what Christ did for us and were beginning to experience the life of the Trinity that he opened for us.

For Origen prayer is an inward dispossession of the soul. It is the soul coming before God its Creator, coming before the One who has redeemed it, coming before the One where it finds its meaning. From the comments the Fathers make about the Lord's Prayer it becomes clear what they meant by prayer in general.

Quite a lot of modern writing assumes that prayer is a purely mental activity. Strikingly, all three of the pre-Nicaea works deal with what you do with your body

during prayer. It was important to them that prayer is not treated merely as a spiritual exercise that ignores the body. They don't assume that it is just the mind at prayer, but emphasize the involvement of the body.

Stress is laid on the body for two reasons: first, because we are more than just a soul. Prayer shouldn't detach us from our bodies, as the body is an expression of what we are, an expression of our soul. Moreover, we communicate with others through our bodies: gestures often express far more of what we mean than the actual words we use. We live through our bodies with other people. Even if prayer is a movement of inwardness, it is not a movement of inwardness that therefore detaches us from the body.

Understand that you have within yourself, upon a small scale, a second universe; within you there is a sun, there is a moon, and there are also stars.

Most of the Fathers emphasize as a result that we should pray standing up with our arms raised, as this signifies our welcoming Christ, welcoming God. Standing is our natural state, which expresses the dignity of the human person and indicates a proper pride in being able to pray: only because we are created in the image of God are we able to communicate with him.

But as prayer also involves confession and repentance, the proper thing to do in this instance is to kneel. Kneeling is an act of prostration, an act of repentance, an act of lowering ourselves in the same way that we have lowered ourselves by sinning. We have besmirched the image of God within us and we repent of this.

Second, prayer is not simply an individual or even a corporate activity but a cosmic act. We align ourselves with the direction of the world, the direction of the cosmos. Moreover, we are praying on behalf of the cosmos in the way that St Paul expresses in Romans 8: our prayer takes up the prayer of the cosmos itself.

All the Fathers ask us therefore to face east when we pray, though they don't all give the same reason for this.

Origen says we face east in the direction of sunrise because in praying we are facing the rising of the true light which is Christ. St Basil agreed with the more common reason mentioned in the Septuagint: Eden is placed over in the east so by facing east we are looking towards our ancient Fatherland. We are looking towards the place where we as a body of Christians, and where humanity itself, came from and where we are seeking to return. It is interesting to note in this connection that

virtually all churches face east as well, although the tradition was broken in the West in early modern times, and Christians until recently were always buried facing East. The following is an extract from *On Prayer*:

> *Disposition is a matter of the soul, and posture of the body. Now Paul, as we said above, was describing disposition when he says that we should pray without anger and without dissent, but posture in 'lifting up holy hands' (1 Tim. 2.8). Accordingly it seems to me that anyone who intends to embark on prayer should lay a foundation for himself by preparing himself a while so that he will be the more attentive and alert throughout his prayer . . . He will put aside all alien thoughts, so coming to prayer, extending his soul, as it were, before extending his hands, his mind intent on God before his eyes and, before standing, raising his intellect from the earth and setting it before the Lord of all. All remembrance of wrongs against anyone who is supposed to have done him injustice should be put away . . . Nor can there be any doubt that, of the numerous dispositions of the body, standing with hands extended and eyes upraised is much to be preferred, in that one thereby wears on the body the image of the characteristics which are becoming to the soul in prayer . . . Yet we should know that kneeling, because it is a symbol of humility and submission, is essential when one intends to confess one's own sins against God and to beseech healing from them, and remission . . . A few words may be said on the direction that one should face whilst at prayer. Since there are four directions, towards the north and the south, towards the rising of the sun and its setting, who would not immediately agree that the direction of sunrise obviously indicates that we should make our prayer facing in that direction, as having the symbolic implication that the soul is facing the rising of the true light?* (On Prayer 31.2)

Attention

In Origen's understanding of the spiritual life the most important factor was the ability to pay attention. Appreciation was needed of what would drain it and what would help it to be maintained.

The quality of attention forms the essential disposition of the soul in prayer. There is a 'wordplay' link between the Greek word for 'attention' – *prosoche* – and the Greek word for 'prayer' – *proseuche*. The whole history of humankind can be seen as a failure to pay attention.

In Origen's doctrine of the pre-existence of souls (for which he was later condemned) all souls were originally paying attention to God. They got bored and their attention wandered. The extent to which their attention wandered determined the place they occupied in creation. Origen suggested that the world of bodies was God's providential scheme for finding our way back to him by recovering our ability to pay attention in true prayer.

REVD PROFESSOR ANDREW LOUTH

EARLY CHRISTIANITY AND THE GOSPEL OF THOMAS

The Nag Hammadi gospels

Kim Nataraja

Introduction

We heard in the first few chapters how central the contemplative way of prayer was in Jesus' teaching. And yet when we look at Christianity in the West nowadays it seems that this is the missing element that distinguishes Christianity from other religions.

Moreover, we are also struck by the great diversity of forms in which Christianity is expressed nowadays. Many of us think that if we went right back to the beginning of Christian times we would escape this diversity and discover one pure form. This is unfortunately an illusion. Christians in the early years were just as divided as we are today: in the second century there were already at least 80 different groups in existence. This internal conflict was even more damaging because it occurred during a time of dreadful persecutions and martyrdom.

The arguments already started among the Apostles. We still have an indication of that in the Gospels that have come down to us. Paul chides the Corinthians for 'contentions', because 'each of you is saying, "I am Paul's man", or "I am for Apollos"; "I follow Cephas", or "I am Christ's"'. We read in Acts and Galatians of conflicts between Peter and Paul, Paul and James, and John and Thomas. Evidence of the latter competition is that in the Gospel of John – and only there – Thomas is called the 'doubting Thomas'.

These and later divisions were caused by the fact that everyone heard and interpreted the teaching of Jesus differently. People heard what fitted into their worldview,

what resonated with them. The questions — who he was, why he had come, and what his relationship with God was — were answered against this background.

Kim Nataraja traces in this chapter the reasons why the *Gospel of Thomas* was considered heretical, why from the fourth century the mystical strand of Christianity lost out, and outlines the importance of the teaching in this Gospel, especially for our time.

Quotations are taken from Marvin Meyer (trans.), *The Gospel of Thomas: The Hidden Sayings of Jesus*, HarperCollins, 1992.

THE HISTORICAL CONTEXT OF THE *GOSPEL OF THOMAS*

To understand the reason why the *Gospel of Thomas* was considered 'heretical' from the fourth century onwards it is essential to set it in its time.

Early in the second century two clear strands appeared in Christianity: one stressed pure faith and an unquestioning acceptance of a set of beliefs based on the agreed Scriptures as the only criteria for being a true Christian. The other accepted that as the foundation but also emphasized the importance of going deeper in contemplative prayer and acquiring intuitive spiritual knowledge of God through Spirit-led insights and experiences, often emerging from reading Scripture.

Among the second grouping were the Montanists. They were a group of charismatics led by Montanus, who stressed the importance of prophecy, visions and dreams. They were very popular, but were considered a divisive force among the early Christians at a time of severe persecutions. They believed in direct access to God without any intervention needed by bishops. Moreover, women played a prominent role. The early Church in these patriarchal times, however, was no longer comfortable with women playing an important role despite the example set by Jesus and Paul.

Besides, in these early centuries there was actually no recognizable institution called the Church. There were very few bishops, there were no creeds and there was no agreed canon of Scripture. Moreover, apart from in Alexandria, people met for safety reasons on the whole in separate scattered house groups, not in dedicated buildings.

One of the few existing bishops, Irenaeus, was called upon to try and deal with the trouble this group was causing. They were, however, basically orthodox, and moreover visions, prophecies and dreams lay after all at the foundation of the Christian faith. Therefore the only way he felt that he could curb their influence was by declaring that new revelations and visions were no longer considered valid as the foundation of faith after the deaths of the Apostles. One can sympathize with his problem, as it is difficult to discern whether visions really come from the Spirit or whether they are delusions of the ego.

St Irenaeus

The attraction of the charismatic interpretation of the faith is shown by the fact that Tertullian, who was a major figure in African Christianity and an early stalwart of the Church, became in the end a Montanist.

The 'Gnostics'

However, the Montanists seemed in Irenaeus' opinion to present not as much of a threat as did the groups he called 'Gnostics'. He especially focused on the one led by Valentinus.

Gnosis means knowledge, not rationally acquired knowledge but a profound, intuitive understanding, based on actual experience of the Divine. Irenaeus was very suspicious of this contemplative approach with its allegorical interpretation of Scripture. The difficulty was that to all intents and purposes this group was truly religious. Tertullian went as far as to call these mainstream Gnostics 'the most faithful and wisest and most experienced members of the church'. They attended church, read the agreed Scriptures and revered the sacraments. But they also had separate additional ceremonies, which went deeper and in which again women played an equal role.

However, it needs to be recognized that not all the groups called 'Gnostics' by

Irenaeus were as centred as Valentinus' group. Most of these groups, with good rea-
son, called themselves Christians, but they were extremely dualistic in their attitude
to creation. They drew a clear division between spirit and matter and saw the spirit
as imprisoned in matter; the phrase *soma sema* – 'the body a tomb' – was associated
with them. Some were not Christian at all; in fact, 'Gnostics' is an umbrella term
covering a wide range of varied groups.

Irenaeus wrote a treatise called *Against Heresies*, throwing together the deeply
Christian groups with all these others and declaring them all 'heretics' – (the term
means literally 'one who chooses'). In this treatise Irenaeus talked about '*gnosis* falsely
so-called', thereby implying that Christianity, in the literal way he interpreted it,
was the true *gnosis*. When he used the term 'false Gnostics' he meant it in a deroga-
tory way as 'know-it-alls'.

To deal with this quandary and the wide diversity that had arisen in these early
centuries, Irenaeus decided to recognize only four Gospels, Matthew, Mark, Luke
and John, and the Letters of St Paul as 'orthodox' – that is, 'right thinking' – with
the aim of achieving some unity in the early Church. He chose the Gospel of John
rather than the *Gospel of Thomas* purely out of a personal choice: his teacher Polycarp
had been a disciple of John.

The *Gospel of Thomas* was actually at that time much more popular than the
Gospel of John, whose perception of Jesus was not shared by everyone in the early
Church; ironically enough John was considered to be 'too Gnostic' by many. By
choosing John over Thomas, Irenaeus destined the latter's view of Jesus' teaching to
oblivion.

True Gnostics

We must not forget that many of the moderate Gnostic thoughts are also to be
found in other Church Fathers, such as Clement of Alexandria and Origen.

Clement, who lived at about the same time as Irenaeus in the second century,
called mature Christians 'true Gnostics', meaning Christians who had come to a
deeper understanding of their faith. He willingly counted himself among them.

Origen succeeded Clement as Head of the Catechetical School of Alexandria,
which was founded by the Christian scholar Pantanaeus, Clement's teacher, around
AD190. This school was attached to the Alexandrian Library and was considered to

be the most important institution of Christian learning at that time. Not only Christian theology but also science, mathematics, and Greek and Hebrew culture were taught there. It is clear from both Clement's and Origen's writings that in their teaching at the school they had to keep in mind those of a more fundamentalist approach as well as those with a more questioning intellectual attitude. Apparent inconsistencies in their writings can sometimes be explained by the fact that they were adapting their teaching to their audience's needs.

Glossary

Apostolic – relating to the Apostles.

Gnosis – deep intuitive knowledge.

Heretic – literally 'one who chooses'; holding beliefs contrary to accepted teaching.

Orthodox – literally 'right thinking'; conforming to accepted standards.

Many thoughtful and educated Christians among Clement's and Origen's pupils were no longer satisfied with the 'literal' interpretation of Scripture as taught by some of the bishops, including Irenaeus. To them that was only the first stage, albeit an important one. They considered it the foundation for an experiential understanding of the faith, based on deep contemplative prayer and intuitive reading of Scripture. Under Origen's influence they saw the latter as the meeting ground with the spirit of Christ. They considered it paramount that Scripture was to be understood allegorically not literally. They saw the justification for this approach in Paul's Letters: 'the letter kills, but the spirit gives life' (2 Cor. 3.6). An allegorical interpretation of Scripture can, however, lead to wild flights of fancy, as can be the case in reliance on visions and prophecies.

Where these early Church Fathers differed from general Gnostic ideas was in their attitude to creation. They did not share the Gnostic dualistic view on a split between spirit and matter, where matter was considered to be wholly evil. To them creation was the handiwork of God and was good, especially as Christ had been incarnated in this world. Although they viewed it as a mere hindrance to the spirit/soul, they considered it much more as an incentive to true growth. Origen even saw creation as the first possible level of contemplation, seeing the Unmanifest through the manifest.

Church unity

Irenaeus' attempt in the second century to unify Christians in this way did not really bear fruit. The divisions in fact multiplied in the next two centuries. However, in

the fourth century there was an important turn of events. The Emperor Constantine had granted freedom of worship to the Christians in 313. This was followed by Constantine calling the 'orthodox' bishops together in the first Council of Nicaea in 325 – the year after he had become sole emperor. He managed to get the bishops to accept a common doctrine, known as the 'Nicene Creed', which we still use in the Church today. The important element in it was the statement that Christ was of the same substance as the Father, a view not shared by every Christian group at that time.

By supporting in this way the largest and best organized 'orthodox' group of bishops he achieved the much-needed unification of the divided early Church. This was further helped by the fact that he granted the 'orthodox' churches privileges and financial backing, whereas he proceeded to penalize all the other churches, which had different interpretations of Jesus and his teaching. He increased their taxes, demanded compulsory public service and awarded no privileges or financial support of any kind.

Constantine at the first Council of Nicaea

Constantine's aim was unity: of the Empire and of the Church. Both went in his view hand-in-hand. A leading light at the council was Athanasius, Bishop of Alexandria, a Copt, who belonged to those who favoured a literal approach. Following the outcome of the council, Athanasius felt empowered to insist on the canon already mentioned by Irenaeus. Apart from the four accepted Gospels, all alternative Gospels were to be destroyed; all other groupings were declared 'heretic'.

It was easy to ban books in these early times, as their continuing availability was dependent on their being copied by monks. So an edict of 'heresy' was very effective, hence the disappearance of writings from that time advocating a mystical approach to the Divine.

The literal approach of Irenaeus and Athanasius was to become the 'orthodox' aspect of Christianity. Since the 'orthodox' believers in later centuries laid the foundations of the Church as it has come to us over the ages, mystical spirituality has ever since then been considered with suspicion.

The *Gospel of Thomas*

As the main aim of the *Gospel of Thomas* was to encourage interiority and a search for the deeper spiritual significance of Jesus' teaching, it became one of the casualties of the Council of Nicaea.

It disappeared from sight, until in 1945 an earthenware jar was found at Nag Hammadi in Upper Egypt near the main monastery of Pachomius, the founder of Christian monasticism. This jar contained not only documents written by the Gnostics, but also other writings that could really be considered to be in the 'apostolic' tradition, the prime example being the *Gospel of Thomas*.

The inclusion of known Gnostic writings in this discovery, combined with the fact that the *Gospel of Thomas* was bound together with the *Gospel of Philip* – still considered Gnostic – led orthodox Christians once again to reject the *Gospel of Thomas* out of hand as 'heretic'. Even scholars assumed it was Gnostic; however, after further research many have come to the realization that it is more apostolic than was at first assumed.

The *Gospel of Thomas* was a product of the still predominantly oral culture of the time of Jesus and the subsequent early centuries. What we have forgotten is that his teaching was primarily passed on by word of mouth. Jesus himself did not write anything down, nor did his immediate disciples, according to research; only when these apostles died did their followers put down their teaching in writing. In the *Gospel of Thomas* the most frequently recurring sayings of Jesus, which had formed part of this oral tradition, were collected together. The date at which they were actually written down is unclear, but it is thought that one compilation of them predated the Synoptic Gospels. There may have been a Syriac version of them written down as early as AD 50–100. Fifty per cent of the sayings in this Gospel are also found in the Synoptic Gospels.

In another related Syriac manuscript, *The Acts of Thomas*, a clear link is made between these writings and Thomas the Apostle, who went to spread Jesus' teaching

Also around this time

AD155
Polycarp, disciple of John, burnt at the stake.

160–230
Tertullian, Carthaginian theologian; later joined Montanists.

284–305
Emperor Diocletius; the most terrible persecutions of Christians were instigated by him.

300–400
First church dedicated to the Virgin Mary built on the hill of the later Chartres Cathedral.

301
Armenia becomes the first country to adopt Christianity as its state religion.

303
Death of St George, who was to become the dragon slayer of later legend.

312
Constantine's conversion to Christianity after his vision of the cross at Milvian Bridge and subsequent victory in battle.

in South India, which would confirm the apostolic nature of both.

Elaine Pagels, an authority on the Gnostic Gospels, no longer considers the *Gospel of Thomas* 'heretic' and draws out in her book *Beyond Belief* many parallels between John's and Thomas' Gospels. She points out that both talked about private teachings of Jesus. Neither spoke particularly of Jesus' death or Resurrection; they assumed the story was known. Both identified Christ with the light that came into being in the beginning, thus connecting Christ with the whole cosmos. Both believed that the Kingdom of God was already here; we were already living in the presence of God.

The essential difference between the two Gospels highlighted by Pagels is that in John's eyes Jesus was unique: God's only-begotten son. Our salvation depended solely on our belief in Christ and the workings of grace. Although this has become the orthodox Christian view, many people did not agree with John in the early Church. In Thomas' view, on the contrary, God's light shone potentially in all of us. We were all children of God.

Effort versus grace

The *Gospel of Thomas* starts with the saying: 'And he said, "Whoever discovers the interpretation of these sayings will not taste death"' (Saying 1, p. 23).

Thomas sees Jesus as clearly laying the responsibility for our salvation on our own shoulders; understanding his teaching is essential in this regard. The discovery of the Truth lies in a combination of our effort and the grace inherent in his words. The emphasis in this Gospel is therefore on personal endeavour and personal responsibility, albeit aided by grace, to discover who we truly are:

Jesus said, 'If they say to you, "Where have you come from?" say to them, "We have come from the light, from the place where the light came into being by itself, established

itself, and appeared in their image." If they say to you, "Is it you?" say, "We are its children, and we are the chosen of the living father."' (Saying 50, p. 43)

Jesus points us therefore in this Gospel very directly to our divine origin. Again the emphasis is on the presence of God, the Kingdom, being within us and more-over among us at every moment:

Jesus said, 'If your leaders say to you, "Look, the kingdom is in heaven," then the birds of heaven will precede you. If they say to you, "It is in the sea," then the fish will precede you. Rather, the Kingdom is inside you and it is outside you.' (Saying 3, p. 23)

This emphasis on each of us containing within ourselves a spark of the Divine was a belief held by many of the Church Fathers, such as Clement of Alexandria and Origen; it was considered an apostolic doctrine in the first few centuries. But it was also a main tenet of the Gnostics. This may well have been the reason that this view was later discredited and supplanted by the 'orthodox' interpretation, which stressed that we were in truth made in the 'image' of God, but that in the 'fall' this 'image' was completely shattered. Only by the grace of Christ could we be saved. We ourselves could do nothing, which was the opposite of the message of the *Gospel of Thomas*.

It is easy to see that this emphasis on personal effort and deep intuitive under-standing, rather than pure belief in the accepted teaching, put the *Gospel of Thomas* outside the canon of accepted orthodox Scripture of the fourth century with its emphasis on the literal surface interpretation.

Interestingly enough, finding the true interpretation of these sayings is similar to the deeply attentive reading of Scripture that Origen stressed, which according to him led to and was aided by contemplative prayer. This profound intuitive engagement with the text was considered to result in a meeting with the presence of Christ, and consequently would lead to a true understanding of the spiritual meaning of Scripture.

Self-knowledge

This spiritual understanding, in turn, would lead to a complete transformation of consciousness: a *metanoia*, a turning around. Then we would see reality as it truly was, and experience that in our essence we were already one with the Divine

through the consciousness of Christ that dwelled in our hearts.

But Thomas' Jesus is very aware of our difficulty in seeing Ultimate Reality: 'The Father's Kingdom is spread out upon the earth, and people do not see it' (Saying 113, p. 65). Moreover, we have covered over the divine spark within us by being focused on our material body and its needs:

> *Jesus said, 'I took my stand in the midst of the world, and in the flesh I appeared to them. I found them all drunk, and I did not find any of them thirsty. My soul ached for the children of humanity, because they are blind in their hearts and do not see, for they came into the world empty, and they also seek to depart from the world empty. But now they are drunk. When they shake off their wine, then they will repent.'*
>
> (Saying 28, p. 37)

This Gospel challenges us to let go of our habitual ways of perception dictated by our material being, the 'ego', which make us 'drunk' and 'blind'. We do not need to let go of the 'ego' itself, but of the disordered drives/desires that are a product of our upbringing and environment. All we need to do is to wake up and discover who we truly are. This search is the most important element in our life, although it is not easy: 'Jesus said, Let one who seeks not stop seeking until one finds. When one finds, one will be troubled. When one is troubled, one will marvel and will rule over all' (Saying 2, p. 23).

It is troubling to realize that the reality we have accepted as the only objective and permanent reality is in fact shaped by the thoughts, images and needs of our material being. But if we persevere, we can part the veil of these illusions and become aware of our true nature and the true nature of reality. The result will then be a real sense of wonder.

To see reality as it is, we need to let go of our false images of ourselves, our 'personas', our 'ego' masks, our 'clothes':

> *His followers said, 'When will you appear to us and when will we see you?' Jesus said, 'When you strip without being ashamed and you take your clothes and put them under your feet like little children and trample them, then you will see the child of the living one and you will not be afraid.'*
>
> (Saying 37, p. 39)

We need to see through these images and detach ourselves from them. This is really

not so dissimilar to what Jesus said in the Synoptic Gospels: 'Anyone who wants to be a follower of mine must leave self ('ego' illusions) behind.' Only then can our true nature be revealed. The same idea is expressed in St Paul's saying about our 'seeing through a glass darkly', but later 'face to face'.

Once we break through the constraints of the ego, we will be free, no longer imprisoned. A double understanding is needed: first, of the way our material being operates and, second, true self-knowledge of our essential being: 'When you know yourselves, then you will be known, and you will understand that you are children of the living father. But if you do not know yourselves, then you dwell in poverty, and you are poverty.'

Living only in the reality that the 'ego' weaves is living in illusion and on the surface – an impoverishment of our true being. Salvation is seen in terms not of becoming children of the Light but of an unfolding awareness of this actual fact. Moreover, Jesus' teaching affirms us in our ability to do so: 'One who seeks will find.' This same exhortation to 'wake up' and 'be alert' is also found in the Synoptic Gospels.

Creation

Most Gnostic writers at that time were profoundly dualistic; the world was often seen as threatening and tempting, basically evil. Yet Thomas on the contrary sees it as permeated by the Light, by the Divine, consequently essentially good. Not only we but all of creation are infused by and embedded in the Light:

> Jesus said, 'I am the light that is over all things. I am all: From me all has come forth, and to me all has reached. Split the wood; I am there. Lift up the stone, and you will find me there.'
> (Saying 77, p. 55)

In early Christian theology Christ was seen as the first Creation, the ground of being, through which all of creation was shaped by God with the aid of the Spirit.

The secret teaching

The fact that the *Gospel of Thomas* relies on secret teaching – as did many of the Gnostic Gospels – is often held against it. But individual 'secret' teaching is also mentioned in the Synoptic Gospels. We hear in Mark 4.11: 'To you has been given

the secret of the Kingdom of God, but for those outside, everything comes in parables.' Similar statements are to be found in the Gospels of Matthew and Luke and also in St Paul: 'But the natural man receiveth not the things of the Spirit of God; for they are foolishness unto him: neither can he know them, because they are spiritually discerned . . . We have the mind of Christ' (1 Cor. 2.14, 16, AV).

This emphasis on 'secret teaching' is often interpreted as an attitude of exclusivity, which was felt to be against Jesus' teaching in general. But there is a very obvious reason to tell some people more than others; an excellent teacher like Jesus would tailor his teaching to the spiritual level of growth of the person he was confronted with at that time. He would tell each one what he or she was ready to hear.

The real 'secret' Jesus was sharing was his message that the Kingdom, the presence of God, is here and now. In the Gospel of Mark (as well as Luke's Gospel) we find an identical emphasis to the one we find in Thomas' Gospel: 'The time has come; the Kingdom of God is upon you; repent and believe the gospel.' The Greek word for 'time' used here was not *chronos* (chronological time) but *cheiros* (infinite, eternal time). Therefore Jesus is saying here in Mark that the eternal, infinite moment is already here; God's time, his Divine Presence, is here. All we have to do is to repent, to change our way of looking at reality, and then we will know the truth of this statement.

Detachment

To see the 'Kingdom' we not only need to let go of our false surface self, but we also need to see that the attachment of the 'ego' to the material world cannot furnish us with lasting happiness or a sense of security. We and the world are impermanent; all passes away; hence it is a 'carcass': 'Jesus said, "Whoever has come to know the world has discovered a carcass, and whoever has discovered a carcass, of that person

the world is not worthy'" (Saying 56, p. 45).[1] It is important to accept that we are more than our 'ego', our body and our attachment to the physical world. Then we remember who we truly are. According to Thomas' Jesus we are already 'enlightened', 'children of the Light'.

In these sayings Jesus is constantly moving the attention of the disciples from an outside reality – seeking for a place – to an inner reality. The important place where he dwells is his spiritual level of consciousness, not to be found in the outside reality:

> His followers said, 'Show us the place where you are, for we must seek it.' He said to them, 'Whoever has ears should hear. There is a light within a person of light, and it shines on the whole world. If it does not shine it is dark.' (Saying 24, p. 35)

Moreover, by realizing this we will help the rest of humanity; our 'enlightenment' is to be for the benefit of all. In our deeper consciousness we are at one with everyone and with God.

Integration and oneness

This emphasis on interconnectedness resonated with people then and resonates with people now. The spiritual world penetrates our material reality; it is not somewhere else. We, creation and the Divine are all interconnected. Our true home is in the world of Light where all opposites, 'motion' and 'rest', are reconciled and transcended: 'If they ask you: "What is the evidence of the father in you?" say to them, it is motion and rest.'

We pass from the world of duality into the infinite and timeless oneness of the Divine. By integrating all the aspects of our being we will achieve unity within ourselves, with others and with the Divine.

> Jesus saw some babies nursing. He said to his followers, 'These nursing babies are like those who enter the kingdom.' They said to him, 'Then shall we enter the kingdom like babies?' Jesus said to them, 'When you make the two into one, and when you make the inner like the outer and the outer like the inner, and the upper like the lower,

1 'of that person the world is not worthy' is a Jewish saying used when praising someone. The word 'carcass' may seem rather harsh here, but we need to keep in mind the emphasis on exaggeration in Jewish rhetoric. Often we hear Jesus use tough language to make a point.

and when you make male and female into a single one, so that the male will not be male nor the female female, when you fashion eyes in place of an eye, a hand in place of a hand, a foot in place of a foot, an image in place of an image, then you will enter the kingdom.' (Saying 22, p. 35)

The message of the *Gospel of Thomas* is essentially about integration. 'Making the two into one' means integrating the purified 'ego' and the deeper 'self', the material and the spiritual. We need to let our true divine nature at our core permeate the 'ego' – so that our behaviour is guided by both. Thus we divinize our whole being, by opening the material to the Spirit, the Light. This entails integrating all aspects of our being, including 'male' and 'female', a process Jung emphasized. Then we will 'enter the kingdom', and experience the being and presence of the Divine.

KIM NATARAJA

SIX

THE CAPPADOCIAN FATHERS

Marcus Plested

Mass of St Basil, *Pierre Subleyras*

Introduction

The time following St Irenaeus was interesting, as during it passionate inter-Christian arguments and controversial debates shaped the belief structure of early Christianity. Important figures who played a crucial role in these were Basil of Caesarea, his brother Gregory of Nyssa and their friend Gregory of Nazianzus. They all lived in Cappadocia in present-day Turkey; hence they are known as the Cappadocian Fathers. These three, with their close associate Evagrius, a foremost Desert Father, are very important for the development of Christian mysticism both in the Christian East and in the West.

Basil and Gregory of Nazianzus each received a classical education and studied together in Athens. A strong Greek influence on their thought came through their admiration for Origen, whose influence was especially strong in Basil's family. His grandmother St Macrina and mother St Emmelia were converted to Christianity by Gregory the Wonderworker, a disciple of Origen.

The three were very different: Basil was a political man of action, Gregory of Nazianzus was the poet and Gregory of Nyssa was the philosopher. All three were respected for their precise formulation of their ideas about the Trinity, which enabled them to defend the Nicene Creed and effectively combat heresy, in particular Arianism.

Marcus Plested in this chapter demonstrates that they are in fact the 'Fathers of Orthodoxy', but at the same time all three had strong mystical leanings, which shows the inseparable connection between theology and both asceticism and mysticism.

St Basil of Caesarea AD330–79

Basil belonged to a family of saints: his grandmother St Macrina the Elder, his father St Basil the Elder, his mother St Emmelia, his brothers St Gregory of Nyssa and St Peter of Sebaste and his sister St Macrina the Younger.

He received a classical education of which he was very proud. On his return from Athens it was his sister Macrina who took him down a peg, taught him the value of humility and converted him to Christianity. After his conversion Basil visited some of the major monastic centres of the time: Palestine, Syria and Egypt. He was wary of the solitary hermetical life as led by the Desert Fathers and Mothers, but was highly impressed by the form of monastic life started by St Pachomius in Upper Egypt.

On his return Basil established, like his sister Macrina, a small monastic community on the family estate, where the emphasis was firmly on asceticism. But he himself was not able to lead a contemplative life for long; soon the issues shaping the Christian Church in the Empire took his attention away from a life of prayer. As Bishop of Caesarea (370) he became passionately involved with the political and theological debates over the Trinity, the divinity of Christ and especially the divinity of the Holy Spirit, as well as the Arian heresy.

Because of all this we have little that he wrote about the actual mystical life apart from a few comments on prayer. But he did formulate a framework for the ascetical life in community and set up one of the first important monastic sets of rules. These were very influential in both eastern and the western monastic development, being more balanced and moderate than those of Pachomius.

The rest of his short life – he died worn out at 49 – he was a committed and charitable bishop tirelessly looking after the poor, fighting heresies and trying to mend church divisions.

St Gregory of Nyssa 335–95

The younger brother of Basil did not have quite the same extensive education, nor was he a man of affairs like his brother. Yet he was very studious and the most philosophical, speculative and daring of the three Cappadocian Fathers, with strong ascetic leanings. His writings dealt with Christian faith, the ascetic life, mystical life and biblical commentary. He is best known for his *Life of Moses*.

He was only a bishop for a short time to help out his brother, after which he led an ascetic life in Pontus for quite a while. After the death of Basil he travelled extensively and we know little of where and how he died.

St Gregory of Nazianzus 330–90

Their friend also came from a devout Christian family. His father was Bishop of Nazianzus when Gregory was born. He joined Basil's monastic community, where both collected the teaching of Origen in the *Philokalia*. Shortly after that Gregory reluctantly became Bishop of Nazianzus at his father's behest, then Bishop of Constantinople. Soon after the Second Ecumenical Council of Constantinople he resigned voluntarily from that post and withdrew to live the rest of his life in seclusion. He was gentle, mild mannered and basically a mystic and a poet. His contribution was to define through poetry the indefinable of the mystical life, thus avoiding the difficulty of expressing theology in intellectual thoughts only. The ambiguity of poetry also makes it easier to avoid being labelled a heretic.

As Bishop of Constantinople he wrote very influential sermons that formed the basis of discussions in the Second Ecumenical Council of 381 in that city, which confirmed the orthodox Cappadocian interpretation of the Nicene Creed. In the Orthodox tradition Gregory is therefore known as 'the Theologian'.

View of Cappadocia

THE CONNECTION BETWEEN THEOLOGY AND ASCETICISM

Most of Gregory of Nazianzus' work is dedicated particularly to the mystery of the Trinity, the nature of theology and the ways we come to experience God. He emphasizes the need for purification, using the image of the soul as a mirror of God, which is one the Cappadocian Fathers used frequently.

> *For nothing seems to me so desirable as to close the doors of my senses keeping the flesh of the world collected within myself, having no further connection than was absolutely necessary with human affairs, speaking for myself and to God. Ever preserving in myself the Divine impressions pure and unmixed with the erring tokens of this lower world, growing more and more to be, and being a real unspotted mirror of God.*
>
> (St Gregory the Theologian, Oration 2)

St Gregory of Nyssa also speaks of 'a mirror': the basic idea being that once one cleans away the dirt of sin and the passions, our true nature is revealed as well as the true nature of our Creator. That is an image with a long pedigree in the Platonic tradition as well.

Yet this is not an easy task. The idea that the inner life, the pursuit of God, is something that demands a great deal of effort is put in vivid language by the Desert Fathers:

> *A woman knows she has conceived when she stops losing blood. So it is with the soul, she knows she has conceived the Holy Spirit when the passions stop coming out of her. But as long as one is held back in the passions, how can one dare to believe that one is sinless? Give blood and receive the Spirit.*
>
> (*Sayings of the Desert Fathers*: Longinus 5)[1]

This is a very uncompromising demand for a sustained effort, which neatly encapsulates the conviction held by virtually all Christians in late antiquity: some degree of ascetic effort is vital for any form of what we call the mystical experience. The approach to God demands ascetic offering, demands self-discipline, demands the cutting away of the passions. The pursuit of virtue – grace – does not come without blood, sweat and tears.

1 Benedicta Ward, *The Sayings of the Desert Fathers: The Alphabetical Collection* (Cistercian Publications, 2005).

But, of course, when considering this conjunction between asceticism and mysticism, we need to keep in mind that we live in an age where the appeal to asceticism is not one that is desperately popular. Passions are, on the contrary, seen as good for the body.

In our day and age asceticism, if thought about at all, simply conjures up an image of extreme deprivation or extreme self-discipline. We see no very obvious point beyond punishing the body. Mysticism itself has been marginalized and, even where it is not rejected, tends to be neutralized by being considered the preserve of a few cloistered monks. Asceticism and mysticism are therefore no longer seen as part of the mainstream Christian tradition. In dealing with these two concepts, we have to re-appropriate the language of the early Church and re-appropriate the root meaning of the terms.

The root meaning of the word 'asceticism' is the Greek word *askesis,* which really only means 'training', 'discipline', 'practice' and 'effort'. The root meaning of the word 'mysticism' is the Greek word *mueo,* meaning 'to initiate someone', for example into the revelation of the world beyond the world of forms. Another meaning is 'to close the eye to something', in the sense of closing the eye to the material world in order to see with the eye of the spirit.

We ought to see asceticism not just as a fairly pointless chastisement of the flesh but as a means to an end rather than an end in itself: the end being union with God.

Mysticism is a much misunderstood term in the modern age because of the various webs of meanings that have been attached to it. It is best thought of as the quest for an experience of union with the divine.

With these definitions in mind we will be better equipped to embrace a more rounded vision of the Christian life in which asceticism is seen as part and parcel of our inheritance, of our calling, rather than being regarded as the pursuit of an elite.

Writings of the Cappadocians

St Basil

Address to Young Men
Homilies on the Six Days of Creation
Philokalia: anthology of extracts of Origen's *On First Principles* and *Against Celsus* about the harmony between faith and reason, compiled with Gregory of Nazianzus
Against Eunomius
Shorter Rules and *Longer Rules*
Sermons and *Moralia*
On the Holy Spirit

Gregory of Nyssa

On Virginity
Against Eunomius
On the Six Days of Creation
On the Making of Man
On the Soul and Resurrection
Catechetical Oration
Life of Macrina
Life of Moses
Homilies on the Song of Songs

Gregory of Nazianzus

Philokalia: anthology of extracts of Origen's *On First Principles* and *Against Celsus*, compiled with Basil of Caesarea
Theological Orations
Letters

Gregory of Nyssa

Both ascetic effort and mystical experience should be seen as inseparable components of the Christian calling, and the Cappadocian Fathers are particularly revealing of how these two go together. In his very important work *Life of Moses* Gregory of Nyssa, following on from Origen's allegorical way of reading Scripture, interprets the biblical narrative of the life of Moses as a paradigm of the soul's ascent to the contemplation of God, a contemplation in which the soul is united to God. Virtually every incident in Moses' life has a parallel with the soul's journey: for example, the crossing of the Red Sea is paralleled with baptism. Both the crossing and adult baptism – traditional at that time – take place not at the beginning of the journey but some way into it.

> *Those who pass through the mystical water in baptism must put to death in the water the whole phalanx of evil such as covetousness, unbridled desire, rapacious thinking, the passion of conceit and arrogance, wild impulse, wrath, anger, malice, envy, and all such things. Since the passions naturally pursue our nature, we must put to death in the water both the base movements of the mind and the acts which issue from them.*
>
> (*Life of Moses* II.125)

The theme of the need to put the passions to death is one that returns again and again. It is considered essential to strip away the passions if one is to achieve any sort of clarity, any sort of balance, any sort of possibility of attaining the mountain. All this is bound up with the sacraments of the Church.

All Christians are called upon to seek out an encounter with God. It is important to avoid the idea of a two-tier Christianity with the 'perfect' and the ordinary Christian. This will help to keep mysticism within the mainstream Church.

The tasting of the bitter waters of Marah signifies the life far removed from pleasures; this way of life is at first very bitter and disagreeable. But ultimately the waters become sweet, for life becomes better than it was before the ascetic life. The ascetic life is a prerequisite for any sort of authentic knowledge of God.

> But if the wood be thrown into the water, that is, if one receives the mystery of the resurrection which had its beginning with the wood (you of course understand the cross when you hear the wood), then the virtuous life, being sweetened by the hope of things to come, becomes sweeter and more pleasant than all the sweetness that tickles the sense with pleasure.
>
> (*Life of Moses* II.132)

If you are going to ascend the mountain of contemplation, it is not just the body that needs to be pure; you have to be pure in soul and body, washed stainless of every spot. Gregory's is a holistic vision of the human person, a composite of soul and body.

> The person who would approach the contemplation of Being (God the source of all being) must be pure in all things so as to be pure in soul and body, washed stainless of every spot in both parts, in order that he might appear pure to the One who sees what is hidden and that visible respectability might correspond to the inward condition of the soul.
>
> (*Life of Moses* II.154)

This purity is needed to cleanse the faculties of perception in order to open the spiritual senses, which is something that Origen speaks a great deal about: spiritual eyes to see the hidden divine realities, spiritual ears to hear the Word of God (see Chapter 4, p. 57). Purification of our faculties of perception allows us therefore to see our own true nature and that of God beyond physical sight and hear beyond our physical hearing. We need to clear the dirt off our mirror.

> The contemplation of God is not effected by sight and hearing, nor is it comprehended

Also around this time

AD313
Constantine declares freedom of worship for the Christians.

324
Constantine becomes sole emperor and moves the Roman capital to Byzantium; a few years later it is renamed Constantinople.

325
First ecumenical Council of Nicaea called by Constantine to unify Christian beliefs. The Nicene Creed is adopted.

326
Church of Nativity built in Bethlehem by Constantine.

360
First recorded celebration of the birth of Christ on 25 December.

by any of the customary perceptions of the mind. For 'no eye has seen, and no ear has heard', nor does it belong to those things which usually enter 'into the heart of men' (1 Cor. 2.9). He who would approach the knowledge of things sublime must first purify his manner of life from all sensual and irrational emotion. He must wash from his understanding every opinion derived from some preconception and withdraw himself from his customary intercourse with his own companion, that is, with his sense percep-tions, which are, as it were, wedded to our nature as its companion. When he is so purified then he assaults the mountain. (Life of Moses II.157)

A lot of the teaching of the Cappadocians on the mystical life is about this central preparatory stage of ascetical purification of the body and soul alike. Gregory of Nyssa makes it clear that you cannot go straight to mystical experience without preparation.

St Gregory the Theologian and the vision of God

Gregory of Nazianzus also has the image of ascending Mount Sinai. He speaks about drawing aside the curtain of cloud and entering within, separating oneself from matter and material things. He speaks of a vision of the back of God. It is a vision not of the nature of God but of what God chooses to reveal of himself.

Gregory was keenly aware of the unfathomable mystery of God. We can learn something on our ascent but we will never exhaust the mystery of God. On the mountain there is, not the eternal nature of God but a manifestation of God's glory, which David calls 'the majesty', the 'glory', the 'Shekinah' of God. It is much like the reflection of the sun in the water: we can't look upon the sun but we can look upon the sun's reflection in the water.

Gregory takes the rock behind which Moses hides as Christ. This is a common understanding of the rock. We will never see more of God than he has revealed in Christ.

The inseparability of theology and mysticism

Theology for the early Church was not an academic discipline but always closely related to a mystical experience, a vision of God. The Cappadocians were closely involved in the doctrinal controversies of their day regarding the

divinity of Christ and the divinity of the Holy Spirit. The Christian tradition has given Gregory the name 'the Theologian', as he was the most talented of the three Cappadocians when it came to articulating the mystery of the Trinity, in both poetry and prose. He used language that today would not be regarded as inappropriate in a theological textbook.

The contemplation of God is not effected by sight or hearing, nor is it comprehended by any of the customary perceptions of the mind. (Gregory of Nyssa)

No sooner do I conceive of the One than I am illumined by the Splendour of the Three; no sooner do I distinguish Them than I am carried back to the One. When I think of any One of the Three I think of Him as the Whole, and my eyes are filled, and the greater part of what I am thinking of escapes me. I cannot grasp the greatness of That One so as to attribute a greater greatness to the Rest. When I contemplate the Three together, I see one great flame, and cannot divide or measure out the Undivided Light. (Oration 49)

Gregory puts it in very mystical language, but at the same time it is, theologically speaking, very precise language. So you see how involved theology and mysticism are; they fit very closely together.

Gregory's thinking on the Trinity, his understanding of theology, which is very experiential, is never separated from devotion to the person of Christ:

Christ bears all me and mine in Himself, that in Himself He may exhaust the bad, as fire does wax, or as the sun does the mists of earth; and so that I may partake of His nature by union with him . . . [At the last day] we shall be no longer divided [as we now are by movements and passions], containing nothing at all of God, or very little, but shall be entirely godlike. (Oration 30)

In their writing, as we have seen, the Cappadocian Fathers illustrate very well the inseparability of mysticism and theology. Theology is considered to be just an abstract speculation; it has no foundation when it is not based on experience. And equally, mystical experience without theology does not allow us to judge the authenticity of that experience. No theology without mysticism; no mysticism without theology.

The difference between Alexandria and Antioch

It is quite common to make a distinction between Alexandria and Antioch. Antioch tends to be characterized by a focus on the literal meaning of any given text, and in considering the person of Christ it tends to focus on his humanity.

Alexandria, on the other hand, was rather more drawn by the allegorical approach, which aimed to see the inner meaning of the texts. They had perhaps a greater appreciation of the divinity of Christ.

Both approaches are needed. You need to appreciate both the humanity and the divinity of Christ. And the Cappadocian Fathers seem to be very good at holding together those two traditions of Alexandria and Antioch.

The Arians stressed the humanity of Christ. They denied that Christ was of the same substance as the Father. We don't have any writings that speak about their mystical experiences, as they were declared heretical by the Council of Nicaea and the formulation of the Nicene Creed excluded their view. But there is no reason to doubt the sincerity of their faith and their devotion to Christ as such. History is written by the winners. In the council the bishops tried to find the common ground, a unified belief, to define orthodoxy. But that inevitably meant, also, defining what was outside of the mainstream Church – the heretics.

The process of the ascent to union with God

Gregory of Nyssa's descriptions of mystical experiences were founded on the basic principle of the radical unknowability of God. God is utterly transcendent, utterly beyond our knowledge. As we have seen, this is sometimes called the apophatic approach to God, which requires us to divest ourselves of any ideas or images we might have of God. Gregory of Nyssa excels Gregory the Theologian in his apophatic approach.

Because of his apophatic approach, St Gregory of Nyssa finds it extremely significant that Moses encountered God in the darkness on Mount Sinai. He talks of darkness beyond the light and union beyond human knowledge.

When St Gregory the Theologian interestingly talks about Moses' ascent of Mount Sinai, he doesn't mention the darkness; he prefers to speak about the light.

But darkness is St Gregory of Nyssa's primary motif for discussing the ascent of Sinai, moving away from affirmation, saying not what God is but what he is not. Interestingly, his darkness is something beyond light; the light we cannot bear. It is essentially a superabundance of light; he speaks of lunar darkness. So it's a way of conveying not absence but presence.

In the same way the light of knowledge is a stage on the way to this perfect knowledge of God that is summed up in this motif of darkness.

> For leaving behind everything that is observed, not only what sense comprehends, but also what the intelligence thinks it sees. The mind keeps on penetrating deeper until by its yearning for understanding, it gains access into the invisible and incomprehensible and there it sees God. This is the true knowledge of what is sought; this is the seeing that consists in not seeing because that which is sought transcends all knowledge, being separated on all sides by a kind of darkness.

This reminds us of the definition of God by Rowan Williams, the Archbishop of Canterbury, as 'that which we have not yet understood'.

Although theologians in the early Church, and later, often tend to prefer either the image of light or the image of darkness, it does in fact amount to the same thing. So this luminous darkness in Gregory of Nyssa somehow conveys both the otherness and the nearness of God. God is utterly transcendent but, at the same time, utterly immanent within us; utterly unknowable by nature, yet making himself known in his self-revelation. He may be radically unlike us, but yet draws us into fellowship and likeness with him.

This clearly brings us back into the territory of paradox, and Gregory of Nyssa speaks of the extraordinary and, in fact, dizzying nature of the theological vision that has been opened up by the tension between the immanence and transcendence of God. He asks us to

> [i]magine a sheer, steep crag, of reddish appearance below, extending into eternity; on top there is a ridge which looks down over a projecting rim into a bottomless chasm. Now imagine what a person would probably experience if he put his foot on the edge

of this ridge which overlooks the chasm and did not find solid footing nor anything to hold onto. This is what I think the soul experiences when it goes beyond its footing in material things in its quest for that which has no dimension and which exists from all eternity. For here there is nothing it can take hold of, neither place nor time, neither measure nor anything else; it does not allow our minds to approach. And thus the soul, slipping at every point from what cannot be grasped, becomes dizzy and perplexed and returns once again to what is connatural to it, content now to know merely this about the Transcendent, that it is completely different from the nature of things that the soul knows. (Gregory of Nyssa, *Commentary on Ecclesiastes* 7)

This is a wonderful description. Gregory gives us a lot of other images for this dizzying encounter between creature and Creator, between man and God. For example, he speaks of sober drunkenness, ecstasy, watchful sleep, trying with all these metaphors to convey this dizzying paradoxical relationship.

Eternal progress

But perhaps the most distinctive aspect of Gregory of Nyssa's spiritual teaching is the explanation of eternal progress, a theme announced in his Preface and that holds the work together. Progress is a form of perfection. Our journey into God is an ongoing one. He affirms God as unknowable and infinite; from that follows the affirmation that our knowledge of God, our drawing closer to God, is also going to be an infinite journey. We are finite creatures; God is infinite. God brings us closer to him, but that drawing closer is going to go on for all eternity. This means straining forward, and it derives from St Paul's Epistle to the Philippians 3.13: 'straining forward to what lies ahead'. This becomes for Gregory the key text for the idea of infinite progress, infinite journeying towards God. Perpetual growth does not mean there will be no satisfaction, but any such feeling will be temporary. One's desire will increase with each stage.

He must wash from his understanding every opinion derived from some preconception and withdraw himself from his sense perceptions. (Gregory of Nyssa)

Although the Cappadocians are very Platonic on the whole, on this particular point they entirely turn Plato on his head. The idea that God is infinite would be horrifying to Plato.

Another distinctive feature of Platonic thought is circularity. In Plato it's absolutely clear that the end is always the same as the beginning, so our destiny is to return to what we once were, beings united in contemplation of the Good. This process is circular, whereas the doctrine of infinity, of infinite progress, is linear. In some sense the mystical ascent is never achieved. We are brought into the divine life, but that is a constant process of striving forward, of coming ever closer to God, but never actually reaching our destination:

> *This truly is the vision of God, never to be satisfied in the desire to see Him, but one must always, by looking at what he can see, rekindle his desire to see more but no limit can interrupt growth in the ascent to God since no limit to the good can be found. Neither is increasing of desire for the Good brought to an end because it is satisfied.*
>
> (*Life of Moses* II.239)

A lecturer was speaking about Gregory of Nyssa's vision of Heaven being this constant striving forward, never quite getting there, being in infinite progress, when apparently somebody put their hand up at the back and said, 'Well it sounds all very well, but in fact when I get to Heaven I look forward to a bit of a rest.'

Gregory certainly has an idea of our nature being mutable, subject to change. This propensity for change does mean that we have the capacity for infinite progress towards the Good:

> *Let us change in such a way that we may constantly evolve towards what is better, being transformed from glory to glory and from perfection to perfection and thus always improving, ever becoming more perfect by daily growth and never arriving at any minute of perfection but that perfection consists in our never stopping and our growth being good.* (Gregory of Nyssa, *On Perfection*)

The life of virtue is unlimited, and in many ways that brings us back to the cultivation of virtue and the extinction of the passions; this too goes on, in a certain sense, through all eternity.

MARCUS PLESTED

SEVEN

THE DESERT TRADITION

Kim Nataraja

St Antony and St Paul

Introduction

In the fourth century many Christians moved into the Egyptian Desert with the aim of leading an authentic devotional Christian life there. This has to be seen primarily as a reaction to the situation in which Christianity found itself shortly after becoming the official religion of the Empire.

When Constantine declared tolerance for the Christian religion in 313 after his conversion at the battle of Milvian Bridge and subsequently supported the outcome of the Council of Nicaea in 325, the number of practising Christians rose in the following decades from 3 to 30 million. It became quite advantageous to be a Christian, as Constantine was pouring money into building churches and supporting the bishops financially, a fact that changed the whole character of the early Church.

St John Chrysostom expressed his dismay at this change quite forcefully in his *Homilies in Ephesus*: 'Plagues teeming with untold mischief have come upon the churches. The primary offices have become marketable. Excessive wealth, enormous power, and luxury are destroying the integrity of the Church.'

Not only were some committed Christians disturbed by the position Christianity now occupied, they were also appalled at the increasing decadence of society: 'Society was regarded [by the Desert Fathers] as a shipwreck from which each individual man had to swim for his life' (Thomas Merton, *The Wisdom of the Desert*, p. 3).

This induced them to go and live out the gospel message in the solitude of the

Egyptian desert with St Paul's saying as their rule of life: 'Do not be conformed to this world but be transformed by the renewing of your minds' (Rom. 12.2).

The Desert Fathers and Mothers laid the foundation of both the Coenobitic and the hermetical life for the ages to come; no great distinction was made in their settlements between monks who preferred the solitary life and those who preferred to live in community. This period formed a significant but final flowering of the contemplative practice before it went underground in the Dark Ages that followed the migration of the Germanic tribes and the break-up of the western Roman Empire.

Apart from the political and social background mentioned above, Kim Nataraja describes further reasons that induced individuals to seek out this ascetic way of life, the different interpretations of that life and its main teaching that is still relevant to our time.

Unless otherwise indicated, quotations from individual Abbas and Ammas come from either Benedicta Ward (trans.), *The Sayings of the Desert Fathers: The Alphabetical Collection* (Cistercian Publications, 2005) or Olivier Clement, *The Roots of Christian Mysticism* (New City, 1993).

THE SIGNIFICANCE OF THE DESERT

Early Christians saw 'martyrdom' as a way of truly following Christ. Since Constantine's adoption of Christianity, persecution had ceased. Those choosing to withdraw to the desert saw going there and giving up all that was considered to be essential in life – family, marriage, an active function in society and owning property – as an alternative kind of martyrdom, a 'white' martyrdom as opposed to the 'red martyrdom' of the real martyrs.

The Life of Pachomius describes the effect that the martyrs had on the faith of Christians and the life they wanted to lead: 'Faith increased greatly in the churches in every land and monasteries and places for ascetics began to appear, for those who were the first monks had seen the endurance of the martyrs.'

Moreover, there had always been a strong tradition of retiring from ordinary life into the desert in the Judaeo-Christian tradition; we just need to think of Moses, Elijah, John the Baptist and Jesus himself. The desert represented for spiritual seekers

The writings of the Desert Fathers and Mothers

We know about the teaching of the Desert Fathers and Mothers through the stories their disciples remembered and that were later copied down. The sayings of the Mothers were originally written down in the *Meterikon* and those of the Fathers in the *Paterikon*. When subsequently these were copied into the *Apophtegmata Patrum,* more emphasis was laid on the sayings of the monks, as we are still dealing with a patriarchal culture. Mainly Amma Theodora and Amma Syncletica are still quoted.

What we have lost sight of by reading them as a collection is the fact that these stories were tailor-made for the needs of particular disciples. To the request 'Father, give me a word to live by' they were offered in a pithy phrase or story the spiritual and psychological correction the individual required. The sayings were more psychological than theological.

The essence of their teaching was also written down methodically, first by Evagrius and then transcribed into more acceptable, orthodox language by Cassian after Evagrius' writings had been declared heretical. Additionally the latter's teachings were spread under the pseudonym of St Nilus and were avidly read throughout the subsequent centuries.

not only a symbol but also an actual manifestation of God; it was similarly immense, awesome, grandiose, limitlessness and unfathomable, causing an immediate response of wonder, the only appropriate response to the Divine: 'Only wonder can comprehend his incomprehensible power' (Gregory of Nyssa, quoted in Clement, *Roots of Christian Mysticism*, p. 27).

However, the need for withdrawal and intensifying one's spiritual practice was not just a reaction to the situation in which the early Christians found themselves; it also seems to be a natural development that happens over time in the practice of any religion. In the villages and cities of Egypt by the middle of the third century there were already people living an ascetical life; they were called *Apotaktikoi.* They renounced family life, sex and material possessions, devoting themselves to prayer and sharing the teaching with others; Macrina and Basil leading a solitary celibate life on their family estate are another example.

Athanasius

A major figure in Egyptian Christianity in the fourth century was Athanasius, a Copt.[1] The Coptic Church looked back to St Mark as its founder. Legend has it that he preached the gospel there in the time of Nero shortly after the death and Resurrection of Jesus, which to some extent explains the Copts' literalist approach to the Christian faith.

Athanasius had a stormy career as Bishop of Alexandria. He was deposed and reinstated several times during the period 327–73, as he was heavily embroiled in Church politics; Christian dogma was the product of passionate and often acrimonious inter-Christian debates and arguments during the time leading up to the Council of Nicaea (324)

1 The name Copt derived from the Greek word *Aiguptous,* meaning Egyptian.

and in the decades that followed. Athanasius played a significant role in the council, where Constantine put his stamp of approval on the simple, literal form of Christianity that Athanasius, among others, preached, which was increasingly becoming the mainstream in the now official Church of the Empire.

The Coptic monks

By writing *The Life of Antony* in Coptic (357), Athanasius played an important role in encouraging Coptic Christians to move to the desert. 'Antony's words persuaded many to take up the solitary life. And so, from then on, there were monasteries in the mountains and the desert was made a city by monks.'[2] These early Coptic hermits were often illiterate and acquired their biblical knowledge orally – this was still a predominantly oral culture; they took Scripture literally and saw God in a decidedly anthropomorphic way.

Athanasius presents the hermetical life in *The Life of Antony* as one of repentance and therefore as a battle with the demons, the forces of evil; in his view humanity was basically sinful. By this 'warfare' the soul may be prepared for God's intervention of grace through Christ, as Athanasius' saying, 'The Word became human so that we may become divine', shows. There is therefore no mention in *The Life of Antony* of contemplation or any ascent to the Divine, only of the demonic struggles of Antony.

St Antony

St Antony was brought up as a Christian and became an orphan at the age of 18. He is portrayed in *The Life of Antony* as not being interested in learning to read and write; instead he went eagerly and regularly to church and committed everything to memory. Scripture played an important part in his decision to move to the desert. Some time after his parents died, he heard in church the passage from Matthew: 'Sell what you own and give the money to the poor . . . then come and follow me.' Antony took this as a word personally addressed to him and literally sold most of his possessions, keeping some for his younger sister. He then later heard 'Be not anxious for the morrow' and sold the rest, making provision for his sister to be taken care of by nuns.

2 The term 'monasteries' really only meant a collection of dwellings. The Greek *mone* meant 'dwelling' or 'lodge'.

Although the influence of *The Life of Antony* was very significant, Antony did not invent the ascetical life but learned it from recluses he visited at the beginning of his journey; persecutions, the demands for Roman taxes and avoidance of conscription had already driven many into the desert. According to tradition the first Christian anchorite was Paul of Thebes, who moved to the desert during the persecutions under the Emperor Decius in the early third century. There is a story of Antony visiting Paul of Thebes. A raven used to take Paul his bread. On the day that Antony visited, the raven took enough for two people!

Antony may not have been the first, but he certainly was the most influential figure to go into the desert.

The 'Origenist' monks

Many educated monks soon joined these early Coptic monks. These were the ones, who were greatly influenced by the teaching of Origen and were therefore known as the 'Origenist' monks; Evagrius and Cassian belonged to this group. They believed, unlike the Coptic monks, that humanity was essentially good and that the soul had an unambiguous likeness to the Divine. Through purification of the emotions and contemplation human beings were, with Christ as intermediary, capable of ascent to and union with God, who could not be captured in thoughts, words or images.

However different their theology may have been, their actual teaching, preserved in short sayings that show deep psychological insights, was similar, as it was based on the same practical experience of a life of deep prayer in silence and solitude. Moreover, the Coptic and the Origenist monks were not as sharply divided as is often portrayed. In contrast with the portrait we get in *The Life of Antony* drawn by Athanasius – to appeal to simple uneducated Christians – we get quite a different impression of Antony in the *Letters of Antony*. There we have clear indications that he was not only familiar with Greek language and thought but even accepted some of Origen's ideas. He stressed, for instance, the importance of knowing ourselves as essentially good, not sinful; he encouraged his readers to keep in mind that they were created in the image of God and therefore could rely on God's grace. He laid stress on insights coming from reading the Scriptures – the meeting place with Christ – that would lead to transformation in preparation for the coming of God's

grace; moreover, he saw asceticism as a way of restoring the body to its natural state rather than punishing it for its sins and escaping from it.

The settlements

By the end of the fourth century there were 30,000 monks and nuns living in the deserts of Lower and Upper Egypt. The famous sites in Lower Egypt were Nitria, Cells and Scetis. Antony himself by that time lived further into the desert.

St Antony's cave

The whole movement began at Nitria in 330. Amoun, a young man who was trying to escape from an arranged marriage, managed to persuade his bride on their wedding night that they should not consummate the marriage but should live as brother and sister. After 18 years of living in that way, they both felt called to live the ascetic life apart. Amoun therefore built two dwellings, one for himself and one for his wife in the desert around Nitria. They were gradually joined by a growing number of monks. Amoun's earliest companions were Pambo, Benjamin and Macarius the Alexandrian.

Eight years later life in Nitria had become too crowded and noisy with all the monks reciting psalms aloud.[3] This constant noise induced Amoun and Antony to establish Cells, which was a walk of a few hours away, for those who were ready for a quieter life; after some time there were about 600 hermits there. Scetis, further south in the desert, was founded at the same time by Macarius the Egyptian and appealed to the even more ascetic hermits. Macarius also had cells in Nitria and in Cells and one further southwest in the desert.

Whereas the latter were hermits, Pachomius (290–340), around the same time that Amoun founded Nitria, was led by divine inspiration in a dream to found

3 Silent reading was unheard of at the time; St Augustine was amazed when he came upon his teacher Ambrose reading silently.

communities near Tabenissi in Upper Egypt, monasteries both for men and women. St Basil visited these monasteries and was impressed enough to shape his ideas of monastic living on what he saw there. Pachomius in fact wrote the very first monastic rule, which became highly influential in the monastic movement. Later it was superseded, along with most other rules, by the *Rule of St Benedict.*

There were groups of women as well as men; in fact half of the Desert hermits were women. They were in a way braver than their male counterparts in going against social convention; at that time a woman had really no rights and was a chattel of her father and later her husband. Some were reformed prostitutes; others came from wealthy backgrounds and lived as dedicated virgins in the family grounds. Others were co-ascetics with their husbands, as in the case of Amoun's wife.

The best known were Amma Syncletica and Amma Theodora. Amma Syncletica was a rich, well-educated young woman who, with her blind sister, moved to the family tomb outside Alexandria to consecrate her life to God. Amma Theodora was the wife of a tribune who took up the hermetical life and lived in abject poverty. They and other women were very influential and were consulted by many monks. Their life cannot have been very easy, but the Christian leaders of their time supported them:

> *Woman is in the image of God equally with man. The sexes are of equal worth. Their virtues are equal, their struggles are equal . . . Would a man be able to compete with a woman who lives her life to the full?*
>
> (Gregory of Nyssa, quoted in Clement, *Roots of Christian Mysticism*, p. 292)

Finally, after the violent clash between Coptic and Origenist monks around 400, many moved to the deserts of Palestine.

The Syrian monks

There were also monks in Syria, less disciplined than the Desert Fathers and Mothers:

> *They wander in the desert as if they were wild animals themselves . . . Like birds they fly about the hills. They forage like beasts. The daily round is inflexible, always predictable for they feed on roots and the natural products of the earth.*
>
> (*The Spiritual Meadow of John Moschos*)

St Catherine's
Monastery

Syria was also the home of the Stylites, hermits perched on pillars; the most famous was Symeon the Stylite, who for 40 years stayed on a pillar near Antioch. They were regarded by ordinary people as intermediaries between heaven and earth, and many visited them for advice. They were, however, frowned on by the Desert Fathers and Mothers as being too extreme.

Daily life

The Desert hermits lived in small groups, their cells often built around a common courtyard, where they planted date palms and olive trees. They planted wheat in the surrounding area and made bread. In growing their food, they were open to the needs of others.

Sr Benedicta Ward, a well-known scholar on the subject of the Desert Fathers and Mothers, observed that the Desert monks were responsible for substantial agricultural improvement in the desert that benefited the life of the ordinary villagers around them. Abba Orr planted a marsh with trees; Abba Copres had a small grove of date palms in his hermitage garden; another planted wheat and distributed that among the nearby villagers. We can still see the result of this care for the environment and for their neighbours when visiting St Catherine's Monastery in the Sinai desert.

Although they ate sparingly we hear many of the sayings urge moderation in ascetic practices:

> *Our holy and most ascetic master stated that the monk should always live as if he*
> *were to die on the morrow, but at the same time he should treat his body as if he were*
> *to live on with many more years to come.*
>
> (Macarius quoted in Evagrius of Pontus, *Praktikos* 29, *The Praktikos and Chapters on Prayer*,
> Cistercian Publications, 1981, p. 29)

To buy anything else that was needed, they earned their own living by weaving mats, ropes and baskets, weaving flax and working in the fields as day labourers.

The elder Desert Fathers and Mothers were sought out for advice not only by their fellow hermits or aspiring ones, but by all from far and wide. Their role was often one of arbiters and mediators in disputes, as their advice was seen to be objective. Some, like Evagrius and Antony himself, would even go to Alexandria to defend Christianity and engage in disputations with pagan philosophers.

All of these were communities of lay people. The emphasis of their life was on prayer and work; liturgy played a minor role. The influence of clergy came much later. They in fact resisted becoming either priests or bishops.

Prayer

During the day there were three set periods of prayer: third hour, sixth hour and ninth hour (9am, 12pm and 3pm respectively). Only six hours, sometimes only four, were devoted to sleep. The rest of the time was spent in prayer, reciting Scripture or with psalmody, the singing of the Psalms. They knew them all by heart and recited most of them every 24 hours. No wonder we have the following saying:

> *Some elders came to see Abba Poimen to ask him, 'If we see some brothers dozing in*
> *the congregation, do you want us to reprove them so that they stay awake?' He said*
> *to them, 'For my part, when I see a brother dozing, I lay his head on my lap and let*
> *him rest.'* (Poimen 92 in Clement, *Roots of Christian Mysticism*)

They prayed standing up, facing east on the whole. They often made prostrations, especially after the singing of the psalms.

Scripture was very important to them; it was read aloud at their weekly gathering, the *synaxis*. Total attention at these times was considered essential: 'The Elder said: "Where were your thoughts, when we were saying the synaxis, that the word

of the psalm escaped you? Don't you know that you are standing in the presence of God and are speaking to God?"' (Nau 146 in Douglas Burton-Christie, *The Word in the Desert*, p. 127). Not only did they know Scripture by heart, they lived the lessons learned in daily life.

During the period they were in their cells they were engaged in private prayer and in interiorizing Scripture by meditation – the solitary repetition of a passage from Scripture without reflection on meaning. In this oral culture this repetition was done aloud: 'We heard him meditating' (Abba Amoun about Abba Achilles; Achilles 5 in Benedicta Ward, *The Sayings of the Desert Fathers*).

They had a strong belief in the spiritual power of the words of Scripture for healing and protection. Psalmody was recommended to overcome depression, despair and the 'demon of acedia', that is, boredom and dryness in prayer. This belief spread to the power of words in general: gossiping and judging was therefore also frowned on: 'The old men used to say, "There is nothing worse than passing judgment."'

This prayer life was fuelled by their wish to do what St Paul taught: 'Pray continually'. Evagrius even said, 'Life is prayer'. Some, however, interpreted this too literally:

> Some monks came to see Abba Lucius and they said to him, 'We do not work with our hands; we obey Paul's command and pray without ceasing.' The old man said, 'Do you not eat or sleep?' They said, 'Yes, we do.' He said, 'Who prays for you while you are asleep? Excuse me, brothers, but you do not practise what you claim. I will show you how I pray without ceasing, though I work with my hands. With God's help, I collect a few palm-leaves and sit down and weave them, saying, "Have mercy upon me, O God, after thy great goodness; according to the multitude of thy mercies do away with mine offences."' He said to them, 'Is this prayer or not?' They said, 'Yes, it is.' And he continued, 'When I have worked and prayed in my heart all day, I make about sixteen pence. Two of these I put outside my door and with the rest I buy food. And he who finds the two coins outside the door prays for me while I eat and sleep. And so by the help of God I pray without ceasing.'
>
> (Lucius 1 in Clement, *Roots of Christian Mysticism*, p. 164)

Therefore as prayer and working went hand in hand, an attitude of prayerfulness pervaded their life. The passages of Scripture they had interiorized in private prayer might also come to mind and reveal their personal meaning for them during work.

Purity of heart

The main reason for their being in the desert was their intense longing to enter the 'Kingdom of God', to live in the Divine Presence. They felt intuitively that this would only be possible by deep, interior, silent prayer. To enable this they had to let go of all self-centred thought, in their words to 'purify their passions', so that they might reach 'purity of heart'.[4] Without letting go of thoughts, pure prayer was considered not to be possible: 'One of the Fathers said, "In the same way as you cannot see your face in troubled water, the soul, if it is not emptied of foreign thoughts, cannot reflect God in contemplation"' (Clement, *Roots of Christian Mysticism*, p. 168).

This 'letting go' included simplifying all aspects of their life back to mere essentials, doing only what was strictly necessary for survival. It required a total attitude of simplicity and poverty, a material poverty, a poverty of mind and a poverty of spirit. They saw all longing for possessions as an attachment of the ego to the material world, to a superficial self-image, which hid their true self-image as a child of God.

In the words of Thomas Merton (*Wisdom of the Desert*, p. 5): 'What the Fathers sought most of all was their own true self, in Christ. And in order to do this, they had to reject completely the false, formal self, fabricated under social compulsion in "the world".'

This was seen in terms of a struggle with the 'demons'. We would now interpret 'fighting the demons' in psychological terms as an attempt to become free from the drives of the 'ego' – 'demons' representing negative energies and unmet psychological needs. These energies are very powerful, so it is not surprising that these forces were personified as 'demons'. Moreover, at that time there was a strong belief both in angels and in demons.

The end result of this struggle was the state of 'purity of heart' or, as Evagrius called it, *apatheia*. This state is not the

Also around this time

AD300–525
During the Gupta Dynasty India trades with the eastern Roman Empire, Persia and China.

325
Emperor Constantine and his mother Helena discover Christ's tomb – shrine of the Holy Sepulchre.

340–97
Ambrose, Bishop of Milan.

350
The Huns invade Persia.

354
Birth of St Augustine in Tagaste, North Africa.

379–415
Hypatia, female mathematician and philosopher, lecturing also on astronomy and geometry, is lynched by a religious mob sent by Archbishop Cyril of Alexandria.

4 We will look more at the meaning of 'purifying of the passions' when we discuss Evagrius.

result of repressing emotions; it means being balanced, not driven and not over-whelmed by any ego-centred disordered emotions. It is a state of serenity and harmony and consequently clarity of vision. It allowed them to see any situation in which they found themselves with clarity and to act out of pure motives, appro-priate to the need at hand.

Obedience, conversion of life and stability

The essence of their way of life and their way of prayer was beautifully captured by St Benedict a century later in his rules: 'obedience, conversion and stability'.

The first essential attitude is 'conversion of life', a turning away from a preoccu-pation with ordinary material existence to a life totally dedicated to God, seeing God in all things.

Next comes 'obedience', in its original meaning of 'listening intently'. The disciples have to listen carefully to the Word of God, to the commandments in the form of the 'Beatitudes' and to their Abba or Amma, their spiritual guide. They need to let go of their own will and leave behind their individual ego desires. Hand in hand with obedience goes an attitude of humility; together they would lead to two of the main virtues mentioned in the Beatitudes: not only 'purity of heart' but also 'poverty of spirit' in the sense of 'knowing their need of God'.

Obedience to the Abba or Amma was paramount. The natural authority of the Abbas and Ammas was based on their wisdom, a result of their own lived experience of deep prayer:

> One day Abba Arsenius consulted an old Egyptian monk about his own thoughts. Someone noticed this and said to him, 'Abba Arsenius, how is it that you with such a good Latin and Greek education, ask this peasant about your thoughts?' He replied, 'I have indeed been taught Latin and Greek, but I do not know even the alphabet of this peasant.' (Arsenius 6 in Ward, Sayings)

They were counsellors, confessors, who interceded on behalf of their disciples, whom they considered to be the children given to them by Christ. They took this responsibility very seriously: 'Abba Lot said, "Confess your sins to me and I will carry them"' (Lot 2 in Ward, Sayings).

And finally 'stability' is stressed in the following saying: 'A brother in Scetis went

to ask for a word from Abba Moses and the old man said to him, "Go and sit in your cell and your cell will teach you everything'" (Arsenius 6 in Ward, *Sayings*).

The emphasis laid on 'stability' was meant to help the hermits to lessen their innate restlessness, both physical and mental.

Restlessness is in our genes; we are descendants of migratory tribes after all. The fact that the hermits found this rule of 'stability' a challenge can be seen from the accounts of many of them wandering from settlement to settlement, a common problem, but one that was not encouraged:

> Amma Syncletica: *'If you find yourself in a monastery do not go to another place, for that will harm you a great deal. Just as the bird who abandons the eggs she was sitting on prevents them from hatching, so the monk or the nun grows cold and their faith dies when they go from one place to another.'* (Syncletica 6 in Ward, *Sayings*)

The virtue of stability is rootedness, a rootedness in God and in the spiritual path.

Silence and solitude

Other virtues stressed were silence and solitude. Early Christianity is really a religion grown out of the harsh, uncompromising but hauntingly beautiful environment of the desert with its profound silence and solitude. The hermits had achieved a state of outer silence and solitude by retreating to the desert, but to reach a similar inner state in their life and prayer was much more difficult. It is so hard to leave the landscape of our own thoughts and feelings. But unless that was done even the desert was no help:

> Amma Syncletica said, *'There are many who live in the mountains and behave as if they were in the town, and they are wasting their time. It is possible to be a solitary in one's mind while living in a crowd, and it is possible for one who is a solitary to live in the crowd of personal thoughts.'* (Syncletica 19 in Ward, *Sayings*)

Inner silence is needed to hear 'the still small voice' and was therefore considered the most essential quality:

> *Once Abba Macarius said to them, after he had given the benediction to the brethren in the church at Scete: 'Brethren fly!' One of the elders answered him 'How can we*

fly further than this, seeing we are here in the desert?' Then Macarius placed his finger
on his mouth and said, 'Fly from this.' So saying he entered his cell and shut the door.

(Macarius 16 in Ward, *Sayings*)

Attention

The interior life of prayer can be very difficult; the hermits needed to pay careful
attention to their state of mind. They felt constantly under attack of demons in the
shape of 'evil thoughts'. Attention focused on prayer was therefore considered to
be paramount.

There was another spiritual man about whom we have read. While he was praying
one day a viper crawled up to him and seized his foot. He did not so much as lower
his arms until he finished his customary prayer, and he suffered no harm whatever
from thus loving God above his own self. (Evagrius, *Chapters on Prayer*, p. 109)

This emphasis on attention also led them to consider all irrelevant talk a danger:

It was said of Abba Ammoes that when he went to church, he did not allow his disciple
to walk beside him but only at a certain distance; and if the latter came to ask him
about his thoughts, he would move away from him as soon as he had replied, saying
to him, 'It is for fear that, after edifying words, irrelevant conversation should slip in,
that I do not keep you with me.' (Ammoes 1 in Ward, *Sayings*)

Poverty, chastity and obedience

Later the essential rules of the monastic tradition were summarized as 'poverty,
chastity and obedience', three very closely linked virtues.

We have discussed the importance of obedience and have seen that it is used in
a much wider sense than we usually interpret it. This is the same with the other
virtues. 'Poverty' really means a general attitude of detachment. It does not only
refer to material possessions, but also applies to thought, speech, opinions and even
knowledge. The hermits were aware of our deeply ingrained acquisitive tendency
and knew that it was caused by what Thomas Merton calls the 'false formal self fab-
ricated . . . in the world' with its need for esteem, power and control, the 'self' in
fact they needed to leave behind. Moreover, possessions in whichever shape or form
are often a cause for worry and conflict.

Abba Theodore, surnamed Pherme, had three good books. He went to Abba Macarius and said to him, 'I have three good books, and I am helped by reading them; other monks also want to read them and they are helped by them. Tell me, what am I to do?' The old man said, 'Reading books is good but possessing nothing is more than all.' When he heard this, he went away and sold the books and gave the money to the poor. (Theodore in Ward, *Sayings*)

Even the attitude we usually associate with the Desert Fathers and Mothers, that of 'fasting', is not just related to food but is a form of 'poverty', 'detachment' related to every aspect of life. We could consider 'solitude' as fasting of sense impressions and distracting social contact, 'silence' as fasting of words and sounds. Acquiring this virtue and others was considered essential, but the Desert hermits were very aware how clever the 'ego' was at hijacking any spiritual achievement, and warned their charges accordingly:

Abba Isidore the priest said, 'If you fast regularly, do not be inflated with pride, but if you think highly of yourself because of it, then you had better eat meat. It is better for a man to eat meat than to be inflated with pride and to glorify himself.'
 (Isidore in Ward, *Sayings*)

Chastity

Even chastity has to be seen in wider terms. It does have to do with sex – no doubt about that. There are several stories of hermits having to stand in cold water to cool their passions. But it is more than that. What chastity really refers to is a state of mind without the need for power over others, the need to use people to fulfil our own sensual and material needs and purposes. Moreover, it really denotes a chaste attitude to all facets of life, conquering the demon of greed and envy.

Compassion

All these virtues achieve their culmination in the supreme virtue of compassion; only increase in love for others is seen to be a reliable sign of spiritual growth. The desert way of life would lead to a total transformation of being, a transformation into the fire of Love:

Abba Lot went to see Abba Joseph and he said to him, 'Abba, as far as I can, I say my little office, I fast a little, I pray and meditate, I live in peace and as far as I can I purify my thoughts. What else can I do?' Then the old man stood up and stretched his hands toward heaven; his fingers became like ten lamps of fire and he said to him, 'If you will, you can become all flame.' (Quoted in Merton, *Wisdom of the Desert*, p. 50)

God, the divine energy, is Love, and experiencing this love deeply within their own being transformed them into Love. Everything the Abbas and Ammas did and taught was done out of compassion for those still caught by their demons:

A brother asked Abba Sisoes, 'What shall I do, Abba, for I have fallen?' The old man answered, 'Get up again.' The brother said, 'I got up and fell again.' The old man continued, 'Get up again and again.' The brother asked, 'Till when?' The old man answered, 'Until you have been seized either by virtue or by sin.' (Sisoes 38 in Ward, *Sayings*)

Their refusal to judge others is another sign of compassion. They saw that judging others was really a result of unresolved woundedness, and often we judge them for behaviour potentially our own. This tendency is moreover seen to come out of the ingrained habit of always judging ourselves. Only when we accept ourselves as we are, warts and all, can we accept and love others.

Not only do they consider judging harmful to the one doing it, it also does not allow for the possibility of change in the other person:

Abba Xanthias said: *'The thief was on the cross and he was justified by a single word; and Judas who was counted amongst the number of the apostles lost his labour in a single night and descended from heaven to hell.'* (Xanthias 1 in Ward, *Sayings*)

Compassion is therefore the true foundation and the fruit of their practice, considered even more important then prayer:

It can happen that when we are at prayer some brothers come to see us. Then we have to choose, either to interrupt our prayer or to sadden our brother by refusing to answer him. But love is greater than prayer. Prayer is one virtue amongst others, whereas love contains them all. (John Climacus, *The Ladder of Divine Ascent*, 26th step)

We can see from that saying also that human relationships are considered to be foundational to living in the presence of Christ:

> Abba Antony said again: *'Life and death depend on our neighbour. If we gain our brother we gain God. But if we scandalize our brother we are sinning against Christ.'*
>
> (Antony 9 in Clement, *Roots of Christian Mysticism*, p. 274)

The ultimate virtue is a self-emptying of all personal desires, a self-giving love, following in the footsteps of Christ:

> *St Antony had prayed to the Lord to be shown to whom he was equal. God had given him to understand that he had not yet reached the level of a certain cobbler in Alexandria. Antony left the desert, went to the cobbler and asked him how he lived. His answer was that he gave a third of his income to the Church, another third to the poor, and kept the rest for himself. This did not seem a task out of the ordinary to Antony who himself had given up all his possessions and lived in the desert in total poverty. So that was not where the other man's superiority lay. Antony said to him, 'It is the Lord who has sent me to see how you live.' The humble tradesman, who venerated Antony, then told him his soul's secret: 'I do not do anything special. Only, as I work I look at all the passers-by and say, "So that they may be saved, I, only I, will perish."'*
>
> (Clement, *Roots of Christian Mysticism*, p. 302)

A way of life appropriate for all

When we hear of the strenuous life these Desert Fathers and Mothers led we tend to dismiss their teaching as being only relevant to monks and nuns, but they themselves did not see it that way. They were convinced of the fact that their attitude was right for everyone:

> *When Christ orders us to follow the narrow path he addresses himself to all. The monastic and the lay person must attain the same heights. Those who live in the world, even though married, ought to resemble monks in everything else. You are entirely mistaken if you think there are some things required of ordinary people and others of monks.*
>
> (St John Chrysostom)

KIM NATARAJA

EIGHT

EVAGRIUS
OF PONTUS

Kim Nataraja

Evagrius of Pontus, *Giorgos Kordes*

Introduction

Evagrius combined within himself the two branches of Christianity that we have
been noting: that which insisted on the 'literal' interpretation of Scripture with em-
phasis on faith within the 'apostolic tradition', and that which emphasized spiritual
experience and a deeper level of understanding of Christ's teaching with its more
allegorical interpretation of Scripture. He was a friend of the Cappadocians, and
therefore at first very much part of the established, 'orthodox' Church at that time;
then subsequently he became a really beloved and respected 'Desert Father', leading
an extremely ascetic life totally dedicated to prayer. Because of his life in the world
as well as in the desert he appreciated the importance of both theology and faith
and actual spiritual experience. He in fact combined heart and mind: 'If you are a
theologian you truly pray. If you truly pray you are a theologian.' He was therefore
at the centre of developing Christian theological dogma as well as an integral part
of one of the most important flowerings of mysticism in Christianity.

Kim Nataraja traces the important influence of Origen on Evagrius and in con-
centrating on his teaching, notes his modern and psychological approach to reaching
self-knowledge with a view to achieving 'purity of heart'.

Quotations from Evagrius are taken from *The Praktikos and Chapters on Prayer*, trans.
John Eudes Bamberger OCSO (Cistercian Studies 4, Cistercian Publications, 1981).

Evagrius of Pontus AD346–99

Evagrius was born in Ibora on the shores of the Black Sea (Pontus). His father was a country bishop. Close by was the family home of St Basil, St Gregory of Nyssa and their sister Macrina. From an early age Evagrius came therefore under the influence of the Cappadocian Fathers. He toyed with becoming a monk, but was more attracted by the stimulating intellectual life in Constantinople. St Basil ordained him reader, and after the latter's death Gregory of Nazianzus ordained him deacon and involved him in the fight against Arianism. Evagrius was handsome, cultured and a brilliant orator poised for an ecclesiastical career. However, he fell passionately in love with a married Roman lady. In a dream he swore an oath that he would leave Constantinople and dedicate himself to the spiritual life. He travelled to Jerusalem, where he met Melania and Rufinus, who had communities there. They were, like the Cappadocians, very influenced by Origen. Evagrius soon forgot his promise and fell almost immediately back into his old worldly habits. But he contracted an apparently incurable disease, which led Melania to think it was caused by his broken promise. This insight cured him miraculously, and about 383 he withdrew to the Egyptian desert. His background and education led him to the group of Origenist monks, of which he soon became the leader. From then on he had no more ambition to rise in the Church; he refused to become a bishop, remembering the saying of the Fathers that 'monks must avoid women and bishops'.

He is considered to be one of the most influential of the Desert Fathers, as he wrote down a comprehensive account of their teaching. He earned his living as a scribe, copying manuscripts and writing down his own thoughts. He died shortly before the Coptic monks drove these intellectual Origenist monks out of the desert.

THE INFLUENCE OF ORIGEN

Evagrius was highly influenced by Origen through his long friendship with the Cappadocians and with Melania and Rufinus, followers of Origen in Jerusalem. On the latter's recommendation he joined, around 383, a group of Origenist monks in Nitria. These were the Four Tall Brothers, disciples of one of the famous Desert Fathers, Abba Pambo, who were well known for both their learning and their asceticism.

Better to throw a stone at random than a word.

Initially Evagrius experienced some difficulties in adapting himself to the desert life after being used to a high-profile

position in Constantinople and Jerusalem. There is a telling story about his asking a Desert Father, probably Macarius the Great, the customary question a disciple would ask an Abba:

> 'Tell me some piece of advice by which I might be able to save my soul.' The old man
> answered him: 'If you wish to save your soul, do not speak before you are asked a
> question.' Now this bit of advice was very disturbing to Evagrius and he displayed
> some chagrin at having asked it, for he thought: 'Indeed I have read many books and
> I cannot accept instruction of this kind.' Having derived much profit from his visit he
> left the old man. (Introduction, p. xlv)

The group he joined was initially led by Ammonius Parotes, but their admiration for Evagrius' abilities and experience is apparent in the fact that before long they all accepted him as their Abba. After staying there for two years, he decided to join the more austere monks in Cells, where he lived for 14 years till his death in 399; he was a disciple of the Coptic monks Macarius the Great and the very austere Macarius the Alexandrian. Once more, therefore, Evagrius forms a bridge, now between the Origenist monks and the Coptic ones.

Origen's cosmology

To understand Evagrius' teaching it is essential to take note of Origen's cosmology, which underpinned his ideas.

According to this, in the beginning all are spirit, pure intuitive intelligence, *logikoi*. All are enfolded in the Divine, which is a single 'Henad', an undivided, integral whole, Pure Intelligence. But through 'satiety' or 'negligence' – Origen is not quite sure why – they assert themselves and turn away from God. As an act of mercy – not punishment – God

Kellia (Cells)

then specially creates appropriate bodies and environments for each of them. There are three levels of creation: angels, humans and demons, depending on the degree of turning away from God. Each is given a special body and appropriate environment: angels' bodies are made of fire and they are very light, invisible and immaterial; the bodies of human beings are made of matter, dominated by sensuality and passions; demons are made of dark, heavy, cold air and are very short-tempered by nature.

Human beings retain their intuitive intelligence (*logikos* or *nous*) as their divine essence. Moreover, they are also given souls – the seat of the passions – to deepen their experiences and rational intelligence to understand them. Although the soul, the seat of the emotions, is part of created being, it is integrally connected with the spirit, the highest part of the soul, the *nous*. In a way the soul is seen as an intermediary between the body and the spirit.

Evagrius feels that a potential return to union with the Divine is part of human nature; in fact, is a vocation possible for all. Whether it was Origen himself or his later interpreters, he was imputed to have implied that all created beings would eventually be saved, even the devil. This was a stumbling block for many Christian thinkers in later centuries.

God's grace and the angels are there to help human beings and show them the possibility of salvation, and help them to return to the Divine Presence through moral practice and prayer: 'If you pray in all truth you will come upon a deep sense of confidence. Then the angels will walk with you and enlighten you about the meaning of created things' (*Chapters on Prayer* 80).

Angels could descend lower on the scale, to help humanity and deliver them from their ignorance. Apart from the angels this is very much Christ's role. He is the only one who did not fall into ignorance; he alone remains united to God. His willingness to come down to our level and be incarnated is an indication of his compassion. Humans are destined to first become angels, but unfortunately they could also slip down and become demons. Angels and humanity welcome the opportunity to work their way back to God, but demons reject it. They work against humanity's efforts.

Be to all as you wish all to be to you.

Warfare with the demons and the role of the emotions

This cosmology explains the stress laid in the Desert spirituality and in Evagrius' teaching on the importance of *praxis*, with its 'warfare' with the demons, who were determined to prevent the ascetics from achieving liberation: 'When the demons see that you are really fervent in your prayer they suggest certain matters to your mind, giving you the impression that there are pressing concerns demanding attention' (*Chapters on Prayer* 10). The most important weapon in the warfare with the demons is prayer. To Evagrius the sole purpose of life is to pray, as we can see from this variation on the Gospel saying: 'Go, sell your possessions and give to the poor, and take up your cross so that you can pray without distraction' (*Chapters on Prayer* 17). But the emphasis is on private prayer.

The emotions play an important role. When humanity was created they were given a soul to deepen and enrich their experiences. But the emotional part of the soul can be both a help and a hindrance. When it is steered overwhelmingly by material desires and unmet needs, they cloud the vision and obstruct access to the *nous*, the highest part of the soul, and to the Divine. The demons resonate with these disordered emotions and are attracted; the 'demons' can be seen as 'thought archetypes' along the lines of Jungian archetypes in the unconscious, fields of negative thoughts grouped around a particular desire. Victory over the demons leads to *apatheia*, a state of emotional balance, serenity and harmony. Then the ascetics are no longer dominated by their passionate 'ego' desires and can become aware of the *logikos*, the light of the Divine within them, enabling them to live in the Divine Presence: 'The Kingdom of God is apatheia of the soul along with true knowledge of existing things' (*Praktikos* 2).

This must not be interpreted to mean that the desires have to be rooted out, but that they have to be purified and transfigured. Disordered impulses have to be

Evagrius' writings

Praktikos
Here Evagrius describes clearly the stages and difficulties on the spiritual path and gives practical advice to those following the ascetical life.

Gnostikos
50 sentences of practical advice written for contemplatives; always joined with *Praktikos* under the name of *Monachikos*.

Chapters on Prayer
His most important work, preserved under the name of St Nilus; contains 153 sentences on prayer.

Kephalaia Gnostica
A major theological and cosmological treatise; highly speculative; it includes several of his doctrines, which were condemned as being 'Origenist'.

Antirrheticos
Deals with the eight kinds of passionate thoughts; quotes relevant scriptural references for support in the battle against these 'demons'.

Sentences for Monks
Advice for monks in monasteries; very influential in the fifth and sixth centuries.

purified back to their original state of divinely given energy. 'The ascetic life is the spiritual method for cleansing the affective part of the soul' (*Praktikos* 78).

Even when they have reached this state of harmony, the ascetics have to be alert; they are never considered to be safe from the 'demons' and their temptations; they have to remain vigilant against attacks, especially at this advanced stage, by the demons of vainglory and pride.

This harmony, the re-integration of their whole being and the ensuing spiritual freedom, move the ascetics to the level of angels. Angels are there to help others; therefore if the ascetics reached this state they too would become more and more concerned about the welfare of others and be transformed into love: '*Agape* is the progeny of *apatheia*. *Apatheia* is the very flower of *askesis*' (*Praktikos* 81). The *praxis* is therefore never seen to be about their own spiritual advancement; on the contrary, the experience of 'unconditional love' in the vision of God leads to an increase in compassionate love for everyone, leading to harmony and unity with all: 'Happy is the monk who views the welfare and progress of all men with as much joy as if it were his own' (*Chapters on Prayer* 122).

Evagrius (like Origen) was finally condemned for this cosmology at the instigation of the Emperor Justinian in 553 at the Fifth Ecumenical Council, but his book, the *Kephalaia Gnostika*, where he describes these thoughts, survived in a Syriac translation.

Moreover, Evagrius' teaching on the practical life of the monk and his advice about prayer, *Praktikos* and *Chapters on Prayer*, survived in writings under the pseudonym of St Nilus, as they were greatly admired. Throughout the Middle Ages this teaching spread from monastery to monastery and was committed to memory. Evagrius' influence in both the Christian East and West is therefore inestimable. Some of the most important teachers who were influenced by him are the writers of the *Philokalia*, as well as Dionysius the Areopagite, Maximus the Confessor, John Climacus and Simeon the New Theologian. Meister Eckhart, ten centuries later, also shows striking parallels with Evagrius' teaching.

The spiritual life

Evagrius is absolutely convinced that the human vocation is to discover the divine 'image' within and achieve divine 'likeness'. He envisions this spiritual journey to

be in two stages: *praxis* and *theoria*. This idea of two stages on the spiritual path went back to Plato, Aristotle, Philo, Clement of Alexandria and Origen. *Praxis* was very much the warfare with the demons and the acquisition of virtues. *Theoria* was the contemplation of God.

Practice righteousness more in deed than in word.

Evagrius sees *theoria* itself also as consisting of two stages. Nature is the object of the first level of contemplation, called *physike*; as a creation of God, a manifestation of the Unmanifest, it is essentially good and allows us to penetrate from ordinary surface reality to the Divine Reality: 'As for those who are far from God . . . God has made it possible for them to come near to the knowledge of him and his love for them through the medium of creatures' (Evagrius, letter to Melania). By seeing the divine essence in everything, we are enabled to get in touch with the divine essence.

Not only nature but also Scripture could fulfil this role in this first level of contemplation. Like Origen before him, Evagrius sees Scripture as a meeting place with Christ. Again it involves a movement from the surface meaning to the actual spiritual meaning.

The second level of contemplation, *theologike*, is the contemplation of things not seen by the senses, for example seeing angels as well as God directly 'by a simple glance of the spirit'. This 'pure' prayer is only possible by moving beyond the surface, by gradually letting go of all thoughts, images and forms. It is a move from multiplicity to simplicity.

All the Desert Fathers agreed that thoughts would obscure the Divine Presence. But Evagrius, like all 'Origenist' monks, goes further and insists that even thoughts and images of God have to be discarded:

> *When you are praying do not fancy the Divinity like some image formed within yourself. Avoid also allowing your spirit to be impressed with the seal of some particular shape, but rather, free from all matter, draw near the immaterial Being and you will attain to understanding.* (*Chapters on Prayer* 66)

Glossary

Acedia
one of the eight 'evil thoughts'; boredom, lethargy, resistance to growth.

Agape
divine, unselfish love.

Ascetics
those that followed the path of *askesis* or *praxis*.

Askesis or *praxis*
the moral practice required to achieve 'purity of heart'; struggle with the 'demons'.

Philautia
self-centredness.

Physike
contemplation of God through creation and Scripture.

Theologike
union with God/vision of God.

Theoria
contemplation of God.

This gradual stripping away of all images and forms will allow direct contact with a formless Trinity. This 'apophatic' approach to God, this view of an imageless God, was fine with the Origenist monks around him, but not with some of the simple Coptic monks.

The ascetics did not have to be perfect at the start of their journey; both *praxis* and *theoria* went hand in hand. It was not considered to be a linear process but a question of sometimes overlapping and sometimes deepening levels of awareness. A sudden deep level of awareness was in fact considered to be the start of the journey. This was called *metanoia*, a turning round, a new way of seeing reality: 'Be renewed by the spirit of your mind' (St Paul). Then the emphasis on *praxis* followed, with both effort and grace being equally important:

> *The Holy Spirit takes compassion on our weakness, and though we are impure he often comes to visit us. If he should find our spirit praying to him out of love for the truth he then descends upon it and dispels the whole army of thoughts and reasoning that besets it. And he too urges it on to the works of spiritual prayer.*
>
> (*Chapters on Prayer* 62)

The condemnation of Evagrius' (and Origen's) teaching really marks the point where the mystical tradition goes underground in the Latin West, only to reappear occasionally in the saints.

The eight passionate thoughts

Because of Evagrius' own experiences of falling for temptations in the ordinary world as well as his experience in the desert, he had acquired profound psychological insights into the workings of the human mind. He was considered to have unusual gifts of 'knowledge, wisdom and discernment of spirits'. Moreover, his background gave him a clear theology. He integrated very much mind and heart. We remember his saying: 'A theologian is one who prays and one who prays is a theologian' (*Chapters on Prayer* 60). Because of this he was greatly admired and many a monk sought him out as a spiritual father, an Abba. He was reported to have performed miracles and have the gift of prophecy.

He was best known for his virtue of discretion and his explanation of the eight 'evil thoughts', the *logismoi*. Of course there was already a vast body of teaching on

this topic by the Desert Fathers. St Antony had already said: 'The demons stir up the *logismoi* through the passionate, desiring parts of the soul.' Not only did the Abbas and Ammas deal with the subject of 'evil thoughts' but it was already part of a long tradition of interpreting the *logismoi*. The Stoics said that 'evil thoughts' were pathological disturbances of the personality. Aristotle considered them neither as virtues nor vices: they were neutral; it was a question of what you did with them. Plato, a strong influence on Evagrius through Origen, drew an analogy of a charioteer driving a two-horse chariot. One horse was of noble breed, the other unruly and rebellious, representing the purified and the emotions. Without horses you go nowhere; one horse was no good either, both were needed for balance.

St Antony's temptation by demons, attributed to *Matthias Grünewald*

Evagrius agreed with Plato that there was nothing wrong with emotions in themselves. He considered them to be a God-given part of our nature, an essential element of being human. Neither considered it to be a question of discarding the emotions, but of purifying those that had got out of control, out of proportion, so that they could be brought back into balance.

The real problem was becoming aware of these 'evil thoughts'. The Desert ascetics saw temptations as a great help in this respect, and much needed for spiritual growth. Only by being tempted in certain situations could the ascetics learn which exaggerated emotional responses dominated them, and where they were stuck in a disordered emotional state. Abba Antony is quoted as saying: 'Without temptation

no one can be saved.' The source of these 'passions' was considered to be an individual's self-centred attitude, called *philautia*, which then in turn attracted these thought archetypes, these 'demons': 'Whoever has *philautia* has all the passions,' said Maximus the Confessor. This self-centredness is driven by the need to survive in this world: 'The cause of this deviation of the natural energies into destructive passions is the hidden fear of death' (Maximus the Confessor, *Questions to Thalassius*, quoted in Olivier Clement, *The Roots of Christian Mysticism*, p. 135).

Evagrius' advice to his disciples is to redirect, educate and transfigure these desires through awareness, so that they would no longer be at the mercy of disproportioned emotions, which clouded their perception of reality and prevented them from seeing the Divine.

Evagrius gives these 'thoughts' the following names: 'There are eight general and basic categories of thoughts in which are included every thought. First is that of gluttony, then impurity, avarice, sadness, anger, acedia, vainglory, and last of all, pride.'

You want to know God? First know yourself!

The following text is included in the *Philokalia*, and in it Evagrius shows beautifully the connection between them all:

> *Of the demons opposing us in the practice of the ascetic life, there are three groups who fight in the front line: those entrusted with the appetites of gluttony, those who suggest avaricious thoughts, and those who incite us to seek the esteem of men. All the other demons follow behind and in their turn attack those already wounded by the first three groups. For one does not fall into the power of the demon of unchastity, unless one has first fallen because of gluttony; nor is one's anger aroused unless one is fighting for food or material possessions or the esteem of men. And one does not escape the demon of acedia, unless one no longer experiences suffering when deprived of these things. Nor will one escape pride . . . unless one has banished avarice, since poverty makes a man humble according to Solomon.*

THE SEQUENCE

'Gluttony/Greed' starts the whole process and applies to all aspects of the ascetic life, not only food; it is considered to be a form of obsessive attachment to everything, which includes physical and intellectual abilities, knowledge and material possessions, however few these may be. It could even extend to sexual relations,

hence to 'unchastity'. 'Gluttony' was really considered to be a general attitude of being immoderate; therefore in the ascetic life it often applied more to extreme fasting than to eating too much food. Moreover, the danger was that it could easily lead to being ruled by the demons of vainglory and pride: Abba Isidore the priest said:

> If you fast regularly, do not be inflated with pride, but if you think highly of yourself because of it, then you had better eat meat. It is better for a man to eat meat than to be inflated with pride and to glorify himself.

Preoccupation with food and fasting could lead not only to pride but also to 'avarice'. The ascetic might be unwilling to break a fast and share a meal with the brother who called because of worries about not having enough food to maintain his health. In doing so he also broke with the important virtue of providing hospitality.

'Sadness' and 'anger' are considered to be strong demons. Evagrius does not mean by 'sadness' genuine grief or depression, but a sadness that arises when desires are thwarted. This is often accompanied by anger at those who have the abilities or possessions the ascetics covet. *Acedia*, the state of spiritual dryness, is an inevitable outcome of all these obsessions.

Disordered or 'evil' thoughts of 'vainglory' and 'pride' are considered by Evagrius to be the most dangerous demons, even when the ascetic is already quite advanced on the path. *Philautia* would hijack even spiritual gifts for its own end.

St Gregory the Great, the first monk to be a pope, brought the desert tradition of the 'eight evil thoughts' at the end of the sixth century into the established Church as the seven deadly sins: pride, avarice, lust, anger, sloth, gluttony and envy. He also saw these as states of mind to be dealt with.

WATCHING THE THOUGHTS

Not only does Evagrius diagnose the problem, he also gives clear advice. The first line of defence is the monastic life itself, with its vows of poverty, chastity, conversion

Also around this time

350
The Huns invade Persia.

354
Birth of St Augustine in Tagaste, North Africa.

378
The Visigoth cavalry defeat the Roman army in the battle of Adrianople.

385
Pope Siricius leaves his wife on becoming pope and tells all priests to be celibate.

386
Augustine becomes a priest and soon after that Bishop of Hippo in North Africa.

389
St Patrick born, missionary and Bishop of Ireland; Celtic monasticism.

395
Death of Theodosius I marks split between Roman and Byzantine Empires.

of life, stability and obedience. Psalmody, prayer and living according to the 'Beati-tudes' and the commands of one's Abba are also essential tools.

But his main recommendation to his disciples is to become aware of the thoughts that pass habitually through their minds. He advises them to become very self-analytical, to become consciously aware of their preoccupations with the aim of recognizing the demons attracted by their unconsciously driven disordered emotions. Then, having identified their drives and desires, they can conquer the demons; they can 'leave self behind'. They will then become, paradoxically through self-awareness, totally unselfconscious, an essential condition for going deeper in prayer. He recommends, in fact, using the mind to be able to descend into the heart.

The fact that insights, arising from carefully scrutinized thoughts, are essential for change and transformation is one that was only rediscovered in the nineteenth century with Freud and Jung. Now it is a commonly accepted working hypothesis for most psychotherapists and analysts. Many of Evagrius' sayings would not be out of place in a modern manual of psychotherapy.

The worst sort of possession is a disreputable life.

Evagrius' advice is a way of detachment, an objective watching of thoughts, watching the mind at work. Christ's help and guidance is considered paramount in this process:

> *If there is any monk who wishes to take the measure of some of the more fierce demons so as to gain experience in his monastic art, then let him keep careful watch over his thoughts. Let him observe their intensity, their periods of decline and follow them as they rise and fall. Let him note well the complexity of his thoughts, their periodicity, the demons that cause them, with the order of their succession and the nature of their associations. Then let him ask from Christ the explanation of the data he has observed.*
>
> (*Praktikos* 50)

Thoughts have to be distinguished from the 'demons' themselves. Thoughts are not bad in themselves. Only when a thought or desire resonates strongly with these basic thought patterns are the 'demons' allowed in to exert their influence. This results in normal emotional energy becoming demonic and the ascetic is then demonically driven into unwholesome action.

Evagrius describes beautifully the chain reaction; the senses are the first indication

of something stirring in the depth: 'The passions are accustomed to be stirred up by the senses' (*Praktikos* 38). Then the ascetics will become aware of a feeling, which leads in turn to a desire, which is then inevitably translated into an action:

> *Whatever a man loves he will desire with all his might. What he desires he strives to lay hold of. Now desire precedes every pleasure, and it is feeling that gives birth to desire. For that which is not subject to feeling is also free of passion.* (*Praktikos* 4)

It is important to keep in mind that Evagrius is not talking about suppressing emotions, but of purifying those that have been distorted by material and emotional needs. In fact emotions need to be expressed, otherwise they will not allow you to pray with a pure heart:

> *When you are tempted do not fall immediately to prayer. First utter some angry words against the one who afflicts you. The reason for this is found in the fact that the soul cannot pray purely when it is under the influence of various thoughts.* (*Praktikos* 42)

This is echoed by Maximus the Confessor's saying:

> *You don't grow, however, by avoiding conflict, irritation or annoyance, but by trying gently to clear up the misunderstandings and if that is not possible, by taking the other person into one's prayer, keeping silent, absolutely refusing to speak evil of him.*

What is needed first is, in fact, an emotional response of remorse and regret; an awareness of harm done by previous wrong actions: 'Pray first for the gift of tears, so that by means of sorrow you may soften your native rudeness' (*Chapters on Prayer* 5). Only then is change possible. When the ascetics have become aware of the true nature of their thoughts, they can recognize and acknowledge their demons, thus robbing them of their power.

Important figures

Melania 383–439
St Melania the Younger; very wealthy Roman lady, who chose after the death of her two young children to lead an ascetic life with her husband's consent and support; friend of St Augustine, St Jerome, Evagrius; visited the Desert ascetics, especially the Origenist monks. Led a life of piety and charity; founded a monastery for women near the Mount of Olives and lived there many years.

Rufinus d. 410
Protégé and companion of Melania; great Greek scholar; shared her devotion to Origen; lived for two years near Melania's monastery near Jerusalem before returning to Italy, where he translated Origen's *On Principles*.

Abba Pambo fourth century
Important Origenist Desert Father known for his learning and asceticism.

Macarius the Great fourth century
Important Desert Father; founder of Scete, extreme ascetic; disciple of St Antony and teacher of Evagrius.

St Jerome 340–420
Bishop of Milan; teacher of St Augustine; first recorded scholar to read silently rather than aloud.

The spirit can, according to Evagrius, also use memories and dreams as another excellent source for insight:

> *Natural processes, which occur in sleep without accompanying images of a stimulating nature, are, to a certain measure, indications of a healthy soul. But images that are distinctly formed are a clear indication of sickness. You may be certain that the faces one sees in dreams are, when they occur as ill-defined images, symbols of former affective experiences. Those that are seen clearly, on the other hand, indicate wounds that are still fresh.* (Praktikos 55)

As the ascetics become more whole and their surface self becomes more integrated and harmonized with the deeper self – in Jung's terms the process of 'individuation' – they become more and more aware of the Christ dwelling at their centre. Yet there lurks at the same time a great danger; Jung called it the danger of inflation. They could then fall prey to an exaggerated sense of self-importance, which could lead to a superiority complex. In this state the demons of 'pride' and 'vainglory' would be poised to hijack all their spiritual achievements. The more spiritual they are, the greater the danger they are in: 'The spirit of vainglory is most subtle and it readily grows up in the souls of those who practise virtue. It leads them to desire to make their struggles known publicly, to hunt after the praise of men' (*Praktikos* 13).

A pond without water is a soul who loves esteem.

Pride follows on the heels of 'vainglory': 'The demon of pride is the cause of the most damaging fall for the soul. For it induces the monk to deny that God is his helper and to consider that he himself is the cause of virtuous action' (*Praktikos* 14).

But all this striving to become aware can be painful and lead to the appearance of the demon of *acedia*: boredom, lethargy, dissatisfaction – in fact all the ways in which the ego will resist the change needed for growth. This demon is the opposite of the virtue of 'stability', inner and outer rootedness. Projection, the tendency to blame others for our own shortcomings, is also part of *acedia*:

> *A brother was restless in the community and often moved to anger. So he said: 'I will go and live somewhere by myself. And since I shall be able to talk or listen to no one, I shall be tranquil, and my passionate anger will cease.' He went out and lived alone*

in a cave. But one day he filled his jug with water and put it on the ground. It happened suddenly to fall over. He filled it again, and again it fell. And this happened a third time and in a rage he snatched up the jug and broke it. Returning to his right mind, he knew that the demon of anger had mocked him, and he said: 'I will return to the community.' Wherever you live, you need effort and patience and above all God's help.

(Ward, *Sayings of the Desert Fathers*)

Evagrius is very aware that we judge others to justify ourselves. Judging, criticizing and gossiping are all projections of our own 'demons', our own unresolved conflicts: 'Interior freedom is not yet possessed by anyone, who cannot close his eyes to the fault of a friend, whether real or apparent' (Maximus the Confessor, *Centuries on Charity*, quoted in Clement, *Roots of Christian Mysticism*, p. 278). This path of awareness leads eventually to *apatheia*, with its inner manifestation of becoming aware of the light of God shining in the soul:

The proof of apatheia is had when the spirit begins to see its own light, when it remains in a state of tranquillity in the presence of the images it has during sleep and when it maintains its calm as it beholds the affairs of life. (*Praktikos* 64)

And the outer manifestation is an increase in love and empathy with everyone: 'Happy is the monk who views the welfare and progress of all men with as much joy as if it were his own' (*Chapters on Prayer* 122). But lest we draw the conclusion that all is dependent on our own efforts, Evagrius reminds us in *Chapters on Prayer* 58 that without God we would be helpless: 'If you want to pray you need God who gives prayer to one who prays.'

KIM NATARAJA

JOHN CASSIAN

Kim Nataraja

John Cassian, *Giorgos Kordes*

Introduction

John Cassian was one generation younger than Evagrius, by whom he was strongly influenced and whom he revered most among the Desert Fathers and Mothers. But we see from his *Conferences* that he sat at the feet not only of Evagrius but also of at least 15 other Abbas, and made their teaching his own as well. Yet it was to Evagrius that he was beholden for most of his ideas. Cassian basically enlarged on the ideas expressed in the short sentences of Evagrius; there is no difference in their emphases and advice. He was however very careful not to mention either Origen or Evagrius, even though their influence permeates his thought and they were not officially banned until the Ecumenical Council called by Justinian in the sixth century.

He softened some of the harshness of the Desert teaching, simplified it and adapted it to the environment of Southern Gaul. Moreover, he created unity out of diversity: he formulated a coherent system of practice and thought based on the individual sayings and teachings of the Desert Abbas and Ammas. He is really the one responsible for bringing the Desert tradition to the Latin West, and in doing so he exerted a great influence on St Benedict and the whole western monastic movement.

Kim Nataraja focuses in this chapter on the teaching of contemplative prayer as transmitted by Cassian, and on his emphasis on the role of effort as well as grace on the spiritual path.

Quotations from Cassian's *Conferences* are taken from either *The Conferences*, ed. Boniface Ramsey (Paulist Press, 2004) or *Conferences*, ed. Owen Chadwick, trans. Colm Luibheid (Classics of Western Spirituality, Paulist Press, 1998).

John Cassian AD365–435

Cassian was born in what is now Romania. He travelled the then known world in search of spiritual teaching. First he went to Palestine with his friend Germanus and stayed in a monastic community at Bethlehem, but found the life there 'mediocre'. From there they got permission to go into the Egyptian desert and sat at the feet of at least 15 Abbas, including Evagrius, whose thought permeated Cassian's teaching for the rest of his life.

Shortly after Evagrius' death, when Cassian was forced out of the desert during the Origenest controversy, he went to Constantinople where he was ordained deacon by John Chrysostom. Then he travelled to Rome, where he was ordained priest. Finally, he settled in Marseilles, where he founded two monasteries, one for men and one for women.

CASSIAN'S CONFERENCES

Cassian's main writings, called the *Conferences*, encompass a comprehensive description of the way of Desert prayer, the way of coming to 'purity of heart' and thus entering the 'Kingdom of God': 'The final end of our profession is the Kingdom of God or the Kingdom of Heaven, but the intermediate goal is purity of heart' (*Conferences* 1.4).

The chapters in his *Conferences* alternate between describing the way to 'purity of heart' and stressing the importance of the acquisition of the supreme virtue of discretion. These *Conferences* were modelled on the situation in the desert; the disciples would sit silently listening at the feet of the Abbas and Ammas, who would be speaking out of their own lived experience of deep prayer. Teaching proceeded not only from listening to the Elders but also from watching their behaviour, as the truth of their teaching was borne out by their action.

Cassian the seeker

Cassian was a true seeker after spirituality. He was trying to answer the perpetual questions about the meaning and purpose of life and about the relationship between the world we see with our senses and the ultimate reality this originates from.

His guiding thought was Jesus' words: 'You come out of the things below: I come from the things above.You come out of this world; I do not come out of this world' (John 8.23). He tried to find ways of accessing this divine reality of the 'things above'.

Like the Desert hermits he emphasizes in his teaching the necessity of 'purifying the emotions', of moral growth leading to 'purity of heart', which enables the monastic to enter the presence of Christ.

To gaze with utterly purified eyes on the divinity is possible – but only to those who rise above lowly and earthly works and thoughts and who retreat with Him into the high mountain of solitude. When they are freed from the tumult of worldly ideas and passions, when they are liberated from the confused melee of all the vices, when they have reached the sublime heights of utterly pure faith and of pre-eminent virtue, the divinity makes known to them the glory of Christ's face and reveals the sight of its splendours to those worthy to look upon it with the clarified eye of the spirit.

(*Conferences* x.6)

St Victor Abbey, 12th century, Marseilles

Although he revered the Abbas and Ammas, he looked carefully at their teaching to see how this could be achieved in the different environment in which he found himself, around Marseilles in Gaul. His reason for founding monasteries for men and women was his utter conviction that it was dangerous to go it alone on the spiritual path. We remember the advice from the desert to 'obey' your Abba or Amma, as it was easy to be misled by the 'demons', a particular risk of leading the

solitary life of a hermit. Experiences needed to be checked against the wisdom and powers of discretion of the elder monks: 'The old men used to say, "When you see a young man ascending up to heaven through his own will, seize him by the foot and pull him down, for this is good for him"' (Benedicta Ward, *The Wisdom of the Desert Fathers* (SCM-Canterbury Press, 2000), p. 112). Cassian felt strongly that one first had to experience the spiritual life in a community, living and practising a life dictated by the virtues of stability, poverty, chastity and obedience. Only after being established in one's prayer life was being a hermit a valid choice.

Although Cassian did address himself specifically to monastics under his care, he did not think this calling was the only way to God; he was convinced that anyone could reach God in this present life: 'The journey to God takes many routes. So let each person take to the end and with no turning back the way he first chose so that he may be perfect, no matter what his profession may be' (*Conferences* XIV.6). This is very similar to the sentiment expressed by Evagrius, who said: 'The person in this world who ministers to the sick is worth more than the hermit who has no care for his neighbour' (*Sentences* 34).

Purifying the emotions

Cassian was an Origenist monk and therefore accepted the cosmology of Origen and Evagrius, as well as their Christian-Platonic view of the relationship between God and human beings. He also shared wholeheartedly their view of the spiritual life as a combination of *praxis*, which he called *scientia actualis*, and unceasing prayer leading to a vision of God, to *theoria*, which he called *scientia theoretike*.

For Cassian, as for Evagrius, *praxis* involves the purification of 'evil thoughts' or fighting the 'demons', and the acquisition of virtues; in Cassian's opinion the vision of God is possible only with 'purity of heart' linked to humility and discretion. Cassian expands on the short sayings of Evagrius

> The person in this world who ministers to the sick is worth more than the hermit who has no care for his neighbour.

and explains the demons in great detail as well as the importance of our struggle against them, especially in *Conferences* V. As with Evagrius, the demons have to be tackled in the right order, beginning with the demon of greed. Yet there are some differences. Cassian uses more Christian terminology than Evagrius and does not

talk about *apatheia* but about 'purity of heart'. He also interprets the relationship between *agape* and *apatheia* in a different way. For Cassian 'purity of heart' is *agape*, whereas for Evagrius *agape* is the child of *apatheia*.

Cassian stresses that contemplation is possible only with 'purity of heart'. But according to him it is additionally very important that this way of prayer is supported by a proper, deep, intuitive understanding of Scripture.

Prayer

In his writings on prayer in Chapters IX and X of the *Conferences*, Cassian brings out the Desert hermits' insistence on the repetition of one particular phrase to aid 'continual prayer':

> *Every monk who longs for the continual awareness of God should be in the habit of meditating on [this formula] ceaselessly in his heart, after having driven out every kind of thought, because he will be unable to hold fast to it in any other way than by being freed from all bodily cares and concerns.*

The 'formula' he recommends is from Psalm 69, a phrase known to every monk because of the daily singing of the Psalms: 'O God, incline unto my aid; O Lord, make haste to help me.' This is mainly seen as an aid to deal with distracting thoughts at the time of prayer, but he goes even further:

> *You should, I say, meditate constantly on this verse in your heart . . . You should not stop repeating it when you are doing any kind of work or performing some service or are on a journey. Meditate on it while sleeping and eating and attending to the least needs of nature.* (*Conferences* X.14)

Cassian sees this repetition of a prayer phrase as an important preparatory stage, a way of training the mind to achieve single-minded, effortless attention. He follows Evagrius' emphasis: 'When attention seeks prayer, it finds it.' It was a way of achieving 'constant and uninterrupted perseverance in prayer'.

It is a defence against distractions of any kind: 'wandering thoughts', demons such as 'sadness' or *acedia*, sensations and images. He calls it 'an impenetrable breast-plate', a 'very strong shield'. Like Origen in *On Prayer*, he recommends combining this with work as the best defence: 'He prays unceasingly who combines prayer

with necessary duties and duties with prayer.'

He sees this one pointed focus, 'an unchanging and continual tranquillity of mind', as essential to 'pure' prayer. He holds up Mary as the great example of what is needed in prayer, namely the quality of fixing the heart and mind on God in single-minded, loving attention (Luke 10.38–42).

Moreover, he describes it as a way of achieving 'poverty of spirit', knowing your need of God:

> *Let the mind hold ceaselessly to this formula . . . until it renounces and rejects the whole abundance of thought . . . Thus straitened by the poverty of this verse, it will very easily attain to that gospel beatitude which holds the first place among the other beatitudes . . . Blessed are the poor in spirit, for theirs is the Kingdom of Heaven.* (*Conferences* X.11)

Cassian's writings

The Institutes: a book for those starting out on the monastic life and for those intending to found communities.

The Conferences: a distillation of the teaching of the Desert Fathers and Mothers, a vast work about obtaining 'purity of heart' through the use of discretion; the even chapters relate to 'discernment' and the odd chapters to 'purity of heart'. *The Conferences* is about sitting at the feet of the Abbas, whom Cassian greatly revered. It is presented as a dialogue between an Abba and a disciple.

Although he lays emphasis on this way of prayer, he explains in *Conferences* IX that all types of prayer – supplications, wordless prayers, intercessions and thanksgiving – are valid, helpful and necessary at one time or another. But to him the highest form of prayer is 'fiery, wordless' prayer, when the mind 'pours out to God wordless prayers of the purest vigour'. To substantiate this he quotes St Antony: 'The monk who knows he is praying is not praying, but the monk who does not know he is praying is praying' (*Conferences* IX.31). This interior prayer is to him the essence of prayer as described in Scripture:

> *We pray in our room when we withdraw our hearts completely from the clatter of every thought and concern and disclose our prayers to the Lord in secret and, as it were intimately . . . We pray with the door shut, when with closed lips and in total silence we pray to the searcher not of voices but of hearts.* (*Conferences* IX.35)

Although Cassian recommends the repetition of a particular phrase, Owen Chadwick in his Introduction to *John Cassian: Conferences* (p. 14) points out that Cassian 'admitted that he personally could not be content with a single unvarying verse. His mind craved variety. He needed the whole body of Scripture, and would let it speak to him or in him as he found it.' He, like the Desert hermits, committed passages of

Scripture to memory to allow Scripture to speak to him in a meaningful way:

As we strive with constant repetition to commit these readings to memory, we have no time to understand them because our minds have been occupied. But later when we are free from the attractions of all that we do and see and, especially, when we are quietly meditating during the hours of darkness, we think them over and understand them more clearly. (*Conferences* XIV.10)

Not only is the repetition of a phrase Cassian's contribution to the development of Christian prayer, but also his insistence on preparation:

For whatever our soul was thinking about before the time of prayer inevitably occurs to us when we pray as a result of the operation of the memory. Hence we must prepare ourselves before the time of prayer to be the prayerful persons that we wish to be.
(*Conferences* IX.3)

It is quite clear, therefore, how all the essentials of prayer for Cassian are based on those of the Desert Fathers and Mothers: attention and detachment, silence and solitude, unceasing prayer; 'perseverance in prayer . . . as much as human frailty allows', imageless prayer; all leading to 'purity of heart' and 'poverty of spirit'.

Moral freedom and grace

Cassian, following in the footsteps of Evagrius, emphasizes both moral freedom and personal responsibility, as well as the workings of grace. This is in marked contrast to the view of St Augustine, who considered only grace necessary for salvation. St Augustine was in agreement with Athanasius. He accepted the theological standpoint of *creatio ex nihilo* and the consequent view that there was an unbridgeable gulf between God and creation. This clashed with the more positive view of human nature held by the 'Origenist' monks to whom Cassian belonged, namely that God's creation, including humanity, is essentially good. According to Cassian, human beings have been made in God's 'image' and therefore have a free choice to decide to lead a life of practice, purification and prayer resulting in acquiring once more a 'likeness' to God.

You should, I say, meditate constantly on this verse in your heart.

St Augustine's theory of 'original sin' implied that humanity had no potentiality

to choose whether to sin or not to sin, and was in fact incapable of personally achieving salvation. Consequently human beings depended entirely on the grace of God, helped by firm leadership given by the Church. This emphasis on the basic sinfulness of humanity since Adam and Eve's fall causes a permanent sense of unworthiness and guilt, and takes away any sense of personal responsibility for salvation. In this view there is therefore no point in purifying the emotions; all that is needed to achieve salvation is a strong faith and trust in God. St Augustine's view, as is generally the case, was very much based on his own experiences and perception of reality. His incapacity to control his own basic urges, especially his sexuality, made him draw the conclusion that this was so for everyone.

Cassian was in fact the spokesman for many monks who were upset by Augustine's denial of the moral validity of the *praxis*, in which they were engaged. He stresses the role of choice based on human free will, while at the same time confirming the necessity of grace. In his eyes Adam and Eve's behaviour does not cause the whole of humanity to become essentially sinful; on the contrary, their role is seen as a warning not to abuse our free will, our capacity to choose. Cassian even implies that the soul is not helpless but can make the first move; the prodigal son and the thief on the cross are cited by him as examples.

In *Conferences* XIII.8,13 he says:

> *Consequently there always remains in the human being a free will that can either neglect or love the grace of Grace . . . The grace of God always works together with our will on behalf of the good, helping it in everything and protecting and defending it, so that it sometimes even demands and expects from it certain efforts of a good will, lest it seems to bestow its gifts wholly on one who is asleep or relaxed in lazy sluggishness.*

Also around this time

AD300–525
During the Gupta Dynasty India trades with the eastern Roman Empire, Persia and China.

325
Emperor Constantine and his mother Helena discover Christ's tomb – shrine of the Holy Sepulchre.

400
Violent clash between Coptic monks and Origenist monks; the latter driven out of the Egyptian desert.

406
Visigoths head south into Italy.

410
King Alaric I occupies and plunders Rome, considered to be fall of the western Roman Empire.

410
White Huns invade Afghanistan and destroy Buddhist culture.

The virtue of discretion

Since, according to Cassian, we have freedom of choice to do either God's will or our own, he lays as much weight on the virtue of 'discernment' as did the Desert tradition, and illustrates the dangers of lack of discernment by the following story in *Conferences* II.5:

> *Remember the old man Hero who was cast down from the heights to the lowest states because of a diabolical illusion. I remember how he remained fifty years in the desert, keeping to the rigours of abstinence with a severity that was outstanding, loving the secrecy of the solitary life with fervour marvellously greater than that of anyone else dwelling here. After such toil how and why could he have been fooled by a deceiver? How could he have gone down into so great a ruin that all of us here in the desert were stricken with pain and grief? Surely the reason for it was that he had too little of the virtue of discernment and that he preferred to be guided by his own ideas rather than to bow down to the advice and conferences of his brethren and to the rules laid down by our predecessors. He practised fasting so rigorously and so relentlessly, he was so given to the loneliness and secrecy of his cell, that even the special respect due to Easter Day could not persuade him to join the brethren in their meal. He was the only one who could not come together with all his brethren assembled in Church for the feast, and the reason for this was that by taking the tiniest share of the vegetables he might give the impression of having relaxed from what he had chosen to do.*
>
> *This presumptuousness led to his being fooled. He showed the utmost veneration for the angel of Satan, welcoming him as if he were actually an angel of light. Yielding totally to his bondage he threw himself headlong into a well, whose depths no eye could penetrate. He did so trusting completely in the assurance of the angel who had guaranteed that on account of the merit of his virtues and of his works he could never come to any harm. To experience his undoubted freedom from danger the deluded man threw himself in darkness of night into his well. He would know at first-hand the great merit of his own virtue when he emerged unscathed. His brothers, who had to struggle very hard at it, pulled him out half-dead. He would die two days later. Worse, he was to cling firmly to his illusion, and the very experience of dying could not persuade him that he had been the sport of devilish skill. Those who pitied him his leaving*

had the greatest difficulty in obtaining the agreement of Abba Paphnutius that for the sake of the merit won by his very hard work and by the many years endured by him in the desert he should not be classed among the suicides, and hence, be deemed unworthy of remembrance and prayers offered for the dead.

Cassian bases his emphasis on 'discretion' on that of St Antony, who is quoted as saying:

The Desert Fathers, fresco

It is discernment, which in Scripture is described as the eye and the lamp of the body. This is what the Saviour says, 'your eye is the light of your body, and if your eye is sound then there is light in your whole body. But if your eye is diseased then your entire body will be in darkness' (Matt. 6.22–23). *This eye sees through all the thoughts and actions of a man, examining and illuminating everything which we must do.* (*Conferences* 11.2)

Cassian teaches that the questions to ask in discernment are first of all whether the matter is important or trivial; whether there is a 'deceptive appearance of piety'; whether the interpretation of Scripture is heretical or whether the 'demons' of 'vainglory' and 'pride' are at work.

Discretion is in his view basically common sense, guided by an attitude of moderation coming out of a lifelong experience of deep prayer. In *Conferences* 11.6 Cassian uses another story to illustrate this point:

And then there were the two brothers who lived on the far side of the desert at Thebais, where the blessed Antony had been. Travelling across the vast emptiness of that uninhabited region they were moved by a lapse of discernment to resolve that the only food they would take would be whatever the Lord himself offered them. They were staggering through the desert, weak from hunger, when they were spotted from a distance by the Mazices. This is a people more savage and cruel than almost any other tribe. Some

shed blood for the sake of loot but these are stirred by sheer ferocity. And yet in spite of their innate barbarism they rushed with bread to the two men.

One of them moved by discernment, accepted with joy and blessing the food offered him, as if it were the Lord himself who was giving it. In his view the food had been made available by God himself. It had to be God's work that those who always rejoiced in the shedding of blood were now giving of what they had to weak and wasted men. The other man refused the food. It had been offered by man. And he died of hunger.

Both had started out with the wrong decision. One, however, with the help of discernment changed his mind about something that he had rashly and imprudently decided. The other man stuck to his foolish presumptuousness. Knowing nothing about discernment he drew down upon himself the death that the Lord had wished to avert. He would not believe that at God's instigation wild barbarians had so forgotten their innate savagery as to come with bread instead of the sword.

The important virtue needed to avoid dangers is the one of 'obedience', which is basically an attitude of humility: 'The first evidence of this humility is when everything done or thought is submitted to the scrutiny of our elders' (*Conferences* 11.10). But even in choosing your Abba discernment needs to be exercised:

We must not follow the tracks or the traditions or the advice of all old men of whom white hair and the length of years are the sole recommendation. Rather, we must follow those who, we know, stamped their youth in a praiseworthy and admirable fashion and who were trained not by their own presumptions but by the traditions of their elders.

(*Conferences* 11.13)

Although Cassian strongly influenced the western monastic movement at its start, his clash with St Augustine meant that his main ideas about prayer did not survive for long. His short recommended phrase, meant for use in private prayer, became part of the set liturgy. His emphasis on personal effort and responsibility, and the discretion that this entailed, became one of obedience to the Church's directives in general.

KIM NATARAJA

ST AUGUSTINE OF HIPPO

Margaret Lane

St Augustine, *Philippe de Champaigne*

Introduction

With Augustine we come to the period in the history of early Christianity when the marriage between the Church and the Roman Empire was consolidated: as Piers Paul Read has noted, 'To be a Roman was to be a Christian.' This development happened partly because of the weakening of the Empire, at that time already besieged by warring tribes.

The Church, surrounded by political turmoil, felt that it needed to be administered and put on a legal footing similar to the Empire. The foundations for this were laid by the administrative and organizational skills of Ambrose, the son of a Roman prefect and senator, when appointed as Bishop of Milan. We need to see Augustine's life and teaching against this background of the need for a strong Church. Although he felt drawn to some form of monastic life initially, he was soon called upon to help to direct the Church. In that role he became one of the most influential Church Fathers.

Margaret Lane shows us, however, that his was a marriage of heart and mind – he was a brilliant philosopher and theologian, whose ideas were fed by a deep spirituality as expressed especially in the *Confessions*.

Unless otherwise indicated, quotations are from Augustine, *The Confessions*, trans. H. Chadwick (Oxford University Press, 1991).

St Augustine AD354–430

Aurelius Augustinus was born in Thagaste in present-day Algeria in North Africa of Berber descent. Although his mother was a Christian his father was a pagan and only converted when Augustine was 16. Much to his mother's dismay Augustine joined the Manichaeans, practitioners of an extreme dualist religion. He studied at the university in Carthage and had the usual classical education of that time, philosophy and rhetoric. Reading Cicero's Hortensius kindled his love of philosophy. He met a young woman with whom he had a relationship over 15 years and fathered a son. He first got a teaching post in Thagaste. When his father died he became a professor of rhetoric, first in Carthage and then in Rome and Milan, where his mother and son joined him.

Before becoming a Christian he was deeply attracted by Platonism. But soon his admiration for Ambrose, Bishop of Milan, coupled with his reading of the Life of St Antony, led him to convert to Christianity. Soon after, he returned to North Africa – his mother died just before he left Italy and soon after so did his son. Once there he started a community for himself and some friends along monastic principles. In 391 he was ordained priest and a few years later was appointed Bishop of Hippo, a position he retained until the end of his life. Yet even as a bishop he continued to lead a monastic existence. He died aged 75 when Hippo was besieged by Vandals.

AUGUSTINE'S INFLUENCE

The importance of Augustine

It would be difficult to overestimate the importance of St Augustine of Hippo. One translator of the *Confessions* has said that 'every person living in the Western world would be a different person if Augustine had not been or had been different'. Augustine was highly intellectual and extremely passionate. He was a great depth psychologist long before the discipline had been invented. He was the greatest Christian thinker before Thomas Aquinas. He was drawn to the contemplative life yet spent his last 35 years as a bishop dealing with pastoral needs, preaching and engaging in doctrinal disputes. Every branch of theology has been influenced by him and he is often cited in support by all sides in a theological dispute.

He has been described as the 'Father of Christian Mysticism' and the 'Prince of Mystics', despite a great deal of argument in some quarters as to whether he was a mystic at all! The argument has arisen because Augustine does not use the language of union to

describe the relationship of the soul with God. In fact he tends to emphasize the distance between man and God. Whether or not he may be regarded as a mystic does not, however, necessarily diminish his contribution to the area of mystical theology.

Whoever does not want to fear, let him probe his inmost self. Do not just touch the surface, go down into yourself; reach into the farthest corner of your heart. Examine it then with care. Then only can you dare to announce that you are pure and crystal clear, when you have sifted everything in the deepest recesses of your inner being. (Sermon 348)

To speak of 'mysticism' in the early centuries is anachronistic for the word was not coined until the seventeenth century. It tends to be associated with a private inner experience of union with God, one that is not mediated through Christ, Scripture or the community. This is not something that can be readily identified within Christianity until the twelfth century, when there was a growing interest in private individual experience. With regard to the earlier centuries Bernard McGinn in *The Foundations of Mysticism* defines the mystical element of Christianity as 'that part of its belief and practices that concerns the preparation for, the consciousness of, and the reaction to what can be described as the immediate or direct presence of God'. He also says that:

the importance of scripture must be clearly grasped if we wish to understand the nature of Christian mysticism because mysticism, especially down to the twelfth century, was for the most part directly exegetical in character. The cultivation of immediate consciousness of the divine presence took place within the exercise of reading, meditating, preaching, and teaching the biblical text, often within a liturgical or quasi-liturgical context.

McGinn notes three aspects to Augustine's mystical thought: (1) an account of the soul's ascension; (2) man as in the image of God and (3) the necessary role of the Church. All three aspects are found in the *Confessions*, which is the most popular and well known of Augustine's works. A common approach to the *Confessions* has been to concentrate on the story of Augustine's life and various conversions, which he presents in the first nine books, and to dismiss the remaining books as too speculative or philosophical. The effect of this has been to distort Augustine's mystical thought by focusing on one aspect of it and treating it anachronistically as an example of that private, individualized experience called mysticism. By ignoring the other two aspects we lose sight of the importance for Augustine of the mediation of Christ, the communal element and Scripture. We will attempt to redress the

Book of Confessions, *Pedro de Ribadeneira*

balance here and look at each aspect in turn, after some general remarks about the *Confessions*.

The Confessions

The *Confessions* is not the only work of Augustine important for his mystical thought (*On the Trinity* and *Expositions on the Psalms* are two other important works), but it is the most influential. It has had a profound effect on many people who have used it to interpret their own lives, including some of the best-known saints of the mystical tradition. Teresa of Avila has this to say:

When I began to read the confessions, I seemed to see myself there, and I began to commend myself often to that glorious saint. When I reached his conversion and read how he heard a voice in the garden, it seemed just as if the Lord said it to me, as my heart felt. I was for a long time all dissolved in tears, and was in great affliction and distress. Oh, how a soul suffers, God help me, from losing the freedom it had to be its own master, and what torments it endures! It amazes me now that I could live in such torment; praised be God who gave me life to come out of such fatal death!

(*The Life of St Teresa of Avila by Herself*, ch. 9)

Bede Griffiths was also deeply influenced:

It was so that the splendour of St Augustine's Confessions broke upon me. I do not think that I took in a tithe of their meaning, but the sense of contact with a mind, which was consumed with an ardour for truth and for that life of virtue which I desired, penetrated into the depths of my soul. It was an experience which I can only compare to the ardour witnnh which I used to read Shelley and Swinburne. But the emotion which it excited in me was no longer the vague emotionalism of Swinburne, but a passion of a religious love of an intensity which I had never known before. But at the

same time it was an 'intellectual love' like that of Spinoza, governed by an intelligence as clear and keen as his, and not blurred like that of Shelley by an undisciplined imagination. Here was, in fact, what I had so long desired to find, a record of a personal experience of passionate intensity and immense imaginative power, engaging all the energies of the intellect and the will in the search for truth.

(*The Golden String*, (Fount, 1979), ch. 3)

The *Confessions* is Augustine's spiritual autobiography. It is written in the form of a prayer to God and consists of 13 books that 'praise the just and good God in all my evil and good ways, and stir up towards Him the mind and feelings of men' (Retractions). In the *Confessions* Augustine takes us with him on his journey to self-knowledge and to God. 'Man must first be restored to himself that, making in himself as it were a stepping-stone, he may rise thence and be borne up to God' (Retractions). In the first nine books he tells the story of his life leading up to his conversions. In Book X he recounts the stages of ascent, giving a detailed explanation of the importance of memory as the pathway to God, and then embarks on a detailed examination of his present inner state (about 10 to 13 years after the last of the events narrated in Book IX). In Book XI he considers the question, 'What is time?' before beginning a detailed interpretation of the beginning of Genesis, which he continues to the end of Book XIII, where we look forward to the Sabbath rest for ourselves and all of creation. Augustine sees his journey, and that of everyone, as the journey in microcosm of the whole created order, passing through the same stages of creation, fall, conversion and fulfilment.

Thou made us for Thyself, and our heart is restless until it rests in Thee.

We travel with Augustine in three dimensions. We travel backwards and forwards in time, outwards to the world and inwards into our deepest being, upwards towards God and downwards into ourselves. We travel back to where and when Augustine began his journey.

Augustine's historical and social context

He was born in AD354 in Thagaste (now Souk Ahras in Algeria), a small provincial town in the hinterland of North Africa. This area had been an affluent part of the

Augustine's writings

Confessions
A personal account of his early life.

On the Trinity

The City of God
Written to boost the confidence of Christians after the Vandals sacked Rome.

Expositions on the Psalms

On Teaching Christianity

Homilies on 1 John

Roman Empire in the first three centuries after Christ because of the grain planted on the Numidian plateau. By the fourth century the area was rather faded, the wealth having moved further south where native Punic-speaking Africans became rich from the production of olive oil. By this time the Roman Empire was declining and Africa, though valued for the payment of taxes, was regarded as a backwater, its inhabitants viewed with some amusement for their distinctive way of speaking Latin.

Augustine was born into a middle-class but relatively poor family who owned an estate of a few acres and a few slaves. His father was a pagan and sat on the town council, which brought social kudos but financial burden. His mother Monnica was a devout Christian. Both were ambitious for the secular advancement of their son. Social mobility was quite possible in Augustine's world with talent and luck. Education was the key to escaping from the provincial backwater, and with financial help from a local patron Augustine was able to acquire a secondary education at nearby Madauros and then go on to university at Carthage, the provincial capital. He trained as an orator before going on to teach rhetoric in his home town, Carthage, Rome and Milan, where he touched the fringes of the imperial service. Augustine's culture was Latin-speaking and his education literary rather than philosophical, Virgil and Cicero being his formative influences.

Augustine was brought up a Catholic Christian. As a child he prayed to God, whom he conceived of in the usual childlike way as 'some large being with the power, even when not present to our senses, of hearing us and helping us' (*Conf.* I.ix(14)). The religion of his childhood was one that placed great store on dreams as sources of divine communication. The African view of God was of a vengeful god who needed to be appeased by sacrifices. The Bible was read in the Old Latin version, which predated Jerome's Vulgate. It was taken literally, and was crude and unappealing to the educated man. Christ was seen as a teacher of wisdom rather than a suffering Saviour.

This is the social and historical context in which to understand Augustine. From this starting point he travels outwards into the world, at first wandering aimlessly, like the prodigal son, away from home in search of worldly wealth and recognition.

Then, on his awakening by Cicero's philosophical treatise *Hortensius* to a desire for wisdom, we accompany him on his long and tortuous search as he explores the Old Latin Bible, the Manichees, astrology and the Sceptics, and then as he draws near to Ambrose the bishop and discovers Platonism and its near compatibility with Christianity. We begin to travel inwards with him at this point.

Finally, though always simultaneously, we travel along a continuum of being where God is absolute being and we are creatures made from nothing. Books I and II tell the story of Augustine's wilderness wanderings away from God, culminating in his fall into 'a region of destitution', namely himself (*Conf.* II.x(18)). This occurred in his sixteenth year during an enforced break in his studies while his family tried to raise the money for him to continue with them. He decided, along with some companions, to steal pears from an orchard, not because he wanted to eat the pears but simply to feast on his own wickedness. His motive is what Augustine regarded as most reprehensible.

Augustine's account of the ascent of the soul

In the *Confessions* Augustine describes several experiences he has of God using the metaphor of the ascent of the soul to God. The first is described in Book VII after he has been introduced to 'some books of the Platonists' (probably Plotinus) in Milan. These introduced him to the idea of a transcendent, spiritual reality, exhorting him to turn inwards, away from the created world, in his search for God (*Conf.* VII.x(16)). Augustine describes this experience as a Christian, not as a Platonist would. In the Platonic worldview there is no sense of a personal relationship between the One and man; the One would not have helped or guided man to his vision of the One, but Augustine's God 'called and cried out loud and shattered my deafness' (*Conf.* X.xxvii(38)). It is also clear that this experience was not one of union with God. If anything it was the opposite. Unlike Plotinus, for whom turning inwards was sufficient to discover that we are divine, Augustine 'entered and with my soul's eye, such as it was, saw above that

Also around this time

AD340–97
Ambrose, Bishop of Milan; teacher of St Augustine.

406–10
Visigoth army overruns Italy and Alaric, Visigoth leader and Roman general, sacks Rome.

418
Jews excluded from public office in Roman Empire.

422
Bible and works of Church Fathers translated into Armenian.

429
Roman Africa invaded by the Vandals under King Gaiseric.

430
St Augustine dies as Vandal army lays siege to Hippo.

439
Vandals occupy Carthage.

same eye of my soul the immutable light higher than my mind'. Our discovery is not that we are sparks of divine essence, of one being with God, but that we are separated from God. 'It was superior because it made me, and I was inferior because I was made by it.' We are creatures created from nothing (*ex nihilo*) by God the creator. What the experience gave Augustine was the realization of the distance between himself and his creator. 'And I found myself far from you in the region of dissimilarity and heard as it were your voice from on high. You cried from far away.' However, the experience did give Augustine faith, hope and love. What more could he want? More of the same – but before he could have this he needed to undergo a conversion of will.

> *I was astonished to find that already I loved you, not a phantom surrogate for you. But I was not stable in the enjoyment of my God. I was caught up to you by your beauty and quickly torn away from you by my weight. With a groan I crashed into inferior things. This weight was my sexual habit. But with me there remained a memory of you. I was in no kind of doubt to whom I should attach myself, but was not yet in a state to be able to do that. 'The body, which is corruptible, weighs down the soul, and our earthly habitation drags down the mind to think many things.' At that moment I saw your 'invisible nature understood through the things which are made' (Rom. 1.20). But I did not possess the strength to keep my vision fixed. My weakness reasserted itself, and I returned to my customary condition. I carried with me only a loving memory and a desire for that of which I had the aroma but which I had not yet the capacity to eat.* (*Conf.* VII.xvii(23))

The second experience he had was a mystical ascent shared with his mother Monnica after he was baptized and just before she died. The communal nature of this vision should be stressed and also the fact that Monnica, who was untrained in philosophy, was able to attain such a vision. Later in the *Confessions* Augustine makes it clear that all faithful believers are capable of seeing the truth, which has a multiplicity of perspectives. This is very different from the Platonic view according to which the higher one moved up the continuum of being, the closer one came to the truth. In both experiences Augustine describes the same process, whereby an ascent is made step by step by withdrawal from external bodily things to the soul, from the soul to the most inward part of the soul, to the power of reasoning, to

Wisdom itself. For Augustine the experience was a foretaste of the beatific vision but in this life could only be a transitory one. His description of it is worth quoting at some length:

> *Our colloquy led us to the point where the pleasures of the body's senses, however intense and in however brilliant a material light enjoyed, seemed unworthy not merely of comparison but even of remembrance beside the joy of that life, and we lifted ourselves in longing yet more ardent toward that which is, and step by step traversed all bodily creatures and heaven itself, whence sun and moon and stars shed their light upon the earth. Higher still we mounted by inward thought and wondering discourse on your works, and we arrived at the summit of our minds; and this too we transcended to touch that land of never-failing plenty where you pasture Israel for ever with the food of truth. Life there is the Wisdom through whom all these things are made, and all others that have been or ever will be; but Wisdom herself is not made: she is as she always has been and will be for ever. Rather should we say that in her there is no 'has been' or 'will be', but only being, for she is eternal, but past and future do not belong to eternity. And as we talked and panted for it, we touched the edge of it by the utmost leap of our hearts; then sighing and unsatisfied, we left the first-fruits of our spirit captive there, and returned to the noise of articulate speech, where a word has beginning and end. How different from your Word, our Lord, who abides in himself, and grows not old, but renews all things.* (*Conf.* IX. x (24) in *The Confessions*, trans. M. Boulding (New City Press, 2001))

St Augustine, *Aidan Hart*

Man made in the image of God

Augustine came to understand that the experience of ascent was not the apogee of the spiritual life but the starting point. Such an experience awakens the soul's longing for God. 'You stir man to take pleasure in praising you because you have made us for yourself, and our heart is restless until it rests in you' (*Conf.* I.1.(1). The real journey then begins. For Augustine man was made in the image of God and the Trinitarian nature of God is reflected in the three faculties of the soul:

Love the sinner and hate the sin.

memory, understanding and will/love (*Conf.* XIII.XI(12)). The spiritual journey is a journey to restore the image of God in man: 'May I remember you, understand you, love you. Increase all these things in me until you reform me fully' (*On the Trinity* 15.28.51). Augustine explores this fully in the later work *On the Trinity*. The trinity is not mentioned at all in the *Confessions* until Book XIII, but the part that understanding, memory and will/love play in the search for self-knowledge and knowledge of God is made clear throughout.

The ascent experiences at Milan gave Augustine a great deal of understanding but he did not have the strength to hold on to the vision. Augustine's ensuing struggle to surrender his own will to the will of God is described in Book VIII as a battle to be sexually continent, culminating in his conversion in a garden in Milan. There, in a state of utter turmoil, he responds to a voice urging him to pick up and read the Scriptures, and his eye falls on the passage, 'not in riots, and drunken parties, not in eroticism and indecencies, not in strife and rivalry but put on the Lord Jesus Christ and make no provision for the flesh in its lusts' (Rom. 13.13–14). Augustine's heart is pierced by the living Word of God and he breaks down in floods of tears. But they are tears of relief, for the breakdown is a breakthrough to the realization that, though he may not have the strength in himself to take the decision to commit to a celibate life, Augustine can rely on God's strength to see him through. And so he undergoes a conversion of will, submitting his will to the will of God.

Confession is crucial in the ongoing battle to align his will with God's. In the second half of Book X, Augustine embarks on a rigorous self-examination of all the ways in which he continues to fall short of being reformed in the image of God. The sexual continence he struggles with before his conversion and baptism is just one example of the self-restraint that Augustine regards as crucial if we are to be single-minded and focused upon our search for God: 'by continence we are all collected and bound up into unity within ourself, whereas we had been scattered abroad in multiplicity' (*Conf.* X.XXIX(40)). He examines the areas where he fails to exercise the appropriate degree of self-control, taking as his framework the scriptural text, 'for all that is in the world — the desire of the flesh, the desire of the eyes, the pride in riches — comes not from the Father but from the world' (1 John 2.16). The desire of the flesh encompasses the desires associated with the five senses. The desire

of the eyes takes the form of unrestrained and inappropriate intellectual curiosity, for example, to know the hidden things of God which cannot be known. Pride in riches speaks for itself. In all cases it is a question of desire that is misdirected and needs to be re-orientated to its proper object – God.

We are fragmented not only on account of our desires but also because we are creatures in time. After his conversion Augustine expresses a desire to spend all his time meditating on Scripture as God's holy Word (*Conf.* XI.II(2)). His problem (and ours) is that God's Word speaks eternally – that is, *NOW* – and we are creatures in time. Augustine therefore examines the problem of time in Book XI not as a philosophical exercise but in an effort to find a pathway to God.

Important figures

Ambrose 337–97
Eminent Bishop of Milan in the fourth century.

Plotinus 205–70
Major philosopher, like Origen a pupil of Ammonius Saccas; father of Neo-Platonism; tremendously influential in Christianity, Judaism and Islam.

Mani 210–77
Prophet who founded Manichaeism, a major dualistic religion with Zoroastrianism, Gnostic, Christian and Buddhist influences.

> *People attempt to taste eternity when their heart is still flitting about in the realm where things change and have a past and future; it is still vain. Who can lay hold on the heart and give it fixity, so that for some little moment it may be stable, and for a fraction of time may grasp the splendour of a constant eternity?* (*Conf.* XI.xi(13))

The third member of the trinity in man is memory, which for Augustine equates to the conscious mind. It is memory that for Augustine provides us with access to God, and he embarks on how this is so largely, though not exclusively, in the first part of Book X. When Augustine has travelled inwards through the various degrees of his soul he comes at last to the 'fields and vast palaces of memory'. He discusses the various contents of his memory and then, crucially, the problem of forgetfulness. It is not that we never knew God but that we have forgotten him. Our conversion consists in remembering what we once knew. This is not however to be mistaken for the Platonic doctrine of *anamnesis*, according to which we are remembering something we once knew in a previous existence. It is a reference to ourselves as fragmented creatures. Conversion involves recollection of our experiences and feelings from the recesses of our memories. This gives us both self-knowledge and knowledge of the immanent God. But something more is needed: knowledge of the transcendent God, a knowledge that can only be revealed by God illuminating our minds from above. This is possible because the self-transcendent character of memory provides the gateway to God:

What is the light which shines right through me and strikes my heart without hurting? It fills me with terror and burning love: with terror inasmuch as I am utterly other than it, with burning love in that I am akin to it. Wisdom, wisdom it is which shines right through me, cutting a path through the cloudiness which returns to cover as I fall away under the darkness and the load of my punishments. (*Conf.* XI.ix(11))

The necessary role of the Church

Augustine's search for God was not an individual one once he had been baptized. Looking back to his pre-conversion ascent at Milan from the perspective of a baptized and ordained Christian, he is struck by the pride of the man who introduced him to the books of the Platonists. These were men who knew the goal but did not know the way (*Conf.* VII.xx(26)). Without knowing the Way, which is Christ,

[m]any have tried to return to you and have not had the strength in themselves to achieve it, so I have been told. They have attempted these methods and have lapsed into a desire for curious visions, and have been rewarded with illusions. For in their quest they have been lifted up by pride in their high culture, inflating their chest rather than beating their breast. (*Conf.* X.xlii(67))

Augustine had discovered everything in the books of the Platonists that married with his understanding of Christianity, except for the crucial thing – the Incarnation. Christ is the one in whom we were gathered from multiplicity into unity and taken up into the Trinity to participate in God's life. But it was important that Christ had become man and shown us the way of humility and hope. The latter books of the *Confessions* stress the communal and ecclesiological nature of Augustine's mystical theology, which is perhaps first hinted at in the fact of a shared mystical vision with his mother Monnica.

Christ is the teacher within us.

Augustine realized that his way to fulfilment or perfection of the image was to meditate on Scripture rather to attempt a Platonically inspired mystical ascent. Scripture is a way that is open to everyone to follow, unlike the ascent by reasoning, which is accessible only to the more philosophically minded, for Scripture may be understood at different levels:

What wonderful profundity there is in your utterances! The surface meaning lies open
before us and charms beginners. Yet the depth is amazing, my God, the depth is amazing.
To concentrate on it is to experience awe — the awe of adoration before its transcendence
and the trembling of love. (*Conf.* XII.xiv(17))

Augustine concludes the *Confessions* with an allegorical interpretation of the
first chapter of Genesis in relation to the Church. Heaven and earth are the spiritual
and carnal members of the Church (*Conf.* XIII.xii(13)). Scripture is the firmament
(*Conf.* XIII.xv(16)). The dry land is the Church and the sea corresponds to the
society of faithless believers (*Conf.* XIII.xvii(21)). The fruits of the earth are the
good works of the active life and the contemplative life is likened to the created
lights that give light to the world (*Conf.* XIII.xvii(22)). The heathen are reptiles and
the perfect Christian the living soul. 'He it is of whom God says, "Let us make man
in our image", so man is renewed in the knowledge of God after the image of him
who created him' (*Conf.* XIII.xxii(32)).

Conclusion

After his conversion and baptism Augustine moves towards self-knowledge and the
knowledge of God by listening to the Word of God in Scripture: 'To hear you speak-
ing about oneself is to know oneself' (*Conf.* X.iii(3)). And he is sustained on his
journey by glimpses of God:

Sometimes you cause me to enter into an extraordinary depth of feeling marked by a
strange sweetness. If it were brought to perfection in me, it would be an experience quite
beyond anything in this life. But I fall back into my usual ways under my miserable
burdens. I am reabsorbed by my habitual practices. I am held in their grip. I weep profusely,
but still I am held. Such is the strength of the burden of habit. Here I have the power to
be, but do not wish it. There I wish to be but lack the power. (*Conf.* X.xl(65))

Hence the importance of confession. It is confession, not ascension, that keeps Au-
gustine moving on his journey to God. Confession of what he is, which he can know
only to the extent that God has revealed him to himself. When God has revealed to
him a shortcoming Augustine confesses it as sin. When God reveals some praiseworthy
quality Augustine hands it back to God in a confession of thanksgiving and praise.

MARGARET LANE

ELEVEN

ST BENEDICT

Esther de Waal
and
Stefan Reynolds

St Benedict, fresco

Introduction

By Benedict's time the Empire had really collapsed in the West, overrun by the Goths; the 'Dark Ages' had begun. Outside the monasteries life was precarious. In the midst of all this turmoil Benedict laid the foundations of western monasticism and in doing so preserved ancient culture and kept the light of spirituality burning.

The chaos of the outside world made Benedict emphasize strongly the Desert virtues of stability and obedience to one's Abba, whose loving guidance was based on discretion and wisdom. His injunction to 'work and pray', *ora et labora*, reflected the need for self-sufficiency at this time. All these virtues, as well as the contemplative interiorizing of Scripture, *Lectio Divina*, and the controlling of thoughts leading to silence, find their source in the desert. Benedict actually mentions Cassian and recommends his *Conferences* and *Institutes* to his monks for daily reading.

Esther de Waal explains that the reason Benedict wrote a rule was to impose a balanced structure of life for a group of men so that they could live together in a way that makes prayer, *Opus Dei*, central. But although written then for a particular purpose, she emphasizes that the *Rule* has an enduring quality that is still of practical relevance to ordinary people today, whether oblates or not.

St Benedict AD480–547

Most of our information about Benedict's life comes from the biography in *The Dialogues of Gregory the Great*, which was written about 40 years after his death based on the memories of actual witnesses. It is a hagiography, so not entirely reliable. Benedict was born in 480 in Nursia into a comfortable middle-class family with servants and fine food. He was sent to study the liberal arts at university in Rome. But it was not to his liking and he escaped with his old nurse to go off and live the life of solitude and prayer. He felt that intellectual study was important, but more important was the wisdom of the heart. By the time he was about 20 years old he was living in a cave at Subiaco in the Apennines. There he lived as a solitary for a number of years, 'holding himself still before the gaze of God'. This was a time of true 'obedience', attentive listening to the Word of God, a time of growing self-knowledge. Soon disciples came, whom he organized in a dozen small communities, but this took away his solitude. After 20 years or so, after an assassination attempt by the local priest, when Benedict was saved by a raven that flew and knocked the cup of poison out of his hand, he left Subiaco and became the founding father of a small community of men at Monte Cassino. Therefore the symbol associated with Benedict is the broken cup.

These were men from every sort of social and ethnic background. There were landowners, illiterate peasants, people with degrees, Goths and Vandals all living together and earning their living manually as well as using their minds in the study of Scripture and putting prayer at the heart of their lives. Soon after, Benedict also started a community of nuns led by his sister Scholastica.

We know about Benedict not only through his biography but especially through his legacy of the *Rule of St Benedict*. The *Rule*, which he wrote for his early disciples in 500, no doubt finds its source, like that of St Basil, in the simple *Rule of St Pachomius*, but it is also directly inspired by an anonymous text, *The Rule of the Master*. From the seventh century onwards it replaced all earlier monastic rules, which were regarded as more severe, and was universally adopted in the West. Anyone therefore who wanted to be a monk had to follow the *Rule of St Benedict*.

ST BENEDICT'S RULE

Benedict comes to write his *Rule* in order to guide his early community. He wants us to listen to him and to God with the ear of the heart. The aim of the *Rule* is to help his followers to love each other against all the odds. It helps them to find time for the balanced life of body and mind and spirit, of manual labour, of intellectual work and above all of prayer. It is about balance and harmony in all aspects of life.

It is very short, about 900 words, and yet it is a *Rule* of wisdom such as can only come out of lived experience. There is nothing abstract or theoretical in this rule; it is a practical handbook. It has such flexibility about it and it shows such insights into the human psyche, that although written for men in rural Italy in the sixth century, it remained a living document able to guide, support and change lives, throughout the Middle Ages and into our time. It has spread so that today there are Benedictines world-wide, men and women, living the vowed life. There are great numbers of lay people, 'oblates', who are attached to some community, but there are also many who are simply finding that, as their loyalty to the Church is sometimes pushed almost to its limit, it is the monastic tradition that speaks to them. Because it comes out of inescapable reality, it can speak to them in a way for which they are immensely grateful.

St Benedict delivering his rule

What is it about the monastic tradition that gives it this enduring quality? Something I read recently said that while the institutional churches are having quite a hard time at the moment, people are waking up to hear the monastic bell calling them.

The monastic day begins with matins or vigils when it is hardly yet dawn. It is a wonderful start: it means to be vigilant, to be attentive, alive, awake. Here the Benedictine monastic tradition shares much with other monastic traditions, Christian and non-Christian, in its emphasis on attentiveness, mindfulness.

By keeping watch for the dawn, keeping watch for the coming of Christ, keeping watch for a sleeping world that doesn't know how to perform that office of keeping watch for itself. Ensure that like the wise virgins in the Gospel, you are alert and awake. Benedict wants all of us to be simply that fully alive and fully awake; not wasting life by being half-hearted, but enjoying the fullness of life.

The Prologue

The Prologue is the most lyrical part of the *Rule* and a most wonderful piece of writing. It stands easily on its own and is like the overture to everything else that is to follow. Terence Kardong OSB wrote that the Prologue is based on the teaching for those to be baptized at Easter in the ancient Church. Quite early on, Benedict gives us the image of Christ standing in the market place, asking us, 'Do you want life? Do you want fullness of days? If you do, stop, pay attention to me because this is what is on offer.'

In the end there is no difference between what Christ is offering in the Gospel and what Benedict is offering. Christ is always saying to people that what is on offer is life. You don't want to drift and you don't want to go through life half asleep. Benedict was in his own day the same sort of man, drawing people to him by the sheer energy of his own Christ-filled life. The *Rule* that he devised for his followers was simply that they should live the life of the gospel, making the very radical values of this gospel immediate and real in their daily lives. Benedict wants us to experience what he himself experienced: the reality of Christ at every turn of the road, at every moment of the day.

If you read the whole of the *Rule*, you will find that Christ, the resurrected Christ, is there on every page and in every chapter. It is the Christ in whose image we are made. The *Rule of St Benedict* is simply basic Christianity taken seriously. Everything in the *Rule*, this practical handbook for daily life, applies to any of us who are following Christ under our baptismal vows; everything in the Benedictine tradition points to the gospel, to the gospel of love and to Christ.

Benedict is not writing anything abstract or theoretical. The *Rule* is based on the reality of the gospel values, worked out in day-to-day situations, and is therefore immediate and real.

There are certain questions in life that are inescapable and are fundamental realities. 'How do I live with myself?' 'How do I live with other people?' 'How do I live with the world around me, with matter, with the tools of daily life?' 'How do I live with God by making sure that praying is the centre of it all?' Benedict tells us that there is no dualism here between the spiritual and the material. The tools of the kitchen, pantry and garden are to be handled with as much respect and reverence as

if they were the sacred vessels of the altar. He teaches respect and reverence for everything and everyone.

From the twelfth century on each monastery had its cloisters: the four sides housing the dormitory, the refectory, the scriptorium or library, and the chapter house, where the monks met daily to read a chapter of the *Rule* before making the day-to-day decisions about administration and the efficient organization of a large and complex building. The fourth side is the church itself, to which the monks go seven times a day for their work of daily prayer. Thus we see here something symbolic – everything flows in and out of prayer, everything is anchored in prayer.

Dom Dominic Milroy OSB has called the walkway that goes along the cloisters a seamless garment, since for Benedict eating, sleeping, working, praying and studying all flow into one another. But in the middle there is an open space, where there may be a fountain; it is this open, uncluttered, empty space that we all need to hold at the centre of our own busy lives, because this empty space is the place where we listen to the voice of God in our hearts.

The *Rule* has a firm sense of structure, with discipline for those who break the rules. Benedict shapes life in the monastery according to order, structure, framework and rhythm; he pays attention to the organization of time and space; the day is planned to flow easily and gently. None of this is done for its own sake but in order for us to have that calm uncluttered space in the centre of our lives. Its aim is to achieve balance between all the aspects of life, physical, cerebral, intellectual.

Underlying this is his recognition that we are all made up of body, mind and spirit. Benedict stresses that the body is good, our physical self is God-given. Therefore there should be enough food and it should be enjoyed; it should be carefully presented with a choice of dishes and some wine. He

Also around this time

AD451
Council of Chalcedon pronounces Christ both divine and human.

452
Attila the Hun invades Italy and three years later sacks Rome.

476
Western Roman Empire formally abolished by Germanic General Odoaker deposing young Romulus Augustus.

527–48
Empress Theodora and her husband Justinian rule Byzantine Empire.

527
Building of St Catherine's monastery in Sinai started by Justinian.

529
Justinian closes Platonic Academy in Athens.

532
Boniface II, first German pope, dies.

537
Goths lay siege to Rome.

541–750
Plague rages around Mediterranean, killing 40 million people.

550–1200
Period of Irish monasticism, keeping civilization alive in the Dark Ages.

even paid attention to clothes; they should fit and be discarded when they get too ragged. He knows there is a real connection between self-respect and having decent clothes. But also our intellect and our imagination are to be stretched and fed. He encouraged his monks to study Scripture and the living tradition of the Church, the riches of the Fathers, the Desert Fathers and Cassian above all.

Benedict was a man absolutely soaked in the Scriptures. If you want some facts, there are 321 quotations from the Scriptures in this very short *Rule*, but it's much more than that; there are resonances of the Scriptures all the way through. He knows the Psalms, he reads the Psalter. He wants his monks to be followers of Christ, the Word. Then he has this way of letting the spirit be refreshed by *Lectio Divina*: you take your word, you take your phrase, and hold it in your heart. You ponder it – from *pondus*, the Latin word for 'weigh'; and you weigh it because it is God's gift to you today. Then it moves from your mind to your heart into silence, and then it breaks into flame.

The Benedictine vows

It would be impossible to talk about Benedict, the Benedictine tradition and the Benedictine contribution to the whole monastic tradition without looking at the Benedictine vows. These are not poverty, chastity and obedience, which were introduced only in the twelfth century. They are the old and original monastic commitments to stability, conversion of life and obedience.

Obedience comes from the Latin *obaudire*, meaning to listen intently; conversion of life is about continual personal change and transformation. Stability is unique to Benedict, and is his great contribution to the monastic tradition. It requires each monk to stay in one place. They are not allowed to wander. Of course, this emphasis is already found with the Desert Fathers: 'Stay in your cell and your cell will teach you everything.'

By this commitment to stability, Benedict is trying to inculcate a firm and strong interior, which is patient and persevering. Without that at the centre of our lives, everything else is going to be very fragile indeed. Stability is also about personal relationships, staying alongside that impossible person, learning to love him or her.

Yet paradoxically Benedict balances it with continual conversion, or continual change and transformation. It is all about the journey. When you read the Prologue,

it is full of words like 'journey' and the urgency of moving forward all the time. It is about transformation, by which we are changed into the likeness of Christ.

That journey is going to be tough; the path will continue to be narrow and steep, but change will come in our own hearts. Benedict promises us that, if we hang on there with stability and allow love to enter into our hearts, they will expand with overflowing love. The bottom line with Benedict is the question we should ask ourselves each day: 'Am I becoming a more loving person?'

The third vow is obedience. Obedience can seem very threatening, and indeed in Benedict's day he had to deal with two rather alarming views of obedience: the Roman civic obedience and that of the Jewish tradition. We see Christ's obedience to his Father, listening to his words. Obedience is an active response to the voice of God in our hearts; not what I want, but what God wants for me.

At the very end of the *Rule* Benedict talks about how, with God's assistance, we will arrive at our heavenly home. One way of looking at the *Rule* is seeing it as a way to bring us home. Benedict wants us to stay on the right path so that, finally, we are welcomed by the Father who is going to accept and forgive us – the image of the prodigal son. The image with which the *Rule* opens: Listen, my son.

Every day for the Benedictines – and in the Anglican tradition – the day began at matins with Psalm 25, with the key phrase, 'Today if you will hear my voice, harden not your hearts.' 'Listen with the ear of the heart' is the daily reminder that there is the loving voice of God that we could hear if we had that uncluttered space within us, the voice calling us home.

ESTHER DE WAAL

———————————

Stefan Reynolds focuses on four important principles or attitudes in the *Rule* that Benedict hopes to foster in us. His quotations are taken from *Saint Benedict's Rule*, trans. and ed. Patrick Barry OSB (Ampleforth Abbey Press, 1997).

Benedict was a Roman. Like any good Roman he had a flair for organization, a concern for order and a respect for authority. Monastic life for him was to be structured; it was to follow a rule and a hierarchical chain of command. He was founding

his monasteries at the time the Roman Empire was breaking apart, weakened by corruption at the centre and barbarian invasion from without. Benedict's monasteries were to be held together by a strong and responsible central leadership. The Abbot or Abbess 'holds the place of Christ'; however, he/she was always accountable to the *Rule* and God. This centre would not be corrupt and would recognize that it was part of a higher chain of command.

As for barbarian invasions from the outside, Benedict wanted his monasteries enclosed. All the necessities of life should be found within; 'there should be no need for monks to roam outside', he writes, 'because this is not at all good for their souls' (ch. 66). Leaving the fortress of the monastery was spiritually unsafe. Journeys needed the Abbot's permission and travellers 'should not presume to relate to anyone what they saw or heard outside the monastery, because this causes the greatest harm' (ch. 67). Benedict was a man of his time.

How then do we now relate to his rule? How much of it is culturally conditioned and a response to the situation of its time? Is it possible to distil from the *Rule* an essence that is applicable to the different social and historical context of today?

'Rule', like the word 'guru' in India, implies something that helps straighten the way to God, a guide that helps us avoid extremes and orientate ourselves in the right direction. What then are the basic principles or spiritual attitudes that Benedict's rule points us towards? Is it the need for authority, spiritual dependence on a father figure or an objective code of behaviour? Is it the need for a highly structured life, where nature and spontaneity is regulated by discipline and self-control? Is it fear of the world, hiding away from the onslaughts of barbarian secularity in a separate spiritual reality?

I propose that all these are responses that suit particular times and temperaments, of history and our own life. They are not the essential orientation of the *Rule*. Benedict is not primarily concerned with the external ordering of our lives but rather with a genuine seeking after God. He is offering the soul a direction and a flat playing field, so that 'as we progress in this way of life and in faith, we shall run in the way of God's commandments' (Prologue). The shape and form of the life can be changed according to circumstance (ch. 40). It is pragmatic rather than programmatic.

Can one then distil a spiritual essence out of the *Rule*? Not in terms of a mystical treatise or a developed teaching on prayer; Benedict pointed beyond himself for

that to the teachings of the Desert Fathers and Mothers (ch. 73). Benedict was concerned with the rudimentary, the beginnings of monastic life. He wanted to give a practical framework on which the higher edifices of the spiritual life could be built. As in all Desert spirituality, moreover, there was for Benedict no split between the outer and the inner. Spirituality was a lifestyle and the way you lived was the way you prayed (and vice versa). So the best expression of an authentic relation to God was the way you related to your neighbour. Life in common was for Benedict the crucible of the spiritual life, both its testing ground and the place where 'zeal for God' expresses itself in patience, mutual obedience and respect (ch. 72). I propose that there are four principles or attitudes on which that common life is grounded and through which Benedict orientates his disciples to God: obedience, peace, faith and works together, and humility.

Obedience

Benedict calls those who would follow Christ to 'the labour of obedience' (Prologue). This involves qualities of attentiveness, listening, readiness of response, cheerful generosity, laying down of one's own will, mutual respect and concern: 'No one is to pursue what they judge better for himself, but instead, what they judge better for someone else' (chs 5, 71, 72).

Peace

'Let peace be your quest and your aim' (Prologue). This involves an esteem for silence (ch. 6), especially at night and in the oratory (chs 42, 52), refraining from gossip (ch. 6), purity of prayer (chs 20, 52), and 'supporting with the greatest patience one another's weaknesses of body or behaviour' (ch. 72).

Faith and works

They always go together. 'Idleness is the enemy of the soul' (ch. 69). Prayer is the 'Work of God', it comes before all else (ch. 47), and must be properly performed (ch. 45). 'Work' includes manual labour, prayerful reading and the work of hospitality (chs 48, 53). The tools of the workplace and kitchen are to be respected like the vessels of the altar (chs 32, 46). Stability in the community and monastery is 'the workshop' in which 'the tools of the spiritual craft' are practised (ch.4).

Humility

'Not to us, Lord, not to us give the glory, but to your name alone' (Ps. 113.9; Prologue). The Twelve Steps of humility (ch. 7) undercut any false sense of complacency or self-satisfaction. They urge vigilance: we have to be continually on our guard against our own destructive tendencies. Humility is what keeps us connected, down to earth, real. It involves a true self-appraisal, not overestimating our strengths but recognizing that we are always in the presence of God. This 'grounding experience' often involves endurance, perseverance and longsuffering.

Conclusion

These I believe are the qualities and orientations that Benedict hopes to foster in us. He is like a gardener removing the weeds so that the flowers can grow, the fruits of the Spirit. The *Rule* therefore acts like a garden hoe and watering can, clearing the space, tidying things up and then making sure the plants are well watered. At times like secateurs it prunes, at times like a lopper it removes what is incompatible with our spiritual growth. That these principles are the true criteria for monastic life can be seen in Benedict's procedure for receiving new members (ch. 58): 'The concern', he writes, 'must be whether the novice truly seeks God and whether he shows eagerness for the Work of God, for obedience and for trials.'

Here are the four attitudes that I see as key to the life Benedict envisions, attitudes which, in the rich meaning he gives them, are applicable to us today. They do not necessarily involve a hierarchical understanding of authority nor a seclusion from the world. They don't necessarily involve changing the external form of our life, except maybe to give adequate space for prayer. They do however challenge us to a conversion of manners, not what we do but the way we do things. Benedict's wisdom is timeless because it is the wisdom of the gospel, yet has always to be newly envisioned so it can continue to be a guide to 'the good life' (Prologue).

STEFAN REYNOLDS

HILDEGARD VON BINGEN

June Boyce-Tillman

Hildegard's self-portrait

Introduction

We are now at the close of the Middle Ages. This was a time of violent contrast and chaos: the luxurious and cultured life of the lords and ladies conflicted sharply with that of the lepers and beggars living on their doorsteps and at the entrances to their churches; beautiful art, learning and piety coincided with the harsh cruelty of summary executions; the town was clearly defined by its defensive walls from the country. Both Empire and Church were in competition as well as in turmoil. Moreover, a schism had occurred between the Latin Church and the Eastern Orthodox Church.

The medieval Church itself was therefore at the beginning of the twelfth century in a sad and impoverished state, with secular lords determining the form and content of its really very basic Christianity. Another consequence was that there was very little conformity between the various churches and even between monasteries, which were each using a different version of the *Rule*.

Because of this and against the background of the first two crusades, a reform movement was started within the monastic orders. The first was introduced by St Benedict of Aniane at the behest of the Carolingian Emperor Louis; the Cluniac movement soon followed. When these Cluniac monastic houses in turn became too richly liturgical, further reform movements ensued: the Cistercians under St Bernard of Clairvaux and the Carthusians under St Bruno of Cologne. In all, the emphasis was on a return to earlier, more rigorous rules, such as the original

'primitive' *Rule of St Benedict* with its emphasis on poverty, asceticism and prayer. Although she was a Benedictine nun, Hildegard did not accept the reform of St Bernard of Clairvaux; instead she followed her own light.

Revd Professor June Boyce-Tillman brings out vividly how the life, interests and talents of Hildegard stand out against this background. She shows us her originality, her independence of thought and action, and her astonishing influence.

Hildegard of Bingen 1098–1179

She was born in Bermersheim, the tenth and last child of her parents. From the age of three she experienced visions, and therefore at the age of eight she was sent to live with the anchoress Jutta of Sponheim. The latter was attached to a newly founded Benedictine monastery at Disibodenberg.

Hildegard took vows in due course, and when Jutta died she succeeded her as Abbess. She entered into correspondence with people in many walks of life, including Bernard of Clairvaux and Pope Eugenius III; later she even wrote to Henry II of England and his wife, Queen Eleanor.

After separating from the monks of Disibodenberg in her forties she established a financially independent convent in Bingen for 18–20 nuns. Later she founded a second community at Eibingen.

She wrote three main theological books and alongside those she produced medical and scientific writings. She undertook four teaching tours along the River Main, in Bamberg, Trier and Cologne. Her sermons were widely distributed and many came to her for advice and healing. She was a mystic, a prophet and a healer.

When she died she was accepted as a local saint but was never officially canonized.

HILDEGARD OF BINGEN'S IMPORTANCE

Hildegard was an astonishing blend of the radical and the conservative. She was critical of the Church and its priests, whom she called 'ravening wolves' for raping and plundering the churches and their congregations. Yet she never joined Bernard of Clairvaux in his Cistercian reforms but remained within the traditional Benedictine Order.

She had visions from the age of three. They made her ill. She interpreted her intuitive visions in images, words and music. It is possible that her visions were

caused by migraine, but as Oliver Sacks points out in *The Man Who Mistook His Wife for a Hat* (Picador, 1985, pp. 158–62), this doesn't invalidate what she was given.

Hildegard was a visionary, a musician, a poet, a theologian, a dramatist and an abbess. She is the first woman to have written scientifically on medicine and women's issues. Moreover, she was the first notated female composer with a large body of musical works. She was the only medieval woman to have permission to preach both to the clergy and the laity.

She is a remarkable figure in the history of European theology and acquired a considerable reputation during her lifetime. She is the first woman to write books with the approval of the Pope and the only woman whose authority was respected with regard to doctrinal matters. She was consulted by many famous people, Bernard of Clairvaux and the Emperor Barbarossa among others. She was, nevertheless, criticized by some for the lack of clarity of her theology. To write obscurely may well have been a deliberate plan on her part to safeguard herself, so that her writing could be understood by those who are in the know in one way and mean another thing entirely to the group of people in power.

After her death she and her music were forgotten relatively quickly. This is the fate of many women composers. We owe her rediscovery partly to Matthew Fox and his creation spirituality.

When thinking about Hildegard it is important to realize that there is a difference between where she sits in her own time and where she sits in ours. We need to contextualize her in her own time. The views presented in her books and in her magnificent pictures of interconnectedness, of the whole cosmos held together, would have been more commonplace in her day. The medieval world saw everything as interconnected, through the 'interrelated fours' – the four elements (air, fire, earth and water), the four seasons, the four humours, the four zones of the earth and the four winds.

But she is also a woman for our time; she is important for the interconnectedness that she can bring to the age we live in, where knowledge is broken up in a fragmented way. Even in her own time knowledge was starting to be divided into faculties at the University of Paris. She provides us still with a way 'to look again at a divided world and see it whole', as Schumacher puts it.

She reminds us also of other value systems we have forgotten, for example the

values of community, relaxation, nurture and intuition. Our society values instead the public, the disembodied, the exciting, the rational, the challenging and the individualistic. She reminds us of these lost ways of knowing and stresses that the answer does not lie in either of the ends; she asks us to establish a flow between them.

She was incredibly creative in all aspects of her life, which she saw as coming directly from God.

Hildegard's story[1]

> I am Hildegard
> I know the cost of keeping silent.
> And I know the cost of speaking out
> Hear my story.

Perhaps you know me as Hildegard of Bingen. It was several miles from Bingen that I was born, in the Nahe Valley in Germany, in the year of Our Lord 1098. Do you know the Rhineland? It is the most beautiful place – rich and green, moist and fruitful. The rolling hills stretch as far as the eye can see, crowned with lush forests pierced here and there with rocky crags and tall watchtowers. Below, the deep valleys are dotted with neat villages and tidy fields that yield ample sustenance for all humankind and their beasts. On the southern slopes, the carefully tended vineyards ripple like green waves lapping the skirts of the hills. And through it all flows the mighty River Rhine, bringing life and greenness to the land, moisture to the air, and the means of movement and transport to all who live there. They call it now, I believe, the Fatherland, but to me it will always be Mother.

For the earth is our mother, she is mother of all that is natural, all that is human. She is the mother of us all, for she contains within herself the seeds of all. The earth of humankind

Hildegard's writings

Hildegard wrote three main theological works based on her visionary experience in the course of her life; her first book, *Scivias* (Knowing the Way), was followed by *The Book of Life's Merits*; and then came her last one, *The Book of Divine Works*. These three books covered the length of her active ministry.

Her pictures are part of *Scivias*, where she sets out God's plan from creation to salvation, and of *The Book of Divine Works*, where she develops the idea of the virtue of charity.

She wrote at the same time scientific and medical works. *The Life of St Disibod* – a Scots-Irish monk– and *The Life of St Rupert* are also by her.

1 The text of the story, which is by Jean Moore, can also be found as chapter 1 in June Boyce-Tillman's book *The Creative Spirit*.

contains all moistness, all verdancy and all germinating power. It is fruitful in so many ways. All creation comes from it. Yet it contains not only the basic raw material of humankind but also the substance of the incarnation of God's own son.

Being the tenth child, I was tithed to God, and sent at the age of eight to live with Jutta, a holy anchoress, who lived in a small house attached to the Abbey of St Disibod. From Jutta I learned so much: of everyday things, of the ever-present, all-encircling love of God (we are embraced by him), and of the Holy Spirit, which flows like sap through our souls, bringing growth and fruitfulness. From my earliest childhood God revealed himself to me in many vivid ways: sometimes in words, sometimes images, sometimes music, sometimes all three, but always he shows himself in the splendour of the natural world. And I learned to see also the evil in the world – the injustice, the corruption of state and Church, the sloth and carelessness of priests, the violation of the natural world and the denial of the giftedness of all creation. And I knew anger as well as joy. I looked and listened, I saw and I heard, but I kept silent.

Yet ever within me grew the pressure to speak out. But how could I, a woman, make my voice heard? Who would listen to me? Who would believe my words, not learned by rote from any human tutor? How could my words in any way be useful? I consulted my superiors and my spiritual director – people I was accustomed to respect and obey. They told me firmly it was not my place to speak out; my role was to tend the daily needs of my community and to pray ever faithfully – but silently. Eventually I became ill both physically and mentally. How could I then have recognized within me the burning torment spoken of by the prophets of the Old Testament, when the Word of God burns in the heart and aches in the bones? It was not out of stubbornness, but out of supposed humility that I refused to speak, and I felt myself pressed down by the whip of God into a bed of sickness.

But behold, in the forty-third year of my life's course, I was taken up in a vision. In great fear and trembling I beheld a great radiance, and in it was formed a voice and the voice spoke to me, saying: 'O frail human being, ash of ash, corruption of corruption, tell and write what you see and hear.' And so I rose up and set my hand to writing and behold, great power and strength were given me and I no longer felt beaten down. The words poured out of me in a torrent, a great overflowing of God's world, his Dhabar ... And contrary to all my previous fears and timidity, I was heard, I began to set down my many visions in my first book which I called *Scivias* – 'Knowing the Way'.

It was to take me ten years to complete. People came to me from far and wide asking for spiritual advice and I entered into correspondence with many of the great folk of my day – rulers, nobles, leaders of religious communities, among them the Emperor Barbarossa and Bernard of Clairvaux. The Holy Father heard of me and, when he came to a Papal Council in Trier, sent a commission to investigate me. They found me competent and authentic, and he wrote, commending and encouraging my writing.

By this time Jutta had died and I had been elected leader – abbess, you might say – of our small community of women. We had grown in numbers and more were coming every year, yet we were still crammed into Jutta's tiny house. The monastery of St Disibod had expanded too, taking up all the available land for their farms and buildings, and they would not yield us an extra inch of space. At first I became anxious, then angry. Abbot Kuno was implacable. Can you imagine the endless committee meetings, the pleadings, the arguments, the counter-arguments and the endless frustration of not being heard? Eventually, we just packed our things and left, taking our dowries with us, without waiting for the men's permission.

After much hardship we began to build a new house near Bingen, which I dedicated to my dear St Rupert. I myself supervised the building, making sure that all was spacious and comfortable. We even had piped water. Perhaps I remembered all those cold winter mornings, the journeys to the well and the breaking of ice on the washing trough. But more, I was concerned because I do not think our Creator God delights in our bodily discomfort, especially when it is self-inflicted. It has been said that the body is at war with the soul, but how can this be? He made us as whole beings and our souls can only find expression through the actions of our bodies. For I am persuaded, when the body and the soul act together in proper agreement, they receive the highest award of mutual joy.

In the years that followed, my sisters and I at St Rupertsberg found new ways to worship God: in poetry, music and drama, sometimes wearing colourful robes and golden crowns – not, I may say, always with ecclesiastical approval! I continued to write and to set down in words and pictures the many visions in which God had become known to me. I wrote many books on a variety of subjects, including medicine and natural history as well as theology and the lives of the saints. My vast correspondence continued. When in my sixties I began to travel the length and breadth of Germany and I, a woman, preached from the pulpits of the great cathedrals and

Also around this time

1109
Anselm, philosopher and
Archbishop of Canterbury, dies.

1119
The Knights Templar founded.

1123
Omar Khayyam, Persian poet
and mathematician, dies.

1126
Birth of Averroes, Arab philoso-
pher, who translates Aristotle
from Greek into Arabic, which is
then translated into Latin.

1170
Birth of Fibonacci, Italian
mathematician; introduces
Hindu-Arabic numbering system
into the West. He discovers the
'Fibonacci' sequence when
studying the Great Pyramid of
Egypt.

1173
St Thomas Becket canonized.

1178
Canterbury monks report an
explosion on the moon, which
created the moon crater.

abbeys. Whenever I spoke of God's justice I exhorted the leaders of the Church and state to excise corruption and to work for the peace and harmony of all creation.

And in it, through it and round it was always the music, for music expresses most deeply the soul's yearning to sing praises to its Creator, and echoes most clearly the harmony of heaven.

But in the last year of my life the music was silenced. It was a time of great grief and heavy sadness. We had buried in our cemetery a young man who had been excommunicated as a revolutionary and we refused to yield up his body. He had confessed and received absolution before he died and his bones were entitled to rest in hallowed ground. We were placed under an interdict by the Archbishop and forbidden to sing the office or to receive communion. I myself, though old and ill, went to the cemetery and removed all traces of the grave that it might not be violated, for I fear the justice of God more than the justice of men. Instructed in a vision, I wrote to the Archbishop, asking him to lift the interdict and reminding him that those who silence music in this life can have no fellowship with the praise of the angels in Heaven. The interdict was lifted and the music continued, but the words and songs I uttered came from no human voice; they were given to me in visions. God moves where he wills and not to the glory of any earthly creature. I am ever in fear and trembling, doubting my own capacities. But I lift my hands to God that he may carry me, as a feather, without power or strength of its own, is carried on the breath of the wind.

I died in the year 1179, but death did not silence me. Some of you, today, may hear my voice. I was 81 years old and so had kept silent for half my life and had spoken for half my life. Perhaps that is the right balance: taking in, receiving, and giving out. In and out – like breathing the breath of God.

Hildegard's thought

Hildegard was very much a traditionalist in her theology, loyal to the Church's teaching in the twelfth century. But her visions were central to her own theology. Her writings were really an interpretation, where she tried to cast her experiences into words. Many of them focused on truth and justice.

The cosmos was for her an interdependent organism, where creation, human beings, angels and God were indivisibly linked. Goodness was the right relationship with everything. She felt strongly that God created all things to be in relationship. Injustice was to her a fracture in that relationship, which was the essence of the fall and sin. She spoke powerfully against injustice wherever she saw it. Salvation is the restoration of the harmonious relationship that was lost.

In line with this sense of interconnectedness is the sense that all duality is also a form of relationship, including that of the soul and the body. Her theology is a strongly incarnational one.

Her medical texts

Hildegard was one of the first to write in depth, in her books *Causae et Cura* and *Physica*, of the properties of herbs and elements. She also explored the connection between the physiology of the human body and the remedies.

As with everything, she takes what would be commonplace in her day and re-works it to her own ends. There were two sorts of medical texts common in the Middle Ages. First, there were texts about the theology of medicine based on the doctrine of 'humours' – blood, phlegm, yellow bile and black bile – with God behind it, holding it all together. Second, there were the more practical 'how to' books of remedies, making poultices and indigestion cakes that were kept in the infirmaries of convents and monasteries. When Hildegard wrote, she brought the two types of texts together in a great sweep.

Hildegard's medicine was set in the context of the medieval system of 'humours' that went back to Galen and beyond him back to Hippocrates himself. By her time the system of Hippocrates was preferred to that of Galen, with its emphasis on balancing sensations – hot, cold, wet and dry. Disease was an imbalance in these elements caused by diet, the environment or the seasons. Included was a theory of

personality types linked to the influence of the four elements – Earth, Air, Fire and Water. The system that Hildegard was working in during the Middle Ages was not unlike ayurvedic medicine and all of those balancing medicines that we are redis-covering in the West today.

Her writings are so beautiful; it is difficult to tell sometimes whether she is writ-ing theology, poetry or medicine. She is the first to write about women's issues and health, menstruation, rape and childbirth. She writes in the following way about pregnancy and childbirth:

> *Then, as God wills it and as he arranged it, the breath of God comes which enlivens this form. Without the mother knowing it, the breath of life comes like a strong warm wind, like a wind that blows loudly against a wall and streams and fastens itself to every joint and limb of this shape. In this way, the various limbs of this form are gently separated from one another, just as the flowers unfold themselves in the warmth of the sun. But there is still such weakness in this form that it cannot move itself, but only lies there, sleeps, and barely breathes. The spirit of life penetrates the entire form, fills and strengthens it in its marrow and in its veins so that they grow more than before, until the bones are spread out over the marrow and the veins become so strong that they can contain the blood. Now the child begins to move, and the mother feels it as though she received a sudden kick; from then on it remains continually in motion. For the living wind, that is the soul, enters into this form, as was mentioned above, according to the will of almighty God, strengthens it, makes it capable of life, and wanders around within it like a caterpillar that spins silk from which it becomes covered and closed in as with a house. In this form, the spirit of life discerns where the soul can divide itself, bend, and turn about; it also pays attention to all the places where there are veins, dries them out like the inner walls of a reed, and joins itself with the flesh so that by the heat of its fire it becomes red like the blood because the soul is fire. Thus it penetrates the entire form of the child with its breath, just as an entire house will be illuminated by a fire at its centre.*

Central to her system is the concept of *viriditas*, meaning life energy and vitality; it is usually translated as a 'greening power' and it appears to be related to the im-mune system.

Her paintings and music

Pictures form part of two of Hildegard's texts, *Scivias* and *The Book of Divine Works*. They are not illustrations; these are the theology; they are firmly rooted in her experience. First she has a vision, which is primarily an image, and then, as we see in *Scivias*, she gives first a short description of what the vision is like and then a longer explanation of its meaning. Her visions are seen to occur not when she is on her own with God but in the context of a community.

In the picture of her having a vision we see her with Volmar, a priest and faithful scribe, who took down the nature of her

Hildegard's 'Universal Man'

visions from dictation. He was urged not to change any of it, except into better Latin.

Unfortunately the main manuscript of the pictures was lost during the Second World War possibly in Russia. We only have reproductions. Moreover they were not painted by Hildegard, but most likely by nuns of her community under her supervision. The colours used are also quite individual; she used real silver, as her visions were filled with a radiant light.

We see the interconnectedness, which is so important to her, also expressed in her paintings in the shape of circles, for instance in the paintings of her visions – like the 'The Man in Sapphire Blue' and 'Choirs of Angels'. These are like 'mandalas' and are often used nowadays for meditation.

Her paintings also show her to be an exuberant person who doesn't conform. For example, she draws a frame and then puts things on the outside of it. Most people would draw a frame and keep within the frame.

Her music too shows this interconnectedness as it flows freely in a continuous stream. In some ways it is plainchant, in some ways not. It leaps and dances in a way that a plainchant does not; it has a real dramatic quality. It was probably written

Hildegard's 'Ecclesia'

down by somebody towards the end of Hildegard's life. There is exuberance about her music, as there is about the images of her visions. Her music uses leaps in the melody that are larger than that usual in her day.

The importance of Mary

Mary is the redeemer of Eva as Jesus is the redeemer of Adam, using the reversal of Eva to Ave which was a favourite medieval device. Mary was crucial to Hildegard and for her she wrote her most beautiful music. Mary Grey in writing about Hildegard saw Mary as replacing the mother Hildegard never had, as she was sent to live with Jutta at the age of eight and would never have seen her parents again. Mary becomes the Divine Mother. Mary in her theology is in a long line of people who have incarnated Jesus; so there are the patriarchs, the prophets and then Mary and Jesus. We too can incarnate Christ through the light of contemplation. In Hildegard we therefore find the theology of mutual indwelling that we will find again in Meister Eckhart.

Wisdom

Hildegard's mutual indwelling theology is in line with the tradition of Wisdom, a female figure, based on the wisdom texts of the Old Testament; she rediscovered this ancient tradition. Wisdom is identified in Book Three of *Scivias* as the 'Knowledge of God', and is veiled as she is too terrifying to look upon. She is a paradoxical figure, who also embodies tenderness.

Wisdom acts as a co-creator with God, and by incarnating human beings she makes them co-responsible with God for creating the universe. Hildegard creates large women figures, for example 'Synagogia', who paves the way for 'Ecclesia'.

As the feminine figures of Wisdom develop they begin to be divided up into the virtues; the virtues come from Wisdom. In her middle book, *The Book of Life's Merits*, we have a very good theology of virtue. There she sets out her theology of

virtues and vices in an effort to settle the dualism that plagues theology. She says that a vice is really only a twisted virtue; we just have to untwist it, that untwisted envy is love.

Her best expression of her theology of virtue is set out in her 'opera', a morality play with music, called 'The Play of the Powers' (*Ordo Virtutem*). There – rather than in an intellectual tome – she sets out the relationship of virtue and vice. There are in her opera a number of virtues, trying to help the soul. The devil is there to hinder, to get the soul to take off the robe of faith. He is the only male figure in the opera who speaks rather than sings. That is because music connects you to God and the devil is disconnected. Again we see Hildegard's insistence on the correspondence between opposites.

Three virtues that become paramount later in her life are peace, humility and love. So she develops her Wisdom theology within a virtue of theology. In the ninth vision of *The Book of Divine Works*, Wisdom wears a green cloak. Thus she is linked with *viriditas*, the greening power at the centre of the universe.

REVD PROFESSOR JUNE BOYCE-TILLMAN

THIRTEEN

ST FRANCIS

Nicholas Alan SSF
and
Samuel Double SSF

St Francis meditating with a skull,
Francisco de Zurbarán

Introduction

The thirteenth century was the time when the dynamic period of change and
growth in Europe, starting in the eleventh century, reached a high point. The
eleventh century had seen the rise of towns and a resulting increase in wealth and
leisure time for the privileged classes; and by the twelfth century the feudal patterns
of the medieval societal structure were losing their hold on society. The population
of Europe doubled; the growing merchant class was beginning to vie for power
with the landowning class. There were the beginnings of an industrial culture; a
money economy was beginning to replace a barter economy.

Although the monastic orders had been the subject of much reform in the
twelfth century, they did not really serve the needs of the ordinary people at this
time. The latter were still the province of uninspired, often illiterate priests, who
were primarily in the service of a secular lord. There was real disaffection with the
state the Church was in, even among the clergy themselves; both clergy and laity
perceived a real need for reform and renewal of the Church.

During this difficult period the new itinerant 'Orders of Friars', the Franciscans
and the Dominicans, were founded roughly at the same time. Unlike the monastic
orders which were rural, the Friars were much more urban based. Their emphasis
was on preaching and teaching ordinary people within the framework of the estab-
lished Church. Both St Francis and St Dominic were charismatic personalities

radiating their spirituality; they attracted ordinary people by the simplicity of their lifestyle and message.

Another reason for the popularity of Francis with ordinary people was his focus on the sacred humanity of Jesus in contrast to emphasis on the Divinity of Jesus, the prevalent view in the preceding centuries. This rebalancing had begun in the previous century with Bernard of Clairvaux, but came to flowering in Francis' life and spirituality.

Brother Nicholas Alan brings out beautifully this close link between Franciscan spirituality and St Francis and the latter's total identification with the person of Jesus, which explains the important role prayer played in the life of St Francis.

Quotations are taken from Regis Armstrong *et al.* (eds), *Francis of Assisi: Early Documents*, Vols 1, 2, 3 (New City Press, 1999).

St Francis of Assisi 1182–1226

Francis was born in Assisi. He was the son of a cloth merchant, Peter Bernardone, and his wife Pica. He enjoyed life and was a good businessman. As a 20-year-old he was taken prisoner in the war with Perugia and spent a year in prison, which led to a severe illness. After his vision in Spoleto and the message from the crucifix in San Damiano, he converted and renounced his former way of life. He parted from his family, and lived among the lepers and rebuilt the church in San Damiano.

Two years later he started the life of an itinerant preacher of penitence. He was soon joined by his first disciples and this led him to write the *Primitive Rule*, which received the blessing of the Pope.

He travelled to Spain, Germany and other countries on missions before going to the crusaders in Egypt and meeting with the Sultan. On his return in 1220 tension among the friars led him to resign as head of the Order. He wrote further rules in the following few years, also for the members of the Third Order.

In 1224 he received the stigmata on the mountain of La Verna. After much illness and blindness he died in 1226, while with the 'Poor Clares' in Portiuncula. He was canonized two years later.

Although Francis stressed simplicity and was not an intellectual, a great intellectual tradition developed soon among the Franciscans, especially in the person of Bonaventura; this is one of the ways in which the Order departed from Francis' original vision. Clare, however, who outlived Francis by 30 years, maintained the true Christocentric Franciscan tradition with its simplicity.

THE BEGINNINGS

Francis was born in Assisi in about 1182. He grew up in a wealthy family, although certainly not an established one. His father was part of the new merchant class; he was in the cloth trade, so he may be regarded as nouveau riche. Francis was quite a good businessman in his early days and also enjoyed the social round; he was very cheerful, popular and generous; in fact he was very much the life and soul of parties.

But there was clearly something in him that was not satisfied by that kind of life; he wanted to do something more, though he was not sure what. The troubadour stories, stories of romance and chivalrous exploits, stories of King Arthur, Perceval and Gawain and other tales circulating at the time, captured his imagination; he heard these, travelling with his father to France on business.

He too wanted to become a famous knight. Back in Italy he became involved in a minor battle between Assisi and neighbouring Perugia. Assisi lost; Francis was captured and taken back as prisoner. Because he came from a wealthy family, he was held for ransom. He was kept in a dungeon for a year with several other young men of the city. He became ill, as he was to be all through his life, before his father ransomed him.

He was released still with ideas of chivalry in his head and soon rode off on another battle. But then he had a dream, in which it seemed to him that God spoke to him, a frequent occurrence for Francis from then on. God asked him whom he would rather serve, the master or the servant. Francis replied in this dream that he would rather serve the master. The voice then asked him what he was then doing serving the servant. He then told Francis that he should go back to Assisi, where he would find out what he should do. Francis took this dream as a revelation.

Soon after that – the sequence of events is not quite clear – he was out riding on his horse when he came across a leper. Francis, like most people at the time, had a great fear of lepers, who were normally forced to leave their towns and homes and live in leper hospitals. If they did move around, they had to wear special clothing and had to ring a bell or sound a clapper board to warn of their coming. They were not allowed to drink from wells or rivers. Yet something made Francis get down off his horse, go up to the leper, embrace him and give him money. Something in this process of overcoming his revulsion began to effect a change in him. He felt

that something that until then had been a horror to him should now become something he sought. He changed around from a pleasure-seeker to someone looking for something entirely different; he began wandering in churches. He went into the church of San Damiano, just outside the city walls, to pray before the crucifix:

Francis' writings

The latest translation of the writings of St Francis and the earliest Franciscan sources: Regis Armstrong *et al.* (eds), *Francis of Assisi: Early Documents*, Vols 1, 2, 3, New City Press, 1999.

Most High, glorious God,
Enlighten the darkness of my heart
And give me true faith, certain hope, and perfect charity,
Sense and knowledge, Lord,
That I may carry out your holy and true command.

He spoke almost like a knight before his Lord, asking for a commission, a command. As he prayed before Christ, he heard words come from the figure on the crucifix: 'Francis, go and rebuild my church which, as you see, is in ruins.'

Later people saw this command as one to rebuild the Church as a whole, but Francis took it literally and began to beg for building materials to rebuild San Damiano. He started to live there and prayed for hours at a time. He took money from his father and also cloth, which he sold. He gave the money to the priest and asked him to keep a light burning before the altar in this church. His father found out where he was and dragged him off before Bishop Guido of Assisi, to try to get the bishop to talk some sense into his son. The bishop told Francis he must give the money back. Francis decided that from this point on he had to commit himself to God and move away from his family. He gave back all the money and even took his clothes off. Then he said, 'Until now I called you my father, but from now on I can say without reserve, Our Father in heaven. He is all my wealth and I place all my confidence in him.' From then on, we know very little about his family. We don't know whether the conflict with his father was resolved, nor does he talk about his mother.

Francis now started to live as a wandering hermit, a holy man praying and preaching, talking about God. He was regarded by some as a madman and people threw stones at him, but others thought that he had discovered something special, because of his serenity, his singleness of mind and his life of total poverty. One of the wealthy citizens of Assisi, Bernard of Quintavalle, invited Francis for a meal. At

night after they retired to bed Bernard wanted to find out if Francis truly was holy. He saw him praying throughout the night in a corner of his room, repeating constantly the phrase *Deus meus et omnia* – 'My God and my all'. This impressed Bernard so much that he became Francis' first companion.

Francis decided they should go and find out what God wanted them to do, how they could follow Christ. Therefore the two of them went to the church with another friend, Peter Cantanii. They decided to find the meaning of their call by opening the Bible at random. The reading was the story of the rich young man – which was very appropriate as they were very rich young men – to whom Jesus said, 'If you wish to be perfect, go, sell your possessions, and give the money to the poor and then come follow me.' They tried again and read about the sending out of the disciples by Jesus, who told them, 'Go into the world, take with you no money in your belts, no bag on your back, no staff, no sandals, preach the Kingdom of God and heal the sick.' And finally, 'If any want to become my followers, let them deny themselves, and take up their cross and follow me.' They felt that they now could make their decision.

Francis had nothing at this time, but Bernard was still very rich. They went to the market place and gave all his possessions away. Sylvester, a priest, came up and reminded them that he had not been paid for the stones for rebuilding the church.

St Francis holding up the falling church,
Giotto di Bondone

Francis gave him all the money he had in his pocket. They stayed in the church in San Damiano. They begged or they worked in the fields for food.

They wanted to live totally according to the gospel and have no money in their belt, no sandals on their feet, so Francis got rid of his belt, wore a rope and walked barefoot. All they wanted to do was to be simple, poor and preach the gospel.

Gradually a few followers joined them, and when there were 12, they felt that they should become more organized. They felt they should have some ap-

proval of the Church; they should have a rule. They went to the Pope in Rome and, with the assistance of the Bishop of Assisi, who happened to be there, secured an audience. There are various anecdotes associated with this meeting. One story is that the Pope, seeing how dishevelled they were, told them to go off to the pigsty. Francis duly obeyed, preached to the pigs and then returned. Despite everything the Pope was impressed by them as being sincere people, who just wanted to preach and not go against the Church. There were many groups doing what the Franciscans were doing and the teaching of some bordered on heresy. The Church was rather on edge about all these radical groups. Francis somehow reassured the Pope that he was orthodox and just wanted to live the life of a poor hermit; he put the Pope's mind at ease, that he was just preaching penance, preaching the Kingdom of God, getting people to return to God in prayer, fasting and almsgiving. The Pope gave his approval and sent them away to pray and then return to work out the detail.

The following extract is from Francis' *Testament*, which he wrote when he was dying. It shows what he regarded as significant as he looked back on his life:

The Lord gave me, Brother Francis, thus to begin doing penance in this way: for when I was in sin, it seemed too bitter for me to see lepers. And the Lord himself led me among them and I showed mercy to them. And when I left them, what had seemed bitter to me was turned into sweetness of soul and body. And afterwards I delayed a little and left the world. And the Lord gave me such faith in churches that I would pray with simplicity in this way and say: 'We adore you, Lord Jesus Christ, in all your churches throughout the whole world and we bless you because by your holy cross you have redeemed the world.'

And after the Lord gave me some brothers, no one showed me what I had to do, but the Most High himself revealed to me that I should live according to the pattern of the Holy Gospel. And I had this written down simply and in a few words and the Lord Pope confirmed it for me. And those who came to receive life gave whatever they had to the poor and were content with one tunic, patched inside and out, with a cord and short trousers. We desired nothing more. We clerical brothers said the Office as other clerics did; the lay brothers said the Our Father; and we quite willingly remained in churches. And we were simple and subject to all.

Often when the brothers were moving around they stayed in leper hospitals and

acted as nurses. They also went into churches and prayed the following prayer:

> *We adore You, Most Holy Lord Jesus Christ,*
> *Here and in all Your churches throughout the world,*
> *And we bless You because by Your holy cross*
> *You have redeemed the world.*

St Francis and prayer

St Francis did not teach about prayer in words but by example: he had his heart and attention focused on God in an unself-conscious way; he felt a deep desire and longing within him for God:

> *With our whole heart, our whole soul, our whole mind,*
> *With our whole strength and fortitude, with our whole understanding,*
> *With all our powers, with every effort,*
> *Every affection, every feeling, every desire and wish*
> *Let us all love the Lord God*
> *Who has given and gives to each one of us*
> *Our whole body, our whole soul and our whole life,*
> *Who has created, redeemed and will save us by his mercy alone,*
> *Who is the fullness of good,*
> *All good, every good, the true and supreme good.*
> (from the *Earlier Rule*)

This prayer shows an overflowing of his heart. He had no learning, but just let the words flow in speaking and preaching; he was a very powerful preacher.

The Franciscans prayed simply; at first they didn't have books but prayed the 'Our Father' and other set prayers. When Sylvester, the priest who had asked them for money, joined them soon after that, he would have recited the offices as he was a priest and would have had a prayer book.

Francis was totally Christocentric. He was drawn to Jesus, who was poor and homeless and 'had nowhere to lay his head'; he was drawn to the humility of the Incarnation and to Christ crucified. Francis would be wrapped up in the sorrow of the crucifixion. At times he was full of joy and then he would suddenly be weeping

for the loss of Christ and for the wounds he suffered. He wept a lot. It used to be thought that one of the reasons he went blind was that he wept so much, tears both of sorrow and joy.

The following prayer is one that Francis prayed though he did not write it. It sums up his relationship to Christ:

I beg you, Lord, let the glowing and honey-sweet force of
your love
Draw my mind away from all things that are under heaven,
That I may die for love of the love of you,
Who thought I a worthy thing to die for love of the love of me.

Prayer was the most important thing for him; he was very disciplined about saying the daily office, morning prayer, matins, lauds and so on throughout the day, even when travelling. At other times he prayed on his own by repeating a single phrase, like 'My God and my All' or the Jesus Prayer.

As was common at the time he probably learned the Psalter off by heart. He wrote *The Office of the Passion*, which contained a selection of verses of the Psalms, corresponding with Jesus' last hours, which he would say in an appropriate sequence at the end of each office.

Francis fasted and embarked on long vigils of prayer. He liked to find deserted and hidden places to pray up on the mountain or in the woods outside town; he was fond of caves. He was drawn to interior quiet and solitude. Francis would have liked to have spent his whole time in prayer, but there was a tension with what others wanted from him, which was to preach.

The man of God, the blessed Francis, had been taught not to seek his own salvation, but what he discerned would help the salvation of others. More than anything else he desired to be set free and to be with Christ . . . In the clefts of the rock he would build his nest and in the hollow of the wall his dwelling. With blessed devotion he visited the heavenly

Also around this time

1187
Saladin defeats crusaders and forces them to retreat from the Holy Land.

1189
Henry II and Holy Roman Emperor Frederick Barbarossa assemble troops for the Third Crusade.

1190
Crusaders begin massacre of Jews in York.

1198–1216
Pope Innocent III raises the power and prestige of the papacy and unifies Christian Europe.

1204
Spanish-born Jewish scholar Maimonides dies. His book, *Mishnah Torah*, is the most important book after the Bible and the Torah.

1204
Fourth Crusade sacks Constantinople.

1207
Birth of Persian poet and mystic Jala ud-din Rumi.

mansions; and totally emptied of himself, he rested for a long time in the wounds of the Saviour. That is why he often chose solitary places to focus his heart entirely on God.

But he was not reluctant, when he discerned the time was right, to involve himself in the affairs of his neighbours, and attend to their salvation. For his safest haven was prayer; not prayer of the fleeting moment, empty and proud, but prayer that was prolonged, full of devotion, peaceful in humility . . . Walking, sitting, eating, drinking, he was focused on prayer. He would spend the night alone praying in abandoned churches and in deserted places where, with the protection of Divine grace, he overcame his soul's many fears and anxieties. (*The Life of St Francis* by Thomas of Celano)

Francis was very devoted to the Eucharist, to finding the presence of Christ in the bread and the wine:

Let everyone be struck with fear, let the whole world tremble,
And let the heavens exult when Christ, the Son of the living God,
Is present on the altar in the hands of a priest.
O wonderful loftiness and stupendous dignity!
O sublime humility! O humble sublimity!
The Lord of the universe, God and the Son of God,
So humbles himself that for our salvation he hides himself under an ordinary
* piece of bread.*
Brothers, look at the humility of God, and pour out your hearts before him.
Humble yourselves that you may be exalted by him.
Hold back nothing of yourselves for yourselves,
That he who gives himself totally to you may receive you totally!
(from *A Letter to the Entire Order*)

He was overwhelmed by the presence of Christ in the Eucharist; he would try to get to Mass every day, although not necessarily to receive it since people only received communion once or twice a year. In medieval times spirituality was all about the presence of Christ in the host; just to be in the same room was enough. The most important part of a communion service was therefore the 'Elevation of the Host'.

Francis was very concerned that holy things be treated properly. And for him every-thing was holy. He would take a broom and sweep the church before Mass. He would pick up pieces of paper on the basis that they contained the letters of the alphabet that also formed the name of Jesus.

He revered the saints, particularly the Virgin Mary and Michael. He prayed the follow-ing prayer 14 times a day:

Stigmatization of St Francis,
Giotto di Bondone

> *Holy Virgin Mary,*
> *Among the women born into the world,*
> *there is no one like you.*
> *Daughter and servant of the most high and*
> *supreme King and of the Father in heaven,*
> *Mother of our most holy Lord Jesus Christ,*
> *Spouse of the Holy Spirit,*
> *Pray for us*
> *With Saint Michael the Archangel,*
> *All the powers of heaven and all the saints,*
> *At the side of your most holy beloved Son, our Lord and Teacher.*

He was always aware of the unseen world, the presence of Mary and the saints.

The stigmata

Two years before his death Francis made one of his many 40-day retreats on the mountain La Verna, which he had been given as a gift; he stayed on the edge of a cliff, fasted and was in silence. This took place between 15 August, the feast of the Assumption, and 29 September, the feast of St Michael and All Angels.

He had an agreement with Leo, a great friend of his and one of the brothers, to take food out to him once a day. The arrangement was that Leo would call out, 'The Lord be with you', and Francis' response, 'And also with you', would be the signal to take the food across. On this occasion there was no answer. Leo went across

the bridge and saw Francis at prayer, levitating off the ground, his arms outstretched, with a great light enveloping him. After a few moments he saw Francis talking to someone, and then the light went. Leo tried to creep away, but Francis noticed him and told him that he had seen a vision of an angel on the cross. As Francis had watched the angel, he had felt sharp pains in his hands, side and feet, but he paid no attention to them. When the light had gone, he looked down and saw the wounds, the five wounds of Christ on the cross, on his own body. He didn't want to people to know, so he wrapped up his hands and feet. Some of the brothers knew because they had to change the cloths.

Here is the prayer he wrote after having received the stigmata. It shows him lost in wonder and praise of God, very different from his first image of God as a feudal overlord from whom he awaited a commission:

You are holy, Lord, the only God,
And your deeds are wonderful.
You are strong, you are great.
You are the Most High, you are almighty.
You, holy Father, are King of heaven and earth.
You are Three and One, Lord God, all good.
You are Good, all Good, supreme Good,
Lord God, living and true.
You are love, you are wisdom.
You are humility, you are endurance.
You are rest, you are peace.
You are joy and gladness.
You are justice and moderation.
You are all our riches and you suffice for us.
You are beauty, you are gentleness.
You are our protector, you are our guardian and defender.
You are courage, you are our haven and our hope.
You are our faith, our great consolation.
You are our eternal life, great and wonderful Lord,
God almighty, merciful Saviour.

At the end of his life Francis stayed with the 'Poor Ladies' (later known as 'Poor Clares') at San Damiano. As an 18-year-old girl Clare had been inspired by Francis. She ran away, joined later by her 16-year-old sister, to follow him and join his order. When this was out of the question, she established the order later known as the 'Order of Saint Clare' or 'Poor Clares', an enclosed order.

Francis died in 1226 and was canonized within two years of his death. There were thousands of brothers throughout Europe by the time he died.

The gift of healing was associated with him; in life and in death he wrought many miracles.

BROTHER NICHOLAS ALAN SSF

Brother Samuel also emphasizes Francis' total identification with the person of Jesus, but this time as shown by the beauty of his prayers as well as his attitude towards peace, poverty and death.

FRANCIS' CONVERSION EXPERIENCE

Giovanni was a very fortunate young man, because he had everything going for him in life. He came from a wealthy family; he had a way with people. He had a lovely singing voice and a happy temperament. He had one ambition in life; he wanted to be a soldier. In fact, everything was going well for him, until one day when he was returning to his own town, his home city.

He was riding home when he saw before him, close to the walls of his town, a man begging. Being a generous young man, particularly with his father's money, he reached into his wallet to hand the man a coin. As he was just about to give it, he suddenly drew back in horror, because he recognized that this wasn't an ordinary beggar; this man was a leper. He had a deep fear within him of disease of any kind, and particularly of leprosy, which in those days was believed to be highly contagious. It was considered to be a disease of the devil, an evil disease.

Therefore he found himself recoiling from the sight of this man and was about to ride by, when he was suddenly brought up short by the man's words from the

side of the road to him: 'For the love of God, for the love of God'; those words went straight to the young man's heart. It was as though in an instant he remembered how for love's sake God had come from his high throne in Heaven to share our human life in Jesus, and to be with us in our suffering and in our brokenness, and even in our death.

Instead of pushing by, the young man got down off his horse and knelt in front of the leper on the road; taking his hands, he kissed them, then he embraced him and called him 'Brother Leper'. He raised the man to his feet and then went on his way.

The young man was never the same again. Giovanni was his baptismal name, but he was known by his nickname Francis, perhaps because his mother was French.

It is good to start with that story of Francis because Franciscan spirituality is perhaps, more than any other tradition of spirituality, tied up with the person of Francis. To have a sense of what Franciscan spirituality is like, it is necessary to have in some way engaged with the person of Francis. It also gives us a very important glimpse into the heart of Francis' spirituality, which has to do with Jesus. His is a profoundly Christocentric mysticism. What converted Francis on the road outside Assisi, what turned his heart, was not just the suffering of a leper; he was actually repelled by leprosy, but it was the sudden recognition that God, in Jesus, had come to share our humanity, our suffering, our brokenness and our weakness.

For ever after, Francis was absorbed with the person of Jesus. It was absolutely central to him. His earliest biographer, Thomas of Celano, would say of him that he had 'Jesus in his heart, Jesus on his lips, Jesus in his eyes, Jesus in his hands and his feet, Jesus in every member'. He would also tell how Francis used to go around just murmuring the words, 'Jesus, Saviour'. He dwelt on the person of Jesus with his whole being:

Almighty, eternal, just and merciful God,
give us miserable ones
the grace to do for You alone
what we know You want us to do
and always to desire what pleases You.
Inwardly cleansed,
Interiorly enlightened

And inflamed by the fire of the Holy Spirit,
May we be able to follow in the footsteps of Your beloved Son,
Our Lord Jesus Christ,
And, by Your grace alone,
May we make our way to You,
Most High,
Who live and rule
In perfect Trinity and simple Unity,
And are glorified
God almighty, forever and ever.
Amen

Important figures

St Clare of Assisi 1194–1253
Inspired by St Francis at the age of 18 and recognized by him as a great soul; Francis assisted her to lead a spiritual life, first with the Benedictine nuns, then he co-founded the 'Poor Clares' with her; ruled for 40 years as the Abbess of San Damiano, which she never left.

Bonaventure 1221–74
Doctor of the Church; studied and lectured at the University of Paris; great scholastic theologian and friend of Thomas Aquinas; became Cardinal-Bishop of Albano and Minister General of the Friars Minor.

Two particular moments of the life of Jesus caught the attention of Francis. One was the lowly birth of Jesus in Bethlehem. He was overwhelmed by the humility of Jesus' birth. It moved and touched his heart that the great God of Heaven should come to dwell among us, weak and powerless as a tiny baby.

It was so much part of his own devotion that one Christmas towards the end of his life, when he was staying in a hermitage at Greccio, between Assisi and Rome, he borrowed a stable from the local farmer and asked for animals, and with a model of a child they put on a play in the church to re-enact the first Christmas. They invited all the local people. Francis, being ordained a deacon, sang the gospel. He peppered his preaching with jokes to draw people in. Some people have thought this might be the origins of the Christmas crib.

Making Christ visible, making Christ real, the reality of God's humility in Jesus, was the keystone in Francis' spirituality and hence in Franciscan spirituality.

The second moment of Jesus' life that touched Francis deeply was the Cross, Jesus' willingness to suffer and die. If he came along the road and saw two sticks lying across each other, he would stand and look at them and be reminded of the Cross and weep at the thought of the suffering of Jesus and God's great condescension towards us, God's brokenness and vulnerability in Jesus. He would then take up the sticks and use them as a mock violin and dance for joy at the love that had led Christ to the Cross.

Francis' own particular signature was the 'tau' cross, the cross in the shape of a 't', the last letter of the Hebrew alphabet. The 'tau' is referred to in Ezekiel 9.4: 'the sign of the tau would be placed on the forehead of those who wept for the sins of Jerusalem'. Later, in 1215, Pope Innocent III at the Fourth Lateran Council made it an official sign for renewal in the Church. For Francis it was a particular personal sign of his love for Christ on the Cross.

His writings

Francis himself did not write very much. He was not a theologian; he did not write a *Summa Theologica* like Thomas Aquinas or commentaries on Scripture like some of the Church Fathers.

His writings consist of a number of prayers; but he did not write the well-known 'Prayer of St Francis', 'Lord, make me the instrument of your peace', which was written 600 years after his death. But he did write 'The Prayer before the Crucifix'.

He also wrote two *Rules* for his Order, of which the first is lost. He wrote admonitions, letters and a final testament and will.

What is noticeable about his writing is that it is profoundly scriptural. He is constantly quoting from the Scriptures. He called himself 'unlettered', yet he inhabited the world of the Scriptures, the images of the Scriptures, the nuances of the Scriptures, the echoes of the Scriptures. He had a tremendous reverence of the Word of God in the Scriptures and was open to the Spirit at work in them. Francis was therefore profoundly Christocentric and scriptural.

The way that Francis really knew the Scriptures and was steeped in them is something that we have totally lost in our Christian culture today; we no longer inhabit the Scriptures, we just know something about them.

Our main sources about Francis are the writings of those who personally knew him. Thomas of Celano, his first biographer, was a follower and wrote two accounts of Francis' life. These were followed by a second generation of stories about Francis, re-evaluating him in the light of his popularity; from the fourteenth century originate elaborations on those stories and immensely popular legends about Francis.

'The Canticle of the Creatures'

This is the great song, the extraordinary poem that Francis composed. It was the first great poem in the Italian vernacular; it is a literary landmark in the Italian language. Francis did not know Latin well enough to write in it. In any case he was a poet who loved the Italian language and who wanted to make his work understood by those who did not know Latin. He saw himself like the troubadours, who were singing the songs of chivalry around Europe. He saw himself as a romantic songster, not of the romantic love of a knight for his lady, but one who was singing the praises of the Lord, telling of his passionate love for God and God's passionate love for us. 'The Canticle of the Creatures' was composed in the last year of his life. Although it talks about the world, the creatures, the environment, the sea and the sky, he actually could not see any of it; he was blind by then. He wrote it for his brothers to sing; it was a way of sharing the gospel:

Most High, all-powerful, good Lord,
Yours are the praises, the glory, and the honour, and all blessing,
To You alone, Most High, do they belong,
And no human is worthy to mention Your name.

Praised be You, my Lord, with all Your creatures,
Especially Sir Brother Sun,
Who is the day and through whom You give us light.
And he is beautiful and radiant with great splendour;
And bears a likeness of You, Most High One.
Praised be You, my Lord, through Sister Moon and the stars,
In heaven You formed them clear and precious and beautiful.

Praised be You, my Lord, through Brother Wind,
And through the air, cloudy and serene, and every kind of weather,
Through whom You give sustenance to Your creatures.

Praised be You, my Lord, through Sister Water,
Who is very useful and humble and precious and chaste.

Praised be You, my Lord, through brother Fire,
Through whom You light the night,
And he is beautiful and playful and robust and strong.

Praised be You, my Lord, through our Sister Mother Earth,
Who sustains and governs us,
And who produces various fruit with coloured flowers and herbs.

Praised be You, my Lord, through those who give pardon for Your love,
And bear infirmity and tribulation.
Blessed are those who endure in peace
For by You, Most High, shall they be crowned.

Praised be You, my Lord, through our Sister Bodily Death,
From whom no one living can escape.
Woe to those who die in mortal sin.
Blessed are those whom death will find in Your most holy will,
For the second death shall do them no harm.
Praise and bless my Lord and give Him thanks
And serve Him with great humility.

There are two poles in Francis' spirituality. On the one hand there is a great sense of the holiness of God, the utter otherness of God, the transcendence, the majesty, the awesomeness and the inapproachability of God; and yet at the same time the other pole is one of God's closeness to us in Jesus, God as alluring, delightful and desirable.

One of the prayers he prayed is known as the 'The Absorbiat':

May your love, O Lord, fiery and sweet as honey so absorb our hearts as to withdraw
them from all that is under heaven.
May we be ready to die for love of your love as you have died for love of our love.

The first two lines of the 'Canticle' give praise to the majesty of God, the awesomeness of God, but also to God's intimacy with us, God's closeness to us in Jesus. God longs for us and longs for us to long for God.

Holding these two poles, living between these two poles, the awesomeness and intimacy of God, is the essence of Francis' spirituality: 'Praised be You, my Lord, with all your creatures'.

For Francis creation is the icon of God. When we consider creation and the world around us, something is revealed of God's goodness, love, fruitfulness, fecundity, generosity and beauty. Everything in some way can point to God. This is parentheism, that God is in everything.

This must be distinguished from pantheism, which says that God is everything and everything is divine; there is no separation, no division between God and the world; there is no transcendence of God. This is not what Francis was saying, nor is it what the Christian tradition says. But in panentheism God is in all things and all things reveal something of the glory of God.

But the 'Canticle' also tells us that creation gives praise to God. As it were, there is a song being sung by creation from all eternity by each thing being what it is: for example, the sun gives praise to God by shining. When we give praise, we are joining in with something going on from all eternity to all eternity. This is not unique to Francis; he is drawing on traditions of the Church, the Scriptures and Psalms, but it does come to a particular focus in the 'Canticle'.

The central passage of the 'Canticle' shows us that in God we are brought into a true relationship with every thing, 'Brother Sun, Sister Moon', because we know Jesus as our brother. As Jesus has revealed to us the true relationship of the Father and greets us as brothers and sisters, we become brothers and sisters to each other and all things.

It is clear that Francis had a great reverence for the world around him, for people as well as for animals. He did not exclude anything; he was brother to a thief as much as to the community he lived in; brother to crows and wolves as much as to skylarks.

It is interesting to note how many holy people have an affinity with animals, Seraphim the Sarov to name but one. Isaac of Nineveh in his 'Ascetic Treatises' says:

The humble man confronts murderous wild beasts. From the moment they see him their savagery is tamed, they approach him as if he were their owner, nodding their heads and licking his hands and feet. They actually scent coming from him the fragrance

that Adam breathed before the fall when they came to him in paradise and he gave them their names.

Francis saw that all things relate together, belong together. It was not a sentimental love of animals, but respect, because everything had a right to be there; even objects of an inanimate nature were brothers and sisters to us, Brother Fire and Sister Water.

Francis' way of 'being' with creation is a way of 'knowing' creation, the natural world, totally and intuitively. It is learning to accept the ugly as well as the good aspects of everything and everybody in a new kind of way, and truly relating to them.

Some poets see the world the same way, such as John Clare, Wendell Berry and Thomas Traherne. This way of being with the world is not for our own sake, not for our benefit or experience or sentimental attachment, but because the world is a precious gift of God. We, like everything else, belong to God and are part of God's family; therefore we are brothers and sisters.

That is Francis' particular point of view, which is a hugely important message for us today in our world situation and for the way we treat the environment. We need to inhabit the world and the environment not as tourists or exploiters but as brothers and sisters. We need to pay attention to the world, because God is revealed in and through it. We are made for God and to give praise to God.

Peace as a characteristic of Franciscan spirituality

Praised be You, my Lord, through those who give pardon for Your love,
And bear infirmity and tribulation.
Blessed are those who endure in peace
For by You, Most High, shall they be crowned.

This verse was added on to the main part of the 'Canticle'. Francis, who by now was very sick, heard of a row between the Bishop and the Mayor of Assisi. He composed this verse and told the brothers to go and sing it to them. They were shamed by the song and made up.

It was a particular characteristic of Francis to preach peace. He emphasized forgiveness and reconciliation and stressed the constant need to work at this, even among the brothers.

Prior to writing the 'Canticle' he spent time (*c.*1220) in Egypt among the crusaders; he joined the Christian crusading army at the Nile delta. As a young man he had had the romantic notion of being a knight in the crusades. Now he went there for a different purpose and was appalled by the state of the army and the attitude of the Christians, who were waging war against the Muslim Egyptians in order to recapture the holy places. Francis was so appalled by the Christian army that he told them that no good would come of their crusade.

He then set out to cross over the enemy lines with one other brother. On the way he was arrested. He was brought to the Sultan's court, which was exactly his intention. He was first treated roughly, but always responded courteously. He was taken to the Sultan, and he then asked permission to speak to the Sultan about Jesus, which he was allowed to do. He did so for two days, talking, discussing, sharing about Jesus Christ and showing reverence to the Sultan's views. The Sultan was not converted, but he did give Francis a safe passage to the holy places.

A sign of Francis' approach to making peace was to cross over to the enemy territory, to address the enemy reverently and to dare say what was closest to his heart. At the heart of it all lies Francis' understanding of the Sultan as his brother.

Francis was a man of his time and would have regarded the Muslim as an infidel, as a person whom he would want to bring to Christ; he unashamedly talked about Christ to the Sultan. But nonetheless he could, even from that cultural faith perspective, still speak with integrity and reverently to the Sultan, which allowed him to communicate something of Christ that could be accepted.

This could be a lesson for us in our interfaith dialogue today. The object is not a kind of syncretism, taking the best from each religion, but to stand truly within one's own tradition and to speak out of that tradition with reverence and with deep respect for the other. Thomas Merton (see Chapter 27) exemplified the right stance; he never stopped being a Christian; he never compromised his own tradition, but he tried to inhabit and to understand the world of the other and perceive the deep connections and respect the differences.

Francis' attitude to death and poverty

Praised be You, my Lord, through our Sister Bodily Death,
From whom no one living can escape.

Woe to those who die in mortal sin.
Blessed are those whom death will find in Your most holy will,
For the second death shall do them no harm.

Praise and bless my Lord and give Him thanks
And serve Him with great humility.

Even death is welcomed and reverenced as part of God's purpose and plan. We see in Francis' life an attempt, right from the moment he embraced the leper, whom he feared, to the meeting with the Sultan and welcoming Sister Death, to incorpsorate the negative, integrate the dark and fearful, the inner and outer enemy, into that relationship of brother and sisterhood within God's love.

His real 'poverty' is his refusal to exploit, to possess anything or anybody, as all are in relationship. Francis' deepest poverty was having everything that he had grown up with taken away from him and yet coming to terms with that situation.

Even in his lifetime the Order had begun to move away from his Christocentric, gospel-centred focus. An explanation might well be the rapid growth between the years 1210, when there were 12 brothers, and 1221 when there were 10,000 in different parts of Europe. Francis resigned from being head of the Order and did have a real sense of sadness and rejection.

Real poverty is given to us; we do not choose it. Poverty is finding ourselves powerless; it is about failure, about the taking away of status, which is summed up in the poverty we experience as we approach death, stripped of everything.

In Francis there is a true integration of the negative. Welcoming death as our sister is very profound; in so doing he accepts death as part of the 'family of God', as part of God's plan and love. It was not easy; we can see him growing into that acceptance during his life.

He was given the stigmata in the last two years of his life, when he was going blind and the Order was going awry, when he was beginning to experience the loss of all things. He was so fixed on God's love in Christ that he reflected in his own body the deep truth of what the Cross stood for, the loss of all things and yet the meeting ground with God's transforming power.

All this was possible, for Jesus had been revealed to him as 'Brother Jesus':

O how glorious it is to have a holy and great Father in heaven! O how holy, consoling to have such a beautiful and wonderful spouse! O how holy and how loving, gratifying, humbling, peace-giving, sweet, worthy of love, and above all things, desirable: to have such a Brother and such a Son, our Lord Jesus Christ, Who laid down his life for His sheep.

And in this deep inner experience he came to know and see how it affected his relationship with all things. The more he related to others as brothers and sisters the more he came to know his own sonship and brotherhood in Christ.

Even though he was highly critical of its wealth, power, hierarchy and structures Francis was a loyal member of the Church. He saw that we need each other. The Christian journey is not a solitary one; it is a journey in fellowship with each other and we need to be in relationship with one another in Christ; hence the importance of the Church.

We adore You, Most Holy Lord Jesus Christ,
Here and in all Your churches throughout the world,
And we bless you because by Your holy cross
You have redeemed the world.

BROTHER SAMUEL DOUBLE SSF

ST DOMINIC

Roland Riem

St Dominic in Prayer, *El Greco*

Introduction

During the twelfth and thirteenth centuries the growth of urbanization forced the Church to deal with more power from below and with the demands of the people for learning; they were no longer content to let only the Church have the truth at its command.

This is therefore the time that schools were being founded, originally very much linked to cathedrals but actually forming the first seeds of university life. New learning, new ways of thinking were coming into people's consciousness.

As we have seen, the ordinary people still felt neglected by the Church, and their thirst for knowledge was now met by the Dominican and Franciscan Friars, as their vocation was largely about sharing the gospel with ordinary people. But there were also other itinerant preachers who went around the countryside, teaching and preaching; many of these were, however, anti-clerical and were regarded as heretical, such as the Cathars and Waldenses. These were inciting a break away from the Church; they encouraged disobedience to the priests and deacons, and discouraged church attendance and the paying of tithes. This was a real concern to the Church. The Dominican Order of Friars, a clerical order – St Dominic had been an Augustinian canon – felt especially called to meet these challenges.

Alongside their apostolic mission the Dominican Order of Teachers and Preachers attached great emphasis to learning. The schools attached to monasteries and

cathedrals of the eleventh and twelfth centuries had led to the establishment of the Universities of Paris and Bologna. The Dominican influence, especially at the University of Paris, was very great: nine out of 15 Doctors of Divinity there were Dominicans, Thomas Aquinas and Meister Eckhart notable among them. Many bishops attended these places of learning, and in this way ordinary priests were supported in a positive way.

The Revd Canon Roland Riem brings out clearly these different strands in the vocation of the Dominican Order, their fight against heresy, their preaching to ordinary people and their intellectual pursuits.

St Dominic 1170–1221

He was born of a noble Castilian family in Calaroga. His mother was very devout and saintly, and was canonized herself in the nineteenth century.

His maternal uncle looked after his education until he went to the University of Valencia. He was a serious and outstanding student who was utterly compassionate to the sufferings of others.

At the age of 26 he became one of the Canons regular at the Cathedral in Osma. With Bishop Diego he became very involved in fighting the Albigensian heresy during the five-year Albigensian crusade ordered by Pope Innocent III. Their poverty and simplicity of life converted many people to orthodox Christianity.

The idea of forming an order of dedicated and educated priests came to him in 1216 when he was based in Toulouse. The Pope approved this the following year.

The rest of his life he dedicated to travelling extensively to teach and preach and support his brethren with understanding and compassion.

THE ESSENTIAL OBJECTIVES OF THE DOMINICANS

There are many famous Dominicans apart from St Dominic himself, including Thomas Aquinas and Catherine of Siena, who was actually known as the second founder of the Dominican spirituality, as well as Fra Angelico and the whole German mystical Dominican tradition: Meister Eckhart, Heinrich Suso, Johannes Tauler.

Although Dominican spirituality as it developed is multi-faceted, it can be summed up as follows: mission through teaching and preaching for the benefit and salvation of all.

The Transfiguration, *Fra Angelico*

Dominic has a lot to teach any of us who are involved in mission. One motto of the Dominicans is *Contemplata aliis tradere*: 'To pass on the things that have been contemplated/studied'.

That is one of the major tasks Dominicans undertake: to study and contemplate with the prime focus on others; concern for the salvation of others is at least as important as our own salvation.

In addition, the Dominicans had a passion for *Veritas* – Truth. The early Dominicans may be regarded as peaceful seekers after truth, because they believed that 'all truth is found somewhere and some truth is found everywhere'. Consequently, a good Dominican would be looking for signs of truth wherever he or she met it.

Although, of course, we cannot forget the Inquisition and the notable role the Dominicans and the Jesuits played in that horrible chapter of human history, we are looking here at the clear stream at the beginning before things got muddied; the search for truth can go wrong, like anything else.

In the Constitution that was written in 1220 we read:

> *Our order is known to have been founded from the beginning for the sake of preaching and the salvation of souls, and our efforts ought above all to be directed primarily and enthusiastically towards being able to be useful to the souls of our neighbours.*

Catherine of Siena said that this was the key to all Dominican spirituality. One thing that Francis, Ignatius and Dominic have in common is that their spirituality is very apostolic. This does not mean that they don't attach importance to contemplation, but they launch the fruits of this outwards to mission.

It might seem strange to make a very strong contrast between the apostolic spirituality and monastic spirituality, because in considering St Benedict himself there were many aspects to his intentions that were apostolic. But it is true to say that by the time we get to this period of history, things have silted up a bit for the Benedictine tradition.

If we look back to the original genius of Benedictine spirituality and the spirituality of the desert, we notice that the key features that made this spirituality vibrant were 'purity of heart', a balance of life between manual work, study and prayer.

Some of these values, such as poverty, obedience and community, have been continued but at the same time transformed in Dominican spirituality.

St Dominic's life

We don't really know St Dominic as much as we do St Francis; we just get glimpses of his character. But with St Dominic we get the impression that he had a passion for the task before him, that he was a very able administrator, that he released other people and enabled them to do what they were best at.

Dominic Guzman was born about 1170 in old Castile and died in 1221. He came from a family of minor nobility, landowners. When he was born his mother had a vision of a puppy emerging from her womb with a blazing torch in its mouth. She understood this to mean that Dominic was going to be a great preacher and set the world ablaze.

He had a good education; he learned Latin from his uncle who was a priest and then was sent to a cathedral school in Valencia. At the heart of the curriculum was the study of Scripture. After about ten years he became a canon and lived by the Augustinian rule of life.

Dominic's fight against heresy

Around this time the Albigensians, a heretical group, gained prominence; these were Cathars who were very dualistic in their spiritual outlook. The Catholic Church felt strongly that something should be done about these groups. Bishop Diego asked St Dominic to accompany him on a diplomatic mission for the King of Spain. They stopped off at Toulouse and

Important figures

Thomas Aquinas c.1225–74
Thomas Aquinas was born near Aquino in Italy. He is a Doctor of the Church and considered by many to be the Church's foremost theologian. He was a philosopher and theologian in the scholastic tradition. He entered the Order of Preachers in 1244.

He was deeply contemplative; for him contemplation is a lifting up of the heart and mind to God. It did not involve a letting-go of knowledge; his was an intellectual spirituality. He used rigorous discipline of the mind in pursuit of truth. He used logic, Scripture, Aristotle and the Church Fathers as sources of authority. He puts his own learning and insights at the disposal of others.

The work he is best known for is *Summa Theologica*.

Catherine of Siena 1347–80
Catherine of Siena was the 24th child out of 25. She explored God in order to love God more. Although she was unlettered she was one of the foremost early writers in Italian. She is said to have met Thomas Aquinas and John the Evangelist in a dream, and they taught her how to write. She had a vision of Christ in papal robes at the age of six, which was her incredible induction into the Christian life. She gave herself to Christ at that moment. By the age of seven she had vowed herself to a life of perpetual virginity.

Continued overleaf

Continued

In 1363 she entered the Dominican Order of Penance, the Dominican Tertiaries. This was an order that only admitted as a rule women who were widows. In 1368 she had a vision of Christ appearing and putting a wedding ring on her finger. In 1370 she heard the command to leave her cell and enter the public life of the world. She then joined a group of women in the service of the sick and poor. Her visions came thick and fast and she even received the stigmata. She became very involved in the politics of the papal schism and wrote forthright letters to those who supported the false pope. Of her writings we have the *Dialogue*, prayers that her followers wrote down as they listened to her at prayer, and her letters.

here St Dominic had his first contact with these heretics.

Another missionary trip took them to Citeaux, where Diego took the Cistercian habit. In 1206 they arrived in Montpelier in the south of France, where the Cistercians were locked in a mission to try to win back the Languedoc region of France from the Cathars. The latter's lifestyle was very attractive to the people because of their simplicity and poverty; they also won many over with the simple way they proclaimed the gospel. The Church was perceived as being distant and too institutional.

St Dominic was concerned to train preachers to fight against these heretics. Diego suggested that the Catholic missionaries should actually imitate the practices of the heretics but with Catholic teaching and instruction, in order to win people back to the old faith. Although the crusades were happening at the time, St Dominic kept his focus on winning back those who had been won over by the heretics.

As people were getting re-converted, there arose a need for founding monasteries and convents. Diego founded a nunnery at Prouille in about 1206, the first for Dominican nuns, but he died soon afterwards, leaving St Dominic to take effective charge of the mission.

To help him in his mission a new bishop in the South of France decided to give him official licensed status. The licensed preachers of the medieval Church were actually the bishops (though others were allowed to give exhortations), and it was quite unusual for him to let St Dominic share his ministry.

In 1215 the Fourth Lateran Council took place, which was intended to try to re-establish the life of the Church and reconnect the Church to the people. Unfortunately much of what was suggested was to do with reforming the clergy, so that through them the Church could take back power. It addressed clergy morals and education. It appointed auxiliary preachers and tried to stop the proliferation of religious orders. But the result of that was that the clergy started to consider themselves an elite, which had the effect of distancing people from the Church even more.

St Dominic wanted to put his Order on a firm footing and tried to get it confirmed by the Pope. But the Church in Rome did not want more proliferations of orders; therefore the Fourth Lateran Council had stated that any new order must find an old rule to live by. Because St Dominic was an Augustinian canon and already lived by that rule, he managed to get his Order accepted by offering to take the Augustinian *Rule* to live by. The new Pope, Honorius III, confirmed that the 'Order of Preachers' was bona fide in 1216. The Dominicans were therefore a clerical movement, a band of preaching clerics. They were not leisured scholars; they were people who were trying to use their scholarship to respond to the needs of the people around them.

Glossary

Tertiary Order – society for those who wish to devote themselves to the religious life without withdrawing from the world.

Scholastic tradition – a rigorous theological method used between 1000 and 1600; at its most influential in the fourteenth century. It relied on careful logical argument and precise descriptions both of philosophical and theological topics.

They had their power base in Toulouse but St Dominic felt inspired by the Holy Spirit on Pentecost in 1217 to send his community to the four corners of the earth in small groups; six went to Paris, four went to Spain and he began shaping his Order. In the next few years St Dominic travelled to Rome, Spain, Toulouse and Bologna, and in 1220 there was the first General Chapter of the Order. He was very organized and aware of how people worked institutionally.

He was a tireless preacher and gave other people encouragement to preach by his prayerful support of them, affection and companionship. He took up an earlier expression that Catherine reiterated, 'that we should always be talking with God in contemplation and about God in preaching'.

His early biographer wrote:

Nothing disturbed the even temper of his soul except his quick sympathy for every form of suffering, and as a man's face shows whether his heart is happy or not, it was easy to see from his friendly and joyous countenance that he was at peace inwardly. With his unfailing gentleness and readiness to help, no-one could ever despise his radiant nature, which won all who met him and made him attract people from the first.

The Dominican Order got off to a flying start, scattering but buoyant; by 1221, when St Dominic died, they were in England, Hungary and Poland. In fact there were already 25 houses in Europe, five provinces and six more on the way. By 1223

there were 120 members in Paris alone. And by 1234 nine of the 15 Doctors of Divinity in Paris were Dominicans.

When he was canonized in 1234 Pope Gregory IX said that he was as sure of St Dominic's holiness as he was of that of St Peter and St Paul.

Enclosed versus itinerant

A distinction between Franciscan and Dominican spirituality is that St Dominic was more concerned with the apostolic task and St Francis was more concerned with the apostolic lifestyle.

Both contrast with the enclosed monastic spirituality of St Benedict. The Benedictine monks were tilling the soil and doing useful manual labour to keep their communities alive, but St Dominic and his preaching friars were itinerant and totally focused on preaching.

The essential features of monastic spirituality were 'listening with the ear of the heart', stability and balance, with an ordered rhythm to the day centred around prayer.

The Benedictine principle of enclosure came from the Desert and from Acts 4.32: 'Now the whole group of those who believed were of one heart and soul, and no one claimed private ownership of any possessions, but everything they owned was held in common.'

The Benedictines like the Cistercians stressed forming a strong community, where monks have a common life and share everything, but this had always existed in tension with the pilgrimage model: 'Foxes have holes, and the birds of the air have nests; but the Son of Man has nowhere to lay his head' (Matt. 8.20).

The Dominicans did want to hold on to community life; they did want to live together in some sort of communal life, even though the Black Death made living in community really hazardous. But they placed their emphasis on itinerant preaching; some therefore stayed in community to support those who went out to preach.

The main element essential to the Dominican Order was the apostolic task, out of which all other conditions flowed. Their life therefore had to be itinerant and consequently they did not fall under the authority of a bishop. They were not confined to one diocese; they were free to wander around between dioceses. Finally, they were educated priests.

This was the very flexible structure that St Dominic managed to create under

the Augustinian *Rule*, which was based on the example of the Apostles and on scriptural principles.

Obedience

As far as the rule of 'obedience' was concerned, Dominic wanted to give this a much more spontaneous character, a kind of generosity to respond to the need of the moment, to circumstances, without being too concerned about the security of rules and regulations. They of course all had a personal obedience to the Master of their Order, but not rigidly to a constitution. The rules of the Order were seen as important, but incorporated in them was the principle of dispensation, so that the rules were in fact adaptable and used as tools for the maintenance of the community's task, but were not essential to Dominican life; they were after all only human rules. What was considered much more important was a sense of personal responsibility and good habits. It had more to do with being loyal to the lifestyle of the Dominicans; with holding on to the values of the community. Ultimately a preacher is answerable to God, not to the Order.

They had a lot of freedom and the Cistercians, who were very austere, trying to live in an enclosed way, had a ready-made insult to throw at the Dominicans that comes from the first chapter of the *Rule of St Benedict*: they called them 'gyrovagues'.

The grace of preaching

Preaching was seen as a grace, as a wonderful act of self-sacrifice, a supreme act of love – a pouring out of God's truth in personal form. Dominicans were giving out by their preaching to their neighbour anything they had received through study or contemplation. It was considered to be a way of life as heroic as martyrdom.

Humbert of Romans, the Fifth Master, said that in leading busy lives there would inevitably be inattention and tiredness, but it was important to persevere and share their gifts. 'The merit gained by good works will outweigh the sins of an active life.'

The task of preaching should lead deeper and deeper into grace. He even said that preaching takes priority over prayer and the sacraments.

The preacher should at all cost avoid pride and despair and rely entirely on grace:

With all my heart I turn to you, Holy Spirit, God most merciful and generous, who

sometimes, when it pleases you, speak many good things even through the mouth of
sinners. I am a poor sinner but, such as I am, I am your servant, and now that you
have inspired me to engage in such an undertaking as this, I beseech you by the mercy
of Christ and the intercession of the most Blessed Virgin Mary, the Mother of that
same Christ, the Crucified, and by the merits of our father, the Blessed Dominic, and
at the prayers of the novices of our Order, whose encouragement and instruction is my
chief concern: in the abundant mercy of your grace, bring this present work to good
effect, through my ministry, to your own glory and honour so that those who read it
may know that it is your grace, Lord, that has achieved this.

(Preface to a book written for novices in 1283 by a novice master in Toulouse)

St Catherine of Siena,
Andrea Vanni

In Dominican spirituality human effort and edu-
cation are met by grace, since without grace our
words bear no fruit and cannot be prophetic. They
knew that this grace was present when the preaching
was effective and fruitful, had led to repentance, con-
version or confessions of sin in the congregation. A
bishop preaches out of the institutional authority that
is given from the Pope, but for the Dominicans the
authority is grace-given, a charism.

But you have to co-operate with grace and hence
the Dominican need for study, because preaching
requires that. There is also a work of character to be
done, which is linked with contemplation, in which
we stand or sit before God with 'poverty of spirit';
and after that we need the courage to launch out on the inspiration of the moment.
By looking deeply within ourselves, we can go out and help others, acting from our
depth. Contemplation leads to compassion for others and consequently action.

For Dominic, preaching is the end and contemplation is the way. Catherine of
Siena phrased it to her confessor like this: 'The greatest consolation she had in life
was talking about God or discussing God with intelligent people.' St Dominic said:
'Hoarded grain goes bad.'

He tells his novices who were quite unprepared to go and preach before they
had studied any theology: 'Go confidently because the Lord will be with you and

He will put into your mouth the word of preaching.'

Poverty

St Dominic wanted to persuade his brothers to abandon possessions, but it is hard when you are preaching to be ascetically poor; you need books to preach. Therefore, already in the history of the early Dominicans, owning books became permitted.

Gradually things changed in the thirteenth and fourteenth centuries. By the mid fourteenth century there were private libraries. The Pope eventually allowed them to retain possessions so they could get on with preaching.

Poverty was redefined as 'poverty of spirit', the awareness that grace comes from God. People can learn to be more responsive to the preaching charism, but it always remains a gift from God, which leads to awareness of our own poverty and unworthiness.

Always see your faults and sins and make as much of them as you can . . . Never stop watching yourself and judging yourself in complete honesty. In all that you do, say, or think, rebuke yourself, and always strive to find occasion for compunction in yourself, by reflecting that even the good you do is incomplete, lacking in fervour, and spoiled by negligence . . . Every hour of the day rebuke yourself in the sight of God as being the most wretched sinner, and consider yourself more worthless and wretched before God because of your faults than anyone else, whatever their sins . . . And also consider very carefully that it is not from yourself that you have any ability to achieve any good, or any grace, or any concern for virtue. Christ gave them to you out of sheer mercy, and if he had wanted to, he could have left you in the mud and given them to someone else.

Ideally this sense of unworthiness takes us into love – by which we count others of more account than ourselves. This is an apostolic spirituality – apostles come last:

For it seems to me that God has made us apostles the last act in the show, like men condemned to death in the arena, a spectacle to the whole universe – to angels as well as men. We are fools for Christ's sake, while you are sensible Christians. We are weak; you are powerful! You are honoured; we are in disgrace! (1 Cor. 4.9f.) (St Vincent Ferrer)

Ideally this sense of unworthiness takes us into love, by which we count others more than ourselves. It also gives a greater awareness of the inspiration necessary to do what we can't do of and by ourselves.

REVD CANON ROLAND RIEM

MEISTER ECKHART

Kim Nataraja

Meister Eckhart teaching

Introduction

Whenever there is turmoil, mysticism flourishes, and this was especially so in the fourteenth century, one of the greatest centuries for Christian mysticism. By Meister Eckhart's time the achievements of the thirteenth century had been badly affected by a period of high instability, a time of political and religious upheaval. The Holy Roman Empire was breaking up into fairly independent states and the Emperor was at war with the papacy. There was a schism in the Church, with two contending popes, one in Rome and one in Avignon, which resulted in the Church being held in very low esteem by the populace at large. The role the Inquisition played further added to this unpopularity.

Moreover, the Dominicans and the Franciscans were at loggerheads, mainly over the rule of 'poverty'. The weakness, the corruption and the worldly power struggles of the Church led to many seeking an alternative spiritual way, and breakaway groups were being formed, the most important being the 'Spiritual Franciscans' under Joachim of Fiore and the 'Brethren of the Free Spirit'.

Meister Eckhart's spirituality was in some respects close to those influenced by the quite pervasive 'Free Spirit' movement, and Kim Nataraja shows how, being a Dominican, he felt called to educate and correct those at risk, especially the nuns in the convents along the Rhine under his jurisdiction, and the remaining devout Beguines, as well as ordinary people. She brings out how his own spiritual experience

and his position in the established Church made him an effective teacher, combining theology and spirituality in the way that Evagrius had done eleven centuries before him.

Meister Eckhart 1260–1328

He was born in Thuringia. He is thought by some to have been the younger son of a noble family, but whatever the truth of that he certainly came from a well-to-do family. He became a Dominican novice at the nearby monastery of Erfurt at the age of 15. His teachers there soon realized he was very bright and sent him to study at the Dominican Studium Generale, first in the Arts Faculty and then in the Theology Faculty in Cologne. Theology was regarded, along with medicine and law, as one of the higher faculties. He would probably have been there for 14 years before continuing his studies at the University of Paris. A few years later he was appointed Vicar of Thuringia and Prior of Erfurt. By 1300 he was back in Paris, where he obtained his master's degree in 1302 at the age of 42. He proceeded to hold many important offices in the Dominican Order, including Provincial of Saxony and Vicar General of Bohemia; this included having the responsibility for 47 monasteries and nine convents. By 1310 he was sent by his Order to occupy the Dominican Chair of Theology in Paris, an honour he shared only with Thomas Aquinas of his Order. In 1324 he became Regent Master of the Studium Generale in Cologne, a post once held by St Albert the Great. Two years later heresy proceedings were instigated against him, but he died before being able to defend himself before the Inquisition.

MEISTER ECKHART'S BACKGROUND

Meister Eckhart is one of the foremost spiritual guides for our time. For centuries his teaching had been forgotten due to the fact that some of his ideas were considered heretical, a stigma he carried until our time. Only recently has he been rehabilitated. Eminent people signed a petition in the 1980s, asking for the possibility to be entertained of issuing an official declaration of orthodoxy, and rescinding the condemnation of his teaching. John Paul II praised him as an outstanding example of Rheno-Flemish mysticism.

Meister Eckhart's duties within his Order were interspersed with periods of studying and teaching at the University of Paris. The fact that he was sent to the University of Paris at various points in his career, which was a much sought after and rare honour, reflects the respect in which he was held by his superiors. At the

age of 42 he received his 'Meister' de-
gree from the University of Paris.
Henceforth he was always referred to
by that title – a clear indication of the
general esteem he enjoyed. He was
elected to many important posts in the
Dominican Order, but he was admired
not only for his many administrative
and intellectual gifts but also for his
spirituality and the holiness of his life.
And yet at the end of his life he was
accused of heresy. To have such a learned
and well-respected Dominican accused
of heresy at the end of a long life of
studying, teaching and preaching was un-

The doors at the Predigerkirche, Erfurt

heard of. He died before he could officially defend himself before the Inquisition.

Meister Eckhart's audience

Apart from his teaching duties within his Order, at the University of Paris and finally
at the Studium Generale in Cologne, Meister Eckhart was concerned with teaching
the ordinary lay person as well, as one would expect of a Dominican. He believed
that the ordinary person ought to be educated: 'If the ignorant are not taught they
will never learn, and none of them will ever know the art of living and dying. The
ignorant are taught in the hope of changing them from ignorant to enlightened
people'(Raymond B. Blakney, *Meister Eckhart*, Introduction, p. xxiii). In the monastic
Orders and the Church itself education now played a greater part. Yet the life of
the ordinary nun or lay woman was not really affected by these changes. The new
Orders of Cistercians and Carthusians had not accepted women. Despite their
emphasis on educating ordinary people, even the Franciscans and Dominicans
largely ignored nuns and women in general.

Those women who wanted to be educated and lead a spiritual life dedicated to
God joined together in supporting communities in the world rather than entering
the convents. These were known as the Beguines, who were mainly established in

Germany and the Low Countries. They taught, studied and earned their own living. In the thirteenth century this was a significant movement that produced three of the greatest women mystics: Hadewijch of Antwerp, Mechthild of Magdeburg and Marguerite Porete. The Beguines (and male Beghards) practised a mystical form of religion influenced by Bernard of Clairvaux. Some, however, were influenced by the 'Brethren of the Free Spirit'. This resulted in the formal condemnation of their way of life in the early fourteenth century. Although an attempt was made to distinguish between devout Beguines and those led astray by the 'Free Spirit' movement, this was not entirely successful; the movement was tarnished.

Because Meister Eckhart taught not only in Latin but also in the German vernacular of his time, he was a popular and charismatic teacher and people flocked to hear his sermons. Especially in the last two decades of his life he was very involved in the teaching of nuns in the many convents along the Rhine that fell under his jurisdiction, and also those Beguines who were left after the condemnation of their way of life. By teaching the latter, however, his orthodoxy was drawn into question.

The condemnation of Meister Eckhart

But despite the popularity of his sermons they are not easy to understand. His language is bold and, moreover, he uses the language of paradox, a favourite way of communication of the mystics in their attempt to express the inexpressible. He shares the difficulty of all apophatic teachers: they feel a strong urge to communicate their lived experience that in essence is non-communicable. Meister Eckhart said in *By compassion the soul is made blessed.* fact, in one of his sermons, that even if there were no one in church, he would still have needed to give his sermons, so strong was his desire to pass on his deeply held convictions.

The problem with bold language and the use of paradox, however, is that any saying, especially if taken out of context, can easily be misrepresented, laying Meister Eckhart open to genuine misunderstandings – and, worse, a deliberate one.

The latter was the case with Heinrich von Virneburg, the Archbishop of Cologne, a Franciscan who at that time was persecuting the Beghards and Beguines in Cologne. He accused Meister Eckhart of heresy. The attack seems to have been very much a personal one, possibly based on envy, but Meister Eckhart's association

with the Beguines gave the archbishop the pretext. The Dominicans came to Meister Eckhart's defence and tried to scupper the archbishop's attempts to prove heresy on Meister Eckhart's part. They held an enquiry of their own, which found him orthodox. But for the archbishop this was not good enough; he delivered the trump card and appealed to the Inquisition, with the result that some of Meister Eckhart's teachings were declared to be heretical in nature. Meister Eckhart never accepted this verdict: 'I may err but I may not be a heretic – for the first has to do with the mind and the second with the will' (Blakney, *Meister Eckhart*, Introduction, p. xxiii). He always saw himself as a faithful son of the Church.

One of the factors that may have contributed to the heresy claim was the fact that most of his German sermons were written down by his audience. In fact his disciple Johannes Tauler pointed out to Meister Eckhart's followers that they were in part to blame for his condemnation by having taken down his words wrongly due to their lack of understanding.

Meister Eckhart's theology

The teaching of Meister Eckhart discussed in this chapter is based on his 'German Sermons', which were taken down in the last ten or fifteen years of his life by his followers. Although most of the statements condemned by the Inquisition were taken from these sermons, they survived the condemnation better than his Latin works due to their widespread distribution and popularity.

Although his education was permeated by the thoughts of Aristotle, his experience inclined him towards the Neo-Platonists. He was influenced therefore as much by Thomas Aquinas of his own Order as by the ideas of St Augustine as expressed in the latter's earlier writings.

There are therefore strong resonances between Meister Eckhart and Clement of Alexandria, Origen, Evagrius and Cassian. He is very much in line with the tradition of 'apophatic' theology, the *via negativa*: 'God is such that we apprehend him better by negation than affirmation.' God cannot be 'named', cannot be known by our *ratio*, our rational consciousness, through the medium of thoughts and images. The only qualities that Meister Eckhart is willing to attach to the Godhead, as outlined in his *Parisian Questions*, are pure being – 'Existence is God' – and consciousness, *intelligere*. We can 'know' God through our *intellectus*, our intuitive consciousness,

which is based on spiritual experience rather than rational knowledge.

Experience therefore informs the theology of Meister Eckhart. In fact he truly represents Evagrius' statement: 'A theologian is one who prays and one who prays is a theologian.' It seems he had a mystical experience of breaking through to the Divine reality:

> *It seemed to a man as in a dream – it was a waking dream – that he became pregnant with Nothing, like a woman with a child. And in the Nothing God was born: He was the fruit of Nothing . . . He has given birth to him in my soul.*

(Cyprian Smith, *The Way of the Paradox*, p. 10)

<div style="float:right; border:1px solid;">

Writings of Meister Eckhart

These are divided into his Latin works and his German works.

His Latin works are *Commentaries* on *Exodus, Genesis, John, Wisdom.* He also wrote the *Book of the Parables of Genesis, Parisian Questions* and *Latin Sermons.*

His German works are his *Sermons,* Books 1 and 2 of *Benedictus, Counsels on Discernment* and *On Detachment.*

</div>

We need to understand 'Nothing' here as 'no-thing', the formless, which is empty of forms but full of potential.

Much of his theology is in a way trying to make sense of this deep experience. He never called himself a mystic. Moreover, he was very much a contemplative in action. His duties and positions were numerous. Perhaps the fact that he had to walk vast distances through the countryside, through nature, in the course of his duties strengthened his contemplative side.

The 'spark'

We have seen how Clement of Alexandria Christianizes the Greek concept of *nous* by equating it to the idea that humanity is created in the 'image and likeness of God' as mentioned in Genesis. The early Church Fathers all agree that this 'image' is contained in everyone without exception, the soul as 'the mirror of God'. This, added to the Greek theory that only 'like can know like', which was fully endorsed by Christian thinkers including Thomas Aquinas, implies that we can therefore come to know God intuitively, as we are already 'like him' in our essence. But to become aware of this essential 'likeness' we need to purify ourselves and strive to lead a life based on the virtues.

Meister Eckhart too supports the view that we can 'know' God because we have something essential in common with the Divine, which he calls 'the spark', 'the

castle' or sometimes the 'ground' of our being. Like Origen and St Augustine he talks of this intuitive knowing as 'the eye of the heart' and stresses that it is the way 'by which God may be seen'. He talks of 'purely spiritual knowledge; therein the soul is rapt away from all bodily things. There we hear without any sound and see without matter . . .' (Smith, *Paradox*, p. 18).

The intuitive capacity of the intellect to know God, our way of being able to have direct contact with the Divine reality, is our divine essence; but at the same time it is also the element that makes us truly human. It gives us the ability to see beyond the ordinary created world and at the same time truly appreciate creation as a manifestation of the Divine.

Meister Eckhart does not at all deny the importance of our rational intelligence, which given his highly intellectual educational background and career is very understandable. Although he feels God cannot be reached by reason, he considers our rational powers to be essential for clarifying our intuitive experience. He sees contemplation as a marriage of mind and heart.

Meister Eckhart goes further than his predecessors by expressing the thought that in this way we can have true knowledge of God, even, in fact, achieve perfect union with God already in this life: 'Similarly I have often said that there is something in the soul that is closely related to God that it is one with him and not just united . . . It is an oneness and a pure union' (Sermon 12 in McGinn, *Teacher and Preacher*, p. 269). He expressed it even bolder in: 'Truly you are the hidden God, in the ground of the soul, where God's ground and the soul's ground are one ground' (Sermon 15 in Colledge and McGinn, *Essential Sermons*, p. 192).

In this respect he differed totally from Thomas Aquinas, who said that true knowledge of God could not be achieved here on earth. Nor did the latter accept a possible identity with God. Similarity has always been accepted within Christianity – the soul as the 'mirror of God' – but total identity with the Divine has always been disputed. Mystics who experienced this identity and spoke about this state of total oneness were viewed with suspicion. This included St Teresa of Avila, who talked in the *Interior Castle* about the seventh dwelling place of the spiritual marriage as a permanent state of union beyond rapture (see Chapter 21, page 300).

Meister Eckhart feels that we are able to 'descend' to this 'ground' of our pure being, to become aware of the 'spark', and thus be transformed into Christ, ascending

with him to God in this life. An important aspect of this potentiality is humanity's deep longing for God implanted by the Divine in the 'spark' within the centre of our being. The urgency of his teaching is occasioned by his conviction of the necessity for everyone to become aware of this potentiality: 'When a man goes out of himself to find God or fetch God, he is wrong. I do not find God outside myself nor conceive him except as my own and in me' (Ursula Fleming, *The Man From Whom God Hid Nothing*, p. 33).

He calls this moment of realization 'the birth of Christ in the soul'. He shares the primacy of this experience with St Augustine, who said: 'What does it avail me that this birth of Christ is always happening if it does not happen in me? That it should happen in me is what matters' (Smith, *Paradox*, p. 6).

The problem with this teaching at this period was that it was very similar to that of the 'Brethren of the Free Spirit'. They and their followers also talked about the birth of Christ in the soul. The difference between them and Meister Eckhart, however, was that the latter stressed the role of Christ and grace, and the Free Spirit movement stressed that this could be achieved solely by works. But despite this difference the similarity provided important fuel for the heresy claim.

The first step on the spiritual path according to Meister Eckhart, just as it had been for Evagrius and the Desert Fathers, is a sudden insight, *metanoia*. This occasions a different way of looking at reality, which entails becoming aware of the spiritual Reality. With this new way of seeing we can then look at our own behaviour and perception with clarity and notice the veils these cause, customarily hiding this higher Reality.

Meister Eckhart had a deep insight into the workings of the human heart and was therefore able to give clear guidance. The invaluable aid in his opinion is the ability to detach ourselves emotionally and psychologically from the reality we create by our thoughts and feelings. The detachment he advocates, combined with contemplation, will lead to self-knowledge and then knowledge of God: 'The reality we call God has first to be discovered in the human heart; moreover I cannot come to know God unless I know myself.'

Despite the emphasis on the intelligence and clarity of thought, both the way and the end for Meister Eckhart is Love: 'God is Love . . . We are turned wholly to God in unshakable love.'

Detachment

Detachment is, according to Meister Eckhart, an indispensable attitude on the spiritual path; it is the only way that the 'Birth of Christ' can take place in the soul. It is this teaching that has made Meister Eckhart truly a guide for our time and explains his universal appeal; his advice resonates with that of Hindu, Buddhist and Sufi teachers.

To understand his emphasis on 'detachment' it is important to keep in mind that Meister Eckhart distinguishes two different ways of being. He talks first about 'individual being', which he stresses is impermanent and subject to change; we would now call that the 'ego', the surface self. But more importantly, we also have our 'true being', which is the idea of ourselves as it already existed in God's mind before creation. This is our Divine essence, our 'spark', which is therefore eternal and unchanging. In fact we have a virtual existence in God.

If you wish to know God, then your knowing must become a pure unknowing.

An inevitable consequence of being created is that we become solely focused on our impermanent and ever-changing 'individual being'; this preoccupation can totally hide our 'true being'. We forget our true origin and destiny. Meister Eckhart considers it therefore essential that we should develop clarity of vision by detaching ourselves from our obsessive concern with our material self and its environment. The word he uses is *Abgeschiedenheit*, which means 'slightly standing apart', creating a distance between us, the world and our concerns. Instead of being pulled hither and thither by the emotional responses of our 'individual being' to what happens to us, we need to stand slightly outside the turmoil of everyday life. And it is contemplative prayer that helps us do this:

Before this birth can happen, we must be at peace, not fragmented by worldly distractions, but united and in harmony within, like the sound of a major chord . . . the mind is stilled and the senses trouble us no longer. (Fleming, *God Hid Nothing*, p. 37)

Whereas his Latin sermons tend to be about theological disputations, his German sermons all deal in one way or another with this required attitude of 'detachment':

When I preach I usually talk about 'detachment': that we have to be empty of self

and all things; second that we should be formed again into that simple good which is
God; third that we should reflect on the great nobility of our soul, so that in this way
we may come again to wonder at God; fourth about the purity of the divine nature, for
the brightness of the divine nature is beyond words. God is a word, a word unspoken.

(Sermon 53 in Colledge and McGinn, *Essential Sermons*, p. 203)

Detachment from all self-centred thoughts – 'leaving self be-
hind' – and from materiality will lead to our remembering
our own divine nature, the 'nobility of our soul', which will
lead in turn to the right attitude to God, 'to wonder at God',
and to true knowledge of his essential being.

Meister Eckhart then proceeds to explain the three things
that hinder us from seeing true reality – the three veils that
hide the face of God:

Three things hinder us from hearing the Eternal Word. The first
is corporality, the second multiplicity, the third temporality. If a
person had passed beyond these three things, he would live in
eternity, in the spirit, in oneness, and in the vast solitude; and
there he would hear the eternal word.

(Sermon 12 in McGinn, *Teacher and Preacher*, p. 267)

By the term 'corporality' he understands the consequences
of being created, being in the world, possessing and being
possessed by the material world. By 'multiplicity' he means
the various images we have of others, the world and self, seen
through our emotional and psychological filters, shaped by
our cultural and religious conditioning. By 'temporality' he
means the effect of created time, of our created mind and
will on our images of God.

Corporality

The first aspect, 'corporality', signifies our attachment to the
material world. When talking about 'attachment' Meister
Eckhart points out that the German word *Eigenschaft* means

Also around this time

1245
Thomas Aquinas becomes the
student of Albertus Magnus in
Paris.

1248
Construction of Cologne
Cathedral begun and Sainte
Chapelle in Paris completed to
house Christ's crown of thorns.

1265
Dante Alighieri born.

1273–91
Rudolf I King of Germany and
Emperor of the Holy Roman
Empire; founds Habsburg
dynasty.

1275
Marco Polo leaves for China.

1280
German merchants form
Hanseatic League.

1294
Kublai Khan, conqueror of Asia,
dies aged 80.

1307
French King Philippe IV
convicts the Knights Templar of
heresy.

1309–77
'Babylonian Captivity' of the
Pope, who leaves Rome and
takes up residence in Avignon
under protection of French king.

not only 'attachment' but also 'ownership'. Endless unhappiness is caused, according to Meister Eckhart, by this desire for ownership with its consequent need to defend our possessions, attitudes, ideas and images of self and of God. He considers this grasping at the material world to constitute a real barrier to the 'birth of Christ in the soul'.

Having possessions, images, and opinions is not wrong per se; it only becomes so when we want to own them for our own 'ego' reasons, dictated by needs coming from the past or desires for the future:

> *If I were so rational that there were present in my reason all the images that all men had ever received, and those that are present in God himself, and if I could be without possessiveness in their regard . . . not in what I did or what I left undone, not looking to past or to future, but I stood in this present moment free and empty according to God's dearest will, performing it without ceasing, then truly I should be . . . as . . . unimpeded by any images as I was when I was not.*
>
> (Sermon 2 in Colledge and McGinn, *Essential Sermons*, p. 177)

This does not at all mean, however, that nothing we do or think has any significance; he stresses the importance of our using our talents, but we must not be attached to the outcome. All must be done without thoughts of possible possessions, rewards, profit or honours either in this world or the next. Everything should be done for its own intrinsic reasons. Even extreme religiosity with an eye to heavenly rewards is condemned strongly:

> *But I am now talking about . . . all those who are possessively attached to prayer, and fasting, the vigils and to all kinds of exterior exercises and penances. Every attachment to every work deprives one of the freedom to wait upon God in the present and to follow him alone in the light with which he would guide you in what to do and what to leave alone . . . Such people present an outward picture that gives them the name of saints; but inside they are donkeys, for they cannot distinguish divine truth . . . They have great esteem in the sight of men who know no better.*
>
> (Sermon 2 in Colledge and McGinn, *Essential Sermons*, p. 178)

This warning was very much needed in his time as there was a great flowering of

exaggerated religiosity. Although the Church came under heavy criticism, religion itself pervaded every aspect of life, which could lead to a 'startling worldliness in other worldly guise' (J. Huizinga, *The Waning of the Middle Ages*).

This advice to 'detach' from the world does not mean in any way that Meister Eckhart denies the value of creation. In a panentheistic way everything is of equal value and all are enfolded and penetrated by the Divine: 'Angels, men, and all creatures flow forth from God equal.' Moreover, creation is the outcome of God's joy: 'He finds it a joy to pour out His nature.' But God needs to be our focus and we should not lose sight of the fact that the real significance of creation is that it is a manifestation of the Divine. The ultimate aim, union with the Divine, far surpasses creation: 'If one takes a fly in God, it is nobler then the highest angel in itself' (Sermon 12 in McGinn, *Teacher and Preacher*, p. 269).

Multiplicity

The second aspect, 'multiplicity', is caused by the myriad images we have of ourselves, all facets of our 'individual being'; they are illusory and transient, a product of our conditioning and 'our created mind and will'. They are dictated by our need for ownership, for esteem and reward, showing our attachment to the world and our adaptation to it. They can, however, block our realization of our 'true being'; we could become lost 'in alien images' and forget our essential Divine essence. To connect with the Divine we need to detach ourselves from these surface images, linked as they are to past and future. God is only in the Now:

> *Everybody who wants to be sensitive to the Highest Truth . . . must be . . . conscious of neither 'before' nor 'after', unhindered by their achievements, uninfluenced by any idea they ever understood, innocent and free . . . there is only one Now. Look!*
>
> (Blakney, *Meister Eckhart*, p. 158)

Meister Eckhart explores in detail how the 'individual being' can imprison us in certain behaviour, regardless of whether we act for the world or seemingly for God. He highlights the difficulty of not confusing God's will with our will. The 'individual being' has a strong tendency to assume that what needs to be done is God's will, when in fact it is the ego, driving us out of its own needs and desires. He stresses that

There where clinging to things ends, is where God begins.

anyone who acts out of his own will, his own perceived needs, is a 'donkey' and not 'free'; we need to detach ourselves from all these desires of the 'individual being' for our actions to be free:

> *We can think what we like, that a man ought to shun one thing or pursue another –*
> *places and people and ways of life and environments and undertakings – that is not*
> *the trouble, such ways of life or such matters are not what impedes you. It is what you*
> *are in these things that cause the trouble . . . Therefore, make a start with yourself, and*
> *abandon yourself.* (Counsel 3 in Colledge and McGinn, *Essential Sermons*, p. 249)

Only when we act by being the 'hands, eyes and ears of God' are we truly free; any merit then comes from the intrinsic merit of the action:

> *But I say that . . . does not deprive a person at all of any of the works he has ever done;*
> *but all this permits him to remain, maidenly and free, without any obstacles between*
> *him and supreme truth . . .*
> (Sermon 2 in Colledge and McGinn, *Essential Sermons*, p. 177)

Only then do we remove the second veil that hides God's presence within us and outside of us. The outcome of, and motive for, this way of acting is love. If you see yourself as the 'temple of God's consciousness', the 'spark of the Divine', then you accept yourself as valuable, loved and esteemed in your own true being. The consequence is then that you see everyone like yourself: 'If you love yourself, you love all men as yourself' (Sermon 12 in McGinn, *Teacher and Preacher*, p. 268).

And this leads to the unselfish love Christ had for all of us: 'If I loved a person as myself, then whatever happened to him, good or bad, death or life, I would be as ready for it to happen to me as to him. This would be true friendship' (Sermon 12 in McGinn, *Teacher and Preacher*, p. 268). Christ, the Trinity, are created out of love and are love: 'Whatever God works, the first breaking forth is compassion' (Sermon 7 in McGinn, *Teacher and Preacher*, p. 253).

Temporality

'Temporality' implies detaching ourselves from the limitations of time, especially with regard to our images of God. Meister Eckhart's concept of God is twofold:

one is Being in time – God/the Trinity – and the other is beyond Being, beyond time – the Godhead.

Meister Eckhart's concept of God is totally apophatic; he cannot be caught in words or images:'God is neither this nor that' (Sermon 2 in Colledge and McGinn, *Essential Sermons*, p. 181). He can only be 'known' in inner contemplative prayer without thought or image: 'You should perceive him without images, without medium, and without comparisons' (Sermon 83 in Colledge and McGinn, *Essential Sermons*, p. 208).

Yet this unknowable God lives within us as the 'spark of our soul', the 'ground of our being'. This is the ultimate paradox: the Godhead is the 'Solitary One', the Transcendent One beyond being, yet at the same time he is immanent in the inner essence of the soul. True knowledge of God is based on an intuitive inner insight coming from this 'inmost part of the soul'.

The first creative outflow of the Godhead is the Trinity, 'Being'. The three Persons share the same essential inner identity, but are different qualities of the one Being. The Father is the creative power, which manifests itself through the Son: 'The Father is a speaking word and the Son is the speech at work' (Sermon 53 in Colledge and McGinn, *Essential Sermons*, p. 204) – the Son as the 'Logos', through which everything is made.

It is at this level that we make God in our image:'Therefore I pray to God that he may make me free of God, for my real being is above God if we take God to be the beginning of created things' (Sermon 52 in Colledge and McGinn, *Essential Sermons*, p. 199). This is one of the bold statements that got Meister Eckhart into trouble. It should be read as follows:'Therefore I pray to the Godhead that he make me free of my images of God, for he and my true being are more than my images.' The emphasis is on remembering our 'spark', which is 'the temple of the Godhead', consisting of the same substance as the Godhead and therefore superior to anything created.

Our images of God are seen by Meister Eckhart to be the consequence of our images of ourselves, which affect in a significant way our relationship with God. Moreover, they keep us focused on the 'external' God, preventing us from discovering the divine 'spark' within. He is very critical of the images of many of his contemporaries and the user mentality they exhibit, and sees these as the main hindrance on the spiritual path:

Some people want to see God with their eyes as they see a cow and to love him as they love their cow – they love their cow for the milk and cheese and profit it makes them. This is how it is with people who love God for the sake of outward wealth or inward comfort. They do not rightly love God when they love him for their own advantage. Indeed, I tell you the truth, any object you have on your mind, however good, will be a barrier between you and the inmost truth.

(Fragment 22 in Blakney, *Meister Eckhart*, p.241)

In fact we need to pray to God for his own sake, not for any reward, as in the well-known saying, 'When I pray for aught, my prayer goes for naught; when I pray for naught, I pray as I ought.'

Many early Christian thinkers shared Meister Eckhart's view that all images of God, whether created in love or in fear, are without significance, even in a way blasphemous. We are here strongly in the apophatic tradition that any image of God belittles God.

Meister Eckhart expresses the impossibility of describing God in language in the following saying, but as always he does this boldly to shock his hearers out of their preconceived ideas: 'If I say that God is good, that is not true. God is not good. I am good. And if I say that God is wise, that is not true. I am wiser than he is' (Sermon 83 in Colledge and McGinn, *Essential Sermons*, p. 207). Our ideas of 'good' and 'wise' in no way can describe the qualities of God.

IX, 18.

Oldest fragment of Sermon 5b

Only by being truly detached from these images and preconceptions can we return to the Godhead, taste the purity of the Divine nature and become totally one: 'The eye in which I see God is the same eye in which God sees me. My eye and God's eye are one eye and one seeing, one knowing and one loving' (Sermon 12 in McGinn, *Teacher and Preacher*, p. 270).

The Aristotelian heresy

Underlying this teaching on 'temporality' are Meister Eckhart's ideas about the relationship between the Godhead, creation and time. He followed Aristotle in saying that God is eternal

and is the 'First Cause'. Because of this, said Aristotle, the world exists from eternity. As we have seen in the chapter on the Desert Tradition, the Judaeo-Christian view formulated in the fourth century was that creation is absolute and from nothing (*ex nihilo*).

Eckhart was therefore accused of the Aristotelian heresy, but he defended himself by saying that he was talking from God's point of view, not from humanity's. He states that we cannot talk about creation in time, because time, as we know it, does not exist before creation. Our concept of time is therefore not applicable to God, as he creates in his eternity continually from a perpetual Now:

> To talk about the world as being made by God tomorrow, yesterday would be talking nonsense. God makes the world and all things in it in this present Now. Time gone a thousand years ago is now as present and as near to God as this very instant.

Here Meister Eckhart is fully in line with St Augustine, who also stressed that God's act of creating took place outside our conception of time. The latter talks in *The City of God* of not only humanity, but all things, existing in their essential being prior to creation as 'seminal ideas' in God. This is the reason why we are still linked with God in our essence.

Meister Eckhart sees creation as a cyclical, dynamic process: we 'flow out' of the Godhead and then 'break through' on our return to the Godhead: 'They [created things] are all called to return into whence they have flowed out' (Sermon 53 in Colledge and McGinn, *Essential Sermons*, p. 205). Creation begins with the Trinity and through Christ comes our 'flowing out', our creation, and our 'breaking through', our possible return. This entire idea is backed up with proof from Scripture and supported by St Augustine, but unfortunately for Meister Eckhart, he phrased his ideas too forcefully.

Meister Eckhart forms in his teaching a bridge between early Christianity and the spirituality of modern humanity in all its diversity. His teaching resonates with the Neo-Platonic tradition of the early Church Fathers and at the same time links with the 'perennial philosophy', the common core of all the world religions and Wisdom traditions.

KIM NATARAJA

SIXTEEN

DANTE ALIGHIERI

Dennis McAuliffe

Dante Alighieri, *Andrea del Castagno*

Introduction

Dante lived in the same turbulent time as did Meister Eckhart, but in Italy this period was at the same time one of great culture; Boccaccio and Petrarch were his contemporaries. He was a scion of an ancient Florentine family, the Alighieri. He was introduced from an early age not only to poetry, especially that of the 'troubadours' and Virgil's classical poetry, but also to the arts, music as well as literature, in particular Boethius' *De Consolatione Philosophiae* and Cicero. He was very attracted by philosophy; he studied it in Florence with the Dominicans at Santa Maria Novella and is reported to have participated in the great debates about the teaching of Bonaventure and Thomas Aquinas. Religion and mysticism also held a great fascination for him, especially as he himself seems to have had a mystical experience: he describes himself as having 'come from time to the eternal' (*Paradiso*). But these interests did not prevent him from engaging fully in the social and political life of his time – with the result that he was banished from Florence.

Professor Dennis McAuliffe discusses how the *Divine Comedy*, through its different levels of possible interpretation, literal, moral and allegorical, shows that Dante was not only an embodiment of the culture and thought of his time but a representation of a man on the spiritual path. We can see this from his commitment to his vision and his willingness to be open to the illumination of Love.

Dante Alighieri 1265–1321

He was born in Florence to an impoverished aristocratic family. His parents both died before he was 17. His education was quite eclectic: he studied with the Franciscans, Dominicans and the Augustinians in Florence and at the University of Bologna, and mixed with many artists, poets and musicians of his time. Although he was married he had a 'courtly love' attachment to Beatrice. He entered politics in Florence, even becoming one of the Priors of Florence. Soon after this he was forced into exile and for the rest of his life he wandered from place to place, writing and occasionally teaching. Towards the end of his life he was offered asylum in Ravenna, where he died in 1321.

DANTE

Dante starts his *Commedia* with: 'In the middle of the journey of our life / I came to myself within a dark wood / where the straight way was lost.' My focus here will be on attention, and in particular on the attention Dante paid to his own experience of life and the way he shaped and expressed his vision in the *Commedia*. We will look at how the works of Dante reflect his voyage into mysticism and the way they describe the stages of the journey, of everyone's journey, towards the Divine.

Influences on Dante

Dante's *Commedia* forms part of a long tradition of mystical literature. The Song of Songs, along with passages from other books of the Old Testament, had a primary influence on Dante's writings. Other influences were some of Jesus' sayings in the New Testament as a continuation of the tradition of Moses and Isaiah in the Old Testament; certain passages of St Paul; and, from the classical world, Cicero's *Somnium Scipionis*, which refers to Macrobius' journey to the 'third heaven', where he had a spiritual experience. Influences from the Middle Ages were such important figures as St Augustine of Hippo, Boethius, Hugh and Richard of St Victor, Bernard of Clairvaux and the two Mechthilds, Mechthild of Magdeburg and Mechthild of Hackeborn, not to forget St Francis of Assisi.

Dante figures in this tradition as someone who assimilated much of the literature produced by these great figures of the mystical tradition and could synthesize them

and present them in his own personal way. But his writing is not only autobiographical; he represents 'everyman', as his use of 'our life' in the very first line of the *Commedia*, cited above, underscores.

Dante's early works

Dante wrote several works before undertaking the *Commedia*, a title used by his early commentators. (The title *Divina Commedia* was used only later on by Boccaccio, the author of the *Decameron*, who was one of the first professors of Dante in the 'Studium Generale', as the university in Florence was first called.) He first presents his ideas, what you might call his 'incipient mysticism', in a work that he wrote around 1290 at the age of 25, called *La Vita Nuova*. It is a story of a conversion, which had to do with his encounter with a girl named Beatrice when they were both nine years old. The name Beatrice was significant to Dante because it means 'she who makes blessed', signifying Dante's desire to be changed by her. The meeting of their eyes and Dante's resulting absorption was a kind of contemplative state that Dante entered at this encounter. From this early period onward, he says, he would write poetry to her. Beatrice died when she was very young, but even after her death he continued to write poetry to her. He collected this poetry into a book and accompanied it by commentaries on the poems, a manual about how to write love poetry, but also the narrative of his autobiographical experience with Beatrice. At the end of the *Vita Nuova* Dante says that he will write things that have never been written before about the 'miracle of woman'.

His first substantial piece of writing after the *Vita Nuova* is the *Convivio*. This is in the form of a philosophical treatise in which he presents some of his poetry and explains it from a philosophical point of view. This might be called imperfect mysticism. In the *Convivio* Dante tried to portray in prose in the language of scholasticism the voyage of knowledge to Blessedness. He gave up on this piece of work about halfway through the writing, realizing that the only way to express his vision was in the form of epic poetry. Dante began writing the *Commedia* in 1304 and finished it shortly before his death. It is not surprising that the writing took some 17 years, given the depth and polysemic nature of the text.

Vision of the mystical mountain

The mystical doctrine of love that is elaborated in the *Purgatorio* and the *Paradiso* is presented first by Dante's guide, Virgil. He meets Dante in the dark valley in which Dante finds himself, as he says in those first lines quoted above. Dante knows that it is the fear

Dante and the Divine Comedy, *Domenico de Micheino*

he felt in this part of his voyage that he has to relive in order to tell his story. He wants the reader to recognize this fear as the reader's own. When talking about trying to get out of the dark forest, Dante sees the sun coming up over a mountain. This is the mystical mountain described in Psalm 24:'Who shall ascend the mountain of the Lord and who shall stand in His holy place? Those who have clean hands and pure hearts, who do not lift up their souls to what is false and do not swear deceitfully.' This is the mountain Dante sees, the mystical mountain that the just man, the man who isn't burdened by sin, can ascend. Who that just man is, we do not know. Was there ever a man who could ascend that mountain directly? Dante certainly cannot. He encounters three beasts as he starts to ascend the mountain, three beasts that represent the three dispositions to sin in every human being, the fallen human condition. Dante cannot get past the beasts. He turns away, and providentially meets Virgil, who will guide him through the difficulties of Hell. The road through Hell is the only other way to the top of the mountain. We read later in the *Purgatory* that it was the southern side of the mountain that Dante had tried to climb directly, but it is the northern side that he eventually has to climb along a circuitous path in order to reach the top, or earthly paradise, where he will meet Beatrice.

Inferno

The *Divine Comedy* consists of one hundred cantos and is divided into three canticles – *Hell*, *Purgatory* and *Paradise*. There are 33 cantos in each canticle, for the sake of symmetry, and one introductory canto. The proper beginning of *Hell* is therefore Canto 2. Here Dante interrogates Virgil as to why he, Dante, in particular was chosen for this voyage into the three realms of the afterlife. Virgil explains that Dante was called to do so, although he was not Aeneas (destined to found Rome and therefore pave the way for both the Empire and the Church, the temporal and spiritual guides for humanity respectively), neither was he Paul who was lifted up into the third Heaven, and who made a voyage into Hell as is recounted in the *Apocalypse of Paul*, a fourth-century text of the New Testament Apocrypha with which Dante was familiar. Virgil further explains that a woman named Beatrice had been sent to him by the Virgin Mary. Beatrice came from her assigned place in Heaven next to Rachel. Rachel is a highly important figure in the history of mysticism, as she represents the contemplative life. Her sister, Leah, represents the active life, since Jacob

Dante and Virgil Enter Hell, *William Blake*

first had to marry her before being allowed to marry Rachel, showing that the active life comes before the contemplative life. This same point is also brought out by the story of Martha and Mary in the New Testament. Beatrice's proximity in Heaven to Rachel immediately establishes her as a representative of the contemplative life. Thus, right from the start Dante makes it clear that he is heading for an experience of contemplation, but it also shows that he understands that there is much to be done before he is able to reach that stage.

Virgil takes Dante into Hell, which is constructed of ten circles subdivided into 24 regions where different sins are punished. Twenty-four is a classical number.

Dante's plan for the construction of Hell is taken from Aris-
totle's *Ethics*, and is intentionally not a Christian place. It is
in fact a non-place, representing a total rejection of true exis-
tence. Beyond the ante-chamber of Hell is the circle of Limbo
where Virgil dwells along with all the noble ancients, who
practised the human virtues – temperance, fortitude, wisdom
and justice – to the highest degree possible. They couldn't be
taken into Heaven because they didn't have the sanctifying
grace of Christ's salvation, as they were not baptized. There are
good reasons to conclude that Dante changed his mind about
this as he matured in the writing of the *Divine Comedy*, and
decided that there was probably another kind of baptism,
which allowed these souls from Limbo to reach Heaven. He
encountered souls in Heaven who were from the time before Christ, but achieved
baptism through desire. This gives hope that Virgil too some day will be found there.
According to Christian tradition, it is not known whether Limbo is eternal or not;
it is known that Hell and Paradise are eternal.

Dante's writings

He wrote *La Vita Nuova* in Beat-
rice Portinari's honour upon her
death in 1290, it being the story
of his love for her. This was
followed by the *Convivio*, a
philosophical essay, part poetry,
part prose; and the *Monarchia*,
a political and philosophical
work; and finally his greatest
work, his life's work, *La Divina
Commedia*, an allegory of the
spiritual path, which he started
in 1304 and completed towards
the end of his life in Ravenna in
1321.

Virgil guides Dante down through all the different circles of Hell. After passing
through the circles of incontinence, they enter into the City of Dis proper, where
sins of violence and deception are punished, down to the dwelling place of Satan.
The latter is unable to talk, because he has three heads and in each of his three
mouths he has a sinner: Brutus, Cassius and Judas. The first two caused injury to
the Empire; and Judas, worst of all, offended God directly. Satan is a fallen seraphim
with six wings that keep fluttering all the time and keep the waters, which flow all
down to the centre of Hell, frozen, so that he is totally immobile – he can't speak
and can't move. Satan keeps himself in this state; he punishes himself. It is not Dante
or God who is punishing the sinner but the sinner who is punishing himself
according to the principle of *contrapasso*, which is the rule of Hell. This means that
each punishment is appropriate to the sin that characterized the sinner's life, a pun-
ishment that fits the crime. This is the case with every sinner Dante meets in Hell.
The further Dante goes in Hell the more he realizes that the sinners he meets fear
all the sins of the preceding ones he encountered as well; once they have fallen into
sin, each sin becomes a composite of all the sins that went before it. The first sin is

'Lust', which is shown in the famous story of Francesca and Paolo, and the worst sin is treachery, the ultimate form of 'Fraud'.

Purgatorio

Purgatory is chronologically, geographically and atmospherically like earth. Movement round the mountain is in a counter-clockwise direction, as you are always turning to the right in your purgation – the idea being that you are undoing what time has done to you on earth. The aim is to reach the state of perfect innocence, where you no longer know sin, where you are no longer even tempted to sin. The day is perfectly divided into 12 hours of day and 12 hours of night. The basic rule of Purgatory is that you are not allowed to do anything active in the 12 hours of the night; you must sit in contemplation. At night you contemplate the theological virtues that govern the night: Faith, Hope and Love, whereas during the day you practise the cardinal virtues that rule the day: Prudence, Justice, Temperance and Fortitude. During the day, you are able to actively purge your sins. For 'Pride', for example, you have to walk with a heavy weight on your shoulders, bent over to the ground, where you see outstanding examples both of the sin and of the virtue of humility (related to the cardinal virtue of Temperance). The day is symmetrically divided between the active and the contemplative life.

Dante and Virgil leave Hell and enter Purgatory by climbing up through a fissure created by the River Lethe that trickles water down into the icy centre of Hell. The River Lethe, from classical literature, is the river of forgetfulness, which we will meet again when we get to the top of Purgatory, the earthly paradise. There are two fountains creating rivers that are self-perpetuating sources of water. One is Lethe and the other the river of good remembrance, Eunoè. In Purgatory all saved souls are deposited on the shore by a boat driven by an angel. On this shore Ulysses and his followers had drowned, a just outcome of their sinful voyage for forbidden knowledge. Ulysses is an anti-Dante figure. He stands for the human being who goes against divine law. This part of Dante's story is not taken from Homer but was created in the Middle Ages: Ulysses, after he returned to Penelope, got bored and set off again with some companions to achieve the ultimate experience of knowledge. In order to pursue this goal he had to disobey the command of the gods who forbade him to go beyond the Pillars of Hercules. At the end of their voyage Ulysses

and his followers came within sight of the Mountain of Purgatory; they saw salvation, but before they could get there Ulysses and all his crew were drowned. The voyage was a failure because it was not inspired by divine grace but rather by human pride.

In Canto 2, Dante and Virgil begin the climb up the mountain of Purgatory and encounter all the souls who have accepted their sin; they have confessed it and have agreed to a penance, which will make reparation for their sin, as far as human satisfaction can go. For purgation it is necessary that you recognize your sin and meditate on that fault. This is the use of meditation as discursive meditation. This contemplative act uses images found in the 'cornice' where the sin is being purged. These are images of both the virtues needed to overcome the fault committed, and outstanding examples of that fault, so that the nature of the sin committed is fully revealed. All sinners in Purgatory have been redeemed; they are all going to Heaven and know they are going there; but before they can go they have to perform acts of penance.

Like Hell, Purgatory consists of ten levels. Purgatory, however, is a place of revelation and so, unlike Hell, it is constructed according to Christian symbolism and architecture. There are three levels of ante-Purgatory, where people wait, for various reasons, to be admitted to Purgatory. For example, those who did not repent until the moment of death have to wait for the same amount of time as they put off their repentance during life. Those who suffered excommunication from the Church have to wait 30 times the amount of time they spent in excommunication.

After you get into Purgatory proper there are seven 'cornices' that you go through. The first cornice is the sin of 'Pride'. Once you have purged yourself of pride, which is at the root of all sin, you go to the next cornice, and so on through all the cornices until you have purged all the sins you have ever committed. Once

Also around this time

1267–1337
Giotto di Bondone, Italian painter and architect, considered first great artist of the Renaissance.

1285–1347
William of Ockham, English Franciscan friar and philosopher.

1291
Fall of Acre, the last Christian foothold remaining from the crusades.

1304–74
Francesco Petrarch, poet and writer, friends with Boccaccio. He was considered to be the father of humanism and was the first to call the previous 900 years the Dark Ages.

1309–75
'Babylonian Captivity' of the Popes. The Pope leaves Rome and takes up residence in Avignon under protection of French king.

1313–75
Giovanni Boccaccio, a humanist writer and poet; from an early age influenced by Dante.

1315–17
Great famine kills millions in Europe.

1337
Start of the Hundred Years' War by Edward III's laying claim to the French throne.

you have purged pride every other purgation is less difficult because pride is the root of every sin. So as you go up you become lighter and lighter; Dante illustrates this ever-increasing lightness by showing that when you enter into Purgatory seven 'p's, for *peccata*, Latin for 'sins', are imprinted on your forehead. When Dante goes through the pass of pardon from the sin of 'Pride', the first 'p' is erased and all the other 'p's lose their depth, becoming a little greyer, and Dante feels lighter, more able to climb up. At the top of Purgatory is the sin of 'Lust', where Dante meets his final challenge: to pass through a wall of fire in order to meet Beatrice who is on the other side, in 'earthly paradise'.

Paradiso

When Dante gets to the other side of the wall of fire, night again falls and he can't proceed because of the Rule of the Mountain. It is at this moment, as he gazes at the stars that are calling him upwards, that he describes for the first time in the *Commedia* his own contemplative state: 'Thus calling back to mind and gazing with attention at [the stars] / sleep took me, sleep that often / before the fact, knows what happens.' A dream follows in which appear to him Leah and Rachel, representing the active and the contemplative life. When Dante awakes and Virgil bids him let desire be his guide from that moment on, Dante wanders through an ancient forest (the Garden of Eden) and by a stream meets a lady, the counterpart of Leah, who is singing of love and gathering flowers. This lady, whose name, Matelda, is not given until the end of their encounter, like Leah represents the active life. She is a precursor and handmaid of Beatrice, who consequently represents the contemplative life. In fact she tells Dante that Beatrice is coming to fulfil Dante's desire to know about God, to receive illumination.

Through Hell, Purgatory and Paradise the three stages of the mystical journey are shown. The first stage is reason and the understanding of the 'fall' of the human condition, the recognition of what is met on the journey. The second stage is purification, repentance, the various degrees that are presented in the completion of purgation of the seven sins. And then finally illumination, the illumination that Beatrice brings at the end of the preparatory stages. She takes, through illumination, the soul or the mind, and possibly the resurrected body − Dante like Paul is not sure whether he is taken up in this body or out of this body − on the journey into

God. Dante is all of a sudden taken up into the beatific vision; he could not have accomplished it for himself. It was the grace of God at work. Dante was a man deeply in love with God.

Definitions of mysticism

Let's end with two definitions of 'mysticism'. The first comes from *Dante and the Mystics* by Edmund Gardner, an outstanding scholar who wrote about religion and literature at the beginning of the twentieth century. There mysticism is defined as follows: 'We might define mysticism as the love-illumined quest of the soul to unite herself with the super sensible, with the Absolute, with that which is.' Certain pantheistic mystics find the goal of this quest in the union of the soul with the spirit of Love and Beauty, which they recognize in nature, as expressed by Wordsworth in those splendid lines at the end of 'The Recluse', and by Shelley in the whole allegory of 'Prometheus Unbound'. The medieval mystics, and their Catholic successors, find it in God, the First Cause, a goal only to be attained perfectly and continuously in the hereafter but realized partially and fleetingly by anticipation here and now. And this realization takes two principal forms: one is the religious experience described by St Catherine of Siena, St Teresa of Avila and others known as the 'spiritual espousal' of the soul with Christ. This form calls back to mind the 'Song of Songs' and all the imagery of the 'mystical wedding' of the soul with Christ; this is exactly what is happening as Dante meets Beatrice: the mystical wedding of Dante and Beatrice that foreshadows Dante's mystical absorption in God.

Gardner continues:

> *The other is an intellectual anticipation of the vision of Divine essence, as in that 'momentum intelligentia', that one moment of understanding, after which St Augustine and St Monica sighed and the one moment that should anticipate the beatific vision.* (pp. 26-7)

This second form is summed up by Dante in lines 141–2 of the last canto of *Paradiso*: 'my mind was struck by a lightning bolt in which its desire was granted'.

So here is the fulfilling of what St Thomas Aquinas taught Dante in the *Summa Theologica*, namely that knowledge comes first and then comes love. Dante achieves all this knowledge of what it is to be human through his voyage into Hell and then through Purgatory, and then realizes that the human being is capable of achieving

the perfect innocence of a child, of humanity before the fall. Dante comes to the full knowledge of that innocence first by forgetting sin by drinking of the River Lethe, and then by remembering all good things by drinking of the River Eunoè, including the good things that were the result of (his) sin, which had been the cause (*felix culpa*) of God's grace. God turns everything to good, even sin. Once Dante has drunk of both these rivers, he remembers everything, but sin is remembered only for the good it has done, the way it has brought him to this readiness to be taken into the beatific vision. Dante uses the phrase 'to become more than human' for the beatific vision, which also means to become 'like God' or even to become God, to be 'deified', as the final lines of the Comedy put it: 'my high and deep vision lost its power; / but already my desire and my will were being turned, / like a wheel that is evenly moved, / by the love that moves the sun and the other stars'.

PROFESSOR DENNIS MCAULIFFE

RICHARD ROLLE, WALTER HILTON AND MARGERY KEMPE

Stefan Reynolds

Richard Rolle

Introduction

In England at this time several outbreaks of the Black Death, as well as famine and war, decimated the population; moreover, by the end of the century the country was in the throes of civil war – the 'Wars of the Roses' – as well as the 'Hundred Years War' with France. Both the landed gentry and the population at large were badly affected, causing a breakdown in the old structures of society leading to the Peasants' Revolt. Not only that, but the Church was in ill repute, with corruption among the clergy far from uncommon.

And once more, at a time of tremendous social and religious upheaval, there was a remarkable flowering of mysticism, this time accompanied by a revival of interest in magic, particularly in East Anglia. This was the time of the 'English Mystics': Richard Rolle, Walter Hilton and Margery Kempe, as well as the author of the *The Cloud of Unknowing* and Julian of Norwich (see the next two chapters). Both the author of *The Cloud* and Julian of Norwich used the vernacular rather than Latin, the liturgical language of the Church, for their teaching; this was, as in Meister Eckhart's case, possibly the reason for their great influence on lay people. The result was that mystical prayer and spiritual experiences were quite widespread among the ordinary people in this part of East Anglia.

Stefan Reynolds illustrates what was most striking about the mystical tradition in the fourteenth century in England, namely the variety of different ways in which

the mystical life was expressed. He tells us about the hermetic way of life, inspired by Richard Rolle, who was deeply contemplative and at the same time a charismatic with many ecstatic experiences. Then he shows how Walter Hilton tried to reconcile this ecstatic mystical expression with the 'apophatic' way of prayer advocated in *The Cloud of Unknowing*. Finally, there is Margery Kempe, in whom the charismatic way of prayer and the general love of going on pilgrimage at that time were combined.

Quotations are taken from the following editions:
Richard Rolle, *The English Writings*, ed. Rosamund Allen, SPCK, 1981.
Richard Rolle, *The Fire of Love*, ed. Halcyon Backhouse, Hodder & Stoughton, 1992.
Walter Hilton, *The Scale of Perfection*, ed. Dom Gerard Sitwell OSB, Burns & Oates, 1953.
Margery Kempe, *The Book of Margery Kempe*, trans. Barry Windeatt, Penguin Classics, 2000.

Richard Rolle 1300–49

He was born in Yorkshire and possibly died from the Black Death, which had reached its peak at that time. He went to Oxford to study, as he was obviously bright. His command of Latin is remarkable. However, he did not get on with the scholastic theology of the time and left Oxford to become a hermit in Yorkshire. His book *The Fire of Love* and his poetry were extremely popular. Though he was theologically orthodox and did use the Bible, he made no appeal to any authority and rarely cited the Fathers of the Church.

Walter Hilton (latter half of the fourteenth century)

Outside of his writings little or nothing is known of Walter Hilton. He may have been an Augustinian canon; there are records of someone of that name in a monastery in Northamptonshire and the register records that person's death in 1395. His writings certainly show evidence of West Midland phrases.

Margery Kempe 1373–1440

Margery is recorded as being born in Lynn in 1373 and dying in 1440. There is a marriage certificate in Lynn dated 1393 and records of 14 children. Her book records that she nearly went insane after the birth of her first child, that she ran a brewery business for some time, paid her husband's debts, insisted on a vow of celibacy, went on pilgrimages, nursed her husband in his old age, accompanied her widowed daughter-in-law back to Germany, and died at the age of 67 in 1440.

ENGLISH MYSTICISM IN CONTEXT

In many ways the fourteenth century was the greatest century for Christian mysticism. Maybe because the old structures no longer held, maybe because the richness of the earlier medieval spirituality provided such fertile ground, there was a daring in mystical thought at this time that is unparalleled in Christian history.

In England this took a particular form; not the adventurous speculative mysticism of the Continent but a practical, pastoral form of spirituality aimed at those living the solitary life. The extremity of the times meant that there were many who wanted to dedicate their life to God. Spirituality was overflowing the containers of traditional religious life and taking new forms.

The *Ancrene Rule*, written at this time, showed a concern for the domestic practicalities of a solitary. Alongside the rootedness of the anchorite vocation, pilgrimage was also becoming very popular. Chaucer showed in his *Canterbury Tales* how people from all walks of life felt called to take to the roads and visit the shrines and relics of the earlier medieval saints. At a time of change one seeks security in the stability and certainties of the past.

There were also more informal hermits and lay people who, in their own homes, were living a focused life of prayer that previously had been a preserve of the monasteries. On the Continent these devout lay people organized themselves into informal groups, the most famous being the Beguines of the Lowlands and Rhineland. These produced some of the greatest mystical writing of the time. The English mystical temperament was more individual, even idiosyncratic.

Richard Rolle

Of all the medieval English mystics, Richard Rolle was the most famous in his time. His poetry, devotions and spiritual works started a tradition of homespun English mysticism that was more devotional than scholastic and more concerned with personal piety than speculative theology. He was also one of the major influences behind English hermit and anchoritic spirituality of the time, with its stress on the individual's experience of God and its affective, emotional language.

His most popular book, *The Fire of Love*, is an eloquent, often rhetorical, plea for a complete devotion to God that involved renunciation of the world. Personally

he felt that any involvement in the world, even attendance at church, was a hindrance to the uninterrupted contemplation he sought. It is this as well as the exuberant and florid nature of his prose that makes Rolle difficult to read today. However, the combination of the beauty and fervour of his language and the idiosyncrasy of his character and lifestyle means that he is never dull.

Rolle was charismatic, both in his personality and in his affirmation of the sensory experience of God. He had 'visions' of Heaven, 'locutions' of the song of angels, 'tastings' of the divine manna and bodily rapture, where God was experienced in the body. He was a mystic of the spiritual senses. As such his mysticism was a lyrical and heartfelt counterbalance to that other strand of English mysticism of the fourteenth century represented by *The Cloud of Unknowing*. For Rolle, God met us in our body. *The Cloud* was concerned to keep the distinction between the physical and the spiritual. God was hidden from our senses and mind, known only in love. Rolle liked to make that love tactile and spiritually tangible.

Rolle related his own experiences of 'heat', 'sweetness' and 'song' in remarkably realist terms. At the beginning of *The Fire of Love* he tells how he felt his shirt was on fire, such was the warmth of devotion he felt in his heart:

> *I was sitting in a particular chapel, delighting in meditation and in prayer's sweetness, when I suddenly felt within an unusual and pleasant heat . . . I call heat that point when the mind is fired with eternal love. The heart simply feels itself burning with a real love, not an imaginary one. For the heart full of fervour and set ablaze, produces a feeling of fiery love.*

In *The Fire of Love* 'sweetness' is linked to 'song'; 'the sweetness of unheard melody'. Again Rolle records in very realist terms an experience of the music of Heaven, the song of the angels which was both exterior and interior:

> *While I was sitting in that chapel, repeating as best I could the night psalms before supper, I heard that singing. A joyous ringing of psalm singing came from above my head. I was praying, reaching out to heaven with a longing heart, when I became aware of this in a way I cannot explain. It was a symphony of song within myself. I felt a corresponding harmony that was totally wonderful and heavenly, and which continued in my mind. Right then my thoughts turned into melodious song, my meditation became*

a poem, my prayers and psalms captured the same sound. The effect
of this inner sweetness was that I began to sing what before I had
only spoken. But now I was singing inside me to my creator.

All this is known as the 'spiritual senses', whereby the soul
is able to hear, see, taste, touch and even smell spiritually.
Many mystics record it. Rolle led the outward senses inward,
not contrasting the physical and spiritual. It is this holistic
treatment of the spiritual senses, which engages our physical senses also, that makes
Rolle highly unusual among mystics and has called down some criticism on him.
For example, *The Cloud of Unknowing*, written a generation later, caricatures those
who would try to 'peep into heaven', 'strain their ears so as to hear the angels sing'
or 'agitate their physical senses in any peculiar way'. Certainly one should not try
to seek these experiences in themselves. The stress in apophatic mysticism is to reach
out to God beyond thought or feeling. So the *Cloud* author says that one should
'rest in no sensible consolation'.

However, Rolle's mysticism is based on an inner experience of the body of Christ.
This is not a eucharistic spirituality (Rolle rarely went to church and speaks little of
the sacraments) but an experience of resurrected physicality. Christ's body is present
to us through his Resurrection, and just as we are able to share in his sufferings so too
we can share in his glory. 'Heat', 'sweetness' and 'song' are foretastes of our own physical
resurrection, our incorporation in Christ, and what it will 'feel like' to be in Heaven.

The danger of concentrating on experiences is that it tends to increase self-con-
sciousness. The aim of mysticism is detachment from self, taking the attention off our-
selves. Some modern critics have said that Rolle runs the risk of making the sensation
of loving God the aim, rather than simply loving God. Rolle argues that if the expe-
rience is real and authentic then attachment to it is transcended in the experience.
The experience itself will keep you humble. Thomas Merton was one of the few
modern writers who came to Rolle's defence, arguing that the sensual approach was
picked up in the Orthodox Hesychast tradition (see Chapter 24). Gregory Palamas,
for example, talked of the 'created energies of God' that were present in the body.

In the West mystics have tended to favour the *via negativa*. The concern is that
one loves God for God's sake and not for anything we may get out of him. The

Writings

Richard Rolle: *The Fire of Love.*

Walter Hilton: *The Scale of
Perfection, The Song of
Angels* (treatise), *On the Mixed
Life* (treatise).

Margery Kempe: *The Book of
Margery Kempe.*

lack of experience of God is therefore a positive stage on the way. In the experience of God's absence our hearts are weaned off any dependence on psycho-sensual consolation. Rolle was part of an older tradition going back to St Augustine that saw 'absence' more as the result of sin; our fallen nature kept us from a full experience of God. For the apophatic tradition, however, it is a method of divine pedagogy, teaching us spiritual detachment and purity of heart.

This is a difference between apophatic and kataphatic spirituality. Rolle was a mystic who cleaved to the light of love he experienced in his heart. However, Rolle did not subordinate the body to the mind in the way Augustine did. For Augustine, steeped as he was in Neo-Platonism, the light of God was reflected primarily in the faculties of the mind: memory, understanding and will. For Rolle it was experienced in the transformation of the senses. The body entered into contemplation. In *The Fire of Love* he talks about posture in prayer and experiments with it:

> *If I stand up, walk about or even lie flat down on the ground while engaged in contemplation, I seem to come away with dryness. So to grasp and attain deep devotion I must sit, and I have decided to do this. I have realized the underlying reason for this. If a person stands or walks a lot their body tires, and so, too, their soul. It becomes wearied and burdened, and they are hindered. They are not as quiet as they can be, and not in the most conducive state for prayer. If Aristotle is right, then it is sitting quietly that makes the soul wise.*

This holistic tenor of English spirituality was taken up by Julian of Norwich a generation later. Julian argued that the purpose of the spiritual life was to lead our 'sensuality' back to our 'substance'. What she meant was that our created nature, body and soul, had to re-find its ground in God. The process of salvation was therefore seen as the healing ('salve') of the wound in our nature and the integration of our whole being, body, soul and spirit. This treating of the whole person was a legacy of Rolle.

As in the Hesychast tradition of the Eastern Orthodox Church, in Rolle's writing there is a strong devotion to the name of Jesus. Repetition of this name was like a mantra to him. In *The Form of Living*, one of the first spiritual treatises written in the English language (*The Fire of Love* was written in Latin), he writes:

If you want to be on good terms with God, and have His grace direct your life, and come to the joy of love, then fix this name 'Jesus' so firmly in your heart that it never leaves your thought. And when you speak to Him using your customary name 'Jesus', in your ear it will be joy, in your mouth honey, and in your heart melody. If you think of the name 'Jesus' continually and cling to it devoutly, then it will cleanse you from sin and set your heart aflame; it will chase off the devil and eliminate terror, open heaven and create a mystic.

In *Ego Domino*, a Latin work, he says:

I appeal to you to love this name Jesus and meditate on it in your heart so that you never forget it wherever you are . . . nothing pleases God so much as true devotion to this name of Jesus. If you love it properly and enduringly and never stop, in spite of anything that people may say or do, you will be carried away in ecstasy into a higher life than you know how to wish for.

In *The Fire of Love*: 'O Good Jesus, you have bound my heart to the thought of your name.'

Rolle distrusted learning; the important thing in the spiritual life for him was humility. He reminds one of *The Cloud of Unknowing*'s dictum that 'God cannot be known by thought but only by love.' Rolle adds that 'clearly the more intellectual people are the more they are able to love aright, provided they really do put themselves down and gladly let themselves be despised by others' – Rolle was well educated, as his command of Latin shows. He studied at Oxford but did not get on with the scholastic theology there. He left Oxford without finishing his studies and went back to his home town in Yorkshire to become a hermit. In *The Fire of Love* he writes:

So many people today burn up in the fires of learning and not of love, that love remains unknown. Though all their study is directed to that end – the burning love of God – yet what love is, and how it feels, escapes them! What a pity! An old wife may know more of God's love and the rejection of worldly pleasure than a theologian!

Rolle did however promote *Lectio Divina*, the quiet reading of Scripture. For this to be of value, though, he felt there needed to be a strong spirit of interiority. The words have to be chewed over, not just said aloud. Again he was critical of the contemporary practice:

Today many are quick to throw the word of God from their hearts and their minds. They will not bear it to remain quiet within them, and are therefore not aglow with the comforting heat. They remain cold, sluggish and neglectful, even after umpteen prayers and meditations on the scriptures. It is because they neither pray nor meditate within their minds.

Also around this time

1300
Florence becomes the Banker of Europe and introduces the florin as its coin.

1300
Start of the Renaissance.

1314–17
Widespread famine in England.

1328–84
John Wycliffe, English theologian and biblical translator, posthumously declared a heretic.

1334–52
Plague kills 25 million people, half of the population of Europe, followed by economic depression.

1337
Start of the Hundred Years War between England and France.

1341
Petrarch crowned poet laureate on the Capitol in Rome.

1345
A conjunction of Saturn, Jupiter and Mars thought to be the cause of the plague epidemics.

1347
The Black Death reaches England and continues until 1350 with recurrences in 1360 and 1369.

He was keen on mindfulness and although he preferred solitude he believed, because of the interiority of prayer, that it could be practised in all circumstances and activities:

If we are true lovers of Jesus Christ, we may, undoubtedly, think of him as we go about, and still hold on to the song of his love when we are in company. We can keep him in mind at the table while we eat and drink. With every bite we eat or sip we drink we ought to praise God. In the intervals we could be praising God with sweet melodies in that cry and desire of the mind and even sigh for him between dishes! If we are working with our hands, what would stop us from stirring our hearts to heavenly things? Why not keep the thoughts of eternal love perpetually in mind? At every moment in our life we should be fervent and not sluggish. Nothing but sleep should take our hearts away from him.

Another theme in Rolle is friendship. This may be surprising for one who was solitary and wrote in praise of the renunciation of the world and of normal human ties but it was a poignant aspect of his personality. Friendship had been a theme in English spirituality since the twelfth century when Ailred of Rievaulx wrote his treatise on friendship in monastic life, where he said that 'God is friendship'. All his life Rolle was longing for a friend with whom he could share his very individual experiences. There is some evidence that he did find a companion and soul mate. After Rolle's death there was a movement for his canonization, and in the 'Office of Lessons'

prepared for his feast there are several references to a certain Margaret Kirkby. Margaret was a recluse under Rolle's direction. She also suffered from seizures. The reading records how one day after a fit Rolle was called to assist her. He held her during an attack. When she recovered she said: 'Is it not against your rule to hold a woman?' Rolle replied: 'Even if you had been the devil I would have held you', and promised her that as long as she lived he would protect her and she wouldn't suffer seizures again. 'The Office' says that she didn't.

This may have been just to give evidence of healing, necessary for canonization, but the fact was that Margaret Kirkby moved to a convent at Hampole in Yorkshire. At the end of his life Rolle also ended up living there, not as confessor or priest but as hermit in residence. The last thing he wrote, the *Form of Living*, was written 'for a nun at Hampole'; one can hazard a guess as to her name. He writes:

> *You may question me with the words; 'You talk a lot about love, tell me what love is?'*
> *and I reply, 'Love is one life, coupling together the one loving and the one beloved.*
> *And when someone has got his love, he can only be happy, because joy emanates from*
> *love. Every lover is assimilated to his beloved. Love makes the loving one become like*
> *the thing they love. God and God's creatures are not beyond or against being loved.*
> *On the contrary, they gladly admit they want to be loved and made happy by love.*
> *Love is a yearning between two people, with constancy of feeling; love is a stirring of*
> *the soul to love God for himself and all other things for God.'*

This may have been one of the unsung mystical friendships of the Middle Ages.

There is much in Rolle that attracts and much that is difficult for the modern reader. All of us have a solitary side to our nature and it is to that that Rolle speaks. However, not all of us can be as other-worldly as he was. Most of us have to find God in the commitments, relationships and responsibilities of our lives, not just in our silent prayer. Rolle can, however, help us to keep the love of God as the focus in all this. He can also remind us that there is more to life than meets the eye. In fact we have spiritual eyes, spiritual ears, spiritual senses that can contact heavenly realities. One is reminded of Gerald Manley Hopkins:

> *The world is charged with the grandeur of God.*
> *It will flame out, like shining from shook foil.*

If only we had eyes to see, ears to hear and the taste to savour what Shakespeare called 'the mystery of things'!

Rolle was one of the earliest of religious poets writing in English. He helped shape the texture of English spirituality, not only with down-to-earth-ness and sublime heights but also with the nearly tactile, natural flow of medieval English that was to flower in Chaucer and *Piers Plowman* a century later. This was a language the common man or woman could relate to, not abstract but concrete, metaphorical but also sensual, a language where sentiment and expression were closely bound. Finally, let's feel and savour the experience of joy in the language of his prose poem *Ghostly Gladness*:

> *Ghostly gladness in Jesu, and joy in heart, with sweetness in soul of the scent of heaven in hope, is health unto healing; and my life lives in love, and light-heartedness laps over my thoughts. I dread nothing which can work woes for me, so much do I whit of well being. It would be no wonder if death were dear, so that I could see him whom I seek. But now it lingers far from me and I must live here till he will release me. Listen and learn of this lore, and you shall not dislike it. Love makes me murmur and joy brings me into jesting. Look you lead your life in light-heartedness; hopelessness, hold it far apart; sorriness, let it not sit with you; but in gladness of God evermore give forth glee. Amen.*

Medieval ladder of perfection

Walter Hilton

Walter Hilton, also writing in the latter half of the fourteenth century, may have been an Augustinian canon. There are records of someone of that name, who died in 1395 at an Augustinian monastery in Northamptonshire. His main book, *The Scale of Perfection*, was very popular. It was copied in Latin and English, printed with the arrival of the printing press in 1494, and had run to eight editions by 1533. Similarly to the author of the *The Cloud of Unknowing* his work can be partly seen as a commentary on Richard Rolle's school of spirituality. He was also concerned to

apply more scholastic rigour to defining what spiritual experience was.

Also, he was writing in the late fourteenth century when the Lollard movement was having an impact. The Lollards were followers of John Wycliffe, who upheld his own translation of the Bible at a time when only the Latin Vulgate was authorized. For Wycliffe's followers Scripture was felt to take precedence over church teaching and sacraments. They were beginning to use Rolle's writings for their cause. Hilton was keen that mysticism should remain theologically orthodox and based on sacramental practice. His work shows genius in combining Rolle's devout Christocentric mysticism with the new interest in the apophatic tradition as shown in *The Cloud*. He also set contemplation within an ascetic and sacramental framework, or 'Scale' (ladder), that needed a steady ascent.

Walter Hilton as spiritual director

Walter Hilton was the archetypal 'spiritual director'. He gave an account of the stages along the spiritual path, the steps on the ladder that lead to God and the pitfalls along the way. He wrote objectively, somewhat impersonally, playing down his own experience. Evelyn Underhill called him a genius: 'kind, tolerant, practical and possessed of a sanctified common sense'. Alongside *The Scale* he wrote two small treatises that showed his moderate, balanced, approach. *The Song of Angels* is a direct response to the followers of Rolle. Rolle, as we have seen, had various psychosomatic experiences, including being able to hear the music of Heaven. Hilton is concerned that one shouldn't try to seek such special experiences in prayer, but he is not as dismissive of them as *The Cloud* author. They are real and grace-given, but not an end in themselves. The other treatise, *On the Mixed Life*, seeks to balance the anchoritic nature of English spirituality, especially Rolle's idea that the mystical life involved a complete renunciation of the world, by affirming the possibility of combining duties and contemplation. *The Scale of Perfection* is a complete companion to the contemplative life. However, Hilton's book also alludes to relating to the world, showing himself to be in touch with the average person.

Hilton's teaching

Just as Hilton was not writing only for hermits, he is concerned to treat the whole of the spiritual life, not just prayer. He looks at the process of conversion as a gradual

ascent from one rung of the ladder to the next, doubly conditioned by God's grace and our effort. He gives ascetic and moral teaching and explains the role of the sacraments as the foundation of the mystical life, the first rungs of the ladder. Sacraments, he says, point towards the inner reality they signify. Writing at the time of the Lollard movement, he is careful to keep the link between external practices and contemplative prayer. He stresses that one cannot leap into contemplation; there is a ladder. Still, he could be controversial at times; fasting and austerities were for him not very important and he felt confession of 'venial sin' to be unnecessary 'for contemplative souls'.

The theme of turning away from the world's values is strong, as with Rolle, but this doesn't necessarily mean being totally uninvolved with it. Many examples from ordinary life are used as a way of leading the reader to 'the experiential knowledge of God in the soul'. The first step is a transformation of faith, but then personal experience comes and we are transformed in 'feeling'. This sense of the 'felt' presence of God doesn't come automatically. Hilton says it grows organically, often out of strong experiences of God's absence. The way up the ladder that Hilton prescribes is both Christocentric and apophatic; always holding on to Jesus and yet also letting go of all thoughts and images. He resolves the paradox thus: as we seek Jesus we should not rest in any 'feeling' of his presence, as though we had fully found him, but always desire more 'as though what you had found was nothing'.

Hilton uses the Gospel parables to show that this Jesus we seek is in our heart. As the woman sweeps her room in search for her missing coin, we are to sweep clean our mind of 'all the dust and dirt in your house, that is to say, all the worldly loves and anxieties within your own soul' (Bk 1, Ch. 46). Hilton uses the parable of the treasure hidden in the field in the same way to point us to interiority, as well as the story of Jesus sleeping on the boat with his disciples in the storm: 'Jesus sleeps spiritually in your heart as he once did in the body . . . rouse Him by prayer and waken Him with the cry of your desire . . .' (Bk 1, Ch. 46).

Hilton says it is 'the noise and disturbance in our heart' that hinders us on this search (Bk 1, Ch. 50). The method he proposes is to love virtue (especially humility and charity) and 'to see and destroy the roots of sin within us' (Bk 1, Ch. 51). To do this Hilton proposes physical stillness, sensual stillness, mental stillness and remembrance of Jesus:

We must cease as far as may be for a time from all bodily works, from all external oc-cupation. Then we must recollect our thought and withdraw it from the bodily senses, so that we pay no attention to what we hear, see or feel – your heart must not be fixed on these things. And after this, empty your mind as far as you can from all images of material things and past actions. This requires little effort when you feel devotion, but you must do it when you feel no devotion, for then it is very much harder. And make this your whole purpose, as if you would neither seek, nor feel, nor find anything except the grace and spiritual presence of Jesus. This is laborious, for useless thoughts will press on to you to draw your mind down to them. (Bk 1, Ch. 52).

What we find, Hilton says, is not Jesus, but remembrance of his Name. Here Hilton shares the same devotion to the Name of Jesus as Rolle did, and there is a fruitful link between English medieval mysticism and the Eastern Orthodox practice of the Jesus Prayer. However, by raising our mind to God with the help of the name 'Jesus', we do not see an image of God but begin to see ourselves, for 'apart from the Holy Name we find nothing but an obscure and heavy image of our own soul, which has neither light to know God nor affection to love Him' (Bk 1, Ch. 52). Hilton calls this an image of sin:

If the roots of sin were withered in you and your soul was truly reformed to the image of Jesus, when you recollected yourself you would not find nothing but you would find Jesus; not only a mere remembrance of His name, but Jesus Christ in your heart teach-ing you . . . but because you are not yet reformed, when your soul withdraws from all bodily things and finds nothing but a darkness and heaviness, it seems a hundred years until it can be out again by some bodily pleasure or vain thought. And no wonder; for who would not soon run out of his house, if he came home and found nothing but a smoking fire and a scolding wife. So your soul, when it finds no comfort in you, but only the black smoke of spiritual blindness and the reproaches of worldly thoughts whose crying takes away all peace, is indeed discontented till it can get out again. This is darkness of mind. (Bk 1, Ch. 53)

Hilton relates the imagery of 'darkness', 'nothing' and 'image of sin' with selfish-ness. He urges his reader not to bother too much about particular sins, for these are only symptoms, but to dry up the source and cause, our ego-centredness. To do this we have to labour in this darkness of mind, holding on to the thought of Jesus, 'for

within this nothing, Jesus lies hidden in his joy'(Bk 1, Ch. 54). Our soul is in the image of God but in the fall it loses its likeness. How the soul is to be reformed in the likeness of him who first created it is the whole purpose of Hilton's writing (Bk 2, Ch.1). So he teaches prayer, for this more than anything 'breaks down and destroys the image of sin which disfigures the fair image of Christ in us' (Bk 1, Ch. 92).

The Passion and death of Jesus are the cause of the reformation of the soul, and prayer 'is the means whereby this free gift of grace comes' (Bk 2, Ch. 17). Prayer is thus a very humble act, for in it 'by the grace of God we see that Jesus does everything, and that we do nothing but allow Jesus to work in us as He pleases' (Bk 2, Ch. 20).

For Hilton, there is therefore no one way of prayer. Each must follow the way God inspires.

However, Hilton does emphasize virtue as the way to dispose ourselves for contemplation, and we learn virtue by considering the way Christ lived (Bk 2, Chs 25, 35). Reflection on the humanity of Christ is therefore the beginning of prayer, and yet gradually God can lead us on to a more mystical prayer by replacing the physical image of Christ with a sense of presence within our own intentionality:

> *If you want to know what this desire consists of it is in truth Jesus. For he creates this desire in you, and it is He who desires in you, and who is also the object of your desire. He is everything and he does everything, if you could but realize. You do nothing but allow Him to act in your soul . . .* (Bk 2, Ch. 24)

Prayer thus becomes simpler, less discursive. The darkness in which we labour in prayer is the result of our self-centredness, but to face that 'image of sin' is already a great sign of progress. As we become accustomed to it, by the grace of God, it becomes easier. In fact the darkness becomes luminous and fruitful, as it draws our attention away from worldly thoughts 'that would prevent us from thinking of nothing':

> *For though you may perceive the gleams and suggestions of idle thoughts pressing in on you, nevertheless you are in this fruitful darkness as long as your mind is not fixed on them. Idle imaginings that crop up unexpectedly trouble this darkness and distress the soul, because it would be quit of them and cannot be so, but they do not take away the value of the darkness, for through it the soul will come to peace. And the darkness is peaceful, when for the time being the soul is free from all these idle thoughts and*

rests peacefully in the desire and longing it has for the spiritual vision it has of Jesus.

<div align="right">(Bk 2, Ch. 24)</div>

Paradoxically, Hilton says that 'indeed the darker the night, the nearer is the true day of Jesus' (Bk 2, Ch.24). Light comes to those who dwell in darkness; the darkest hour comes just before the dawn:

For such souls the true sun will rise and illuminate their reason to know the truth and will enkindle their affections with burning love, and then they will both burn and shine. By the power of the heavenly sun they will burn with perfect love and shine with knowledge of God and spiritual things, for then they are reformed in feeling.

<div align="right">(Bk 2, Ch. 26)</div>

Hilton gives a metaphor to explain this transition from the false light of worldly thoughts and sense perception into the darkness of nothing as a journey into one's own soul, into self-knowledge:

It is as if a man has been a long time in the sun and then comes suddenly into a dark house. He will be as if blind at first, and see nothing, but if he will wait a bit, he will soon be able to see about him; at first large objects, and then small, and then everything that is in the house. It is the same spiritually; those who renounce self-love and acquire knowledge of themselves are in the dark to begin with. But if they persevere and continue with assiduous prayer, and often repeat their determination to love Jesus, they will come to see many things, great and small, of which at first they were unaware.

<div align="right">(Bk 2, Ch. 27)</div>

This direction of interiority is so that we can discover our own soul, for it is there, as in a mirror, that we will see God. Hilton says that we should not be satisfied with self-knowledge but seek a higher knowledge of God:

So in the first place you must discover your mirror and keep it bright and clean and then hold it well up from the earth, so that you may be able to see it, and also our Lord reflected in it. (Bk 2, Ch. 30)

Throughout Hilton's work there is a rich use of imagery and metaphor all pointing towards contemplation. At the end of the book he sums up prayer:

> *All these terms I have used of it: Purity and rest of spirit, inward silence and peace of*
> *conscience, elevation of thought and integrity of soul, an awareness of life and grace*
> *and seclusion of heart, the opening of the eyes of the spirit, the luminous darkness and*
> *rich nothing I spoke about before, the wakeful sleep of the spouse and tasting of heav-*
> *enly savour, ardent love and shining light, the entry of contemplation and the reform*
> *of feeling . . . though they differ verbally they all mean the same thing* (Bk 2, Ch. 40).

The English Women Mystics

We have looked in depth at Walter Hilton's work, but it is worth noting the English women mystics of the last part of the fourteenth century. Dame Julian of Norwich (see Chapter 19) was an anchoress. An anchoress in the middle of the city often played an important role as spiritual director and counsellor for many people. Margery Kempe, for example, records having visited Julian for advice.

Julian's *Revelations of Divine Love* combines a strong devotion to the humanity of Christ, especially the Passion, with an emphasis on her personal experience and a unique individual revelation. Margery Kempe, likewise, speaks strongly about her own experiences. In this, the women writers continue the autobiographical, devotional, personal, even idiosyncratic fashion made popular with Rolle. However, they were living at a time when theological adherence to the Church needed to be expressed. Julian does not deny her own experience, but also is at pains not to deny church teaching when they seem to contradict.

As women, their situation may have been particularly precarious, especially if they were seen to be instructing others. Margery was often accused of being a Lollard because of the idiosyncrasy of her life, although her intense devotion to the Eucharist and relics showed this certainly was not the case. Julian is a very creative theologian; however, the purport of her writing is always in the end pastoral and not speculative. She wrote for all Christians and didn't limit the significance of her *Revelations* to those of the solitary life. By the end of the fourteenth century, and especially with the women mystics, the eremitical movement with its intensely personal spirituality was being opened up to all.

Margery Kempe

Margery Kempe is a wonderful example of this. Born around 1373 she lived until

1440, a long time for that era and especially if one considers the rigour of her life.

The manuscript of *The Book of Margery Kempe*, her dictated spiritual autobiography, was discovered only in 1934. It is a sort of English 'Dead Sea Scrolls' in terms of its late discovery and the light it sheds on the spirituality of its era. It is the earliest autobiography in the English language.

Margery Kempe was already known from a seven-page pamphlet of some devotions that had been in circulation since the Middle Ages. In the sixteenth century she was referred to as 'a devout ancress'. However, the full text reveals

Margery Kempe

how the eremitic movement overflowed into spirituality for lay people.

Margery was in fact married at 20 and had 14 children. At the age of 40 she persuaded her husband to a vow of chastity. She was not a quiet hermit but a very controversial figure of her time. Far from subdued, her loud weeping and cries divided priests, congregations and fellow pilgrims into friends and enemies. She was in danger of being burnt at the stake as a Lollard, although her practice was orthodox. Far from being an anchoress, she travelled on her own to Rome, Jerusalem and Santiago. She combined in her own way the life of a solitary, a pilgrim, a wife, a mother and a consecrated celibate. She even made her own religious habit out of white cloth, making her more conspicuous as a travelling woman – nuns at this time were still always enclosed.

The Book of Margery Kempe

This book is not an autobiography in the modern sense. There is no chronology, no sense of time, aging or the phases of life. Though much of her book records her travels, she is not a travel writer. There is little observation or description of the outer world.

Margery was middle class, had little formal education and could neither read nor write. She dictated her story to a scribe. Much of the text carries the directness of the spoken word. The texture of the English and the overall organization may be the style and work of another. However, the quality of the spoken word and the

uniqueness of the orator shine through. It is written in the third person, Margery often describing herself as 'this wretched creature'. She records only the details of her life that she feels are relevant to her spiritual journey: her madness at the birth of her first child; the failure of her brewery business in Lynn; her conversion to God; her difficulties with her husband in terms of trying to take a vow of celibacy; her visits to holy people to seek their guidance; her lone pilgrimages to Rome, Santiago and Jerusalem; all the troubles she encountered on her travels; the opposition and ridicule she received, which she was pleased to accept on Christ's behalf; her ecstatic devotions, loud cries and uncontrollable tears; her intimate conversations with God.

Even as a dictated text, her 'book' contains many very human biographical details: her husband was later on a great support to her, as she was to him in his final illness. However, in the early days of her conversion, she took a vow of celibacy that was not warmly received. Margery relates how God lent her a hand by terrifying her husband when he made amorous approaches. Finally she makes a deal with him when, 'while travelling on a sultry June day', he threatens to resume his conjugal rights: she would pay his debts in return for being left in peace. In great humility she relates how, soon after this, she is tempted to unchastity with another man! She even goes so far as offering herself to him, only to be spurned.

She remains throughout very human, lovable and humble, and at the same time very courageous. Maybe because she had no formal religious education, she is often very unconfident in herself, constantly seeking the advice of wise spiritual directors. Yet when needed, she was able to stand up strongly for herself. Because of her loud weeping and eccentric dress she often had to face the antipathy of her fellow pilgrims on her travels.

She suffered. On her return from Santiago she was arrested and had to face an examination by the Mayor of Leicester. Imprisoned and guarded by a 'lewd steward', she related her fears for her chastity. Then she was sent for questioning by the Archbishop of York: 'Why do you weep so, woman?' Her answer as always was sharp: 'Sir, you shall wish one day that you had wept as sorely as I.'

Even at the age of 60 she travelled to Germany escorting her daughter-in-law home after the death of one of her sons. This was a last-minute decision prompted by charity but without asking her spiritual director, and without adequate funds. While travelling, Margery's excessive piety embarrassed her ward and she was conveniently abandoned before they reached the daughter-in-law's family. She had to

walk back, often having to sleep rough. When finally she got back to England, her confessor refused to see her. In spite of all her troubles and the ill-treatment she received, she never complained about others. She carried insult and denunciation as a sharing in Christ's rejection, a fool for Christ. And nearly always along the way there was someone to take her part. She took to herself the Jewish promise: 'Blessed are those who bless you.'

Spiritual influences

The spiritual influences behind Margery Kempe's writing are certainly *The Fire of Love* by Rolle, but also Hilton, as she liked to have *The Scale* read to her. She was also influenced by the women mystics of the Continent, especially *The Bride's Book* by Bridget of Sweden, which records how another married mystic made the transition from being a wife to 'a bride of Christ'.

Margery's use of very realist nuptial imagery is quite uncommon in England at this time and shows that she may well have come across the richly figurative language of continental women mystics, like Mary of Oignes in Germany, Angelina of Foligno near Assisi and Catherine of Siena – all of whom saw themselves as intimately married to Christ. The dialogue Margery records of her prayers to Christ has its own particular down-to-earth charm, illustrated in this quote from Barry Windeatt's Penguin edition (pp. 126–7):

> The Lord answered me in my mind and said: 'As it is appropriate for the wife to be on homely terms with her husband, be he ever so great a Lord and she ever so poor a woman when he weds her, yet they must lie together and rest together in joy and peace, just so it must be between you and me, for I take no heed for what you have been but what you would be, and I have often told you that I have clean forgiven you all your sins. Therefore I must be intimate with you. I must lie on your bed with you. Daughter, you greatly desire to see me, and you may boldly, when you are in bed, take me to you as your wedded husband, as your dear darling, and as your sweet son, for I want to be loved as a son should be loved by the mother, and I want you to love me, daughter, as a good wife ought to love her husband. Therefore you may boldly take me in the arms of your soul and kiss my mouth, my head, and my feet as sweetly as you want.'

STEFAN REYNOLDS

THE CLOUD OF UNKNOWING

Patrick Moore
and
Stefan Reynolds

Cloud of Unknowing, *Helena Hadala*

Introduction

With the *The Cloud of Unknowing* we are firmly back in the apophatic mystical tradition. This fact makes it ironic that we do not know who the author was. It is a treatise written in English as a guide for a young man who wanted to lead the contemplative life of a hermit. The hermetical life exercised a great attraction for many people at this time because of Richard Rolle's example and teaching in his very popular book, *The Fire of Love*. The spiritual director who was giving this young man advice at the start of his spiritual journey was very keen to counterbalance that influence. As a corrective to Richard Rolle's emphasis on ecstatic, sensual experiences the author of *The Cloud of Unknowing* emphasized that to know God we have to let go of all experiences, thoughts and images; in other words, he was advocating the *via negativa*. He did stress that we did indeed find God in the experience of love, but this was beyond any image or ordinary sensual experience.

Brother Patrick Moore describes for us how *The Cloud of Unknowing* follows in a long line of traditional teaching on the 'apophatic' way of prayer and how the author shows great insight into human nature and awareness of the obstacles that may be encountered on the spiritual path. He points out that the teaching is not heavy-handed but practical and approached with humour, which may account for its great popularity with those wanting to lead a spiritual life in our own time, another period of uncertainty and turmoil.

> ### The author of *The Cloud*
>
> The author was anonymous; the latest idea is that he was a Carthusian or connected with the Carthusians. He could also have been a Dominican because he shows some of Thomas Aquinas' ideas, especially on 'grace'. The Black Friars, the Dominicans, were regularly sent over to the Rhineland from Cambridge and vice versa, following the trade routes. Seven hundred years ago the author didn't want his identity to be discovered and it is therefore fitting that we still don't know.
>
> We do know that he lived either in Nottinghamshire or Leicestershire as he wrote in the East Anglian dialect. He is writing this treatise as a spiritual director; he is well trained theologically but not a scholar.

INFLUENCES ON *THE CLOUD*

It is important to understand the context in which the author of the *The Cloud* is writing, especially as he will be re-stating the ideas expressed in *Hidden Divinity* or *Mystical Theology*, an influential work that he had translated into English. This was a treatise written about the year 500 by a monk who called himself Dionysius the Areopagite.

For a thousand years Western Christians believed that this was someone who had the authority of Scripture; he was presumed to be the famous convert of Paul in Athens, Dionysius the Areopagite, mentioned in the Acts of the Apostles. He is now referred to as Pseudo-Dionysius to distinguish him from the Areopagite.

The author was actually a Syrian monk who gathered together the Neo-Platonic worldview, which spoke of the soul ascending to God by direct experience. From him comes also our knowledge of the ordering of the angelic hierarchy. Moreover, Dionysius was the first to set out what have become to us the well-known stages of the mystical journey: purgation, illumination and union. The author of the *The Cloud* speaks about union as 'being one-ed' with God.

God may well be loved but not thought.

Mystical Theology is a very important work; it had an enormous influence on the later mystical tradition. It is most fascinating that the basic text of western spirituality came from the eastern tradition.

Its influence on the author of the *The Cloud* came through the Victorines, who

Dionysius, in the
Menologion of Basil II

were Augustinian canons living in Paris in the twelfth century. This Monastery of St Victor was a school of mysticism, and a rich tradition of wonderful texts has been produced there. They associated the 'apophatic' way with darkness; this association was already there in the Patristic era, in particular in Gregory of Nyssa. His idea was that when you entered into true light, you couldn't see. An example of this is St Paul, who paradoxically could only see truly when he was blinded. They also associated the *via negativa* with love.

The author of the *The Cloud* saw Mary Magdalene, Mary the sister of Lazarus and Martha, and Mary, the woman who anointed the feet of Jesus and wiped them with her hair, as one and the same woman. He saw Mary, although she was the greatest sinner, as the one who loved much; for him she became the symbol of the contemplative call to go to the depths, beyond ideas or images. Another influence on *The Cloud* may have come from the Dominicans, in particular Meister Eckhart, who was involved with the Beguines, lay women dedicated to living a spiritual life. Their religious experience fed into Meister Eckhart and Meister Eckhart's fed into theirs. This stream of spiritual thought may have then come to England; we do know that there were Beguines in Norwich, and that the Black Friars, the Dominicans, were in Cambridge at the time of writing of *The Cloud*; there were always German masters from the Rhineland there and Cambridge always sent some of its teachers to the Rhineland to be further educated. It is possible that there was a strong Rhenish influence.

The teaching of The Cloud

The author of *The Cloud* belonged therefore to the trad-
ition that began with St Augustine and came through the
Victorines to England; this stressed the role of desire and
stated that we are drawn to God by God's attractiveness.
Hence the author of *The Cloud* laid emphasis on 'piercing
the heart of God with a flaming dart of love'.

Writings

The Cloud of Unknowing

The Book of Privy Counselling

Dionysius' Mystical Teaching

Epistle of Prayer

In the Preface the author stressed that this book was only meant for some people.
It was intended for those who had a tremendous hunger and desire for God, so
much so that they were ready to give up their ideas and images of God to go much
deeper. It is important to note, however, that the author did not regard contempla-
tives as an elite or a special 'sinless' group; his model was Mary Magdalene.

His way was the tradition of *via negativa*. We are not capable of comprehending
God with our minds. God is beyond reasoning. If that is so, then, the author of *The
Cloud* says, rather than getting more ideas about God, we need to move in the
other direction.

He explains that it is the nature of our intellect to contain and understand. God,
however, is incomprehensible and cannot be grasped. Our intellect enables us to
grasp ideas and images, but with regard to God we must let go of this ability in
order to become more receptive to him. He can be known but not known about.
Therefore we have to forget what we know and go to deeper levels of ourselves,
and thus draw extremely close to God. First we are in a 'cloud of forgetting', then
we move into a 'cloud of unknowing' and, in that cloud of not knowing God, we
can take a dart, which is love, and pierce the heart of God; in that piercing of the
heart of God, we can be one-ed with God (ch. 6). We must love him for who he is
not for what he does (ch. 5).

One of the important things in many different forms of prayer is the use of the
imagination, but here the author says that, by forgetting and becoming comfortable
in the situation of not knowing, we may have a way of drawing extremely close to
God. Keats described this as the essential ability of the poet: 'being able to live in a
state of uncertainty, mystery, doubt, without any irritable reaching after fact and
reason'. He called that 'negative capability' in a letter to his brother in the year 1815.

The contemplative experience is a lifelong process. Unlike the work of helping to feed the poor, the contemplative life is a foretaste of our activity in Heaven and therefore very worthwhile; but we can only make a start now while we live in this world of images and physicality. The love between the soul and the Lord in contemplation is based on who the person is rather than what the person can do. Equally, the love of the soul for God is for who God is not for what he can do. In fact at the very end of *The Cloud* the author says 'it is not what you are or have been that God looks at with his merciful eyes, but what you would be' (ch. 75).

A naked intention directed to God, and himself alone, is wholly sufficient.

When we move into the 'cloud of unknowing' we are no longer in control. When we are stripped of words, images and defence mechanisms that give us security, we are in a vulnerable place. To tolerate that level of insecurity requires a great deal of psychological maturity and is not to be attempted without guidance. The author of *The Cloud* stresses therefore that to follow this way we must lead an ethical Christian and balanced life supported by a spiritual guide. But he also talks about waiting for God to do the work. We must become passive so that God can become active (ch. 2). It cannot be merited; it is a pure gift (ch. 24).

Finally, *The Cloud* is a practical book and the author has a sense of humour. His advice at one stage is, if you can't fight temptation, roll yourself into a ball and ask God to take care of it!

BROTHER PATRICK MOORE

————————————

Stefan Reynolds looks specifically at the relevance of *The Cloud* to our time, in particular at six specific attitudes or ways of being that are still important to us. His quotations are taken from *The Cloud of Unknowing and The Book of Privy Counseling*, ed. William Johnston (Doubleday, 1973).

THE CLOUD TODAY

The Cloud of Unknowing was written as spiritual advice to a young man of 24 who wanted to live a solitary life. It was written in a very different era from today, at a time when renunciation of the world was seen as a prerequisite for contemplation. The fourteenth century in England saw a flowering of the hermit and anchorite life. *The Cloud* is part of that tradition; contemplative life is praised above active, prayer is considered more important than study, and absorption in God is set as the ideal. There are six ways in which it continues to speak to us today.

First, the solitary life that the author of *The Cloud* encourages his 24-year-old disciple to lead has to be at 'the deep solitary core of your being'. The premise of solitude is therefore interiority; its fruit is the ability to be who we are. There is only one of us in the world and therefore to be ourselves is to be solitary. He also teaches that mindfulness and living in the present moment are the fruit of contemplation. Therefore, instead of making us other-worldly, prayer can make us 'attentive to time and the way we spend it'.

The author of *The Cloud* says that 'there is nothing more precious than time': 'God, the master of time, never gives the future. He gives only the present, moment by moment, for this is the law of the created order; time is for man and woman, not man and woman for time.'

Second, he teaches us that we cannot know God with our thoughts. God-logic, Theo-logy, has its scope. It can know how God works (creating, incarnation, redemption, etc.) but it cannot know God in God's self. However, the author of *The Cloud* points out that human beings have another faculty, that of love. He says that this is the highest purpose of our creation: 'Human beings were created to love and all other things were created in order to make love possible.' This capacity to love is able to grasp and comprehend God, because it is of the same nature as God who is love:

Also around this time

1340–1400
Geoffrey Chaucer, English poet.

1348
Start of pogroms all over Europe as Jews were blamed for plague.

1349
Death of William of Ockham, English Franciscan scholastic philosopher.

1350
Boccaccio meets Petrarch in Florence.

1381
Peasants' Revolt led by Wat Tyler.

1382
Earthquake toppled tower of Canterbury Cathedral during heresy trial of John Wycliffe.

1387
Geoffrey Chaucer writes *The Canterbury Tales*.

'Truly, this is the unending miracle of love: that one loving person, through their love, can embrace God, whose being fills and transcends the entire creation.'

Third, he teaches us that in order to enter into contemplation we must let go of all thoughts. Not just thoughts about worldly things but thoughts about spiritual things. Knowledge of all created things and their works (that is, science and the social sciences) must be put beneath a 'cloud of forgetting', but also God must be approached 'nakedly' and 'blindly' in a 'cloud of unknowing' and not through reflection. 'I prefer to abandon all I can know,' he writes, 'choosing rather to love him whom I cannot know.'

> For I tell you, everything that you dwell on in this work becomes an obstacle to union with God. For if your mind is cluttered with these concerns there is no room for God. Yes, and with due reverence I go so far as to say it is equally useless to think that you can nourish your contemplative work by thinking of God's attributes.

Fourth, the author of *The Cloud* reminds us that contemplation is not easy. In fact to persevere in the 'nothing' and 'nowhere' that contemplation leads one to can even be 'painful' to the body and the mind, both of which, like demanding children, are used to being the centre of attention. Instead he calls the reader to have 'a naked intent towards God in the depth of their being': 'You will feel frustrated, for your mind will be unable to grasp God and your heart will not relish the delights of his love . . . But learn to be at home in this darkness.'

Lift up your heart to God with humble love and mean God himself not what you get out of Him.

With a 'cloud of forgetting' between them and created things and a 'cloud of unknowing' between them and God, contemplatives are sandwiched rather uncomfortably. However, if they persevere, the author says, he is confident 'that God in his goodness will give you a deep experience of himself'.

Fifth, the author of *The Cloud* is practical and does give advice on how to enter the contemplative way and encouragement to continue on the path. The problem is thoughts. If all thoughts are distractions at the time of prayer, how does one deal with them? He proposes that his readers take a short word of one syllable like 'God' or 'Love' that expresses the intention of their heart and is meaningful to them. When thoughts come one simply answers with that word: 'Fix it in your mind so that it will remain there come what may.'

He encourages his readers not to analyse the word, for that would take them back into thought, but to take the word whole:

If your mind begins to intellectualize over the meaning and connotations of this little word, remind yourself that its value lies in its simplicity . . . Use this word to beat upon the cloud of darkness above you and subdue all distractions, consigning them to the cloud of forgetting beneath you.

Sixth, he has further advice in case thoughts remain, since he is aware of the unruliness of the mind. First try simply ignoring them: 'Look beyond them – over their shoulder, as it were – as if you were looking for something else, which of course you are.'

Here the prayer word helps to 'unhook' one's attention from a thought and fix it on God who is 'beyond'. The mind needs something to do and won't just be quiet on demand. So the word fulfils a dual purpose, taking the attention off our thoughts and giving the mind a simple task to be getting on with. If thoughts still continue, he says, maybe we are trying too hard to fight them off. This gives them power. His advice is to relax our effort and surrender to God, who will come to our help. If thoughts still continue, he tells us to accept them, put up with them; God may be using precisely our feeling of weakness in prayer to keep us humble. But we should keep on trying to keep the mind on God: 'distractions may be our purgatory on earth. Do not be curious to know more; only become increasingly faithful to this work until it becomes your whole life.'

Fix this word fast to your heart, so that it is always there, come what may.

Contemplative prayer only for the few?

What do we make of the author's insistence on the fact that contemplative prayer is only for those who have renounced involvement in the world and dedicated themselves completely to God? Well, the text was written at a particular time and in a culture where spirituality was seen as a 'retreat' from worldly concerns. Times have changed and we now recognize that God can be found in and through creation. In fact it is now recognized that we are called to be co-creators with God in shaping a better, more just and loving world. The 'Kingdom of God' is not only 'within' but also 'among' us. Relationships are part of the journey to God because they are part

of who we are. However, writings like *The Cloud* and those of Rolle can remind us that, to be contemplative in the world, we do need to take time out from our every-day concerns. We have to give regular 'quality time' to prayer, and in that time follow the work of detachment and transcendence with ever more attentive hearts.

The heights of contemplation for the author of *The Cloud* may be the preserve of solitaries, but this does not narrow his assessment of those who are called. At one point he says that 'sinners make the best contemplatives'. This may seem a surprising statement from one who has previously said that various levels of perfection must be reached before contemplation is achieved. However, one must remember that he works within an Augustinian theology of grace. Contemplation in the end is a gift from God, not something we achieve, and God gives as he pleases. The more conscious we are of sin, therefore, the more aware we are of our need of God and the more open to the workings of his grace. He also says that this 'work' is the one thing in which no moderation need be kept. Here the abandonment and letting go that makes a good sinner finds its proper direction. Those who are temperamentally self-sufficient and restrained may be at a disadvantage. It must be remembered that *The Cloud* does, however, urge moderation in all things but this.

Is the author of The Cloud *a woman?*

Could the author of *The Cloud* have been a woman? There was certainly a great movement in women's mysticism in the fourteenth century. We can tell from the English dialect of *The Cloud* that the author came from East Anglia like Julian of Norwich and Margery Kempe. However, the odds are against it. The tenor of the book does not match women's mysticism of the time. Spiritual experiences like visions and visualiza-tions were important for medieval women, but are dismissed in *The Cloud*. Also, the psycho-physical experience that played an important role in many women writing at the time is played down here. It could have been a corrective. However, the fact that the *Ancrene Rule*, a rule for anchoresses written at the beginning of the fourteenth century, is not mentioned would be the most surprising omission. Male hermits were not bound by that rule and a lot of the 'advice' given fits someone shaping their own 'way of life'. An anchoress advising a male hermit with the air of authority that *The Cloud* shows

Strike that thick cloud of unknowing with the sharp dart of longing love.

would be anachronistic. Lastly, the author of *The Cloud* translated Latin versions of Dionysius the Areopagite, showing a particular linguistic and theological training still sadly rare for women. The odds are against it but the possibility remains.

The Spirituality of The Cloud

The Cloud shows the meeting of two forms of spirituality in late fourteenth-century England: the apophatic 'hiddenness' of God from human perception and cognition, and the 'darkness' of Dionysius the Areopagite, on the one side; and on the other the native English individualism, which is here expressed in a practical, pastoral and colloquial style that shies away from the more speculative mysticism of the Continent.

The whole of mankind is wonderfully helped by what you are doing.

The author of *The Cloud* inherits Richard Rolle's love of mysticism and dresses it in Dionysian garb. He takes Rolle's charismatic passion out of any psycho-physical ambiguity and makes some clear scholastic distinctions between what is physical and what is spiritual. Love must be stripped bare of body and mind so it can reach out 'naked and hidden' to God. His spirituality is thus one of deep interiority. Many times he ridicules fervent expressions of devotion that are too 'outward'. He critiques any search for extra-ordinary experience. In modern terms he grounds the charismatic in the contemplative.

However, at the same time, somewhat hidden under his ridicule of bodily posturing, there is a deep and very English appreciation of the wholeness of the human person. Once he has made clear that the spiritual does not follow the physical, he does

Noli me Tangere, *Fra Angelico*

not press this to a Platonic dis-identification with the body. For the author of *The Cloud* the body is able to follow the spirit. At times there is an overflow of spiritual experience into sensual consolation. For him this is a foretaste of the bodily resurrection that will join our bodies to our souls at the end time. These experiences are not to be sought, but the holistic benefits of contemplation can be evident even in this life:

> *As a person matures in the work of love, he will discover that this love governs his demeanour befittingly both within and without. When grace draws a man or a woman to contemplation it seems to transfigure him or her even physically so that though they may be ill-favoured by nature, they now appear changed and lovely to behold. Their whole personality becomes so attractive that good people are honoured and delighted to be in their company, strengthened by the sense of God that they radiate.*

Conclusion

Any reader of *The Cloud* must read text and context together. At times the author seems a little strict as to the criteria of 'would-be contemplatives', but this results from the cultural conditions of his time. Mary Magdalene is offered as the archetypal contemplative; hardly a cloistered nun even in medieval imagination! She was at that time equated with the Mary who wept at Jesus' feet, drying them with her hair, and whose 'many sins' he assured her were forgiven, not, note, because she was repentant but because she 'loved much'. That is the criterion for contemplation.

That same Mary is again equated with Mary the sister of Martha, whom again Jesus defended as having 'chosen the better part' in sitting at the Lord's feet doing 'the one thing necessary', which seems remarkably like nothing for those 'busy and distracted about many things'. *The Cloud* can help those of us who have 'many things' to do to at least do them without getting 'distracted'.

STEFAN REYNOLDS

JULIAN OF NORWICH

Margaret Lane

Julian of Norwich, *Anna Dimascio*

Introduction

We know very little about Julian of Norwich apart from the fact that, as she worked out the meaning of her revelations, she lived as an anchoress in her cell adjoining the church of St Julian and St Edward at Carrow. The cell had two windows: one looked out onto the world, and people, including Margery Kempe, came to this window for counselling. From the other window onto the church she was able to watch the Elevation of the Host at Mass, the high point of any Mass at that time, and could take part in all the Church's offices in that way.

Norwich, the city she lived in, was the second-largest city in England at that time. Its port was the only one unaffected by the 'Hundred Years War', which allowed thriving commerce with the Continent – East Anglia was the centre of the wool trade. Some of the wealth of its merchants was used to engage in a period of extensive church-building. There were many monasteries and convents within its walls. Apart from the Benedictine priory – now the cathedral – all the other major religious Orders had houses here: the Franciscans, the Dominicans and the Augustinians, even the Beguines may have had communities here. Yet the background to all this prosperity was the constant reality of death, because of the recurrent outbreaks of the plague.

Margaret Lane focuses on Julian and her relevance for people of today, especially on her emphasis in her teaching on the suffering humanity of Christ, and yet her

positive attitude to sin and suffering and the motherhood of God, and takes us carefully through Julian's *Revelations*.

Quotations are taken from either the 'Short Text' (ST) or the 'Long Text' (LT), which are both included in *Julian of Norwich: Showings*, trans. and ed. James Walsh and Edmund Colledge (Classics of Western Spirituality, Paulist Press, 1978).

Julian of Norwich 1342–1430?

When she was 30 years old, in 1373, Julian came to live in her anchor hold in St Julian's church. We are not quite sure whether this was after the severe illness she suffered and her 'Showings' or before. She lived there for the rest of her life. There she meditated on the visions of God's love that she had received. Julian wrote in Middle English, the first woman to do so. She called herself 'unlettered', but that may only mean that she was not formally educated in Latin. We don't know when she died; documentary evidence tells us that she was still alive in 1413.

Her *Revelations of Divine Love* has become one of the most-loved mystical writings of all time. It is in two versions: the 'Short Text' was written fairly soon after the experiences she describes in it, and the 'Long Text' was written after about 20 years' reflection on these experiences.

JULIAN, A WOMAN FOR OUR TIME

God of your goodness
Give me yourself
For you are enough for me,
And I can ask for nothing which is less which can pay you full worship.
And if I ask anything which is less, always I am in want; but only in you do I have
 everything. (LT 5)

Julian is one of a group of four fourteenth-century mystics known collectively as the English Mystics. The others, Richard Rolle, Walter Hilton and the anonymous author of *The Cloud of Unknowing*, were all better known than Julian in their lifetime, but nowadays Julian is far better known than they are. Her book, *Revelations of Divine Love* (in its two versions – see above), was first published in the seventeenth century, but it was not until the 1960s that her popularity really took off. In response to an incoming tide of Eastern mysticism, Julian was among the hidden

treasures of the Christian mystical tradition that were unearthed. Popular interest in her preceded more serious, scholarly and ecclesiastical interest. A critical text of the *Revelations* was not published until 1978, when *Julian of Norwich: Showings* was also published as the first volume in the series 'The Classics of Western Spirituality'. Since 1980 she has been remembered as a spiritual writer in the Church's calendar on 8 May, the date of her revelations (13 May in the old Julian calendar, which was replaced by the Gregorian calendar in the sixteenth century).

Window in Mother Julian's cell

Who was she?

We can be sure of very little about Julian. We do not even know her name, which was almost certainly not Julian. She is known by the name of the church to which her cell was attached. We do know the date of her revelations which, she tells us, occurred on 13 May 1373 when she was 30 years old. This enables us to put her year of birth as 1342. We know she was alive in 1413 and, at that stage, was a recluse at Norwich (ST i). She may have still been alive as late as 1416 because there is a reference to a Dame Julian in a will of that date. Julian describes herself as unlettered (LT 2), but this is an ambiguous piece of information, if we are trying to build up a historical picture. 'Unlettered' may mean the absence of a formal education rather than an inability to read and write. There are several hints in the 'Short Text' that point to her being a laywoman living at home at the time of the revelations. For example, her mother is present at her side (ST x) and she calls the priest, who comes to give her the last rites, 'my curate' (ST ii).

Julian became an anchoress at some stage. We know this from *The Book of Margery Kempe*. Margery, who was fond of visiting the holy people of Norfolk, recounts in detail her visit to Norwich, to the anchoress Dame Julian, an expert in discernment (ch. 18). An anchoress is a female anchorite. ('Anchorite' is a word taken from a

Greek word, *anchorein*, meaning 'to withdraw'.)
Anchorites withdrew from the world to live an
intense life of prayer. They were regarded as dead
to the world, to such an extent that a burial serv-
ice was performed before they were walled up
in their cell. However, not all contact with the
world ceased, because from one window of their
cell, which looked onto the church, the an-
chorite could participate in church services, and
from the other window, which looked onto the
street, he or she would offer spiritual guidance.
Apart from those who came for spiritual guid-
ance, the anchoress would also have had contact

Door to Mother Julian's cell

with a priest for confession and guidance and one or two servants who took care of all
the domestic tasks, leaving her entirely free to pursue the inner life.

Julian's context

Before turning to the revelations themselves, it is helpful to consider the wider con-
text in which Julian lived and wrote, and which would have contributed to her un-
derstanding of her experience. With regard to the historical context, there was great
political and social unrest at that time. Recurrent outbreaks of the plague during
her lifetime killed a third of the population. The Hundred Years War was into its
fifth year when she was born. Bad harvests led to famine and civil unrest, which
culminated in the Peasants' Revolt of 1381.

The Church was in a state of disarray. This was the time of the Great Schism
when three men claimed to be pope, following the period when the papacy had
moved from Rome to Avignon. Everywhere there were stirrings of discontent at
the abuses of the system of indulgences (whereby people paid for remission of sins)
and at the corruption among the clergy. The Lollards, who were the followers of
John Wycliffe, completed the first translation of the Bible into English in 1390. By
1397 they were being burnt as heretics, just around the corner from Julian's cell.

The spirituality of the time was one in which the Passion of Christ was central
and the suffering humanity of Christ was emphasized. Both during the performance

of the liturgy and in their private devotions, Christians were encouraged to imagine the Passion. The tradition of affective meditation on the Passion seems to have begun with Bernard of Clairvaux in the twelfth century, and was built upon by the Franciscans. The translation of a work by the Franciscan Bonaventure was the most popular of those works that prescribed the method to adopt when meditating on the Passion. Devout souls were encouraged to saturate their minds with detailed imaginings of the Passion. People often used woodcuts of the wounded Christ as devotional aids. One popular image was copied from an icon of the 'Man of Sorrows' in the church at Santa Croce, where Pope Gregory is said to have experienced a vision of Christ, who was surrounded by instruments of the Passion (lance, spear and nails) and displaying his wounds. The more literate Christian would find the same image as an illustration to an accompanying prayer in a Book of Hours. There was a particularly thriving devotion to the wounds of Christ. Some prayers for the wounds made use of the idea that the wounds of Jesus were caused by particular sins or that they acted as antidotes for particular vices. The side wound, which Julian was shown in her tenth revelation (ST xiii, LT 24), had a particular fascination, for it gave access to the heart and thereby became a symbol of refuge in God's love.

Her near-death experience

What Julian experienced might be described as a near-death experience. She was so close to death that she had been given the Church's last rites. The priest who attended her was following the prescribed Order of Service for Visitation when

God is our clothing. In his love he wraps and holds us.

he held up a crucifix before her face and said, 'I have brought the image of your Saviour; look at it and take comfort from it' (ST i, LT 3). She had initially agreed to look at the crucifix, because it was easier to look straight ahead than up to Heaven. Later, she is tempted to turn away from the crucifix and look up to Heaven, but she manages to resist and so chooses Jesus for her Heaven (ST xi, LT 19). Julian understood that the only way to be united with God was through the suffering humanity of Christ. Her visions all centred on the crucifix. They occurred at the point when she had no feeling from the waist downwards and when her eyes were already fixed. At this point, the point of death, all pain left her. Her experience parallels that of her ninth revelation of Christ when, at the point of death, Christ's appearance

Julian's writings

Revelations of Divine Love, ed. A. C. Spearing and E. Spearing, Penguin Classics, 2003.

Showings, trans. and ed. James Walsh and Edmund Colledge, Classics of Western Spirituality, Paulist Press, 1978.

suddenly changed to one of joy (ST xii, LT 21). Despite being free of pain, she still assumed she was going to die, because she understood the revelation to relate to the afterlife. She had 16 visions in all, 15 in a five-hour period; the sixteenth revelation came the following night as a dream and as an affirmation of the authenticity of the other 15, after she had gone through a period of doubt. Julian tells us that she experienced the visions in three ways – bodily, spiritually and by words formed in her understanding (ST vii, LT 9).

Her understanding of her experience as revelations or lessons of divine love

Julian understood her illness and the visions she experienced as answers to prayer. Some time in her youth she had asked God for three things: (1) recollection of the Passion of Christ, (2) a bodily sickness when she was 30 years old, from which she would think she was dying and (3) three wounds – of contrition, compassion and sincere longing for God (ST i, LT 2). She recognized that her first two requests were not usual ones, so she added a condition, 'if it be thy will', and subsequently forgot all about them. It was only when her second request seemed to have been fulfilled that it came into her mind to ask for the second wound of compassion for Christ (ST iii, LT 3), but she makes it clear that she never asked for bodily sight of the Passion, though this is in fact what she was granted. Her second request may seem strange to us, but it was commonly thought at that time that actual physical pain was helpful in identifying with the pain and suffering of Jesus. She was influenced in her request for the three wounds by the story of St Cecilia, who died from receiving three wounds in the neck (ST i).

Julian sets out her understanding of her experience in the two versions of her book *Revelations of Divine Love*. The 'Short Text' was written fairly soon after the experiences she describes in it and the 'Long Text' was written after about 20 years' reflection on those experiences. By comparing the two versions we can see how her understanding of herself and of God developed over this period. The major differences between the two texts are that in the Short Text there is no mention of the Trinity, the godly will, the motherhood of Christ or the allegory of the master and servant. Another significant difference is in Julian's understanding of the twelfth revelation when the Lord appears in all his glory (ST xiii, LT 26). At the time of writing the

Short Text, Julian appears to take the visions to mean that some contemplatives are given a glimpse into God himself, whereas by the time she comes to write the Long Text she understands it to mean that rest for all Christians is in Christ. However, she still seems to distinguish between contemplating God, which was not common to all Christians, and seeking God, which was. She also still regards herself as a contemplative, though perhaps this comes across more subtly by the time she writes the Long Text (LT 56). There are also small, but interesting, matters of detail in the Short Text, which she has omitted from the Long Text: for example, a reference to her mother who is at her bedside, holding up her hand to close Julian's eyes as she thinks she is already dead (ST x). Also there is reference to the gender of a friend, whose future she wishes to be reassured about (ST xvi). Her reference to the influence of St Cecilia is omitted from the Long Text, as are references to a small boy who accompanies the priest who comes to carry out the last rites, and to paintings of Christ's crucifixion (ST i). The fact that the priest addresses her as 'daughter' in the Short Text is omitted from the Long Text.

> *The best prayer is to rest in the goodness of God.*

Most spiritual guides are suspicious of visions that are sought for their own sake, and Julian was no exception. She makes it quite clear that she is not given the revelations because she deserves them, but that they come with a responsibility to pass on what she has learned to others (ST vi, LT 9 and 37). The effect of the revelations on her is to increase her compassion for her fellow Christians (ST vii, LT 8), and this is the fruit which determines whether a vision is from God or not.

In the Long Text Julian has divided her visions, which she calls showings, into 16. Julian does not give equal attention in her book to all 16 of her revelations. To most of them she devotes one chapter, though there are cross references throughout the book. She spends more time on the first revelation (LT 4–9), which provides the foundation for, and is connected to, all the others. Most of her reflections relate to the thirteenth revelation about sin and suffering (LT 27–40) and the fourteenth revelation about prayer (41–63). We will look at each of these in turn.

Her visions

Julian's first vision was a bodily vision of the red blood of Jesus, hot and flowing copiously from under the crown of thorns. This was accompanied by inward sight

of the young Virgin Mary and sight of what Julian describes as 'familiar love'. It is not clear what this was sight of, but it led Julian to the realization that God was everything that is good, and she described him as 'our clothing, who wraps and enfolds us for love, embraces us and shelters us, surrounds us for his love, which is so tender that he may never desert us'. At this time Julian was also shown something small and round; no bigger than a hazelnut in the palm of her hand. She was given to understand that the small round object represented everything that was made, and that it was made, and is upheld in existence, purely by the love of God. Her reflection that everything is nothing without the love of God brought her to the same realization that Augustine had come to, that the Happy Life or perfect rest cannot be had except in God. She is influenced by Augustine in her use of the language of the restless heart to express her understanding of this (ST iv, LT 5).

It is important not to misunderstand Julian when she talks about how we should 'despise as nothing everything created in order to love God'. She understood that 'the fullness of joy is to contemplate God in everything', not in any one thing. That is why, when Julian wants to know specifically the fate of someone she loves, she is told that she must love God in all things rather than in one specific thing (ST xvi, LT 34).

She also saw God's marvellous goodness at work in our humblest functions:

A man walks upright, and the food in his body is shut in as if in a well-made purse. When the time of his necessity comes, the purse is opened and then shut again in most seemly fashion. And it is God who does this, as it is shown when he says that he comes down to us in our humblest needs. For he does not despise what he has made, nor does he disdain to serve us in the simplest natural functions of our body for love of the soul which he created in his own likeness. For as the body is clad in the cloth, and the flesh in the skin, and the bones in the flesh, and the heart in the trunk, so are we, soul and body, clad and enclosed in the goodness of God. (LT 6)

Julian, as we all are, was challenged by the problem of sin and suffering, and wondered why God had allowed it. Her thirteenth revelation took the form of a locution. She heard the words, 'Sin is necessary but all will be well, and all will be well, and every kind of thing will be well' (ST xiii, LT 27). She understood 'every kind of thing will be well' to mean two things. No matter how evil a deed was or how much suffering was caused by it, and no matter how small something is, all

will be redeemed (LT 32). She found it especially difficult to trust that this would be so, when she had been taught that some people would be eternally condemned in hell. In the end, after struggling with trying to see how this could be so, she came to the same conclusion we all come to in our hearts, but find hard to hold on to with our minds. She came to the conclusion that, despite our attempts to delve into the mystery of suffering and how it would all come well, this was not something that would be revealed to us in this life. 'God had great sympathy with us but I saw truly in our Lord's intention that the more we busy ourselves in that or in anything else the further we shall be from knowing' (LT 33). Rather than expending energy in pursuing the mystery that will remain hidden, we would do better to concentrate our efforts on discovering what has been revealed, because God longs for us to know this (LT 31). These are mysteries which he has revealed to us through Christ, and it is only our blindness and ignorance that prevent us from understanding them (LT 34). If we knew that we were loved by God we would not sin:

> **Also around this time**
>
> **1368–1644**
> Ming Dynasty in China.
>
> **1370**
> Andrei Rublev, Russian icon painter, born.
>
> **1386**
> University of Heidelberg founded.
>
> **1400–71**
> Sir Thomas Malory, English author of *Le Morte D'Arthur.*
>
> **1422**
> William Caxton, first English printer, born.
>
> **1429**
> Joan of Arc leads French troops to victory against the English at Orléans.
>
> **1436**
> Johannes Gutenberg invents printing press with movable type.
>
> **1440**
> Establishment of Eton by Henry V.

Man is changeable in this life, and falls into sin through naiveté and ignorance. He is weak and foolish in himself, and also his will is overpowered in the time when he is assailed and in sorrow and woe. And the cause is blindness, because he does not see God; for if he saw God continually, he would have no harmful feelings nor any kind of prompting, no sorrowing which is conducive to sin. (LT 47)

An optimistic view of sin

Julian appeals to us because her view of man and sin is so optimistic. She developed the idea that there is in each of us a godly will that is not capable of assenting to sin. This, which she calls our 'substance', is the highest part of our soul and it remains forever united in God (LT 53). We therefore have a natural longing for God. But the lower part of our soul, or our 'sensuality', is the part that has turned away. God is still in our sensuality. Julian understood this from her last revelation, when she

saw her soul as an endless citadel and Jesus sitting in the centre of it. Nevertheless, to be completely at rest our sensuality must be reunited to our substance. Their reunion depends on our growing in self-knowledge, and because our substance is hidden in God our growth in self-knowledge is concomitant with our growth in the knowledge of God (LT 56). Our attention should therefore be focused on how to come to the knowledge of God and ourselves. Julian has some helpful things to say. She looks upon us as needing to be healed, and she looks upon our three medicines as being those of 'contrition by which we are made clean, compassion by which we are made ready and true longing for God by which we are made worthy' (LT 39). The wound of contrition may be opened by our pain and suffering, thus purifying us into greater humility and bringing us to confess both our sin and our dependence on God. We shouldn't dwell on our sins or on the sins of others but look upon them from God's point of view with compassion (LT 79). We also have the help of our natural reason, the Church and the Holy Spirit (LT 80).

God is the still point at the centre.

God judges us in our substance not in our sensuality, and that is why Julian can see no anger or blame on God's part towards us (LT 45). When man thinks God is angry it is simply man's anger at himself, which he projects onto God (LT 48).

She came to understand this with the help of an example of a master and servant that was revealed to her. It took her a while to understand the full implications of what she was being shown. The allegory of the master and servant forms the centrepiece of the revelations (LT 51 and 52). Julian saw a master sitting at rest and peace. A servant stood before him anxious to do his will. The master sent him off and in his haste and eagerness he immediately fell into a ditch. He was physically hurt and mentally inconsolable. All he could think about was his own suffering. The worst thing was that he couldn't see his master looking at him kindly. None of this was his fault. The only cause of his falling was his good will and his great desire. The master, seeing all that the servant suffered in the course of service to him, decides he should reward him so that he is in a better position than he would have been in if he had never fallen. Julian understood the servant to be Adam and that Adam stood for all men. His will was preserved but he was unable to see what that will was. So as a result of the fall he cannot see God and he cannot see his true will. A restoration of these two – sight or knowledge of God and of our own true will –

brings salvation. Looking more closely at the master's face, Julian could see a mingling of compassion and pity with joy and bliss. She understood that the compassion and pity were for Adam and the joy and bliss were for Christ. She understood that Adam and Christ were one. During our lifetime we have this marvellous mixture of well-being and woe. The more we suffer in this life the greater will our honour be in Heaven. If anyone is tempted by this to suffer more, then this is an indication that they are being tempted by the devil, says Julian.

Julian's advice on prayer

Julian has very helpful things to say about prayer, which was the subject of her fourteenth revelation. The Lord said to her, 'I am the ground of your beseeching. First it is my will that you should have it, and then I make you to wish it, and then I make you to beseech it. If you beseech it, how could it be that you would not have what you beseech?' (ST xix, LT 41). If our prayer is in accordance with God's will for us, it will not go unanswered. If it does, it is because either what we are asking for or when we are asking for it is not in accordance with the will of God. Prayer is particularly pleasing to God when it feels dry and barren to us. Our feelings, or whether we receive consolations or not, are not important. What is, is our intention. It is not we who pray but God who prays in us. The end of prayer is to be united and like to our Lord in all things. With God's grace we may get glimpses of him in this life but we will not see him face to face until we die (LT 43).

We shall see God face to face, simply and wholly.

The motherhood of God

In connection with the fourteenth revelation Julian reflects at length on the motherhood of God (LT 58–63). In doing so she is building upon a tradition of describing God in maternal imagery that can be discerned in Scripture itself (for example Isa. 49.15, 66.13; Ps. 131; Matt. 23.37; Gal. 4.26, 31). In formulating her ideas about divine motherhood, Julian would have been able to draw on many sources in addition to Scripture, for it is a tradition that has been picked up by spiritual writers throughout the ages, including Augustine, Anselm and the writer of the *Ancrene Rule*, which governed the life of anchoresses such as Julian.

Julian associates the motherhood of God with the Second Person of the Trinity

(LT 58), who is wisdom and in whom we are reformed. Jesus is our true mother
(LT 59). She sees three aspects to the motherhood of God. God is our mother in
nature, our mother in grace and our mother in works (LT 59). Julian goes on to
make comparisons between what our natural mothers can do for us, and what our
true mother can do for us. First, she says, our natural mothers carry us and bear us
into a world of pain and death, whereas our true mother carries us within him until
we are born into joy and endless life. Our natural mothers can feed us with their
milk but Jesus feeds us with himself. Our natural mother can lay us at her breast but
our true mother can lead us into his breast through his open side. (This is a reference
to the side wound of Jesus, which was revealed to Julian in her tenth revelation.) Our
spiritual birth involves being brought to acknowledgement of our dependence on
our true mother and realization of the love, pity and longing that our true mother
has for us (LT 61 and 62). Julian completes her musings on the motherhood of God
with some very profound words, 'I understand no greater stature in this life than child-
hood, with its feebleness and lack of power and intelligence until the time that our
gracious Mother has brought us up into our Father's bliss' (LT 63).

Julian sums up the overall meaning of her revelations in one word, 'Love':

*And from the time that it was revealed, I desired many times to know in what was
our Lord's meaning. And fifteen years after and more, I was answered in spiritual un-
derstanding, and it was said: What, do you wish to know your Lord's meaning in this
thing? Know it well, love was his meaning. Who reveals it to you? Love. What did he
reveal to you? Love. Why does he reveal it to you? For love. Remain in this, and you
will know more of the same. But you will never know different, without end. So I was
taught that love is our Lord's meaning. And I saw very certainly in this and in everything
that before God made us he loved us, which love was never abated and never will be.
And in this love he has done all his works, and in this love he has made all things
profitable to us, and in this love our life is everlasting. In our creation we had beginning,
but the love in which he created us was in him from without beginning. In this love we
have our beginning, and all this shall we see in God without end.* (LT 86)

MARGARET LANE

ST IGNATIUS OF LOYOLA

Winifred Morley

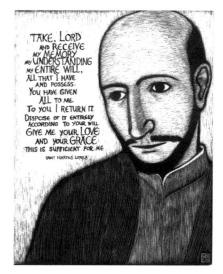

St Ignatius Loyola, *Maria Laughlin*

Introduction

St Ignatius, the first of the great Spanish Mystics of the sixteenth century, was born in the same year as Henry VIII. During his lifetime Europe was experiencing change on a grand scale. There was an explosion of intellectual curiosity and a great sense of adventure. New discoveries were made daily both in the sciences and on the great voyages of exploration. The rediscovery of the great classical culture introduced the Renaissance in Italy and rejuvenated art, literature and learning all over Europe. This is the time of Michelangelo and Leonardo da Vinci, the time of Erasmus publishing the New Testament in Greek and Latin and Thomas More writing *Utopia*.

It was, therefore, on one level a 'Golden Age': Columbus sailed off to discover the East Indies, ending up in the Americas, and bringing back untold riches. Holland, England, Portugal and Italy were also sending discoverers and trading ships over the seas, coming back with myriad treasures, fuelling the wealth of the many merchants, which in turn percolated down to all levels of society. This had beneficial effects as well as more challenging ones. The general spirit of enquiry also entailed a challenge to the established order, causing social and political change and a reappraisal of all aspects of life including the Church, heralding the time of the Reformation. Moreover, it was also the time of the Inquisition and the beginning of the slave trade.

Sister Winifred Morley paints us a picture of Ignatius very much as a man of his time: as energetic, passionate, adventurous and enterprising in his chivalrous career

as on the spiritual path after his conversion. She explains that he did not expect anything from anyone that he would not do himself or had not done himself. We need to see the *Spiritual Exercises* in that light.

Ignatius of Loyola 1491–1556

Ignatius was born in 1491 in the Basque region of northern Spain in the village of Loyola. The next important date for Ignatius is 1521, when he was injured in the battle of Pamplona and his whole conversion began. In 1522 he spent time in a cave and in the monastery in Manresa and Montserrat to allow the conversion process to deepen within him. In 1524 he began to put on paper the first text of the *Exercises*. And eventually he moved from Spain to Rome, dying there in 1556.

IGNATIUS, THE MAN

Many people are put off by Ignatius because they consider him too military and disciplined as a person and his book, the *Spiritual Exercises*, as too formal, too set out; moreover, they feel he doesn't give much space for personal freedom.

But as we begin to look at his life, a different picture emerges. We actually find a man with a typically Spanish passion for life. He was very passionate about whatever he was doing; first about being a soldier and then about God, a passion that deepened as his life unfolded.

He had a strong character and was quite ruthless with himself, very disciplined in his own way of life, but at the same time he could also be very gentle with other people, whose path he shared. His orderliness, his military precision and need for organization came from his training. But setting clear boundaries actually enables freedom, rather than limiting it. It is freeing to know the rules and boundaries within which one is working; it allows us to be free to go where God is leading us.

The story of his life

He was born in the village of Loyola, into a fairly comfortable family of about ten children. But while he was still very young his mother died, maybe in childbirth. Because of this, Ignatius was passed around the family to be taken care of. First of all he had a nanny, called Maria, who lived in the village, and whom he loved very much; she was very good to him in those first formative years.

When he was about five or six, his eldest brother got married and Ignatius was brought back into the family home, where his sister-in-law, also called Maria, looked after him and brought him up as her own child. Again, his memories of her were very loving. The relationship with the two Marias determined his relationship with Mary, the Mother of Jesus, who plays a pivotal role in his life. She figures very much in the *Spiritual Exercises*. First of all Ignatius wanted to gain honour and fight battles for Mary, and later, when he had outlived the military stage, she became his intercessor with Jesus.

The following incident shows how deeply influential Maria and Mary were in his life. In the 'Book of Hours' that he later used, some of the initial letters were illustrated and one of them had an outline of a woman's face. This distracted Ignatius so much that he had to cover it up because it reminded him too much of the Marias and Mary.

As a young man he went off to train to be a soldier. There is some notion that he was even then thinking of becoming a cleric, but it could just have been a passing phase as it didn't develop into anything until very much later. He was also someone who enjoyed the good things in life and verged on the vain side.

The Spanish were fighting the French in Pamplona, famous today for the bull fights. The Spanish looked as if they were losing and the commander favoured a retreat. Ignatius felt they could win, suggesting a fight to the end. But unfortunately they did not win and both his legs were shattered by cannon balls. On the battlefield they pulled his legs back into place, bound them up and sent him home. Once there, he realized that his legs had not been set straight. One of them had a bone that was protruding, which hurt his vanity because it meant that he could not wear the boots he liked. He insisted that they break and re-set his leg; he almost died recovering from that.

His conversion

During Ignatius' convalescence his conversion took place. He asked for books to read, but unfortunately the only books there were the lives of three saints and the Gospels. The saints he read

Ignatius dressed as a knight

about were St Francis, St Dominic and St Humphrey, who was a local hermit. Ig-
natius read these books avidly and, as he pondered their achievements, he felt that
he could do better. He wanted to do more than they did; one of his hallmarks was
always to take 'one step more'. He always tried to go that extra mile, as we are also
invited to do in the Gospels.

While he was dreaming of what he might do, he began to read the Gospels and
to write them out, writing the words that Jesus spoke in red, and the few that Mary
spoke in blue. But something else also preoccupied him at this time; there was a lady
at court that he had set his eyes on. We don't know who she was, but he used to
daydream about how life would be, if he married her. And then again he would
wonder what he was going to do for God; while he was reflecting on all this some-
thing was happening in his heart. When he was actually daydreaming of this lady,
all was fine, but as soon as he stopped thinking about her he began to feel dry, bored
and irritable. But on the other hand, when he dreamed of doing things for God he
was left very much at peace. When he daydreamed about God, he had a feeling of
being in the right place at the right time, whereas his daydreams about the lady at
court left him feeling restless. He didn't understand what was happening, but he
was really learning how to discern what was moving in his heart, what spirits were
moving him there, what was moving him away from God and what was moving
him to God.

Searching for his vocation

When Ignatius got better, he decided that he would set off and do whatever God
was inviting him to do, which was in line with what Francis and Dominic had done.
First he decided to spend about ten months in prayer in the caves of Manresa, doing
penance for his past life with the Benedictines there. It was from them that he
learned about prayer. He prayed over the Scriptures, and in doing so went through
what we now know as the Spiritual Exercises. He didn't at that point write them
down; that came much later.

It took him a long time to realize what God was asking. He had lots of false starts.
One day he even let his donkey determine which way to go. He first thought that
God was perhaps asking him to go and live in Jerusalem, to be in the place where
Christ lived, to walk in those places where Jesus was brought up. Unfortunately that

was not to be. He did reach the Holy Land, but the Franciscans didn't want him and sent him away.

When he returned to Loyola, he thought that he should perhaps lead the life of a beggar; so he accosted a beggar on the roadside and exchanged clothes with him. But the beggar got arrested and Ignatius was forced to bail him out and change clothes back again.

Then he thought that being a hermit was the right thing to do; he allowed his hair and his nails to grow. His friends soon discouraged him from doing that because he was beginning to look quite ugly. Once he had cut his hair and his nails, he started to wonder once more what God really was asking of him.

Ignatius at Manresa

Eventually, he came to the realization that God was inviting him to go back to study. If he wanted to follow Christ closely, maybe becoming a priest was the way to go. He went back to school with the younger students to learn Latin and then proceeded on to university in Paris.

While he was there he gathered men around him, like François Xavier, who were of similar dispositions, who also wanted to do things for God, who also wanted to help other people. They were the first members of what we now call the Society of Jesus; then they were called the Companions of Jesus. While they were in Paris, they were helping and guiding the people with their prayer and preaching, although they were not yet ordained. When Rome got to hear about this, Ignatius and his companions were called twice before the Inquisition. Fortunately it could find no fault with their teaching and their preaching during cross-examination, and they were allowed to go free. Perhaps because of this, Jesuits take a fourth vow of obedience to the Pope, in addition to the usual vows of chastity, poverty and obedience.

Eventually Ignatius arrived in Rome and remained there until his death. The thrust of his life was to 'seek and find God in all things', mainly by using the Spiritual Exercises. Under duress from the brothers he wrote these down towards the end of his life.

The Spiritual Exercises

The main point and purpose of Ignatius' spirituality is to enable a person to become free of all 'disordered desires', to stand in that place of freedom before God, where we only want what God wants. An aspect of that was 'finding God in all things', which is a phrase often linked with Ignatius because that is what he was striving to do and what he encouraged others to do in the *Spiritual Exercises*.

Ignatius often referred to this spiritual journey as his 'pilgrimage' and called himself the 'pilgrim'. The journey is in the shape of a circle, or rather a spiral, which means that we can begin this journey at any point on the circle or the spiral. When we begin an Ignatian 'eight-day' retreat, we begin at the point where we are right now; we therefore don't always start at the beginning. We may start with, perhaps, one or two meditations of the beginning, just to get a feel of where we are spiritually. Then the Spirit moves us on, to where we need to be within this scheme.
The *Spiritual Exercises* is not a book to be read: it's a manual for the retreat-giver. Therefore, for this journey to make sense you need to make it with a guide.

The retreat begins with the 'Foundation', which is very practical and wide-reaching. It is the foundation for life, the basis from which we want to live. The essence of the beginning is that God has created us to 'praise, reverence and serve God, our Lord', and has given us all of creation to help us do that. The *Spiritual Exercises* are based on Scripture and they therefore begin where Scripture begins, with creation, the gift of God to us, the sign of God's love for humankind.

It is important that we understand who the God is that we pray to, what our image of God is. It is easier to love God when we have an intimate relationship with him, like the God of Jesus, whom we can call Father, rather than one who is remote.

Once we become aware of God's goodness and the personal love he has for us, we begin to acknowledge that we have not always been responsive to that love; we have failed, we have sinned, we have refused that love. But we also know that we are, despite everything, still loved, as a sinner, by God; and so we reflect on our failings, while held in the loving hands of God.

God invites us. It is we who push him away in different ways. Ignatius asks us to look at the obstacles that prevent us from reaching out to God. It is often difficult

for us to think that we are really loved, just as we are and not for what we do. Ignatius invites us to come to a right response to God's love and become aware at the same time of Jesus' healing love. Yet God leaves us free to do so in our own time, and it is here that we begin to desire that freedom, which is one of the threads that will take us right through the whole of the retreat.

In this context Ignatius used the term 'indifference'. This is not the same idea as 'detachment', which is more passive, but is an active standing ready, being 'poised', with a sense of freedom to accept whatever one is given: riches or poverty, a long or short life. It is the freedom to want only what God wants.

We are now faced with a very important time of reflection on what the call of Jesus, the call to serve Jesus and his Kingdom, means to us. We don't know what that call is, but we are invited to pray, not to be deaf but to hear God's call.

As this knowledge deepens, so we desire to follow Christ and be with him. If we want to do that, then, very logically, Ignatius invites us to find out who this Jesus is. Therefore quite a large section, the second stage, consists of really looking at the life of Jesus, how he lived, what he did, what he taught, not for the sake of being entertained but being able to identify with him. We reflect on the life of Jesus so that we can come to know him more, in order to love and follow him more, whatever the cost to ourselves, wanting only God and nothing else.

As we move into this companionship stage, Ignatius asks us to pray the prayer of Richard of Chichester:

> *Thanks be to Thee,*
> *O Lord Christ,*
> *For all the benefits which Thou hast given us;*
> *For all the pains and insults which Thou hast borne for us.*

Also around this time

1453
Fall of Constantinople – end of Byzantine Empire.

1455
Gutenberg prints the first Bible in Mainz.

1480
Start of Spanish Inquisition.

1492
First voyage of Columbus to America, which he thought was Asia. Age of explorers: John Cabot reaches North America, Vasco da Gama reaches India and the Far East via the Cape of Good Hope, Vespucci reaches Brazil.

1503
Thomas à Kempis publishes *The Imitation of Christ*.

1503
Building of Canterbury cathedral finished.

1513
Building of Chartres Cathedral finished.

1510
Start of slave trade for workers on sugar plantations in Brazil.

1510
Martin Luther Professor of Theology in Wittenberg.

O most merciful redeemer,
Friend
And brother,
May we know Thee more clearly,
Love Thee more dearly,
And follow Thee more nearly;
For Thine own sake.

If we are making the full 'Exercises', Ignatius invites us to attempt to make new choices for our lives, or reform the way of life we have already chosen. He uses the word 'election'. We need to spend some time reflecting on how we can respond more generously to what Jesus is inviting us to do by his example.

Then we come to the third stage, which is associated with the word 'surrender'. We need to examine whether we are willing to go the whole way in following Jesus, even through the Passion and his death, even if it entails pain for us. Then we move to the fourth stage, that is, the stage of joy, sharing in the joy of his Resurrection.

Finally, Ignatius moves us to regard the rest of our lives; we have moved onto the path of love, reflecting on God's love and all he has done for us, and now we need to consider what response we desire to make in return. He does this by giving us at the end a 'contemplation to attain the love of God'. It's virtually the first time throughout the whole of the *Exercises* that he actually mentions the word 'love', yet it is always implied. That love is deepening as we go through the whole of this dynamic, this pilgrimage.

He begins, in a very practical way, with a very short and telling statement: 'Love shows itself more in actions than in words.' Ignatius invites us, in the light of all that God has given us, to make a response, and the response is that beautiful prayer, 'Take, Lord, and receive.'

At the 'Call of the King' there is an echo of that prayer and in the midst of the second stage we have a slight echo. But it's only at the end, when we have been through the whole of this dynamic, that we can actually pray that prayer. A priest in our convent in Liverpool advised us only to say this prayer if we meant it.

Spiritual consolations and spiritual desolations

A retreat is not plain sailing. Our experience in retreat is not always of being very close to God; on the contrary, sometimes God feels absent, withdrawn; all we can do is struggle on. Ignatius recognized that there would be ups and downs; he called them 'spiritual consolations' and 'spiritual desolations'. These are movements beyond our control, but they help us to recognize our dependence on God. They are movements that we either rejoice in or feel trapped by; we can do nothing but wait for the shift within. At such times it is helpful to share these movements with a director or guide, as talking about them is often helpful. Ignatius said that when we are experiencing desolation we need to be reminded that it is not permanent. Desolation is a feeling of the withdrawal of God's presence; yet at the same time we trust and know that God is there, and that we will feel his presence again.

We need to be generous and open on retreat in giving time to prayer and following where God is leading. As a spiritual director it is important not to talk too much but allow God to be with the retreatants, and to allow the retreatants to hear God.

The Annotations

That, in a very brief outline, is the pattern of the '30 days' retreat. But as well as the pattern for the '30 days', the book of the *Exercises* contains much more. At the beginning, Ignatius gives what he calls a set of annotations or preliminary notes, which are invaluable guidelines. There are 20 of them altogether, but some of them are really important for the person making the retreat and others for the person giving the retreat.

The first one is very important because he explains what he means by 'Spiritual Exercises': 'By the term "Spiritual Exercises" is meant every method of examination of conscience, of meditation, of contemplation, of vocal and mental prayer, and of other spiritual activities that will be mentioned later.' This book contains about 15 different ways of praying, so when we talk about Ignatian prayer it is a lot more than just using our imagination.

He called them 'Exercises' because, just as in exercising our body, whether we are walking or jogging, there needs to be discipline involved. Ignatius says we need that same discipline with prayer and it needs to be regular. God needs to be told

regularly that we love him. Ignatius continues to give us guidelines as we move through the text.

Some prayers he tells us to meditate on, meaning we need to use our mind, our memory, our thoughts, our understanding. We ponder them and we 'relish' them. 'Relish' is a word he often uses, in the same way as it is used in one of stages of *Lectio Divina*. Then they will maybe lead us on to that place of stillness and quiet before our God.

He talks about using vocal prayers, because they may be helpful to us. He talks about using our senses to go back over the day, not taking in any new material, but 'relishing' what God has given us during the day.

He also talks about 'repetition'; by that he doesn't mean picking up the same Scripture reference. What Ignatius means by 'repetition' is returning to those points in the passage or that time in our prayer that were really helpful to us. Or on the other hand, if the prayer felt dry, then we should stay with it, try to understand why it felt dry. 'Repetition' helps us to go deeper.

Discernment

There are two aspects to discernment: discerning God's will for us and discerning the spirits.

There are different ways to discern God's will. For some it comes as a blinding flash, as for St Paul or Mary the Mother of Jesus. For most of us it is not like this; we need to note the inner movements of our hearts and look at our history to see where God has been leading us.

Discernment is not a question of choosing between a good thing and a bad thing, but of choosing between two good things. The practical way to discern, perhaps helped by a guide, is to sit with the two options for a few days each; usually it then becomes clear which of the two creates a deep feeling of inner peace.

Another way of discerning that Ignatius also suggests is to imagine ourselves on our deathbed and then reflect on what choice we wished we had made; or giving advice to a friend who finds himself or herself in exactly the same situation.

It was in his attempts to discern God's will that Ignatius had his mystical experiences, though we do not know what they were. He has not written most of them down. The ones he has written down are obscure, and it is difficult to know what they might mean.

The Examen

To know God's will to the best of our ability we need to be living a reflective life; as a tool, Ignatius offers us the 'Examen'. This is now called the 'examination of consciousness', not to be confused with an examination of conscience. This is a useful exercise to do at the end of the day.

It is a prayer technique that helps us to reflect on part of the day or all of it to discover where God was in our actions and to give thanks, or to ask forgiveness for where we acted alone. Then we look in preparation at the day ahead. In this way we become more aware of God being with us on our journey through life.

Other rules

Ignatius also gives us rules about fasting. He suggests that when we finish one meal, we decide what we are going to eat at the next. The reason for this is to discipline our senses.

He also talks about 'scruples' and how to deal with them. This is based on his own personal experience when he was in the cave in Manresa, so he knew what he was talking about.

Ignatius then talks about rules for giving alms, particularly for the gentry who might be given great legacies: what to do with their heritage, their patrimony, how to use it in the service of God.

Finally he recommends something he calls a 'colloquy', which simply means a chat; at the end of the prayer time, we are encouraged just to talk about our feelings and experiences with Our Lady, with Jesus or with the Father.

Ignatius the mystic

We might well ask ourselves what happened to transform the soldier eager to fight into a man of God, who could write such a text as the *Spiritual Exercises*.

After his recovery and conversion experience Ignatius withdrew to the caves at Manresa and there:

> *Inigo was strengthened, taught and illuminated by His Divine Majesty in a wholly singular manner. As a consequence he began to look at the things of God with entirely*

different eyes, to distinguish and test the different spirits, to relish interiorly divine things and to impart them to his neighbour with the same simplicity and love with which he himself had received them. (Laynez, an early biographer)

Hugo Rahner SJ explains it in *The Spirituality of St Ignatius* as follows:

The emphatic underscoring of the words 'God alone' can have only one meaning when considered in reference to that mystical grace, which, as Ignatius himself phrases it, turned the Manresa pilgrim 'into a new man with a new intellect'. The mystical action wiped out, so to speak, all that preceded; it was as if his 'slow thinking mind' had been removed altogether and his heart could only cry out in astonishment, what strange life is this that I am now beginning to live?

We are able to mark clearly three stages in the mystical evolution of the Manresa penitent – the quiet beginning period, the mystic 'night of the soul' and the period of Trinitarian visions.

The distinguishing feature of the first of these periods was, according to Ignatius' own testimony; 'a mood of great equanimity coupled with abundant joy, without, however, any clear knowledge at all of the interior spiritual life'. He spoke of the phenomenon which he often saw in broad daylight – something like a serpent with many eyes – and he derived much consolation and joy from the sight. Somewhat later we learn from him 'that he had marvellous illuminations and extraordinary spiritual consolations'. Yet later he found that these visions had a diabolic significance. At this time he was still discerning the spirits, as he did at Loyola.

The second period is replete with the most frightful sufferings of the soul, even to the point of thinking about committing suicide. There were violent attempts to regain his former grace and peace of soul by fasting, depriving himself of sleep and praying for seven hours daily. This is also the advice he gives to those who find prayer difficult during the retreat – fast, pray longer or do some penance, thus exerting our will over that of the evil one.

The third period brings grace and Ignatius described himself as 'a man who had been awakened from a drugged sleep'. Divinely bright sunlight shone into his soul. He then had a vision of God, of the Blessed Trinity. 'So strong was the impression made upon him that it was never erased from his memory the rest of his life and

that henceforth he felt a great devotion to the Divine Majesty whenever he prayed to the Blessed Trinity.' (Rahner, *Spirituality*)

From this time on devotion to the Blessed Trinity was the distinguishing mark of Ignatius' spirituality. On his journey to Rome he had a vision at La Storta, again emphasizing the importance of the Trinity: 'Place me with your Son!'

He also mystically beheld how all things in creation proceeded from the triune God. Ignatius tells us: 'I saw, felt in my interior, and penetrated with my mind all the mysteries of the Catholic Faith.'

In these words he points out to us what the fundamental grace of the vision was:

> the synthetic view which it gave him of the connection between all the truths of divine revelation, of the relation of all things to the majesty of the Blessed Trinity, and of how all this was contained in Christ, in the struggle between the spirits and finally in the Church. (Rahner, *Spirituality*)

Thus the vision brought about the transformation of Ignatius the pilgrim and penitent into the man of the Church. The 'finding God in all things' would be a good summary of his journey and a way of life for us all.

We can conclude that, while Ignatius was very much a man of his own times, much of his message has a great bearing on our lives today. His psychology and spirituality speak loudly to us, even though the language and examples he uses may not sit easily with us; nevertheless, what they illustrate gives powerful lessons. The Jesuit motto, 'for the greater glory of God', sums up the life of Ignatius very simply and gives us food for thought.

SISTER WINIFRED MORLEY

ST TERESA
OF AVILA

Julienne McLean

St Teresa of Avila, *D. Joseph Garzia*

Introduction

In this great age of reformation, transformation and renaissance, Spain was in a different situation from the rest of Europe. It had been the home of Jews and Muslims as well as Christians for many centuries. The Jews probably arrived in the Iberian Peninsula after the destruction of the Second Temple in Jerusalem in the first century AD, but legend has it that they were already settling down there after the destruction of the first Temple in the sixth century BC, or even earlier in Phoenician times from the tenth century BC onwards. The Muslims arrived in the eighth century AD. The three faiths co-existed more or less peaceably during long periods. This situation changed abruptly with the ascent to the throne of Ferdinand of Aragon and Isabella of Castile, whose marriage united Christian Spain at the end of the fifteenth century. They decided not only that the Moors had to be driven out, but also that the Jews had to be expelled. The fall of Granada in 1492 allowed them to carry out their plans. The choice they presented to both Muslims and Jews was to convert or leave. This had another significant consequence; it meant the prominence of the Inquisition in Spain in a way unparalleled in the rest of Europe; the Spanish Inquisition was given wide-ranging powers to investigate, torture and try those whose conversion had only been superficial. Although, therefore, from a materialistic standpoint this time could be called the 'Golden Age' of Spain, culturally and spiritually the situation was highly unstable

and deplorable. Once more it was a climate of fear and insecurity that was the seedbed of an exceptional mystical life.

Julienne McLean explains how St Teresa was very much a product of these culturally and politically uncertain times, as she herself came from a family of Jewish converts. But she points out that in her teaching Teresa is ageless and speaks to all on the spiritual path, especially because of her straightforward and unpretentious language and immense wisdom and practicality. Julienne explores in detail Teresa's most mature reflection on the spiritual path as expressed in *The Interior Castle*.

This chapter is based on the author's book, *Towards Mystical Union* (St Paul's, 2003), in which she quotes from *The Life of Teresa of Avila by Herself*, trans. J. M.Cohen (Penguin Classics, 1957) and *The Complete Works of St Teresa of Jesus* (Sheed & Ward, 1946).

St Teresa of Avila 1515–82

Teresa de Cepeda y Ahumada was born in Avila in central Spain. She came from a well-to-do and deeply religious family. Her mother died when she was 12 years old, an important factor in her devotion to Mary. She joined the Carmelites in Avila in the Convent of the Incarnation at the age of 21, making her profession two years later. A year after her profession she became seriously ill; she barely survived and never really regained her health. But it led her to serious reading, especially Francisco de Osuna's *Third Spiritual Alphabet*. In the convent she had already been taught the prayer of quiet, but de Osuna became from then on her spiritual guide for her prayer life. Although right from the beginning she had mystical experiences, she found her prayer life very difficult. But by her fortieth year she had experienced a second conversion and a deepening of her relationship with Christ; from then on her practice of contemplation led to a state of habitual union. Rather than at this stage retiring into a private contemplative life she felt called to start the reform of her Order. Fired by the intensity of her spiritual life she became truly a contemplative in action. Her awareness of the presence of Christ did not ever make her lose her true humanity, sense of humour and practicality. When she was 53 she met St John of the Cross, whom she inspired to reform Carmel among monks. The last ten years of her life she experienced a permanent union with God – the spiritual marriage. This did not stop her active life; by the time she died she had founded 13 communities of the new 'Discalced' Order.

ST TERESA – A PERSON FOR OUR TIMES

How what is called union takes place and what it is, I cannot tell. It is explained in mystical theology, but I cannot use the proper terms; I cannot understand what mind is, or how it differs from soul or spirit. They all seem one to me, though the soul sometimes leaps out of itself like a burning fire that has become one whole flame and increases with great force. The flame leaps very high above the fire. Nevertheless, it is not a different thing, but the same flame which is in the fire. What I want to explain is the soul's feelings when it is in this divine union. It is plain enough what union is; in union two separate things become one.

(*The Life of Teresa of Avila by Herself*, trans. J. M. Cohen)

St Teresa, like other saints and masters of the Christian spiritual life, maintained that it is possible, in a real sense, for the human soul to attain union with God. In her extraordinary autobiography, Teresa's pen flows spontaneously and creatively, expressing many of the most important events, encounters and spiritual transformations that God worked in her heart and soul in her journey towards divine union.

Teresa of Avila was a truly remarkable woman. Born in the early sixteenth century into a noble Castilian family, with direct Jewish descent, she showed marked interest in spiritual matters as a child, and took up the religious vocation at the age of 21. She was an acknowledged mystic in her own lifetime, and underwent a staggering range of supernatural graces. She was a prolific writer – her writings being initially intended as spiritual direction texts for her nuns.

Ever since, countless generations down the centuries have been guided and directed by the wisdom and holiness of the saint towards the deepest dwelling places of contemplative prayer. Edith Stein once wrote about Teresa that 'the number of those who owe to her their way to the light will become clear only on the Day of Judgement'.

So direct and penetrating is her insight, knowledge and understanding, so unpretentious and straightforward is her language, that we cannot but see our own spiritual yearnings and longings, our progress and 'death and transfiguration' in the love of Christ mirrored in her writings. They reveal a powerful and penetrating

honesty and intimacy, a complete integrity, an essential pragmatism and compassion, but above all, a deep humanity that has hardly been surpassed in the whole corpus of Christian mystical literature.

Teresa was popularly known during her lifetime as the 'Holy Mother' and was canonized as a saint 40 years after her death. In 1970, Paul VI gave Teresa's gifts of sanctity and wisdom their due and proclaimed her a Doctor of the Church, the first woman saint to be so recognized.

Carmel

'Carmel' is a Hebrew word for an orchard or vineyard. From time immemorial Mount Carmel, near Haifa in Israel, has been a holy mountain, known as the sacred mountain of the Holy Land. It is best known as the location of the acts of Elijah, regarded as the greatest and holiest of the prophets of the Old Testament. Over the centuries it became a place of veneration and pilgrimage for all the 'People of the Book', the Jews, Christians and Muslims.

The Order was founded in the twelfth century during the period of the crusades, when a group of Latin crusaders established themselves on Mount Carmel, aiming to live the eremitical life of solitude and contemplation as hermits and ascetics in the grottoes of the sacred mountain, following in the ancient Elijan tradition.

Around 1210, St Brocard approached Albert, the Latin Patriarch of Jerusalem, to write a constitution that would serve as the rules for the community then identified as the brothers of the Blessed Virgin Mary of Mount Carmel – this was the community that would become better known as the Carmelites. Mount Carmel is also known as the mountain of Mary, and even from the earliest times churches dedicated to the Virgin Mary existed on it.

Elijah is the main inspiration and founder of the Carmelite Order and, interestingly, several Fathers of the Church – Jerome, John Chrysostom, Basil, Gregory – name both Elijah and Eliseus as patrons and patterns of the contemplative life. Elijah features prominently in the *Rubrica Prima*, which contain some

Teresa's writings

J. M. Cohen (trans.), *Teresa of Avila by Herself*, Penguin Classics, 1957.

K. Kavanaugh (trans.), *The Way of Perfection*, ICS, 2000.

K. Kavanaugh and O. Rodriguez (trans.), *The Collected Works of St Teresa of Avila*, Vols 1–3, ICS, 1978, 1980 and 1985.

E. Allison Peers (trans.), *The Complete Works of St Teresa of Jesus*, Vols 1–3, Sheed & Ward, 1946.

The Interior Castle, Fount/HarperCollins Religious, 1995.

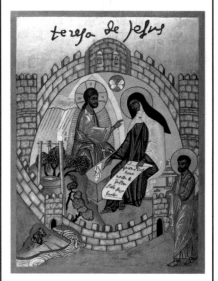

Icon of St Teresa, the Melkite sisters in the
Monastery of the Annunciation

The icon describes, in symbolic terms, the
'interior castle' of the soul – how 'the secret
union, or spiritual marriage, takes place in the
innermost centre of the soul, where God Himself
must dwell' (*Interior Castle*, Seventh Mansions,
Chapter 2). Above the image of the spiritual
marriage, and within the castle, a butterfly
illustrates the metamorphosis of a silkworm into
a butterfly as symbolic of the journey of
spiritual transformation (*Interior Castle*, Fifth
Mansions, Chapter 2). A section of the prayer of
St Teresa is depicted on the scroll in her hand.

In the lower left, the four waters of prayer are
depicted – the early stages of prayer by drawing
water from the well, and the third and fourth wa-
ters by a stream running through a garden. St
Joseph, for whom Teresa had a particular devo-
tion, is in the lower right.

of the earliest Carmelite documents, such
as this version written in 1324:

> We assert . . . that from the time of
> Elijah and Eliseus the prophets, who
> dwelt on Mount Carmel, holy fathers
> for the sake of contemplation without
> doubt dwelt in that place, near the
> Fountain of Elijah in continued suc-
> cession . . . After the incarnation of
> Christ their successors built there a
> church in honour of the Blessed
> Virgin Mary, choosing her as their
> patroness.

This is the ancient spiritual tradition
that Teresa felt called by God to reform
and return to its essential spiritual roots
of prayer and contemplation. Teresa def-
initely felt herself to be the heir to this
spiritual patrimony and responsible for
the transmission of its values. The signif-
icance of the connection with Carmel is
not primarily geographical or historical.

Carmel, for Teresa, is a family, and rep-
resents the people who lived on the bib-
lical mountain of Elijah who now form
the choir of the saints of the Carmelite
Order in Glory. In one of her poems, she
expresses the desire to journey together
towards the Mount of Glory, as an image
of the interior pilgrimage towards the as-
cent of Mount Carmel: 'Let us journey
on to heaven, nuns of Carmel.' For Teresa,

the remembrance of the saints of Carmel is truly a motive of pride and joy, and a definite stimulus towards the deeper contemplative journey.

Teresa's context

Spain, at the beginning of the sixteenth century, was newly triumphant. The country had been recently united under the reign of Ferdinand and Isabella, the new Catholic monarchs. With the fall of Granada in 1492, after 800 years of fighting, the Moors had finally been driven out of Spain; while, across the Atlantic, the wars and triumphs of the conquistadors in the New World were beginning to amass untold wealth for Spain.

Within this new political and economic stability was also a growing movement towards cultural and spiritual instability. Spain began a ruthless policy of ethnic cleansing, where Jews and Muslims were given three options – to leave Spain, convert to Christianity or be burnt at the stake. The Jewish community had inhabited the Iberian Peninsula probably since Phoenician times and, when the Edict of Expulsion was passed in 1492, they had to leave Spain within four months or convert. The entire Jewish community, some 200,000, were expelled from Spain, and those who did not convert were burnt alive in autos-da-fé (meaning 'acts of faith') carried out in town squares across the country.

The Spanish religious authorities were also concerned about the activities of the recent Jewish and Muslim converts to Christianity, called *conversos* or *marranos* (meaning 'pigs'). The authorities attempted to enforce the new policy of maintaining religious and ethnic purity strictly and to check that the new converts were not lapsing into old habits; the Spanish Inquisition was given wide-ranging powers to investigate, torture and try those found backsliding. In 1948, the Jewish ancestry of Teresa was discovered, when documents came to light in Valladolid concerning her grandfather, Juan Sanchez, who had been a *judeo-converso*, a Spanish Jew forced by the Inquisition to convert on pain of death or expulsion.

Sixteenth-century Spain's statutes of 'Purity of Blood' – *limpieza de sangre* – created a vulnerable climate for these new Christians; aristocracy of a sort could be bought at great cost. Teresa's grandfather purchased his certificate of *hidalguia*, a quasi-knighthood, around 1500 and moved his family from Toledo to Avila to begin a new life where his Jewish past would not be known and he could assimilate into

Also around this time

1521
Luther excommunicated by
Pope Leo X.

1522
Bible printed in Spain in Hebrew,
Greek, Latin and Aramaic.

1530
Charles V, last Holy Roman
Emperor to be crowned by the
Pope.

1531
Portuguese Inquisition very
active against Protestants.

1531
Henry VIII installed as Head of
Church of England.

1531
Zwingli, Swiss reformer, killed in
civil war between Catholics and
Protestants.

1532
Calvin starts reformation in
France.

1532
Pissarro enters Inca Empire.

1550
Jews expelled from Genoa.

society and resume his merchant profession.

He was successful in creating a new life for himself and inventing a fictional lineage. Teresa's father, Alonso Sanchez de Cepeda, married first Catalina del Peso y Henao and, after her death, the 14-year-old Beatriz de Ahumada, Teresa's mother. In 1528 Beatriz died, exhausted, having borne Alonso nine children. Thus, Teresa was brought up in a climate that was deeply conscious of its Christian heritage, while being uneasy and apologetic about its more ambiguous roots. Her family was certainly a microcosm of Spanish society and ethnic racial mix, which was common at this time.

Teresa's life

Teresa was by nature passionate and, from all accounts, a rather attractive and charming young lady. In her autobiography, *The Life of Saint Teresa of Avila by Herself,* she confesses to certain youthful indiscretions of the flesh, which were the cause for scandal in the closeted Spain of her time. Teresa entered the Carmelite Convent of the Incarnation in Avila in November 1536 at the age of 21, where she was to live for the next 22 years of her life, which were filled with incident. There was a great disparity in the wealth and living conditions of the women entering the religious life at that time. She writes in her *Life* that she was only half converted during this phase of her life, and not until she was about 42 years of age did the beginnings of sanctity appear in her. To use a favourite image of her own, she was a plant of slow growth, and needed a great deal of watering.

Teresa revelled in the social atmosphere of the Incarnation and proved immensely popular, but below the surface ran a darker strain. Just after her profession of vows in 1538, Teresa's health totally collapsed. Even before entering the Incarnation, she had suffered from serious fainting fits and various fevers, and her entry into the religious life increased their frequency.

In August 1539 she fell into a serious decline and was even pronounced dead,

with her Requiem Mass being celebrated and a grave dug for her! Thankfully she recovered, remaining in a greatly debilitated state for almost eight months, and for several more years her paralysis, though gradually improving, continued to cripple her. It was not until her fortieth year that the effects of it entirely left her.

During this time she began to turn back to a deeper life of prayer and forsook the diversions she had previously indulged in with such gusto. During these formative years, she was greatly influenced by a popular devotional book of the time called the *Third Spiritual Alphabet* by a Franciscan, Osuna, as well as by St Augustine's *Confessions* and St Ignatius' *Spiritual Exercises*. She also consulted the Jesuit fathers, who had recently founded a house in Avila. Previously, the contemplative life had been a sealed book to her, but now, following Osuna's leading, she was passing through the stage of discursive prayer and in time was being raised to the prayer of quiet, and occasionally even to the prayer of union.

By the late 1550s, when she was in her forties, change was in the air. In the convent, she was well settled into a strict regime of prayer and *Lectio Divina* and it is from this time that we get accounts of 'Teresa the mystic'. There are many eye-witness accounts of the extraordinary graces that God was granting to her: locutions, visions, levitations and ecstasies.

The quickening of Teresa's spiritual life is often described as her 'second conversion'; it began about 1555, when she describes the return of a sense of God's presence more vivid than anything she had known before. Teresa herself, as we read in her autobiography, became matter of fact about the visions, ecstasies and unusual experiences that God was granting her, and regarded the supernatural graces as primarily having meaning and value within the context of her life of prayer and good works.

Through a deepening contemplative call from Christ, Teresa was soon to embark on her destiny to reform the Carmelite Order, which forced her to withdraw from the Incarnation to form a new community, much simpler and smaller, based on the austerity of the original *Rule of St Albert*. Amid the greatest secrecy, Teresa's first foundation was made on St Bartholomew's Day, 24 August, 1562. Her convent of St Joseph's opened with four new nuns of the 'Discalced' (literally shoeless) reform. Her triumph was short-lived, as two days later the City Council decided that the convent must be shut down, and even took to the law courts! As soon as

the proposal became generally known, it met with the most severe opposition and persecution, the strongest resistance coming from her own nuns at the Incarnation!

It was an extremely difficult time for Teresa; however, two years later she finally won and settled into her new home. The Reform of the Carmelites had begun. She called the next four and a half years 'the most restful years of my life'. She devoted herself to the establishment of her new convent, and began her writing career in earnest, completing her first two works – the *Life* and *The Way of Perfection*.

From then until the end of her life she was concerned with the establishment and spread of the Reform that she had begun. In 1567, a new house was founded at Medina del Campo and foundations at Valladolid, Malagon, Toledo, Salamanca, Segovia and elsewhere followed. The remarkable stories of all these foundations are contained in her *Book of Foundations*.

The same year, 1567, was also significant for Teresa's first encounter with one of the most influential people in her life, the mystic and saint St John of the Cross. Although he was only 25 when they met in Medina, Teresa, at 52, immediately recognized his great spiritual gifts and proposed that he help her in establishing a male branch of her Reform – which he duly did. The two of them got on famously, yet sadly their correspondence has not been preserved.

July 1571 saw Teresa elected as Prioress of her old alma mater at the Convent of the Incarnation. The convent was exactly divided as to those who supported her and those who opposed her, but being no stranger to such situations, she simply began the lengthy and not unsuccessful process of reconciliation. She even sought an audience with Philip II, the King of Spain, who had become favourably disposed towards her situation, taking an active interest and becoming involved in establishing the Reform.

Further troubles were ahead, and moves were afoot to have the Reform suppressed. In April 1575, a General Chapter of the Carmelites was held in Spain, which decided to suppress her 12 convents, prohibit her from founding new ones and recommend that she should 'retire' indefinitely to a convent of her choice in Castile – effectively becoming a prisoner. She obeyed her superiors but continued to battle from behind the walls of the Toledo convent.

John of the Cross was spared even that luxury, being kidnapped by fellow monks in December 1577 and held prisoner in a cell at the Discalced monastery in Toledo

for nine months (see next chapter, page 309).Yet as this reign of terror and perse-cution towards her Reform was at its height, these two mystics, separately and intensely, turned within themselves to their tremendous spiritual resources and pro-duced some of the greatest works of mys-tical literature.

By 1580, peace was declared and Teresa, 65 by now and calling herself 'an old crone', set off on the road to continue founding more convents. John, having escaped, began to write and preach in earnest, but this had

Window in the Convento de Santa Teresa, Avila

by now taken a heavy toll on his health, and he died at the age of 49 in 1591.Teresa struggled on. By 1579 she had made the thirteenth of her foundations, and in 1581 she heard that the conflict within the Carmelite Order had ended in partition.

By the 1580s, however, it was clear that she was coming to the end of the road. In 1582, she was asked by the Duchess of Alba to attend the labour of her daugh-ter-in-law so that the delivery would be blessed by the presence of the saint.When she arrived, she was told the child had already been born and she was no longer re-quired. Exhausted and totally worn out, she retired to a convent at Alba de Tormes and there sank quickly. She died at nine o'clock on 4 October 1582.

The stages of the contemplative journey

The contemplative path of prayer – the journey towards, and in, Christ – is, and always has been, fraught with manifold difficulties, delusions, battles and shadows.Without an accurate road map of the spiritual terrain and the wise spiritual direction that the great Christian saints and mystics have provided, it is a dangerous and perilous journey.

One of the basic ideas in western mysticism is that the contemplative life moves through various stages.This classical division is known as the purgative, illuminative and unitive stages.The first stage is known as the way of awakening, purgation and purification, the *via purgativa*, the second stage as illumination, the *via illuminativa*, and the third stage as mystical union, the *via unitiva*.

The Interior Castle, Teresa's best-known mystical text, is the product of her most mature reflection on the contemplative journey of prayer and of a lifetime of observing and directing her spiritual daughters – the nuns of Carmel. She completed this text in 1577, five years before she died.

The Interior Castle

In 1579, Teresa had a vision in which she saw the soul as 'a most beautiful crystal globe, made in the shape of a castle, and containing seven mansions, in the seventh and innermost of which was the King of glory, in the greatest splendour, illumining and beautifying them all'. In the text, she describes our interior castle as 'containing many mansions, some above, others below, others at each side; in the centre, in the very midst of them, is the principal chamber in which God and the soul hold their most secret discourse'.

For Teresa, the contemplative journey is the deepening journey of the heart to the innermost chambers where God's Divine Love infuses into, and unites with, the life of our soul. This is traditionally known as bridal mysticism, a deepening love affair where the bride is the soul and the bridegroom is Christ. Her experience and expression of contemplative spirituality throughout most of her writings are suffused with the language of symbols, imagery and allegory – describing the soul as a garden, a tree, a castle, a butterfly, and the action of the Holy Spirit through symbols of water and fountains.

The text is essentially a description of and guide to spiritual change, progress, surrender and transformation throughout seven dwelling places (the literal meaning of 'mansions'), which represent three main stages in the life of interiorization and prayer. In the first three mansions, of awakening, purification and purgation, she tells of what the soul can do to move towards the more interior mansions where God dwells.

The fourth mansion, of illumination, is the transitional stage where the soul begins to undergo spiritual transformation, and God begins to take over. The most interior mansions, towards union, are where Teresa describes God as increasingly purifying the soul towards his likeness, leading to a state of spiritual marriage in the seventh, and innermost, mansion.

The symbol of a castle, or house, with interior dwelling places or rooms is from John's Gospel 14.2: 'In my father's house are many rooms, or mansions.' It is a powerful

and dynamic symbol that contains, integrates and unifies many of the dimensions of the spiritual life that Teresa describes in such detail throughout the text. Through using this symbol, she is saying that the soul is a place of immeasurable beauty, capacity and spiritual depth, with prayer being the constant journey inwards to the depths of the heart where the most secret things pass between God and the soul.

The seven dwelling places of prayer

The first dwelling place represents the awakening to life in the Spirit through sincere devotion and ardent longing for God, and prayer, meditation and spiritual reflection are the gateways into this castle. This is the beginning of our spiritual conversion, the re-centring of our life on God, in Christ, and the affirmation of our true self as made in God's image and likeness, which is being anchored in prayer, faith and virtue and a deepening development of self-awareness, self-examination and self-appropriation.

Teresa likens our spiritual development to the cultivation of a garden, and uses metaphors of how a garden is watered to describe various kinds of prayer, in a four-fold deepening of interior silence and stillness. The Lord is the gardener; we are the assistants or 'tenants', the plants are the virtues and the water is that experience of God in prayer that we call 'consolation'. There are four different ways of drawing water for the garden; these relate to the threefold pattern of prayer of recollection, prayer of quiet and prayer of union, which describe deepening degrees of contemplation on the mystery of God and Divine Love.

The predominant prayer in the earliest mansions is the prayer of recollection, where our mind is quite active and discursive methods and techniques of prayer are essential. The prayer of quiet begins to develop in the fourth and fifth mansions, where a quality and depth of inner stillness and quiet begins to 'take root' and grow; this is the beginning of infused contemplation. This prayer of contemplation is purely a gift of God, which we can do nothing to bring about, and normally will come only after many years of a deepening life of prayer.

This interior stillness and quiet of the faculties and senses enables the opening of the heart in the prayer of union in the innermost mansion, which ends in profound silence and solitude, where we are able to become utterly receptive to God's action through the Divine Love of Christ. Teresa's prayer teaches an interior mode

of surrender and listening for his divine guidance, which begins with methods and techniques and ends in the abandonment of our personal will and selves into the divine 'arms of Love'.

In these early stages, she specifically counsels 'perseverance, humility and self-knowledge' in equal measure. This text is a profound document of the psyche as well as the soul, and her understanding of depth-psychological dynamics, as well as God's movement within the soul, is expressed interchangeably. Her use of 'soul' includes what we would refer to today as psyche, and her basic assumption throughout is that spiritual growth is generally accompanied by psychological growth and maturity.

She puts special emphasis on the importance of self-knowledge – knowing ourselves is about growing familiar with, and accepting of, our fallibility, our needs, our shadow, where we are most vulnerable and unloved, our blocks, psychic and emotional pain, and the limitations of what we can do on our own.

The central role of deepening humility is one of the vital character ingredients on the spiritual journey that is particularly emphasized in many of her writings, and she notes that the cultivation of deepening humility is a surer test of holiness than any enjoyment of mystical visions and favours. True humility engages in the struggle against false pride and excessive self-love, self-interest and egotism. It is also essential to keep close to spiritual teachers and mentors in the outer mansions, as the soul is not strong enough to defend and guide herself alone, needing protection and assistance in the nurturing of hope and faith.

The early dwelling places are fraught with difficulties, blocks, distractions and obstacles that seem constantly to pull us away from God. As we turn towards prayer, we usually encounter whole dimensions that are unconscious, hidden and unknown, which Teresa symbolizes as the 'lizards and the snakes' in the moat outside the castle. In modern psychological language, these are the shadow parts of the psyche, all the neglected, dark, undeveloped, unacknowledged parts of our personality that preoccupy and distract from the deeper contemplative path.

In the second dwelling place, Teresa concentrates on the role of prayer as the doorway into our interior castle and the importance of perseverance. There is, as yet, no spiritual 'depth' within the soul for God to touch directly – he can only communicate indirectly, mainly through objective means such as literature, sermons and inspiring friendships. It is the beginning of the painful and arduous process of

interior transformation, purgation and purification towards, and in, God. The more our soul is turning towards him and reaching out to the Divine Spouse, the more he is reaching out and eagerly beckoning us towards him.

She writes about the cacophony of temptations, distractions and conflicts that can occur when our spiritual life deepens. Here, the real temptations, trials and deeper processes of inner *ascesis* are beginning, where physical, psychological and spiritual disciplines and efforts, aimed at cleansing, purifying and healing ourselves, are increasingly important.

Steadfast discrimination, spiritual discernment and moral courage are required as the inner war within the soul can become more intense, as we are more aware of our internal contradictions, insecurities, discord, conflicts and shadow, and experience more dryness, negative thoughts and other distractions in prayer.

The task of the contemplative life is ultimately active life in the world and the discerning of meaningful service for each of us as individuals, according to our vocation, gifts, talents and character, aligning our will with the will of God. As it is very difficult to orientate ourselves without spiritual guidance and discernment, Teresa emphasizes the fundamental necessity for spiritual direction and increasingly keeping company with like-minded companions and being part of a church, community or religious group.

The third dwelling place is the call to a life of deeper spirituality and love for, and in, Christ, and surrender to his will, where we are entering the deeper chambers of our heart. The human personality and will are still in control at this stage, and our psychological and spiritual maturity, sincerity and willingness to surrender to God's will is being tested. The third dwelling place is an extended meditation on Matthew 19 – the story where Jesus, when questioned by a rich man as to what he must do to possess eternal life in addition to keeping all the commandments, responds by commanding total commitment and surrender.

Teresa refers to this story several times as the spiritual message at this stage. This is where we are too secure, comfortable, self-satisfied, well-ordered and safe, the place of spiritual stalemate, or impasse, because it is at the end of what our own efforts can do. It is a deeper call to more radical change, awakening and transformation in the love of God, as Teresa emphasizes that we have not yet fully surrendered to God – our own will, efforts and striving have brought us to this place.

The fourth dwelling place is the place of spiritual transition and transformation, where infused grace now begins to operate more fully, and our progress is up to God alone. From the arduous, seemingly never-ending purification and purgation of the outer mansions, the soul enters this difficult and painful, yet truly illuminating and transforming mansion. This is a more profound level of surrendering into mystery and unknowing, being the movement from ascetical efforts of prayer and good works to the more contemplative and mystical stages.

This is the place where the natural and the supernatural combine, an intermingling of natural and supernatural prayer, with a deeper level of conversion and abandonment of our own will. Teresa says the rational faculties must be decreasing as our capacity to love and be loved is increasing. This is the beginning of supernatural prayer, infused contemplation, or passive, mystical prayer, where God takes over in the centre of our heart. Our own efforts are ceasing and there is a more direct contact and loving embrace with God.

There is a deepening stillness and quietness within, the beginning of a greater awareness of the presence of God, and the sense of being absorbed, suspended or immersed in him in an apparently passive way. Teresa speaks here about an increasing sense of deep joy, of an intense ecstasy, of the gradual indwelling of an indescribable Love.

In this place of deeper quiet, the human will and the divine will are in stages of deeper absorption, in preparation for the more permanent and established state of union. She is irresistibly drawn to the symbol of water, and uses it throughout her writings to describe the mystical life. She uses the water fountains to describe and understand the different experiences and states of prayer.

From the fifth dwelling place to the end of the text she is concerned with describing the perils and delights of the union of the soul with God. The soul is beginning to undergo a deeper state of interior spiritual transformation where the heart is surrendering even more to being infused and penetrated by the Holy Spirit and God's Love. This mansion is explicitly associated by Teresa with the text from Colossians 3.3: 'You have died and your life is hid with Christ in God' – hiddenness being the keynote.

She describes a deepening prayer of quiet that is now the prayer of union, the beginning of the betrothal of the soul to God. Teresa equates the prayer of union

with the metaphor of the wine cellar, based on the book of the Song of Songs. This is the beginning of the union of human and divine will, and she emphasizes that it is not possible to enter these more interior dwelling places by personal effort alone, but only by the grace of God, effortlessly.

Teresa amplifies her understanding of the prayer of union by using the metaphor of the transformation of silkworms into butterflies: the analogy to the contemplative soul being transformed by the Love of God is clear. Our deepening prayer relationship with God is the container, or cocoon, for transformation, and by emptying ourselves we are slowly building the presence of God around us. Here, the soul is in the process of spiritual metamorphosis, becoming so filled with Christ that she emerges 'like the butterfly', as the transformed soul, fragile and restless, but beautiful as she was not before.

In this dwelling place, Teresa writes that the Beloved is giving the grace of the Holy Spirit as a token of the impending betrothal to the soul, in preparation for her becoming his bride. The soul cannot understand the mystery of spiritual union – it is inexplicable and paradoxical to the rational faculties. Teresa emphasizes the importance of weaving this focus of deep prayer into the praxis of daily life, and the test of the authenticity of our prayer life is whether our love for our neighbour is growing in response. There are manifold dangers and trials that present themselves at every stage, and there are particular temptations and difficulties in this fifth mansion, where spiritual direction is particularly important.

The sixth mansion occupies nearly a third of the text, and deals with interior states of prayer and the intensification of the spiritual life, covering the nature of both the suffering and the various ecstasies of prayer that can occur. The sixth mansion is a time of great trials and tests, often called the 'dark night of the spirit'. She emphasizes the importance of the ongoing process of spiritual discernment, since deeper purification and infusion of Divine Love into the soul is occurring with increasing subtlety of internal and external tests, trials, obstacles and opposition.

There is now an increasing hunger for solitude, to be alone in prayer as much as possible. The graces, the taste and vision of God, which are being given to the soul, are by now so deeply imprinted that its only desire is to behold him again. Teresa is famous for her unusual and intense spiritual experiences that she writes about here. Her guidelines are full of common sense, emphasizing the importance

of looking at their effects and how they have been integrated into life, advising prudence and patience until time reveals their fruits. All true spiritual phenomena will lead to a greater awareness of God and his Love, a greater sense of humility, and a deepening awareness and compassion for others and their suffering.

The seventh and innermost mansion, Teresa writes, is different from all the others. The soul is entering the bridal chamber of Our Lord, where the mystical marriage of Christ to the soul is being consummated. After the transformation of the middle mansions, the turbulence, agony and ecstasies of the fifth and sixth mansions, all comes to an end now. There is a sense of completion, peace and rest. She describes the seventh mansion as where 'this secret union takes place in the deepest centre of the soul, which must be where God Himself dwells', quite independent of the physical senses or faculties.

By choosing to open ourselves totally to God, and surrender to life in the Holy Spirit, we become what we truly are, what we are meant to be – made in the image and the likeness of God. In this innermost mansion, it is interesting that Teresa gives little attention to interior experiences, looking instead to the effects of this union in our relationship to others and the world. The purpose is the 'birth always of good works, good works' and a call to action and a life of active love in the world, with the confidence that it is possible to maintain an indwelling presence of God in the innermost recesses of our heart, 'being, and resting, in eternity, in union with God'.

The living waters are for the flowers, and the purpose of the contemplative journey is to be even more engaged in the world around us, in activities and works of service, charity and loving action, while simultaneously united with the Lord in the innermost dwelling places. The life, writings and experience of St Teresa of Avila show that it is possible, and indeed, is every person's spiritual birthright to be called into the deeper contemplative life, into unceasing prayer, into 'union with God', as the life of Jesus Christ and all of his saints throughout the centuries have shown and testified.

JULIENNE MCLEAN

ST JOHN OF THE CROSS

Peter Tyler

St John of the Cross, *Lynne Taggart*

Introduction

During a time of religious and cultural upheaval the position of one born into one of the disadvantaged groups is far from enviable. This was the case with St John of the Cross. His father was of *converso* origin and his mother is thought to have been of Moorish descent. The marriage caused St John's father to be disowned by his wealthy family, and when moreover he died quite young it left his wife and three boys in dire poverty. Throughout his life St John was faced with often inexplicable antagonism, which may well have been based on prejudice due to his origins.

Despite his ecstatic states his view of the Divine and his clarification of his mystical experiences put him firmly within the 'apophatic' tradition. Whereas he stated himself that his intellect was silenced faced by the Divine Presence, yet he placed it at the service of explaining soberly, clearly and profoundly what might be of support to those on the spiritual path.

Peter Tyler reminds us how John's mentor Don Alonso Alvarez and particularly St Teresa of Avila realized the beauty of his nature and his clear intelligence despite his serious and withdrawn manner. Peter stresses that he did have a difficult life – he was withdrawn, serious, but also caring and deeply spiritual – and calls him 'that much misunderstood Mystic'. Out of his deepest suffering came the most sublime poetry.

St John of the Cross 1542–91

He was born in Fontiveros in Castile, 24 miles north west of Avila, on 24 June. He studied the humanities at a Jesuit school and subsequently entered the Carmelite Order, professing in 1564. He moved to Salamanca, where he studied at the University. He met St Teresa of Avila and supported her in the reform of the Carmelite Order. This resulted in his imprisonment in 1577 in Toledo. Nine months later, after torture and public humiliation, he managed to escape. While in jail he composed his most famous poem, 'The Spiritual Canticle'. His suffering was reflected in all his subsequent writing. He continued despite his imprisonment with the reform, and with St Teresa set up the 'Discalced Carmelite' Order. He is well known for his co-operation with her and for his spiritual writings, especially his poetry about the growth of the soul by its detachment from the world and its attachment to God. He died on 14 December 1591.

I hear my love.
See how he comes
leaping on the mountains,
bounding over the hills.
My love is like a gazelle,
like a young stag.

See where he stands
behind our wall.
He looks in at the window,
he peers through the opening.

My love lifts up his voice,
he says to me,
'Come then, my love,
my lovely one, come.
For see, winter is past,
the rains are over and gone.

Flowers are appearing on the earth.
The season of glad songs has come,
the cooing of the turtledove is heard in our land.

The fig tree is forming its first figs
and the blossoming vines give out their fragrance.
Come then, my love,
my lovely one, come.
(Song of Songs 2. 8 –13)

THE MISUNDERSTOOD MYSTIC

Over the 400 years since his death in 1592 Juan de Yepes, or as he is more commonly known, St John of the Cross, has been perhaps one of the most misquoted and misunderstood of all the writers in the Christian mystical tradition. Dean Inge, writing of him in his famous *Christian Mysticism* of 1899, says that John 'carried self-abnegation to a fanatical extreme, and presents the life of holiness in a grim and repellant aspect' (p. 223).

The association of the phrase 'Dark Night of the Soul' with his name has led to many misconstruals of his approach to the spiritual life – usually centred on, as Inge describes it, welcoming 'every kind of suffering' and 'always choosing that which is most painful, difficult and humiliating'. Yes, it is true that John lived a difficult life – sixteenth-century Spain was no bed of roses, especially if, like John, you were born 'on the wrong side of the tracks'. Yet to portray him as some sort of pain freak or masochist is completely to miss the thrust of his message. If anything, his spirituality is closest to that of the 'Song of Songs' with which we began – ecstatic, erotic, sensual and loving – a poem he loved throughout his life and that influenced much of his own mature writing.

From the dispositions given after his death for the process of his beatification, one of the main sources we have for his life and personality, he comes across as a deeply loving, gentle and caring soul. People travelled great distances to seek his advice and counsel and he was known for the gentleness of his pastoral touch – undergoing mortifications himself but never insisting on them for others or laying 'burdens on people greater that they could withstand'.

John's writings

The Dark Night of the Soul
The Spiritual Canticle
The Living Flame of Love
The Ascent of Mount Carmel: a commentary on The Dark Night of the Soul

Recommended translations:

Regis J. Armstrong OFM and Ignatius C. Brady OFM (trans.), St John of the Cross, Classics of Western Spirituality, Paulist Press, 1991.

Lucinio Ruano de la Iglesia (ed.), San Juan de la Cruz: Obras Completas, Biblioteca de Autores Cristianos, 2002.

K. Kavanaugh and O. Rodriguez (trans.), The Collected Works of St John of the Cross, Institute of Carmelite Studies, 1979.

So how has this misunderstanding of John arisen? We can cite many factors. Steven Payne in 'The Influence of St John of the Cross in the United States: A Preliminary Study' points out that a 'complete' edition of John's writings in English did not appear until 1864, translated by David Lewis. Yet it was not until 1934–5 that the first scholarly edition of his works appeared in English, translated by the great Hispanist E. Allison Peers. The more recent translation by Kavanaugh and Rodriguez (see 'Recommended translations', p. 303) has extended scholarly interest in John's work and allowed a flowering of 'sanjuanist' scholarship in the past 20 years or so. (See 'Suggested reading', p. 427, for more examples.) Yet despite new research on his work, the label of the 'gloomy saint' remains, and it seems as though it will take some time for John to acquire his place in the hearts and minds of Christians everywhere.

His life and times

When writing a review of John's poetry, the British poet W. H. Auden once referred to him as 'an odd person in an odd place at an odd time'. In some respects he was right as Spain has always been the 'exceptional case' in Europe. Part of this arises from its unique history with respect to the rest of Europe. Shortly after the revelations to the Prophet Muhammad and the beginning of Islam, in 711 a combined force of Arabs and Berbers from the Maghreb crossed the straits of Gibraltar under Musa Ibn Nuseir and defeated the last Christian Visigothic kings of Spain at Guadalete. The invading forces quickly captured Sevilla, Córdoba and Toledo, and by 714 much of the north of Spain had been occupied.

The new government promised freedom of worship to both Jews and Christians and, combined with the unpopularity of the former Visigothic kings and intermarriage between the two groups, an atmosphere of reconciliation was established. The subsequent history of the Peninsula saw the establishment of broadly Muslim governments in the middle and south of the land and the slow re-emergence of Christian kingdoms in the north.

By 1085 the so-called Christian *Reconquista* or 'Re-Conquest' of Muslim Spain reached a significant turning point when the ancient capital of Toledo was retaken by Alfonso VI. The king, like his fellow Muslim viziers, respected the rights of his co-religionists in the city and laid the foundations for a great 'School of Translators' to arise in the city under the later King Alfonso X – *El Sabio*, or 'The Wise'.

With the fall of Córdoba and Sevilla to Christian armies in 1236 and 1248 respectively, most of the main stretches of southern Spain had fallen into Christian hands. The next 200 years saw the Christians consolidating their new lands, while the Kingdom of Granada ensured that the southern tip of Spain, including the Alpujarras Mountains, remained under Muslim control. This small kingdom finally fell to *Los Reyes Católicos* – 'Their Catholic Majesties' Ferdinand and Isabella – in 1492, thus marking the end of almost 800 years of Muslim, Christian and Jewish interaction on the Peninsula that fascinates and challenges scholars today.

The same year, 1492, was also, of course, the key moment when western exploration of the 'New World' began with Christopher Columbus's voyage sponsored by Ferdinand and Isabella. These two events, the new homogenization of Spanish society under sole Christian rule and the discovery and assimilation of the wealth of the New World, would dominate events in Spain over the next centuries and profoundly influenced the life and writing of John of the Cross.

John was born in 1542 in the little village of Fontiveros on the Castilian plain. He was born on 24 June, the feast day of St John the Baptist, so it is probable that this is how he acquired his name. His father, Gonzalo de Yepes, belonged to a wealthy family of silk merchants originally from Toledo with *converso* origins (see Chapter 21, page 289). His mother, Catalina Alvarez, was from a family of poor and humble weavers whom Gonzalo met on one of his business trips to Medina del Campo in Castile. Some commentators have speculated that she was from Muslim stock and it has been suggested that some of the persecution John received later in his life arose from suspicions of his Jewish and Muslim ancestry (a situation not uncommon in sixteenth-century Spain: John's great co-worker, St Teresa of Avila, was also from *converso* origins).

Gonzalo's family did not take kindly to his 'love match' with Catalina and promptly disowned him. The couple married in 1529 and set about establishing a family in Castile. John was the youngest of three boys of whom only two survived; his middle brother, Luis, was to die when John was eight. When John was three years old his father died. Catalina went to the family in Toledo and the surrounding towns begging for assistance to help bring up the boys, but she was disowned by them all. Accordingly John's earliest childhood was in great poverty, and when he was nine the family moved to Medina del Campo so that Catalina could bring up the boys.

Also around this time

1550
Inquisition given additional powers by Emperor Charles V.

1550
Giorgio Vasari, architect and painter, publishes *Lives of the Artists*.

1551
Archbishop Thomas Cranmer publishes his '42 Articles' for the Church of England, accepted by Edward VI two years later.

1559
Elizabeth I crowned Queen of England – Church of England re-established.

1563
William Byrd, English composer, appointed organist at Lincoln Cathedral.

1563
Jews expelled from France by order of Charles VI.

1564-1616
William Shakespeare.

1568
Leaders of Flemish opposition to the Spanish Inquisition beheaded in Brussels.

1575
Treaty between French Catholics and Huguenots signed.

John enrolled in the 'Catechism School' – the Colegio de la Doctrine – which was intended for the children of orphans and was orientated towards teaching these poor children how to develop a craft or trade that would help them in later life. Thus John was taught carpentry, tailoring, bricklaying and painting – the 'gloomy saint' of popular imagination remained an accomplished builder and 'brickie' for the rest of his life, and some of his structures still stand to this day. A helpful antidote to the image of the other-worldly and cold ascetic!

At the age of 17 he found employment in the Plague Hospital of Nuestra Señora de la Concepción, where he found favour with his employer Don Alonso Alvarez, who became something of a mentor and father figure to the young lad. The hospital had around 50 beds and served the poor, who had ulcers and contagious diseases, and many of whom were suffering from the new incurable disease of syphilis that had returned from the New World with the conquistadores. We hear how the boy 'told stories and sang songs' to the suffering patients, and it seems as though John's celebrated gifts as a gentle and sensitive pastor were developed at this early age.

Don Alonso saw that John had brains and encouraged him to enrol at the newly founded Jesuit College of Medina. Between 1559 and 1563 he studied metaphysics, rhetoric, grammar, and Greek, Latin and Spanish literature. At this time the Jesuits were providing the very best in education in the new Renaissance humanities, and John profited enormously from his education here, being taught by, among others, the great Jesuit humanist scholar Juan Bonifacio (see Chapter 20 on St Ignatius of Loyola). His classical learning and skill came out in his later poetry and prose.

Don Alonso wanted John ordained so that he could serve as chaplain to the Concepción, and accordingly paid for him to study at the University of Salamanca. However, before he did this John joined the Carmelite Convento of Santa Ana in

Medina in 1563 when he was 21 years old, taking his vows in 1564 and adopting the name of Juan de Santo Matía.

John now entered the Carmelite college of San Andrés at Salamanca. With Oxford, Bologna and Paris, Salamanca had been one of the four great medieval universities of Europe, and again John benefited from a training in philosophy and theology second to none. Although we do not know exactly which classes he took it is likely that, as well as philosophy and theology, he studied ethics, astronomy, grammar, logic and music. He retained a great love of the natural world for his whole life and he would derive much pleasure from observation of the night sky, the planets and stars in later life.

In 1567, at the age of 25, he was ordained a priest, and because of his love of solitude, quiet and the ascetic life he was seriously considering joining that most ascetic of religious orders, the Carthusians. However, fate intervened when he returned to Medina and met the charismatic founder of the 'Discalced' reform of the Carmelites, St Teresa of Avila (see chapter 21). At this time Teresa was 52, more than twice John's age. Fresh from founding her first convent in Avila, she was preparing her second foundation at Medina. They immediately seemed to have an easy spiritual rapport, and Teresa persuaded John to remain in the Carmelite Order and work with her to reform it from within. Calling him 'my novice' she persuaded him to begin the first male house of the reform at Duruelo near Avila with four others.

On 28 November 1568 the Carmelite Father Provincial heard the four friars renounce the *Mitigated Rule* of the Carmelites and embrace the *Primitive Rule of Our Lady of Mount Carmel* (see Chapter 21, page 292). John also now took the name for which he has become universally known – Juan de la Cruz, John of the Cross. In spring 1569 the Father Provincial raised the status of the foundation to that of a Priory with permission to receive novices, and in June 1570 the community moved to Mancera de Abajo as they had become too numerous for the old farmhouse. A community was now established at Pastrana, east of Madrid, and John was named Rector of the Colegio de San Cyrilo at the new Renaissance University of Alcalá de Henares in 1571.

This same year of 1571 also saw the election of Teresa as Prioress of her old alma mater La Encarnación in Avila. Teresa's appointment aroused not a little controversy and she quickly asked John if he would come as confessor to the convent to assist

City of Toledo

her reforms. He took up the post in 1572; it was a salaried post that had previously been held by Mitigated Carmelites. John's acceptance of the post did not help to alleviate the tensions that were growing between the two groups, and he spent the next five years living in a workman's hut on the edge of the property. He brought his famous pastoral gifts to the post as well as his equally honed skills as a spiritual director. In this role he undertook the task of giving spiritual direction to Teresa herself. Avila was a hotbed of reform at this time, and the new instructions on the spiritual life from the Council of Trent were being enacted with vigour in the granite mountain city.

As the Discalced reform of the Carmelites continued under the guidance of John and Teresa it began to run into problems. New houses of the reform were forbidden in Andalusia but the Dominican Apostolic Commissioner Vargas, with the encouragement of King Philip II, authorized new foundations at Sevilla, Granada and La Peñuela that included taking a house of the Mitigated Carmelites and giving it to the Discalced.

In 1575, following a chapter of the Order in Piacenza, Italy, new foundations were forbidden, Teresa was ordered to 'rest' in a convent of her choice and a General Visitor, Padre Tostado, was appointed to Spain, who immediately confronted King Philip and the Apostolic Nuncio, Nicolás Ormaneto. Although the Visitor wanted John removed from his post at Avila, the nuns, and the Apostolic Nuncio, wanted him to stay.

Ormaneto died suddenly in 1577 at the young age of 35 and John was seized by a group of Mitigated Carmelites on the night of 2 December and taken blindfolded to the Mitigated Priory at Toledo. He was held here for some nine months under the most terrible conditions. His cell was six foot by ten and had previously been used as a latrine. He endured the freezing cold of a Castilian winter and the stifling heat of the summer in this cell. The decisions of Piacenza were read to him and he was asked to renounce the reform, which he refused to do. He was accordingly 'disciplined' by each member of the community scourging him on the refectory floor after he had eaten his food – bread, sardines and water. The lashes he received were violent and his health was severely affected for years afterwards, probably contributing to his early death.

Six months into the imprisonment he was given a new warden, who had some compassion for the poor friar and whose testimony was to constitute part of the beatification process after John's death. He was given a change of clothes and paper and ink to write with.

Thus, in dereliction and darkness, John began his new career as a writer and spiritual poet. He managed to write the first 31 stanzas of the
Spiritual Canticle while in prison and began the famous poem *En una Noche Oscura* (*On a Dark Night*).

On 16 August 1578, while the friars rested after the feast of the Assumption, John effected his escape 'through a combination of good fortune, planning and some mystery' (J. Welch, *When Gods Die*). He let himself down from the prison window with torn-up bed sheets and after an initial wrong turn into the neighbouring convent garden managed to find the Discalced sisters' house of Toledo, having wandered through the ancient Muslim streets of the city, which are still preserved to this day. After a little rest with the sisters he was smuggled south to

Philip II of Spain, *anonymous*

Andalusia, where he was named Superior of the community of El Calvario. He would remain in Andalusia for the next few years, being appointed Superior of the new Discalced House of Studies in Baeza, Prior of Granada and Vicar Provincial of Andalusia.

In 1580 the Holy See, under pressure from King Philip II, granted the Discalced their own jurisdiction, although not complete autonomy. In the beautiful warm southern lands John completed his great poems and began the prose commentaries on them – full of the warmth, colour and life of an Andalusian spring. The house at Granada, Los Martires, was built in the shadow of the great Muslim palace of the Alhambra, whose water John redirected with his own aqueduct to water the priory's vegetable gardens. These six years were to be some of the happiest in his short life.

In June 1588 he was elected Definitor of the Reform and Prior of Segovia in Castile. In the beauty of his new surroundings he continued his writing, and in the caves above the priory was to experience ecstatic states of communion with God. His brother, Francisco, whom he had not seen for years, was a regular and loved visitor. However, the peace was not to last.

The new Vicar General of the Discalced, Nicolás Doria, began to effect changes to the new community that went against the spirit of the recently deceased St Teresa. John, Jeronimo Gracián and Sister Ana de Jésus all opposed him and encountered a ferocious counterattack. Gracián was dismissed from the Reform for wanting to promote apostolic activity in Africa and 'The Indies'; and a case was begun against John using defamation of character to have him removed – the very founder of the Reform!

During this process in 1591 John became ill and was moved from La Peñuela to Ubeda in Andalusia, where he was not greatly loved. The Prior, who also did not get on with him, assigned him an unpleasant cell and refused to give him special treatment. The disease spread to his back, where a tumour appeared. On 13 December he called the Prior and begged forgiveness for the expense he had incurred the priory. The Prior was overcome and fled the cell in tears. John died later that night.

He remained a controversial figure for the next 150 years, and although a process for beatification was begun in the early 1600s, it was not until 1726 that he was canonized as a saint of the Roman Catholic Church, and then not without controversy. He was made a Doctor of the Universal Church in 1926, an honour he shares with his old co-worker, St Teresa, the first woman Doctor of the Church.

Teaching and doctrine

Where have you hidden,
My love, and left me moaning?
Like a stag you fled
Having wounded me;
I went out calling you, and you had gone.

And all who are free,
Tell me a thousand graceful things of you;
And all wound me more,
And leave me dying:
A don't-know-what which lies behind their babbling.

Why, if you wounded this heart
Don't you heal it?
And as you stole it from me,
Why do you leave it as it is
And not carry off what you have stolen?
 The *Spiritual Canticle*, verses 1, 7, 9

These passionate verses from the beginning of the *Spiritual Canticle* reveal something of the spirit of John's spirituality. From a life of no little hardship and suffering, he has left us some of the most beautiful love lyrics of all mystical writing. In them he combines his own passionate love of God – and experience of absence of God in the soul – with his classical and theological training to produce verses that are second to none in the Spanish language.

These lines, first conceived in the dark of the Toledo prison, are the dynamo from which the rest of his spirituality flows. It is the cry of someone who has lost a lover and is totally heartbroken. John is a master at recognizing all the stages of spiritual growth that accompany our journey to God, but where he excels is in that mature moment when God 'weans us off' the delights and consolations of our spiritual 'youth' and leads us into the 'dark night' where only 'the light that burns in the heart' is a guide. He puts the onset of this magical moment beautifully in his

most famous poem, *En una Noche Oscura* (*On a Dark Night*):

On a Dark Night
Inflamed with anxious love
– Ah the sheer grace! –
I went out unseen
My house being now all quiet.

In darkness and secure,
Disguised by the secret ladder
– Ah the sheer grace! –
In darkness and concealed,
My house being now all quiet.

On that blessed night
In secret, for no one saw me,
Nor did I look at anything,
With no other light or guide
Except that which burned in my heart.

This moment of the spiritual life, what John refers to as the 'Dark Night', is a place of the deepest existential anxiety and trauma. It is the place where we encounter our own nothingness and insecurity. Yet it is also the *noche dichosa* – the blessed, warm, Mediterranean night – when God reveals God's self. It is a place of paradox. All security and comfort is removed, but it is also the *noche amable más que el alborada*, 'the night more lovely than the dawn', 'the guiding night' – the gentle, warm, loving night.

For at the heart of John's teaching is not some spiritual boot camp but the simple message that lies at the heart of all Christian spirituality – the Bad News that we are all prone and subject to the forces of the unconscious, destruction and sin, but the accompanying Good News that through faith in Christ we are able to transform this suffering into a new and transfigured life in Christ.

It is not easy. John makes clear that the way forward is difficult and will require sacrifice:

To reach satisfaction in all
desire its possession in nothing.
To come to possess all
desire the possession of nothing.
To arrive at being all
desire to be nothing . . .
To come to be what you are not
you must go by a way in which you are not.
 (*The Ascent of Mount Carmel* 1.14)

We may think that to achieve control over our wayward passions and desires we simply have to grit our teeth and 'think of Jesus'. 'No!' says John. If we suffer from greed, pride, ruthless ambition, alcoholism, emotional insecurity, violent and murderous impulses, these aren't going to go away. We cannot wish them away; they are part of our nature as human beings. Rather, as the Desert Fathers and Mothers once recognized, we must offer them up to Jesus who will be able to 're-order' our disordered attachments through 'a more intense enkindling of another, better love'. The genius of John was that he recognized that we do not vanquish the appetites through our own efforts and the denial of them, but by surrendering to the 'higher and better love' of Jesus Christ.

For as we stated at the beginning of this chapter, John's teaching is essentially a teaching of love – the true and real love of Jesus that alone can transform the soul and prepare it for eternal life. John states in *The Ascent of Mount Carmel* that 'it is better to experience [this love] and meditate upon it than to write of it'.

This is probably why he resorts to poetry to convey his spiritual message. He recognizes that the written word can never adequately express the nature of our deep love relationship with God and the cosmos, but in the ambiguous and shifting images of poetry he can come nearest to giving us something of a flavour of the eternal banquet of love that awaits us. It is an image that is not surpassed by the final beautiful stanzas of the *Spiritual Canticle* of which the great Hispanist Gerald Brenan wrote:

I do not think that in the whole of Spanish poetry there is a passage that calls up so vividly the Castilian-Andalusian scene before the incidence of motor transport: the

string of horses or mules descending slowly to the river; the vague suggestion of frontier warfare, now over; that sense of endless repetition, of something that has been done countless times before being done again, which is the gift of Spain to the restless and progressive nations. In these last two wonderful lines, with their gently reassuring fall, the horses descending within sight of the waters are lifted out of time and made the symbol of peace of this land of eternal recurrence. (St John of the Cross, p. 115)

The sighing of the air,
The song of the sweet nightingale,
The grove and its beauty,
In the serene night
with the flame that consumes and is painless.

No one looked at her . . .
Nor did Aminadab appear,
The siege was completed,
And the cavalry
At the sight of the waters descended.

PETER TYLER

GEORGE HERBERT AND THOMAS TRAHERNE

Patrick Moore

George Herbert, *unattributed*

GEORGE HERBERT

Introduction

The latter part of the sixteenth century, when George Herbert was born, was one of the richest times in terms of English culture and language. When he was a boy of about ten and a pupil at Westminster School, Shakespeare's *Sonnets* were published. Not just Shakespeare but the entire world of the Elizabethan/Jacobean dramatists – Ben Jonson, Fletcher, Marlowe – was a dynamic force in the culture of that time.

Although there had been a formal break with the Church of Rome during the reign of Henry VIII, little had in practice really altered: Latin liturgies were still used. Only once Edward VI ascended the throne in 1547 were significant changes made to the religious life of England. The first Book of Common Prayer was produced at a meeting of bishops, although it is generally accredited to Thomas Cranmer. During George Herbert's time there was an outpouring of spiritual poetry not only by Herbert and Traherne but by John Donne and many others – the so-called 'metaphysical poets'.

Shortly after Herbert died, the Church of England, in terms of its Book of Common Prayer, its episcopacy, its priesthood and its liturgy, was dispossessed; it ceased to exist in the legal sense, certainly in any external formal way, during the time of

the 'Commonwealth' under Oliver Cromwell and the Puritans. Only Puritan writings were then allowed and the reading of these poets was forbidden.

This is the point at which Brother Patrick Moore starts this chapter on George Herbert. In doing so he emphasizes both the Church of England and its Book of Common Prayer as foundational to the life, work and poetry of George Herbert.

George Herbert 1593–1633

George Herbert was born in Montgomery, Wales, of a wealthy family. He had six brothers and three sisters. After the death of his father the family moved to London. He was educated at Westminster School and Trinity College, Cambridge. He took his degrees, BA and MA, with distinction and was elected a major Fellow of Trinity. In 1618 he was appointed Reader in Rhetoric and elected public orator, a post he carried out from 1620 to 1628.

His mother died in 1627; her funeral sermon was delivered by Donne. Herbert married Jane Danvers in 1629. He took holy orders in the Church of England in 1630 and spent the last three years of his life as a much loved and respected rector in Bemerton, near Salisbury. He died of consumption in 1633.

AN AUSPICIOUS TIME

The 'winter' of the Church of England began shortly after the death of George Herbert. And so it does seem to be true, as we will discover through George Herbert, that in terms of religious groupings, as well as in everything else, everything is seasonable. Many of us like to live in a perpetual spring and summer. But the difficulty is that, unless there is an autumn and a winter, some very essential things are lost. It is so stimulating to know, as we are moving into the chill of the autumn and forward into winter, that we are at a time when there isn't growth above ground. It looks as though we have physical death all around us, and yet the autumn leading into the winter is the time when life really grows deep below the soil. Sometimes we forget that the spring and the summer are absolutely dependent upon the autumn and the winter. There was a winter period for the Church of England right after the death of George Herbert, but that would be an essential part of its life as a corporate group.

One of the most tremendous things about the rediscovery of our eastern and western Christian mystical tradition, and the traditions of non-Christian groups over the last 20 or 30 years, is that the old boundaries have come down. If we look

at the whole field of spirituality, we don't see the denomination lines any more. The Holy Spirit doesn't seem to like boundaries very much. When we look at Teresa of Avila and Thomas Merton, their words are not exclusively for Roman Catholics. In the same way, George Herbert is much too big to be limited to the Anglicans.

The importance of The Book of Common Prayer

George Herbert was born of a very privileged family living on the Welsh borders. There were ten children of whom George was the eighth. His father died early in his life, so his mother, a very strong figure and a close friend of the priest, poet and Dean of St Paul's, John Donne, was central. Donne was George's godfather.

When her husband died, Magdalen Herbert moved from Montgomeryshire to Oxford, where her eldest son was at university. Shortly after that, she moved the family down to London to the Charing Cross area. Young George Herbert was sent as a day pupil to Westminster School, and there he grew up, imbibing The Book of Common Prayer, which is the key to his life and writing.

The Book of Common Prayer was not limited to those who were literate, as it was not meant so much to be read as to be heard; the same applies to George Herbert's poems, as it actually does to the Bible as well. The purpose of reading out loud is that the text can be internalized and truly heard. In this way the Word of God comes from the outside, enters the ear and goes down to the heart. Corelli's painting of the Annunciation shows the Holy Spirit entering Mary through her ear. In the same way George Herbert's poems need to be heard rather than read. They should not be analysed, but taken in meditatively.

It is a happy loss to lose oneself and to find God in exchange.

What Cranmer tried to do with The Book of Common Prayer was to return to the early idea of St Benedict, namely that daily prayer was to happen in community for everybody, especially the laity. In terms of The Book of Common Prayer every large family was supposed to begin the day at home with its morning prayer and end it with its evening prayer. In wealthier homes all the servants and workers would be gathered with the family for these occasions.

If you went, as Shakespeare did, to one of the new grammar schools, every day you would have heard The Book of Common Prayer for Morning Prayer and Evening Prayer. If you went to the university, every day the same pattern would be









followed. This meant that the cadences of Cranmer's great religious prose, the cadences of the Authorized Version of the Bible, were something that everyone inherited: the literate and the non-literate. Cranmer advocated his hearers, moreover, to 'read, mark, learn, and inwardly digest'.

George Herbert at Cambridge

When Herbert moved from Westminster School to Cambridge University and became an undergraduate at Trinity College, Launcelot Andrewes was the Bishop of Ely and his local bishop, and maintained his great influence on him. It was also at Cambridge that he met Nicholas Ferrar, who was to remain his great friend for the rest of his life.

The turning point in his life came while he was at Cambridge, as is shown in the following poem he sent to his mother:

Writings of George Herbert

George Herbert, *The Country Parson, The Temple*, ed. John N. Wall, Classics of Western Spirituality, Paulist Press, 1981. *The Country Parson* deals with the recommended way of living of a parson.

George Herbert, *The English Poems of George Herbert*, ed. C. A. Patrides, Littlehampton Book Services, 1974.

George Herbert, *The Works of George Herbert*, ed. F. E. Hutchinson, Clarendon Press, 1967.

The Temple – basically his prayers in the form of poems, published after his death by his friend Nicholas Farrar.

My God, where is that ancient heat towards thee,
Wherewith whole shoals of martyrs once did burn,
Besides their other flames? Doth Poetry
Wear Venus' livery? Only serve her turn?
Why are not sonnets made of thee, and lays
Upon thine altar burnt? Cannot thy love
Heighten a spirit to sound out thy praise
As well as any she? Cannot thy dove
Outstrip their Cupid easily in flight?
Or, since thy ways are deep, and still the same,
Will not a verse run smooth that bears thy name?
Why doth that fire, which by thy power and might
Each breast does feel, no braver fuel choose
Than that which one day worms may chance refuse?

Sure, Lord, there is enough in thee to dry
Oceans of ink; for, as the Deluge did
Cover the earth, so doth thy majesty;
Each cloud distils thy praise, and doth forbid
Poets to turn it to another use.
Roses and lilies speak thee; and to make

A pair of cheeks of them is thy abuse:
Why should I women's eyes for crystal take?
Such poor invention burns in their low mind,
Whose fire is wild, and doth not upward go
To praise, and on thee, Lord, some ink bestow.
Open the bones, and you shall nothing find
In the best face but filth; when, Lord, in thee
The beauty lies in the discovery.

Trinity College was the wealthiest College in Cambridge. George Herbert graduated, became a Fellow of Trinity College and was elected University Orator. His role was to greet everyone important visiting the University; he composed orations to greet the King, nobles or foreign dignitaries.

Like English monarchs throughout the centuries, James I liked horse racing. He came frequently to Newmarket, which is very close to Cambridge; consequently, George Herbert began moving in the Court of James I. He proceeded to read Divinity and at the same time became an MP for the Montgomery Borough.

George Herbert's church career

George Herbert was ordained Deacon, then Canon in Lincoln Cathedral and was given the 'living' of a little village called Leighton Bromswold. Canons received their incomes by being given a particular living, and the money from that living then supported them.

All our thoughts must be infant-like and clear.

George's living was a small village with a medieval church about three miles from Little Gidding, where his friend Nicholas Ferrar had just established a religious community. Herbert never visited Leighton Bromswold, but he designed, sponsored and paid for the whole interior furniture of that church. Since he couldn't visit it himself, Nicholas Ferrar supervised the project.

Herbert saw the Church of England as that middle way between the glories of Rome and the plainness of Geneva, between the Roman Catholics and the continental Protestants. There were four formal reunion talks at this time between Charles I and his Court and Rome. Unfortunately Rome had to stop the conversations because, as

they formally told the Church of England, there were two things that were unacceptable: the different liturgy and the use of the vernacular.

The domestic spirituality of the rural parish priest

Despite his privileged family background, and his high placed friends in Cambridge and the Court, Herbert took all of this learning, culture and privilege to become a rural parish priest with a congregation of three to four hundred people, mainly illiterate farmers, in two little villages outside Salisbury. The social position of a parish priest at that time was not high, but Herbert felt God deserved the best, and he used his privilege and his talents in the service of his parishioners in this small village of Bemerton to the end of his

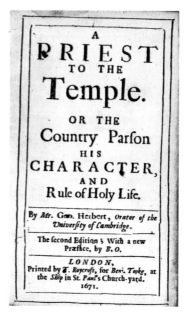

A
PRIEST
TO THE
Temple.
OR THE
Country Parſon
HIS
CHARACTER,
AND
Rule of Holy Life.

By *Mr. Geo.* Herbert, *Orator of the University of Cambridge.*

The ſecond Edition ; With a new Preface, by *B.O.*

LONDON,
Printed by *T. Roycroft,* for *Ben'. Tooke,* at the *Ship* in St. *Paul's* Church-yard.
1671.

Folio page from *The Temple*, 1671.

life. These were the last three years of his life, but those years became the model for the Anglican clergyman down to the present time.

Also around this time

Famous painters, writers and musicians of the seventeenth century: Cervantes, Caravaggio, Couperin, Daniel Defoe, John Donne, Marlowe, Milton, Molière, Rembrandt, Samuel Pepys, Sir Walter Raleigh, Vermeer, among others.

1610
Galileo sights Jupiter's moons and Mars.

1611
King James Bible published in-corporating Tyndale's translation.

Continued opposite

The word 'curate' implies care and cure; Herbert was in charge of the cure and care of these few hundred souls in this village in Wiltshire. There is something else extremely exciting about this experience. One of the most intriguing elements of Christian spirituality is when the doctor of the body and the doctor of the soul become one. We find a wonderful example in *Romeo and Juliet* – Friar Lawrence. The young lovers go to him for spiritual direction and advice, but what else is Friar Lawrence involved in? He is a herbalist, a chemist. Most healing in the time of George Herbert was based on biology and botany, and was herbal. Therefore, one of the responsibilities for both the vicar and his wife was to grow herbs, to learn their medicinal value, and to dispense them to members of their congregation. Hence, we see Herbert as

the physician of the body and of the soul.

Two things need to be stressed with regard to George Herbert. The first is the nature and importance of the domestic home that he described in terms of the parsonage. The second is the harmony between external religion and internal spirituality. In emphasizing both, he differed from the two very great Puritan men of spirituality, John Milton and John Bunyan, who came slightly later. Milton in *Paradise Lost* stressed primarily the necessity for all of us to search for a paradise within; and Bunyan in *The Pilgrim's Progress* again emphasized a solitary, inward journey. George Herbert saw in The Book of Common Prayer, and in the Authorized Version of the Bible, that the charitable care of your neighbour was all that was needed to nourish the internal journey. He lived at a time, before the breakup of the Church of England, when the external religion and the internal spiritual journey were married together. It does seem that there is something, at least to us, rather revolutionary in George Herbert, when he saw the religious exercises of the external Church as sufficient nourishment for the full interior spiritual life.

The Country Parson

The reason his book *The Country Parson* is interesting lies in the fact that it is a little treatise on what the country parson should do, how he should live and how the house should be kept.

Marjorie O'Rourke Boyle, in her very interesting book *Divine Domesticity* (Brill, 1996), points out that in its first three centuries the Christian Church was primarily focused in the home. One of the extremely important things about the Beguines movement is the fact that there too we find a domestic spirituality, with the home as the actual dwelling place of God; this was the first time that women had been economically

Continued

1616
Death of Shakespeare.

1623
First folio edition of Shakespeare's plays published.

1634
Harvard College founded in Cambridge, Massachusetts.

1639
Descartes publishes *Discourse on Method.*

1625–49
Charles I King of England Ireland and Scotland; executed 1649.

1612–51
Period of English Civil War starting with the Battle of Edgehill between Royalists and Parliamentarians – Cavaliers versus Roundheads.

1646
George Fox (b.1624) abandons Church of England – his teachings are basis of Quakers.

1653–8
Oliver Cromwell 'Lord Protector' of England, Ireland and Scotland.

1660
Charles II restored to the throne.

1665
Isaac Newton invents calculus and explains gravity.

1666
Plague and Great Fire decimate London.

1666
Shah Jahan builds Taj Mahal.

1673
'Test Act' bans Catholics from public office.

independent and each had her own small house. We see this same domestic spirituality in George Herbert when he talks about the home of the parson.

George Herbert's poems

Herbert was a married man with two adopted daughters. He really only blossomed at the end of his life. He had a great deal of interior toil and struggle, which was only brought into wholeness in the last three years at Bemerton in the writing of *The Country Parson*.

But the poems he had been writing his whole life, like those of Emily Dickinson and Gerard Manley Hopkins, were never intended for publication. These are prayers, and it is possible to read them as prayers; they have stayed with us and many are sung as hymns. Like Charles Wesley and his hymns, George Herbert's spirituality may be accessed through his poems.

LOVE

Love bade me welcome: yet my soul drew back,
Guilty of dust and sin.
But quick-ey'd Love, observing me grow slack
From my first entrance in,
Drew nearer to me, sweetly questioning,
If I lack'd any thing.

A guest, I answer'd, worthy to be here:
Love said, you shall be he.
I the unkind, ungrateful? Ah my dear,
I cannot look on thee.
Love took my hand, and smiling did reply,
Who made the eyes but I?

Truth Lord, but I have marr'd them: let my shame
Go where it doth deserve.
And know you not, says Love, who bore the blame?
My dear, then I will serve.
You must sit down, says Love, and taste my meat:
So I did sit and eat.

PRAYER

Prayer the Church's banquet, Angels' age,
God's breath in man returning to his birth,
The soul in paraphrase, heart in pilgrimage,
The Christian plummet sounding heav'n and earth;
Engine against th'Almighty, sinners' tower,
Reversed thunder, Christ-side-piercing spear,
The six-days-world transposing in an hour,
A kind of tune, which all things hear and fear;
Softness, and peace, and joy, and love, and bliss,
Exalted Manna, gladness of the best,
Heaven in ordinary, man well drest,
The milky way, the bird of Paradise,
Church-bells beyond the stars heard, the soul's blood,
The land of spices, something understood.

ANTIPHON

CHO. *Let all the world in ev'ry corner sing*
My God and King.

VERS. *The heav'ns are not too high,*
His praise may thither fly:
The earth is not too low,
His praises there may grow.

CHO. *Let all the world in ev'ry corner sing,*
My God and King.

VERS. *The church with psalms must shout*
No door can keep them out:
But above all, the heart
Must bear the longest part.

CHO. *Let all the world in ev'ry corner sing,*
My God and King.

An important factor here is that George Herbert was a musician, and music features heavily in his images of the spiritual life. He lived at a time when music was considered still to be a religious science, as Plato had pointed out. He compares us here to musical instruments. A delicate stringed instrument constantly needs tuning. In the same way we all go out of tune with God and need to be constantly retuned. Herbert was like the Orthodox in that once a week he took his instrument and walked the several miles to Salisbury to sing in the choir at church evensong. He would often spend the afternoon in concert, playing with other musicians in the cathedral. We think he played the lute and the viol.

The Compleat Angler

Although Herbert's *The Country Parson* was published in 1653, almost no publishing of Anglican spirituality or theology took place during that time of the Commonwealth, 1645–60. The Church of England had no prayer book between these years; two to three thousand priests were put out of their parishes; there was no Archbishop of Canterbury or episcopacy.

Charles Cotton's
fishing house, 1674

In the midst of this, when you could only have Puritan religious writings, Sir Isaak Walton, a layman, a retired ironmonger from Clerkenwell, wrote *The Compleat Angler*, one of the finest books on the contemplative life. It is the most repeatedly printed book after the Bible and The Book of Common Prayer. Walton, in talking about

fishing, used the poetry and the country myths of the time. He said that Jesus chose Peter and John, Andrew and James because they were fishermen and, according to Walton, fishermen are natural contemplatives. This book could be published during the Commonwealth because it was about fishing. And yet we find the whole religious tone of Anglicanism preserved there; there is no division between the sacred and the secular.

When the Church of England was re-established, Isaak Walton wrote the lives of George Herbert, John Donne and Richard Hooker. Through the eyes of a layman, who never went to university, we have one of the great classics of English religious literature. A great deal of our information about Herbert comes through Isaak Walton.

Richard Hooker lived during the reign of Elizabeth I; he was the Thomas Aquinas of the Anglican Communion, a great thinker who systematized the whole Anglican world, going back to Aristotle. Aristotle said that 'Virtue is always in the middle between two extremes.' Hooker had a deep influence on Herbert. We always find that sense of balance with Herbert, as with Hooker and Walton.

George Herbert's poems are his personal prayers and they were nearly lost to us. On his deathbed he sent his writings to Nicholas Farrar, telling him to do with them as he saw fit and only publish them if he thought they might be helpful to 'any dejected soul'. Fortunately Farrar had a printing press and the community at Little Gidding printed these poems and prayers in 1633 to great acclaim.

BROTHER PATRICK MOORE

THOMAS TRAHERNE

Introduction

Brother Patrick Moore now introduces us to Thomas Traherne, a recently discovered seventeenth-century poet who was very influenced by George Herbert, when he was able to read him after the restoration of Charles II. Although he was born during civil and religious disorder and brought up during the reign of the Puritans, he had a very optimistic view of humanity. This Brother Patrick traces back to his being influenced by the writings of Marsilius Ficino and the Neo-Platonic views expressed there.

Quotations are from Thomas Traherne, *Centuries of Meditation*, ed. Bertram Dobell (Cosimo Classics, 2007).

> ### Thomas Traherne 1637–74
>
> Thomas Traherne was an Anglican clergyman, a mystic and a poet.
>
> He was the son of a Hereford shoemaker. A relative paid for him to go to Brasenose College, Oxford. After obtaining his BA he was presented in 1657 to the living of Credenhill, Herefordshire, which he held until his death. It was there that he had a powerful mystical experience. He was ordained in 1660. He spent most of his time at Oxford, studying. He obtained an MA and then a BD. He only very occasionally visited his parish. In 1667 he became chaplain to Sir Orlando Bridgeman, the Lord Keeper, who remained his patron throughout his later life.
>
> Apart from his poetry his best-known prose work is *Centuries of Meditation*, which was discovered in 1897. The meditations are called 'Centuries' because they are arranged in groups of a hundred.
>
> Traherne died in Teddington, Middlesex, where he is buried.

DIFFERENT VIEWS ON THE 'FALL'

Thomas Traherne died towards the end of the seventeenth century and did not really come to light until the end of the nineteenth and the beginning of the twentieth centuries, following the discovery of manuscripts.

Many Christians in the intervening time, including C. S. Lewis, could not truly relate to Traherne, because they felt that there was not enough negativity in him to be a Christian. What caused the problem was his attitude towards the effects of 'original sin'. There are differing opinions about humankind's essential nature; some are of the opinion that we have a natural tendency to evil; others believe our natural tendency is towards good.

It is clear that, whatever one's view of 'original sin', we live in a 'fallen' world. A myth to explain the 'fall' is common to every tradition. In the Judaeo-Christian tradition we have the story in Genesis of Adam and Eve. Within the western Christian tradition there are significant differing interpretations as to the effect of the 'fall', all of which claim the authority of St Augustine. He spoke of the *Imago Dei* (image of God) as being implanted within the human being, but as being irrevocably broken in the 'fall'. Some theologians like Calvin and Luther take the view that the *Imago Dei* had been essentially broken by the 'fall'. Others like Aquinas and Traherne take the view that the *Imago Dei* had been accidentally broken by the 'fall' and that humankind could reclaim its original image:

A sight of Happiness is Happiness. It transforms the Soul and makes it heavenly, it powerfully calls us to Communion with God, and weans us from the Customs of this World . . . All Things were well in their Proper Places, I alone was out of frame and had need to be Mended, for all things were Gods Treasures in their Proper Places, and I was to be restored to Gods Image.

Writings of Thomas Traherne

Poems

Centuries of Meditation

Both interpretations are theologically valid within the Christian tradition and across denominations. At different times and in different situations one or the other may feel more valid to us, but each will have different consequences for society and spirituality.

The Calvinistic approach would see the exercising of control as prime because of our essentially 'bad' nature. A good example of this would be William Golding's novel *Lord of the Flies*, where a group of boys quickly become savages when released from the constraints of parents, teachers and a police force. Those adopting this approach would also not accept that God could be revealed through nature, because nature is just as damaged as we are. Therefore revelation can only come through Christ.

On the other hand, for those like Aquinas, who believed in the essential goodness of humankind, revelation may come not only through Christ, but also through Reason and Nature.

We hear in Traherne:

The Corn was Orient and Immortal Wheat, which never should be reaped, nor was ever sown. I thought it had stood from Everlasting to Everlasting. The Dust and Stones of the Street were as precious as GOLD. The Gates were at first the End of the World, The Green Trees when I saw them first through one of the Gates Transported and Ravished me; their Sweetness and unusual Beauty made my Heart to leap, and almost mad with Extasie, they were such strange and Wonderfull Thing(s); The Men! O what venerable and Reverend Creatures did the Aged seem! Immortal Cherubims! And young men Glittering Sparkling Angels and Maids strange Seraphick Pieces of Life and Beauty! Boys and Girles Tumbling in the Street, and Playing, were moving Jewels. I knew not that they were Born or should Die. But all things abided Eternaly as they were in their Proper Places. Eternity was manifest in the Light of the Day, and som thing infinit Behind evry thing appeared: which talked with my Expectation and moved my Desire. The Citie seemed to stand in Eden, or to be Built in Heaven. The

*Streets were mine, the Temple was mine, the People were mine, their Clothes and Gold
and Silver was mine, as much as their Sparkling Eys fair Skins and ruddy faces.*

Calvin and Luther felt we would be inclined to do the wrong thing, unless we
were corrected. But Traherne, like Aquinas, considered that it was our natural
propensity to be drawn towards the good. Many criticized Traherne for not em-
phasizing evil in the world enough.

Thomas Traherne's context

Given the time in which Traherne lived, a time of tremendous civil and religious dis-
order, his optimistic view is quite surprising. Six years after he was born the Civil War
started. He lived at Hereford, which was deeply involved in that conflict between the
Puritans and the Royalists. Both his parents died, leaving him to be raised by an uncle.

Traherne grew up therefore in a completely Puritan world and he went, at the
age of seventeen, to Brasenose College, Oxford, a very Puritan college. After receiving
his BA he went to a little village four miles north of Hereford and was appointed to
the post of a Free Church minister. The year 1660 saw the restoration of Charles II,
and consequently the restoration of the Church of England. Soon Traherne became
Chaplain to a member of Charles' Court. He then was exposed to and influenced
by the Anglican tradition of John Donne, George Herbert, Richard Hooker, The
Book of Common Prayer and the Authorized Version.

The Neo-Platonic view

But not only that, Traherne was an extraordinarily well-educated person, and very
well read. Among his papers there was a particular notebook with verbatim quotes
from the writings from the Renaissance in Florence in the fifteenth century.

At the time of the de' Medicis and the Council of Florence, when Marsilius Fi-
cino translated Neo-Platonic texts into Latin for the West, some manuscripts written
by Hermes were also discovered. Therefore it is clear that there was a time when
Christians regarded Hermes highly and studied his works. This is also apparent from
the fact that in the Cathedral at Siena the figure of Hermes appears as a figure of
Wisdom, and that he even appears as part of the décor in the papal apartments. The
manuscripts of Hermes were probably written in the second or third century AD,

but at the time of the Renaissance it was thought that they were written long before that, and that Hermes lived at the same time as Moses. It was thought that Hermes took his spirituality from the ancient Persians and the Zoroastrians and passed this down through Orpheus, Pythagoras and Plato.

Thomas Traherne copied out Ficino's work in his private notebooks and brought all of this 'pagan wisdom' into his spirituality. He thus rediscovered the Neo-Platonic tradition – the revival of Plato's thoughts in the western world – that had been lost during the Middle Ages. Apart from Aquinas and Aristotle he read the whole of the Neo-Platonic tradition. Here he found the emphasis on the goodness of humankind and children in particular. For Plato all learning is remembering. To prove this, Plato extracted in his *Dialogues* the nature of mathematics from a young boy. A comparison was made by the Christians of the Renaissance between that boy and Jesus, at 12 years of age, teaching in the Temple.

> *I speak it in the presence of GOD and of our Lord Jesus Christ, in my Pure Primitive Virgin Light, while my Apprehensions were natural, and unmixed, I cannot remember, but that I was ten thousand times more prone to Good and Excellent things, than evil. But I was quickly tainted and fell by others. Our Saviour's Meaning, when He said, He must be Born again and become as a little Child that will enter into the Kingdom of Heaven, is Deeper far than is generally believed. It is not only in a Careless Reliance upon Divine Providence, that we are to become as Little Children, or in the feebleness and shortness of our Anger and Simplicity of our Passions; but in the Peace and Purity of all our Soul. Which Purity is a Deeper Thing than is commonly apprehended; for we must disrobe our selves of all false Colors, and unclothe our Souls of evil Habits; all our Thoughts must be Infant-like and Clear; the Powers of our Soul free from the leven of this World, and disentangled from men's conceits and customs.*

The thought of Thomas Traherne influenced a group that we call the 'Cambridge Platonists', in Emmanuel College, Cambridge. They were also in contact with Descartes on the Continent and welcomed the new coming of science, seeing that as part of the whole Christian Renaissance, culminating in the latter part of the seventeenth century.

Traherne is very much part of the tradition of Coleridge, Wordsworth and Blake. The following is a passage from Coleridge about the importance of Nature:

> *In looking at objects of nature . . . as at yonder moon dim glimmering through the dewy window pane, I seem rather to be seeking a symbolic language for something within me that forever and already exists, than observing anything new. Even when that latter is the case, yet still I have always an obscure feeling, as if that new phenomenon were a dim awakening of a forgotten or hidden truth of my inner nature.*

We find ideas about childhood like Traherne's in Wordsworth, who wrote that we come into this world at birth 'trailing clouds of glory'. The time of childhood is for these poets the closest we can come to the Divine.

It is clear how such a view of childhood and of the essential goodness of humankind might influence the society we live in and shape the university system, the school system, the ecclesial system and the parental system.

> *Will you see the infancy of this sublime and celestial greatness? I was a stranger, which at my entrance into the world was saluted and surrounded by innumerable joys. My knowledge was divine. I was entertained like an angel with the works of God in their splendour and glory. Heaven and earth did sing my Creator's praises and could not make more melody to Adam than to me. Certainly Adam in Paradise had not more sweet and curious apprehensions of the world than I. All appeared new and strange at first, inexpressibly rare and delightful and beautiful. All things were spotless and pure and glorious, the corn was orient and immortal wheat which never should be reaped nor was ever sown. I thought it had stood from Everlasting to Everlasting.*

The Neo-Platonic tradition stated that physical beauty led to spiritual beauty; therefore the cultivation of beauty and the arts is the path to the Divine, of which an important aspect was always the return to childhood.

There is a psychological maxim that the adult is the person who can bring back the child that the adolescent had to banish. If looked at it like that, then what Traherne might be saying is that the adult Christian goes back to the Eden that he or she had to leave.

BROTHER PATRICK MOORE

THE JESUS PRAYER

Andrew Louth

Icon of Christ Pantocrator,
*c.*6th century

Introduction

Whereas in the Latin West the stream of 'pure' prayer had gone underground from the sixth century onwards and had become the province of a few saints, blossoming more generally in certain periods of turmoil and insecurity, in the East this way of prayer continued to feed the spirituality of the Orthodox Church. The teaching of the fourth-century Desert monks, as written down by Evagrius, John Cassian and Diadochus of Photike among others, continued to exercise great influence. This contemplative way of prayer became known as the 'Jesus Prayer'.

Famous theologians giving teachings on it were St Simeon the New Theologian (tenth century), St Gregory of Palamas (fourteenth century), St Nicodemus of the Holy Mountain (eighteenth century) and Sts Seraphim and Theophan the Recluse. The Jesus Prayer was taken by Greek missionaries to Russia in particular, where in the twentieth century the translation of the *Philokalia* and the anonymous nineteenth-century classic of Russian Orthodox spirituality, *The Way of a Pilgrim*, drew the West's attention once more to this way of prayer. Rather than just being the province of a few saints it became a way of praying for ordinary people in all walks of life.

The Way of a Pilgrim is the starting point for Revd Professor Andrew Louth's explanation of the meaning and significance of the Jesus Prayer. He explains the essential qualities of this prayer as a way of attaining inner peace and sets it in the wider context of Christian prayer and the prayer of the Name in particular.

THE WAY OF A PILGRIM

The 'Jesus Prayer' has only become well known since the 1930s with the publication of a translation of a book called *The Way of a Pilgrim*, an anonymous book published in Russian in 1881. There is also a second volume, *The Pilgrim Continues His Way*. Both are stories about a pilgrim, intelligent though without formal education. It is not known whether he was an actual pilgrim or whether it is a fictional account put together to introduce the practice of the Jesus Prayer. The translation of *The Way of a Pilgrim* popularized the Jesus Prayer. Now it is used more than ever, not just in the Orthodox tradition but by people of all traditions and none. J. D. Salinger in his book *Franny and Zooey* mentions the Jesus Prayer. This shows that the prayer was already known outside religious circles by the 1950s, for Salinger was not a particularly religious person.

In Russian *The Way of a Pilgrim* was called *The Sincere Confessions of a Wanderer*. The word 'pilgrim' does not perhaps convey perfectly what is meant. In some ways the Russian *strannik* is more like the Latin *peregrinus*, which is better translated as 'alien' or 'someone not at home'. In late nineteenth-century Russia there appeared the phenomenon of people who wandered from state to state. There were many reasons why people started doing this; some were fleeing the taxman, some were fleeing themselves and others were unable through their own inadequacy to live within society. The pilgrim in *The Way of a Pilgrim* chose this way of life because he wanted to learn to pray without ceasing; he wanted to fulfil St Paul's command to do so (cf. 1 Thess. 5.17). He therefore goes around asking people how this can be done. He is given all sorts of answers that he feels are avoiding the question. Eventually he finds the answer in the Jesus Prayer, which he is told can be said all the time and which over time will take over and become part of him.

There is also a reference in *The Way of a Pilgrim* to the *Philokalia*, which the pilgrim manages to get hold of. This was originally published in a large volume in Greek in 1782 in Venice, because Christians in the Ottoman Empire were not allowed to use the printing press. The *Philokalia* is a collection of ascetic texts with the aim of purifying and illumining the soul and bringing it to union with God (the word *philokalia* means 'anthology'). The texts are arranged in chronological

Illustration from
*The Way of a
Pilgrim*, 1881

order from the fourth to the fourteenth century, ostensibly starting in the Egyptian
desert with Antony, the first solitary we know anything about; the texts attributed
to Antony, however, are probably Stoic in origin.

After the publication of the *Philokalia* in 1782, it was quickly translated by a
Russian monk on Mount Athos, Paissy Velichkovsky, into Church Slavonic, the litur-
gical language monks used. When he translated it, he called it *Dobrotolyubiya*, making
a literal translation (a 'calque') of the word *philokalia*, thereby producing a word that
in Slavonic could only suggest the meaning: 'love of the beautiful'. This work be-
came very popular in Russia. It was read by devoted Christian people generally, not
just by monks. It is this edition that the pilgrim acquired and carried around in his
rucksack, and clearly read very diligently.

Use of the Jesus Prayer became popular in nineteenth-century Russia at a time
that saw the revival of monasticism as an ideal that focused on prayer. Until then
monasteries had mostly fulfilled the role of charitable institutions, doing the job of
hospitals, hospices and orphanages. These activities were still carried on, but now
within the overall context of prayer.

We begin to come across the word *staretz* at this time, which meant 'an elder' in
the sense of a 'spiritual guide'. Dostoyevsky in his novel *The Brothers Karamazov*

bears witness to this new phenomenon in the figure of the elder Zossima, who is such an influence on the young Alyosha Karamazov. The early chapters capture this new monastic institution and show that the role of the *staretz* was not just to train monks, but also to be a source of spiritual wisdom to outsiders.

The practice of the Jesus Prayer

The Jesus Prayer is a way of attaining inner prayer by repeating a simple phrase; the normal formula used nowadays is 'Lord Jesus Christ, Son of God, have mercy upon me (a sinner)'. The prayer may be said in the plural and there are other variations; what is constant is the recitation of the Divine Name.

Attention and repetition

The essence of the Jesus Prayer is attention. Attention, in this sense, is indivisible: if we cannot be attentive in prayer, we shall probably find ourselves failing in our attentiveness to other people.

The attention on the prayer and the repetition of it is a way of enabling us to pray in silence; it is praying as a way of being. The length of period for which the prayer is prayed may vary. It is a way of trying to create and preserve silence, in which one can be attentive to God.

But maintaining silence in prayer is very difficult indeed. As soon as we try to invoke the presence of God, we very quickly find that all our hopes, desires, fears and longings are there too; we are caught up in our attachments. If we try to pray early in the morning, we soon start to wonder what the day will hold. Very quickly we are sitting in a noisy, echoing chamber with all our thoughts flying about.

Asking for mercy in the Jesus Prayer is an acknowledgement that although part of me wants to be in the presence of God, there is a part of me that doesn't, as we are so unaccustomed to it. The Jesus Prayer addresses and confesses this problem.

Sometimes the Orthodox use a prayer rope to aid attention in repetition; if you are going to repeat something slowly, it is quite helpful to have something in your hands to mark the succession of the prayers (as with a rosary), and gives your fingers something to do. It is indeed physically similar to the rosary, but is usually made not from beads but as knots in a rope. In fact, in some Orthodox countries, Romania especially, the prayer rope does look rather like the rosary, and some of them are

very elaborate. The use of a prayer rope is comparatively recent, probably going back to the eighteenth century. Father Sophrony, who founded the Orthodox monastery in Essex, used to insist that prayer ropes were not fashion accessories to be hung from belts or round wrists. When not being used for prayer, they should not be on display.

A way of calming ourselves

The use of the Jesus Prayer can also be calming, because it draws us back to what we want to have at the heart of our lives – God. This way of using the Jesus Prayer can be found in the Russian teachers, particularly St Theophan the Recluse. He was a priest monk, who became a bishop, but soon retired to live a life of withdrawal in the forest. The way of using the prayer that he recommends is not constant repetition during the time of prayer, but rather use of the prayer as a way of finding a still centre within ourselves, the place of the heart. So he suggested saying the prayer until one found a sense of calm and had entered the interior silence; only when one found that the silence was ebbing away, should one start using the prayer again.

Eastern Orthodox prayer rope, *chotki*

Bringing the mind into the heart

In this way, Theophan the Recluse suggested that the Jesus Prayer could be used to discover the 'heart', so that it becomes a preliminary to real prayer. As we call on the Holy Spirit to come into our heart, so we become more and more aware and whole, and can pray properly.

> *You must pray not only with words but with the mind, and not only with the mind but with the heart, so that the mind understands and sees clearly what is said in words, and the heart feels what the mind is thinking. All these combined together constitute real prayer, and if any of them are absent your prayer is either not perfect, or is not prayer at all.*

Theophan says that when we place the 'mind in the heart', we stand before God,

Important figures

Diadochus of Photike
fifth century
Bishop of Photike, student of
Evagrius of Pontus; author of
'100 chapters on Spiritual
Perfection'.

Seraphim of Sarov
1759–1833
One of the most renowned
staretz and mystics in the East-
ern Orthodox Church; taught lay
people about contemplation.

Theophan the Recluse
1815–94
Important saint in the Russian
Orthodox Church. Wrote many
books on the spiritual life and
played important role in translat-
ing the *Philokalia* from Church
Slavonic into Russian.

the unifying source of all we do. We then act from the heart rather than from different aspects of ourselves. Consequently, the Jesus Prayer is sometimes referred to as 'The Prayer of the Heart'.

When talking about the heart, this is to be understood in the biblical sense, especially in the sense found in the Psalms (Ps. 50, or 51 in the Hebrew Bible). Here the heart is not thought of as the 'seat of emotions', but in a more holistic way. The Psalms talk about the 'heart' as the place where our thoughts come from; but it is more than mind, it is more than our thinking capacity: 'The heart is the innermost man, or spirit. Here are located self-awareness, the conscience, the idea of God and of one's complete dependence on Him, and all the eternal treasures of the spiritual life' (Theophan the Recluse).

Theophan saw it therefore, in Paul's words, as the 'inner man'. Thus we need to become truly self-aware. We tend to suppose that we know who we are, but what we have is generally only a very limited view of ourselves. When we try to pray seriously, we soon realize that we are not really clear who we are. The distractions that come up in prayer are reflections of aspects of ourselves, of which we are often unaware, or even ashamed.

The ascetic tradition was well aware of the fact that we have hidden aspects of ourselves. But hiding parts of ourselves is not the best way of dealing with them. The best advice was given in *The Macarian Homilies*, which presents an interesting picture of what it is to be human. It compares us to a house with lots of hidden rooms. Ordinarily we experience ourselves as divided, but in prayer the whole house becomes light and unified. The Christian ascetical tradition knew about the un-conscious, long before Freud.

Christian tradition about prayer

To understand the real significance of the Jesus Prayer we need to look back through the Christian tradition about prayer.

The origins of the Jesus Prayer itself really go back to the Gospels, if not earlier

than that to the Hebrew Bible. In the Gospels, for example, we hear blind Barti-maeus calling out: 'Jesus, Son of David, have mercy on me!' (Mark 10.47). We also hear Jesus praising the prayer of the publican who just says: 'O God, have mercy on me, sinner that I am' (Luke 18.10–14).

The essence of these prayers in the Gospels is that they are cries for help, not just formulas. The Jesus Prayer is essentially a prayer, a form of the plea, 'Lord have mercy', a human cry for help to God.

In the earlier centuries there is little evidence as to what words Christians actu-ally used when they prayed. We know to a small extent what words they may have used in a strictly liturgical context and we know when they prayed, namely in the morning, in the evening, at midday and at midnight.

We know something of how they prayed and their posture as they prayed. They would kneel or make prostrations, but on the whole they stood up, as they were con-vinced that we have the right to stand boldly in God's presence and talk to him. In most of the Christian eucharistic liturgies the words that introduce the saying of the 'Lord's Prayer' make this point clearly, namely that we have the freedom to speak before God – so, for instance, in the Liturgy of St John Chrysostom, the Lord's Prayer is intro-duced by the following words: 'And count us worthy, Master, with boldness and without condemnation to dare to call upon you, the God of heaven, as Father, and to say ...'

At the beginnings of the monastic literature there is an indication of the kind of words people used and this is, perhaps, where the tradition of the Jesus Prayer really begins. John Cassian (see Chapter 9), who went and lived among the monks in the Egyptian desert in the fourth century, wrote *The Institutes* and *The Conferences*, in which he gave guidance on prayer. He introduced the idea of concentrating your prayer into a short phrase, and then repeating it. The phrase he gave as an example was: 'O God, come to my aid, O Lord, make haste to help me' (Ps. 69[70].2).

At the heart of this prayer is the need to be attentive to God; but soon we find out that this sounds easy, but is actually very difficult, as our minds keep wandering off. One of the ways that Cassian suggested we use these short prayers was as a way of drawing our minds back to attend to God.

Cassian was not suggesting that you used a 'formula' for its own sake as a tech-nique; it was always seen as an engagement with God. The words have meaning; they are a cry to God for help.

The point of the short prayer is that anyone attempting to pray silently on their own for long periods finds that the greatest problem is distractions, caused by one's own mind. In some ways sitting quietly exacerbates this. There is a lot of discussion especially in Evagrius and Cassian about how to overcome distractions and achieve quietness – *hesychia*. The Jesus Prayer or some other short formula helps with distractions by reminding you what you are supposed to be focusing on.

In this history of short prayers the strand that leads into the practice of the Jesus Prayer as found in the *Philokalia* is difficult to trace. Most of the teaching about the Prayer has not been written down. From the fifth century in the monastic tradition there arises the idea that short prayers are best. Later, there are from time to time references that would suggest a tradition developing of using some sort of short phrase that includes the name of Jesus as a way of drawing our attention back to God.

The first reference to what might be the 'Jesus Prayer' is a chance reference in the work that belongs to Diadochus of Photike, a Greek bishop. He refers to something called the 'Lord Jesus' – presumably a prayer beginning, 'Lord Jesus'. He says that when 'we are troubled by anger . . . or oppressed by deep depression, the soul must cling to the memory of Lord Jesus (Diadochus, *Gnostic Chapters*, 71).

Seraphim of Sarov also speaks about the use of a repeated prayer: 'Lord cleanse me a sinner.' This may not be technically the Jesus Prayer because it does not include the word 'Jesus', but it is clearly the same prayer in essence.

From the twelfth century onwards texts show that recitation of the prayer was linked with breathing. This recalls an idea common to other religions, that if you slow your breathing and concentrate on it, it will automatically have a calming effect. There are various other techniques associated with the Jesus Prayer; all are attempts to try to reduce or disperse distractions.

Round about the beginning of the second millennium there were works that envisaged the use of the Jesus Prayer as making possible a way of living the monastic life as an essentially eremitical life, in which long periods are spent in silent prayer. This emphasis on silence and stillness became known as 'Hesychasm'. There was a controversy in the fourteenth century on the Holy Mountain called the 'Hesychast Controversy', which revolved around the practice of the Jesus Prayer and the claim that monks who practised it could ultimately come to the experience of God himself. This took the form of beholding the uncreated light of the Godhead, which

they were convinced was a genuine experience of the Divine Presence, although others maintained that it was a hallucination.

The great defender of the Hesychasts was Gregory Palamas, Archbishop of Thessalonica, in which diocese Mount Athos lay. Gregory is one of the two main writers included in the *Philokalia*, the other being St Maximus the Confessor, a profound thinker, who was concerned with the kind of transformation that takes place when a person surrenders himself to God.

In the Hesychast controversy, people like Palamas defended the idea that if we devote ourselves to praying the Jesus Prayer, despite dry periods, the grace of God will come and dwell in us and we will be vessels, in which it can come to rest. The Jesus Prayer is only part of the attempt to dedicate the whole of our lives to God. We become people fit to be in God's presence. The grace of God manifests itself not only psychologically but also in the way we relate to other people.

The 'Name'

One of the reasons the Jesus Prayer came to be so important was that it summed up many of the elements central to the tradition of the 'Name'. The *staretz*, when speaking about the Jesus Prayer in *The Way of a Pilgrim*, emphasized the invoking of the Name and began to reflect on what is meant by the Name.

This is an interesting and complicated philosophical problem. In an early dialogue of Plato, the *Cratylus*, he discussed the meaning of names. Two ideas were suggested: either a name was simply a label or it sprang from the reality being designated. In many traditions, experience suggests that a name is more than a label. For example, people are given a name at baptism and change their name on becoming a monk – the name is one shared with your patron saint, who becomes your protector and intercessor.

In the Hebrew Bible personal names were thought of as being significant. There are lots of examples of changes of name in the Old Testament, for example Abram to Abraham, Jacob to Israel. The change of name is always significant and corresponds to a new stage in someone's life, which is often bound up with the meaning of the new name.

There was a special reverence in the Hebrew Bible for the name of God, which none might pronounce aloud. It could definitely not just be a 'name', as we do not

know what God's 'name' is. The 'name' of God is there simply represented by four consonants, the 'tetragrammaton', and was only pronounced in the Temple as part of the High Priest's blessing, invoking in that way the presence of the Lord among us in grace and blessing. This is brought out in Deuteronomy where we read about 'the place which the Lord your God will choose to cause his name to dwell there'(Deut. 12.11).

In the New Testament the same respect is shown for the name of Jesus, which means 'someone who saves', but now anywhere can be hallowed by the praying of the name of Jesus:

> *Therefore God also highly exalted him and gave him the name that is above every name, so that at the name of Jesus every knee should bend, in heaven and on earth and under the earth, and every tongue should confess that Jesus Christ is Lord, to the glory of God the Father.* (Phil. 2.9–11)

It is easy to see how the practice of the invocation of the 'name' arose out of such texts. It is a great privilege for Christians to be able to pronounce the name in our hearts.

The Jesus Prayer became important in the Orthodox tradition because it was felt that the use of the 'name' was actually effective; the repetition of the name was a way of invoking the Divine Presence. This fits in with another aspect of Orthodoxy – the use of icons – because in an icon we come face to face with the person represented; with the icon of Christ we come face to face with Christ, with an icon of the mother of God with the Blessed Virgin. Icons remind us that prayer is about a face-to-face encounter, fundamentally a face-to-face encounter with Christ. Icons always have inscribed on them the name of the one depicted, for there is a close link between the face and the name. When we meet someone face to face, we are introduced by name.

The Jesus Prayer as a confession of faith

The form the Jesus Prayer eventually took was: 'Lord Jesus Christ, Son of God, have mercy on me, a sinner.' It became fixed in that form, because it seemed to contain everything that a Christian would want to say in prayer. It is an intensely Christological prayer encompassing both Jesus' human and divine nature.

To say 'Lord Jesus Christ' is a confession of faith; it is to confess that Jesus is both Lord and Christ, which is at the heart of Christian faith. One step further is to see Jesus Christ as the 'Son of God', that is, the Son of God the Father. St Paul said that we can only say 'Jesus Christ is Lord' in the power of the Spirit. Therefore in saying 'Lord Jesus Christ, Son of God' we are invoking the Three Persons of the Godhead and thus expressing our faith in the Christian doctrine of the Trinity. Finally, it is a prayer for mercy by a sinner. Therefore it is also a confession of our sinfulness and our need for God. In other words it encapsulates totally the basic tenets of the Christian faith.

REVD PROFESSOR ANDREW LOUTH

EVELYN UNDERHILL

Liz Watson

Evelyn Underhill

Introduction

From the seventeenth century onwards we enter the desert as far as mysticism is concerned. From then on the scientific materialistic viewpoint, which started with Descartes and Newton, increased in strength; empiricism and determinism dominated; the universe was seen as merely obeying certain mechanical laws with predictable outcomes: 'The Clockwork Universe'. Even humanity itself was considered to be no more than a mere mechanism.

This position does not leave much room for creativity and freedom for the universe or the individual, or for any intrinsic connectedness between humanity and the Divine. Human beings are seen to be uninvolved observers of the rest of creation, not part of the whole cosmic process at all.

The mystical tradition had therefore gone underground, only to emerge again at the end of the nineteenth century as a heartfelt reaction to the Industrial Revolution. But just as in the fourteenth century the re-emergence of the mystical tradition was accompanied by an increasing fascination with the occult and spiritualism, often muddying the waters. The first important work that legitimized the mystical tradition was William James' *The Varieties of Religious Experience* in 1902. This was followed in 1911 by Evelyn Underhill's *Mysticism*, in which she described for our times the essence of Christian mysticism.

Liz Watson sees this book as establishing Evelyn Underhill, an apparently ordinary

woman, as an authority on the subject of mysticism, and gives us a comprehensive and sympathetic overview of Evelyn's thought at that stage of her life, before tracing how it develops over the years as seen in her last book, *Worship*.

Evelyn Underhill 1875–1941

Evelyn Underhill was born on 6 December 1875 in Wolverhampton. Her father was a barrister, later knighted. We know little about her mother, Alice Lucy Ironmonger.

She lived most of her life in Kensington, London. She was educated at a private school in Folkestone and later at King's College for Women, where she studied botany and history. In 1907 she married a childhood friend, Hubert Stuart Moore, a barrister like her father.

She travelled extensively in Europe, fascinated by the beauty of the architecture and the art. She was an avid reader of early Christian writings, which led her to mysticism.

Although she came from a well-to-do background she cared for the poor, even doing social work in the slums of London.

She died in 1941 and is buried in St John's Church in Hampstead.

A WOMAN OF HER TIME

On Evelyn Underhill's gravestone in the cemetery by the church of St John, Hampstead, we read 'Evelyn, wife of Hubert Stuart Moore' and 'daughter of Sir Arthur Underhill', which has nothing to arouse any particular interest. From one point of view her life was indeed ordinary, that of a typical upper-middle-class woman of her time. Her father was a barrister; her mother Lucy occupied herself with good works; Evelyn was their only child. She was born in Wolverhampton in 1875, but the family soon moved to London and settled in Kensington. She was educated first at home, then at Sandgate House near Folkestone, going on to study history, botany, art and languages at the newly opened Ladies' Department of King's College London in Kensington Square, a short walk from home. When she was 32 she married her childhood friend Hubert Stuart Moore and went to live round the corner in the family home in Campden Hill Square. Hubert was a barrister like her father. 'Comfortable' and 'quiet' described their life well; they owned a good house, employed two servants and kept a steady rhythm in the daily round. Hubert worked from Lincoln's Inn and had a workshop at home for jewellery making and enamelling. Evelyn was based at home and there were no children. She might be seen as a typical Edwardian lady,

Writings of Evelyn Underhill

Evelyn Underhill, *Mysticism: A Study in the Nature and Development of Man's Spiritual Consciousness*, Methuen, 1930 (in University Paperbacks, 1960).

Evelyn Underhill, *Worship*, Collins (Fontana), 1962.

with a study for her reading and writing and scope for her bookbinding. Together the couple enjoyed a full social life with a good deal of entertaining, lively conversation, visits to the countryside and boating trips.

Yet this 'wife' and 'daughter' of the gravestone became one of the best-known spiritual writers in Great Britain during her lifetime. She wrote 39 books and produced more than 350 articles, translations, reviews and broadcasts. She was the first woman to be invited to give a lecture series in theology at Oxford University, was elected a Fellow of King's College and awarded an honorary Doctorate of Divinity from the University of Aberdeen. Her friend T. S. Eliot said of her: 'Her studies have the inspiration not primarily of the scholar or the champion of forgotten genius, but of the consciousness of the grievous need of the contemplative element in the modern world.' She was the first laywoman to lead retreats in the Church of England and to have an extensive ministry in retreat-giving and spiritual direction. A later Archbishop of Canterbury, Michael Ramsey, believed that she did more than anyone else to keep the life of prayer alive in the Anglican Church in the period between the wars. Canon Donald Allchin recounted a memory of her first intervention at a meeting of the Fellowship of St Alban and St Sergius (founded in 1927 to bring together Anglicans and Eastern Orthodox), when the noted Russian theologian Fr Sergei Bulgakov was led to ask the secretary afterwards, 'Whoever is that little woman? She knows far too much' (Ramsey and Allchin, *Evelyn Underhill*, p. 16).

Whoever was that little woman? A pioneer of the spiritual life, a woman in a world and an area of life still dominated by men, yet one who took no official position or sought any particular status in society, church, university or institution. In a letter of 1932 she wrote, 'it is one of the advantages of being a scamp, that one is unable to crystallize into the official shape, and so retains touch with other free lances, and realizes how awful the ecclesiastical attitude and atmosphere often makes them feel' (Ramsey and Allchin, *Evelyn Underhill*, pp. 20–1). Her pioneering spirit was not in the least political, polemical or self-important. She remained restrained and private. Yet she had a passion to open windows for people into eternity. She wanted to de-mystify the mystics, to convince people of the possibility of contact with the Divine,

to inspire them with a vision of Reality, to show that the ordinary had a capacity for the extraordinary. The way she tried to do this was first through her writing and later, increasingly, through retreat-giving and spiritual direction.

Mysticism

Evelyn's first book on the mystical way was published in 1911, *Mysticism: A Study in the Nature and Development of Man's Spiritual Consciousness*. This book straight away established her as an authority on the subject and is the title with which she has been most readily associated ever since.

She sets out her subject in the first chapter; it is to be an examination of something that is universal in humanity, East and West, in all times, and that is the love of Truth. For most people, she believed, the passion for Truth is a short-lived intuition, soon snuffed out, or at least covered over, by the practical concerns of living. But for others – a particular type of personality – this search comes to mean everything and they are prepared to make enormous sacrifices for it, denying the world in order to reach it, struggling to find the way back, or way out, to satisfy this deep craving. Because the aims, doctrines and methods of those we call mystics have been essentially the same through different ages and cultures, albeit understood and expressed under a variety of symbols, there is good reason to accept and take seriously what they claim to have experienced and discovered. They claim to have come face to face with 'the Reality behind the veil', to have established immediate communication between the human spirit and 'that immaterial and final Being, which some philosophers call the Absolute, and most theologians call God'.

The first part of the book is presented under the title, 'The Mystic Fact', and is a description of the body of evidence formed by the experience of the mystics. The second part, 'The Mystic Way', is an attempt to set out a 'definite theory of the nature of man's consciousness', tracing it through the various stages of its organic development.

THE MYSTIC FACT

The subject is, then, universal, common to all human beings, and it is do with human experience, human mystical experience. Evelyn's approach is deliberately non-historical and non-contextual. She is critical of many previous books on the subject because they are limited to giving merely historical information:

mysticism avowedly deals with the individual not as he stands in relation to the civ-ilization of his time, but as he stands in relation to truths that are timeless . . . the place which they happen to occupy in the kingdom of this world matters little.

Mysticism, p. xiii)

Also around this time

1876
Queen Victoria becomes Empress of India.

1897
Queen Victoria celebrates Diamond Jubilee.

1901
Death of Queen Victoria; succeeded by Prince Albert as King Edward VII.

1902
Balfour's Education Bill enabling abler children from humble back-grounds to get scholarships to grammar schools.

1910–36
Reign of George V.

1911
Great industrial unrest, dockers, railway men and miners' strike.

1914–18
First World War.

1922–30
The Depression, increasing unemployment; 1926 General Strike.

1928
Equal Franchise Act – vote for all women over 21.

1939–45
Second World War.

1940
Chamberlain resigns in favour of Winston Churchill.

The first seven chapters are intended as a comprehensive introduction to mysticism, clearing the ground of misunder-standing and making the necessary connections and discrim-inations between this particular field of human endeavour and associated disciplines – philosophy, psychology, science, the-ology, symbolism and magic. The mystics can only be studied with any degree of fruitfulness in their own writings, she believes, but she also knows that this literature does not offer up its strange fruits very readily to a mind that is unfamiliar with its ways of expression and unprepared to see the links between mystical apprehension and normal perception.

The word 'mysticism' itself needs, she says, to be rescued from serious misuses and restored to its full and proper meaning.

One of the most abused words in the English language, it [mysticism] has been used in different and often mutually ex-clusive senses by religion, poetry and philosophy: has been claimed as an excuse for every kind of occultism, for dilute transcendentalism, vapid symbolism, religious or aesthetic sen-timentality, and bad metaphysics. On the other hand it has been freely employed as a term of contempt by those who have criticised these things. It is much to be hoped that it may be restored sooner or later to its old meaning, as the science or art of the spiritual life. (*Mysticism*, p. xiv)

At the end she slips so easily into a definition of mysticism that it could easily be missed, 'The science or art of the spiritual life'. She puts it slightly differently in the next paragraph: 'Broadly speaking I understand it to be the expression of the innate tendency of the human spirit towards complete har-

mony with the transcendental order.' And later:

> *It is the name of that organic process which involves the perfect consummation of the Love of God: the achievement here and now of the immortal heritage of man. Or, if you like it better – for this means exactly the same thing – it is the art of establishing his conscious relation with the Absolute.* (*Mysticism*, p. 81)

The focus of the book is mystical experience. What does she mean by that? First, it is not ordinary sensory experience; we cannot encounter the absolute through ordinary limited consciousness. What we call the external world may seem very real; we may regard it as reality per se, the only reality. However, if we begin to consider the experience of our senses more closely and clearly, we have to recognize that this is actually only the self's projected picture of reality. To defend this view she calls on Meister Eckhart:

> *Every time that the powers of the soul come into contact with created things, they receive the created images and likenesses from the created things and absorb them. In this way arises the soul's knowledge of created things. Created things cannot come nearer to the soul than this, and the soul can only approach created things by the voluntary reception of images. And it is through the presence of the image that the soul approaches the created world: for the image is a Thing, which the soul creates with her own powers. Does the soul want to know the nature of a stone – a horse – a man? She forms an image.* (*Mysticism*, p. 6)

And then to illustrate the point she calls on a metaphor from daily life. The messages coming down the metaphorical communication lines from the external object to the receiver can never reveal the actual reality of the object, and the receiver can never know the real nature of the object at the other end.

> *The sphere of our possible intellectual knowledge is thus strictly conditioned by the limits of our own personality. On this basis, not the ends of the earth, but the external termini of our own sensory nerves are the termini of our explorations; and to 'know oneself' is really to know one's universe. We are locked up with our receiving instruments: we cannot get up and walk away in the hope of seeing whither the lines lead.* (*Mysticism*, p. 7)

Notice how Evelyn presents her argument. She makes a statement, refers to mystical writing for confirmation, brings us back to our everyday life and then summarizes her points. The power of her writing lies in the skilful blending of her own extensive reading, intellectual rigour and clarity of thought with imaginative use of the ordinary to point beyond itself. She has an ease of expression infused with energy and passion, which gives the impression of an ordinary person talking to other ordinary people, but about extraordinary things. She has the skill to draw us into reflection on our own experience and then persuade us to journey with her in a logical manner to the very edge. There ordinary experience opens out on to the supernatural, from where we hear the voices of the mystics resounding. Then, when we read the quotations from the mystics that are everywhere embedded in the text, our ear has already been attuned and they seem less strange. She is indeed a scholar but her main concern is not to display her scholarship – we should remember that she was not attached to any academic institution – nor is it simply to pay homage to her mystical friends of the past. She wants to persuade her readers that there is another dimension to life that needs to be taken seriously.

With the distinction between ordinary and mystical consciousness set out, the ground is cleared for an examination of the relationship between mysticism and philosophy, psychology, science, theology, symbolism and magic. The key to the relationship is the distinction between 'knowing about' and 'being' or 'loving' (the two latter are almost synonymous in her understanding):

> *[Mysticism] is the science of union with the Absolute, and nothing else, and the mystic is the person who attains to this union, not the person who talks about it. Not to know about, but to Be, is the mark of the real initiate.*
>
> (Dana Greene, *Evelyn Underhill: Artist of the Infinite Life*, p. 51)

Mysticism is not an idea, an opinion, a point of view, or the pursuit of knowledge; it is a lived process of transformation.

This becomes clearer if we look at the way Evelyn approaches philosophy. She argues that philosophy cannot lead us to the Absolute. It can describe glimpses of it, create diagrams, reason and persuade, but the Absolute in philosophical systems remains impersonal and unattainable, however beguiling the language of description might be. For the mystic, in sharp contrast, the Absolute is 'lovable, attainable, alive'. If we take the metaphorical philosophy road as far as we can, we may come to the brink of the seen, looking across to the unseen, but there remains a gulf between ourselves and the Absolute that we have not yet started to cross. Even the leading school of philosophy at that time, Idealism,

> perhaps the most sublime theory of Being which has ever been constructed by the human intellect . . . is stultified by the exclusive intellectualism of its own methods: by its fatal trust in the squirrel-work of the industrious brain instead of the piercing vision of the desirous heart . . . when we ask the idealist how we are to attain communion with the reality he describes to us as 'certainly there', his system suddenly breaks down; and discloses itself as a diagram of the heavens, not a ladder to the stars . . . It interests man, but does not involve him in its process: does not catch him up to the new and more real life which it describes. Hence the thing that matters, the living thing, has somehow escaped it; and its observations bear the same relation to reality as the art of the anatomist does to the mystery of birth. (Mysticism, p. 13)

The line between those who only think about the mystical and those who taste the experience is sharply drawn. The movement is less one of the self going out to explore, more a drawing out of the whole person to its true home, a journey of the heart (the principle of unity in the person) rather than the mind.

> Living union with this One . . . is a definite form of enhanced life. It is arrived at by an arduous psychological and spiritual process, entailing the complete remaking of character and the liberation of a new, or rather latent, form of consciousness.
> (Mysticism, p. 81)

THE MYSTIC WAY

It is this psychological and spiritual process to which the second part of the book turns its attention under the title 'The Mystic Way'. The following passage from the Part One chapter 'Mysticism and Psychology' makes an apt bridge between the two parts:

Glossary

Determinism
the view that every event is controlled by natural laws.

Empiricism
the claim that only sensory experience or observation is the source of knowledge.

Spiritualism
the belief in the possibility of communication with the spirit world through mediums.

Transcendental matters are, for most of us, always beyond the margin; because most of us have given up our whole consciousness to the occupation of the senses, and permitted them to construct a universe in which we are contented to remain. Only in certain states – recollection, contemplation, ecstasy and their allied conditions – does the self contrive to turn out the usual tenants, shut 'the gateways of the flesh', and let those submerged powers which are capable of picking up messages from another plane of being have their turn. Then it is the sense-world which retreats beyond the margin, and another landscape that rushes in. At last, then, we begin to see something of what contemplation does for its initiates. It is one of the many names applied to the chain of processes which have for their object this alteration of mental equilibrium: the putting to sleep of that 'Normal Self' which usually wakes, and the awakening of that 'Transcendental Self' which usually sleeps.

(*Mysticism*, p. 57)

Here is a hint of the practices required for the mystic way, recollection, contemplation, and a suggestion of the extraordinary experiences that are encountered as a person gradually moves from one plane of consciousness to the next. We are reminded here of Evelyn's plan to set out a 'definite theory of the nature of man's consciousness', to chart the psychological development that marks the formation of mystical consciousness, to describe its typical progress and features.

From the outset she acknowledges that presenting a schema is fraught with difficulty. Despite her assumption that the mystic is a particular sort of personality, the very varied temperaments of the mystics and the free and original way in which the inner impulses arise make any sort of classification only a rough and ready framework. In addition, it is observably the case that in one mystic a particular stage of the process may be crucial that is very much less significant for another, or indeed even absent altogether. A further problem arises in that a linear presentation of stages of progress hides the real pattern of the process as it is lived out, which is generally more labyrinthine than a smooth path from A to Z. Nonetheless it is legitimate, she believes, to present a sort of composite portrait, as long as the cautions above are borne in mind.

The scheme she sets out has five stages (*Mysticism*, pp. 169–70). The first is 'the awakening of the Self to consciousness of Divine Reality', usually abrupt and well marked with feelings of joy and exaltation. Second, because of this new awareness of the Divine, the soul 'realizes by contrast its own finiteness and imperfection, the manifold illusions in which it is immersed, the immense distance which separates it from the One'. This moves the person into the stage classically known as Purgation, marked by striving through pain and effort to remove all that stands in the way of progress to union with God. Having struggled up the path and become detached from the world of sense, there is the third stage, which is Illumination, looking metaphorically upon the sun, a direct knowledge of Reality, a state of happiness. This stage is accompanied by many degrees of deepening contemplation, visions and allied mystical experiences that provide a sort of spiritual education and training. Along with the previous two stages this forms the 'first mystic life', beyond which many do not proceed. 'Illumination brings a certain apprehension of the Absolute, a sense of the Divine Presence: but not true union with it.' For those who do move beyond Illumination 'there follows the final and complete purification of the Self, which is called by some contemplatives "mystic pain" or "mystic death", by others the Purification of the Spirit or Dark Night of the Soul'. The joy of basking in the sun of Divine Presence gives way to an intensely painful sense of Divine Absence:

> now the purifying process is extended to the very centre of I-hood, the will. The human instinct for personal happiness must be killed . . . The Self now surrenders its self, its individuality, and its will, completely. It desires nothing, asks nothing, is utterly passive.

This prepares the Self for the final stage, the true and ultimate goal which is union.

> In this state the Absolute Life is not merely perceived and enjoyed by the Self, as in Illumination: but is one with it. It is a state of equilibrium, of purely spiritual life: characterized by peaceful joy, by enhanced powers, by intense certitude . . . That permanent establishment of life upon transcendent levels of reality . . . described by individual mystics under symbols such as those of Mystical Marriage, Deification, or Divine Fecundity.

The first chapter of the second part of the book sets out this scheme and is followed by chapters examining the stages in more detail, drawing on copious examples and quotations from the European mystics from the earliest Christian

centuries up to her own day. In a similar way she presents chapters on voices and visions, recollection, contemplation, ecstasy and rapture, each involving careful consideration of what distinguishes true from false, mystical from neurotic and so on.

When the book was published many thought it had been written by a man, and a trained theologian at that, which we may take as an indication of the breadth, depth and seriousness of its scope, intention and understanding. Its immediate popularity, though, speaks more of the power, clarity and conviction with which she writes, drawing us into the lives of the mystics and helping us, with them, to engage with our humanity and to see the possibilities of being drawn into their super-humanity. She is redefining what it is it to be religious and what it is to be fully human, and the way each of these two things is part of the other. By implication, as much as by direct statement, Evelyn is saying that the essence of religion is not assent to doctrine, or fidelity to Scripture or external authority. The heart of both religion and humanity is to be in love with the Absolute (or Reality, God, or Truth – all symbols for the same thing) and to be transformed through love.

Development

Amid widespread acclaim for her great work of 1911 there was one particularly critical voice. This was Baron von Hügel, an Austrian Roman Catholic layman living in England, who was a scholar, leading modernist, ecumenist and outstanding spiritual director. In 1908 he had published *The Mystical Element of Religion,* in which he distinguished the mystical-emotional, the historical-institutional and the intellectual-scientific aspects of religion, insisting that none could be complete without the others as complements and correctives. What he criticised in *Mysticism* was Evelyn's deliberate neglect of the historical and institutional dimensions, and a theocentricity that on the one hand took scant account of the incarnational and on the other hand tended at times to lose sight of the transcendence of God and slip into pantheism or monism. He also thought that she was too heavily influenced by the philosophy of Vitalism developed by Henri Bergson. Bergson made a fundamental distinction between intellect and intuition, positing that there is within every living thing a dynamic vital impetus that is accessed through the intuition.

At a personal level, this critical encounter with von Hügel was the beginning of a relationship that provided exactly what Evelyn needed for the next stage of her own

Baron Friedrich von Hügel

development. Some of the limitations and contradictions that von Hügel found in her writing reflected some of the author's personal struggles. For instance, despite her attraction to the corporate in religion and to the Church, the focus of *Mysticism* was the individual search for truth. As we know from her letters, this sprang from her own difficulties with intimacy in close relationships. Despite the book's insistence on the journey being one of the whole person, what is presented is passionate but abstract and disembodied, reflecting the areas where she herself would need to expand into greater openness and wholeness. Von Hügel became her friend and spiritual director until his death in 1925 (after which she was sensitively guided by the renowned Anglican Reginald Somerset Ward). Von Hügel seemed to her saintly, truthful, sane and tolerant, someone she could trust completely, with whom she could feel safe and happy. Under his influence, and deeply affected by having to face the personal and corporate suffering visited by the First World War, she began to find an incarnated faith and healing for her soul. In 1923 she wrote to von Hügel:

> *The Christocentric side has become so much deeper and stronger – it nearly predominates. I never dreamed it was like this. It is just beginning to dawn on me what the Sacramental Life really does involve . . . I have never known before such deep and real happiness, such a sense of having got my real permanent life and being able to love without stint where I am meant to love . . . All this, humanly speaking, I owe entirely to you.* (Greene, *Evelyn Underhill*, pp. 83–4)

Worship

If we bear these personal factors in mind it comes as less of a surprise to find Evelyn turning to the subject of worship for her major work of 1936, 25 years after the publication of *Mysticism* and five years before her death. The 1911 book remained key to her approach to the relationship between human and divine, but her perception and experience had developed, owing much to the influence of von Hügel. The relationship between the human and the Absolute described in *Mysticism* was intensely

personal and limited to a few particular souls. *Worship* focuses on the universal impulse to respond to God that is expressed in worship.

The centre of attention shifts now from processes within the human psyche to the activity of the Divine. The priority is God's self-outpouring to which the human responds with her own self-giving.

> *Not man's needs and wishes, but God's presence and incitement first evoke it. As it rises toward purity and leaves egoistic piety behind, He becomes more and more the only fact of existence, the one Reality; and the very meaning of creation is seen to be an act of worship, a devoted proclamation of the splendour, the wonder, and the beauty of God. In this great Sanctus, all things justify their being and have their place. God alone matters, God alone is — creation only matters because of Him.* (*Worship*, p. 15)

The human response becomes more grounded in the historical and institutional context, more rooted in the demands of living in dependence on the world of time and space.

> *If human worship be essentially theocentric, creaturely, disinterested, the humble and graded response of man the finite to the generous and graded self-revelation of the Infinite God ... it must have embodiment, concrete expression. Man lives under condition of time and place. Nothing is fully realized by him, or becomes really fruitful for him, until it has been limited to these limitations ... His desires and convictions do not become actual until expressed in words or deeds, even though this expression is seldom adequate; and the more fundamental the interest, the stronger is the impulse to expression.* (*Worship*, pp. 22–3)

Adoration became the dominant chord at the end of her life. She was housebound and sometimes bed-ridden by asthma, beset with concerns about her husband, and about the war raging around them in which she maintained a pacifist stance. Yet this was now the continuous ground note of her life, as expressed by one of her beloved mystics, Søren Kierkegaard:

> *As the bird sings without ceasing to the glory of the Creator, such also is the Christian life ... for this properly is the hymn of praise, the paean, the song of songs; by joyful and unconditional obedience to praise God when one cannot understand Him.*
>
> (Greene, *Evelyn Underhill*, p. 143)

LIZ WATSON

ETTY HILLESUM

Liz Watson

Etty Hillesum

Introduction

Europe was in turmoil and, as at other times of strife and toil, the Second World War witnessed the emergence of an important mystic, Etty Hillesum. She was of Jewish background and lived in the Netherlands, a country occupied early on in the war by the Nazis, who brought with them their anti-Semitic persecutions.

Holland had up to that point had a flourishing Jewish community, especially in Amsterdam where Etty lived, which had been totally assimilated into Dutch society. But as we progress through her journal and letters the situation for Jews in Amsterdam becomes dangerous and harrowing, as her friends are killed and deported. In 1943 she and her family were in turn taken to Westerbork and finally to Auschwitz and death.

In reading her journal we must not lose sight of this background to her life. Her writing is a personal reaction to the environment and the situation in which she found herself. She had to wrestle with the apparent inevitable victory of evil and had to face the apparent powerlessness of the individual in the face of such ruthless repression. This could easily have led to despair and self-centredness, but we see in Etty the triumph of humanity's spiritual nature and basic goodness over the evil that tries to destroy all.

Liz Watson shows how Etty discovered her own spirit during this time, unrelated to any religious tradition or dogma, and that her mysticism was spontaneous and

based on deep experience of the Divine. She describes how she found her own way to her source and from that source was able to be a loving support to all who came within her sphere.

All quotations are taken from *An Interrupted Life: The Diaries and Letters of Etty Hillesum* (Persephone, 1996).

Etty Hillesum 1914–43

Etty (Esther) was the daughter of a Dutch father and Russian mother. Her father, Dr Louis Hillesum, was a teacher of classical studies who became headmaster of a Gymnasium in Deventer in the east of the Netherlands by the mid 1920s. Consequently, Etty and her two brothers Jaap and Mischa grew up in an intellectually stimulating environment. All three were highly intelligent and very gifted. Mischa was a brilliant musician and Jap was a medical student. Etty first took a law degree, then studied Russian in the Faculty of Slavonic Studies and finally turned to the study of psychology. During the war she worked as a secretary in the Jewish Council, an organization set up by the Nazis, whose staff were under the illusion that they could alleviate some of the worst effects of the persecutions. Because of this connection Etty was able to volunteer to go to Westerbork, a transit camp, to help the inmates there. They were finally transported to Auschwitz, where Etty and her parents died very soon after arriving in September 1943. Mischa died in March 1944 and Jaap survived the camp but died on the way back to the Netherlands.

A TRANSFORMED LIFE

Here goes, then. This is a painful and well-nigh insuperable step for me: yielding up so much that has been suppressed to a blank sheet of lined paper. The thoughts in my head are sometimes so clear and sharp and my feelings so deep, but writing about them comes hard. The main difficulty, I think, is a sense of shame. So many inhibitions, so much fear of letting go, of allowing things to pour out of me, and yet that is what I must do if I am ever to give my life a reasonable and satisfactory purpose. It is like the final, liberating scream that always sticks bashfully in your throat when you make love. I am accomplished in bed, just about seasoned enough I should think to be counted among the better lovers, and love does indeed suit me to perfection, and yet it remains a mere trifle, set apart from what is truly essential, and deep down something is still locked away. The rest of me is like that too. I am blessed enough intellectually to be

able to fathom most subjects, to express myself clearly on most things; I seem to be a match for most of life's problems, and yet deep down something like a tightly wound ball of twine binds me relentlessly, and at times I am nothing more or less than a miserable, frightened creature, despite the clarity with which I can express myself. (p. 3)

So begins the diary of Etty Hillesum, and how startling it is. Here is the point at which the writer has found the courage to stop and confront, unflinching, the way things really are. We immediately recognize the humanity of it; it attracts us with its honesty and directness, and ironically for its lack of shame in speaking of shame. We also recognize that what she is saying is in some way true for ourselves. Perhaps we are relieved that she can do this for us, put stark words to what we may be less ready to spell out quite so baldly and boldly. Etty does not profess any particular faith but the Judaeo-Christian resonances are so strong that it gives her no disrespect to say that, like Adam and Eve, she has seen her nakedness, and she reminds us that we have to see ours too. But while she feels keenly the shame, she knows that this time she has to resist the temptation to hide in the bushes, that reaction which was the second downfall of our mythical forebears. Whether we are religious readers or not, we instinctively know that this is a turning point, a moment of conversion. Somehow – and in these moments of grace, insight brings wisdom, courage and trust in its wake – she has found within herself an intimation that if she makes this act of self-exposure she will not be undone by it. The word she will give to this in due course is faith.

Nineteen months later, among the last entries in her diary, we read: 'I have broken my body like bread and shared it among men. And why not, they are hungry and had gone without for so long' (p. 281). The spareness and simplicity of these two sentences compared with the complexity of the opening lines points up the contrast between the 'miserable, frightened creature' of the opening and the self-possessed, unself-conscious, self-sacrificing, compassionate woman she has become. We are led to the question, what has happened to her in this brief 19 months to bring about such a profound change? Reflecting on this herself, she sums it up in paradoxical terms: 'A soul is forged out of fire and rock crystal. Something rigorous, hard in an Old Testament sense, but also as gentle as the gestures with which his tender fingertips sometimes stroked my eyelashes' (p. 280). She is speaking, of course, of universal experience understood from her own particular life. She has encountered a new force

Writings of Etty Hillesum

An Interrupted Life: The Diaries and Letters of Etty Hillesum, trans. Arnold J. Pomerans, Persephone, 1996 (abridged text).

Etty: The Letters and Diaries of Etty Hillesum 1941–43, ed. Klaas D. Smelik, trans. Arnold J. Pomerans, Eerdmans, 2002 (complete text).

of love, God, and as all lovers of God must, she has met him in both aspects, purifying fire and tender caress – as the twentieth-century theologian Rudolf Otto concisely expressed it: '*mysterium tremendum fascinans*' (mystery at once overwhelming and attractive).

The historical context

The historical context for the forging of this young woman's soul is the Nazi persecution of Dutch Jews, yet as Eva Hoffman remarks in the Preface to *An Interrupted Life*, the writings resist being read primarily in the light of the Holocaust. That is to say, to focus only on the context is to miss the main point. This life could only have been lived and transformed in this particular way because it was lived in this particular context; in that sense the context is relevant. However, this transformed life bears contours and features of a human life transformed by the divine life, and her voice echoes the voices of mystics down the centuries. They all witness to the otherwise unimaginable possibilities of human being. From the last letter – so simply:

> *Opening the Bible at random I find this: 'The Lord is my high tower'. I am sitting on my rucksack in the middle of a full freight car. Father, Mother, and Mischa are a few cars away. In the end, the departure came without warning . . . We left the camp singing, father and Mother firmly and calmly, Mischa too. Thank you for all your kindness and care.* (p. 426)

Biographical details

The writings we have are Etty's diaries from 9 March 1941 up until 13 October 1942, and letters to friends from 23 November 1942 to 15 September 1943. The diaries after October 1942 are lost. Etty, properly Esther, Hillesum was born in Middelburg, Holland on 5 January 1914. Her parents were secular Jews, her father Dutch, her mother Russian, and she had two brothers, Mischa and Jaap. When we meet her in the diaries she has already studied law, Russian and psychology and is living in Amsterdam, studying, trying to write, earning money teaching Russian,

working as a secretary, and living a bohemian life, enjoying philosophical discussion with friends, a series of lovers and with no particular religious affiliations. This is where we catch up with her through the diaries, shortly after she has met a therapist, Julius Spier, who quickly becomes a catalyst in the process of her inner awakening. The diaries were written primarily as an aid to the inner life and so the external events that are the crucible in which her humanity is being forged are recorded only incidentally. A few of the letters do record events in detail and the reading can at times be deeply harrowing. But the bare events are briefly these.

Holland fell to the Nazis in May 1940. Anti-pogrom strikes in February 1941 were met with intensified action against Dutch Jews. In April 1942 Jews were forced to wear the yellow star and began to be rounded up into the Amsterdam ghetto. From the diaries we have some insight into the way Etty's own existence was physically, psychologically and socially limited by increasing restrictions on what she could own or purchase and where she was allowed access outside the house. In July, she was persuaded to go and work for the Jewish Council, whose highly ambivalent role was to help the Nazis effect their plans, hoping to do so in ways that might mitigate the worst effects. In this way a worse fate was postponed for Etty. More and more Jews, perceived deviants and dissidents were being sent to Westerbork transit camp outside Amsterdam, from where successive trainloads were finally transported to Theresienstadt and Auschwitz. In June 1943 Etty asked to go and work in Westerbork. There she eventually found herself nursing, among many others, her own parents and brother. On 7 September 1943 they were all transported to Auschwitz. Her parents were gassed on arrival three days later. Etty's death is recorded on 30 November. Neither of her brothers survived.

The inner life

With this background in mind, we can return to the question of what happened in those 19 months from the perspective of

Westerbork Concentration Camp

the central concern of the diaries, the inner life. As Etty notes in the opening lines of the diary, quoted above, the outward image is of someone who can cope very well with life. There are enough clues in the diaries to be able to imagine meeting an outwardly successful, competent, socially well adjusted, lively and talented woman, well educated, intellectually gifted. The inner dimension to her existence, however, is one she does not know how to deal with; it has been masked so far by her outer abilities and achievements but she is now seeing more clearly that it must be taken seriously. She is a clear thinker and a writer, yet at this point she cannot find a way to use her skills of articulation to give words to the thoughts and feelings that well up from the deeper recesses of her being. Indeed it is that frustration in her creative life as a writer, and the judder of repeated frustration, that has propelled her to the crisis she has reached in those opening sentences. She cannot bear it any longer; she has to find a way to set free what she knows has been suppressed, 'like a tightly wound ball of twine'. In another key area of her life, her sexual relations, the constriction is felt as the frustration of the desire for consummation. But now she is realizing that she has been looking for consummation and liberation in the wrong place, in the superficial strata of human being, kept in place by shame, fear and inhibition.

Acceptance of self and others

As Etty makes the move beyond shame, fear and inhibition and is able to look inwards, several guiding principles emerge very quickly. The first is the necessity of being prepared to face reality, however painful that is. To start with, the reality of herself:

> And I suddenly got a feeling of, he's seen right through me; now he knows exactly
> how materialistic I am . . . What can be described is the sudden realization: now he
> has seen through me, knows what I am really like. And the horror of it. (p. 76)

The second is the necessity to accept reality, an inner movement which is closely linked with yielding up, letting go, allowing: 'I am still ashamed of myself, afraid to let myself go, to let things pour out of me; I am dreadfully inhibited and that is because I have not yet learnt to accept myself as I am' (p. 42).

The twin of growing self-acceptance is growing acceptance of others; she must look at the reality of others and not flinch. She becomes more and more convinced

that she must struggle to resist the temptation to hate anyone, those who hurt her or her loved ones, even those who are committing daily atrocities before her eyes. So this is not a passive or supine acceptance that lacks courage, concern, will or sense of responsibility in the face of evil. (She acknowledges that there are some who are called to outward action in this fight.) Her own sense of responsibility, far from diminishing, grows into a heightened responsibility for her own actions and a profound concern for their effect on the world. It is a commitment to the deepest and most truthful response she knows and a commitment not just to her own life or the life of the world in her own time but to succeeding generations and to the eternal purposes of God. She is never unrealistic enough to suggest that her stance is going to avert the present crisis, but still she says that 'each of us must turn inward and destroy in himself all that he thinks he ought to destroy in others. And remember that every atom of hate we add to this world makes it still more inhospitable' (p. 259). Because she is coming to know her own heart she understands well the common human responses to evil. In her diary and letters she observes the ways people try to cope with aspects of reality that are inimical or fearful to them: by denial, trying to minimize or normalize the situation for as long as possible, by cowering and hoping for the best, by fleeing, or its opposite, putting up the barricades, by fighting recklessly or carefully organizing resistance. But Etty is learning a different reality. She does not condemn others for their responses; she has learned not to condemn herself and therefore cannot condemn in others what she knows as part of her own humanity. Her way is one that has grown autonomously within her and become stronger, deeper and calmer as it has been forged in the fire of her daily experience; she believes it to be God's way in and through her. Ultimately she says to God,

Also around this time

1919
Adolf Hitler joins German Workers Party.

1927
First Nuremberg Rally of Nazi Party.

1930
Unemployment reaches four million in Germany.

1933
Adolf Hitler becomes Chancellor of Germany; first concentration camp started in Dachau.

1934
Hitler becomes President of Germany.

1936
Hitler and Mussolini form military alliance.

1937
Bombing of Guernica in Spain by Luftwaffe.

1938
German army mobilizes; 'Crystal Night': 7,500 Jewish shops destroyed and 400 synagogues burnt down.

1939
Britain and France declare war on Nazi Germany after German invasion of Poland.

1940
The Netherlands, neutral country, invaded and surrenders.

But one thing is becoming increasingly clear to me: that You cannot help us, that we must help You ourselves. And that is all we can manage these days and also all that really matters: that we safeguard that piece of You, God, in ourselves . . . You cannot help us, but we must help You and defend Your dwelling place inside us to the last. And there are those who want to put their bodies in safe keeping but who are nothing more now than a shelter for a thousand fears and bitter feelings. And they say, 'I shan't let them get me into their clutches.' But they forget that no one is in their clutches who is in Your arms. (p. 218)

The courage she is developing is also devoid of the characteristics we frequently associate with it. It is not obstinate, aggressive, defensive or heroic; rather, it is the courage to bear everything, to make space for it within, so that pain and fear are not turned back against others as hate and anger: 'after this war, two torrents will be unleashed on the world: a torrent of loving-kindness and a torrent of hatred. And then I knew: I should take the field against hatred' (p. 255). The space within the human heart that is making room for God is the space that can bear pain; it is also a space big with love, compassion and forgiveness. In the opening sentences she expresses her desire to go beyond 'mere trifles' and find what is essential, what is at the heart of existence, what is deepest in her own heart. What she finds is love and beauty. These endure, these are indestructible. Life is good in its essential nature. No outward circumstances can alter that truth. Whatever is done to her, to the people, to the land, nothing can negate that truth, which is not just an idea but a liveable reality. She lives in a situation in which such a truth is severely tested by everyday realities. But it is to that conviction that she continually returns, out of that reality that she learns to live and respond to whatever comes.

Sometimes I might sit down beside someone, put an arm round a shoulder, say very little and just look into their eyes. Nothing was alien to me, not one single expression of human sorrow. Everything seemed so familiar, as if I knew it all and had gone through it all before. People said to me, 'You must have nerves of steel to stand up to it', I don't think I have nerves of steel, far from it, but I can certainly stand up to things. I am not afraid to look suffering straight in the eyes. And at the end of the day there was always the feeling: I love people so much. Never any bitterness about what was done to them, but always love for those who knew how to bear so much although nothing had prepared them for such burdens. (p. 277)

We remember at this point the 'miserable, frightened creature' of the opening.

The necessity for dispossession

A third theme that runs through Etty's diaries is the necessity for dispossession. She quickly recognizes that possessiveness is a poison that paralyses her in every

Jews being deported to Westerbork Transit Camp

aspect of her life. One of the most sustaining aspects of life for her is the beauty of nature. She always has flowers on her desk, she drinks in the sight of the sky and the changing forms of the tree branches outside her window, but one day she says:

> *I have hit upon something essential: Whenever I saw a beautiful flower, what I longed to do was press it to my heart, or eat it all up ... I was too sensual, I might almost write too greedy. I yearned physically for all I thought was beautiful, wanted to own it. Hence that painful longing that could never be satisfied, the pining for something I thought unattainable.* (p. 16)

Soon after:

> *But that night, only just gone, I reacted quite differently. I felt that God's world was beautiful despite everything, but its beauty now filled me with joy. I was just as deeply moved by that mysterious, still landscape in the dusk as I might have been before, but somehow I no longer wanted to own it. I went home invigorated and got back to work. And the scenery stayed with me, in the background, as a cloak about my soul ...* (p. 17)

Here is the paradox: letting go of what you think you need, of what you desire, of what you think will satisfy you, opens you to a God-given reality that is freer, richer and more satisfying than anything you could have imagined. Clutching anything to yourself closes you in on yourself, preoccupies you, prevents you from opening your arms to receive and give, drains your energy, leaves you deeply unsatisfied.

Etty sees how this possessive tendency is at work in her relationships. In the opening quotation she has realized that her series of sexual partners amounts to very little, and before long she can see that she is driven by a desire to possess a man's body, to own him in a material way. 'Really, it is all a game, and you don't have to have an affair with a man to have an intimate understanding of him. But it's hard going all the same' (p. 21).

Love

In succeeding diary entries she charts a wonderful unfolding and integrating where her sexual energies are brought into a new, divine focus. The love affair she is being drawn into with God brings with it a deepening understanding of the meaning of love and intimacy in human relationships. In the burgeoning spiritual context, the outer, physical aspect of relationships is seen for what it is: limited to short-lived satisfactions that make for increasing frustration. She has noticed that in previous relationships she has always begun with a sense of adventure, fuelled by her irresistible 'erotic curiosity', projected in fantasies of how good and beautiful it will be this time. But it soon turns to ashes. It is the relationship with the therapist Julius Spier that exemplifies this change and reveals the previously unguessed depths and wonders of a relationship developing at the level of spirit: 'With every fresh step the relationship seems to gain in intensity and all that went before seems to pale in comparison, so much more many-sided and colourful and eloquent and inward does our relationship become all the time' (p. 132).

Stones and grit in the well

No process of human growth can be traced by a straight line. Etty talks of God dwelling in a deep well inside her but often buried beneath a blockage of stones and grit that must be dug out; and this is a repeated process. When there is blockage there is lack of motivation, indiscipline, wasting time and energy on achieving sickeningly little, swinging between sentimental attachment and a masochistic independence, between fantasies of a great future and a fear of going to the dogs, between wallowing in illness and hiding it beneath a brave face. This is accompanied by 'an exaggerated self-consciousness' and a desperate need to be liked, all creating an inner chaos, not knowing how the different bits of her should fit

together, 'being all over the place' as we say. But when these stones and grit have been cleared away she notices how much more motivated and focused she is; she can get down to work, giving attention to whatever task is before her, humdrum or elevated; she spends less time analysing her condition and is not so shaken by what others think of her. Noticing, or listening in, as she describes it, is the key to this process of clearing the blockages, digging God out again, and again, and again. She learns to notice her thoughts and moods so that she can detect when the grit is accumulating. It is important to note, though, that 'listening in' is different from the exaggerated self-consciousness that besets her at the start. It is less the self-obsessed, tense, analytical watching that winds her more tightly into herself, more a mindful observing that serves the rhythms of unfolding, releasing and transforming. For example, she comes to see her bouts of depression as a regulator that lets her know that she is going wrong. With that insight she can begin to free herself from the two opposite and equally unhelpful habitual reactions, making excuses for herself or condemning herself. Then she can set herself back on the right path: 'And I listen into myself, allow myself to be led, not by anything on the outside, but by what wells up deep within' (p. 96).

The Divine

But who is God for Etty and how does she speak about God? We saw earlier that the tools she had well honed for the intellectual and creative life were not adequate for dealing with the inner life. What she does not do, therefore, is try to define God, weigh competing claims, or call up images from her poetic imagination; this would be too materialistic and imply trying to possess him. She has to learn a new way to apply her gifts. Even the act of thinking changes: 'As I walk through the streets I am forced to think a great deal about Your world. Think is not really the right word, it is more an attempt to plumb its mystery with a new sense' (p. 229). There is an appealing naturalness in the way she describes her growing relationship with God. For example, to begin with there is a tentative movement on her part, 'God take me by Your hand, I shall follow You dutifully, and not resist too much' (p. 77). Soon it is God who is the moving force: 'Last night, shortly before going to bed, I suddenly went down on my knees in the middle of his large room, between the steel chairs and the matting. Almost automatically. Forced to the ground by something

stronger than myself' (p. 90). Then God becomes a deep, internal source of life with which she simply has to co-operate: 'Something in me is growing and every time I look inside, something fresh has appeared and all I have to do is accept it, to take it upon myself, to bear it forward, and to let it flourish' (p. 160).

The relationship grows to a stage of oneness, which she attempts to describe: 'And that probably expresses my own love of life: I repose in myself. And that part of myself, that deepest and richest part in which I repose, is what I call God' (p. 242). As God enters into every aspect of her life she uses a wide variety of words to express what the word 'God' signifies for her: faith, faithfulness, beauty, richness, meaning, peace, harmony, love, intimacy, joy, strength, gratitude, contentment. God is immeasurable, infinite, mystery, silence, simplicity, being.

A chronicler of this age

A strong part of Etty's self-identity was her ambition as a writer. Returning to the opening lines of the diary, there is recorded a new insight that somehow she has to let things pour out of her unedited, onto the blank sheet of paper. In her developing self-understanding she sees that her frustration arises from being caught between overweening ambition and the fear of failure.

> *The most fatuous little essay is worth more than the flood of grandiose ideas in which you wallow . . . Just organize things a little, exercise some mental hygiene . . . Don't overestimate your own intensity; it may give you the impression that you are cut out for greater things than the so-called man in the street.* (pp. 10–11)

The ground of her self-identity is continually shifting from her own achievements into identification with God himself, and thus her ambition to write is modified and indeed recedes. She does not want to write anything that is inessential and does not spring from an inner necessity, where the words have grown inside her until they are ready to be born. Words must have a relationship with silence. 'All that words should do is to lend the silence forms and contours' (pp. 167-8); '. . . the great wordless background of God, Life, Death, Suffering and Eternity' (p. 211).

She is living life intensely in grotesque circumstances and doubts she could ever put down in writing what she has experienced in 'living letters'. At one point she reflects:

And I shall wield this fountain pen as if it were a hammer, and my words will have to be so many hammer strokes with which to beat out the story of our fate and of a piece of history as it is and never was before . . . a few people must survive, if only to be the chroniclers of this age. I would very much like to become one of them. (p. 211)

This desire to be a writer keeps on jostling with her sense that the act of 'moulding one's inner life' is the most creative thing a human being can do, and that in any case this situation would take a greater poet than she to describe it. Her final words on the subject are:

I may never become the great artist I would really like to be, but I am already secure in You, God. Sometimes I try my hand at turning out small profundities and uncertain short stories, but I always end up with just one single word: God. And that says every-thing and there is no need for anything more. And all my creative powers are translated into inner dialogues with You. (p. 395)

One of Etty's ambitions was to be remembered and fêted as a writer, a serious writer of essays, novels, poetry in the intellectual tradition. That ambition was not fulfilled; we have no surviving examples of those more formal genres, rather, many indications of continuing frustration in that regard. But in the opening lines of the diary we read of another longing, simply to pour out what was in her, uninhibited by possessiveness, self-aggrandizement, fear or shame, and this is what she succeeds in doing in the diaries. The diary turns out to be both a means to an end, an aid in realizing the inner life and, ironically, the vehicle for fulfilling her ambition to be remembered as someone who can speak to others about the great themes of life. Paradoxically, the greatest of all themes turns out to be very simple: 'The story of the girl who gradually learned to kneel is something I would love to write in the fullest possible way' (p. 74). These words are tossed off casually in a tangle of other thoughts early in the diary, but this is exactly what she has done. 'What a strange story it really is, my story: the girl who could not kneel. Or its variation; the girl who learnt to pray' (p. 279).

LIZ WATSON

TWENTY-SEVEN

THOMAS MERTON

Peter Tyler

Thomas Merton, *Joseph Malham*

Introduction

Thomas Merton was at first very much influenced by St Thomas Aquinas and scholastic thought, and strongly advocated strict monasticism and in particular the eremitical life. He saw this as an alternative way of being in our materialistic culture, even as a rejection of it. But soon he started to modify his severe interpretation of the monastic life and no longer saw solitude as a way of escaping from the world but as an essential ingredient of the spiritual life in general, a way of finding one's true self in Christ. Moreover, his own need for solitude made him aware of the benefit of this for everyone, not just monastics but also the laity. He became convinced that solitude and contemplative prayer were excellent tools for living in the everyday world. His practice of contemplative prayer contributed to his growth in compassion for those having to live in the world; he started to engage with the social and political issues of his time. But in the last few years of his life he came to the conclusion that the life of a political and social activist did not accord with being a true hermit. His attention turned from then on to Christian mysticism and mysticism in general, and the pursuit of wisdom.

Peter Tyler describes Merton as a postmodern mystic and outlines the growth and development of his thought from strict monasticism to emphasis on the spiritual journey as a way to find one's 'authentic self'. In doing so he distinguishes seven distinct categories in Merton's spiritual approach.

Unless otherwise noted, quotations from Thomas Merton are taken from *The Seven Storey Mountain* (SPCK, 1948).

Thomas Merton 1915–68

Thomas Merton was born in France the son of two artists; his father came from New Zealand and his mother from the USA. His mother died when he was six and his father when he was 16. His education started in France, then England and finally the USA. He studied at Clare College, Cambridge for a year, but graduated from Columbia University. Before entering the Trappist Abbey of Our Lady of Gethsemani at age 26 he taught English for a year at St Bonaventure University. He took his solemn vows in 1947 and was ordained a priest two years later.

He had important posts in the Monastery: teaching students preparing for priesthood, and Master of Novices. Despite these duties he was a prolific writer, bringing out a book practically every year. The last three years of his life he was allowed to live as a hermit in the Monastery grounds. He died an accidental death in 1968 in Bangkok, Thailand.

THE SEVEN STOREY MOUNTAIN

At the beginning of his best-selling autobiography, *The Seven Storey Mountain*, Thomas Merton, the twentieth-century mystic, political activist, writer and Cistercian monk, writes:

> *On the last day of January 1915, under the sign of the Water Bearer, in a year of great war, and down in the shadow of some French mountains on the borders of Spain, I came into the world. Free by nature, in the image of God, I was nevertheless the prisoner of my own violence and my own selfishness, in the image of the world into which I was born.* (p. 3)

The passage, written barely four years after his entrance to the Cistercian (Trappist) Abbey of Our Lady of Gethsemani, Kentucky, is classic early Merton – dramatic, incisive and raising more questions than it answers. The facts of his birth were that he was born during a snowstorm on 31 January 1915 in Prades, a French Pyrenean village near the border with Spain. His parents, the American Ruth Jenkins and the New Zealander Owen Merton, were both artists and had met as students in Paris. In Forest's words they had 'an artist's attraction to southern light, inexpensive living

Writings of Thomas Merton

The Seven Storey Mountain, SPCK, 1948, reprint 1990.

The Sign of Jonas, Harcourt, 1953.

Conjectures of a Guilty Bystander, Doubleday, 1966.

Faith and Violence, University of Notre Dame Press, 1968.

Zen and the Birds of Appetite, Abbey of Gethsemani, 1968.

Contemplative Prayer, Darton, Longman & Todd, 1973.

The Asian Journal of Thomas Merton, New Directions, 1975.

The Hidden Ground of Love: The Letters of Thomas Merton on Religious Experience and Social Concerns, ed. William H. Shannon, Farrar, Straus & Giroux, 1985.

The Courage for Truth: Letters to Writers, ed. Christine M. Bochen, Farrar, Straus & Giroux, 1993.

Witness to Freedom: Letters in Times of Crisis, ed. Wiliam H. Shannon, Farrar, Straus & Giroux, 1994.

Turning Toward the World: The Pivotal Years. Journals 1960–1963. ed. A. Kramer, HarperCollins, 1996.

Essential Writings, ed. Christine M. Bochen, Orbis, 2001.

Peace in the Post-Christian Era, Orbis, 2004.

and the presence of friends nearby' (J. Forest, *Living with Wisdom*, p. 5).

Merton acknowledged in his autobiography the artistic debt he owed his parents, especially his father, and this artistic skill and insight would be something that would inform his later work, especially in writing and photography. This ability to see what the Jesuit poet Gerard Manley Hopkins called the 'instress' of objects was a significant element of Merton's spirituality and can be seen most clearly in his striking later photography.

With the advance of the First World War the Mertons soon left France and returned to New York. Here, in 1921, when Merton was six years old, his mother Ruth was diagnosed with stomach cancer. She decided to communicate this to young Thomas by writing him a letter. Merton's account of reading this letter 'under the maple tree in the back yard' evokes a poignant mixture of sorrow and spiritual yearning:

I worked over [the letter] until I had made it all out, and had gathered what it really meant. And a tremendous weight of sadness and depression settled on me. It was not the grief of a child, with pangs of sorrow and many tears. It had something of the heavy perplexity and gloom of adult grief, and was therefore all the more of a burden because it was, to that extent, unnatural. (p. 14)

Again, the Merton tone is there – portentous but perplexed; we can sense some of the confusion the little boy held but also the power he found in the words that he sat with and 'made out'. Words were to remain his lifelong friends and allies in all his future battles.

After five more years in the USA, Owen Merton decided it was time for the family (minus Thomas' younger brother John Paul) to return to France, and this they duly did in 1925

when they returned to St Antonin near Toulouse. Here Owen was diagnosed with tuberculosis while Thomas spent time at the Lycée at Montauban. This was followed by a period when Thomas was sent for schooling in England, first at Ripley Court School and then at Oakham in Rutland. Thomas described England in his autobiography as the land where 'every impact of experience seemed to reach the soul through seven or eight layers of insulation' (p. 61). And so it was that he lived with his Aunt Maud in Ealing, West London, 'where all the Victorian standards stood entrenched in row upon row of identical houses'. Thomas' combination of being from an artistic background and being fluent in French 'added up to practically everything that Mrs Pearce [the headmistress of Ripley Court] and her friends suspected and disliked' (p. 64). While on holiday in Scotland and preparing to enter Oakham School, Thomas again received a message from his remaining parent, which heralded disease and death. This time his father, taken ill in London, wrote a mysterious telegram, 'Entering New York Harbour. All well'.

> I sat there in the dark, unhappy room unable to think . . . without a home, without a family, without a country, without a father, apparently without any friends, without any interior peace or confidence or light or understanding of my own – without God, too, without God, without heaven, without grace, without anything. (pp. 71–2)

This existential nihilism accompanied Thomas throughout his father's decline and death from a brain tumour in 1931 and his own move from Oakham to Cambridge in 1933, where he studied Modern Languages at Clare College. According to his autobiography his own nihilism combined with the 'dark, sinister atmosphere of Cambridge' to produce lethal consequences. Reflecting on these events twenty years later he felt there was 'a subtle poison in Europe . . . some kind of a moral fungus, the spores of which floated in that damp air, in that foggy and half-lighted darkness' (p. 126). For the young Thomas Merton 'most of the people were already morally dead, asphyxiated by the stream of their own strong, yellow tea or by the smell of their own pubs and breweries, or by the fungus on the walls of Oxford and Cambridge'. Although his superiors asked him to omit detailed reference to these events in his autobiography, his subsequent biographers (Forest, 1991; Furlong, 1985) mention two events in particular. Merton got a young woman 'not of our class' pregnant; the woman and child apparently later died during the Blitz although this

Glossary

Scholasticism
A method of speculation used by medieval theologians to reconcile ancient Greek philosophy, in particular Aristotle, with Christian theology.

was never verified. The second traumatic event seems to have been a sort of drunken mock crucifixion performed on Merton at a party, which got out of control and necessitated calling the Cambridge police. Merton apparently retained a scar on one of his palms for the rest of his life and sometimes referred to it jokingly as 'my stigmata'. In 1934 Merton left Europe, the continent of his birth, never to return.

Once in the USA, the 'poison' of England seemed to have been drawn and he began to flourish as a writer, journalist and student at Columbia University. As well as his studies in Spanish, German, Law, Geology and Contemporary Civilization he worked on the student magazines *The Jester*, *The Columbia Review* and *The Spectator*. This work and the contacts he made would profoundly influence his future writing career. For example, he met here Robert Giroux who would later publish *The Seven Storey Mountain*. Particularly important influences at this time were Étienne Gilson's *The Spirit of Medieval Philosophy* and William Blake, concerning whose poems Merton wrote his Master's thesis in 1938/9. Of equal importance was the influence of the nineteenth-century Jesuit poet Gerard Manley Hopkins, as interpreted by G. F. Leahy's biography. On a September night in 1939 in his lodgings on West 114th St, as Europe slid into war, Merton read about Hopkins' conversion to Roman Catholicism while a student at Oxford in 1866:

> *All of a sudden, something began to stir within me, something began to push me, to prompt me. It was a movement that spoke like a voice: 'What are you waiting for?' It said. 'Why are you sitting here? Why do you still hesitate? You know what you ought to do? Why don't you do it?'* (p. 215)

After a while he could contain himself no longer, put on his coat and walked the nine blocks to the RC church of Corpus Christi where he had been attending Mass. The priest welcomed him and in the parlour he finally blurted out: 'Father, I want to become a Catholic.'

From this moment onwards Merton seemed swept up in the tide of the Holy Spirit that would eventually deposit him at Our Lady of Gethsemani. However, before arriving at Gethsemani Merton tried his vocation with the Franciscans in New York, who accepted him for the novitiate in June 1940. But, after reflecting

upon his application over the summer he felt that he had not been sufficiently honest with the Franciscans and had omitted certain details of his past life, such as that he had fathered a child in England. Once the fathers heard this they felt it was best that Merton withdraw his application and reconsider his vocation.

Finally in 1941, having taught for a year at a Franciscan college, he decided to spend Holy Week on retreat at Gethsemani. As he entered the doorway to Gethsemani with its inscription *Pax Intrantibus* – 'Peace to All Who Enter' – on a still April evening with the Easter moon in the sky, Merton was overwhelmed by 'the effect of that big, moonlit court, the heavy stone building with all those dark and silent windows': a moonlit place he would later so wonderfully describe in the 'Fire Watch' of his later *Sign of Jonas* (1953). 'This', he wrote, 'is the center of America. I had wondered what was holding the country together, what has been keeping the universe from cracking in pieces and falling apart' (quoted in Forest, *Living with Wisdom*, p. 73).

According to the narrative of *The Seven Storey Mountain*, written some four years after the event, Merton's entrance into the novitiate of Gethsemani in February 1942 marked the end of his 'life in the world' and the beginning of the rest of his life in the quiet and peace of the Abbey. The book itself was written in 1946 with the encouragement of the Abbot, Dom Frederic, the son of a bookbinder and publisher, but with a certain misgiving by Merton himself.

His old friend Robert Giroux, now at Harcourt Brace, accepted the manuscript for publication. It was an immediate runaway success and sold 600,000 copies in clothback alone and millions in paperback. Merton seemed to have struck a chord with a war-weary world that was seeking a way back to its spiritual roots. By turning his face against modern western culture Merton had ironically offered an

Interior of Thomas Merton's hermitage

alternative vision of salvation for that culture. As Forest puts it: '*The Seven Storey Mountain* was an electrifying challenge to the idea that human happiness consists mainly of a proper diet, a good job, a comfortable address and an active sex life' (*Living with Wisdom*, p. 90).

Yet with the benefit of hindsight Merton would later describe his autobiography, whose success often seemed to embarrass him, as the work of a 'young man' whose certainties and clear assertions, especially regarding other Christian denominations (Protestantism and Anglicanism come off particularly badly in *The Mountain*), he later repudiated.

What brought about this change and how could the somewhat conventional and rather prudish monk of the 1940s transform into the open-minded and pioneering 'campaigning monk' of the 1960s? As has been argued here, some of this lay in Merton's personality itself, not least in the spiritual and artistic insight into 'awareness' given him by his artistic parents, especially his father. However, we are fortunate in that Merton continued to publish a voluminous amount of material throughout his religious life that charts his personal spiritual development with sometimes painful honesty. This has been more than supplemented since his death in 1968 by a succession of posthumous diaries, notebooks and writings that have laid bare his soul in even greater depth.

In Gethsemani itself, Dom Frederic, who had been a spiritual father to Thomas, had died in 1948 and been replaced in 1949 by Dom James Fox. A graduate of Harvard Business School, it was clear in retrospect that his functional and managerial approach would clash with Merton's more irenic anti-capitalist counter-culturalism. In particular Merton showed a prescient sense of the dangers of ecological damage and objected to the new agricultural methods Dom James was introducing, especially the use of toxic chemicals such as DDT, which would, a decade later, galvanize the nascent environmentalist movement. Yet despite this incongruence between the two monks, Dom James allowed Merton to continue his writing career in the monastery and entrusted some key posts to him, such as Novice Master and Head of Scholastics.

Merton's move from the other-worldly monastic described in the final pages of *The Seven Storey Mountain* to the postmodern contemplative of his final years is encapsulated by a famous account of an 'epiphany' he had on 18 March 1958 while

in the nearby town of Louisville on an errand:

> *In Louisville, at the corner of Fourth and Walnut, in the center of the shopping district,*
> *I was suddenly overwhelmed with the realization that I loved all those people, that*
> *they were mine and I theirs, that we could not be alien to one another even though we*
> *were total strangers. It was like waking from a dream of separateness, of spurious self-*
> *isolation in a special world, the world of renunciation and supposed holiness. The whole*
> *illusion of a separate holy existence is a dream.* (Conjectures of a Guilty Bystander, p. 140)

From now on Merton would not be concerned with cultivating a spurious elite 'religiosity' but concentrating on awareness of 'God in all things' through cultivation of the 'authentic self' through spiritual freedom (Tyler, 'Thomas Merton'). It is no accident that this new insight coincided with a renewed interest in psychoanalysis, which he had earlier rejected in *The Seven Storey Mountain* as dangerous to religious belief (see below). In addition he reversed his earlier views on non-Catholic Christians and people of other faiths.

Thomas Merton outside his hermitage

In 1965, having long asked permission, Merton was finally granted his wish to live as a hermit in the grounds of Gethsemani. His life now took on a new intensity as all its various and disparate elements seemed to come together. He wrote in his journals of his passionate communion with the beautiful Kentucky landscape around him while continuing his campaigning on social issues and his exploration of 'inner' space through psychoanalysis and studies in other religious contemplative approaches, especially Zen Buddhism, Tibetan Buddhism, Sufism and Hasidism.

Merton's interest in eastern religions reached its climax with his fateful visit to Asia in 1968. He had been invited to address the Bangkok Conference of Asian Benedictine and Trappist Superiors, and in October he set off for Bangkok via

Calcutta. Following a conference there he travelled to Dharamsala to meet the newly exiled Fourteenth Dalai Lama and his Tibetan community in exile. From northern India Merton moved to Sri Lanka in late November and there occurred, some two weeks before he died, another one of those deep 'mystical experiences' that seemed to punctuate his life. While viewing the famous statues of the reclining Buddha at Polonnaruwa:

> *I was suddenly, almost forcibly, jerked clean out of the habitual, half-tied vision of things, and an inner cleanliness, clarity as if exploding from the rocks themselves, became evident, obvious.* (The Asian Journal, p. 233)

Sadly, having delivered his paper on 'Marxism and Monastic Perspectives' to the Abbots' conference in Bangkok on 9 December, Merton was found dead later that afternoon in his accommodation. It seems as though after a shower a faulty fan had fallen on him and electrocuted him. Ironically, his body was flown back to the States in a USAF aeroplane in the company of the bodies of US military fighting in Vietnam, for whom he had so tirelessly campaigned. He was buried at Gethsemani.

After his morning conference on the day he died, a nun had complained that he had said nothing about conversion. Accordingly, his final recorded words were:

> *What we are asked to do at present is not so much to speak of Christ as to let him live in us so that people may find him by feeling how he lives in us.*
> <div align="right">(quoted in Forest, Living with Wisdom, p. 216)</div>

Spiritual teaching

'Once you have grace,' wrote Merton in *The Seven Storey Mountain*, 'you are free.' Spiritual freedom is perhaps the cornerstone of much of Merton's view of the spiritual life. 'You will know the truth,' says Christ in St John's Gospel, 'and the truth will set you free.' Merton, with his insistence on the harmony of the spiritual life with personal freedom, represents a distinctly modern, if not postmodern, approach to the questions of the spiritual life. For Merton the religious search is the search for the 'authentic self', and he is a vocal critic of all forms of 'false religious self' or 'religiosity'. At a conference of Loreto nuns in 1966 (Tyler, 2000, p. 82), he suggested that religious people in particular have a tendency to create a false 'religious self'

that is opposed to their 'actual self', 'and then waste energy coping with the false problems that arise'. Merton's life can be interpreted as a journey to finding that real self, which he seems eventually to have found in his religious life at Gethsemani, but open to all the social and religious movements present in the contemporary world. Coming as he does at the end of the 'modern' era and the beginning of the 'postmodern' critique of that era, it would not be too far-fetched to call him a 'post-modern mystic'.

I shall characterize his spiritual approach (which is almost impossible to sum-marize, so vast being his interests and writings) by defining it in seven categories: contemplation, an engaged social ethic, psychological insight, embodiment, God in the everyday, awareness of creation and ecumenism.

Contemplation

For Merton, contemplation or, to use the term of his French contemporary Simone Weil, 'awareness', was at the heart of Christian life. For Merton this was not just something for 'religious professionals' but something that was gifted to all Christians as their divine right. His whole life can be seen as an attempt at living with and trying to articulate the strange processes of the 'subtle nothingness of prayer'.

In one of his last books, *On Contemplative Prayer*, published posthumously in 1973, he states:

> *We should not look for a 'method' or 'system', but cultivate an 'attitude', an 'outlook': faith, openness, attention, reverence, expectation, supplication, trust, joy. All these finally permeate our being with love in so far as our living faith tells us we are in the presence of God, that we live in Christ, that in the Spirit of God we 'see' God our Father without 'seeing'. We know him in 'unknowing'.*

Prayer and contemplation are not, then, an 'add-on' to life for Merton, they are at the heart of life. This 'divine unknowing' is the beginning of all wisdom and the heart of Christian contemplation. 'It is the seriousness', Merton reminds us, 'of breathing when you're drowning' (R. Baker and G. Henry, *Merton and Sufism*, p. 154). Once we recognize our nothingness and helplessness before God then we can begin to pray. From such a perspective, even a coldness or impossibility to begin prayer is in itself a sign of this helplessness before God – a sign of his grace towards us and

Also around this time

1941
Japan attacks Pearl Harbor;
USA enters the Second World
War.

1945
Yalta Conference agrees to joint
Russian/US occupation of Korea.

1950–3
Korean War– UN troops sent to
defend South Korea. Costs the
lives of four million people.

1947–51
Hollywood under investigation by
'House of Un-American Activi-
ties', set up to investigate
unpatriotic behaviour.

1950–4
Joseph McCarthy's 'witchhunt',
accusing people in State Depart-
ment and military of belonging to
the Communist Party; finally
censure passed in Senate on
McCarthy.

1954
Start of American involvement in
Vietnam War.

1960
J. F. Kennedy President of the
USA.

1961–3
US Military Advisors in Vietnam
increased from 500 to 16,000.

1963
J. F. Kennedy assassinated in
Dallas, Texas.

1964
'Civil Rights Act' outlaws discrimi-
nation in public places: 'Freedom
Summer' and 'Freedom Schools',
and 'Anti-Poverty Act' passed.

Continued opposite

the necessity for our dependence upon his grace. For as Mer-
ton reminds us, ultimately there can only ever be one teacher
of prayer – and that is the Holy Spirit. Such a prayer, such a
contemplatio, is not a *fugit mundi*, a flight from the world, but
leads us back into life, into the arms of the world. This leads
us to our second aspect of his spirituality: an engaged social
ethic.

An engaged social ethic

As we have seen, throughout his life Merton never saw the
Christian vocation, especially the contemplative life, as some-
thing that could be divorced from the struggles and sufferings
of our times. The twentieth century saw the most horrendous
atrocities committed; Merton lived through them all and
wanted Christians to reflect especially on their complicity
with unequal and ultimately murderous social structures.
When he arrived at Columbia University in the 1930s he
was conducted through a tour of the city morgues as part of
his 'contemporary civilization' course. The sight of the
corpses of so many poor and homeless people made him re-
alize the privileged life he had been leading and the need for
greater social justice even in the wealthy and developed city
of New York. From Merton's writings we can draw out three
aspects of his understanding of such an engaged social ethic.

First, how such an ethic reiterates the essentially Trinitar-
ian nature of Christian spirituality. Much Christian discourse
over the past half century has sought to re-engage with the
Trinitarian model at the heart of Christian theology and
social anthropology. In the opinion of modern theologians
we could describe ourselves as *homo relationis* – instead of 'I
think therefore I am', our twenty-first-century motto could
be 'You are therefore I am'. As God is defined in terms of
relatedness then our basic anthropology, as reflecting God's

triune life, can also be defined through relatedness. In Merton's words, it is our deep need for 'community, for a genuine relationship of authentic love with our fellow men and women' (*Faith and Violence*, p. 30) that lies at the heart of our Christian lives and practice.

The second aspect of Merton's understanding of the 'engaged social ethic' is our relationship to and analysis of violence in society. In *Faith and Violence* (p. 78) he places our First World, western, consumerist behaviour in the context of a radical social analysis that still bites today:

> *The population of the affluent world is nourished on a steady diet of brutal mythology and hallucination, kept at a constant pitch of high tension by a life that is intrinsically violent in that it forces a large part of the population to submit to an existence which is humanly intolerable . . . The problem of violence, then, is not the problem of a few rioters and rebels, but the problem of a whole structure which is outwardly ordered and respectable, and inwardly ridden by psychopathic obsessions and delusions.*

We are systemically part of the structures of violence that envelop our society and we have complicity in the violence of society.

The third and final part of Merton's social ethic in a way combines the first point with the second: that there can be no social engagement unless it is rooted in deep contemplation and awareness of self. In the famous 'Letter to an Activist', written to Jim Forest on 21 February 1965, Merton emphasizes the importance of not attaching to the results of activism: 'face the fact that your work will be apparently worthless and even achieve no result at all, if not perhaps results opposite to what you expect' (*The Hidden Ground of Love*). 'All the good that you will do', he adds, 'will come not from you but from the fact that you have allowed yourself, in the obedience of faith, to be used by God's love.' Along with alcohol, sex, food and consumer goods, it seems we can add social activism to the list of things we use to fill the void that lies at the centre of our aching hearts. 'The great thing', he concludes, 'is to live, not to pour out your life in the service of a myth: and we turn the best things into myths.'

Continued

1965–9
Escalation of Vietnam War under President Lyndon B. Johnson. Average age US servicemen 19.

1967
Large anti-war demonstration on the steps of the Pentagon, particularly against large draft call-ups.

1969–73
Anti-War movement gains strength; gradual withdrawal of American troops.

Psychological insight

As a young man wanting to reject Christian values, Merton had turned towards psychoanalysis. At this point he saw analysis as offering an opportunity to 'indulge the appetites':

> *I, whose chief trouble was that my soul and all its faculties were going to seed because there was nothing to control my appetites – and they were pouring themselves out in an incoherent riot of undirected passion – came to the conclusion that the cause of all my unhappiness was sex-repression!* (p. 124)

In *The Seven Storey Mountain* he is censorious about psychological analysis and suggests that 'if I ever had gone crazy, I think psychoanalysis would have been the one thing chiefly responsible for it'. However, as he continued to live at Gethsemani, coming into increasing conflict with Abbot James and wondering if the Cistercian vocation was right for him, he became increasingly interested in psychoanalysis. Prompted by meetings with the psychiatrist Gregory Zilboorg he began to take this element of the personality more seriously. By the time he was addressing his conferences to novices in the sixties he was becoming interested in types of what we would today call 'transpersonal psychology' that took the spiritual life seriously and sought to integrate it into psychological development. His last books show a deep integration of psychological and spiritual insight. In *Contemplative Prayer*, for example, the integration of the two is almost seamless and he writes with mastery of the spiritual life using tropes from the early Desert Fathers and metaphors from Freud and Jung such as 'the ego' and 'the unconscious' with ease:

> *The 'flame' of which St John of the Cross is speaking is a true awareness that one has died and risen in Christ. It is an experience of mystical renewal, an inner transformation brought about entirely by the power of God's merciful love, implying the 'death' of the self-centred and self-sufficient ego and the appearance of a new and liberated self who lives and acts 'in the Spirit'.* (*Contemplative Prayer*, p. 110)

Examining the life of Thomas Merton we see exactly this 'reintegration of the self in Christ' through marriage of different poles of the self. Merton, living from the unconscious as a young man, embraces the hard ethical demands of the Christian

life when he enters Gethsemani. Only with age and experience does he realize that the hard edges of ego-control have to be surrendered to allow a softer entrance of the spirit into all aspects of the self, bringing about what Blake, his great inspiration, calls the 'marriage of heaven and earth'.

Embodiment

Merton's later spirituality is not only psychologically aware but embodied. It takes all aspects of the self seriously, including the erotic and the libidinal. As a young man he ping-pongs between indulgence of the body and repression of its desires. With age he begins to integrate the two so that when he falls in love again at the age of 50 with a local nurse he is able to act with restraint and discernment while still being able to love again.

Christians seem to be notoriously bad at accepting their embodied selves, yet Merton acknowledges that this must sometimes be a journey of 'unknowing and faith' as we trust the wisdom of the body. His spirituality is not just a school of the head but a school of the heart and intuition that gives as much importance to the arts, liturgy and embodied expression as it does to scholastic theology. As he puts it in *Zen and the Birds of Appetite* (p. 30):

> *In our need for whole and integral experience of our own self on all its levels, bodily as well as imaginative, emotional, intellectual, spiritual, there is not place for the cultivation of one part of human consciousness, one aspect of human experience, at the expense of others, even on the pretext that what is cultivated is sacred and all the rest profane. A false and divisive 'sacredness' or 'supernaturalism' can only cripple us.*

God in the everyday

The breakdown of the barrier between the sacred and the secular leads to our fifth aspect of Merton's spirituality – the breakdown of the barrier between the ordinary and the extra-ordinary. It is what Jean Pierre de Caussade referred to as the 'sacrament of the present moment'. Merton again, put it thus:

> *There is no longer any place for the kind of idealistic philosophy that removes all reality into the celestial realms and makes temporal existence meaningless . . . we need*

to find ultimate sense here and now in the ordinary humble tasks and human problems of every day.

As mentioned above, Merton seems to have been very influenced here by the artistic vision of his father, Owen Merton, and there is no doubt that the 'quiddity' or 'thisness' of everyday objects (and here he was very influenced by Gerard Manley Hopkins) played a significant role in his developing spirituality. This is very evident in his photography. Here we see the essence of the Creator 'shining out like shook foil' in all creation.

Awareness of creation

This awareness of the present moment – 'the power of now' – leads to a wider awareness of the cosmos and our own place within creation. Faced with the ecological disasters of the late twentieth century we are forced more and more to reassess our own place within creation and our commitments and responsibilities to the world around us. Merton in the late 1960s talked about the need to address those problems 'which threaten our very survival as a species on earth' (*Zen*), and as we have seen, he was prescient in his negative response to the new agricultural technologies being introduced at Gethsemani by Abbot James in the 1950s. When such concerns became mainstream in 1962 with the publication of Rachel Carson's *Silent Spring*, he responded positively to her critique: 'We are in the world and part of it and we are destroying everything because we are destroying ourselves, spiritually, morally and in every way. It is all part of the same sickness' (*Turning Toward the World*, p. 274).

Merton saw the destruction of the environment as the counterpoint to self-hatred and self-destruction; only when we can respect ourselves can we respect the created order.

Ecumenism

The seventh and final aspect of Merton's spirituality to highlight here is the importance of openness to dialogue between the Christian denominations and the world faiths. As we live at this precarious moment in our planet's future the ecumenical imperative becomes even more important than ever. As with so many aspects of his teaching, Merton was again ahead of his time, embracing dialogue with Buddhists, Muslims, Jews, Hindus and Sikhs at a time when it

was not only unfashionable but even frowned upon. As we have seen, following his conversion to Catholicism and his entry to Gethsemani he was rather sceptical towards other Christian denominations and took up a 'fortress mentality' towards his Roman Catholicism. However, reflection and conversations in the 1950s and 1960s, in particular with Thich Nhat Hanh, Boris Pasternak, D. T. Suzuki and the fourteenth Dalai Lama, led him to ever greater awareness of the need for dialogue between the denominations and faiths. As we have seen, this culminated in his Asian journey and the extraordinary mystical vision of unity he experienced at Polonnaruwa just before he died. Although in many respects his approach to interfaith dialogue does not have the sophistication of much contemporary work, he was a pioneer in the field and works such as *Zen and the Birds of Appetite* and his lectures to novices on Sufism (P.M. Tyler, 'Sufism and Christianity', p. 603) are groundbreaking and still relevant today.

In conclusion then, this brief survey has attempted to show how Merton combined all the facets of his myriad interests to create a spirituality that is authentic and speaks to us today. We began with contemplation, and there is no doubt that all Merton did and achieved arose from his deep commitment to the contemplative life. However, for him this was no *fugit mundi* but something that takes us to the heart of the conflicts and struggles of our contemporary society. 'If your spirituality is worth anything', he seems to say, 'then it must be tested in the fires of the world.' Merton did exactly this and found that we could enter those fires consoled and guided by the gentle breeze of the Holy Spirit, for he wrote in *The Courage for Truth* (p. 57):

> *Life is on our side. The silence and the Cross of which we know are forces that cannot be defeated. In silence and suffering, in the heartbreaking effort to be honest, in the midst of dishonesty (most of all our own dishonesty), in all these is victory . . . Much in us has to be killed, even much that is best in us. But Victory is certain. The Resurrection is the only light, and with that light there is no error.*

PETER TYLER

SWAMI ABHISHIKTANANDA

Shirley du Boulay

Swami Abhishiktananda

Introduction

With Swami Abhishiktananda, Christian mysticism in the Latin West moved out of its traditional arena and was placed in an encounter with another faith tradition. Although there had been a renewed interest in mysticism in the twentieth century, accompanied by a sporadic flowering of the contemplative aspect of prayer, it remained the province of the few and was not really accepted by the Church or even taught as such in the monasteries.

Henri Le Saux, although he was a Benedictine monk, would not have been introduced to contemplative prayer in any formal way. His background was very traditional, and yet he personally felt a strong urge to a deeper way of relating to God, to go beyond the usual confines. Somehow this seemed to be linked with a passionate desire to go to India.

Shirley du Boulay describes how his spiritual journey led him to engage in an endeavour to reconcile the traditional views of Christianity, with which he had been brought up, with his search for Oneness, the experience of union between God and humanity.

> Swami Abhishiktananda 1910–73
>
> He was born Henri Le Saux in Saint Briac in Brittany to an extremely devout Roman Catholic family. For seven years he was the only child, which explains his close relationship with his mother and the caring role he played with his later siblings.
>
> From an early age he felt a vocation for the priesthood; in 1921 he entered a minor seminary and in 1926 the major seminary in Rennes. Three years later he responded to the call of the monastic life by entering L'Abbaye de Sainte-Anne de Kergonan, where he was ordained priest in 1930.
>
> At the start of the war he joined the army, but was soon captured. He escaped and returned to the monastery.
>
> Since 1934 Abhishiktananda had felt a longing to go to India, but the opportunity did not arise until 1948, following the death of his mother. By 1950 he was with Father Monchanin in the Shantivanam Ashram, where he took the name Abhishiktananda.
>
> Strong Hindu influences on his spiritual life were Sri Ramana Maharshi, the mountain of Shiva Arunachala and Sri Gnanananda.
>
> More and more he was sought out by theologians and others on the spiritual path and took part in many conferences, but constantly he was drawn back to solitude and stayed several times in the Himalayas. At the end of his life he lived as a hermit there and died of a heart attack in 1973.

AN UNUSUAL FIGURE

Abhishiktananda was one of the most unusual figures of the twentieth century and one of his characteristics was his passion for anonymity. He wanted to lose himself in the vastness of God, to be so much one with reality that there was no separate self for him to claim. One of the moving things he said of himself was that he was 'A being lost in my source, a being lost in my fulfilment. And in this very loss, I am . . .'

His life was dedicated to a search for oneness, for living in the present moment, for simply being – which of course isn't simple at all. He loved God – or truth, or reality, or simply the Other, whatever your particular language is – with a rare passion. His search for the truth was so passionate, so dedicated, that at times he was overwhelmed by it and for much of his life he was in anguish. He was a contemporary mystic whose story is a story of transformation and whose life was lived in the tension of contradiction.

He was also intensely human and extremely funny, never taking himself too

Abhishiktananda's writings

Guru and Disciple: An Encounter with Sri Gnanananda, a Contemporary Spiritual Master, ISPCK, 1970.

The Church in India: An Essay in Christian Self-Criticism, The Christian Literature Society, 1971.

Hindu–Christian Meeting Point: Within the Cave of the Heart, ISPCK, 1983.

The Further Shore: Three Essays, ISPCK, 1984.

Swami Abhishiktananda: His Life Told Through His Letters, ed. James Stuart, ISPCK, 1989.

The Mountain of the Lord: Pilgrimage to Gangotri, ISPCK, 1990.

Saccidananda: A Christian Approach to Advaitic Experience, ISPCK, 1997.

The Secret of Arunachala: A Christian Hermit on Shiva's Holy Mountain, ISPCK, 1997.

Ascent to the Depth of the Heart: The Spiritual Journey of Swami Abhishiktananda, ed. Raimon Panikkar, trans. David Fleming and James Stuart, ISPCK, 1998.

Prayer, ISPCK, 1999.

seriously and loving conversation as much as he loved solitude and silence. You could say of him, as was said of Teresa of Avila, he was 'extraordinarily ordinary'. He once pleaded, 'Let me find fulfilment in each of my actions, eating my rice, washing my feet, listening to boring stories.' And he mocks himself deliciously when he writes of being invited to sit next to his guru in front of the other disciples, leading the discussion with him. Seeing himself through others' eyes he wrote how it must have been 'mighty strange to see this Benedictine monk seated on a tiger skin beside the master, with bare shoulders, saluted with protestations'.

Most people when they die leave something behind – something material and tangible. It might be several houses and a yacht; it might be a tiny flat and a few hundred pounds. Apart from his writings, and some very good friends, Abhishiktananda left nothing, nothing at all. It was as if he had never been. Almost everything to do with Abhishiktananda has disappeared.

However, numerous articles, books and letters remain, revealing a man who must surely be regarded as one of the great mystics of our time and someone, I would claim, whose time has come. Abhishiktananda broke boundaries. He was a mystic of such significance that it is hard to find many people that one can mention in the same breath – I would suggest the Dalai Lama, St John of the Cross, Meister Eckhart and Ramana Maharshi.

When Swamiji – as he was known in India – died, he was simply removed from the face of the earth. There is nothing to hang on to, nothing to make into a relic. There seems to be a profound symbolism here. It's as if the Spirit did not want to hang on to anything material to do with Swamiji. We must meet him on the inside; try to understand his extraordinary inner life. He wrote something to a friend as early

as 1956 that has echoes of this wish for the absence of anything material: 'In the final analysis the Mystery is only accessible to the one who allows himself to be consumed in the fire, the fire of camphor, which leaves no residue at all.'

So Abhishiktananda, though he was a good theologian and respected by theologians, should not be considered as a theologian, for theology is on the outside looking in. Swamiji was on the inside looking out. Always he put experience first. He valued theology only to the extent that it expresses experience and gives it a context.

He was a man for whom God was everywhere – in practice not just in theory. A man who told a religious sister looking to him for holy words that God is as much in the making of a good soup or the careful handling of a railway train as he is in our most profound meditations. He is not an easy person to talk about. He was a voice calling, 'Do not seek without, enter within yourself. Everything is there.' Or its equivalent in the Upanishads: 'Seek to know the one who dwells in the cave of the heart.'

His life

He was born Henri Le Saux, the oldest of eight children, in 1910. His parents ran a grocery shop in St Briac, in Brittany. They were very devout, very French – indeed very Breton. He was the eldest by seven years, which made him almost a second father to his siblings and gave him a special, very deep, relationship with his mother; after all, he had had her to himself for a long time. He was also a very practical man, which somehow one does not expect.

He was a brilliant student and in 1929 became a Benedictine monk at the monastery of Kergonan in south Brittany. He did this completely wholeheartedly, writing very typically: 'A monk cannot accept mediocrity – only extremes are appropriate for him.'

He was not a man for half measures. His monastic routine was interrupted when he did his military service and again in 1940 when general mobilization was decreed and he served as a foot soldier. He was captured in the Mayenne when his unit was surrounded by German troops. He managed to escape before the names were taken and somehow contrived to borrow a bike and rode home to St Briac. His practical streak proved useful.

On his return to the monastery he was made Cérémonaire, the monk in charge

Glossary

Bhakti – devotion – expression of love and surrender to God.

Darshan – a gathering in the presence of a holy person.

Rishis – Indian holy sages from time immemorial.

Vedanta – a system of Hindu philosophy based on the end of the *Vedas*, the *Upanishads*, *Brahmasutras* and *Bhagavad Gita*; has both *dvaita* (duality) and *advaita* (non-duality) groupings.

of the liturgy, one of the most important jobs. Even in those days when liturgy was strict, he was considered an exceptionally strict and punctilious liturgist. When we see how he developed in his long years in India this has a comic side to it – he himself would laugh when he remembered the way he insisted that everything was done 'just so', 'spick and span'. Despite this fussiness and strictness he was very popular with the monks because he did everything in such a kind and friendly way. He was also librarian and taught Church History and Patristics.

He was a good and devoted monk and it must have been assumed that he would see out his days in the monastery of Kergonan. However he had, unknown to absolutely everyone – the monks, his Abbot, even his devoted family – become obsessed with the idea that he must go to India. This can be dated with some accuracy to 1948, when he was only 24 years old and even before he was ordained. How he acquired this passion to go to India has an intriguing element of mystery in it. It seems that a few articles in magazines sent to Kergonan by a Belgian monastery were the only possible source of his interest. His friend Canon Lemarié, with whom he corresponded all his life, told me that it was a mystery to him too, as there was little on the subject in the library at Kergonan (neither *Upanishads*, nor *Bhagavad Gita*) – just a few reviews of the missions to the East.

His attitude to his monastery was ambivalent. On the one hand he had taken a vow of stability, requiring him to remain in his monastery for the rest of his life, and he loved Kergonan, only weeks before his death admitting: 'Kergonan has been the background of all that I have been able to do here.'

On the other hand there were times when the negative side could not be contained and he admitted to 'distaste for the monastery' and conceded that life there did not fulfil him; indeed, that 'It was in my deep dissatisfaction that my desire to come to India was born.'

But there is still the mystery of what drew him to India particularly and perhaps it is appropriate that this remains such a mystery. It adds to the force of his passion that it was so unreasonable, based on so little direct information. It was as if something

was in his blood that he simply could not deny. And certainly this is what it looked like from his actions. His efforts to get to India started immediately after the death of his beloved mother – he would not have left France while she was alive. He went to see his Abbot, explaining that he wanted to go to India to establish the contemplative monastic life there in a completely Indian form – or if that was not possible at least to live in India as a hermit.

For four years he wrote letters to likely people in India, enduring disappointments, vacillations, hesitancy and the changing of ecclesiastical minds. He persisted and, on 26 July 1948, he set sail for India – the fulfilment of a dream that had had him in its grip for 14 years.

India

He arrived in India in August 1948, a year after Independence and six months after the assassination of Gandhi, though curiously he writes little about these momentous events. He joined Father Monchanin, an extraordinary French diocesan priest who had been living in India for some time. In 1951 the ashram for which they both longed – which they called Shantivanam, Forest of Peace – was inaugurated and they both took Indian names, Henri Le Saux becoming Abhishiktananda. He wanted Indian monasticism to be firmly established on a well-tested *Rule*, and to take its inspiration from the best products of western monasticism. In other words he wanted to Christianize India along Benedictine lines. How he was to change!

For the next 18 years he lived in Shantivanam – or perhaps it would be truer to say that Shantivanam was his base, for he spent much of his time wandering around India, wanting to experience the country and its spirituality for himself; he was not content to read about it or even just to talk about it. Once again we see his passion for experience.

The question that arises is when did he start to lose interest in Shantivanam, for lose interest he most certainly did – somehow the spark does not really seem to have been lit, even in the early days. The first problem was that his relationship with Monchanin was difficult – for many reasons, one being that Abhishiktananda rather resented having to do all the practical work . . . Monchanin was in poor health and impractical by nature, so one can see the difficulties for him too.

The most probable cause of Abhishiktananda's loss of interest was that he had

only been in India for a few months when something
happened that was to blow his mind, affect the rest of
his life and, more immediately, affect his attitude to
Shantivanam. He went to Tiruvanãmmalai, to the
Holy Mountain of Arunachala where the great sage
Ramana Maharshi lived.

Ramana Maharshi

Ramana Maharshi

Meeting Ramana Maharshi was perhaps the greatest
and most important moment of his life so far. Ramana
taught mainly through silence, seeking what he called
'Awakening'. When pressed he would constantly ask
the question, 'Who am I? What is the Self?' Sometimes he would answer his own
question by saying, 'The Self is only Be-ing, not being this or that. It is simply Being.'

Though Ramana's writings had not been translated into French at the time,
Abhishiktananda had read enough about him in articles in various periodicals to
be convinced that his visit to the famous sage was going to be a high point in his
life.

It was 1949. Ramana was 70 when Abhishiktananda and Monchanin went to
see him, and very frail after a life of asceticism. Abhishiktananda was convinced that
something was going to take place between them, that he would receive a message,
if not in words, at least something that would be communicated spiritually. But
there is nothing as destructive of fulfilment as high expectation. Nothing happened.
He felt let down and filled with sadness. He did not even like the context in which
he met the sage – the liturgical atmosphere, the constant reference to him as 'Bha-
gavan', which, as it means 'Lord', he considered almost blasphemous when applied
to a human being. All he could see was an old man with a gentle face and beautiful
eyes; so ordinary, rather like his own grandfather. All through the meal that followed
the *darshan*, Abhishiktananda could not take his eyes off him. He watched him eat
the same food as they did; use his fingers just as they did, occasionally talk as they
did. But how could he accept being called 'Bhagavan'? Why did he allow himself to
be worshipped in this way? Where was the halo? Ironically, in view of the importance
Ramana was to have in his life, this first meeting was a huge disappointment.

That evening, for the first time, Abhishiktananda heard the *Vedas* chanted, as timelessly and simply as they had been chanted by the Rishis in the forests for thousands of years. These archetypal sounds drew him as nothing so far had done. Something was stirring, though this was not destined to be the high experience for which he had hoped. He woke next morning with a fever and by the evening he knew he had to leave. He could not burden the ashram with illness.

But before he left he had an important encounter with Ethel Merston, a sensitive and kindly Englishwoman who had known Gurdjieff, Ouspenski and Krishnamurti and who always spent her holidays at Tiruvanāmmalai. On hearing of his disappointment she spoke bluntly: 'You have come here with far too much "baggage". You want to know, you want to understand. You are insisting that what is intended for you should necessarily come to you by the path which you have determined. Make yourself empty; simply be receptive: make your meditation one of pure expectation.'

Perhaps the outer fever was an expression of some profound inner transformation. After Ethel's firm and kindly words his consciousness mysteriously changed, even before his mind recognized it:

> the invisible halo of the Sage had been perceived by something in me deeper than any words. Unknown harmonics awoke in my heart. A melody made itself felt, and especially an all-embracing ground-bass . . . In the Sage of Arunachala of our own time I discerned the unique Sage of the eternal India, the unbroken succession of her sages, her ascetics, her seers; it was as if the very soul of India penetrated to the very depths of my own soul and held mysterious communion with it. It was a call which pierced through everything, tore it apart and opened a mighty abyss.

Six months later he returned to Tiruvanāmmalai, now released from his western clothes and comfortable in *kavi*, the two strips of orange cloth worn by Hindu ascetics, only to find Ramana very ill with a tumour on his arm and unable to see anyone but his medical helpers and closest friends. However, Ethel used her influence to find him somewhere to stay, and during his time there Ramana began to hold *darshan* again, Abhishiktananda saying of this that he did his best to keep his rational mind in abeyance and tried 'simply to attend to the hidden influence'.

He spent some time wandering round the caves hewed into the side of the mountain, meditating in crevices in the rock but careful not to disturb the hermits

Arunachala mountain, Tamil Nadu

living there, motionless in their caves. He talked to Ramana's disciples and learned more about the Sage he was coming to venerate so deeply. Once again it was Ethel Merston who opened his eyes to something that had so far eluded him. At Arunachala there was not only a great sage, but a temple and, most of all, a mountain – Arunachala itself; grace could be bestowed through any of these three channels. One day it would be the mountain itself that would draw him.

He listened carefully to Ethel Merston, but it was to be some time before he really understood. And understanding served only to multiply the divisions inside him. He had already admitted to having 'two loves' – India and France. Now more divisions were appearing. He was wearing the clothes of a Hindu ascetic and longing to penetrate the spirit of Hinduism. Yet he was a French priest, deeply Christian, and of the old-fashioned variety, never travelling without his Mass kit and unable to say Mass unless there was room to stand upright and a door that could be locked to prevent the sacred vessels being profaned – two conditions not readily found in a cave in a mountainside. Now, as he came to love the mountain, he found his heart divided between the sacred river Kavery, at Shantivanam where he lived with Father Monchanin, and the sacred mountain of Arunachala, home of Ramana Maharshi.

Yet it was two and a half years before he returned to Tiruvanammalai, and by then Ramana Maharshi had died. When he arrived at Arunachala the *Vedas* were being chanted at Ramana's tomb and once again Abhishiktananda fell under their spell; even more significantly, he discovered that there were hermitages scattered round the mountain-side and a Brahmin, who looked after the visitors, told Abhishiktananda that there was an empty cave overlooking the Temple and that he was welcome to settle there. He began to understand: 'If Ramana was himself so great, how much more so must be this Arunachala which drew Ramana to himself?'

He wrote, 'In silence you will teach me silence, Arunachala.' The mountain had begun to cast its spell over him. Much later he wrote a book about Arunachala. His relationship with the Holy Mountain is as profound and important as a relationship between people. Here is one of many moving passages about the mountain:

> It is all up with anyone who has paused, even for a moment, to attend to the gentle whisper of Arunachala. Arunachala has already taken him captive, and will play with him without mercy to the bitter end. Darkness after light, desertion after embraces, he will never let him go until he has emptied him of everything in himself that is not the one and only Arunachala and that still persists in giving him a name, as one names another – until he has been finally swallowed up, having disappeared for ever in the shining of his Dawn-light, Aruna . . .

The last 20 years

The first 40 or so years of Abhishiktananda's life were the bedrock of his extraordinary inner life. Much more was to follow. Abhishiktananda was to live another 20 years, all of them spent in India – he never returned to France or went anywhere else, all that time working out the implications of his experiences, most of all trying to reconcile the Christian faith from which he never wavered with the bliss and peace of *advaita* – non-duality. He once wrote: 'I am like someone who has one foot on one side of the gulf, and the other on the other side. I would like to throw a bridge across, but do not know where to fasten it, the walls are so smooth.'

He also had an eventful outer life, travelling widely over India. He made numerous friends and wrote 12 books, many articles and thousands of letters – and it is from these friends and in these thoughts that we can learn about his life, his memory kept alive, his thoughts and vision expressed in his writing. Increasingly he was asked to speak at conferences and to take retreats – but only rarely did he accept. He was in almost every way a *sannyasi*, someone living a life of total renunciation. He learned – at the very end of his life – to leave everything behind: 'Please don't add anything to my myth. There was no grand vision, but a waiting, an awakening, quite peaceful, to something which is neither life not death.' So he was propelled further along his extraordinary path – a journey that took him from strict old-fashioned French priest to a hermit living in the Himalayas.

Also around this time

1914–18
The results of the First World War and the trench warfare on the Western Front left France devastated for more than a generation. The war spelled the end of empires – German, Russian, Austro-Hungarian and Ottoman – and redrew the map of Europe.

1940
Fall of France; Vichy government, collaborating with the occupying forces, established in the south of France.

1942
Launch of 'Quit India Movement' in response to Mahatma Gandhi's call for immediate independence.

1944
Liberation of France.

1947
Indian independence from Britain; partition of India and Pakistan; ensuing religious riots.

1971
East Pakistan, Bangladesh, secedes from West Pakistan.

Abhishiktananda was a priest who knew that if we stand in the presence of reality all we can do is open our mouths – he used to refer to it as the 'Ah' of the Kena Upanishad: 'The cry "Ah!" when lightning has flashed, the cry "Ah!" when it made them blink – such it is with respect to the divine sphere.'

In 1973 he had a heart attack. He described this as the greatest moment of his life – the moment when he really understood. He was in a street in Rishikesh when it happened and this was what he wrote to his sister in France:

It was a marvellous spiritual experience. The discovery that AWAKENING has nothing to do with any situation, even so-called life or so-called death, one is awake, and that is all. While I was walking on the sidewalk, on the frontier of the two worlds, I was magnificently calm, for I AM, no matter in what world! I have found the GRAIL – and this extra lease of life – for such it is – can only be used for living and sharing this discovery.

He was transformed. It was the moment when the lightning struck him and he died to everything as never before. The mist fell from his eyes and he was able to answer the question he had asked ever since that day nearly 25 years earlier when he had first asked: 'Who am I?'

Five months later, on 7 December 1973, he died.

Swamiji – a man of paradox

You can hardly say anything about Swamiji without having to contradict it. He was less and less interested in trying to found anything, or form anything. He became content not even to know where he was going; he was always on the move; he did not really belong anywhere; a real nomad. His hut in the Himalayas, then Indore Nursing Home, or Shantivanam: all were bases from which to wander. He was hungry for 'beyond'; he would never settle down.

For many years he wasn't a man of peace, but a man living through extreme

tensions. He knew *advaita* – non-duality – was true. He loved and believed in Christ and was seriously threatened by people who doubted that he was a real Christian, shaken to the core if anyone doubted his orthodoxy. He felt deeply that 'Only in Christ do we experience God.'

He wanted Roman Catholics to know he was a real Roman Catholic. The great tension of much of his life, causing him real anguish and suffering, was how to reconcile Advaita and Christianity. He remained a priest and he remained a Benedictine monk, but he was a long way from the average expectations of a Catholic priest. He was beyond all structures, yet he remained a disciple of Jesus. He reached a level of knowing beyond any words. In the end even the Mass became unimportant – he could celebrate or not: everything was divine, so it didn't really matter. But when he did say Mass, they were momentous occasions. Murray Rogers remembers Masses said on the banks of the Ganges, going on and on – it could not be too long for him, it was so wonderful.

As far as the Church is concerned, Swamiji never left the Church but he did become distanced from it:

> If only the Church was spiritually radiant, if it was not so firmly attached to the formulations of transient philosophies, if it did not obstruct the freedom of the Spirit … without such niggling regulations, it would not be long before we reached an understanding.

He came to see more and more clearly the false duality of the Church, for instance in regarding people as active or contemplative. For him the role of the contemplative was 'to awaken others from within; from the depth of their soul to summon each soul to its own depth, which is the most vital need in the increasing agonizing crisis of the Church'.

Duality simply didn't exist for him. He couldn't make distinctions – he couldn't insist on keeping Christianity separate and on top – or claim that Christian mysticism took people further. 'It is quite impossible to make comparison at the conceptual level between Vedanta and Christianity. Both of them are in the first place experiences.'

One distinction he did make was between 'being' and 'doing'. That was a constant. Most of all he wanted simply to be. As he wrote to Raimundo Pannikar: 'To do? To do what? I am not here to do anything, but to be.'

SHIRLEY DU BOULAY

TWENTY-NINE

BEDE GRIFFITHS

Shirley du Boulay

Bede Griffiths

Introduction

Bede Griffiths, who was practically a contemporary of Abhishiktananda, also felt the call of the East. Before he went to India he had expressed his desire to find 'the other half of my soul' (*The Marriage of East and West*). When he arrived there in 1955 he felt totally at home. He was struck by the way people lived so spontaneously and were still so in touch with the unconscious and the sacredness of life, unlike in the West where the rational side of being, the 'ego', dominated.

He also soon realized that the way European Christianity was presented in India would not find any true resonance with the Indian soul. He was convinced a common ground had to be found. This he tried to express in the way of life of a Christian ashram, especially in his years in Shantivanam, in the Saccidananda Ashram. This ashram had been established by Father Jules Monchanin and Father Henri Le Saux (Swami Abhishiktananda), pioneers in finding a meeting ground between the Hindu and Christian ways of worship, who already at that stage incorporated elements of the Hindu *sannyasi* tradition in their worship. Bede Griffiths took over the ashram from Abhishiktananda in 1968, when the latter decided to retire to the Himalayas. Monchanin had died in 1957.

In his practice Bede returned to the beginning of our journey through the mystical tradition, to the Desert tradition with its emphasis on meditation, the repetition of a spiritual phrase in silence and solitude. His practice was the Jesus Prayer springing

from the 'Hesychast' tradition of the Fathers of the Desert.

Shirley du Boulay sees his openness to other traditions and his emphasis on the contemplative path as modelling a way of being Christian that is in tune with our age.

Bede Griffiths OSB 1906–93

Alan Richard Griffiths was born into an English middle-class family, the youngest of four children, on 17 December 1906. His parents were Anglican, yet formal religion does not seem to have been important to him. He was educated at Christ's Hospital and Magdalen College, Oxford, where he first read Classics and then was drawn by the nature poets, Wordsworth, Shelley, Keats and Blake to English Literature. He was a lifelong friend of C. S. Lewis, Hugh Waterman and Martyn Skinner.

He became a Benedictine monk in 1932, and was given the name Bede. He was for some time at Prinknash Abbey. After 23 years he left England and the monastery for India to search for 'the other half of my soul'. In 1968 he settled at Saccidananda Ashram in South India by the Cauvery River.

He studied other religious traditions deeply and was very involved in interfaith dialogue, while remaining deeply rooted in Christianity. He tried to integrate the Christian experience and worship into the surrounding culture and bring about a marriage of East and West. He became a *sannyasi*.

He had a stroke in 1990, followed by a supreme mystical experience of overwhelming love. He recovered to teach and travel widely in the last two years of his life. He died in 1993.

I would like to explore why Bede affected so many people and touched so many of our lives; why he had such an impact and why his thinking and personality continue, several years after his death, to influence people. It could even be claimed that he had an effect on the spiritual climate in which we live, and that his life and writing have caused a perceptible shift in our thinking.

One reason that he touched so many lives is that in many ways he was so much like us – he was like us only more so. It is as if he was the macrocosm to our microcosm. He lived fully the inner, spiritual life so many of us are drawn to, though most of us are distracted by the world, by relationships, by sex, marriage, children, jobs, while he was utterly dedicated to his vision. He was like us, but so much bigger

than us. We are, as Newton famously said, dwarves standing on the shoulders of giants. If we see further than our ancestors it is because of people like Bede.

He was English, middle-class and Anglican. He was born in 1906 and had all the conditioning and inhibitions of that time. He was, for many years, a reserved and inhibited man, as were so many with that background. He lived and was educated in the south of England and went to Oxford. He was very English; indeed his Englishness was sometimes affectionately laughed at. That precise Oxford accent must have sounded extraordinary when it was first heard among the coconut groves. He never quite lost the air of a rather patriarchal, donnish, very English figure – and he knew it.

Mystical experience

The most important single experience of his life, the great mind-blowing catalyst of his youth, happened when he was 17 years old. It was so crucial to his life that it needs to be quoted in full.

He was walking in the school playing fields. He had walked this way before; he had seen other beautiful evenings; he had often heard the birds singing with that full-throated ease that precedes the dying of the day. But this day was different:

> *I remember now the shock of surprise with which the sound broke on my ears. It seemed to me that I had never heard the birds singing before and I wondered whether they sang like this all the year round and I had never noticed it. As I walked on I came upon some hawthorn trees in full bloom and again I thought that I had never seen such a sight or experienced such sweetness before. If I had been brought suddenly among the trees of the Garden of Paradise and heard a choir of angels singing I could not have been more surprised. I came then to where the sun was setting over the playing fields. A lark rose suddenly from the ground beside the tree where I was standing and poured out its song above my head, and then sank still singing to rest. Everything then grew still as the sunset faded and the veil of dusk began to cover the earth. I remember now the feeling of awe that came over me. I felt inclined to kneel on the ground, as though I had been standing in the presence of an angel; and hardly dared to look on the face of the sky, because it seemed as though it was but a veil before the face of God.* (The Golden String)

Many of us have had similar experiences. I had one such when I was 15, also at school. I cannot talk as articulately as Bede about it, actually I can hardly talk about it at all, but I know it changed my life, determined the direction my life would take, just as in a much more complete way Bede's experience determined his future. I know too that one of the reasons I was drawn to Bede so strongly and instinctively was that he had written about his experience and thus enabled me to understand my own a little better.

It is almost impossible to overestimate the importance of that experience in Bede's life, for there is a sense in which his whole life was a living out of it. For much of his life, consciously or unconsciously, he was always seeking the state of ecstasy he had glimpsed on that summer evening. As a young man it led him to maintain that a new religion was needed and that its prophets were Wordsworth, Shelley and Keats, for his religion was the worship of nature and he could see no connection between the God manifested in nature and the God preached in church. From that moment in his young life everything changed: his only pleasure became the mysterious, almost sacramental communion with nature. One of the most moving things about his life was that he had to wait until he was over 80 years old before he recaptured it in its fullness. But here, in the school playing grounds, in the year of 1924, his search for God had begun.

The influence of the classics

In 1925 Bede went up to Oxford to read Classics, where he found the university was divided into two categories – the 'athletes' and the 'aesthetes'. Bede, it need hardly be said, came into the second category, industrious, poor, rarely meeting girls, loving nature and walking and spending most of his free time with two special friends, Martyn Skinner and Hugh Waterman. (It says something for that friendship that it continued all their lives, until, one by one, they all died.)

This classical background shows in much of his thought and writing – it was

Writings of Bede Griffiths

Christ in India, Templegate, 1984.

The Cosmic Revelation, Collins, 1987.

Vedanta and the Christian Faith, Bear & Company, 1991.

The New Creation in Christ, Templegate, 1994.

Universal Wisdom: Sacred Wisdom of the World, Fount, 1994.

River of Compassion: Commentary on Bhagavad Gita, Templegate, 2002.

The Golden String, Medio Media, 2003.

Return to the Centre, Canterbury Press, 2003.

The Marriage of East and West (sequel to *The Golden String*), Canterbury Press, 2003.

the intellectual backbone of his life, as the great mystical experience was the heart of his spiritual life. He did well in Classics but decided to change to English Literature, hoping that the poetic imagination would help him to keep in touch with the reality he had glimpsed that summer evening at school. It was through reading English Literature that he met C. S. Lewis and came to know members of the famous 'Inklings' set, though he was never a member. One of the reasons he was not a full member reflects rather sadly on him. There was a lot of drinking and laughing, and at that time Bede was considered rather serious, rather lacking in humour.

It is poignant that he had to wait so long to reach his spiritual goal, but his search for a repeat of his childhood experience, for its full realization, was delayed by too great an emphasis on the intellect. However, while this could have held him back spiritually, his intellect is another reason that he is so valuable to us today. He delved and thought and explored and learned about eastern religions and about Christianity – he was not content with a wishy-washy sentimentality as so many of us are today. If his learning delayed his joy, then so did it enrich his legacy, for he really knew, with both mind and heart, what he was talking about, what he sought, what he had experienced.

Community

The year 1930 was crucially important, for he spent it with Hugh and Martyn in a small community in Eastington, trying to live what they called 'The Great Experiment'. The three young men – they would have been in their early twenties at the time – intended to reject the civilization they had come to criticize so deeply and to live without machines or gadgets or any products of civilization – in fact they wanted to have nothing to do with anything made during or after the Industrial Revolution. They were not only totally self-sufficient, they filled their pitchers from the village tap, read by candlelight, wrote with quill pens, refused to use razor blades and shunned the gramophone and the wireless. Once again they did it in style, carried out their ideals to the letter. It was idealism writ large.

They were remarkably ahead of their time. For those of us who were young in the 1960s it does not seem remarkable to live as near to nature as possible in small, self-sufficient communities. But the preceding generation simply did not do it and, apart from a few rare exceptions like Tolstoy, hadn't even thought of it.

Yet community and ecology and our attitude to the earth is deep in our hearts. I remember the beginning of the rape of the hedges, which led to the prairie lands that are all over England now. It devastated us, but few of us did anything about it. Here again Bede was ahead of his time. He saw, he cared and tried to do something about it, not by campaigning or writing letters to the press, but by trying to live out his ideals.

So already by the time he was in his twenties, Bede was seen to be like us but taking it further, being braver – in short, being a pioneer. The fact that the little community broke up after less than a year does not make it any less significant. Many bold, significant pion-eering attempts have failed. Think of Scott of the Antarctic. He reached the South Pole at his second attempt, only to find that Amundsen had beaten him to it. He and his comrades all died on the return journey. But who is the best re-membered, the best loved, of the great explorers?

'The Great Experiment' should not be considered a failure. They were pro-foundly influenced by their shared motivation and the sense of unity deriving from their conviction that what was nearest to nature was good. Bede referred to it as 'the decisive event of our lives'. It bound the three of them together with hoops of steel.

Christianity

Probably many of us who were brought up Christians have known what it is like to lapse. So it was with Bede. He was brought up an Anglican, but by the time he was at Oxford he and his friends were finding Christianity 'drab and out of date'. The seeds of his Christianity were nourished in conversation with C. S. Lewis, who at the time was no more a Christian than Bede was. It was a curious friendship. Bede said that a tutorial with Lewis was 'a battle of wits, and it was through oppos-ition that one came to friendship with him'. Lewis said their friendship 'began in disagreement and ended in argument'. Yet friendship it undoubtedly was – and they became Christians at the same time, in the 1930s, arguing to the brink, for Bede became a Roman Catholic and Lewis, an Ulsterman and a Protestant to his bones,

Glossary

Atman – Sanskrit term for the divine aspect of the individual soul.

Brahman – Sanskrit term for the Divine.

Hesychast – a mystic devoted to silence and inner prayer.

Sannyasi – a person dedicated to the spiritual life having given up material life; a Hindu religious mendicant.

was convinced Bede was trying to convert him. They fell out quite badly over that, but remained friends always.

Many people will resonate with this development of a Christian upbringing, followed by disillusion, then conversion.

The pull of the East

Many of us will also resonate with Bede's dissatisfaction with western Christianity and his longing to go to India. Bede touches my life here again. Like many people, in my twenties I had a fleeting understanding of 'nirvana', and how in nirvana the Atman is absorbed into Brahman – it blew my mind. I started practising an eastern meditation soon after that.

Some of us have perhaps visited India, or even spent long periods there. Here again Bede took our longings further. He went to live there when he was 49 and spent the remaining 38 years of his life there. He dressed like a Hindu *saddhu*, he ate Indian food, he incorporated Hindu rituals into the liturgy. Most of all he absorbed Indian philosophy and religion. He was a pioneer in the marriage of East and West.

What do people, what did Bede, seek in the East? He himself expressed, with his usual classical clarity, why he needed to go to India:

> *I had begun to find that there was something lacking not only in the western world but in the western Church. We were living from one half of our soul, from the conscious, rational level and we needed to discover the other half, the unconscious, intuitive dimension. I wanted to experience in my life the marriage of these two dimensions of human existence, the rational and intuitive, the conscious and unconscious, the masculine and feminine. I wanted to find the way to the marriage of East and West.*
>
> (*The Marriage of East and West*)

He is very clear about what he sought – and he found it. For the first time it was not the beauty of nature that entranced him so much as the sheer beauty and vitality of the people, of the human form. Like anyone visiting India for the first time he was overwhelmed by the smells, the noise, the exuberant swarming masses, children running round naked, women in saris, men in turbans, cows wandering round the streets, even sleeping, disdainful of danger, in the midst of the traffic. Almost imme-

diately he felt at one with the Indian people and began to discover, as he had hoped he would, the dimension he had found missing in the West, 'the other half of his soul':

> *Whether sitting or standing or walking there was grace in all their movements and I felt that I was in the presence of a hidden power of nature. I explained it to myself by saying that these people were living from the 'unconscious'. People in the West are dominated by the conscious mind; they go about their business each shut up in his ego. There is a kind of fixed determination in their minds, which makes their movements and gestures still and awkward, and they all tend to wear the same drab clothes. But in the East people live not from the conscious mind but from the unconscious, from the body not from the mind. As a result they have the natural spontaneous beauty of flowers and animals, and their dress is as varied and colourful as that of a flower garden.*
>
> (The Marriage of East and West)

Bede Griffiths with Brother
John Martin and Brother
Christudas

He found exuberance, colour, a sense of the sacred, and a respect for the earth. Over the years India confirmed his instinct that God need not be claimed as the exclusive property of any one religion, but that the various religions have the same goal; that there are, as the Indian poem has it, 'many ways up a mountain'.

Another thing that sets Bede apart was that he studied. He was not much of a linguist, but he did try to learn Sanskrit. He read the texts and had an excellent grasp of the theology and philosophy underlying eastern religions.

A new era of consciousness

Bede was foremost among those who feel that we are entering a new era of consciousness. As early as 1966, he was writing that we were in a stage of transition, between the break-up of ancient cultures and the birth of a new civilization. He was brought up in these ancient cultures and could see it more clearly perhaps than we can now, as Latin and Greek become a dim memory and just something our grandparents cared about. Six years later, in 1972, he wrote to a friend: 'I feel that we are on the eve of a breakthrough in consciousness, of a new wave of civilization.' In 1979, daring to speak on the very public platform of *The Tablet*, he criticized the Church, to which he remained loyal for his entire life, saying, 'Could not the Church be more aware of the tremendous search for God, for a new consciousness beyond the mental consciousness, for a new age of spirit-uality which many believe is now dawning?' I give the dates, 1972 and 1979, as proof, if proof were needed, that he was, if not ahead of his time, at the very least at its cutting edge.

Bede was convinced that the dawning of this new consciousness was a result of the West coming into contact with the East. He realized that we are leaving the age of western domination. We are at the end of an age and a new order of being and consciousness is emerging.

Many of us become aware of a shift of consciousness, a change of paradigms; even if we cannot always be very articulate about it. We are no longer a patriarchy, the feminine is regaining its true place: we acknowledge feelings rather than commending the stiff upper lip; we favour dialogue over control – at least in theory; we realize that man is the steward of creation and not its ruler – again at least in theory.

Meditation

One of the best ways – I sometimes think the only way – to evolve spiritually is through meditation. It was at the heart of Bede's teaching. Martyn Skinner's daughter, who knew him well, once asked him what he could teach her and he said: 'Meditate. That's all I can tell you. Meditate.' It is very likely that many of us have received little or possibly no training in prayer. We welcome, as Bede did, the discovery of the practice of meditation, in particular two aspects that tend to be neglected in

Christian teaching – method and posture. In the West such things are often dismissed as putting technique before grace, but we would do better to give them their due as helpful aids on the path of reflection and contemplation.

Bede pointed out this shortcoming in an article in *Monastic Studies*. He wrote that western methods of prayer and meditation, while having a deep supernatural basis, are extremely weak when it comes to a natural basis. He realized that westerners, seeking a contemplative lifestyle, needed to listen to the voice of the East and learn methods of prayer and discipline and contemplation. Just as he needed to go to India to find the other half of his soul, so he recognized this need in others:

> *In the world today young people are everywhere seeking a new understanding and a new experience of God, the infinite reality. Many of them are now going to Hindu ashrams and Buddhist monasteries, where they can learn methods of meditation and of control of mind and body, which they believe can lead them to this goal of 'God-realization'. A Christian monastery should surely be a place where this 'God-consciousness' can be found.*
>
> ('Eastern Religious Experience', *Monastic Studies*, Vol. 9, 1972)

This, incidentally, was quite a brave thing to say in a periodical like *Monastic Studies* in 1972. And it was of course one of the things he was trying to do at Shantivanam.

There are people in the Christian West who resist eastern methods of meditation and are convinced that everything needed is available in Christian prayer and liturgy. Bede was not among them. Nor am I, if I may speak from the ranks of the dwarves. For too long, he claimed, we have been content with a form of prayer that remains on a level of adoration, praise, thanksgiving, petition, repentance.

Also around this time

1900
Nietzsche dies age 55; Max Planck (1858–1947) presents 'Quantum Theory' at Physics Society in Berlin; Freud publishes *The Interpretation of Dreams*.

1906
Einstein first introduces his 'General Theory of Relativity'.

1907
Pope Pius X forbids modernization of theology; Henri Bergson, French philosopher, writes *Creative Evolution*.

1914–18
First World War.

1932
Heisenberg, German physicist, discovers the 'Uncertainty Principle' of quantum physics.

1938
Neville Chamberlain and Adolf Hitler sign the Munich agreement.

1939
Britain and France declare war on Germany after German invasion of Poland.

1940
Start of Blitz on London; continues for 57 nights.

1942
Luftwaffe bombs Coventry.

1945
Death of Dietrich Bonhoeffer, German Protestant theologian, at the hands of the Nazis.

1984
Death of Karl Rahner, German theologian.

And the ancient ideal of contemplation, of the direct experience of God in prayer, has been almost lost to view. In the same way we have been content with a theology which is based on reason illumined by faith, but does not lead to an experience of God in the Spirit. (The Sources of Indian Spirituality, quoted in du Boulay, Beyond the Darkness)

He felt this renewal of the spiritual life of the Church was – and indeed is – its most urgent need. He went further, saying that 'it may be said with certainty that this renewal cannot take place today without contact with the Oriental tradition'. He often reminded us how the Church went to Greece and Rome to learn theology and law, but that she has to go to the East to learn spiritual wisdom: 'We are entering on a new age of the Church and the world, and it is the meeting of East and West at the level of meditation and contemplation which is the sign of the new age' ('Indian Spiritual tradition and the Church in India', *Outlook*, 1976, quoted in du Boulay, *Beyond the Darkness*).

In this meeting of East and West it became clear how Bede fitted into the mystical tradition. He was nurtured by the mysticism of the past, but his great contribution came from his ability to fuse the tradition of the West with that of the East. It is no accident that one of his most important books is called *The Marriage of East and West*. But how do we accommodate the East and West within us? Speaking for myself, I first came across eastern meditation in the early 1960s. After just a few weeks, after years of rather desultory Anglicanism, I began to glimpse the meaning of the Fourth Gospel; I thrilled to a new understanding of what the Psalmist meant when he said: 'Darkness and light to Thee are both alike.' I read *The Cloud of Unknowing*, moved to the core by lines such as, 'A naked intent directed to God, and himself alone, is wholly sufficient.' Twenty-five years later, after hours of eastern meditation, much reading of eastern texts and Christian mystics, in particular Meister Eckhart, I became a Roman Catholic. The East, far from taking me away from Christianity, had drawn me to its heart in a new way.

For Bede, the aim of meditation was to pass beyond the limits of the rational consciousness and awake to the inner life of the Spirit, to the indwelling presence of God. Again he was in tune with his time. The diversity of modern living has strengthened our need for unity; the flight from God to science and technology has led to our realization that we are nothing if we do not make the journey in-wards.

We are learning the value of silence, learning that silent meditation can lead to a sense of union, travelling beyond doctrine and dogma to a glimpse of the transcendental reality. We are learning that, though there are many methods of meditating, indeed many religions, many

Bede Griffiths celebrating an Indian Rite Mass

faith traditions, they all lead to the same place. This knowledge resonates more with today's seekers than dogmatic and doctrinal formulations of a religion. Many of us want to reach the Source, the still point which every religion shares. Meditation is the first step on this journey. It is not only the first step, it is the journey itself and it is the end as well. In meditation the meditator is taken beyond the duality that pervades so much western thinking to an experience of unity. This emphasis on direct experience is precisely in tune with many westerners, who are unwilling to pray with concepts; many are even unhappy with images, in the Ignatian style. John Main, whom Bede much admired, used to say: 'Meditation verifies the truths of your faith in your own experience.'

God is both our Mother and our Father.

Duality

I remember going to a quiet week run by the Bede Griffiths Sangha at the Rowan Tree Centre and there was someone there who constantly said in a sad, wistful voice: 'Christianity is always going on about duality.' I had never seen it so clearly, but this man was voicing something so many of us feel in our hearts, even if we have not pinpointed exactly what it is about. Much Christian thinking is devoted to seeing things in dualistic terms – God and man, heaven and earth, I and Thou, good and bad – whereas Vedantic Hinduism has always searched for the transcendent reality beyond the phenomena of the senses.

Bede was very drawn to this Hindu teaching of *advaita*, which simply means 'not two'. Going beyond duality was, he felt, the only way to reach what he called 'differentiated wholeness', and the best way to go beyond duality was by meditation. He would say also that you could reach beyond duality through love of another human being. When you love somebody completely you give yourself totally to them, they give themselves to you; you are not two and yet you are not simply one. You don't lose yourself in love; you find yourself.

While the word comes from the *Vedas*, there can also be a Christian *advaita*. Abhishiktananda, the French Benedictine, who was one of the original founders of Shantivanam, wrote: 'In reality "advaita" is already present at the root of Christian experience. It is simply the mystery that God and the world are "not two".'

By 1981 Bede felt that he had become more and more *advaitin*:

It seems to me that we have ultimately to go beyond all forms of thought – even beyond the Trinity, the Incarnation, the Church etc. All these belong to the world of 'signs' – manifestations of God in human thought – but God himself, Truth itself, is beyond all forms of thought. All meditation should lead into silence, into the world of 'non-duality', when all the differences – and conflicts – in this world are transcended – not that they are simply annulled, but that they are taken up into a deeper unity of being in which all conflicts are resolved – rather like colours being absorbed into pure white light, which contains all the colours but resolves their differences.

(Letter to Nigel Bruce, 21 August 1981, quoted in du Boulay, *Beyond the Darkness*)

So too he wrote, as Abhishiktananda did, about Christian non-dualism:

So Jesus and his father had this total oneness and yet distinction. The Hindu says 'I am Brahman'; it is a wonderful insight but the danger is that you identify with Brahman, with Atman, and your individual self disappears. But in Love you don't disappear, you surrender yourself totally, you go beyond your ego, your limited self and you find your real self in God, in Brahman. Jesus finds himself in the Father and the Father in him. And he calls us to share in that non-dual relationship with the Father, 'That they may be one as I in Thee and Thou in me'. That is Christian non-dualism.

('Beyond Duality', *The Bridge*, No. 8, quoted in du Boulay, *Beyond the Darkness*)

He often quoted those lines from St John's Gospel: partly because he believed them

profoundly, but also, I often think, because it was a way to get through to those Christians who were resistant to anything savouring of the East. He knew it was possible to learn from the East and to remain a Christian; indeed he felt that it was in that way that the full depths of Christianity could be discovered; but he also knew that some people feared stepping beyond their immediate doctrinal position. He was quite realistic in the way he talked to people about ideas that might not be immediately appealing to them.

Thoughts may take us to the furthest outreach of space, but they can neither find nor relate to God.

His stroke

In 1990 Bede had a stroke. It was to lead to his greatest mystical experience. There is a way in which the whole of Bede's life can be seen as a search to re-experience those moments in the school playground, when he knew. Somehow, during all those 66 years, though he had longed for a repetition of the experience, it had not happened. He had had to struggle through years during which the search had taken place mainly in his head, for his longing for experience had not broken his preoccupation with reasoning and knowledge. But at last it happened and he was like a man reborn. In these weeks of extreme illness, he reached something beyond any experience he had previously had. Before he had talked about it; now he knew it.

So what happened to him then? He felt totally free. The ego collapsed, all the barriers broke down. He was in a state of complete surrender.

> *I had some breakfast and then I felt sort of restless, disturbed, not knowing quite what was happening. The inspiration came suddenly again to surrender to the Mother. It was quite unexpected: 'Surrender to the Mother.' And so I somehow made a surrender to the Mother. Then I had an experience of overwhelming love. Waves of love sort of flowed into me. Judy Walter, my great friend, was watching. Friends were beside me all the time. I called out to her: 'I'm being overwhelmed by love.'*

Everything was becoming love:

> *Death, the Mother, the Void, all was love. It was an overwhelming love, so strong I could not contain myself. I did not know whether I would survive. I knew 'I' had to die, but whether it would be in this world or another, I did not know. At first I thought*

I would die and just be engulfed in this love. It was the 'unconditional love' of which
I had often spoken, utterly mysterious, beyond words.

At last he had the experience he had longed for since his first experience at 17 years old. Now he was privileged to know in a way that few people know this side of the grave.

Bede was both like us and beyond us. The reason he touched our lives so deeply was that he stood at the same crossroads as many of us do – longing for the meeting of religion and direct experience, recognizing a new era of consciousness, valuing meditation, seeking a state of unity beyond duality, a state of pure being in which we can be fully ourselves, while, if we wish, retaining the faith to which we are attempting to be true. He was a great man and a great prophet and we are fortunate to walk in the wake of his vision.

SHIRLEY DU BOULAY

JOHN MAIN

Stefan Reynolds

John Main

Introduction

With the Benedictine monks, Swami Abhishiktananda, Bede Griffiths and John Main, Christian mysticism comes up to our own time and we are at the end of our journey through the mystical tradition through the centuries. But we are not at the end of the mystical tradition itself; indeed, our time promises to be a new beginning. John Main, in rediscovering the contemplative tradition in the teaching of the Desert Fathers in the fourth century and opening this way of prayer to all people, has linked the present to the past in a fruitful way. It may well be the way forward for Christianity. Karl Rahner has predicted that Christians of the future will be mystics or they will not exist at all.

The mystics of this book represent milestones along the way. There is diversity but also a common thread. Tradition is passed on, it develops, and it is this that makes it a true doctrine, a living word. The continuity and adaptability of the mystical tradition can be seen in the case of John Main.

Stefan Reynolds starts by showing how John Main continued the dialogue between Christianity and other faiths in a practical way by discovering the parallels in meditative prayer. He then explains how he focused all his teaching on meditation as an authentic Christian way of prayer and how for him it was the distillation of the essential monastic spirit.

Quotations are taken from John Main, *Essential Writings*, ed. Laurence Freeman (Orbis, 2002); John Main, *Word into Silence* (Darton, Longman & Todd, 1981).

John Main 1926–82

He was born in 1926 in London of an Irish family. He was called Douglas, John being the name he adopted on becoming a monk. The Main family previously lived in Ballinskelligs on the western tip of Kerry, within view of the Skellig rocks where Celtic monks lived and prayed.

Douglas Main studied law at Trinity College in Dublin; on graduation he took a job with the British Colonial Service in the Far East. It was there in Malaya that he met Swami Saccidananda and first learned to meditate. On his return from Malaya he taught International Law at Trinity, Dublin.

At the age of 35 he felt a sense of vocation to religious life and applied to join the Benedictines at Ealing Abbey in London. There, at the interview with the novice master, he was told to give up his meditation practice. He accepted the advice, wanting to commit fully to monastic life and obedience.

He was sent to Rome to study at the time of Vatican II; on his return from Rome he worked in the school at Ealing and then went to St Anselm's Abbey in Washington, DC and became headmaster at the school there.

When he was there a young student came to visit the monastery asking about Christian mysticism. Through this encounter John Main read the writings of John Cassian, a fourth-century monk, and there discovered the Christian tradition of the mantra. With joy he returned to his practice of meditation.

In 1977 he accepted an invitation from the Archbishop of Montreal to found a monastic priory based on meditation. In Montreal he was able to experiment with his vision of a new monasticism where laypeople and monks could meditate together. The Oblate community in Montreal became a sign that these monastic values were relevant to people in many walks of life.

In 1980 he was diagnosed with cancer. He continued to lead the meditation groups and keep up his correspondence with mediators around the world. Weakened by his illness, he was felt by many to be more and more transparent to God. He died peacefully on 30 December 1982.

MOVING BEYOND THE USUAL BOUNDARIES

Drawing on the teaching on prayer of the early Desert Fathers, John Main took monastic spirituality beyond its traditional boundaries. He showed that 'pure prayer' beyond thought and image was a universal calling, the birthright of all Christians and a normal flowering of baptismal grace. The purpose of the monastic channel was always to overflow its banks and make its teaching accessible to all people.

In the relation between Christian meditation and the meditation practices of eastern religions, the universal relevance of the monastic teaching on prayer took on a further and more expansive dimension. Here was a common ground between many faiths. Echoing the Vatican II, John Main believed that 'we have nothing to be afraid of from the spiritual riches of other religions; in fact we may have much to learn'.

In this John Main was speaking from his own experience. While working as a diplomat in Malaya in the 1950s he had learned the art of meditation with a mantra from a Hindu monk; and he later discovered a parallel teaching in the *Conferences* of the early Christian monks of the desert recorded by Cassian (see Chapter 9). Thirty years on, when teaching meditation from the Christian tradition, John Main said that he always came back to the wisdom, the simplicity and the purity of the teaching he received in the East.

The Kingdom of God is not a place but an experience.

Teaching on prayer

By that time John Main had himself become a Benedictine monk. It was in Cassian, St Benedict's teacher, that he found the teaching on the continuous repetition of a prayer phrase:

> *Let the mind hold ceaselessly to this formula [Oh God come to my aid; Oh Lord make haste to help me] . . . until it renounces and rejects the whole wealth and abundance of thoughts. Thus straightened by the poverty of this verse, it will very easily attain to that gospel beatitude which holds the first place among the other beatitudes. For it says, 'Blessed are the poor in spirit, for theirs is the kingdom of heaven.'*
>
> (*Conferences* x, in *The Conferences*, ed. Boniface Ramsey (Paulist Press, 2004))

John Main with the Dalai Lama and Laurence Freeman

John Main's teaching on prayer was never theoretical but always a way of experience. His concern was to draw people into an encounter with God in the silent depths of their heart. He felt that the wisdom of the monastic teaching on prayer was the practical response to the problem of human alienation and communal needs of our time.

In *Word into Silence* (p. 25) he writes:

The modern Christian's mission is to re-sensitize our contemporaries to the presence of a spirit within them-selves . . . Our first task, in the realization of our own vocation and in the expansion of the kingdom among our contemporaries, is to find our own spirit because this is our lifeline with the Spirit of God . . . Humanity finds its own spirit fully only in the light of the One Universal Spirit.

John Main's emphasis on personal experience and self-discovery in God, as well as the clear method of prayer he uncovered for Christians, made Bede Griffiths call him 'the most important guide in the Church today'. The practice of Christian meditation was, for John Main, the distillation of the essential monastic spirit. In meditating every day, twice a day, people could share in the heart of what the monastic movement, which began in the fourth century, was all about – the search for God. He was convinced this was a way for all people. He writes:

All of us need to find something, some principle in our lives that is absolutely reliable and worthy of our confidence. All of us feel this impulse somehow or other to make contact with this rocklike reality . . . Saying the mantra is like dropping anchor.

The teaching of Christian meditation became John Main's principal work. The early monks had transmitted their wisdom by word of mouth. By leading weekly

meditation groups and through retreats in England, Ireland and the USA, John Main took his place within this oral tradition. Through the tape recordings of his talks, the teaching was to meet the needs of a growing meditating community.

The other ancient Christian form of communication was the letter; and John Main began his quarterly newsletter. He was pleased that technology and telecommunications could help the spiritual path. But he always reminded his readers and listeners that the important thing was commitment. He wrote:

> Meditation cannot be reduced to a commodity and the Spiritual tradition is not a supermarket to shop in or a stock market to gamble on. Because we do think in these terms however there can be a real danger that meditation is presented in terms of return and pay off . . . the only important thing is that your spirit lives.

His concern was to help people into the silence of pure prayer – a state of poverty, with no thoughts, no images. This was, as Julian of Norwich put it, 'a condition of complete simplicity costing not less than everything'. For John Main this was the *askesis* of the mantra: 'Our death consists in the relentless simplicity of the mantra and the absolute renunciation of thought and language at the time of our meditation.'

In meditation we turn the searchlight of consciousness off ourselves. By renouncing self we enter the silence and focus upon the other. In this sense we have to forget and un-know everything we have been, if we are to bring ourselves to completeness: 'Meditation is the prayer of faith because we have to leave ourselves behind before the Other appears and without the pre-packaged guarantee that he/she will appear.'

To pray is to trust your whole being onto God. It is on this capacity for simply being that the significance and quality of our action depends.

John Main's teaching on prayer was always practical: 'Our theories can make us impotent and self-important, like people with a car manual but no car.'

Writings of John Main

Word into Silence, Canterbury Press, 2006.

Word Made Flesh, Canterbury Press, 2009.

The Way of Unknowing, Darton, Longman & Todd, 1989.

Christian Meditation: The Gethsemani Talks, Continuum, 2000.

Essential Writings, ed. Laurence Freeman, Orbis, 2002.

Monastery without Walls: The Spiritual Letters of John Main, ed. Laurence Freeman, Canterbury Press, 2006.

Door to Silence: An Anthology for Meditation, ed. Laurence Freeman, Canterbury Press, 2006.

The Hunger for Depth and Meaning, ed. Peter Ng, Medio Media, 2007.

The Inner Christ, Darton, Longman & Todd, 1987.

The importance of the mantra

He taught the way of the mantra not as a technique but as a discipline. A technique would involve the ego trying to get something, but the mantra helps to purify the heart through the letting go of desire. That is why it is important to stay with the same mantra. Rootedness leads to growth as the word moves from the mind to the heart.

> **Glossary**
>
> **Oblate** – a lay person dedicated to the spiritual life, connected to a monastery.

'Conversion is commitment to the creativity of love.' By saying the word we learn commitment; by listening to the sound of the word within us we learn attentiveness. These are the first steps beyond self-consciousness, as we realize that it is not we who are praying, but the Spirit is praying within us.

'Say the Mantra until you can no longer say it.' Gradually one enters the silence beyond the ego. However, because this is beyond the ego we don't choose when to stop saying the word. John Main reminded us, again drawing from the monastic tradition, that there is a 'pernicious peace', a sort of 'holy floating' where we stop the work of meditation and try to posses the experience. We get attached to the feeling of peace, and are disconsolate when we don't get it. In this way the ego monitors the meditation practice, always trying to get something out of it. Rather, we should 'enter into the experience of transcendence', by saying the word continually and letting go of all self-consciousness.

The ideal mantra John Main recommended was the word Maranatha, meaning 'Come Lord'. It was to be repeated silently, interiorly, as four equally stressed syllables: Ma-ra-na-tha. Not only was this one of the most ancient Christian prayers, in the language Jesus spoke, it also has a harmonic quality that helps to bring the mind to silence. Other words or short phrases could be used, but he saw it as important that during the meditation one doesn't think about the meaning or use the imagination. The use of a sacred word in an unfamiliar language, like Aramaic, helps to lessen this. Also, if possible, it is best to receive a mantra from a teacher, so that from the beginning one practises as part of a tradition and in a spirit of self-transcendence.

Distractions will always come, but one simply comes back to the word, with no discouragement and, at the end, no evaluation. Meditation is a pilgrimage; the important thing is simply to be on the way; it does not matter where one is on it. In fact in meditation we are all beginners. Each time we sit down, morning and

evening for two half hours, as John Main recommended, we are beginning again. The journey will lead us deep into God. In fact he always reminded us that 'it requires nerve to become really quiet'. He wrote:

> *As we enter the silence within us we are entering a void in which we are unmade. We cannot remain the person we were or thought we were. But we are in fact not being destroyed but awakened to the eternally fresh source of our being. We become aware that we are being created, that we are springing from the Creator's hand and returning to him in love.*

Important figure

Karl Rahner – foremost twentieth-century German Roman Catholic theologian.

In meditation we declare our own poverty.

Meditation creates community

In this practice of Christian meditation John Main felt that the heart of monastic spirituality was distilled; it is pure prayer lived out in obedience, stability and conversion of life; it is a turning away from selfishness, finding ourselves and the whole world centred in God. This tradition of 'poverty of spirit', as it was called, could be made accessible, he felt, to people in all walks of life. Twice daily meditation and complete fidelity during those times to the sound of the mantra was a monastic tradition well suited to our modern need for silence, stillness and simplicity.

It was also true that meditation created community. A growing Oblate community and an extended World Community started to share a common life inspired by a common practice. In his quarterly newsletters from Montreal, John Main kept people connected and encouraged them to continue 'on the way'.

The Trinitarian theology of meditation

In these newsletters John Main also began to offer a profound Trinitarian theology of meditation. The basic fact of Christian awareness, he felt, was that the human consciousness of Jesus dwells within us, and is in union with us. If we can be open to that, then the union is consummated, is fulfilled; then we go with Jesus on his journey to the Father. This love of Father for the Son and Son for the Father is the Holy Spirit which prays within us. Therefore the prayer of Jesus, his Spirit, his life, in us, is our prayer. In meditation we give up 'my' prayer and become one with 'his'

Also around this time

1897
Sri Ramakrishna founds order of monks; emphasis on personal experience; ecumenism; respect for truth in all religions.

1920
Government of Ireland Act creates Northern Ireland.

1921
Anglo-Irish Treaty results in civil war until 1923, during which Irish Free State is established in 1922.

1957
Independence of Malaya.

1961
Malaysia established.

1962–5
Vatican II; main topics ecumenism, relationship with other faiths, renewal and liturgy.

prayer, his journey beyond himself to the Father. That is what it means to pray in the Spirit and Truth. In this Trinitarian communion we find our full humanity by sharing in the divine nature. 'As we are unformed Christ is formed in us.'

After only six years of teaching Christian meditation, in 1980 and at the age of 54, John Main was diagnosed with cancer. Faced with the vulnerability of the human condition, his last talks conveyed more and more the urgency he felt in the communication of Christian meditation and also the gentleness whereby that practice is lived out. In one of his last talks he was asked, 'What is the best way to prepare for meditation?' He answered 'By little acts of kindness.' It was, he felt, the genius of the *Rule of St Benedict* that self-transcendence was always in the fullness of our humanity. In his last months he lived more and more completely in the present moment. When one morning he was found fallen from his bed during the night, his disciple Fr Laurence said that they would laugh about it one day. John Main looked at him, smiled and said: 'Why not laugh about it now?'

On 30 December 1982 John Main took the last step on his pilgrimage. He died peacefully. The community he had founded had attracted people from all over the world because of the depth of its practice and teaching. In that community he had always been an icon of Christ. The more vulnerable his illness made him, the more obvious the source of his inner strength became. For John Main the alchemy of love was: 'We come to know and love God as much as we allow him to know and love us.'

His genius was his insight into the relationship of meditation to relationship and community. Prayer was a way of 'being in love':

In meditation we turn the searchlight of consciousness off ourselves.

Only when we live in and from love do we know that miraculous harmony and integration of our whole being which makes us fully human . . . Saying the mantra is the process of polishing the mirror within us so that our hearts become fully open to the

work of God's love for us, fully reflecting the light of that love . . . The mystery of love
is that we become what we delight to gaze upon, and so when we open our hearts to
his light we become light.

John Main's life

John Main's life journey is a parable of his teaching. His movement towards 'the
one thing necessary' took him on a circuitous, labyrinthine route. That one thing
for John Main was the saying of the mantra. Born in 1926 in London of an Irish
family, he was called Douglas (John being the name he took on entering the
monastery). The Main family previously lived in Ballinskelligs on the western tip
of Kerry, within view of the Skellig rocks where the Celtic monks lived and prayed.
This spirit of the frontier, of new beginnings and adventure, was to infuse John
Main's own monastic vision. In the last year of the Second World War Douglas
joined the army and worked behind enemy lines as a radiographer in the intelli-
gence unit. His job was to pinpoint the exact location of enemy radio signals. Later
he was to use this as an analogy for the mantra, which helped one to stop drifting
in prayer and tune in with precision to the wavelength of Jesus, the Word or sound
of God that vibrates in us and in all creation.

After the war he joined an Augustinian religious order, the Canons Regular, and
went to study in Rome. However, the stuffiness and misogyny he encountered there
dissuaded him from continuing. Later on he was to teach that deep prayer leads to
fullness of life; this was the real 'religious life' and one that was open to all people.
On his return from Rome, Douglas Main studied law at Trinity College in Dublin;
on graduation he took a job with the British Colonial Service in the Far East. It
was there in Malaya that he met Swami Saccidananda and first learned to meditate.
On his return from Malaya he taught International Law at Trinity College, Dublin.

At the age of 35, however, two things happened that made him reassess the di-
rection of his life. He fell in love and one of his nephews was diagnosed with a
brain tumour. His realization that he was not called to mar-
riage and his accompaniment of his dying nephew made him
centre his life more and more on meditation. He realized that
his meditation practice was the most important thing for him.
The old sense of vocation to religious life returned and he

As breathing is for the
body, meditation is for
the spirit.

applied to join the Benedictines at Ealing Abbey in London.

There, at the interview with the novice master, he was told to give up his meditation practice. He accepted the advice, wanting to commit fully to monastic life and obedience. However, giving up meditation was the beginning of a long desert of prayer. In later years he said he was grateful that he had learned detachment from what was the most important thing for him. When he was to come back to meditation 12 years later, conscious of its Christian tradition, it was 'on God's terms not on my own'.

He was sent to Rome to study at the time of Vatican II, and was greatly enthusiastic about the changes that tallied well with his adventurous, generous and life-loving temperament. The Church was no longer a fortress of fixed identity but a pilgrim people journeying to God. There was a new openness to relating to the world. On his return from Rome he worked in the school at Ealing and then went to St Anselm's Abbey in Washington DC and became headmaster at the school there.

It was at this busy time, raising money, reorganizing and running the school, that there was another major turning point in his life. For years the primary focus of his prayer had been the singing of psalms and the celebration of Mass. However, a young student came to visit the monastery asking about Christian mysticism. John Main was asked to advise him. Through this encounter John Main read the writings of John Cassian, a fourth-century monk, and there discovered the Christian tradition of the mantra.

There is no way to truth or to the spirit that is not the way of love.

The experience of prayer beyond image and thought led him to reassess monastic identity. What is the particular form of education that monasteries are there for? He came to realize that it was to teach contemplation. In 1974 he founded a house for laymen in the grounds of Ealing Abbey, which was to host the first meditation group. In 1977 he accepted an invitation from the Archbishop of Montreal to found a monastic Priory based on meditation. Laurence Freeman, who had been a pupil at Ealing School, a member of the laymen community in Ealing Abbey and then a novice at the monastery, was his companion in the foundation.

In Montreal he was able to experiment with his vision of a new monasticism where laypeople and monks could meditate together. Monasticism was, from its beginnings with the Desert Fathers and Mothers, a movement of laypeople, an alternative lifestyle based on the values of silence, stillness and simplicity. The Oblate

community in Montreal became a sign that these monastic values were relevant to people in many walks of life. The new monasticism would be primarily a lay monasticism. The practice of Christian meditation was the distillation of the essential monastic spirit. In meditating every day, twice a day, people could share in the heart of what the monastic movement, which began in the fourth century, was all about – the search for God. John Main writes:

> *All of us need to find something, some principle in our lives that is absolutely reliable and worthy of our confidence. All of us feel this impulse somehow or other to make contact with this rocklike reality.*

By the time of his death, the community at Montreal had expanded into new premises, was accepting monastic novices and had opened a women's community. It had become a sign that the values of silence, stillness and simplicity were relevant to people in many walks of life. John Main was often felt to be a larger-than-life personality. The meaning of his life certainly went beyond his death at the early age of 56. He once said that 'humanity is most Godlike when we give ourselves without measure; when we love, and it is without measure that God gives himself to us'.

The expansiveness and generosity of his spirit showed a life rooted in God. It was a courageous journey because 'the essence of all poverty consists in the risk of annihilation. This is the leap of faith from ourselves to the Other. This is the risk in all loving.'

However, John Main's humour and humanity showed that 'the saint is not superhuman but fully human'. His vision of a 'new lay monasticism' continues in the World Community for Christian Meditation, founded in 1991. What began as a small seed has grown into a tree, with meditation groups, retreats and seminars all over the world. That seed was the life and teaching of John Main.

STEFAN REYNOLDS

Suggested Reading

General
Olivier Clement, *The Roots of Christian Mysticism*, New City, 1993.
F. C. Happold, *Mysticism*, Penguin, 1990.
William Johnson, *Mystical Theology*, HarperCollins, 1995.
Kenneth E. Kirk, *The Vision of God*, James Clarke & Co., 1990.
Andrew Louth, *The Origins of the Christian Mystical Tradition*, Oxford University Press, 2007.
John Macquarrie, *Two Worlds are Ours*, SCM Press, 2004.
Bernard McGinn, *The Presence of God: A History of Western Christian Mysticism*, Vols 1–4, Crossroad, 2004.
Evelyn Underhill, *Mysticism*, Dover Publications, 2003.

ONE *Jesus*
Raymond E. Brown, *An Introduction to the New Testament*, Doubleday, 1996.
Raymond E. Brown et al. (eds), *The New Jerome Biblical Commentary*, G. Chapman, 1997.
Evagrius Ponticus, *The Praktikos and Chapters on Prayer*, Cistercian Studies 4, Cistercian Publications, 1981.
Laurence Freeman, *Jesus: The Teacher Within*, Continuum, 2000.
Kahlil Gibran, *Jesus the Son of Man*, One World, 1993.
R. Girard, *Violence and the Sacred*, Johns Hopkins University Press, 1977.
Michael Grant, *Jesus*, Weidenfeld & Nicholson, 1977.
Elizabeth A. Johnson, *Consider Jesus: Waves of Renewal in Christology*, Crossroad, 1997.
Marvin Meyer (trans.), *The Gospel of Thomas: The Hidden Sayings of Jesus*, HarperCollins, 1992.
Gerald O'Collins, *Jesus Risen*, Darton, Longman & Todd, 1987.
Jaroslav Pelikan, *The Illustrated Jesus Through the Centuries: His Place in the History of Culture*, Yale University Press, 1997.
Ian Wilson, *Jesus: The Evidence*, Weidenfeld & Nicholson, 1996.

TWO *St John and St Paul*
J. A. Fitzmeyer, *Paul and His Theology*, Prentice Hall, 1989.
Albert Schweitzer, *The Mysticism of St Paul the Apostle*, Johns Hopkins University Press, 1998.

THREE *Clement of Alexandria*
Charles Bigg, *The Christian Platonists of Alexandria*, BiblioBazaar, 2009.
Andrew Louth, *The Origins of the Christian Mystical Tradition*, Clarendon Press, 1981.

FOUR *Origen*
Gabriel Bunge, *Earthen Vessels: The Practice of Personal Prayer According to the Patristc Tradition*, Ignatius Press, 2002.
Henry Chadwick, *Early Christian Thought and the Classical Tradition*, Oxford University Press, 1966, reprinted 2002.
Andrew Louth, *The Origins of the Christian Mystical Tradition*, Oxford University Press, 2007.
Alistair Stewart-Sykes (trans.), *Tertullian, Cyprian and Origen – On the Lord's Prayer*, St Vladimir's Seminary Press, 2004.

FIVE *Early Christianity and the Gospel of Thomas*
Bart D. Ehrman, *Lost Christianities*,Oxford University Press, 2005.
Karen King, *The Gospel of Mary of Magdala*,Polebridge Press, 2003.
Marvin Myer (trans.), *The Gospel of Thomas:The Hidden Sayings of Jesus*, HarperCollins, 1992.
Kim Nataraja, *Dancing with Your Shadow*, Medio Media, 2006.
Elaine Pagels, *Beyond Belief*, Macmillan, 2004.

SIX *The Cappadocian Fathers*
Anthony Meredith, *The Cappadocians*, St Vladimir's Seminary Press, 1998.
Gregory of Nyssa, *TheLife of Moses*, trans. and ed. Abraham J. Malherbe and Everett Ferguson, Classics of
 Western Spirituality, Paulist Press, 1978.

SEVEN *The Desert Tradition*
Roberta Bondi, *To Pray and to Love*, Burns & Oates, 1991.
Gabriel Bunge, *Earthen Vessels*, Ignatius Press, 2002.
Douglas Burton-Christie, *The Word in the Desert*, Oxford University Press, 1993.
Derwas J. Chitty, *The Desert a City*, St Vladimir's Seminary Press, 1996.
John Chryssavgis, *In the Heart of the Desert*,World Wisdom Books, 2003.
Olivier Clement, *The Roots of Christian Mysticism*, fifth edition, New City, 1998.
Irenee Hausherr, *Spiritual Direction in the Early Christian East*, SJ Cistercian Studies 116, Cistercian
 Publications, 1989.
Belden C. Lane, *The Solace of Fierce Landscapes*, Oxford University Press, 1998.
Thomas Merton, *The Wisdom of the Desert*, Darley Anderson, 1988.
Laura Swan, *The Forgotten Desert Mothers*, Paulist Press, 2001.
Benedicta Ward (trans.), *The Sayings of the Desert Fathers:The Alphabetical Collection*, SJ Cistercian Studies 59,
 Cistercian Publications, 2005.
Benedicta Ward, *The Wisdom of the Desert Fathers*, SCM-Canterbury Press, 2000.
Rowan Williams, *Silence and Honey Cakes*, Medio Media, 2003.
John Wortley (trans.), *The Spiritual Meadow of John Moschos*,Cistercian Publications, 1992.

EIGHT *Evagrius of Pontus*
Olivier Clement, *The Roots of Christian Mysticism*, New City, 1993.
Evagrius Ponticus, *The Praktikos and Chapters on Prayer*, trans. John Eudes Bamberger OCSO, Cistercian
 Studies 4, Cistercian Publications, 1981.
Anthony Meredith, *The Cappadocians,* St Vladimir's Seminary Press, 1988.
Simon Tugwell,*Ways of Imperfection*, Darton, Longman & Todd, 1985.
Benedicta Ward (trans.), *The Sayings of the Desert Fathers:The Alphabetical Collection*, SJ Cistercian Studies 59,
 Cistercian Publications, 2005.

NINE *John Cassian*
John Cassian, *Conferences*, ed.Owen Chadwick, trans. Colm Luibheid, Classics of Western Spirituality,
 Paulist Press, 1998.
John Cassian, *The Conferences*, ed. Boniface Ramsey, Paulist Press, 2004.

TEN *St Augustine of Hippo*
Augustine, *The Confessions*, trans. M. Boulding, New City, 2001.
Augustine, *The Confessions*, trans. H. Chadwick, Oxford University Press, 1991.
Peter Brown, *Augustine of Hippo*, Faber & Faber, 1979.
Henry Chadwick, *Augustine:A Very Short Introduction*, Oxford University Press, 2001.

Gillian Clark, *Augustine: The Confessions*, Cambridge University Press, 1993.
Andrew Louth, *The Origins of the Christian Mystical Tradition: From Plato to Denys*, Oxford University Press, 1981.
Bernard McGinn, *The Presence of God: A History of Western Mysticism*, Vol. 1, *The Foundations of Mysticism*, Alban Books, 1995.

ELEVEN *St Benedict*
Patrick Barry OSB (trans. and ed.), *Saint Benedict's Rule*, Ampleforth Abbey Press, 1997.
Joan Chittister OSB, *The Rule of St Benedict: Insight for the Ages*, Crossroad, 1992.
Esther de Waal, *A Life-giving Way: A Commentary on the Rule of St Benedict*, Geoffrey Chapman, 1995.

TWELVE *Hildegard von Bingen*
June Boyce-Tillman, *The Creative Spirit*, Morehouse Publishing, 2001.
Matthew Fox, *Hildegard of Bingen's Book of Divine Work with Letters and Songs*, Bear & Company, 1987.
Matthew Fox, *Illuminations of Hildegard of Bingen*, Bear & Company, 2003.
Wighard Strehlow, *Hildegard of Bingen's Spiritual Remedies*, Healing Arts Press, 2002.

THIRTEEN *St Francis*
Brothers Austin, Nicholas, Alan and Tristram, *A Sense of the Divine: A Franciscan Reader for the Christian Year*, Canterbury Press, 2001.
Liam Francis Costello, *Through the Veils of the Morning*, Veritas Publications, 2002.
Adrian House, *Francis of Assisi*, Pimlico, 2001.
Damina Kirkpatrick *et al.* (eds), *Joy in All Things*, Franciscan Association of Great Britain, 2002.
Brother Ramon, *Franciscan Spirituality: Following St Francis Today*, SPCK, 1994.
Michael Robson, *St Francis of Assisi: The Legend and the Life*, Geoffrey Chapman, 1991.
William J. Short, *Poverty and Joy: The Franciscan Tradition*, Traditions of Christian Spirituality Series, Darton, Longman & Todd, 1999.

FOURTEEN *St Dominic*
Giuliana Cavallini, *Catherine of Siena*, Continuum, 2005.
Paul Murray, *The New Wine of Dominican Spirituality: A Drink Called Happiness*, Continuum, 2006.
Suzanne Noffke, *Catherine of Siena: The Dialogue*, Classics of Western Spirituality, Paulist Press, 1990.
Simon Tugwell, *Early Dominicans: Selected Sources*, Classics of Western Spirituality, Paulist Press, 1982.
Simon Tugwell, *Albert and Thomas: Selected Writings*, Classics of Western Spirituality, Paulist Press, 1989.
Simon Tugwell, *Henry Suso: The Exemplar*, Classics of Western Spirituality, Paulist Press, Paulist Press, 1989.
Any of the writings of Simon Tugwell OP.

FIFTEEN *Meister Eckhart*
Raymond B. Blakney, *Meister Eckhart*, Harper Perennial, 1941.
Edmund Colledge and Bernard McGinn (eds), *Meister Eckhart: Essential Sermons*, Classics of Western Spirituality, Paulist Press, 2005.
Oliver Davies, *God Within: The Mystical Tradition of Northern Europe*, Darton, Longman & Todd, 2006.
Ursula Fleming, *The Man From Whom God Hid Nothing: Meister Eckhart*, Collins, 1990.
Matthew Fox, *Meditations with Meister Eckhart*, Bear & Company, 1987.
J. Huizinga, *The Waning of the Middle Ages*, Dover Publications, 2009.
Bernard McGinn, *Meister Eckhart: Teacher and Preacher*, Classics of Western Spirituality, Paulist Press, 1994.
Bernard McGinn, *The Mystical Thought of Meister Eckhart*, Crossroad, 2001.
Reiner Schurmann, *Wandering Joy*, Lindisfarne Books, 2001.
Cyprian Smith, *The Way of the Paradox*, Darton, Longman & Todd, 2004.

SIXTEEN *Dante Alighieri*
Dante, *The Divine Comedy*, ed. John D. Sinclair, Oxford University Press, 1981.
Edmund Garrett Gardner, *Dante and the Mystics*, Kessinger, 2009.
Matthew Pearl, *The Dante Club*, Vintage, 2004.
Dorothy Sayers' translation of *The Divine Comedy* comes highly recommended: Penguin Classics, 1949, reprinted 1955, 1962.

SEVENTEEN *Richard Rolle, Walter Hilton and Margery Kempe*
Karen Armstrong (trans. and ed.), *The English Mystics*, Kyle Cathie, 1991.
Eric Colledge (ed.), *The Medieval Mystics of England*, John Murray, 1962.
Walter Hilton, *The Scale of Perfection*, ed. Dom Gerard Sitwell OSB, Burns & Oates, 1953.
Grace Jantzen, *Julian of Norwich*, SPCK, 1987.
Margery Kempe, *The Book of Margery Kempe*, trans. Barry Windeatt, Penguin Classics, 1994, new edn 2000.
David Knowles, *The English Mystic Tradition*, Burns & Oates, 1961.
Joan Nuth, *God's Lovers in an Age of Anxiety: The Medieval English Mystics*, Darton, Longman & Todd, 2001.
Brant Pelphery, *Christ Our Mother*, Michael Glazier, 1989.
Richard Rolle, *The English Writings*, ed. Rosamund Allen, SPCK, 1981.
Richard Rolle, *The Fire of Love*, ed. Halcyon Backhouse, Hodder & Stoughton, 1992.
Tony D. Triggs, *The Book of Margery Kempe: Autobiography of a Wild Woman*, Burns & Oates, 1995.
Nicholas Watson, *Richard Rolle and the Invention of Authority*, Cambridge University Press, 1991.

EIGHTEEN *The Cloud of Unknowing*
William Johnston, *The Cloud of Unknowing and The Book of Privy Counseling*, Doubleday, 1973.
William Johnston, *The Mysticism of the Cloud of Unknowing*, Anthony Clarke Books, 1978.
Evelyn Underhill, *The Cloud of Unknowing*, Dover Publications, 2003.
Clifton Wolters (trans.), *The Cloud of Unknowing and Other Works*, Penguin Classics, 1961.

NINETEEN *Julian of Norwich*
Robert Llewelyn, *Enfolded in Love*, Darton, Longman & Todd, 1980.
Gloria Durka, *Praying with Julian of Norwich*, St Mary's Press, 1989.
Ritamary Bradley, *Julian's Way: A Practical Commentary on Julian of Norwich*, HarperCollins, 1992.
Grace Jantzen, *Julian of Norwich*, SPCK, 1992.
Madeleine O'Callaghan, 'Dame Julian of Norwich: A Perspective on Love', in Eileen Conn and James Stewart (eds), *Visions of Creation*, Jon Carpenter, 1996.

TWENTY *St Ignatius of Loyola*
George Aschenbrenner, *Stretched for Greater Glory*, Loyola University Press, 2004 – excellent explanation of the *Spiritual Exercises*.
William A. Barry, *Letting God Come Close*, Loyola University Press, 2003.
Sheila Dennis and Matthew Linn, *Sleeping with Bread*, Paulist Press, 1995 – explanation of the 'Examen'.
Michael Ivens, *Understanding the Spiritual Exercises*, Gracewing, 1998.
Joseph Munitiz, *St Ignatius of Loyola: Personal Writings*, Penguin Classics, 2005.
Hugo Rahner, *The Spirituality of St Ignatius*, Pergamon Press, 1968.
Philip Sheldrake, *The Way of St Ignatius*, SPCK, 1991.
William J. Young (trans.), *St Ignatius' Own Story*, Loyola University Press, 1982.

TWENTY-ONE *St Teresa of Avila*
Shirley du Boulay, *Teresa of Avila: An Extraordinary Life*, Bluebridge, 2004.
K. Egan, *The Carmelite Prayer*, Paulist Press, 2003.
E. Howells, *John of the Cross and Teresa of Avila: Mystical Knowing and Selfhood*, Crossroads, 2002.
J. McCaffrey, *Captive Flames*, Veritas, 2005.

J. McLean, *Towards Mystical Union: A Modern Commentary on the Mystical Text 'The Interior Castle' by St Teresa of Avila*, St Paul's, 2003.
E. Allison Peers, *Mother of Carmel: A Portrait of St Teresa of Jesus*, SCM Press, 1945.
E. Allison Peers, *Studies of the Spanish Mystics*, Burns & Oates, 1954.
J. Welch, *Spiritual Pilgrims: Teresa and Jung*, Paulist Press, 1982.
Rowan Williams, *Teresa of Avila*, Continuum, 2000.

TWENTY-TWO *St John of the Cross*
W. H. Auden, *Selected Poems*, Faber & Faber, 1979.
G. Brenan, *St John of the Cross: His Life and Poetry*, Cambridge University Press, 1973.
R. Inge, *Christian Mysticism*, Methuen, 1899.
I. Matthew, *The Impact of God*, Darton Longman & Todd, 1995.
S. Payne, 'The Influence of John of the Cross in the United States: A Preliminary Study', in *Carmelite Studies* VI, ICS, 2000.
F. Ruiz (ed.), *God Speaks in the Night*, ICS, 1991.
C. Thompson, *St John of the Cross: Songs in the Night*, SPCK, 2002.
J. Welch, *When Gods Die: An Introduction to St John of the Cross*, Paulist Press, 1990.

TWENTY-THREE *George Herbert and Thomas Traherne*
George Herbert
John Jeremiah Daniell, *The Life of George Herbert of Bemerton*, BiblioBazaar, 2009.
Graeme Watson, 'Poetry and Prayer Beyond Images', *The Way*, January 2007, Campion Hall Oxford.
Oliver Davies and Denys Turner (eds), *Silence and the Word*, Cambridge University Press, 2002.
Anna Jeffrey, *Five Gold Rings*, Dartman, Longman & Todd, 2003.
Mark McIntosh, *Mystical Theology*, Blackwell, 1998.
Isaak Walton and Charles Cotton, *The Compleat Angler*, Oxford Paperbacks, 2000.
Rowan Williams, *The Wound of Knowledge*, Wipf & Stock Publishers, 2001.

Thomas Traherne
A. M. Allchin, Anne Ridler and Julia Smith, *Aspects of Thomas Traherne: Profitable Wonders*, Amate Press, 1989.
Colin Burrow (ed.), *Metaphysical Poetry*, Penguin Classics, 2006.
Donald R. Dickson, *The Fountain of Living Waters*, University of Missouri Press, 1987.
Graham Dowel, *Enjoying the World: The Rediscovery of Thomas Traherne*, Continuum, 1990.
Denise Inge, *Thomas Traherne: Poetry and Prose*, SPCK, 2002.
David Scott, *Sacred Tongues: The Golden Age of Spiritual Writing*, SPCK, 2001.
Thomas Traherne, *Centuries of Meditation*, ed. Bertram Dobell, Cosimo Classics, 2007.

TWENTY-FOUR *The Jesus Prayer*
Elizabeth Behr-Sigel, *The Place of the Heart: An Introduction to Orthodox Spirituality*, trans. Stephen Bigham, Oakwood Publications, 1992.
Gabriel Bunge, *Earthen Vessels*, Ignatius Press, 2002.
R. M. French (trans.), *The Way of a Pilgrim*, SPCK/Triangle, 1942.
Irenee Hausherr, *The Name of Jesus*, Cistercian Studies 44, Cistercian Publications, 1989.
Archimandrite Sophrony, *The Undistorted Image: Staretz Silouan the Athenite*, Faith Press, 1958.
Kallistos Ware, *The Power of the Name*, Fairacres Publications, 1986.

TWENTY-FIVE *Evelyn Underhill*
Dana Greene, *Evelyn Underhill: Artist of the Infinite Life*, Darton, Longman & Todd, 1991.
A. M. Ramsey and A. M. Allchin, *Evelyn Underhill: Anglican Mystic*, Fairacres Publications, 1997.

TWENTY-SIX *Etty Hillesum*

Michael Downey, 'A Balm for All Wounds: The Spiritual Legacy of Etty Hillesum', *Spirituality Today*, 40/1, Spring 1988, pp. 18–35.

Peter King, *Dark Night Spirituality: Thomas Merton, Dietrich Bonhoeffer, Etty Hillesum: Contemplation and the New Paradigm*, SPCK, 1995.

Elizabeth O'Connor, 'The Thinking Heart', *Sojourners*, October 1987, pp. 40–2.

Alexandra Pleshoyano, 'Etty Hillesum: For God and with God', *The Way*, 44/1, January 2005, p. 20.

Rowan Williams, 'Religious Lives', Romanes Lectures, Oxford, 2004, available at www.archbishopofcanterbury.org/1043

Patrick Woodhouse, *Etty Hillesum: A Life Transformed*, Continuum, 2009.

TWENTY-SEVEN *Thomas Merton*

A. M. Allchin, 'Can We Do Wales Then?' *The Merton Journal* 13/2, 2006.

R. Baker and G. Henry (eds), *Merton and Sufism: The Untold Story*, Fons Vitae, 1999.

J. Forest, *Living with Wisdom: A Life of Thomas Merton*, Orbis, 1991.

M. Furlong, *Merton: A Biography*, Darton, Longman & Todd, 1985.

P. M. Tyler, 'Sufism and Christianity', in *The New SCM Dictionary of Christian Spirituality*, ed. P. Sheldrake, SCM Press, 2005.

P. M. Tyler, 'Thomas Merton: Ikon of Commitment for the Postmodern Generation', *The Way* Supplement 2000, p. 98.

TWENTY-EIGHT *Swami Abhishiktananda*

Shirley du Boulay, *The Cave of the Heart: The Life of Swami Abhishiktananda*, Orbis, 2005.

Shirley du Boulay (ed.), *Swami Abhishiktananda: Essential Writings*, Orbis, 2006.

Sara Grant, *Swami Abhishiktananda: The Man and his Message*, ISPCK, 1993.

Harry Oldmeadow, *A Christian Pilgrim in India*, World Wisdom, 2008.

Murray Rogers and David Barton, *Abhishiktananda: A Memoir of Dom Henri le Saux*, Oxford Sisters of the Love of God, 2003.

Video: *Swamiji: An Interior Journey*.

TWENTY-NINE *Bede Griffiths*

Bruno Barnhart (ed.), *One Light: Bede Griffiths' Principal Writings*, Template Publishers, 2002.

Shirley du Boulay, *Beyond the Darkness*, Doubleday, 1998.

Beatrice Bruteau, *'The Other Half of My Soul'*, Quest Books, 1996.

Kathryn Spink, *A Sense of the Sacred*, SPCK, 1988.

Wayne Teasdale, *Toward a Christian Vedanta*, Asian Trading Corporation, 1987.

Judson Trapnell, *Bede Griffiths: A Life in Dialogue*, State University of New York Press, 2001.

THIRTY *John Main*

Laurence Freeman (ed.), *John Main: The Essential Writings*, Orbis, 2002.

Laurence Freeman and Stefan Reynolds (eds), *John Main: The Expanding Vision*, Canterbury Press, 2009.

Paul T. Harris (ed.), *John Main by Those Who Knew Him*, Darton, Longman & Todd, 1991.

Paul T. Harris, *John Main: A Biography*, Medio Media, 2009.

Monastic Studies 15, Advent 1984, In Memory of John Main, Benedictine Priory of Montreal, 1984.

Peter Ng (ed.), *The Hunger for Depth and Meaning*, Medio Media, 2007.